1993

THE PELICAN HISTORY OF ART

Founding Editor: Nikolaus Pevsner

Joint Editors: Peter Lasko and Judy Nairn

J. B. Ward-Perkins

ROMAN IMPERIAL ARCHITECTURE

John Ward-Perkins, born in 1912, was from 1946 to 1974 Director of the British School at Rome. He taught in the United States and in Australia, and conducted architectural research and excavations in Italy, North Africa, Turkey, and Britain. He was largely responsible for the 'Pompeii A.D. 79' exhibition. The best known of his many publications are his and Jocelyn Toynbee's *The Shrine of St Peter* (1956) and his *Cities of Ancient Greece and Italy* (1974). John Ward-Perkins died in 1981.

J. B. Ward-Perkins *Roman Imperial*

Architecture

Penguin Books

PENGUIN BOOKS

Published by the Penguin Group
27 Wrights Lane, London w8 5TZ, England
Viking Penguin, a division of Penguin Books USA Inc.,
375 Hudson Street, New York, New York 10014, USA
Penguin Books Australia Ltd, Ringwood, Victoria, Australia
Penguin Books Canada Ltd, 2801 John Street, Markham, Ontario, Canada L3R 1B4
Penguin Books (NZ) Ltd, 182–190 Wairau Road, Auckland 10, New Zealand

Penguin Books Ltd, Registered Offices: Harmondsworth, Middlesex, England

First published as Parts Two–Four of *Etruscan and Roman Architecture* 1970
Second (integrated) edition published under the title *Roman Imperial Architecture* 1981
Reprinted 1983, 1985, 1987, 1989, 1990

Library of Congress Cataloging in Publication Data
 Ward-Perkins, John Bryan, 1912–1981
 Roman imperial architecture
 (The Pelican history of art)
 Bibliography: p. 498.
 Includes index.
 1. Architecture, Roman. I. Title. II. Series:
 Pelican history of art.
 NA310 W34 722′.7 79-26799

ISBN 0 14 0560 45 9 (U.K. hardback)
ISBN 0 14 0561 45 5 (U.K. and U.S. paperback)

Made and printed in Great Britain
Typeset in Monophoto Ehrhardt by Filmtype Services Limited, Scarborough
Printed by Butler & Tanner Ltd, Frome and London

Series design by Gerald Cinamon
This volume designed by Bob Wright

CONTENTS

FOREWORD

In its original form the present work appeared as part of a composite volume, of which the first section, by the late Axel Boëthius (now issued separately), covered the architecture of the Etruscans and of Republican Rome and the remaining three sections, by myself, that of Imperial Rome. This first edition was at the time criticized as, in effect, consisting of two distinct books, juxtaposed between two covers but not interwoven into a single continuous narrative. There was some justification in this criticism. Given the very different scale and character of the source material and the necessarily rather differing approaches of Boëthius and myself to that source material, some lack of continuity was almost inevitable. But the problem was undoubtedly exacerbated by the terms of the chronological and geographical framework within which each of us was working; and although the appearance of this second edition as two distinct volumes has removed the element of internal inconsistency, the break in continuity of treatment between the earlier, formative stages of Roman architecture and its full flowering under the Empire still remains. A few introductory words of explanation and clarification seem to be called for.

Boëthius's text deals almost exclusively with the architecture of central Italy, and in particular of Rome itself, from its beginnings down to the emergence of the 'consuetudo italica', that highly successful marriage of the native Italic and Hellenistic Greek traditions which characterized the architecture of Rome and of Campania during the closing years of the Roman Republic. This is a story that can quite legitimately be told almost exclusively in terms of a steady onward progress within Italy itself, and west central Italy at that. Except in so far as the conquest of the Greek east in the second century B.C. intensified the processes of Italo-Hellenistic

assimilation that were already at work, the provinces were not directly involved. Viewed in this perspective it is a fair assessment of Augustus's great building programme in the city of Rome that it was 'mainly a new, more splendid, classicized version of the hellenized late Republican town'. Well into the first century A.D. the history of architecture in the capital did continue to be rooted in the ideas and traditions of its own recent past, backed by greatly increased resources but with very little real change of heart. It is a remarkably consistent, self-contained story, and one that can be told with surprisingly little reference to current events elsewhere.

But perspectives change according to one's viewpoint, and continuity casts its shadow backward as well as forward. The present volume starts with the fall of the Roman Republic. But although as a political institution the Roman Empire only took shape after the assassination of Julius Caesar in 44 B.C. and the triumph of his nephew and heir, the future emperor Augustus, in 31, as a territorial fact the Roman Empire had by then been in existence for well over a century; and while it is true that in these early stages Greece was emphatically the dominant partner in the resulting cultural exchange and that the reciprocal influence of Italy on most of the Greek east was still very limited, the future was already taking shape: no student of Roman Imperial architecture can afford to ignore the fact of Republican Rome's territorial expansion. In very few of the provinces is the architecture of the early Empire intelligible without reference to its own recent past, and even in Italy it is becoming steadily more apparent that late Republican architecture did not present the sort of monolithic unity which a more narrowly Romanocentric vision is apt to suggest. Side by side with the architecture

of the capital it comprised a number of distinctive local architectures, in Campania, in southern Italy and Sicily, in the new Roman cities of the north, and in the rest of peninsular Italy. Of these one may perhaps leave the last-named out of account as being almost exclusively derivative. Southern Italy, on the other hand, and Sicily had almost as much in common with late Punic North Africa as with Rome, an association which inevitably left its mark on subsequent developments, while North Italy was the seed-bed and forcing-house of many of the schemes of planning and the architectural stereotypes that were to shape the early Imperial architecture of the European provinces. Campania occupies a more equivocal position. In certain respects, notably in the development of the new concrete-vaulted building technology, Latium and Campania were at one. But there were also many popular Roman building types that originated in Republican Campania, among them the amphitheatre built of masonry, the Roman-type theatre, the heated bath-building, the macellum, almost certainly the basilica, and very possibly the combined atrium-peristyle house. The list is an impressive one; and although with the Augustan settlement the balance of architectural patronage and creativity swung decisively away from Campania to the capital, the architectural legacy of Republican Campania was unquestionably a factor of considerable importance in shaping the larger Imperial scene.

Another factor making for discontinuity of treatment between Boëthius's volume and my own is the dramatic increase in scale as one moves out into an Empire that stretched from the Tyne to the Euphrates. No treatment of nearly four centuries of the history of this vast area can be all-embracing. It has to be selective, not only in its choice of individual monuments for discussion but also in its choice of those aspects of them that are significant in the larger setting. So far as is possible in the present state of knowledge I have tried to strike a consistent balance between the impersonal political, geographical, social, and cultural forces that conditioned them and the more intimately personal contributions of patron and architect; but the most that I can hope to have achieved is the presentation of a reasonably coherent picture of some of the forces that were at work shaping the larger scene, within which each individual reader will have to make his own assessment of the buildings that especially concern him. The sheer quantity of fresh source material that has become available in some areas during the twenty-odd years since I started work on the first edition, and our continued ignorance of other areas that are potentially no less important, would both make nonsense of any more exaggerated claim.

In revising this second edition, I am once again conscious of my indebtedness to friends and colleagues far too numerous to name individually. Where I have referred to the results of work that is as yet unpublished I have tried to acknowledge this in the relevant notes, but even here I am conscious of omissions. In this foreword I must be content to name a few of those who have been especially helpful in checking and preparing the text and illustrations of this edition. To Roger Agache, Fernando Castagnoli, Lucos Cozza, Robert Etienne, Mark Hassall, Teofil Ivanov, Peter Parr, Jim Russell, Michael Strocka, Yoram Tsafrir, Luciana Valentini, Susan Walker, John Wilkes, and, last but far from least, Sheila Gibson, whose contribution to both editions is so inadequately represented by the small print at the end of this volume: to them and to all those others who have been so generous with their time, knowledge, and practical advice I express my warmest thanks.

Cirencester, August 1979

Maps

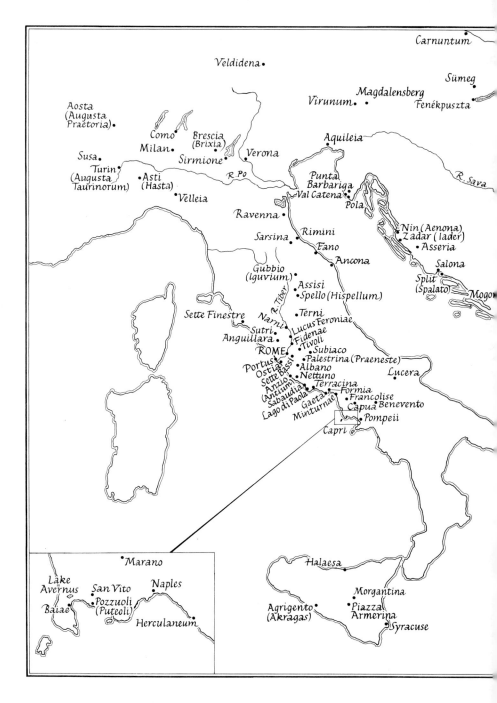

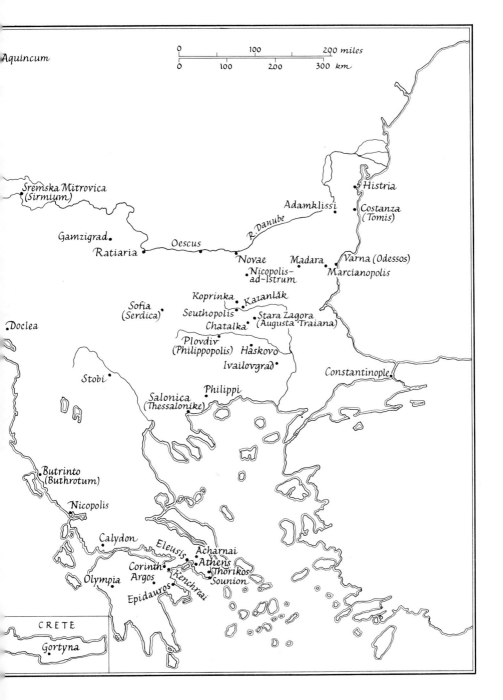

Aquincum

0 100 200 miles
0 100 200 300 km

Sremska Mitrovica
(Sirmium)

Histria

Adamklissi

Costanza
(Tomis)

R. Danube

Gamzigrad

Ratiaria Oescus

Novae Madara Varna (Odessos)

Nicopolis-
ad-Istrum Marcianopolis

Koprinka Kazanlâk

Sofia
(Serdica) Seuthopolis Stara Zagora
Chatalka (Augusta Traiana)

Doclea

Plovdiv
(Philippopolis) Hâskovo

Ivailovgrad Constantinople

Stobi

Philippi

Salonica
(Thessalonike)

Butrinto
(Buthrotum)

Nicopolis

Calydon

Eleusis Acharnai

Corinth Athens

Olympia Argos Thorikos
Kenchrai Sounion

Epidauros

CRETE

Gortyna

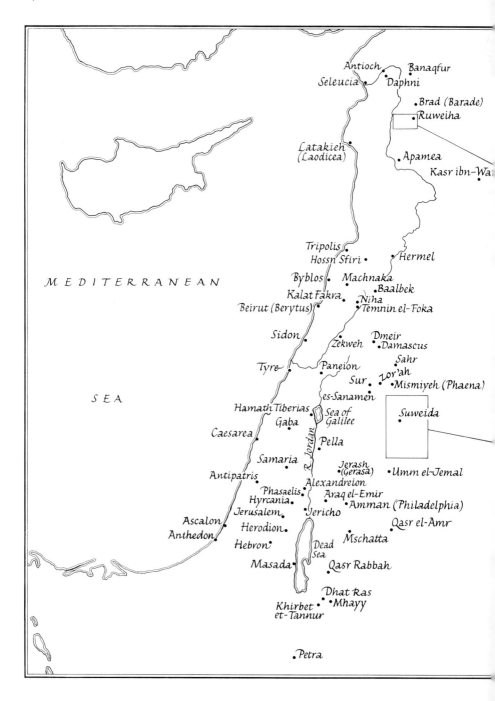

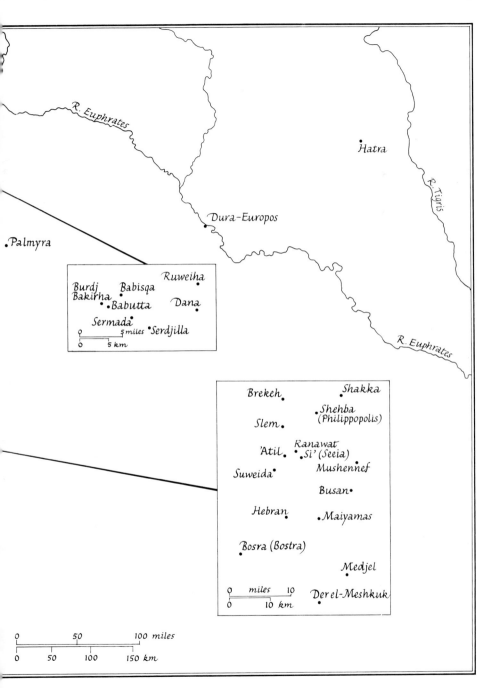

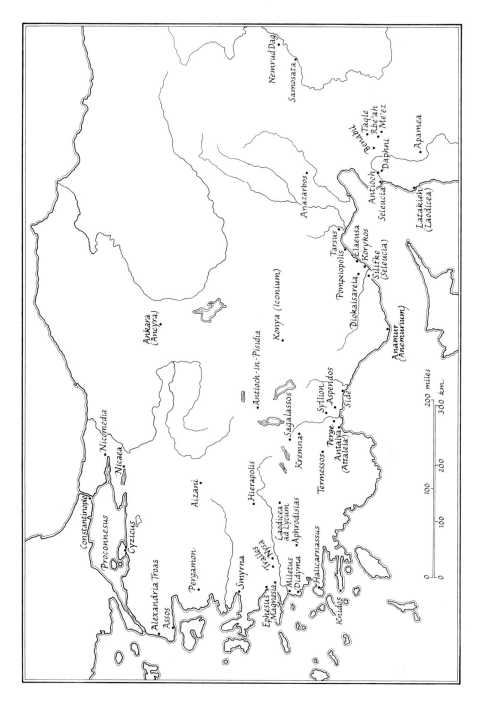

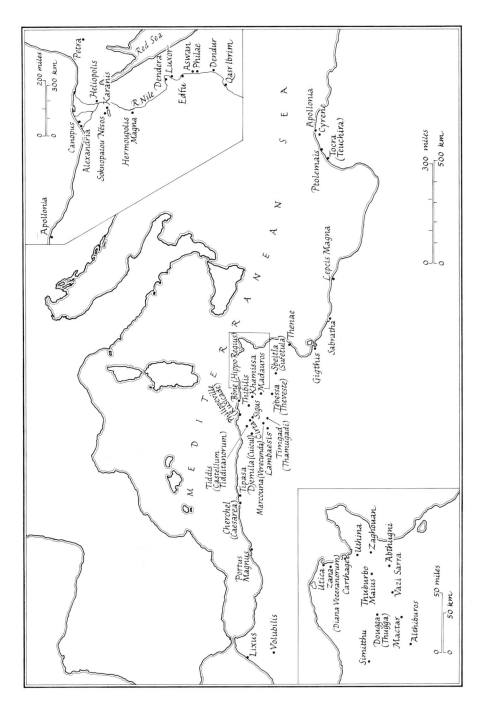

ROMAN IMPERIAL ARCHITECTURE

ARCHITECTURE IN ROME AND ITALY
FROM AUGUSTUS
TO THE MID THIRD CENTURY

CHAPTER I

AUGUSTAN ROME

In 44 B.C. the murder of Caesar plunged the Roman world into the last and bloodiest of the civil wars that had bedevilled the last century of the Republic. It was not until thirteen years later, in 31, that the defeat of Antony and Cleopatra left as undisputed ruler of the Roman world Caesar's nephew and heir, Caesar Octavian, and indeed four years later still, in 27, that Octavian was granted the title of Augustus and his position formally established upon an effective, if not yet explicitly acknowledged, basis of individual personal rule. Now, for the first time within living memory, the civilized world was able to draw breath and to profit from a long period of internal peace and stable government. Now, at last, the immense energies and creative potentialities of the Rome of Sulla and Cicero, Pompey and Caesar could find a constructive outlet in the ordering and developing of the Empire of which she suddenly found herself the undisputed centre and mistress.

One of the first beneficiaries of the new situation was the city of Rome itself. It was Augustus's boast that he 'found Rome a city of brick and left it a city of marble', and in his autobiographical testament, the *Res Gestae Divi Augusti*, we have in his own words a list of the public monuments in Rome which he claimed to have built or restored.[1] When one recalls that this list makes no mention of the many impor-

tant buildings created in the capital on the initiative of other magistrates or wealthy private citizens, it is indeed an impressive document; and since through all its many vicissitudes the subsequent architectural development of the city during the Empire took place very largely within the framework established by Augustus, it is with the Augustan city and its buildings that any study of the Roman architecture of the Imperial Age is bound to start.

We do not lack for information. The record of building activity in the capital between the death of Caesar and that of Augustus in A.D. 14 is almost embarrassingly full by comparison with the number of surviving monuments. To follow it up in all its detail would be to compile a list of buildings about many of which we know virtually nothing except the fact and circumstances of their erection. Nevertheless it is important to have some idea of the extent and character of the building programme as a whole. One of the most striking characteristics of the surviving Augustan buildings is their variety; and although this may be explained in part as the product of an age in rapid transition, it was undoubtedly accentuated by the legacy of the recent past, by the diversity of patronage in its early, formative stages, and by the very size of a programme that could only be carried out by pressing into service all the very varied re-

sources available. These have left their mark upon the surviving buildings; and before turning to the latter, it is essential first to glance at the historical record.

One very important factor in shaping the early development of Augustan architecture was the legacy of ideas and of uncompleted buildings inherited from Julius Caesar, at the vigour and versatility of whose vision one cannot cease to marvel. His was the grandiose conception of replanning the city on the partial basis of which Augustus, through Agrippa, laid out large parts of the Campus Martius and himself remodelled the ancient centre of the Forum Romanum; his were the first plans for the Saepta and the Theatre of Marcellus, the Curia, the two basilicas in the forum, and the Rostra; it is in his buildings that we find the first consistent use of the mortar made with red pozzolana which was to revolutionize Roman building practice; and it is almost certain that it was he who first envisaged the hardly less revolutionary innovation of the large-scale exploitation of the quarries of Carrara (Luni). It is characteristic of the sober genius of Augustus that he recognized the significance of the programme of his brilliant predecessor, and that he was able to put so much of it into practice.

Another important legacy from the preceding age was the tradition whereby triumphing generals were expected to contribute to the public welfare by devoting a part of the booty from their campaigns to building. Several of the most important works of Augustus himself and of his successor, Tiberius, are recorded as having been paid for *ex manubiis* (i.e. from spoils of war); and many of the buildings in the period immediately following the death of Caesar were in fact the work of public-spirited or politically ambitious private individuals. In an age when the tastes of the patron were still an important factor, this circumstance alone would have been enough to ensure a considerable stylistic variety. Recorded examples of such private munificence include a temple of Neptune in the Circus Flaminius, vowed in 42 B.C. by L. Domitius Ahenobarbus, a follower of Brutus and later of

Antony, and built probably in 33 B.C.; the restoration of the very ancient shrine of Diana on the Aventine by L. Cornificius at some date after 33 B.C.; the Amphitheatre of Statilius Taurus in the Campus Martius, dedicated in 30 B.C. and the first stone amphitheatre in the capital; the Porticus Philippi and the Temple of Hercules Musarum, built by L. Marcius Philippus in the late thirties or early twenties; the Atrium Libertatis, built after 39 B.C. by C. Asinius Pollio, another friend of Antony, to house the first public library in Rome; and, one of the last of these great private benefactions, the Theatre of Balbus, built by L. Cornelius Balbus and dedicated in 13 B.C. Of none of these, except for traces of the Theatre of Balbus beneath the Palazzo Caetani and possibly of the Temple of Neptune, are there any identifiable remains, although the plans of several are known from the Severan marble map of Rome [61].[2]

Other Augustan buildings have been more fortunate. For example, of the restoration of the Temple of Saturn in the Forum Romanum undertaken, probably in the early twenties, by L. Munatius Plancus enough remains to show that it was built partly of Italian marble; the surviving column bases are of an unusual hybrid form, which probably represents an early attempt at translating into the new medium a type that was current in Late Republican Rome. The Regia, the official residence of the Pontifex Maximus, restored after a fire by Cn. Domitius Calvinus in 36 B.C., is another early marble building of which the carved detail betrays the inexperience of the masons engaged upon it. By contrast, the Temple of Apollo in Circo is a building of considerable technical refinement. The elaborately carved detail [1] closely resembles that of the arch erected in the forum in 19 B.C. in honour of Augustus's diplomatic victory over the Parthians, with which it must be roughly contemporary. The gulf that separates the elegant, sophisticated work on this temple from that of the Regia or the Temple of Divus Julius, dedicated in 29 B.C., is the measure of the variety which was possible even

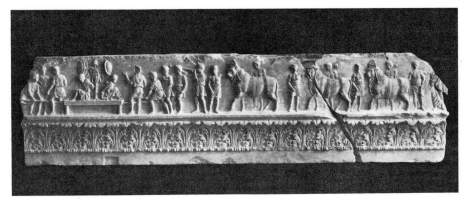

1. Rome, Temple of Apollo in Circo, *c.* 20 B.C., frieze from the interior of the cella

in this early phase, and which was to provide the ferment for so much of the later Augustan achievement.[3]

After Augustus himself, the great builder of the first half of his reign was his friend and collaborator, Marcus Agrippa, whom we find already in 33 B.C. engaged upon the programme of public works with which he was to be concerned off and on until his death in 12 B.C.[4] A great deal of his work was of a strictly practical, utilitarian character. Under his direction the whole drainage system of the city was overhauled and renovated; the retaining walls of the Tiber were repaired against flooding and a new bridge, the Pons Agrippae, added; a fine new warehouse, the Horrea Agrippiana, was built beside the Vicus Tuscus, between the Forum Romanum and the riverside wharves of the Forum Holitorium; and the city's water supply was doubled by the radical restoration and enlargement of the four existing aqueducts and by the addition, by Agrippa and after his death by Augustus himself, of no less than three that were new, the Aqua Julia in 33 B.C., the Aqua Virgo in 19 B.C., and the Aqua Alsietina in 2 B.C. Not much of Agrippa's own work has survived the repairs and restorations of the centuries. It remained, however, the basis of almost all subsequent work in these fields, and an interesting record of a slightly later phase of the same

programme can be seen in the still-surviving arch which carried the restored Aqua Marcia (5 B.C.) over the Via Tiburtina, and which was later incorporated into the third-century walls as one of the city gates [2]. Built throughout of travertine, it is a characteristically Augustan monument, in its material and detail still firmly rooted in the practices of the later Republic, but formally, with its archway framed by pilasters and pediment, already reaching out towards the new types of arch and gateway that were to play so large a part in the monumental architecture of the Empire.

Agrippa's activities as a builder were not by any means limited to this severely practical programme. On the level ground of the Campus Martius he built a whole new monumental quarter, which included the Saepta, the Pantheon, the Basilica Neptuni, and a bathbuilding, the Thermae Agrippae, laid out in a spacious setting that included gardens, porticoes, a canal, and an artificial lake. The whole area was swept by the disastrous fire of A.D. 80, and little or nothing of Agrippa's work has come down to us. The Saepta, completed in 26 B.C., is recorded as having been an enclosure with marble porticoes a mile in length. Of Agrippa's Pantheon, dedicated the following year, the core of the podium has been recognized, incorporated within the foundation of its Hadrianic

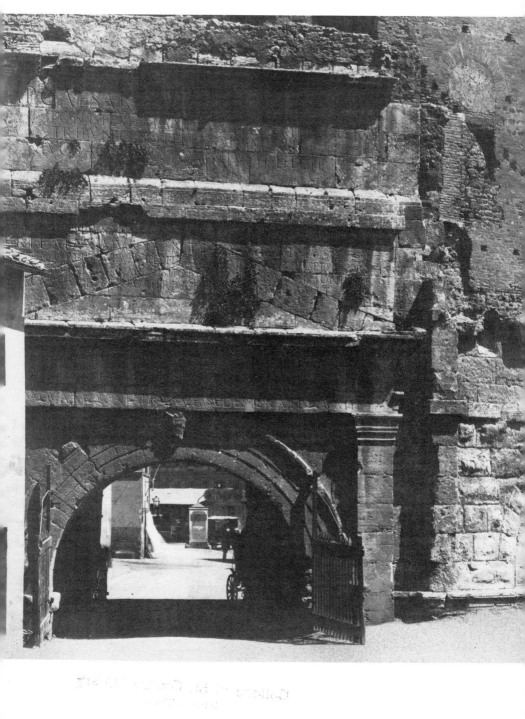

successor; the plan appears to have resembled that of the Temple of Concord, with a porch which was narrower than the body of the temple behind it.[5] Of the Basilica Neptuni also dedicated in 25 B.C. we know nothing except that it was also known as the Stoa of Poseidon, and was presumably therefore a multiple columnar building, open along one side in the manner of the Republican basilicas of the Roman forum. Of the Thermae, which were served by the Aqua Virgo and cannot therefore have been completed until after 19 B.C., enough is known to show that they merited their reputation as the first of the series of great public bath-buildings that were to play so large a part in the later development of Roman monumental architecture.

The details are scanty, but they are enough to show that Agrippa's work in Rome offers in miniature a faithful picture of the Augustan building programme as a whole in its early, formative stage. The utilitarian programme, tuned as it was to the practical requirements of daily life, was conservative in character. The sewers were built in squared stone, the aqueducts in typical contemporary concrete work, with a rather coarse facing of tufa reticulate; the bridge over the Tiber, which disappears from the record at an early date, may have been an experimental, and in the event unsuccessful, venture in the latter medium. For work of a more spectacular character we have to turn to Agrippa's monuments in the Campus Martius. The Saepta, which he inherited from Caesar, had been one of the first Roman buildings of this size, if not the very first, to be planned in marble.[6] We shall never know whether, in conceiving this grandiose project, Caesar intended from the first to make use of the marble of Carrara; but it was certainly the opening of these quarries that made this aspect of Augustus's building programme possible, and by the twenties the new material was evidently already available in large quantities. The Pantheon, too, must have been built partly at any rate in marble, and Pliny records the significant detail that the columns, presumably those of the porch, were decorated with caryatid figures by the Athenian sculptor Diogenes.[7] The influence of Athenian craftsmen is one of the continuing features of the Augustan scene, culminating in the Forum Augustum, the many classicizing Attic details of which again included caryatid figures, copied from those of the Erechtheion [9]. In the case of the Pantheon we can document not only the fact but also something of the circumstances of the loan. One of the few buildings which Agrippa is known to have built outside the city of Rome is the odeion in the Agora at Athens [168], a building which in its own way represents a no less striking convergence of Greek and Roman tastes and skills, Greek in its material, craftsmanship, and detail, Roman in its bold axial relationship to the other buildings of the Agora, and in the technical experience that devised its huge timber roof of 80 foot unsupported span.[8] There is nothing to suggest that Cicero's correspondent, Appius Claudius Pulcher, the donor of the Inner Propylaea at Eleusis, was ever responsible personally for any public building in Rome. But it was undoubtedly enterprises such as these which afforded the background of reciprocal Graeco-Roman exchange that is so characteristic of the Augustan Age.

Of the buildings erected by Augustus himself and listed in the *Res Gestae* we are fortunate in possessing the remains of several of the most important. None is complete, and of several others, such as the temples of Divus Julius and Apollo Palatinus or the mausoleum, the surviving elements are tantalizingly fragmentary. But enough has come down to us to convey at least a partial picture of the quality as well as the mere quantity of the architecture of Augustan Rome.

2 (*opposite*). Rome, Porta Tiburtina. Arch, 5 B.C., carrying the Aqua Marcia across the Via Tiburtina, later incorporated as a gateway into the Aurelianic Walls (A.D. 270–82)

The Theatre of Marcellus [3, 4] owes its preservation to its conversion in the Middle Ages into a fortress, and in the sixteenth century a palace, of the Savelli family. Projected though probably not actually begun by Caesar on the site of the old theatre-temple complex *ad Apollinis* built by M. Aemilius in 179 B.C.,[9] it was not finally completed and dedicated until 13–11 B.C. The stage-building still lies buried; to judge from its representation on the Severan stage-buildings of later practice.[10] The substructures of the seating, on the other hand, are well preserved beneath the later palace, and the curved façade, freed from later accretions and restored, is among the most impressive surviving monuments of the capital. The scheme of the façade, a system of superimposed arcades framed within the compartments of orders that are purely decorative, stems directly from the traditions of the later Republic, as represented

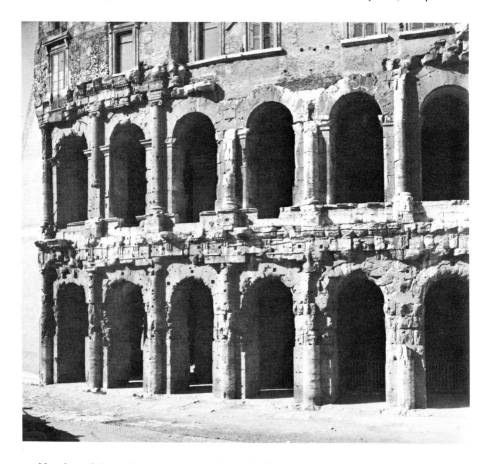

marble plan of Rome it was, and remained through successive restorations, quite simple in plan, with none of the elaborate play of projecting and receding features that characterizes the in the great sanctuaries at Praeneste (Palestrina) and at Tivoli and, in Rome itself, in the Tabularium.[11] The principal advances on the earlier buildings are the use of travertine for the

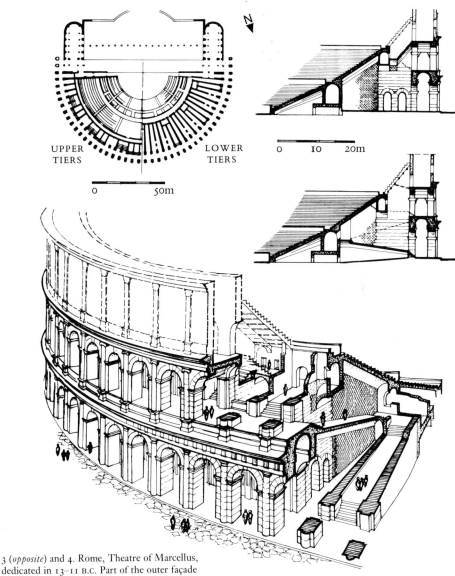

UPPER TIERS · LOWER TIERS

0 50m

0 10 20m

3 (*opposite*) and 4. Rome, Theatre of Marcellus, dedicated in 13–11 B.C. Part of the outer façade and plan, sections, and sectional view

entire façade and the greater boldness of the rhythm of contrasting voids and solids. It has usually been assumed that the external order was triple, as later in the Colosseum. It should, however, be noted that in fact only the two lower orders, Doric and Ionic respectively, are preserved, and some scholars have suggested that the lost superstructure may have been a

plain attic (as, for example, in the amphitheatre at Pola, in Istria) rather than the Corinthian order of canonical practice.

That there was a superstructure of some sort, corresponding in height approximately to the walls of the present palace (which thus presents an appearance not altogether dissimilar to that of the Roman building), is certain from the remains of the seating and of the elaborate substructures that supported it. The latter [4], built partly of cut stone and partly of reticulate-faced concrete with concrete barrel-vaults, were radially disposed, incorporating an ingeniously contrived system of ascending ramps and annular corridors for the ingress and egress of the spectators (about 11,000 according to the latest calculation), who sat in three ascending tiers of seats, each tier pitched more steeply than the one below it, and the uppermost certainly of timber. The outer corridor was vaulted with a series of radially disposed barrel-vaults carried on massive transverse architraves, one bay to each compartment of the façade, in order to counteract the outward thrust of the upper tiers of seating. The façade and outer ring of galleries were in effect as much a gigantic buttressing feature as a convenience in handling large crowds of spectators, and they demonstrate the characteristic ingenuity with which the Roman architect was prepared to turn such problems to practical advantage. While the theatre derives directly from the great Republican monuments of Latium, it looks forward no less directly to such engineering masterpieces as the Colosseum.

The Theatre of Marcellus represents a substantially pre-existing Republican tradition of building which was able to survive, with remarkably little new admixture, the impact of the Augustan Age. It was a developing tradition, but the development was in answer to new practical demands rather than to the stimulus of ready-made ideas brought from without. At the other end of the scale we have a monument such as the Ara Pacis Augustae [5], the Altar of the Augustan Peace, which once stood on the west side of the Via Flaminia just north of Agrippa's

buildings.[12] Decreed in 13 B.C. and dedicated four years later, it consisted of an almost square enclosure on a low platform and, on a smaller, stepped platform in the centre, the altar itself. The whole of the superstructure is of Carrara marble, and the elaborately carved detail, which includes symbolic figured panels, a long processional frieze, panels of spreading acanthus scrollwork, and a frieze of pendant garlands, is of a quality unsurpassed in the history of Roman monumental sculpture. Here is a monument for which there was no native tradition. The material, marble, was one of recent introduction, and from the detail of the ornament it can be seen that the workmen who carved it were Greek. Even the plan of the altar seems to be derived from that of the Altar of Pity in the Athenian Agora. And yet the content of the monument and the theme that it expresses are already subtly but unmistakably Roman. No idealized procession this, but a portrayal of the actual procession which took place on the fourth of July 13 B.C.; and the figured carvings stand at the head of the long line of architectural reliefs which are one of Rome's principal contributions to the sum of classical artistic achievement. At no moment in the history of Roman architecture was the Roman genius for adopting, adapting, and taking creative possession of the traditions of others to play a larger part than in the Augustan Age.

The traditionalism of the Theatre of Marcellus and the hellenism of the Ara Pacis represent the two poles of Augustan architectural taste. It was the mingling of these two currents that provided the ferment for much that was best and most vigorous in this and the immediately ensuing period. Nowhere is this process illustrated better than in the Forum Augustum, which in many respects marks the culmination of Augustus's whole building programme [6, 7]. The Temple of Mars Ultor (Mars the Avenger), which stood in the same relation to the forum as the Temple of Venus Genetrix to the Forum of Caesar, had been vowed as long before as the battle of Philippi in 42 B.C.; but it was still incomplete when the

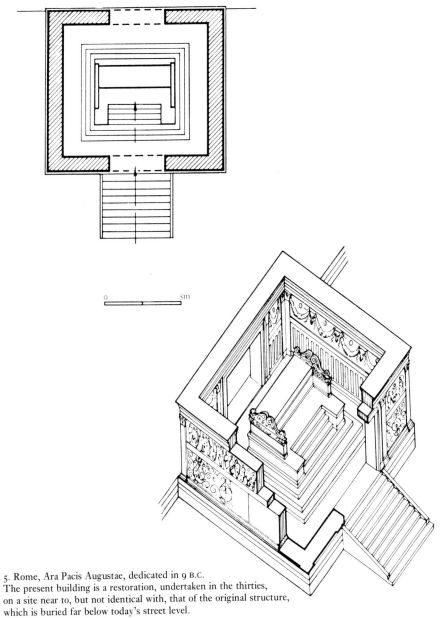

5. Rome, Ara Pacis Augustae, dedicated in 9 B.C.
The present building is a restoration, undertaken in the thirties,
on a site near to, but not identical with, that of the original structure,
which is buried far below today's street level.
Plan and axonometric view

6. Rome, the Imperial Fora. Plan

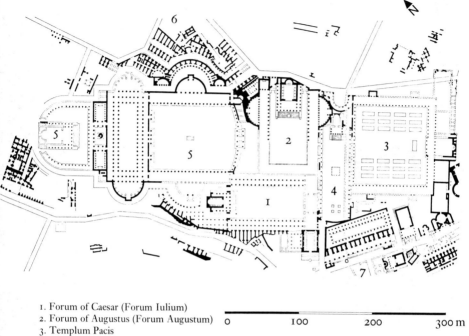

1. Forum of Caesar (Forum Iulium)
2. Forum of Augustus (Forum Augustum)
3. Templum Pacis
4. Forum Transitorium
5. Forum of Trajan and Basilica Ulpia
6. Markets of Trajan
7. North-east corner of the Forum Romanum

0 100 200 300 m

forum itself was inaugurated in 2 B.C., and much of the work of both buildings belongs undoubtedly to this later period. The forum and the temple may reasonably be regarded as representative of the architecture of the Augustan Age at the moment of its full maturity.

The purpose of the forum, like that of the Forum of Caesar before it, was to provide additional space for the public needs of the growing population of the city, and it followed essentially the plan established by its predecessor, though in a considerably developed form and more compactly self-contained. The temple stood at the far end of an elongated open space flanked by two colonnaded halls, off which opened two semicircular courtyards set at the extremities of a cross-axis that corresponds with the line of the façade of the temple. Today, with

the lateral halls razed and half the length of the forum buried beneath the street, the proportions look very different [7]; but when standing the temple, which was almost square in plan with a deep porch, can only have been really visible from the front and, set on its lofty podium at the head of a flight of seventeen steps, it towered impressively above the long, surprisingly narrow space between the flanking porticoes [8]. Suetonius records the further detail that Augustus was unable to purchase all the land that he wished to use. This probably refers principally to the east corner, where the resulting asymmetry of the ground plan was skilfully concealed by the flanking porticoes.

For all the hellenizing detail, and there was much of this, the basic conception of the design was very Roman. The plan itself, with the

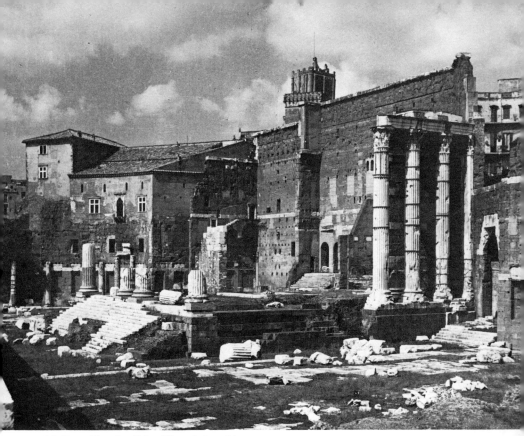

7 and 8. Rome, Temple of Mars Ultor, dedicated in 2 B.C.,
and part of the Forum Augustum, with restored view

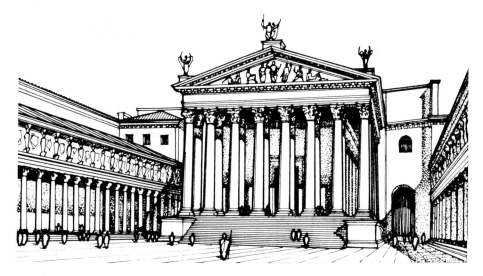

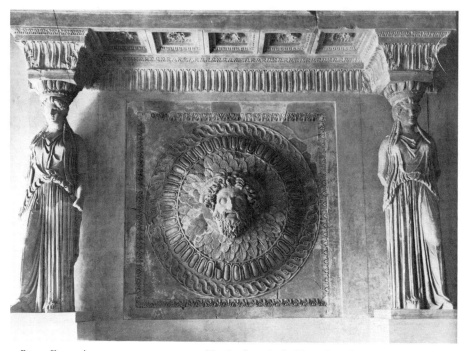

9. Rome, Forum Augustum, *c.* 10–2 B.C., caryatid order from the flanking colonnades

temple set on a lofty platform against the rear wall dominating the rectangular space before it, is in the direct Italian tradition; so too is the rigid axiality of the whole design, imposed forcibly on the ground, where a Greek architect might well have preferred to exploit the irregularities of the setting. Roman architects were always prone to treat individual monuments in isolation, and in this case the effect was accentuated by the enormous precinct wall, 115 feet (35 m.) high, which served the double purpose of a firebreak and a visual screen between the forum and the crowded tenement quarter of the Subura. The sense of enclosure was made more complete by the height of the flanking porticoes, the façades of which carried an attic above the colonnade, upon which caryatid figures supported a coffered entablature and framed a series of roundels carved with the heads of divinities. The only contrasting accent was that

afforded by the two courtyards that opened off the inner sides of the porticoes. They doubtless served a practical purpose, probably as courtrooms, and their form may well have been suggested in the first place by the limitations of the space available at the east corner of the building. The introduction of a discreet cross-accent was, however, a no less characteristically Roman device, taken up and developed a century later in the Forum of Trajan.

The broad concept of the forum, then, its purpose and its plan are all characteristically Roman. In its detail, on the other hand, there was a great deal that was new and exciting. Whereas the splendid bossed masonry of the enclosure wall, with its skilful alternation of Gabine stone and travertine, is in the best Late Republican tradition, the finely drafted marble masonry of the temple, with its tall socle of marble orthostats capped by a projecting course

decorated with a carved maeander, is no less distinctively Greek, almost certainly from Asia Minor and derived from the same source as, for example, the Temple of Augustus at Ankara [179]. That the architect was also familiar with the monuments of Attica, including such near-contemporary buildings as the Inner Propylaea at Eleusis, is clear from such features as the caryatids of the forum [9] and an exquisite

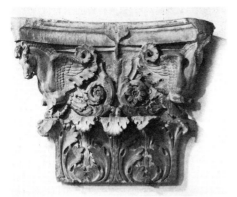

10. Rome, Temple of Mars Ultor, dedicated in 2 B.C., figured pilaster capital from the interior of the cella

Pegasus pilaster-capital from the temple [10], as well as from a great many details of the mouldings of both forum and temple. Many of the workmen too must have been Greek, brought in to work the profusion of marble columns, entablatures, pavements, and wall-veneers with which the forum was enriched – not only the white marble of Carrara, but coloured marbles from Numidia, Phrygia, Teos, Chios, and Euboea, to name only those that can still be seen in place. This was not the first time that coloured marbles had made their appearance in Rome, but it was the first time that they had been used on this lavish scale. The contrast between the gleaming white of the temple and the profusion of colour around it must have been as effective as it was novel, provoking Pliny to class this with the Basilica Aemilia (another lavishly marbled building) and Vespasian's Templum Pacis as the three most beautiful buildings in the world.[13]

About the interior of the temple, which was gutted by the marble-burners of the Middle Ages, we know sadly little except that it was very richly detailed. There was an apse, in which stood statues of Mars, Venus, and the Deified Julius, and the roof was supported by two lines of columns set out from the walls, with corresponding pilasters against the walls themselves. One of the column bases, recorded in the Renaissance, closely resembles those of the Temple of Apollo in Circo, indicating yet another strain in the pedigree of the ornament of the temple and forum.[14] These strains had not yet fused, and never did fuse, into a single 'Augustan' style; but they were rapidly being absorbed into a wide and varied repertory of styles and motifs that was at the call of every metropolitan Roman builder. Never again in the history of Roman architectural ornament was there to be so extensive and so vigorous an infusion of new idioms and new ideas, or so wide a range of decorative traditions all in active contemporary use.

Although there was hardly a monument in the Forum Romanum with the building or rebuilding of which Augustus was not in some way associated, much of this work consisted of the completion or restoration of buildings initiated by Julius Caesar. Four of the principal buildings with which he was in this way concerned, the Basilicas Aemilia and Julia, the Curia (senate house), and the Rostra, were all part of Caesar's project to bring some sort of architectural order into the hitherto haphazard development of this time-honoured centre. A fifth, the Temple of Divus Julius (the Deified Julius), dedicated in 29 B.C. but possibly substantially complete some years earlier, was in effect a completion of the same scheme, balancing the Rostra and establishing a decisive architectural accent at the narrow south-east end of the open space of which the two basilicas formed the two long sides.

Except as elements of this ambitious plan the Rostra (orators' platform) are of historical

rather than of architectural interest, and the Augustan Curia was so badly damaged in the fire of A.D. 284 that it had to be completely rebuilt by Diocletian. Coin representations show that it was very like its successor, a tall, gabled building with three rectangular windows above a shallow porch stretching the length of an otherwise plain façade [11]. Of the two

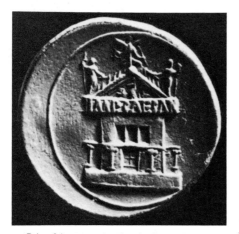

11. Coin of Augustus showing the Senate House (Curia), as restored in 44–29 B.C.

basilicas, on the other hand, enough is known to give us quite a good idea of their general appearance. Though broadly similar in design, location, and purpose, they offer an interesting picture of the variety of architectural practice prevailing in Augustan Rome.

The more conservative of the two was the Basilica Aemilia. Rebuilt after a fire in 14 B.C.,[15] recent excavation has shown that the new building [12A] followed very much the same lines as its predecessor. It consisted of a long, narrow central hall, lit by a clerestory and surrounded on all four sides by an internal portico with a gallery over it. This hall, which measured some 295 by 90 feet (90 by 27 m.), was open to the south-east, and along the north-east side it had an additional row of columns, which from its position close to the outer wall seems to have been decorative rather than structural in

intention. Constructionally it seems to have been a rather conservative building, remarkable more for the wealth of its materials and decoration than for any novel architectural features. Along the south-east side, towards the forum, it was closed by a row of outward-facing shops, the Tabernae Novae, probably themselves in two storeys and opening on to a two-storeyed portico, the façade of which was composed of piers carrying arches, framed within the compartments of a boldly projecting Doric order [13]. This portico is usually identified as the Portico of Gaius and Lucius, dedicated in 2 B.C., and it was for all practical purposes an independent building, a translation into contemporary Roman constructional terms of the hellenistic stoa. The façade was manifestly designed to answer that of the Basilica Julia opposite.

The Basilica Julia, destroyed by fire shortly after its completion, probably in 12 B.C., and completely rebuilt between then and A.D. 12, offers an interesting contrast. Built to house the centumviral law courts (which were held in the central hall, divided up if necessary by curtains or wooden screens), in one respect it conforms more closely to the Republican pattern, in that it was open on three sides and closed only on the south-west side, away from the forum, where a two-storeyed row of shops or offices opened inwards on to the outermost of the internal porticoes and the gallery above it [12B]. But although in other respects the plan (345 by 150 feet, or 105 by 46 m., exclusive of the offices) is only a rather more elaborate version of that of its sister basilica, with a double instead of a single ambulatory portico and gallery surrounding the central hall, the principle of construction is entirely different. Instead of being carried on columns, the structure was arcaded, on rectangular piers, and the ambulatory porticoes were vaulted, only the central hall being timber-roofed.[16] The inner piers were cruciform and built of travertine, those of the outer row of solid marble, and the arcades of the two principal façades were framed within the semi-columns and entablatures of a double Tuscan order.

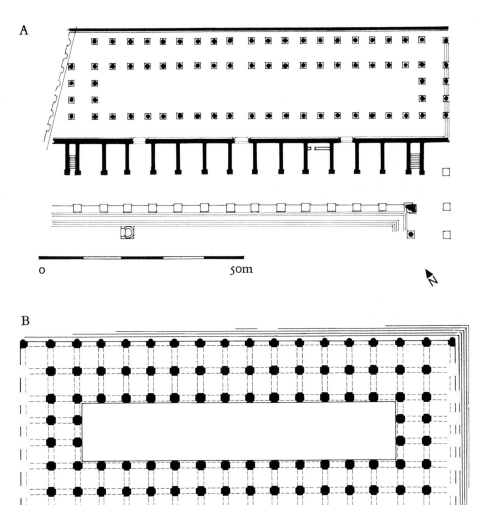

12. Rome. (A) Basilica Aemilia, rebuilt after 14 B.C.;
(B) Basilica Julia, rebuilt between *c.* 12 B.C. and A.D. 12. Plans.
For the façade of the portico in front of the Basilica Aemilia
cf. illustration 13

13. Rome, Basilica Aemilia, rebuilt after 14 B.C. Drawing by Giuliano da Sangallo

Except for the greater richness of the materials, the structural scheme is remarkably similar to that of the Theatre of Marcellus and offers an interesting, and in this form and context unique, example of the reinterpretation of the traditional architectural theme of the columnar basilica in terms of contemporary constructional methods.

The architecture of the Augustan temples was by its very nature weighted on the side of conservatism. In the relatively restricted space available within the city there was no room for the daring innovations that had characterized the great sanctuaries of Latium in the Late Republic; and although under Augustus and his successors there were still such distinctively Italic features as the tendency to place the actual temple against a rear wall, facing forwards, and

the almost universal use of a tall podium, with or without a frontal flight of steps, the general trend was undoubtedly towards a more typically Greek hellenistic tradition. Many of the older shrines, with their low columns and spreading roofs, must still have survived. But as they burned or were restored they were replaced by buildings which, both in their proportions and in much of their detail, approximated far more closely to the norm of late hellenistic design.

One of the earliest and finest of the Augustan temples was that of Apollo on the Palatine, built between 36 and 28 B.C. Of solid Carrara marble and adorned with many famous statues, it was acclaimed as one of the wonders of its day. Adjoining it were a portico carried on columns of Numidian marble (one of the first recorded uses of coloured marbles on such a scale) and a

Greek and a Latin library. After the great fire of A.D. 64 the libraries were rebuilt at a higher level by Domitian, and their remains can be seen behind the great triclinium of the Flavian Palace. Of the temple, on the other hand, nothing has survived above ground except the core of the podium and a few marble fragments, but the current excavations confirm that it was pseudo-peripteral in plan, with a widely spaced hexastyle porch facing out across the Circus Maximus at the head of a majestic flight of steps, flanked on one side by Augustus's house and on the other by a courtyard and the two libraries. All that we know of these early Augustan monuments suggests that they represent a moment of lively architectural experiment. Had more of this influential building come down to us, much that is obscure about the later development of Augustan architecture might well have been made clear.[17]

The neighbouring Temple of the Great Mother (Magna Mater, or Cybele) offers a striking contrast. Its restoration by Augustus after a fire in A.D. 3 followed thoroughly conservative lines, probably re-using much of the material of the Republican building and a part of its actual structure, with a liberal use of stucco both for the finished masonry surfaces and for the architectural detail. A first-century relief in the Villa Medici, which illustrates the façade of the Augustan building [14], gives an interesting picture of the refinement that was possible in this material, so much used and so rarely preserved. The masonry convention portrayed approximates closely to that of the Temple of Mars Ultor.

At a time when there was so much building going on all at once, there must have been many other instances of a similar conservatism. Of the eighty-two temples in the city which Augustus claimed to have restored in 28 B.C. one cannot doubt that many were done in traditional materials and following traditional lines. Even where the restoration amounted in effect to a complete rebuilding there must often have been a considerable stylistic time-lag. An extreme example of this may be seen in the three small

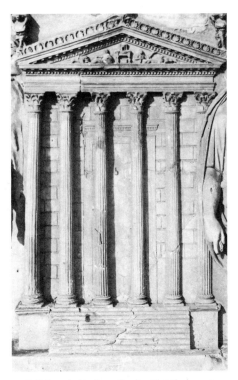

14. Relief, probably from the Ara Pietatis Augustae, dedicated in A.D. 43, depicting the façade of the Temple of Magna Mater on the Palatine, restored after A.D. 3. The extant remains show that much of the detail here portrayed was executed in stucco

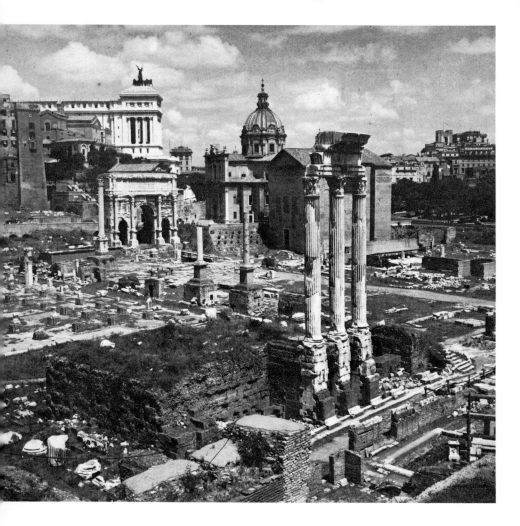

15. Rome, Forum Romanum seen from the Palatine.
In the foreground the Temple of Castor, rebuilt between 7 B.C. and A.D. 6.
Beyond it (*left*) the Basilica Julia and (*middle distance*) the Arch of Septimius Severus, A.D. 203,
and the Senate House, rebuilt by Diocletian after the fire of A.D. 283

temples of the Forum Holitorium, preserved as a result of their partial incorporation in the structure of the medieval church of S. Nicola in Carcere. On the evidence of the materials employed and other seemingly archaic features, all three have been accepted as Republican buildings, possibly even as early as the second century B.C.; but it now seems probable that at least one, the Doric temple, which is built in travertine, and very possibly all three, are almost entirely Augustan work, replacing the buildings destroyed in the fire that devastated the whole area in 31 B.C. The two almost identical Ionic temples incorporate features that appear to derive from the Late Augustan Temple of Castor, and one of them is almost certainly to be identified with the Temple of Janus, which was not finally ready for re-dedication until A.D. 17. At a time when supplies of materials and the labour resources of the city must have been strained to the uttermost it is not altogether surprising that these small and unimportant shrines should have had to wait so long for completion, or that when complete they should have retained many features that belonged properly to an earlier age.[18]

There are two other Augustan temples that call for brief comment, the Temples of Castor [15] and of Concord, both very ancient buildings beside the Forum Romanum that were completely rebuilt during the last twenty years of the emperor's life. That of Castor,[19] as rebuilt by Tiberius between 7 B.C. and A.D. 6, was a grandiose peripteral structure standing on a double podium, the front of which, like that of the near-by Temple of Divus Julius, rose sheer from the pavement of the forum and was used as an additional platform for public speakers. The main body of the podium was of blocks of tufa enclosing a core of concrete, except beneath the columns, which rested on piers of travertine; the whole was faced with Carrara marble, and between the column footings there were recesses which may have been used as strongrooms. The three surviving columns, 47 feet (14.20 m.) high and capped by a section of the original entablature, all of Carrara marble, were

already a landmark in the fifteenth century. The cella has almost entirely vanished, but the interior is known to have had a decorative order of columns along each of the side walls, as in the Temple of Mars Ultor. Attempts to date the superstructure to an otherwise unrecorded restoration undertaken in the late first or second century A.D. are certainly mistaken. There are manifest differences, it is true, between this work and that of the near-contemporary Temple of Mars Ultor; but there are also a great many details that are no less typically Augustan and, as we have seen, the possibility of such difference is characteristic of the Augustan Age. Of the two buildings, the surviving remains of the Temple of Castor give the impression of being the work of craftsmen who were less directly under the influence of Greek models.

The Temple of Concord, also rebuilt by Tiberius and dedicated in A.D. 10, stood on the site and repeated the unusual plan of its predecessor, in which the longer axis of the cella lay across the building, so that the porch occupied a part only of the front of the cella.[20] It was distinguished by the opulence of its marbles and the wealth of fine sculpture and painting with which it was endowed, and although sadly little of this remains, that little is enough to show that the architectural ornament too was extremely rich, foreshadowing the opulent schemes of the ensuing Julio-Claudian age. The surviving fragments include a section of the richly carved main cornice [16]; a column base from the internal order of the cella, closely resembling those of the Temple of Mars Ultor; and a figured Corinthian capital with pairs of rams at the four angles in place of the usual angle volutes. The massive door-sill was of Chian marble, and other marbles attested from the floor and walls of the interior include Euboean, Phrygian, and Numidian.

To anyone familiar with the subtleties of Greek temple architecture it is natural to ask whether in the case of the Augustan temples one can make any useful generalizations about the types of plans employed, the spacing of the columns, the proportions, etc. The question is

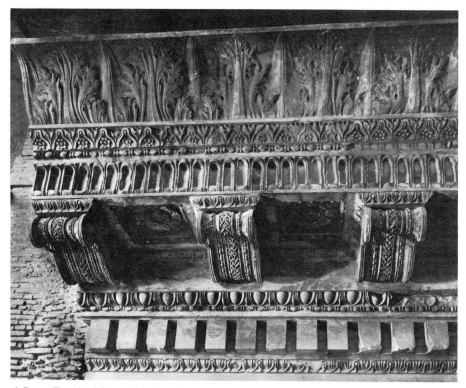

16. Rome, Temple of Concord, dedicated in A.D. 10.
Restored marble cornice block, now in the Tabularium

one that would have been perfectly intelligible to the section of contemporary architectural opinion of which Vitruvius is the representative figure; and if the contemporary answers did not always satisfy Vitruvius and his colleagues, this is not altogether surprising in an eclectic age which was also one where technical achievement was rapidly outrunning the forms of architectural expression currently available.

The plans, as one might expect, reveal little uniformity. There were too many models available, too many competing architects of very varied training, taste, and experience. Of the five largest temples, that of Concord was a special case; two, those of Diana on the Aventine and of Quirinus on the Quirinal, were octastyle and dipteral;[21] the other two were octastyle and peripteral, that of Mars on three sides only, in accordance with the familiar type classified by Vitruvius as *sine postico*. The rest were all hexastyle and indiscriminately prostyle, pseudo-peripteral, or peripteral.[22] There was a marked tendency towards height at the expense of length, an extreme case being the Temple of Mars Ultor with its eight columns across the façade and only nine (including the terminal pilaster against the rear wall) down either side; and the height was in most cases increased by the use of unusually lofty podia, double in the case of Divus Julius and of Castor. The latter stood over 100 feet high from the pavement to the apex of the gable. In no less than four of the

temples (Divus Julius, Apollo in Circo, Castor, and Saturn) the podium also rises sheer in front, accentuating the effect of height. This may in each case be due to special circumstances; but it is worth noting, since it was not without its effect on subsequent architecture in the provinces (e.g. the Temple of Rome and Augustus at Lepcis Magna, the Capitolium at Sabratha). With the exception of the three temples in the Forum Holitorium (which can hardly be considered as typically Augustan buildings) and possibly also of Saturn, Divus Julius, and Apollo Palatinus, all three of them early buildings, the normal order was, and was thereafter to remain, Corinthian, and the columns seem to have settled down to a norm of fairly close spacing. This last, though it may have been dictated as much by practical as by theoretical considerations, once again had the effect of increasing the appearance of height.[23] Finally it may be noted that the three largest temples all had elaborately carved orders down the internal side walls of the cellas. This feature, which initially at any rate had a practical as well as a decorative purpose, lessening the span of the roof, had Greek precedents, but there were also Republican Italian prototypes such as the apsed hall at Praeneste and the Nymphaeum of the so-called Villa of Cicero at Formia. It had already been used in Pompey's Temple of Venus Victrix, and it was to play a considerable part in the temple architecture of the post-Augustan age.

The domestic architecture of the Augustan period is discussed in a later chapter. In the present context it must be enough to note that it was here, particularly in the big country residences of the wealthy, that the Augustan builders made some of their most significant advances. Another field in which, side by side with traditionalism, fantasy and experiment played a surprisingly large part was that of funerary architecture. This too will be referred to briefly in a later chapter. The outstanding public monument in this field was the Mausoleum of Augustus in the Campus Martius, beside the river, begun in 28 B.C. and ready for

use in 23 B.C. Cleared of the accretions of centuries, it is today a sorry ruin; but enough remains to establish the essential form, which was that of a tall, hollow, concrete drum, 290 feet (88 m.) in diameter, faced with travertine and surmounted by an earthen tumulus, at the centre of which stood a colossal bronze statue of the emperor. There was a central tomb-chamber and no less than four internal rings of concrete, faced according to their position with travertine or tufa reticulate, and broken up into compartments to contain the earthen mass. It was an exceptionally large example of a type of grandiose family mausoleum that was in widespread use among the noble families of the period, two finely preserved and approximately contemporary examples being of those of Caecilia Metella beside the Via Appia and of Munatius Plancus at Gaeta. The summit of the tumulus was planted with evergreen trees and it stood in wooded grounds, which included a grove of black poplars, within the enclosure of the family crematorium. Landscaping is not a feature that survives the passage of time but, as we know from the literary sources, it was widely used and esteemed, and was indeed an integral feature of many architectural schemes. Another well attested Augustan example is that of Agrippa's buildings in the Campus Martius, a short distance to the south of the mausoleum – in which, very appropriately, he was one of the first to be buried.

In the techniques of building, the Augustan Age was marked rather by a steady advance in the handling of existing techniques than by any notable innovations. In the use of locally quarried ashlar masonry it was increasingly the finer qualities only, notably travertine and Gabine stone, that were employed in positions where they could be seen, the other, poorer varieties being relegated to footings and internal walls. With the example of the temples of the Forum Holitorium before us, one must beware of excessive reliance upon such criteria as evidence of date: what applied to public building did not necessarily apply to private construction; still less did it apply outside the immediate peri-

phery of the capital. But with the ever-increasing availability of concrete as a cheap and efficient substitute, there was a clear tendency for cut stone to be used, if at all, sparingly and to deliberate effect. Notable examples of fine ashlar masonry in Augustan Rome are the Theatre of Marcellus and the precinct wall of the Forum of Augustus, or, used purely structurally, the podium of the Temple of Castor.

As regards concrete, although there were no sensational innovations in the uses to which it was put, there was a steady improvement in the quality of the concrete itself. Whereas, for example, in Late Republican monuments it is still normal to find horizontal lines of cleavage running right through the core, corresponding to the successive stages of the work, by the turn of the century this phenomenon is becoming increasingly rare; the masons had evidently evolved a slower-drying mixture, enabling the whole body of the core to fuse into a virtually homogeneous mass. So too, arches and vaults reveal a clear evolutionary tendency away from the Republican form with irregular chunks of stone laid radially around the intrados, like the voussoirs of an arch, towards one in which the whole mass, intrados and all, is bedded horizontally and which stood, once the centering was removed, purely by virtue of the quality of the concrete. Most important of all, Roman builders had begun to realize that for everyday purposes the local red volcanic sand (*pozzolana*) had the same remarkable properties as its namesake, the *pulvis puteolanus* from Puteoli (Pozzuoli) on the coast of Campania, which they had long been importing for the building of harbours, bridges, and similar hydraulic works. It was the hydraulic character of this local red pozzolana, when mixed with lime, which gave the Roman mortar of the Empire its great strength; and although the Romans were unaware of the theoretical reasons for this phenomenon, the pages of Vitruvius show that by the twenties of the first century B.C. they had achieved a wide practical experience of the properties of this and other types of mortar. The study of the monuments shows that it was in the

time of Caesar that Pozzolana mortar made its first appearance in Rome, but that it was only under Augustus that it passed into general, everyday use.[24]

The evolution of the successive types of concrete facing has been extensively studied and offers a useful criterion of date, though one to be used with far greater caution than is often the case. A careful study, for example, of the masonry used in the Agrippan repair-work to the aqueducts shows how wide a range of practice was possible even between the different firms engaged upon a single enterprise. One cannot expect absolute uniformity. In Rome, already quite early in the Augustan Age, reticulate work with tufa arches and quoins had very largely replaced the earlier, more irregular forms, and it remained a common type of facing until well into the following century. The most significant innovation was undoubtedly the occasional use of brickwork,[25] which makes a cautious appearance in the monuments from the middle of the first century B.C. onwards. Throughout the Augustan period such 'bricks' were invariably broken tiles or roof-tiles, broken or sawn to shape; and although Vitruvius, writing between 25 and 22 B.C., refers to their use in apartment-house construction, not until a quarter of a century later do we have, in the Columbarium of the Freedmen of Augustus, a building of which the outer face was built entirely of bricks. The Rostra Augusti (*c.* 20 B.C.) offer an early instance of their use in a public monument. The great value of this new medium was that it allowed the builder to dispense wholly or in part with vertical shuttering, and although its full potentialities in this respect were not realized until well after the death of Augustus, taken in conjunction with the improvements in the quality of the concrete itself, it paved the way for the revolutionary advances that took place under his successors.

*

Faced with the quantity and variety of building that took place in Rome in the sixty-odd years that lie between the death of Caesar in 44 B.C.

and the death of Augustus in A.D. 14, it is at first sight hard to detect any single consistent pattern. In a sense this is a true picture. The architectural development of Augustan Rome (as indeed that of almost any period and place within the Empire for the next three hundred years) falls into a number of distinct and at times bewilderingly varied patterns. It is only with the hindsight of history that one can see what these had in common and whither they were leading.

Fundamental to the shaping of the Augustan building programme were the historical circumstances in which it took place. It was the return of peace and prosperity to a war-weary world that called into being a programme of such unprecedented proportions; and the fact that Rome was now the undisputed mistress and centre of the civilized world meant inevitably that the resources of skill, materials, and artistic talent of that world were all at her disposal. The surprising thing is not that there are derivative elements in the architecture of Augustan Rome, but that these were so rapidly and effectively acclimatized in their new home. More significant in the long run are the reciprocal currents that began to flow outwards from Rome. Just as the architecture of Republican Italy is unintelligible except within the larger framework of the hellenistic world, so now for the first time the arts of the hellenistic East began to find themselves affected by their participation in a yet larger organism, that of the Roman Empire.

A very important factor in this situation was the strength of the native Italic tradition. The hellenistic, and ultimately hellenic, element in this native tradition was inevitably pronounced, particularly in Campania, where historical circumstance had favoured the fusion of the two traditions; but it had been absorbed into, and in part transformed to meet the requirements of, a vigorous and organically developing Republican architecture which had strong local roots of its own. A distinctive characteristic of this architecture had been its exploitation of the structural and aesthetic possibilities of the arch, relegating the column and architrave of hellenic practice to a secondary and often a purely decorative role; another was the substitution of vaulting for the time-honoured system of roofing in timber. The strength of this tradition is apt to be obscured by the bias of the numerically largest group of surviving monuments, the temples, at the expense of the secular architecture, in which the native Republican element was far more pronounced but of which fewer examples have come down to us. Buildings such as the Theatre of Marcellus and the Basilica Julia, which belong to a line of development that leads directly from the sanctuaries of Latium and the Tabularium to the Colosseum and the Circus of Domitian, are in fact representative of a wide class of administrative and commercial buildings, of which all too few have survived. Yet another characteristic of this Italic tradition was the development to meet local conditions of such distinctive architectural types as the basilica. Here again Campania, with its mixed Graeco-Italic society, had played an important role in the formative stages of the new architecture; but the Augustan Basilica Aemilia, for all its wealth of exotic materials, was as Roman a building as the Basilica Julia, though in detail more old-fashioned. Even the temples prove on examination to be far less directly hellenizing than at first sight they appear. The basic architectural forms already had a long period of acclimatization and adaptation behind them; it was only the materials and detailed treatment that were new. So far as we know, there was no building in Augustan Rome (certainly not after the very early years) that was so directly and unashamedly derivative from Greece as the little Republican circular temple in the Forum Boarium.

In its most vigorous and characteristic forms the Republican building tradition was ultimately connected with the exploitation and development of the building materials available in Central Italy. The hellenizing strain in the architecture of Augustan Rome was no less intimately associated with the introduction of an alien material, marble. Previously available only as an exotic luxury, the opening of the quarries of Carrara within the space of a few years

poured so abundant a supply of it upon the Roman market that, to work it, it was necessary to import large numbers of skilled craftsmen; and the only part of the ancient world where marble-workers were readily available was Greece. Taken in conjunction with the deep Roman admiration for all things Greek, the result was a profound and rapid hellenization of the established Republican traditions of architectural ornament. The sculptors, many of them trained in the neo-classicizing schools of Attica, inevitably brought and used the motifs with which they were themselves familiar. What is unexpected in all this is not so much the fact of the sudden appearance of a new decorative repertory as the rapidity with which that repertory was absorbed and adapted to suit the requirements of a specifically Roman taste. Judged by the standards of classical Greece the proportions and detail of a great deal of this work are deplorable – but it would be wrong to apply such standards. This was something new. Within the space of a few decades we can see the emergence from the melting-pot of a style that was new and specifically Roman, a style which was to dominate the architectural ornament of the capital for over a century to come.

By comparison the importation of large quantities of coloured marble for the columns, pavements, and wall-veneers of the great Augustan monuments was a less revolutionary event than it might at first sight seem to have been. There was nothing new in architectural polychromy as such; this was only a richer, subtler variant of a familiar idea. What was more significant was the scope which the new material offered for an ever-increasing dissociation of decoration and structure, a tendency which was already at work in the architecture of the Republic, but which only reached full fruition within the brick-faced concrete architecture of the later Empire.

Seen within the perspective of its own generation, the dominant note of Augustan architecture in Rome appears as one of opulence, coupled with a cautious conservatism and a respect for the architectural traditions of Rome's own recent past. Its only really important formal innovations lay in the field of architectural ornament. But the size, the quality, and the variety of the great Augustan building programme made it an unfailing source of inspiration to successive generations of architects; the circumstances of its creation gave it a unique authority; and it was the school in which the builders of the next generation learned the mastery of the materials which they were to put to such new and revolutionary uses. In architecture, as in so much else, the real significance of the reign of Augustus lay in the fact that it set the stage for the age that was to come.

ARCHITECTURE IN ROME

UNDER THE JULIO-CLAUDIAN EMPERORS

(A.D. 14–68)

For all the variety of influences already at work, the architecture of Augustan Rome has a topographical and chronological unity that makes for simplicity of presentation. This is still true, though to a lesser extent, of the period that follows. With a few notable exceptions such as Spain and Gaul, the provinces were still, architecturally speaking, largely self-contained and can justifiably be discussed separately. Within Italy the situation was more complex. But although in certain fields Campania still exercised a considerable creative individuality, elsewhere the flow of ideas was still predominantly from the centre towards the periphery. Throughout the first century A.D. it was Rome itself that continued to call the architectural tune. It is reasonable, therefore, to begin with an account of public buildings in the capital and in the immediate neighbourhood; and since the individual emperors undoubtedly exercised a strong influence upon the work undertaken under their auspices and in their names, this has been classified according to their reigns. Two subjects call for more extended treatment and will be discussed separately. One of these is the domestic architecture of town and country during the period in question. The other is the profound change in architectural thinking which took place in the period between the accession of Nero and the death of Hadrian, and which has here been termed the 'Roman Architectural Revolution'.

TIBERIUS (A.D. 14–37)

The reign of Augustus's successor, Tiberius, saw little building in Rome itself. While his predecessor was still alive he had contributed largely to the official programme, being directly responsible for two of the largest and finest of the later Augustan monuments, the Temples of Castor and of Concord; and after Augustus's death Tiberius carried to completion a number of works that had been left unfinished. But after half a century of unprecedented building activity, a pause cannot have been altogether unwelcome; and the increasing embitterment of his later years, culminating in the retirement to Capri, removed what little incentive there may have been to the continued embellishment of the capital.

The majority of the recorded buildings of Tiberius in Rome belong, as one would expect, to the earlier part of his reign. Several small temples dedicated in A.D. 17 were all buildings of which the restoration had been begun and left unfinished by Augustus. An arch erected in the Forum Romanum in A.D. 16 to commemorate the German victories of his destined successor, Germanicus, and a pair added to the Forum Augustum in A.D. 19, in honour of Germanicus and the younger Drusus, are of interest chiefly for the evidence that the scanty surviving remains give of the development of a specifically Julio-Claudian style of architectural ornament. The same is true of the restoration of the Basilica Aemilia in A.D. 22, a restoration which appears to have involved the substantial replacement and enrichment of the upper part of the building. Of the Horrea, or warehouses, of Sejanus nothing is known; it is to Ostia that we have to look for similar buildings of Tiberian date. Nor has anything survived of the restoration of the stage-building of the Theatre of

Pompey, undertaken after a fire in A.D. 21. The fact that it is one of the only two Tiberian public buildings in the capital thought worthy of mention by Tacitus indicates that it was a work of some importance, presumably the replacement of the earlier structure in richer materials and with a more lavish use of coloured marbles.[1]

The second building mentioned by Tacitus is the Temple of the Deified Augustus, an undertaking to which, for dynastic reasons alone, Tiberius must have felt himself committed, and which he did in fact bring to virtual completion before his death in A.D. 37, although it was left to his successor, Caligula, to dedicate it. It lay in the as yet unexplored area to the south of the Basilica Julia. No remains of it have been recorded, but it is usually identified with an Ionic hexastyle building which figures prominently on the coinage of Caligula [17]. A less

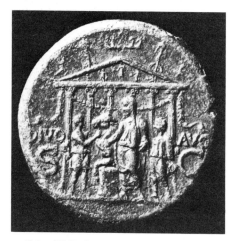

17. Coin of Caligula, A.D. 37, showing an Ionic temple, usually identified as that of the Deified Augustus

generally accepted, but not unattractive, suggestion is that the building on the coins is the Temple of Apollo Palatinus, another building which had very close associations with Augustus; and that for the Temple of Divus Augustus we have to look instead to a coin type which

makes its appearance during the last few years of Tiberius's life, between A.D. 34 and 37, and which is usually interpreted as a representation of the Temple of Concord. What the conventional view leaves unexplained is why the latter building, dedicated in A.D. 12, should have been so singled out for representation a quarter of a century later; nor can there be much doubt that the Ionic treatment of the façade of the temple featured on the Caligulan coins accords better with what we know of the somewhat experimental architecture of the early years of Augustus's reign than with what we know of the tastes of the ageing Tiberius. This is clearly a matter that only further exploration can decide. For the present it must suffice to note that the conventional interpretation of the coin evidence, though widely accepted, is not altogether free from difficulties.[2]

Architecturally, as indeed also politically, the most significant Tiberian building that has survived in the capital is the camp of the Praetorian Guard, built in A.D. 21–3 at the instigation of its commander, Tiberius's aide and evil genius, Sejanus. In it were concentrated the troops that had hitherto been scattered throughout the city and its environs; and although its location just outside the city limits respected the letter if not the spirit of the convention that no troops might be stationed in Rome, its establishment was a decisive step down the slippery slope that led to open autocracy. Architecturally, too, it marks an epoch: not only does it represent the first appearance in the capital of an architecture that had been evolved in the military encampments of the Provinces, but the outer walls, large stretches of which can still be seen incorporated in the third-century city walls [18], have the additional distinction of being the first major public monument to have been built almost entirely in brick-faced concrete. The plan, a rectangle with rounded corners, measuring 470 by 406 yards (430 by 371 m.) and enclosing an area of over 14 acres, is that of a typical military camp, divided, equally about the longer axis and unequally about the shorter, by two intersecting

streets and served by four gates placed at the corresponding points of the outer walls. The form of the gateway is a translation into brick of an architectural type that was already firmly established in stone (e.g the Augustan arch at Rimini), in which the archway is framed between decorative pilasters that carry a pedimental entablature set against a plain, rectangular attic. Flanking the gateway, and projecting a mere foot from the face of it, was a pair of low, rectangular towers, and there were similar walk; above this stood a parapet 4 feet (1.20 m.) high, with a coping upon which were set small, widely spaced merlons. The little that has survived of the internal barrack-blocks suggests that, in contrast to the outer walls, they were built in reticulate work. Considering the novelty of the medium, the treatment of the outer walls is remarkably assured. Walls, towers, and gates alike, though fully adequate to the limited military requirements of the situation, were clearly designed almost as much to impress as

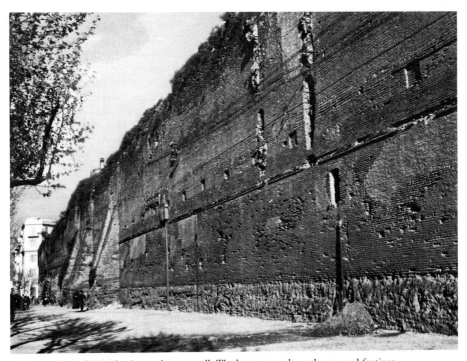

18. Rome, Castra Praetoria, the north outer wall. The lower part, above the exposed footings, is original (A.D. 21–3) up to and including the projecting string course and, just above it, the remains of the early parapet and merlons. The upper part dates from the incorporation of the camp into the Aurelianic Walls (A.D. 270–82)

towers at intervals along the rest of the wall. The outer face of the wall itself stood upon a three-stepped plinth, rising 9 feet 6 inches (2.90 m.) to a projecting string-course, which marks the height of the pavement of the internal rampart for their defensibility; the towers, with their very shallow projection, can have served little military purpose. The mouldings of the gates in particular can be seen to foreshadow a simple but effective tradition of decorative brickwork

which was to play a long and distinguished part in the architecture of the capital.[3]

Another building that might be expected to throw light on this interesting transitional phase in the history of Roman monumental construction is the new residence which Tiberius built on the Palatine. Current excavations are confirming that Augustus's own residence had been remarkable more for the ostentatious intimacy of its relationship to the Temple of Apollo than for its size or the opulence of its fittings. Beside it, on the north-west corner of the Palatine, Tiberius, shortly after his accession, began to add a new and larger residence, the Domus Tiberiana. The site, a rectangular platform measuring 200 by 130 yards (180 by 120 m.), is now very largely inaccessible beneath the gardens laid out upon it in the sixteenth century by Cardinal Alessandro Farnese. There are records of brick-faced as well as of reticulate masonry, and an oval fish-pool near the south-east angle suggests that the strict rectilinearity of the outer perimeter was not rigidly observed throughout the building. Nearly all of what is now visible, however, towards the Forum Romanum, is the work of later emperors, and it may well be that work on the new building was far from complete and was suspended when Tiberius finally abandoned Rome. It is outside Rome, on Capri, and perhaps also at Albano, that we have to look if we are to form any idea of the way the earlier Julio-Claudian emperors were housed. This will be discussed in a later chapter.[4]

CALIGULA (A.D. 37–41)

The reign of Tiberius's successor, Gaius, better known as Caligula, may be thought to have been too brief and his character too frivolous to have left much permanent mark on the architectural development of Rome. Of his grandiose plans for the remodelling of the Palatine, and in particular for the enlargement of the Domus Tiberiana in the direction of the Forum Romanum, little has survived. There are the scanty traces of an arched courtyard with a central pool on the site of the medieval church of S. Maria

Antiqua and at the upper level there is a huge vaulted cistern, of interest in that it offers the first recorded instance of the lightening of a vault by the use, as aggregate, of carefully selected materials, in this case a porous yellow tufa mixed with pumice.[5] Caligula began, but did not complete, the construction of two new aqueducts,[6] while demolishing the terminal section of the Aqua Virgo to make way for a new amphitheatre, which in the event was never built. The Circus of Gaius in the Vatican area, which was to achieve notoriety under Nero on the occasion of the persecution of the Christians after the fire of A.D. 64, and its near neighbour, the Gaianum, an open space for the practice of chariot-driving, are of more topographical than architectural importance. It was to adorn the former that Caligula brought from Heliopolis, in Egypt, the obelisk that now stands in the centre of the piazza in front of St Peter's. The list of public works is short. Even if one adds the buildings of Tiberius that Caligula completed and dedicated, it does not constitute a very distinguished achievement.

There are, however, two aspects of the building activity of Caligula that are of rather wider significance. One is in the field of domestic architecture. Suetonius records that outside Rome he built many villas and country houses; and Pliny the Elder writes that the whole city was ringed around with the dwellings of Caligula and Nero.[7] The coupling of the names of Caligula and Nero is significant. Just as nineteenth-century Rome was still encircled by the villas and parks of the princely families (many of which, indeed, were laid out in conscious imitation of classical precedents), so Rome at the end of the Republic was all but enclosed within a ring of wealthy villas and gardens, many of which in course of time passed by purchase, inheritance, or expropriation into imperial possession. It was probably under Tiberius that the Horti Lamiani (on the right bank of the Tiber) and the Horti Sallustiani (near the modern Palazzo Barberini) became imperial property. It was while directing architectural operations in the former that Caligula received the delegation of Jews from Alexandria

of whose reception Philo has left us such a graphic account.

Building of this sort must have been very much to the emperor's taste; and although nothing of it has survived, we can at least get an indication of the wealth and quality of its ornament from the galleys of Lake Nemi. The traditional view of these strange vessels is surely the right one. They were villas afloat, equipped with every luxury, including running water, and adorned with floors and walls of patterned marble and mosaic, partitions and doors covered with painted wall-plaster, or painted and inlaid with strips of ivory and gilded bronze, marble colonnettes, painted terracotta friezes, tiles of gilded bronze, as well as sculpture and numerous finely wrought fittings of moulded bronze. What is almost more striking than the luxuriance of the ornament is the superb quality of the joinery and of the workmanship generally. In all of this one is reminded irresistibly of the decorative taste displayed in the palaces of Nero twenty years later; and one may hazard a guess that in the formal qualities, too, of the architecture there was much that anticipated later practice. In an age when the tastes of the patron might be quite as important of those of the artist, and in a field that lent itself so admirably to experiment and fantasy, the impact of Caligula's enthusiasm upon the domestic architecture of its age should not be underestimated.

Another field in which the emperor's tastes found ample scope for personal expression was that of religious architecture. Although the great Augustan building programme must have left the buildings of the traditional state cults in better condition than they had ever been before, the vital currents of contemporary religious belief were increasingly turning towards the so-called mystery religions of the East. The practices of these religions ranged from the frankly orgiastic fertility rites of Cybele and Attis, through the often exalted mysticism of the cults of Isis and Mithras, to the austerely rational beliefs of such quasi-philosophical sects as the Neo-Pythagoreans; but all shared with Christianity the powerful inducements of a message that was addressed ultimately to the individual, offering to the qualified initiate comfort in this world and salvation in the next. Together they unquestionably constituted the most powerful spiritual force at work during the first three centuries of our era.

The architectural impact of the mystery religions was as varied as their message. Those that were politically acceptable were free to develop a monumental architecture of their own, although not by any means all of them did in fact do so.[8] Of those that were unwilling or unable to compromise with the state some, like Christianity, were content to forgo an architecture of their own and to meet in private houses. Others were driven, quite literally, underground. The so-called Underground Basilica beside the Via Praenestina [19] is such a building. Constructed about the middle of the first century A.D. to serve the requirements of a Neo-Pythagorean sect, it was suppressed soon

19. Rome, Underground Basilica beside the Via Praenestina, mid first century A.D. The stucco decoration indicates that it was the meeting place of a Neo-Pythagorean sect

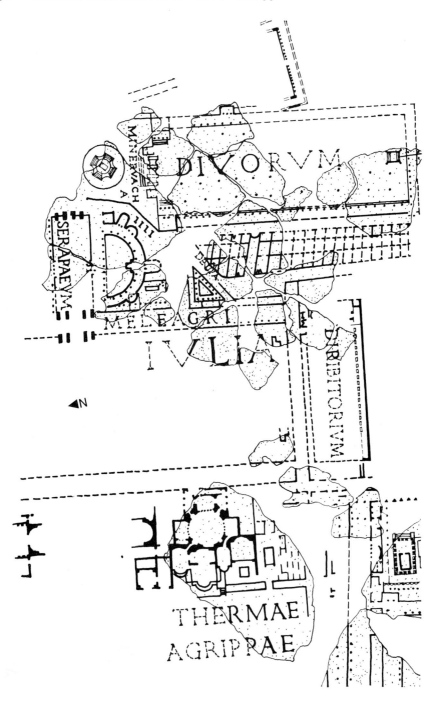

after its construction and was filled in and forgotten. The form, an antechamber and a basilican nave with three equal aisles leading up to a single apse, anticipates that which, for not dissimilar reasons, the Christians were to adopt nearly three centuries later; and the method of construction, whereby trenches were cut in the tufa and concrete laid in them to form the walls and the piers, the remaining tufa being excavated only after the walls and vaults had set, is a good illustration of the ingenuity of the Roman architect in handling the new medium. With its uniquely preserved facing of delicately moulded stucco and its air of timeless withdrawal, it is a singularly moving monument, one of the few that call for little or no effort of the imagination if one is to clothe the bare bones with the flesh and blood of the living building.

Midway between the two extremes came those cults which, while prepared to conform to the requirements of the state, were able to retain much of their outward as well as of their spiritual individuality. Prominent among such was the cult of the hellenized Egyptian divinities, Isis and Serapis; and the chance that Caligula was personally attracted by this cult gave its devotees an opportunity that they were quick to seize. The room with Isiac paintings on the Palatine, which was preserved by its incorporation within the substructures of the Flavian Palace, and which used to be attributed to Caligula, is now generally recognized to be half a century earlier in date;[9] but there is a strong presumption that it was he who was responsible for building the sanctuary of Isis and Serapis in the Campus Martius. The latter was damaged in the fire of A.D. 80 and restored by Domitian, and again by Alexander Severus. As recorded in the Severan marble map of Rome [20] it comprised two distinct shrines opening off the long sides of an enclosed rectangular forecourt. Whether Domitian's restoration followed the same general lines as its predecessor we cannot say; nor do we know to what extent the remarkable curvilinear plan of the southern building reproduces or reflects Isiac practice elsewhere. Architecturally, the significant fact is that it was in a field such as this that new architectural ideas were free to circulate, and that they should in this instance have involved so radical a break-away from the traditional forms of classical religious building.

The fittings of the sanctuary, as distinct from the buildings, were unequivocally Egyptian in character, many of them being actual Egyptian pieces imported for the purpose. Much of the sculpture still survives, in the Capitoline Museum, in the Vatican, and elsewhere, and two of the smaller obelisks are still in use near the site of the temples, one of them in the piazza in front of the Pantheon, the other carried by Bernini's elephant in the Piazza della Minerva. A taste for Egyptian and egyptianizing themes is a recurrent feature of Roman architectural ornament, ranging from the import of such formidable pieces as the great obelisks, which, resurrected and put to new use, are still such a striking feature of the Roman scene, down to the dilutely and romantically egyptianizing Nilotic scenes beloved of interior decorators of all periods. The Egyptian cults were not by any means the only influence at work. There were the Alexandrian stucco-workers, for example, and more generally there was the Alexandrian component in the hellenistic tradition that was responsible, at its best, for such masterpieces as the great Barberini mosaic in the sanctuary at Palestrina. But the cults, too, had a part to play, and the establishment of these exotic temples in the Campus Martius is a minor but significant landmark in the long process of the orientalization of Roman beliefs and Roman taste.

20 (*opposite*). Part of the Severan marble map of Rome, showing the Porticus Divorum, the Temple of Minerva Chalcidica, the Sanctuary of Isis and Serapis, part of the Saepta Julia, the Diribitorium, the Baths of Agrippa, and (*bottom right*) the north end of the group of Republican temples in the Largo Argentina, and the north-east corner of the colonnaded gardens behind the Theatre of Pompey

CLAUDIUS (A.D. 41–54)

The emperor Claudius had little in common with his predecessor. Elderly and pedantic, but endowed with an unexpected streak of practical good sense, not for him the costly luxury of building for its own sake. Although at least two more estates, the Horti Luculliani on the Pincian Hill and the Horti Tauriani on the Esquiline, were confiscated to the imperial domain during his reign, there is no record of any new construction in either. He seems to have been responsible for some alterations and additions on that part of the Palatine that was later occupied by the Flavian Palace, but nothing of any great extent; and his religious dedications appear to have been limited to the addition of altars or statues to existing buildings and the building of an altar modelled on the Ara Pacis, the Ara Pietatis Augustae, in honour of Augustus's widow, Livia. At least one temple that had been destroyed by fire, that of Felicitas, was not rebuilt. There are records of two commemorative arches celebrating the victories of the emperor's generals in the field, but such arches may by this date be considered a commonplace requirement of Imperial architecture. Both are known from coins, and that which carried the Aqua Virgo over the Via Lata is also known from old drawings.[10] So far as one can judge, they were very similar in general design, with widely spaced twin columns resting on a single base and supporting an entablature with an attic above, the principal difference between the two being that the entablature of one was pedimental whereas that of the other was plain. Both probably carried equestrian statues of the emperor between trophies.

A task which Claudius inherited from his predecessor, and which must have been more to his taste, was the completion of the two aqueducts begun by Caligula but left unfinished, the Aqua Claudia and the Aqua Anio Novus, and the replacement of the destroyed terminal sector of the Aqua Virgo. The last-named was built throughout of a hard grey-brown tufa (*peperino*) with travertine details, and an engraving by

Piranesi of one of the several arches that carried it over the streets of the city centre [23] shows it to have been treated in the same highly mannered rustication as another, better-known Claudian building, the Porta Maggiore. The latter is the monumental double arch on which the two new aqueducts crossed the Via Labicana and the Via Praenestina just before their point of junction. Used by Aurelian as the nucleus of the Porta Praenestina, one of the gates in the third-century city walls, in 1838 it was stripped of its later accretions, and it stands today as the finest and most familiar of the surviving Claudian monuments of the city [21, 22]. Over 80 feet high, it is built throughout of fine travertine masonry. That of the attic, which carried the two conduits and bore a handsome commemorative inscription, is dressed smooth, whereas, apart from the carved capitals and entablatures, that of the lower part has been deliberately left rough, as laid, without the slightest attempt at refinement. This was a deliberate mannerism, not simply unfinished work, and it was doubtless work such as this that inspired architects of the Renaissance such as Michelozzo, in the Palazzo Medici-Riccardi in Florence, and Bernini, in the Palazzo del Montecitorio. Highly mannered rustication of this sort is found in several Claudian buildings in and near Rome,[11] and taken in conjunction with the no less characteristically Claudian, and in such a context decidedly old-fashioned, predilection for cut-stone masonry, one is tempted to regard it as a personal fancy of the emperor himself. Away from the city the two new aqueducts were built in the normal contemporary faced concrete, the main distinguishing feature being the very poor quality of much of the work. The Claudian contractors seem to have deserved their reputation for graft.

Without question, Claudius's most important contributions to the development of Roman architecture lie in a field which one might be tempted to dismiss as mere engineering, were it not that it was so obviously the practical forcing-house of much that was most vital in contemporary Roman building. It was in great

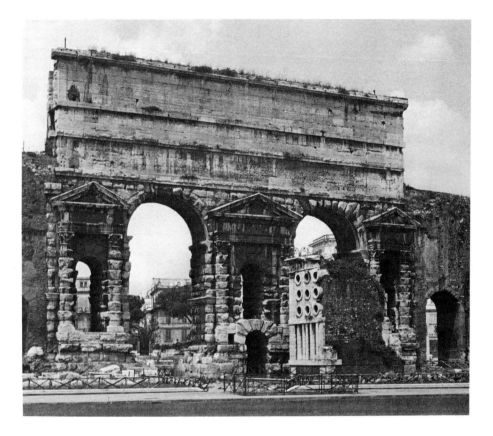

21. Rome, Porta Maggiore, a monumental double archway of travertine, built by Claudius
to carry the Aqua Claudia and the Anio Novus across the Via Labicana and the Via Praenestina.
Completed in A.D. 52. Later incorporated into the Aurelianic Walls

Condotto dell' acqua vergine. A Monumento di Claudio, B Investitura di terolozza fatta agli archi ante
edenti e asseguenti allo resso monumento C Nuova forma dell aquedotto innalzata dai moderni cin
que palmi dallo speco antico D Questo condotto rimane luogoi interrato a livello de capitelli del monumento

22 (*opposite*). Rome, the Porta Labicana (*left*) and Porta Praenestina (*right*) of the Aurelianic Walls (A.D. 270–82, modified by Honorius, A.D. 403, with many later accretions), incorporating the Claudian archway at the Porta Maggiore. Drawing by Rossini, 1829

23 (*opposite, below*). Rome, archway of rusticated travertine, A.D. 46, carrying the restored Aqua Virgo. Engraving by Piranesi, based on the upper part of the arch, all that was visible in his day

public works such as the new harbour at the mouth of the Tiber, near Ostia, and the draining of the Fucine Lake that engineers and architects (the distinction would have been meaningless to a Roman) learned the complete mastery of their materials which lay behind the revolutionary architectural progress of the later part of the century. The draining of the Fucine Lake was one of the many projects which Julius Caesar is said to have had under consideration at the time of his death; and it is not at all improbable that Claudius was further influenced in his choice by his own antiquarian researches into the Etruscans, those early masters of hydraulic lore. It is significant that at about the same date (the masonry is Julio-Claudian) there was also a restoration of the emissary of Lake Albano, the original drainage of which in the early fourth century B.C. had been achieved under Etruscan guidance. Whatever the precedents, the draining of the Fucino into the river Liri, four miles distant, was an enormous undertaking. It took eleven years to complete; and although ancient writers understandably make much of the several humiliating setbacks which the project underwent as a result of the venality and incompetence of the contractors, the planning and organization of the work was of a high order. A detail which illustrates how strongly Roman building practice rested on experience rather than on theory is that much of the mortar used is of poor quality because, in mixing it, the builders chose to use a ferruginous red sand from the bottom of the lake, which bears a superficial resemblance to the red pozzolana of the Roman Campagna, rather than the readily accessible yellow pozzolana, which looked like clay. Claudius was still importing pulvis puteolanus from Pozzuoli for his harbour works. The very considerable practical knowledge already acquired of the uses of pozzolana was

evidently not accompanied by any theoretical appreciation of the reasons for its hydraulic properties.[12]

One of the principal purposes of the new harbour at Ostia was to ensure the regularity of the grain-supply, and it is not surprising therefore that Claudius should have concerned himself also with improving the arrangements for its storage and distribution. A great deal of the storage was provided at Ostia itself.[13] But although fewer buildings of the sort have been identified in Rome, this must be partly due to the difficulties of distinguishing and dating such utilitarian buildings from the very fragmentary remains that have come down to us. It is now generally believed that the traces of a very large porticoed building along the west side of the Via Lata beneath and adjoining the Palazzo Doria, long but erroneously thought to be those of the Saepta, are in fact what survives of the Porticus Minucia Frumentaria, which about this date seems to have become the main distributing centre within the city.[14] The piers surviving beneath the church of S. Maria in Via Lata are of travertine and rusticated in the Claudian manner; they were free-standing and carried flat arches. Others, no longer visible, were cruciform, indicating a vaulted superstructure. If this is indeed the Porticus Minucia, which is known from inscriptions to have had at least forty-two distinct entrances, or offices, one must assume that much of the storage space was accommodated on an upper storey or storeys, and was accessible, as often at Ostia, by ramps.

Another commercial building which from its masonry may well be of Claudian date is the easternmost of the two early buildings beneath the church of S. Clemente. It consists of a number of small, uniform chambers grouped around three sides of a rectangular enclosure (the fourth side, with the entrance, is missing).

The openings into the individual chambers are narrow, suggesting that the commodity handled was less bulky than grain; and the provision of windows may indicate that the building combined the functions of depot and bazaar.

Finally, one may mention the grandiose temple and precinct begun in Claudius's honour immediately after his death by his widow and alleged poisoner, Agrippina. Although the visible remains are almost entirely the work of Nero, who incorporated the site into the gardens of the Golden House, and of Vespasian, who completed the temple, the elaborately rusticated travertine masonry [28, 29] is so very closely in the tradition of the Claudian Aqua Virgo and the Porta Maggiore [21–3] (and so very much in contrast with the elegant refinement of most Neronian building) that they constitute a fitting postscript to the work of the emperor in whose memory they were erected.

NERO (A.D. 54–68)

The emperor Nero was seventeen when he succeeded his stepfather, Claudius. He was a young man of decided artistic tastes and some talent, but temperamentally unstable and wholly unfitted for the responsibilities of unbridled power. Two circumstances singled his reign out to be a turning-point in the history of Roman architecture. One was the fire which in A.D. 64 destroyed half the centre of ancient Rome, with results that may fairly be compared with the aftermath of the Great Fire of London of 1666. The other was the situation created by the great advances in building materials and techniques that had taken place during the preceding half century. Although there was no single dominating architectural personality comparable to Sir Christopher Wren, contemporary building practice had within itself the resources for a development unprecedented in the history of ancient architecture. They only awaited an outlet and a stimulus. The fire provided the one, Nero the other.

The resulting revolution in architectural technology and taste, of which Nero's buildings

were the first public expression, and the wider implications of the great imperial residences upon which he lavished so much money and attention are discussed later.[15] In the pages that follow we are concerned only with his public building, and with his palaces in so far as they affected the architectural development of the city as a whole or illustrate the personality of their builder.

During the early part of his reign Nero's interests were those of a wealthy young patrician of his day. In the Vatican area he completed the unfinished Circus of Caligula and built a new bridge across the river, the Pons Neronianus, to give access to it. He laid out a temporary stadium in the Campus Martius (possibly the forerunner of the Stadium of Domitian) and in 57 a temporary amphitheatre, the lavish appointments of which – marbles and precious gems, ivory inlay, golden nets hung from tusks of solid ivory, and star-spangled awnings – are very much in character with what we know of the builder of the Domus Aurea. In more serious vein he was responsible for a market-building on the Caelian, the Macellum Magnum, dedicated in 59. The building itself has vanished, but coins show a two-storeyed columnar pavilion within what appears to have been a porticoed enclosure, also of two storeys. It was evidently an elaborate version of the single-storeyed market-buildings of Pompeii, Lepcis Magna [245], and other early sites.[16]

Nero's most popular building was without question the public baths, the Thermae Neronianae, which he completed in 62 or 64 in the Campus Martius, near the by now sadly inadequate Baths of Agrippa. 'What worse than Nero, what better than Nero's baths?' was Martial's verdict.[17] The building underwent a major restoration at the hands of Alexander Severus in 227, and it was on this occasion that it took on the form that was recorded in the Renaissance, showing a symmetrical building of the same general type as the Baths of Titus, Trajan, and Caracalla. It is a great pity that we have no means of telling what, if any, part of this represents Nero's original design, and that we

cannot, therefore, determine whether it represented a first step towards the formation of the 'Imperial' type which was to dominate later Roman practice. We can only say that such an innovation would have been in character with what we know of contemporary planning trends. Adjoining the baths was a gymnasium – an interesting anticipation of the provision made in the great public bath-buildings of the

also on the Oppian[19] by building across the low saddle that is now crowned by the Arch of Titus and the church of S. Maria Nova. Although it was all swept away in or after the fire, enough has come down to us to give an idea of the combination of rich materials and a meticulous refinement of detail which was the hallmark of Nero's personal taste. One well preserved fragment,[20] buried deep within the platform of

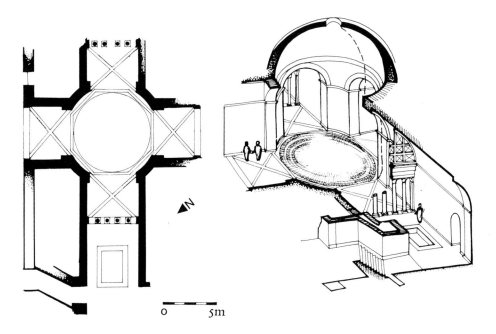

24. Rome, junction of two corridors within Nero's Domus Transitoria, before A.D. 64,
later incorporated within the platform of the Temple of Venus and Rome. Plan and sectional view.
The form of the dome is conjectural

second and third centuries for the social and educational activities which had belonged to the Greek gymnasium.[18]

Nero had inherited from his father a town house beside the Via Sacra, and it must have been this fact which first suggested the idea of the Domus Transitoria, which was to link the extensive imperial properties on the Esquiline and on the Palatine and, it now seems, a nucleus

Hadrian's Temple of Venus and Rome, comprises a small, circular, and presumably domed chamber at the intersection of two barrel-vaulted corridors [24]. There were shallow, marble-lined pools behind columnar screens in two of the arms, and the whole was paved in rich colours, partly in marble, partly in a geometric design of tiles of semi-opaque glass paste. Apart from its materials, however, this fragment of a

larger complex, with its wide penetration of a small, circular, and probably centrally lit, domed chamber by vaulted corridors, offers a valuable foretaste of one of the most striking and significant features of the Golden House, namely the interest of its architect in the interplay of enclosed curvilinear forms. As we shall see in a later chapter, the Golden House may

well have been the first major public monument in which this tendency found monumental expression. But the ferment was already at work, and in a surprisingly sophisticated form.

Another well preserved fragment of the Domus Transitoria is the sunken fountain court, or nymphaeum, beneath the triclinium of the Flavian Palace [25]. This was an elongated

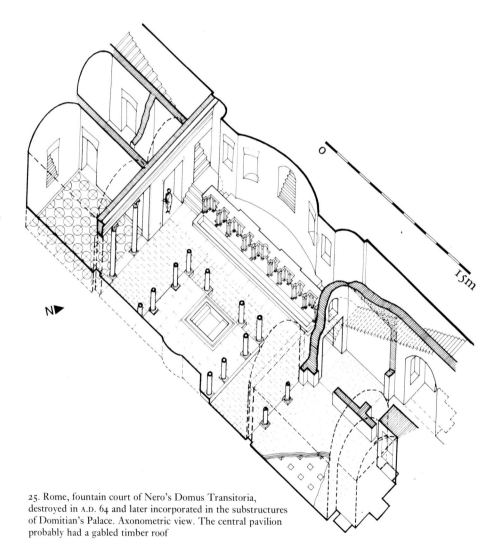

25. Rome, fountain court of Nero's Domus Transitoria, destroyed in A.D. 64 and later incorporated in the substructures of Domitian's Palace. Axonometric view. The central pavilion probably had a gabled timber roof

rectangular building recessed into the valley bottom between the two eminences of the Palatine Hill. In the centre was an open courtyard, with an elaborately scalloped fountain and cascades occupying the whole of one wall and, opposite it, a square dais covered by a columnar pavilion; facing each other across the courtyard from either end, there were two suites of small rooms, very richly decorated with marble intarsia, marble panelling, and vaulted ceilings covered with paintings and elaborate stuccowork, enriched with coloured glass and semiprecious stones. This was a suite for intimate, *al fresco* dining and repose in hot weather, comparable both in form and in intent to such Renaissance nymphaea (themselves based on classical models) as that built by Ammanati in the Villa di Papa Giulio. The fountain bears a distinct family resemblance to the scaenae frons of a theatre, the pavilion to those that one sees in the wall-paintings of Pompeii; the materials were the richest money could buy – on the floor and walls are specimens of all the finest varieties of marble and porphyry from Greece, Asia Minor, Egypt, and Africa, several of them appearing here for the first time; and the workmanship matched the materials. To cite a single instance, the decoration of the walls was protected from damp by an air-space contrived by means of specially constructed tiles. The floor too was specially damp-proofed.

The fire of 64, which started in the Circus Maximus and spread thence eastwards and southwards across the Palatine and Caelian towards the Esquiline, swept away the Domus Transitoria and with it many of the oldest and most populous quarters of Rome. Of the fourteen administrative Regions into which the city was divided, three were totally destroyed and only four were untouched. Nero had the authority which, in similar circumstances, Wren lacked, and he was quick to seize his opportunity. To provide for his new and yet more ambitious residence, the Domus Aurea or Golden House, he annexed the properties adjoining his own estates throughout an area of some 300–350 acres, roughly the equivalent of Hyde Park, or about one-third of Central Park, New York, and comprising the whole basin of which the depression occupied by the Colosseum is the natural centre. For all the perversity of its conception, the result was a remarkable and highly individual complex of buildings and parkland which, in several respects, can fairly claim to have been a turning-point in the history of Roman architecture.

In essence the Golden House was a wealthy country residence established in the heart of urban Rome [26]. It was this fact, not its opulence, which was its crime in the eyes of Nero's contemporaries, and it was this fact which determined the whole layout. The centrepiece was an artificial lake on the site later occupied by the Colosseum. Facing out across the lake from the sheltered lower slopes of the Oppian Hill (an offshoot of the Esquiline) was the main domestic wing; streams fed by specially built branches of the aqueducts cascaded down the slopes; and, grouped along the waterside and scattered picturesquely through the parkland as far as the eye could reach, were fountains, baths, porticoes, pavilions, and tempietti. The boundaries were sited so that from the terrace in front of the residential wing one saw nothing of the encircling town. Only towards the Forum Romanum, along the Velia, was there a monumental group of buildings. Here the fire had destroyed the Temple of Vesta and everything to the south of it, and here Nero built a grandiose vestibule on the site later occupied by the Temple of Venus and Rome. In the centre stood a colossal gilt bronze statue of himself, 120 feet high; and down the western slopes of the Velia the Via Sacra was taken out of its traditional winding course and made the axis of a monumental approach flanked by multiple streetside colonnades.[21]

All this was swept away after Nero's death, and over most of the area its only lasting result was to make available to Nero's successors the ground upon which were built most of the great monuments of Rome during the next half-century – the Templum Pacis, the Temple of Venus and Rome, the Colosseum, the Baths of

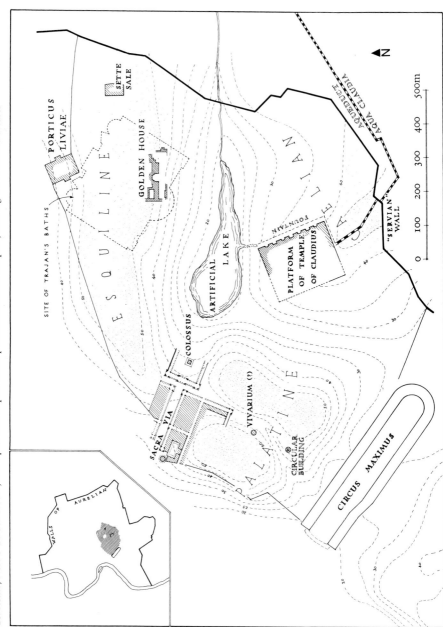

26. Rome, Nero's Golden House, A.D. 64–8. Sketch-plan of the probable extent of the park, showing the known structures

Titus and of Trajan, and the Flavian Palace, to name only some. Only the residential wing survived long enough to be incorporated within the substructures of Trajan's Baths and so preserved to be rediscovered by the artists and antiquarians of the Renaissance. Its vaulted chambers were the *grotte* where Raphael and his followers saw and studied the models for the style of which the name 'grotesque' has since passed into the language – a strange but not altogether inappropriate memorial to the bizarre fancy of its one-time imperial patron.

The Romans were not alone in failing to observe the real architectural significance of what was going on around them. By its contemporaries the Golden House was seen principally as a feat of engineering and as a repertory of mechanical marvels.[22] Nero's taste was above all for the novel and the spectacular, and his architects, Severus and Celer, were practical engineers who had been associated with the ambitious enterprise (begun but never completed) of cutting a canal from Lake Avernus to the Tiber. They were well equipped to provide such wonders as the artificial lake, a revolving banqueting hall (or a hall with a revolving ceiling) representing the motions of the heavenly bodies, coffered ivory ceilings which scattered flowers and scent upon the guests beneath, or baths supplied with sea-water and with water from the sulphur springs near Tivoli; and they were able within the compass of a few years to plan and to carry into effect the whole vast programme of landscaping and construction that lay behind the contrived rustic simplicity of this extraordinary enterprise. That

one of them was also the architect of vision who saw and exploited the aesthetic possibilities of the new concrete medium is entirely possible; but upon this aspect of the Golden House the sources are silent.

Nero himself is remembered (and would undoubtedly have wished to be remembered) for his Golden House. He deserves, however, to be given credit also for the admirable regulations which he drew up to govern the rebuilding of Rome after the fire.[23] The new city was to be laid out with regular, broad streets instead of the tortuous alleyways of the old town; streetside porticoes were to be provided, from the flat roofs of which fires could be fought; no building was to be more than seventy feet high;[24] every house was to be structurally independent of its neighbours; timber was to be restricted to a minimum and the use of certain fire-resistant stones encouraged. Human nature being what it is, these regulations were not always observed. But for a more positive view of their effectiveness one has only to look at the streets and apartment-houses of second-century Ostia, which in this, as in so much else, copied what was going on in Rome. Nero's regulations expressed and codified changes that were already in the air. The time was ripe for the replacement of the ramshackle tenement-houses of old Rome by the neat, orderly insulae which the newly developed concrete medium had made possible. The Great Fire furnished the occasion; and if it was, broadly speaking, a new Rome that rose from the ashes, Nero most certainly deserves a substantial share of the credit.

ARCHITECTURE IN ROME FROM VESPASIAN TO TRAJAN

(A.D. 69–117)

VESPASIAN (A.D. 69–79)

When the dust and confusion of the civil war that followed Nero's death had settled, the Roman Empire found itself with a new dynasty, the Flavians, established on the imperial throne. The family was of sound, middle-class, Central Italian stock, and the founder of the dynasty, Vespasian, a capable general and a shrewd administrator, had all the virtues and limitations of his modest origins. The heir to a bankrupt treasury, which during the ten years of his rule he successfully replenished by a policy of rigid economy and sound finance, not for him the indulgence of lavish building for its own sake. One may be sure that any architectural enterprise of his was undertaken with a clear purpose. It is perhaps for this reason that the list of his work, though short, contains so much of real architectural importance.

An immediate and urgent necessity was the rebuilding of the official state sanctuary, the Temple of Jupiter Optimus Maximus on the Capitol, which had been burnt to the ground during the last stages of the civil war. Rededicated in A.D. 75, it was again totally destroyed by fire five years later, and no fragment of Vespasian's building has come down to us. But from the literary record and from representations on coins[1] [27] we know that, as was appropriate in such a case, the design was conservative, somewhat taller than its Late Republican predecessor and doubtless making far more use of fine marbles, but in other respects following the traditional plan and repeating such time-honoured features as the four-horsed chariot of Jupiter above the apex of the gable.

The decision to complete the Claudianum, the temple of the Deified Claudius, left incomplete and partially dismantled by Nero, was an astute political move, designed to lend respectability to the new dynasty's claim to succeed the Julio-Claudians and yet at the same time to dissociate itself from the policies of the last member of that family, Nero. Of the original project very little had probably survived except the great platform, some 220 by 175 yards (200 by 160 m.) in extent, which occupied the top of the Caelian Hill. To this was added a wide axial staircase on the shorter, northern side, towards the Colosseum, and down the west side, facing the Palatine, a double order of travertine arcades, the remains of which have recently been restored fully to view within

27. Coin of Vespasian depicting the Temple of Jupiter Optimus Maximus Capitolinus, as rebuilt after A.D. 70 and rededicated in 75. It was again destroyed by fire in 80

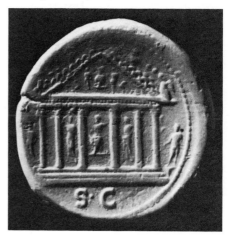

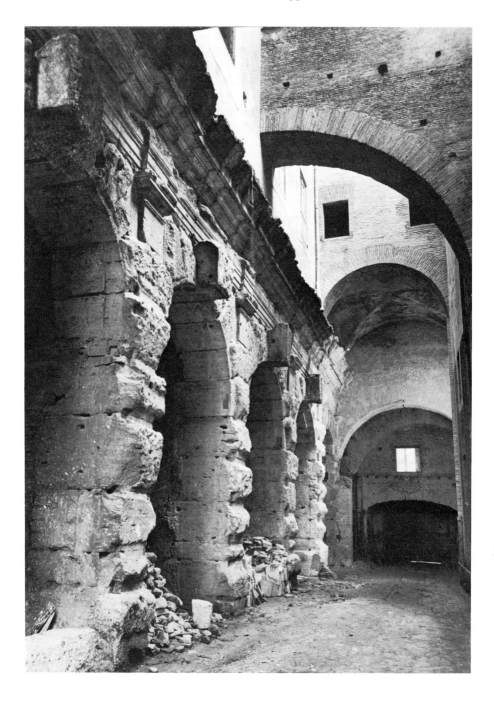

28 (*opposite*) and 29. Rome,
Temple of the Deified Claudius (Claudianum),
completed by Vespasian after 70.*
The rusticated travertine west façade of the terrace
and detail of upper order

*From this point onwards, all dates are A.D.
unless otherwise noted.

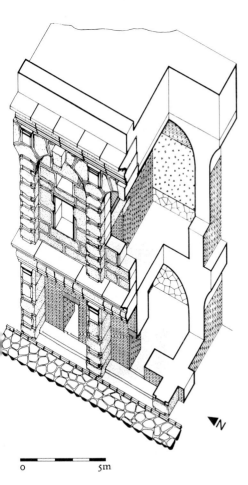

o 5m

the grounds of the monastery of the Passionist
Fathers; down the east side the ornamental
fountain added by Nero was allowed to remain.
The west façade[2] [28, 29] consists of two orders
of elaborately rusticated masonry; the lower
openings are rectangular, with flat arches and a
cornice carried on shallow Doric pilasters, and
the upper openings round-headed, framed be-
tween pilasters that rise to carry a projecting
entablature. The keystones of the upper arches
project in bold relief, and of the masonry only
the pilaster capitals, the two cornices, and the
architrave of the upper order are carved, all the
rest being left rough and in high relief, with only
a hint of the architectural framework in the
deeply channelled joints. Set back within the
openings of this double order were the closure
walls of a continuous façade. Those of the
ground floor were of brick-faced concrete, with
single doorways opening into a range of shops;
those of the upper floor of rusticated travertine,
with rectangular windows lighting a range of
interconnecting chambers. It is, however, the
arcaded framework that dominates the scheme,
presenting a bold, rhythmical façade towards
the Palatine. For all its complexity of detail, one
is closely reminded of the Temple of Jupiter
Anxur at Terracina,[3] from which it is indeed in
the direct line of descent.

Of the temple itself nothing is preserved, but
the plan is known from the Severan marble map
of Rome. It was a hexastyle prostyle building,
set on a tall podium, and it stood somewhat to
the east of the centre of the platform, facing
westwards across the shorter axis. The open
space around it was planted with rows of trees,
or shrubs, and it was at any rate in part enclosed
by shady porticoes. That the surviving traver-
tine façade of the platform (and *a fortiori* the
temple and other superstructures) is the work of
Vespasian is almost certain. Not only is it built
against the core of an earlier, simpler platform,
but it faced on to a paved street, which would
have been completely out of place in the
parklands of the Domus Aurea. But the
masonry, with its mannered rustication, is so
characteristically Claudian, recalling that of the

Porta Maggiore and the Aqua Virgo [21–3], that one is tempted to wonder whether it may not have been remodelled on some surviving elements of the original project.

The Templum Pacis, often though less correctly referred to as the Forum of Vespasian, was another dynastic monument, vowed in 71 after the capture of Jerusalem and designed, like Augustus's Ara Pacis, to identify the new dynasty with the blessings of peace after a period of civil and external strife.[4] It took the form [30] of a rectangular enclosure, 120 by 150 yards (110 by 135 m.) in extent, laid out upon the same alignment as the Forum of Augustus, towards which it faced, but from which it was separated by the line of the Argiletum, the busy street that linked the Forum Romanum with the crowded urban quarter of the Subura. The greater part of the site was occupied by an open space, slightly shorter than it was broad, which was laid out as a formal garden and enclosed on three sides by porticoes with columns of red Egyptian granite. On the fourth side, towards the Argiletum, instead of a portico there was a

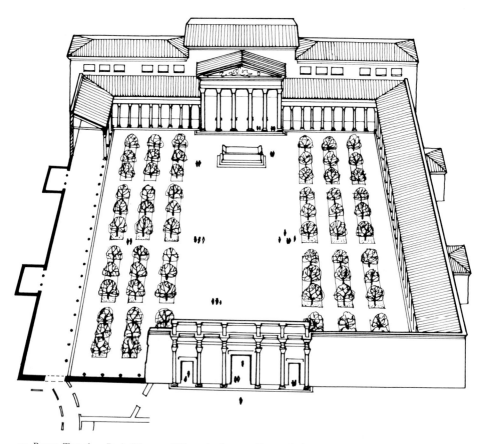

30. Rome, Templum Pacis ('Forum of Vespasian'), 71–9. Restored view, looking south-eastwards across the Forum Transitorium [cf. 6 and 35]

colonnade of even larger columns of africano marble, set close up against the entrance wall; and pairs of columns of the same marble spanned the entrances to four square exedrae which opened, two and two, off the lateral porticoes. The actual temple faced north-westwards, down the shorter axis, and instead of projecting into the open central area it was so placed that the façade stood on the line of the south-east colonnade, the porch occupying the breadth of the portico and the apsed cella projecting beyond it, terraced into the rising ground of the Velia. Opening off the south-east portico on either side of the temple was a range of large halls, one of which contained a library. Another was later used to house the great Severan marble map of Rome.

There are many points of interest about this plan. The choice of the shorter axis and the use of trees, or shrubs, to accentuate the architectural design are features that it shares with the Claudianum. The exedrae opening off the lateral porticoes recall the great precinct of Baalbek or, later, Hadrian's Library at Athens. The colonnade along the inner face of the north-west wall is an early, if not the earliest, monumental example of the application to an external wall of a decorative device long familiar in interior architecture (it is a pity that we do not know exactly how the entablature of the colonnade was related to the wall behind it). Above all, the relation of the actual temple building to the forecourt has qualities of reticence that are, to say the least, unusual in metropolitan Roman architecture.[5] The precinct was focused upon, but in no way dominated by, the temple. To an exceptional degree it was the whole building that constituted the *Temenos Eirenes*, as the Greek writers call it, and it derived its effect as much from the simplicity of its lines and the skilful interplay of trees and architecture as from the richness of its materials and the wealth of its fittings. In it, alongside such trophies of the Jewish war as the Seven-branched Candlestick and the Ark of the Covenant, were displayed some of the finest masterpieces of Greek painting and sculpture, and Pliny names

it as one of the three most beautiful buildings of the Rome of his day (the others on his list being the Forum of Augustus and the Basilica Aemilia). One of the last great buildings in the conservative Roman tradition, barely touched by the innovating currents of contemporary architectural thought, it was also one of the finest.

Very much the same might be said of the Flavian Amphitheatre or, to give it its familiar name, the Colosseum [31, 32]. One of the wonders of its own day, ever since the Middle Ages it has been a symbol of the majesty and enduring might of Rome. One recalls the words of the Venerable Bede, as translated by Byron:

'While stands the Coliseum, Rome shall stand;
When falls the Coliseum, Rome shall fall:
And when Rome falls – the World.'

For that very reason it is not an easy building to view dispassionately in its contemporary context. Even its popular name, however apt, lacks classical authority and may well be derived at second-hand from the Colossus of Nero, which stood near by.

Of the amphitheatres already existing in Rome, that of Taurus had been recently damaged by fire, and those of Caligula and Nero were both temporary structures, manifestly inadequate to the needs of a rapidly growing population.[6] As a popular gesture by the new dynasty, the construction of a new, permanent amphitheatre was a wise choice. Equally shrewd was the choice of the site, the valley bottom that had housed the artificial lake of Nero's Golden House. At one resounding stroke Vespasian was able to redress one of the most bitterly resented wrongs of his predecessor, while at the same time securing an ideal site for his new building – central, ready-excavated, easily drained, and with a compact clay subsoil admirably suited to carry the vast weight of the projected building. It was probably begun early in his reign and was unfinished at his death. Exactly which parts are the work of Vespasian, and which of Titus and Domitian, are questions of little importance. Apart from modifications to the attic storey during construction, the outstanding character-

istic of the building is the skill and foresight with which the unknown architect can be seen from the very outset to have marshalled the whole gigantic enterprise towards its predetermined conclusion.

The problem that he faced was the seating and the orderly handling of vast and potentially unruly crowds of spectators, usually estimated as between 45,000 and 55,000 persons. There were plenty of precedents, though none on this enormous scale. The solution adopted by the architect of the Theatre of Marcellus [4], itself presumably modelled on that of the yet earlier Theatre of Pompey, is one that we find in an infinite number of local variants throughout the theatres and amphitheatres of the Roman world, in every province and at every date, wherever these had to be built up from level ground instead of resting against the slope of some convenient hillside. The seating was terraced upwards and outwards on the rising vaults of a network of radiating, wedge-shaped chambers and ambulatory corridors; and into the resulting voids was fitted a system of radiating staircases or ramps (*vomitoria*) and lateral passageways, so contrived as to provide separate access to each wedge (*cuneus*) of seating, and within each wedge the several concentric sectors (*maeniana*) into which the whole of the interior was divided by horizontal gangways. In the case of the Colosseum there were no less than seventy-six numbered entrances; and wherever necessary, movement could be further controlled by wooden barriers. In addition to providing lateral circulation, the outer ring of corridors helped to buttress the outward thrust of the seating.

All this was familiar ground. What was new was the sheer size of the structural problems involved. The plan, as regularly in the amphitheatres of the Roman world, was an ellipse, and it measured no less than 615 by 510 feet (188 by 156 m.) externally and 280 by 175 feet (86 by 54 m.) internally, the seating (*cavea*) forming a uniform ring 167 feet (51 m.) wide and 159 feet (48.50 m.) high from the pavement to the outer cornice. Up to the full height of the third external order the seating was of marble carried on substructures of vaulted masonry. Above this height it was of wood (the 'maenianum summum in ligneis' of the texts) in order to reduce the weight at a point where the outward thrust was contained only by the thickness and solid construction of the outer wall. Below this level the doubling of the ambulatory corridors and the radially vaulted vomitoria afforded a system of buttressing that was more than adequate to the demands made upon it. Porches in the middle of the two long sides gave access to the imperial box and to the seating for senators [31].

Structurally, the interest of the building lies mainly in its choice of materials and the evidence that it offers of working methods. As always in the best Roman building, enormous care was lavished on the foundations. To support the cavea a vast elliptical ring of concrete, about 170 feet (51 m.) wide and 40 feet (12 m.) deep, was laid down, the lowest part of it (about 20 feet/ 6 m. in depth) being laid directly in a huge trench cut into the compact clay subsoil, while the upper part (another 20 feet) was contained within a massive outer ring of brick-faced concrete. Built into this upper part were drains and practical facilities, and the whole was capped with a platform of travertine blocks.[7] On this platform was built a framework of piers of travertine, specially quarried near Tivoli, and it was this squared stone masonry which constituted the essential load-bearing skeleton of the entire building up to the springing of the vaults of the second order. Between the piers were inserted the radial walls, which were of squared tufa up to an irregular line corresponding roughly with the floor of the second order, and above this of brick-faced concrete. With the exception of one of the smaller, internal corridors, which has a groined vault, the vaults are all of barrel form, in some cases incorporating ribs of brick, a very early use of a device which, though of little or no independent structural value, was widely used in later Roman architecture to facilitate the actual processes of construction.[8] The use of a

31. Rome, Amphitheatrum Flavium (Colosseum), inaugurated in 80.
Plans, sections, and sectional view

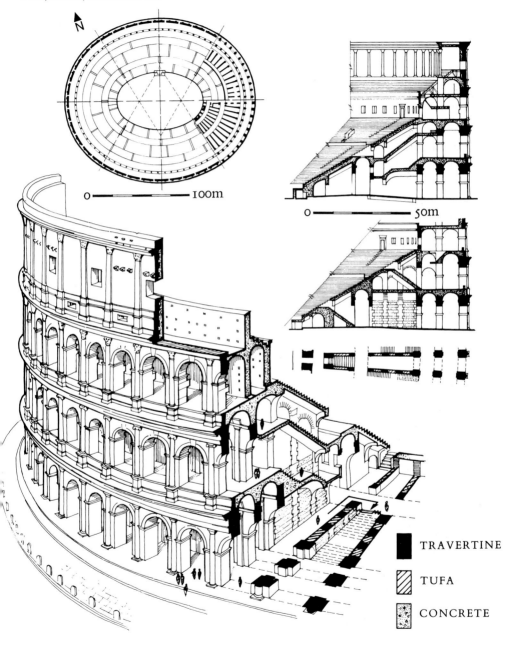

TRAVERTINE

TUFA

CONCRETE

variety of materials was undoubtedly an economy in time as well as cost, since each was handled by a different group of workmen, the tufa and the concrete being added when the travertine skeleton was already in place, and the timberwork and the marble seating later still. The work was further speeded by dividing the building laterally into four or more sectors. At least two gangs can be seen to have been at work simultaneously on the surviving half of the travertine facing of the attic storey, and in a building that had been so carefully thought out in advance there would have been no difficulty in applying the same system throughout.

Architecturally there was little that was new in the travertine façade [32]. It consisted of three superimposed orders, Doric, Ionic, and Corinthian respectively, of which the half-columns and entablatures were purely decorative, and above these a tall attic storey with lofty Corinthian pilasters supporting the crowning entablature. The three orders framed arches opening on to the ambulatory corridors, while smaller, rectangular windows, placed in alternate bays, lit the corridors serving the upper part of the cavea. Except for the elaborately marbled porches surmounted by statuary which projected from the four cardinal points of the plan, the entire circumference was uniformly treated. All this follows conventional lines, the architect's principal contribution lying in the skill with which he handled the proportions of what could so easily have become a mere unwieldy bulk of masonry, and in the unobtrusive ingenuity with which he manipulated the detail of the orders to meet the requirements of the structures within. Two points only call for comment. One is the use of huge decorative shields of gilded bronze, alternating with the windows of the attic storey; the supports for these are still visible. The other is the arrangements for supporting the *velarium*, the huge awning that protected the spectators from the sun, for the manipulation of which a special detachment of sailors was quartered near by. The poles supporting this were carried on large brackets, three of which can be seen just below

the entablature of each bay of the attic; and it was further braced by bollards set at pavement level a short distance out from the steps of the lowest order.[9]

About the interior, which was stripped of its marbles during the Middle Ages, there is little to be said. The remains of an order with large granite columns must come from a portico somewhere near the top of the building, perhaps carrying a timber roof over the wooden seats of the *summum maenianum*. The elaborate network of service corridors and chambers below the arena is mainly the work of Domitian. Among them were lifts with an ingenious system of counterweights for hoisting scenery or wild beasts to the floor above, a feature for which the amphitheatre at Puteoli in Campania offers interesting parallels.

The Colosseum was not a building of any great originality. It was as conservative in its structural methods and choice of materials as it was in design, preferring in both cases to refine upon a tradition that went right back to the Republic, to buildings such as the temple at Praeneste and the Tabularium. Formally and materially it represents a strain in Roman architecture that was very shortly to be swept away by new techniques and new aspirations. For all that, this was a tradition capable of a great strength and dignity, and one well suited to display the qualities of bold, orderly planning and technical competence which characterize the best Roman work of all periods. In the Colosseum it found a worthy consummation.

TITUS (A.D. 79–81)

Vespasian's elder son and successor, Titus, did not live long enough to stamp his personality upon the architecture of Rome. Apart from continuing his father's work on the Colosseum, he was responsible for initiating only two major enterprises, the Temple of the Deified Vespasian and a new public bath-building, the Thermae Titi. He was also accorded an honorary arch, probably to be identified with the triple arch that stood in the middle of the curved

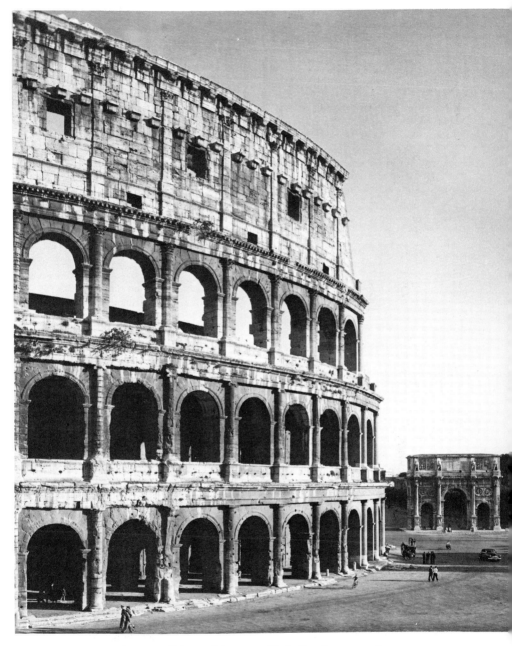

32. Rome, Amphitheatrum Flavium (Colosseum), inaugurated in 80. Exterior

end of the Circus Maximus; and it is not impossible that he began the well-known arch at the end of the Via Sacra, between the Forum Romanum and the Colosseum.

For the Temple of Vespasian he chose a site at the foot of the Capitoline Hill, beside the Temple of Concord. Apart from the steps, which owing to the limitations of space available were set back between the columns of the façade, the hexastyle peristyle plan followed conventional lines. Rather unusually for so late a date the travertine of the podium was left exposed, but the cella (which was almost certainly completed by Domitian) was elaborately finished in fine marbles. The three standing columns are an early example of the careful restoration of an ancient building, undertaken by Valadier in 1811. The entablature, preserved in the substructures of the Tabularium, is an outstanding example of Flavian architectural ornament, bold, deeply cut, and very rich, a style native to Rome, where one can follow its evolution, step by step, from Late Augustan and through Julio-Claudian and Flavian times down

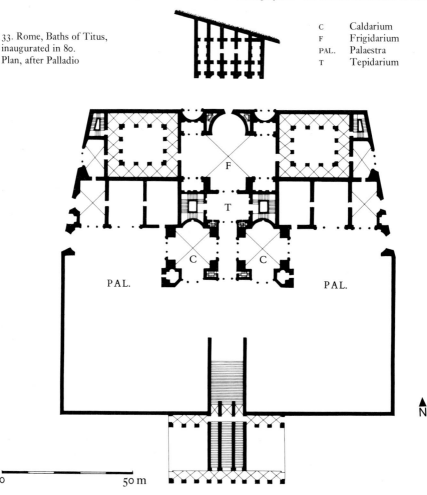

33. Rome, Baths of Titus,
inaugurated in 80.
Plan, after Palladio

C	Caldarium
F	Frigidarium
PAL.	Palaestra
T	Tepidarium

0 50 m

N

to Domitian and to the early years of Trajan.

The Baths of Titus, built in haste to grace the dedication of the Colosseum in A.D. 80, followed the precedent established by Vespasian in using ground that had belonged to Nero's Golden House, standing alongside the main domestic wing and looking out over the valley. Except for the remains of a portico of brick-faced concrete with engaged columns, across the street from the Colosseum, hardly anything has survived, but the plan, which is known from a measured sketch by Palladio [33], suggests that this was the essential structural material throughout.[10] Palladio's plan, whatever the reliability of its detail, reveals unmistakably that the layout was of the so-called 'Imperial' type. This type, which had a long and important history before it, consisted essentially of a large, approximately rectangular enclosure and, placed symmetrically within it, a central bathing block. The bathing block was itself symmetrical about its shorter axis, transversely across the northern end of which (or in the later examples centrally) stood the main *frigidarium*, or cold room, a lofty three-bay, groin-vaulted hall, buttressed by smaller, barrel-vaulted bays containing cold-plunges; and at the south end, often projecting so as to take full advantage of the sun, the main *caldarium*, or hot room. Along the north side were disposed two identical ranges of smaller suites of changing rooms (*apodyteria*), exercise yards (*palaestrae*), latrines, and other services, and along the south side two identical ranges of smaller heated rooms. Around the outer perimeter of the enclosure lay the cisterns, and facing inwards from it on to gardens were halls to house the manifold social activities for which these great bathing establishments served as centres – meeting rooms, libraries, lecture halls, museums, etc. Such in brief was the fully developed 'Imperial' type of baths. Those of Titus were small by comparison with the later giants (less than half the equivalent linear dimensions of those of Trajan), and the outer enclosure was little more than a large rectangular terrace along its southern side. But most of the essential elements were already present,

as indeed they may well have been twenty years earlier (though this cannot now be proved) in the Baths of Nero.[11] In either case, like so much that is vital to the development of later Roman architecture, the seeds are to be sought in the fruitful middle years of the first century A.D.

DOMITIAN (A.D. 81–96)

Domitian, Vespasian's second son, succeeded his brother in A.D. 81. During the fifteen years of his reign he was responsible for a great deal of building, and although his work, viewed as a whole, may be regarded as broadly progressive rather than revolutionary, it did by its very quantity leave its mark upon Roman architecture at a critical stage in its development. It included, moreover, the creations of Rabirius, one of the few Roman architects of distinction whose name is known to us. Domitian has every right to be considered one of the great builder emperors.

Domitian's work may conveniently be discussed under three headings: buildings that he inherited unfinished from his father or his brother; those that he restored after the great fire of 80; and those that he initiated *ex novo*, although he did not in all cases live to complete them.

To the first category belong the Colosseum, the Baths of Titus, and the Temple of Vespasian, all of which have already been sufficiently described. The well-known arch at the head of the Via Sacra may also have been begun by Titus, but it was certainly finished after his death as a commemorative monument. Built of Pentelic marble about a concrete core, it is remarkable chiefly for the simple dignity of its architectural lines and for its sculptured ornament, which includes the two familiar panels illustrating Titus's triumph after the capture of Jerusalem. It is one of the earliest public monuments to use the Composite capital, which had been invented by Augustan architects but which only now began to come into common use. It is also the first metropolitan Roman building since the Republic known to have been

built of imported white marble. Incorporated in the Middle Ages into a fortress of the Frangipane family, it was not restored to its familiar form until 1821, by Valadier, whose use of travertine to distinguish the new from the original masonry is an early and wholly successful example of scientific restoration.

The fire of 80 left a heritage of buildings damaged or destroyed which extended all the way from the Capitol to the Pantheon and which ranged from the Temple of Jupiter Optimus Maximus, re-dedicated barely five years before, to the great complex of monuments built by Agrippa in the Campus Martius. Almost without exception the buildings destroyed are known to have been restored by Domitian, and something is known about several of them from the Severan marble map of Rome, including the Temple of Isis and the Baths of Agrippa [20]. But of the buildings themselves little or nothing has survived. On the Capitol only the little Republican Temple of Veiovis beside the Tabularium has preserved any substantial remains of its Domitianic restoration, which took the form of replacing the timber roof by a fireproof concrete vault and decorating the interior with an elaborate scheme of coloured marble. The Temple of Jupiter was once again restored on traditional lines, with a wealth of fittings such as gilded bronze tiles and doors plated with gold. But although this time it stood undamaged until late antiquity, hardly a trace of Domitian's work has come down to us.

The buildings initiated by Domitian himself cover a remarkably wide range of techniques and architectural styles. At one end of the scale we have the Flavian Palace, described later in this chapter; and at the other we have the stadium in the Campus Martius, now the Piazza Navona, the open space of which is still that of the Roman racetrack, while the houses incorporate much of the structure of the seating. Constructionally a two-storey version of the Colosseum adapted to the elongated shape of a stadium, it was a thoroughly conservative building, with its marble seating carried on substructures of travertine and brick-faced con-

crete and the travertine arcades of its outer façade framed in the traditional manner by decorative classical orders. Indeed, its principal claim to distinction is that it is the last building in Rome which we know to have used travertine ashlar as a monumental material in its own right.

Between the two extremes lie a large number of buildings which, though essentially in the classical monumental tradition, can be seen to have introduced novelties of design or detail that are significant for the subsequent development of Roman architecture.

Nothing has survived above ground of the Porticus Divorum, but the plan is known from the Severan marble map [20]. An elongated rectangular enclosure, dedicated to the two deified emperors of the Flavian dynasty, it probably served also as a marshalling ground for the triumphal processions of Domitian himself. At one end stood a grandiose triple arch (the Porta Triumphalis?) and at the other an altar. Two small tetrastyle temples faced each other across the inner face of the arch, and along the rest of the two long sides and across the far end ran colonnaded porticoes. The proportions are quite different from those of Vespasian's Templum Pacis, but in other respects there are many similarities: the formal planting of the central space; the rectangular exedrae that open off the porticoes; the emphasis upon the monument as a whole at the expense of the individual temples; and the deliberate exclusion of the outer world by means of high enclosing walls.

In this last respect we can trace two distinct currents in the temple architecture of the Early Empire. In the Forum Romanum, for example, successive emperors were content to follow the traditional Italic practice of treating each temple as an integral part of the urban setting to which it belonged. Side by side with this, however, there had been during the later Republic a growing fashion for setting temples within porticoed enclosures, such as the Porticus Metelli (soon after 146 B.C.), and this tendency was accentuated and given fresh emphasis in the Imperial Fora. The great enclosing walls of

these may, as it is often claimed, have been designed partly as firebreaks; but it is almost certainly true also that they reflect the increasing Roman contacts with the hellenistic East, in particular with Syria and Egypt, where the enclosed, inward-facing sanctuary was the rule rather than the exception.[12] In the eastern provinces, as we shall see, the tradition was continuous into Roman times. Here in the west one result was to accentuate the trend towards formalism that was one of Roman architecture's strongest and most enduring characteristics. The Roman architect was not the blind slave to symmetry that he is often portrayed as being. But it is true that in his monumental architecture he preferred to avoid the intangible. He had little of the classical Greek architect's instinctive feeling for placing buildings in casual but harmonious relationship, and he was happiest when dealing with problems that were capable of clearly defined, 'drawing-board' solutions.

Another area in which Domitian was engaged was that of the Imperial Fora [6], where he built the Forum Transitorium, dedicated after his death by Nerva, and where he seems to have been active also both in the Forum of Caesar and in the area later occupied by Trajan's Forum. Eusebius in fact lists the last-named as one of Domitian's buildings, and it is certain that at the end of it adjoining the Forum of Augustus it was Domitian who started cutting back the lower slopes of the Quirinal Hill to clear space for some monumental building.[13] Since, however, it is no less certain that the Domitianic project was very different from that finally put into effect, the credit for the planning as well as for the execution of the latter must go to Trajan and to his architect, Apollodorus of Damascus. We shall never know what exactly Domitian had in mind for this area.

The rebuilding of the Temple of Venus Genetrix in the Forum of Caesar is another enterprise that was certainly completed by Trajan, who is known from an inscription to have re-dedicated it in 113, the year of his own great forum. The evidence for attributing the inception of the work to Domitian, namely the distinctively Flavian style of its richly carved entablature [34], is not in itself conclusive. Sculptural styles did not change overnight, and this could have been a purely Trajanic project, carried out by workmen trained under the previous regime. On the other hand, the whole area had suffered damage in the fire of A.D. 80 and it is very likely that the repairs were begun by Domitian but finished after his death by

34. Rome, Temple of Venus Genetrix, rebuilt by Trajan and dedicated in 113. Marble cornice block from the pediment

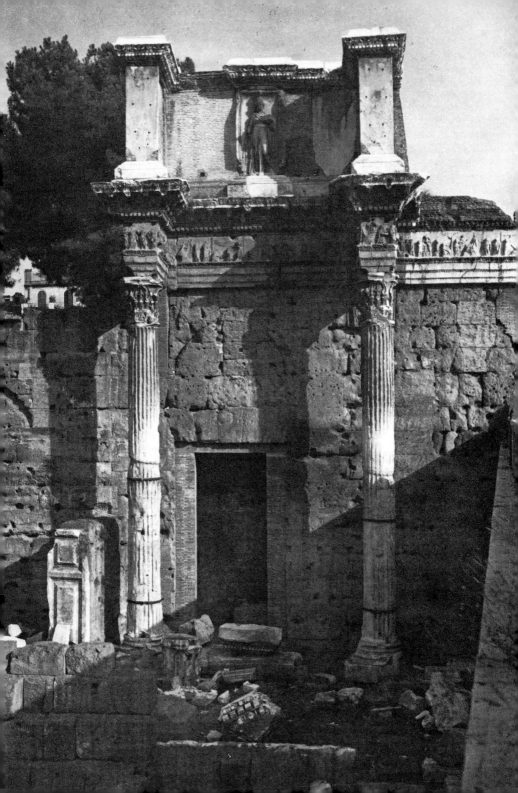

Trajan, who deferred their inauguration to coincide with that of his own forum. The plan of the new temple closely followed that of its predecessor, of which it incorporated the podium. The front of the latter rose sheer from the pavement in front, access to it being by two small lateral staircases, and the temple itself was short in proportion to its breadth, with very closely set columns, eight across the front and eight down either flank. The columns, three of which were re-erected in the thirties, and the entablature were of Luni marble, and against the inner walls of the apsed cella there were decorative colonnades of Numidian marble with very elaborately carved capitals and bases. A feature of the marble revetment of the cella is that it was channelled to imitate drafted masonry.[14]

The Forum Transitorium occupied a long and narrow space (about 395 by 150 feet; 120 by 45 m.) between the Fora of Caesar and Augustus on the one hand, and the Templum Pacis on the other. The site offered little scope for architectural originality, and is remarkable chiefly for the still-standing remains ('Le Colonnacce') of the decorative colonnades with which the two long walls were treated [35]. These were free-standing to capital height, only the entablature and the attic storey above being bracketed out to form a series of pedestals and re-entrant bays. Attic and frieze alike were richly carved. Such semi-engaged decorative colonnades had long been a common feature of interior architecture, but their use as a monumental enrichment of exterior walls was a novelty of which there is no certain example before the Flavian period. Of the Temple of Minerva, which stood at the south end, in much the same relation to the forum as the Temple of Venus Genetrix to the Forum of Caesar, the greater part was still standing until 1606, when it was demolished to provide materials for the fountain of Paul V on the Janiculum, and it is known both from Renaissance drawings and

from the Severan marble plan. It was hexastyle prostyle with elegantly fluted columns of Phrygian marble and a colonnaded interior ending in an apse. The awkward problem of the projecting south-eastern apse of the Forum Augustum was resolved in characteristically Roman manner by siting the end wall of the forum proper at the level of the front of the cella so as to conceal the greater part of the wall behind, and by using the irregular space beyond to house a semicircular portico (the Porticus Absidata), which served as a monumental entry from the crowded urban quarters to the north and east into the new forum and, through it, to the Forum Romanum, to the Fora of Caesar and of Augustus, and to the Templum Pacis. After over a century of piecemeal development this whole monumental complex now for the first time began to acquire a certain architectural unity.

There are two of Domitian's buildings of which we may particularly regret the absence of any surviving remains. One is the Temple of Minerva Chalcidica, which stood in the angle between the Porticus Divorum and the Iseum [20]. The plan of it on the Severan marble map is curiously at variance with the record of a circular temple with an outer and an inner ring of columns given by Panvinio on the basis of measurements by Pirro Ligorio.[15] The other is the family mausoleum which Domitian built on the Esquiline, on the site of the family house of the Flavii where he himself had been born. References to it by contemporary writers show that it was circular in shape.

Finally, before turning to the great complex of buildings on the Palatine which represents the principal contribution of Domitian and his architect, Rabirius, to the history of Roman architecture, it is well to be reminded of the tremendous amount of everyday architecture that was going on in Rome throughout the latter part of the first century A.D. The great fires of 64 and 80 had left a legacy of destruction that must

35 (*opposite*). Rome, Forum Transitorium (Forum of Nerva), dedicated in 97. 'Le Colonnacce', part of the decorative façade of the Templum Pacis [cf. 30]

have taken many years to make good, and while much of this was undertaken by successive emperors, a great deal more was left to private initiative. This is not the place to catalogue the long list of buildings on the Caelian, Aventine, and Esquiline Hills, in the Campus Martius, and elsewhere, known from their brick-stamps and other indications to belong to the Flavian period.[16] They include private houses (a good example is that which lies beneath the apse of the chuch of S. Clemente), private bath-buildings (Martial, writing under Domitian, mentions eight such), shops, warehouses (the Horrea Vespasiani, the site of which is not known, and the Horrea Piperataria, or Spice Market, on the site of what later became the Basilica of Maxentius), minor public monuments such as the Meta Sudans, and a multitude of fragments of masonry which, in the nature of things, are almost bound to remain anonymous. What happened at Ostia under Hadrian and Antoninus Pius was happening in Rome a generation or so earlier. These buildings, many of them individually of little importance, together constituted an almost total reconstruction of the heart of ancient Rome, and they were the school in which the builders of the later Empire learned much of their craft.

Domitian's enduring monument is the great imperial residence on the Palatine, known officially as the Domus Augustana (or Augustiana) and in popular usage as the Palatium [38]. The residential block of the Golden House may have remained in intermittent use for some time after Nero's death, but the construction of the Colosseum and the Baths of Titus, cutting it off from the centre of the city, deprived it of any value it may have had as an official residence. It is not surprising, therefore, that Domitian should have decided to abandon it altogether and to turn instead to the development of the pre-Neronian nucleus on the Palatine. Here there already existed the Domus Tiberiana, which, together with a group of venerable monuments at the angle overlooking the river, occupied the whole of the Germalus, the western of the two eminences into which the Palatine

Hill was divided. Except for its northern spur, its eastern counterpart, the Palatium, had already been appropriated by Nero; and it was here, occupying the saddle between the two and the whole of the central and south-eastern part of the Palatium, that Domitian built the main block of his great palace [36].

The Domus Tiberiana itself does not seem to have been greatly altered, but below it, at the level of the Forum Romanum, the area between the Temple of Castor and the Horrea Agrippiana was converted into a monumental vestibule serving the whole complex. The vestibule we know from brick-stamps to have been an afterthought, added during the last years of Domitian's life. All the rest was undertaken early in his reign and, except for the 'stadium', was completed in time for the inauguration of the palace in 92. The architect was Rabirius.[17] His plan lacks the rather obvious formal unity of many Roman buildings, but there is nothing makeshift about it. It was an ingenious and on the whole very successful answer to the problem of combining the conflicting requirements of a palace and a private residence on a site of some initial complexity. With remarkably few additions and modifications (undertaken chiefly by Hadrian and Septimius Severus) Domitian's building was to remain the official Roman residence of the emperor right down to late antiquity, the eponymous precursor of all subsequent 'palaces'.

Of the factors that determined the choice of plan, the most important was the need to site the state rooms where they would be readily accessible from the Clivus Palatinus, the road that ran up the valley between the Germalus and the Palatium and at that time the only direct means of access from the city centre. They were accordingly grouped together at the west end, terraced up above the saddle, where they formed an almost independent block, with the main façade facing down the valley and a secondary façade towards the Domus Tiberiana. (Within the make-up of the terrace were incorporated and preserved the Late Republican 'House of the Griffins', the Augustan

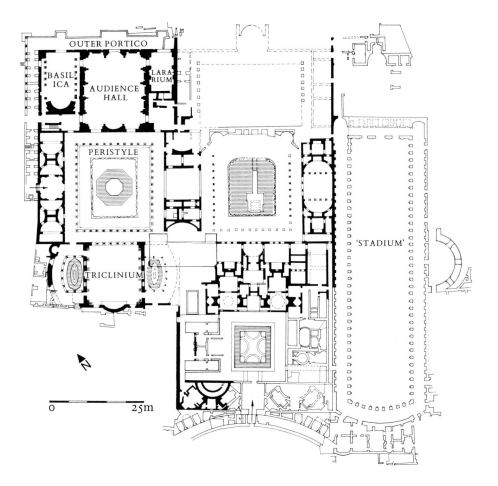

OUTER PORTICO

BASIL‑ ICA

AUDIENCE HALL

LARA‑ RIUM

PERISTYLE

TRICLINIUM

'STADIUM'

N

0　　　　25m

36. Rome, Flavian Palace (Domus Augustana), inaugurated in 92. Plan.
Solid black indicates buildings at the upper level still in whole or part upstanding

painted Isiac hall, and the nymphaeum of Nero's Domus Transitoria.) To the east of the official wing, alongside but almost independent of it, lay the emperor's private apartments, and to the east of this again a sunken garden in the shape of a stadium. On the side facing the Circus Maximus it was the domestic wing which dictated the layout of the façade, with a wide, shallow, central exedra, flanked on one side by the imperial box, overlooking the circus, and on the other by a formal terrace masking the irregularities of plan that arose at this point from the need to respect the Augustan Temple of Apollo and other venerable monuments. Towards the Forum, on the other hand, the whole architectural emphasis was upon the façade of the public wing, which reared its impressive bulk directly above the head of the Clivus Palatinus. As one approached up the hill the domestic wing lay round the corner to the left, with its main block set well back beyond a pair of colonnaded courtyards. On plan the as yet only partly excavated buildings to the north of the stadium may seem to balance the projection of the public wing; but they were certainly far less bulky, and there does not in fact seem to have been any attempt to treat the whole north façade as a monumental unit. The intention here was rather to emphasize the separate character of the two parts of the palace. It was only internally, at the level of the two peristyle courtyards, that the two wings were linked by a clearly established cross-axis. Towards the east Domitian's work remained unfinished at his death, and it was left to Septimius Severus to complete the development in this direction.

The official wing of the palace formed an elongated rectangular block, with three great state rooms opening directly off the façade and, beyond them, a large colonnaded courtyard leading to the state banqueting hall (*triclinium*). The state rooms were (from west to east) the basilica, in which the emperor sat in judgement, and two rooms conventionally known as the 'throne room' ('Aula Regia') and the 'palace chapel' (*lararium*). The basilica was a large

rectangular hall, with an apse at the far end and, set about 6–7 feet out from the side walls, two ranges of Numidian marble columns, which helped to provide a broad seating for what is usually thought to have been a coffered vault – a disposition which in its essentials goes right back to the vaulted nymphaea of the Late Republic.[18] Quite soon after construction the outer wall began to show signs of settlement, and the whole north-west angle had to be elaborately buttressed by Hadrian. That the central hall, the throne room, was vaulted is doubtful. The span was considerably greater than that of the basilica, and although the walls were robust and well buttressed laterally it is very questionable whether they would have stood up to the resulting pressures. Projecting rectangular piers broke the inner faces up into a series of bays, within which were decorative aediculae containing statuary, the bays themselves being framed between tall fluted columns of Phrygian marble carrying a highly decorated order; a shallow apse at the south end housed the imperial throne. The 'Lararium' was a smaller room, and would have presented no problem to vault, although the addition of internal buttresses by Hadrian suggests that even here Rabirius may have under-estimated the structural problem involved. There was no axial staircase leading up to the façade, but an external portico, which ran right across the façade and along part of the west side, linking the state rooms with the Clivus Palatinus and the Domus Tiberiana.

The courtyard behind was surrounded by a portico enclosing a fountain and a formal garden and it was flanked by a series of small rooms of interesting curvilinear design. The whole of the south side was dominated by the great triclinium, or banqueting hall [37]. Nearly as large as the throne room, it must have been timber-roofed. Towards the courtyard it was open between six huge columns of grey Egyptian granite behind an octastyle porch of the same proportions and materials. At the far end there was a shallow apse and a raised dais for the emperor and important guests, and along each

37. Rome, Flavian Palace (Domus Augustana),
inaugurated in 92.
Restored axonometric view

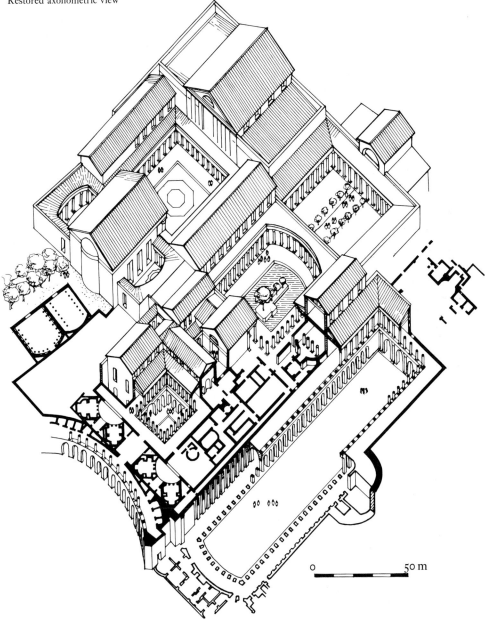

50 m

of the side walls, helping to support the roof, stood columns of the same granite, between which two doors and three large windows opened on to a pair of identical fountain courtyards. Except for a portico round three sides, the latter were open to the sky, with a large, elaborately scalloped, oval fountain in the

beneath the floor – a very early example of such heating used domestically.

The private wing of the palace was built on ground that sloped steeply down towards the Circus Maximus, and the level corresponding with the official wing was here that of the upper storey. The main entrance was in the ground

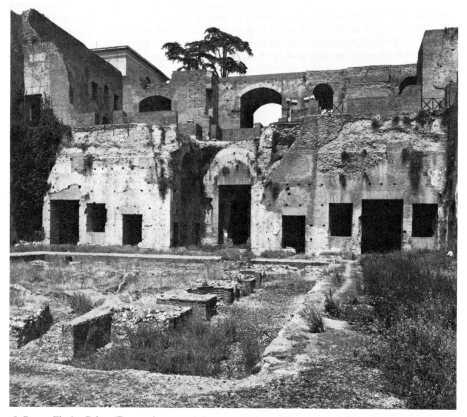

38. Rome, Flavian Palace (Domus Augustana), inaugurated in 92. The courtyard of the domestic wing looking northwards. The door and windows on the left are those of the room shown in illustration 46

centre, the curve of which was picked up and repeated by the outer wall and portico of the courtyard itself. Wherever they sat the guests would have looked out on vistas of ornamental water and greenery, framed in a setting of richly variegated marble. To ensure their comfort in any weather Hadrian inserted a hypocaust

floor, 35 feet below, and opened off the middle of the curved portico that occupied the centre of the south façade. From it a rectangular vestibule led into a square central courtyard [38], the two storeys of which were probably carried on piers with arches (as in the later apartment-houses of Ostia) rather than on columns. The whole

central area was occupied by an elaborately curvilinear fountain in the form of four juxtaposed 'pelta' designs adorned with statuary. Along the east and west sides, grouped about rectangular light-wells, were stairs to the upper storey, together with a number of smaller rooms, some of them at mezzanine height; along the north side, terraced into the rock of the hillside, were the three polygonal domed chambers which are the best-known features of this still very incompletely published monument [46]. The upper storey was more complex. Most of the rooms faced inwards, but along the north side there were two elaborately interlocking ranges of rooms, the one facing inwards, the other outwards on to the peristyle courtyard to the north.[19] Owing to the rise of the ground the latter was already at the upper level and was the principal architectural link between the domestic and the official wings. The importance of the domestic wing lies above all in the evidence which it gives of the architect's intense interest in creating novel spatial forms and of the great progress that had been made in this direction during the twenty years since Nero built his Golden House. This aspect of the building will be discussed more fully in the following chapter.

The sunken garden that delimited the domestic wing to the east was a conceit, laid out in the semblance of a stadium,[20] 175 yards long and 55 yards wide (160 by 50 m.), with five large vaulted chambers in place of starting gates at the north end, fountains representing the turning-posts (*metae*), and a segmental curve at the south end. Around three sides ran a double portico, the lower one arcaded with brick piers, the upper one probably colonnaded. In the middle of the east side there was a large vaulted exedra, suggesting that the garden might also be used for displays (as it has been in recent times), and at the south end, facing outwards, was the imperial box overlooking the Circus Maximus. Unfinished at Domitian's death, the whole complex was completed, with some modifications, by Hadrian. To the east of it, traces of Flavian masonry show that Domitian was plan-

ning yet further work, possibly a bath-building on the site of that finally constructed by Septimius Severus; the aqueduct which served the latter, an offshoot of the Neronian branch of the Aqua Claudia, was in origin certainly Domitianic. Towards the north, too, the great platform which occupied the whole of the northern spur of the Palatium, and which carried the Aedes Caesarum (the shrine of Augustus and all succeeding deified emperors, later incorporated into Elagabalus's Temple of the Sun), seems to have reached its definitive form under Domitian, thereby not only establishing the line of the Clivus Palatinus, but also restricting the effective northern façade of the palace to the west wing – a circumstance of which, as we have seen, the architect took full advantage. Finally one may note Domitian's reconstruction at a new, higher level of the two Augustan libraries, damaged in the fire of 64, in the angle behind the triclinium; and, terraced down the slopes beyond them, the so-called Paedagogium and the lodging of the imperial heralds, completing the build-up of the whole southern façade of the palace. It is only when one assembles all these scattered elements that one can fully appreciate the ingenuity and thoroughness with which Domitian and his architect, Rabirius, tackled the problem of welding the whole Palatine Hill into a coherent architectural unity, as a proper setting for the great palace itself.

The palace vestibule, the grandiose public entrance from the Forum, was one of Domitian's last works, left incomplete at his death and finished by Hadrian. It replaced an earlier and differently oriented structure, perhaps Caligula's notorious extension of the Domus Tiberiana, and it consisted of three distinct elements: the huge reception hall (long thought to be the Temple of Augustus), which lay immediately behind and was oriented upon the Temple of Castor; beside this hall and to the east of it, the building which later became the church of S. Maria Antiqua, and which is plausibly identified as the quarters of the palace guard; and to the east of this again, zigzagging

up the hillside, the triple ramp that led up to the Clivus Victoriae and the Domus Tiberiana.

The reception hall itself was a huge construction of brick-faced concrete, measuring 109 by 80 feet (33.10 by 24.50 m.) internally, of which the ceiling or vault sprang from at least 60 feet above pavement level. A portico ran round the two exposed façades, of which that along the west side was replaced by Hadrian with a series of buttresses, no doubt as a result of the settlement which finally brought the roof and almost the entire west wall to the ground. The interior seems to have been quite plain except for a series of alternately rectangular and curved recesses, the doorways being off-axis and sited so as to blend unobtrusively with the pattern of the recesses.[21] The reason for this was no doubt partly practical, to facilitate the strict control of visitors, who then had to pass by a devious route through the guardrooms to reach the ramp beyond. It is hard to believe, however, that in forgoing so established an architectural device as the monumental axial entrance, the architect was not also aware of the greatly enhanced impact of sudden, unprepared entry upon the enormous, almost empty space beyond. With the possible exception of the throne room (which was, anyway, very different in conception, with a well established movement from one end of the hall to the other) this was in fact the largest uninterrupted volume of space (some 700,000 cubic feet) that had ever yet been brought beneath a single roof. Lit from above by two large windows placed in the two end walls, it must have been a very impressive building indeed, an awe-inspiring foretaste of the architectural marvels that lay beyond.

NERVA AND TRAJAN (A.D. 96–117)

Domitian was murdered in A.D. 96. The only claim of his successor, Nerva (96–97), to architectural distinction is that he completed and dedicated in his own name the forum built by his predecessor. Without question the principal event of his reign was his choice as heir and successor of the great soldier-emperor Trajan, the effective founder of the adoptive dynasty which was to reign unchallenged for nearly a century to come and was to bestow on the greater part of the known world a period of unprecedented peace and material prosperity. Trajan, born of an old Romano-Spanish family and the first Roman from the provinces to become emperor, was a dynamic personality, active in many fields, and the buildings of his reign, though distinguished rather by the grandeur of their conception than by any great architectural originality, may be regarded as marking the climax, and in many respects the completion, of the great building programme in the capital initiated over a century before by Augustus.

When one recalls that in later antiquity Trajan had the reputation of being an avid builder and restorer, the literary record of his work is sadly thin.[22] There is no mention, for example, of the rebuilding of the House of the Vestals in the Forum Romanum to substantially the form in which we see its remains today, although it is certain from the brick-stamps that this was undertaken during the first decade of his reign. The rebuilding of the Forum of Caesar and the Temple of Venus Genetrix is another wholly or partially Trajanic enterprise about which the literary sources are silent. Allowing for the gaps in the record, however, it is evident that his work in and near the capital falls under three main heads: the building of the great baths on the Esquiline Hill; the undertaking of a series of major engineering works to improve the port and wharf facilities of Ostia and Rome; and the definitive completion of the complex of monumental piazzas, temples, and other public buildings that had grown up to the north of the Forum Romanum by his construction of the forum, basilica, libraries, and market that occupy the low ground between the Forum Augustum and the southern slopes of the Quirinal [6].

The Thermae Traianae, the great Baths of Trajan on the Esquiline, were dedicated in 109, and although there was a consistent tradition in later antiquity which coupled Trajan's name with that of Domitian, this was certainly mis-

taken. The Golden House, on the site of which it stood, was not burnt until 104; and the evidence of the large number of surviving brick-stamps shows conclusively that the whole structure was Trajanic, the work of Apollodorus of Damascus.[23] The claim, sometimes made, that this was the first of the great 'Imperial' baths requires qualification. The essential elements of the 'Imperial' plan were already present in the Baths of Titus, and may indeed go back to Nero's bath-building in the Campus Martius. What was new and significant for the future was the sheer bulk of the structure (the actual bath-building covered three times the area of that of Titus) and the development of the outer precinct to include the gardens, libraries, meeting rooms, lecture halls, and rooms for all the many social activities which henceforth were to be regarded as an essential part of one of these great centres of daily social life.[24]

The site chosen was that part of the Golden House which lay immediately to the north-east of the Baths of Titus and included the main residential wing of Nero's Palace, which thus finally vanished from sight barely forty years after its first construction. Fortunately the axis chosen for the new layout was somewhat oblique to that of the earlier buildings, in order to take fuller advantage of the sun in the afternoon, the normal time for bathing; and since the site of the Neronian palace coincided with that part of the new construction which had to be terraced outwards from the hillside, the existing structures were left largely intact. (It is to such terracing operations that we owe many of the best-preserved monuments of ancient Rome – for example, the House of the Griffins, the S. Clemente Mithraeum, and the Vatican cemetery.) Little enough of the baths has survived, but that little is sufficient to confirm the substantial accuracy of the careful drawings made in the sixteenth century, when a great deal more was still visible. These reveal an overall plan that conforms closely to that of the later and far better preserved Baths of Caracalla and of Diocletian, except that the main bathing block, instead of being free-standing in the middle of the outer enclosure, projects inwards from the middle of the northern side. Compared with the contemporary Baths of Sura on the Aventine,[25] the layout of which on the Severan marble plan is still that of a typically Pompeian bath-building, with the bath-suite occupying the whole of one side of a porticoed courtyard [61], this is a thoroughly up-to-date plan. It displays many similarities of detail to Domitian's palace, and it reveals its architect, Apollodorus, as a master of the contemporary concrete medium.

Another ambitious but essentially practical enterprise was the construction of a new inner harbour at Portus, the suburb and eventual successor of the ancient Tiber-mouth harbour of Ostia. The steady deterioration of the Tiber as a navigable stream had created a problem that called for a drastic and definitive solution. Claudius had sought an answer by abandoning the actual river-mouth and cutting a pair of canals on a more direct line to an artificial harbour a mile or so to the north. Here too, however, the predominantly northward set of the coastal currents was already creating serious difficulties, and these Trajan's engineers now undertook to resolve by digging a vast inner basin, the flow of water into and out of which could be controlled and the basin itself maintained by dredging. The basin, hexagonal in shape and nearly half a mile in mean diameter, was equipped with berths for nearly a hundred ships, and all around it, parallel with the wharves, ran warehouses (*horrea*), long series of deep rooms of equal size, set back to back and opening on to porticoes or covered galleries. There was also a lighthouse of canonical type, with its beacon carried on a superimposed series of diminishing cubical structures, after the model of the Pharos of Alexandria; a colossal statue of Trajan; a portico of which the exaggeratedly rusticated travertine masonry shows it to be a relic of the Claudian harbourside buildings; a pair of temples, whose curved pediments indicate a dedication to the Egyptian divinities Isis and Serapis;[26] and a substantial bath-building. One of the warehouses, probably

of Severan date, has ramps leading to an upper gallery, and the raised pavements of the ground floor show that it was for grain.

Another commodity attested by the surviving remains at Portus is marble, many blocks and columns of which have been recovered still in the rough form in which they were shipped from the quarries. They were evidently off-loaded here and transhipped to barges for transport to the marble yards of the capital, which lay in the 'Marmorata' quarter on the river bank below the Aventine. Such transhipment seems to have been normal practice,[27] and a natural corollary of the work at Portus was the improvement of the riverside facilities of Rome itself. When the modern embankments were built along the left bank the extensive remains were uncovered of a system of wharves, berths, and mooring-rings, loading-ramps and warehouses, all in characteristically Trajanic brick-and-reticulate masonry. This reticulate work, a conscious revival of a practice that had gone out of use in the capital half a century earlier, was to enjoy a considerable vogue under Trajan and his immediate successors and is one of the many symptoms of a renewed interest in the architectural heritage of Rome's own recent past. Another commercial building, found and destroyed in 1878 on the right bank near the Farnesina, was an imperial storehouse for wine, built in 102. It was a rectangular structure, resembling the horrea, with vaulted storehouses full of amphorae at ground level and above them a complex of courts surrounded by long porticoes of plaster-faced travertine columns – a surprisingly late use of this material in such a context.

The monument upon which above all Trajan lavished his resources and which most vividly mirrors the curiously eclectic architectural aspirations of his reign is the forum which he built out of the spoils of the Dacian War and dedicated in 113 [6]. Physically as well as stylistically this was a building of unusual complexity. To provide a level space some 220 yards long and 130 yards wide (200 by 120 m., exclusive of the exedrae) for the main complex,

the saddle of higher ground between the Quirinal and Capitoline Hills and the lower slopes of the Quirinal itself were cut back to a maximum depth of 125 feet (38 m.), a figure of which Trajan's column, 125 feet high, was designed to preserve a dramatic visual record. Three-fifths of this level area was reserved for the open space of the forum proper and for the two lateral porticoes, the central sections of the outer walls of which were broken outwards to form large semicircular exedrae. Both the plan and the order of the lateral colonnades, the attic storey of which is decorated with large ornamental roundels and caryatid figures of Dacian prisoners, clearly derive from the Forum of Augustus. The gently outcurving entrance wall seems, on the other hand, to have been inspired by the flanking walls of the Forum Transitorium. In the centre of it, surmounted by a six-horse chariot, was a monumental entry, of which the coins give a lively picture; and the centre focus of the whole forum, at the intersection of the two axes, was a gigantic equestrian statue of the emperor. There were gilded statues of horses and military standards along the roofs of the lateral colonnades, and there was a great deal of other statuary, some of it carved in polychrome marbles and all of it devoted to the theme of the emperor's triumphs. But despite the opulence of its detail, the forum was saved from mere grandiloquence by its fine proportions and by the purposeful sweep of the design as a whole. When the emperor Constantius II visited Rome for the first and only time, in 357, of all the monuments of the city this was the one which he most admired.[28] There was a grandeur of conception about it to satisfy even the most jaded taste.

The fourth side of the forum was occupied, not by the temple as in all the previous Imperial fora, but by a huge, transverse, basilican hall. The Basilica Ulpia (the name derives from Trajan's family name of Ulpius) was by any standards an imposing building. The main hall, exactly twice as long as it was broad, extended the full width of the forum (some 400 feet). Within it two ambulatory colonnades enclosed a

long, narrow, central nave, the timber roof of which had a span of 80 feet (25 m.) and was nearly 260 feet (80 m.) long. At either end of the building, spatially independent except as viewed through the columns of the ambulatories, were two large apses. The main hall is usually, and probably rightly, restored as having had galleries over one or both the ambulatory colonnades. The apses had semi-engaged decorative orders round the inner faces and must have been independently lit; but how exactly they were related in elevation to the rest of the building is uncertain. Outstanding among the rich variety of marbles with which the interior was lavishly faced were the columns of grey Egyptian granite. Another noteworthy feature was the ceiling, which was sheathed with sheets of gilded bronze. It was presumably coffered and lit by clerestory windows, soaring in brilliant and effective contrast above the relative obscurity of the galleries beneath. Externally the dominating feature was a shallow tetrastyle porch in the centre of the façade, at the culminating point of the axis established by the outer archway of the forum and the central equestrian statue. This porch too was illustrated on the contemporary coins.[29]

Beyond the basilica, within a small colonnaded courtyard off which, to right and left, opened a pair of libraries, stood Trajan's Column. It is characteristic of the 'drawing-board' mentality of so much Roman architectural thinking[30] that, although the column and the temple beyond it picked up the line of the long axis of the forum, there was no visual continuity whatsoever between the two. The library complex was quite independent, accessible from the basilica only by a pair of doors, which seem to have been deliberately placed so as to avoid any direct relationship with those of the main façade. Unlike the basilica and forum, the libraries were built of brick-faced concrete and vaulted, presumably as a protection against fire and damp. They were plain rectangular halls of conventional classical library design, the cupboards for the scrolls being contained in two tiers of rectangular recesses, of which the upper tier was accessible from a gallery served by an independent staircase.

The column stood 125 feet (38 m.) high and was built throughout of finely jointed blocks and drums of Carrara marble of colossal dimensions (each drum weighed about forty tons). It comprised a tall plinth carved with Victories and trophies of arms, a sculptured shaft with a Doric capital, and a pedestal bearing a gilded bronze statue of Trajan.[31] Within the base was a tomb-chamber, destined for the emperor himself, and carved out of the solid marble of the shaft was a spiral staircase of 185 steps. There were many Republican precedents for the erection of such commemorative columns. What was singular and original about Trajan's Column was the continuous spiral frieze that wound unbroken from base to capital, carved in exquisite low relief with a dramatized historical narrative of Trajan's two Dacian wars. It is hard to admire unreservedly the relegation of this sculptural *chef d' œuvre* to a situation in which even the vigorous use of colour would have left many of the upper scenes barely visible, let alone intelligible in terms of the narrative which they set out to portray. On the other hand, there cannot be the slightest doubt either of the masterly quality of the sculpture itself or of its outstanding importance for the later development of Roman narrative art; and that the scheme of the column and its sculpture struck the imagination of antiquity is shown by the several copies of it that were erected later, in Rome by Commodus and in Constantinople by Theodosius I and by Arcadius.

Beyond the column, completing the grand design, lay the temple which after Trajan's death was dedicated by Hadrian in honour of Trajan and of his wife, Plotina. The remains of the temple itself still lie buried beneath and beyond the church of S. Maria di Loreto, but from the coins and from a fragment of the Severan marble map of Rome we know that it was an enormous octastyle building, standing on a tall podium and set against the semicircular rear wall of a colonnaded enclosure. Its size is graphically attested by part of one of its col-

39. Rome, Trajan's Market, *c.* 100–12. Axonometric view.
Centre foreground, the hemicycle of Trajan's Forum;
left foreground, one end of the Basilica Ulpia

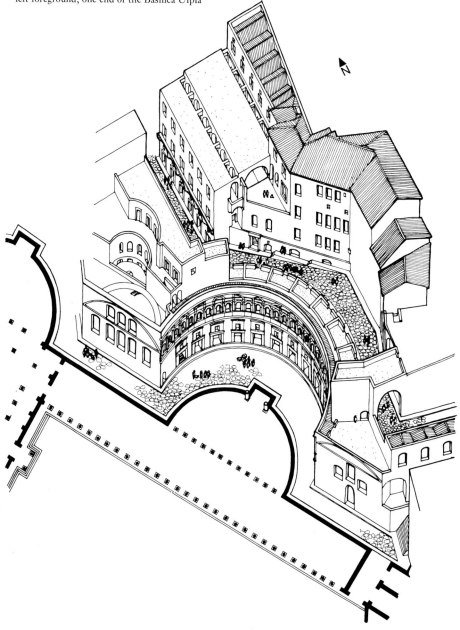

umns, of grey Egyptian granite, which is now lying near the base of Trajan's Column. When complete it was one quarter as long again as the columns of the porch of the Pantheon, and it must have weighed nearly a hundred and twenty tons.[32]

To the north-east of the forum complex, terraced steeply up the artificially steepened lower slopes of the Quirinal Hill, lay the Markets of Trajan, an elaborately planned commercial quarter, containing more than one hundred and fifty individual shops and offices and a large covered market hall, linked by stairs and streets and accessible at three different levels – at the foot of the hill by a broad street laid out along the outer perimeter of the forum and basilica; at the level of the third storey by what in the Middle Ages became the Via Biberatica; and two storeys higher again by a street facing towards the Quirinal [39]. The whole complex was built of brick-faced concrete with travertine details. It is a remarkable example of the vaulted cellular construction of which the Roman architects of the capital had already shown themselves masters, the unit throughout being the *taberna*, the single-roomed, wide-doored, barrel-vaulted shop of standard Roman commercial practice. Both in plan and to a lesser extent in elevation (there was often a wooden mezzanine gallery lit by a window above the door) this unit itself was capable of considerable adjustment, and used in conjunction with vaulted corridors and staircases it lent itself admirably to the requirements of what could hardly have been a more irregular site. An interesting technical novelty is the use of tiles as a substitute for planking in the centering of the vaults, a device that had made a first tentative appearance in the Domus Aurea and in the Colosseum and which was to be widely used in the second and third centuries to achieve flexibility and speed of construction by reducing carpentry to a minimum.

The shops were for the most part laid out in single rows, facing on to streets or corridors that followed closely the run of the steeply sloping hillside. At one point only were they grouped into a more intimate relationship. This was in the covered market hall [40, 41], a tightly planned building laid out at three distinct levels. There was an independent row of six shops facing directly on to the Via Biberatica, at the south end of which a flight of steps led to the storey above, which was that of the main market hall. This was a vaulted rectangular space, 92 feet long and 32 feet wide (28 by 9.80 m.), with two rows of six shops each opening off either side of it at two levels, those of the upper floor being shallower and served by a gallery-like corridor with balustraded openings corresponding to the six bays of the central vault. The latter was cross-vaulted, a utilitarian version of the vaulting characteristic of the central hall of one of the great 'Imperial' baths, with massive travertine brackets used instead of marble columns to reduce the span at the springing-points. Staircases linked the successive levels, and there was a second entrance at gallery level leading in from the upper street. The whole design has the inevitability of good planning and, compared with the stolid simplicity of the earlier market halls at Tivoli and Ferentino, it admirably exemplifies the progress which Roman architecture had made in practical as well as in monumental fields since Late Republican times.

Although this was essentially an architecture of function, remarkable chiefly for its practicality and for its extraordinary flexibility in the face of a potentially very difficult site, it could, wherever appropriate, achieve a certain austere monumentality. The three-storey façade of the market hall towards the Via Biberatica [42], with its robust, travertine-framed shop-fronts at ground level and shallow 'balconies' bracketed out over the mezzanine windows, is a typical example of what, as we know from the streets of Ostia, was the appearance of much of the new Rome that had been coming into being since the great fire of 64. More elaborate is the well-known hemicyclical façade where the

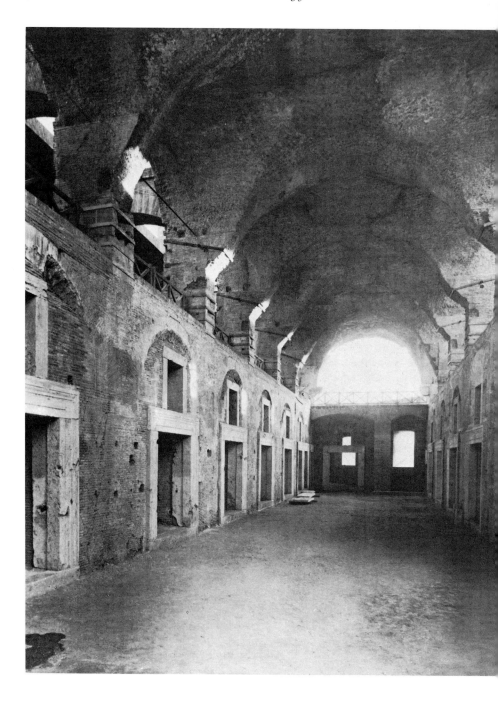

40 (*opposite*). Rome, Trajan's Market, *c.* 100–12. Interior of the market hall

41 (*below*). Rome, Trajan's Market. Axonometric view. The main market hall, *c.* 100–12. Foreground, the street that later became the Via Biberatica

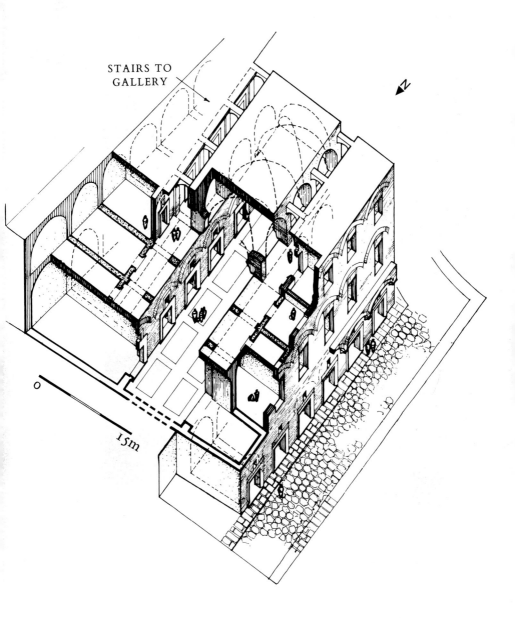

STAIRS TO
GALLERY

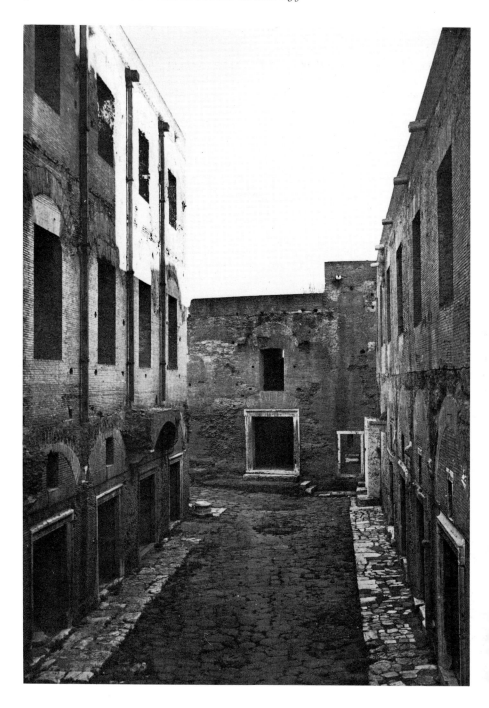

lowest street frontage of the markets conformed to the outward curve of the forum exedra [43]. Here the range of uniform, round-headed windows which is the dominant feature of the upper of the two storeys is framed within the pilasters and continuous entablature of a decorative order, which was broken out in shallow relief to form a series of linked aediculae, every fourth pediment of which was triangular, alternating with groups of three in which a low segmental pediment was framed by two triangular half-pediments. Such broken pedimental schemes had made their appearance at least half a century earlier on the walls of Pompeii, but they

had yet to establish themselves in monumental usage, at any rate in Italy. Their employment on this occasion is doubtless to be connected with the use of a medium – stuccoed brickwork – which was still in the process of developing a monumental language of its own.

(In view of the long-established belief that this well-known façade was part of Trajan's Forum itself, it is worth emphasizing that it was never in fact visible from within the forum, nor could it ever have been viewed frontally, as it is today, to the detriment both of its proportions and of the quality of its detail. It was meant to be seen from street level, obliquely and in receding

42 (*opposite*). Rome, Trajan's Market, *c.* 100–12. The former Via Biberatica, with shops at ground level and, above them (*left*), the façade of the market hall. Note the remains of shallow balconies (*maeniana*) over the shops

43 (*below*). Rome, Trajan's Market, *c.* 100–12, façade of the lower hemicycle [cf. 39]. In antiquity the left-hand part of the façade would have been hidden by the high, curving outer wall of Trajan's Forum, now robbed to ground level

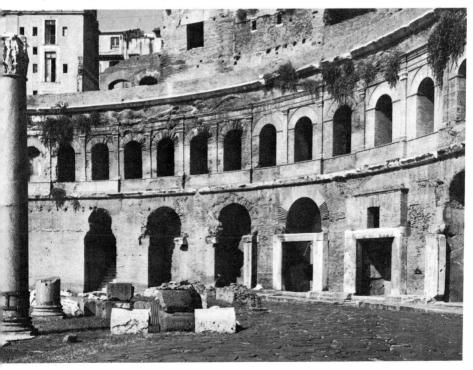

perspective [43], its length suggested by the curve of the street and by the repeated rhythm of its design, but nowhere in fact visible in its entirety, and its delicate relief picked out by the cross-fall of the light and contrasting with the massive simplicity of the wall opposite.)

The Forum and the Markets of Trajan were contemporary and complementary monuments, the two halves of a single plan; and yet it would be hard to imagine two groups of buildings that were more different in almost every respect – the one ruthlessly imposed upon its site and developed with an arrogant self-sufficiency within the circuit of its high containing walls, the other conditioned at every turn by the accidents of the ground on which it was built and meaningful only in terms of its wider architectural setting; the one ultra-conservative in its choice of materials, in its spatial relationships, and in its taste for rich classical ornament, the other the last word in contemporary taste and techniques. The contrast is, of course, symptomatic of an age in transition. The markets represent one of the outstanding achievements of the 'modern' architecture which is the subject of the next chapter, whereas the forum and basilica belong to a field in which the traditional pomps and grandiosities were still a required currency. It is inevitably the former that engage the sympathies and interest of most twentieth-century observers, but it is well to remember that it was the latter that was regarded both by its contemporaries and by later generations as the outstanding monument of its age; and since this is also one of the few great Roman building schemes of which we know the name and something of the history of the architect, it is worth while, in conclusion, to inquire briefly what was his architectural training and what was his impact upon the contemporary architectural scene.

There is little to suggest that Apollodorus of Damascus was influenced by his Eastern origins. His bridge over the Danube reveals him as a first-class structural engineer, and even the short list of buildings in Rome that can be attributed to him with certainty[33] is sufficient to indicate a broad catholicity of taste and ability. On the one hand the baths and the markets show him to have been quite as much at home in the contemporary Roman concrete medium as his predecessor, Domitian's architect, Rabirius: from such of their work as has survived, Rabirius may perhaps be thought to have been the more important innovator, but in this respect both Apollodorus and Rabirius belong to the same broad stream of historical development. The forum and basilica, on the other hand, have surprisingly little to do with recent architectural trends in Rome. The combination of basilica and forum into a single, closely knit unit in itself derives from schemes that had been evolved elsewhere in Italy and in the western provinces – one of the earliest instances of such reciprocal influence upon the architecture of the capital.[34] At the same time both the planning and the detail of the forum reveal a marked break away from the Flavian tradition and a return to the Augustan sources. We see this very clearly in the adoption of such features as the exedrae of the forum and the caryatid order of the flanking porticoes, both copied directly from the Forum Augustum. We see it again in the details of the individual mouldings, many of which are barely distinguishable from those of the Augustan building.[35] More generally we can see it in the rejection of concrete (except, for practical reasons, in the libraries) in favour of the traditional materials, dressed stone and timber. Apart from its two apses, the Basilica Ulpia is still essentially an enlarged and enriched version of an Augustan monument. In its ornament too, just as Augustus's own architects had turned to the classical monuments of Athens for inspiration, so now Apollodorus turned back to those of Augustus.

By the authority of its example the Basilica Ulpia did more perhaps than any other single building to keep alive in the capital a tradition which in many other fields was dying, if not already dead. This was the building which above all others came to be felt to epitomize the grandeur of Roman Imperial might at the peak of its power. Though it had no immediate

successors in Rome, and though two centuries later, when Maxentius gave the capital its last great public basilica, it was the contemporary architecture of the great bath-buildings that supplied the model, the Basilica Ulpia was very widely copied in the provinces. Moreover, it was still standing in Constantine's day, venerable and universally admired; and whatever may have been the reasons that led him and his advisers to select the basilica as the preferred architectural type for the places of worship of the newly enfranchised Christian religion, Trajan's building was one that must inevitably have been in every mind. The Basilica Ulpia may not have been a building of any profound architectural originality. But there are few monuments of antiquity that enjoyed a greater and more enduring prestige, or that did more to shape the subsequent course of architectural history.

MATERIALS AND METHODS:

THE ROMAN ARCHITECTURAL REVOLUTION

The death of Trajan in 117 is as good a moment as any to pause and take stock of what had been happening to the architecture of Rome in the 160-odd years since the murder of Caesar. Not that there was any real break in the development at this time, or indeed at any other time before the third century. But the new era was to bring new problems and new perspectives. The impetus of the great Augustan building programme was all but spent. For over a century it had carried the architecture of the capital along on its own momentum. Throughout the first century, besides creating the circumstances that made possible the revolution in architectural thinking which is the special subject of the present chapter, it had been the accepted framework of reference for all architectural thinking, progressive and conservative alike. Now the horizons were once more widening. The balance of wealth and prosperity was beginning to shift away from Italy and towards the provinces, and increasingly it was towards the latter that the architect of the second century looked for those aspects of his craft which were not satisfied locally.

There were, of course, certain elements of the classical tradition which were now so deeply and so widely rooted that they transcended all frontiers. The classical system of column, capital, and entablature, for example, was to remain an established part of the architectural scene for centuries to come, whatever the setting and whatever the circumstances; not until Justinian was architecture to break significant fresh ground in this respect. But there were a great many other, hardly less fundamental respects in which there were wide divergences of practice from one part of the Mediterranean world to another. In Italy, for example, the widespread

tendency to relegate the traditional classical forms to a purely decorative role had already taken on a monumental shape of its own during the last century of the Republic, and it was upon the well established Italic version of this wider hellenistic tradition that Augustus had drawn for an important part of his programme. The Stadium of Domitian, the last great public building in Rome to clothe the arcaded structure of its façade in a continuous framework of applied classical 'architecture', marks the end of an epoch that spans the whole of the last century of the Republic and the first century of the Empire.[1]

Many of the changes that were now taking place are, of course, explicable in purely local terms. In the case just referred to, for example, one can see that brick-faced concrete, henceforth the building material *par excellence* of the capital, lent itself naturally to an altogether simpler exterior architecture, one that was expressive of the constructional material with little or no overlay of extraneous classicizing detail. It is to the interiors, and to the decorative skins of marble and painted stucco with which they were clothed, that such detail was increasingly relegated. But even in such essentially conservative fields of practice as temple architecture and the carving of the detail of the classical orders, one can detect an important shift of allegiance. The Augustan monuments remained in this respect an inexhaustible repertory of ideas and motifs, time and again to be quarried by later Roman architects in search of inspiration. But, just as the Stadium of Domitian marks the end of an epoch, so one may single out a building such as Trajan's Forum as one of the last representatives of a tradition of planning and ornament that derives, almost

without a break, from the buildings of Augustan Rome. Barely a generation later, for his great Temple of Venus and Rome, we find Hadrian looking instead to Asia Minor. This is symptomatic of what was happening in many fields. Although the development of concrete architecture was, and was for some time to remain, essentially a domestic phenomenon, the stage was being set for wider things.

We have already had occasion to observe, in buildings such as the Golden House and the Flavian Palace, something of the new spatial ideas that were developing in Rome during the second half of the first century A.D. As has so often happened in the history of architecture, it was the advent of new materials and new methods that stimulated and shaped the new theoretical approach. In this case the new material was Roman concrete, and to follow the development of progressive architectural thinking during the period in question, it will first be necessary to describe in rather greater detail than has yet been done its properties, its advantages, and its limitations.

First, a word of definition. Roman concrete (*opus caementicium*) was neither a concrete nor a cement in the modern sense of those words, a material that could be mixed and poured, or used in its own right independently of other materials. It was a combination of mortar and lumps of aggregate (*caementa*) and it was almost invariably laid in roughly horizontal courses, not poured, the only difference from the mortared rubble of contemporary usage (into which, indeed, the poorer qualities of Roman concrete shade imperceptibly lying in the better quality of the mortar. It was, in fact, the strength of the mortar that gave Roman concrete its unique properties; and although the concrete core was regularly faced with other materials, the facing was structurally of altogether secondary importance.

In the fully developed Roman concrete these properties were the result of mixing lime with the local volcanic sand (*pozzolana*). This was not a sudden, dramatic discovery; still less was it the result of any theoretical knowledge of the chemical processes involved. It was the product of centuries of trial and error, each generation adding its quota of practical experience until, by the last century of the Republic, what had started as a mere inert fill suitable only for the interiors of platforms, city walls, etc., had become a building material in its own right, which could be used not only for the construction of walls but also of arches and vaults. The history of pozzolana (the Latin *pulvis puteolanus*) is in itself a graphic illustration of the extent to which the whole development was governed by the chance discoveries and rule-of-thumb wisdom of successive generations of contractors. One of its most valuable properties is that with it one can make a mortar that will harden in contact with water, a property that must have been discovered in the first place in the course of waterside building in the harbour of Puteoli (the modern Pozzuoli) in Campania, whence it took its name and whence it was regularly imported to the capital for use in bridges, riverside wharves, and harbour jetties. There are plentiful supplies of an identical volcanic sand in and around Rome, and under Augustus the local pozzolana was in fact already being used regularly in ordinary building. And yet fifty years later we find Claudius still importing it from Puteoli for his harbour works at Ostia.[2]

It is against such a background of cautious, practical conservatism that we have to envisage the whole history of the early development of Roman concrete. Such slow, empirical advances are in the nature of things hard to document. It is the successes that survive, the failures that are swept away. For example, the workmanship of Agrippa's very extensive programme of aqueduct building and repair was so faulty that it had to be undertaken afresh almost in its entirety by Augustus twenty years later. The Aqua Claudia, dedicated in A.D. 52, needed drastic repairs in 71, and again under Domitian. These are simply two examples about which we happen to be unusually well informed, thanks to the survival of the treatise of Frontinus, who had himself been a water commissioner. It is not altogether

surprising therefore that under Augustus, and for a long time thereafter in conservative building circles, squared stone was still the preferred material whenever it was a question of carrying a serious load. This was still the attitude of, for example, the builders of the Colosseum. Although by the beginning of the Christian era concrete was already in widespread use as an efficient and economical substitute for the ashlar walls and timber roofing of traditional classical practice, there is little indication that it was yet thought of as a monumental building material in its own right. In this respect the great Republican sanctuaries of Latium stand in curious isolation from what immediately followed them.

An aspect of Roman concrete construction that has led to a great deal of confusion of thought is the regular practice of applying a facing of some other material to the exposed wall-surfaces. These wall-facings range from the squared stone or the irregular stone patchwork (*opus incertum*) of the earliest faced walls,[3] through the neat chequerboard *opus reticulatum* which took shape during the last years of the Republic [51], to the brickwork (*opus testaceum*) characteristic of the fully developed Roman concrete. But the study of these facing techniques, valuable though it may be as a guide to the chronology of individual monuments, is of only marginal importance to any understanding of the architectural properties and possibilities of Roman concrete as such. It was in the mass of mortar and aggregate forming the core that the strength of Roman concrete lay. Apart from providing a neat finish suitable for the application of marble or stucco, the principal function of the facing was to simplify the actual processes of construction by providing a carefully built and quasi-independent framework within which the main body of the wall could be laid accurately with a minimum both of shuttering and of skilled supervision.

The relative unimportance of the facing is a fact that needs to be stressed, since to facilitate its construction the concrete-builders of the Empire, and in particular those working in brick, made widespread use of such familiar devices as built-in arches over doorways, windows, and any point of special architectural strain (cf. illustrations 76, 79, 85). The arches, the flat-arched lintels, and the relieving arches that are such a characteristic feature of the brick-faced monuments of the capital convey an almost irresistible impression of a 'live' material within which each of these elements plays an active part in carrying and distributing the load of the structure as a whole. In reality this is true only in a very special and limited sense. They did unquestionably play an active and useful part during the actual construction of the building, and to a diminishing degree during the period of its drying out. Once the concrete had hardened, however, they served no further structural purpose whatsoever; indeed, by introducing potential lines of cleavage they were, if anything, a source of weakness. The same is true in varying degrees of such features as the brick ribs not uncommon in later Roman vaulting, or the so-called 'bonding courses', flat single courses of large tiles that were introduced at regular intervals into many Roman walls, running right through them, facing and core alike [79]. The use of brick ribs will be discussed in a later section. The main purpose of the 'bonding courses' was to provide a neat, level finish at the end of each stage of construction, but they served also to prevent any minor settlement in the still fluid mass of the concrete from spreading vertically.[4]

It was the strength of the core that really mattered, and it was the steady progress in the quality of this that was the most significant advance of the Augustan and early Julio-Claudian period. From the time of Augustus onwards the quality of the mortar itself was improved by the regular addition of the local pozzolana. Another significant improvement was the gradual elimination of the horizontal lines of cleavage that mark the divisions between the successive stages of the work in so many of the earlier concrete buildings. This was presumably achieved by using a somewhat slower-drying mixture, which enabled the successive horizontal layers of the core to fuse into a

virtually homogeneous mass. As the quality of the concrete improved, so the vaulting techniques too were simplified, and the vaults themselves strengthened, by the omission of the radially laid intrados of rough stones which characterizes so many Republican vaults. Henceforth the concrete of the vaults was laid against the shuttering in precisely the same horizontal beds as the walls themselves, and it stood by virtue of the almost monolithic quality of the finished concrete mass.[5]

Roman architects were surprisingly slow to appreciate the revolutionary architectural possibilities inherent in the new material that was developing under their eyes. When it did come, however, the realization was rapid and complete; and thanks to the fortunate circumstance of the survival of a number of the key monuments, we are able to document the process in unusual detail. At Hadrian's death in 137 there must have been persons still living who could remember Nero and the great fire of 64; and yet between these two dates there took place all the essential stages of the revolution in architectural thinking which is Rome's great original contribution to the history of European art.

The first great public monument in which we can detect the ferment at work is Nero's Golden House. To contemporary eyes it was the incongruity of the setting – a luxurious country villa in the heart of Rome – and its manifold engineering marvels that constituted the principal novelty of this singular building.[6] Seen in such a perspective the recessed courtyard in the centre of that part of the façade which has been exposed by excavation, with its flanks splayed out to form three sides of an irregular hexagon, though a newcomer to the architecture of the capital, was one for which, as we shall see in Chapter 8, there were already plenty of precedents in the seaside villas of Campania and Latium. Though symptomatic of the general breakdown of the tyranny of the right-angle, its architectural significance is slight in comparison with that of the octagonal hall in the middle of what we may still for convenience refer to as the east wing.[7] The latter [44, 45] is a structure of

which it would be hard to overestimate the historical significance. Here, for the first time in the recorded history of Roman architecture, we have a room which was not only breaking away from the conventionally rectangular pattern of the complex of which it was a part, but was also deliberately designed to exploit the novel spatial effects so obtained. The fact that many of the resulting problems of planning were left unresolved and that much of the detail, such as the small, box-like, triangular spaces in the angles between the radiating chambers, is clumsy, cannot conceal the startling novelty of the vision so embodied. This is essentially an architecture of the interior, in which light and space are every bit as important as the actual masonry. In a subtle but significant way the emphasis has suddenly shifted from the solids to the voids. At the same time there is a deliberate playing down of the constructional problems. Walls and vaults are no longer the distinct contrasting factors of a clearly stated structural equation, but the complementary and merging elements of an envelope enclosing a shape. Moreover, the shape itself is elusive. Although the plan is rigidly centralized upon a common focus, the eye is in fact drawn away from the centre, out through the oculus or down the tantalizing vistas opened up by the radiating chambers. The lighting, too, through oblique slots above the extrados of the dome, displays the same qualities of deliberate evasiveness. Here in embryo we have all the elements that were to characterize so much of later Roman architecture.

To see how new all this was, one has only to pause to reflect on the extent to which all previous architecture of the ancient world had been dominated by the concept of mass, and by the explicit statement of the structural problems involved in supporting a roof on four walls. Whether in Greece or in the ancient East its effects had been very largely achieved by the orderly marshalling of masonry and by the contraposition of such tangible features as wall and roof, platform and superstructure, column and architrave. Greek architecture had been logical, rational, lucid, an architecture of which

the niceties lay in the subtle exploitation of familiar structural themes. In particular it had been essentially an architecture of the exterior, to be viewed and comprehended from without rather than experienced from within. Even when, as in such great assembly halls as the Telesterion at Eleusis, it became necessary to roof over a large interior space, the result was at best an uneasy balance between the physical requirements of the situation and an aesthetic tradition to which such problems were essentially alien.[8] It was left to Rome to evolve an architecture to which the concept of interior space was fundamental, and of this evolution the octagon of the Golden House is a decisive milestone.

Because the Golden House is the first building in which we can clearly and unequivocally observe the full impact of this new vision, it does not, of course, follow that it was the result of a sudden, blinding revelation, or indeed that this was even the first time that it had found explicit architectural expression. On the contrary, the plan of the octagon itself has all the appearance of having been evolved independently in the first place and rather summarily adapted to fit into its present location. One thinks inevitably of the garden pavilions, fountain grottoes, and other architectural conceits of the wealthy parks of Julio-Claudian Rome, which have left tantalizing traces in the contemporary literature (e.g. Varro's celebrated aviary at Casinum) and painting, but so sadly few actual remains. Here was a natural ground for experiment and fantasy, and it may very well be that, like so much else in the Golden House, the immediate inspiration for the octagon came from some garden pavilion of one of Caligula's urban villas or Nero's own Domus Transitoria.[9]

More important, however, than the possible derivation of the octagon, as such, from some particular building is the recognition that most of the ideas which it embodies were in themselves already familiar features of the architectural scene. What was new was their convergence upon a single building. Already, for example, in the Roman architecture of the Late

Republic one can detect a growing awareness of the properties of interior space. This is the essential difference between the Greek stoa and the Roman basilica and it is none the less significant for being in other respects still contained within the rigidly rectilinear framework of a conventional classicism. Seen from this point of view the Basilica Ulpia and the central hall of Trajan's Market are the collateral branches of a single Roman tradition. Hardly less significant was the growing taste, already evident in Augustan times, for curvilinear or polygonal forms, a taste for which the wealthy seaside villas, with their spreading porticoes, their fountains, and their tempietti, afforded such ample scope. At a more functional level it found expression also in the building of amphitheatres and theatres, a task for which by its flexibility concrete early showed itself to be admirably suited. From the placing of sloping vaults over the radial segments of an ellipse, a regular feature of amphitheatre construction, it was a short step to the realization that with concrete one was no longer tied to the very restricted repertory of architectural forms proper to the traditional building materials. Once a concrete had been developed which, by comparison with other known building materials, would stand as an almost monolithic unit, there was very little but the force of tradition to limit the shapes of either walls or vaults. The key to a new world of architectural ideas stood ready in the lock, and by Nero's death it had been firmly and irrevocably turned. In the Golden House not only do we find the architect actively exploring the possibilities of the new medium for the creation of new and exciting spatial forms but – possibly for the first time ever – we also find him giving these forms monumental expression within the best known and most discussed building of its day.

Once this decisive step had been taken progress was rapid and assured, as we see very clearly in the great palace of Domitian, completed less than twenty-five years after the Golden House.[10] The first and most obvious advance is in the quality of the material and the

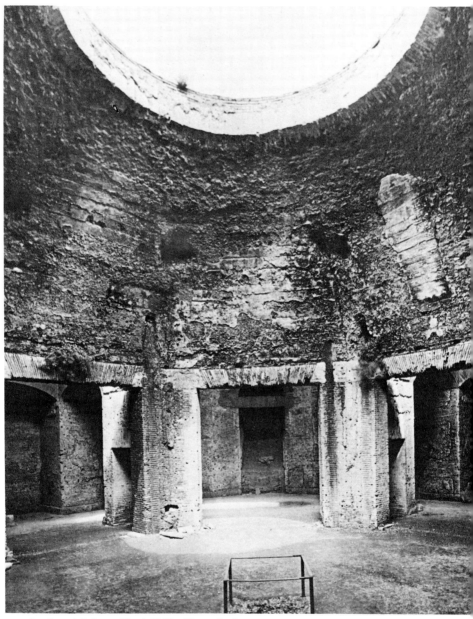

44 and 45 (*opposite*). Rome, Nero's Golden House, 64–8.
Octagonal fountain hall with axonometric view from below, section, and plan

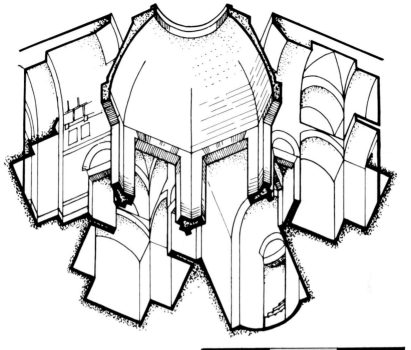

0 15m

LIGHT

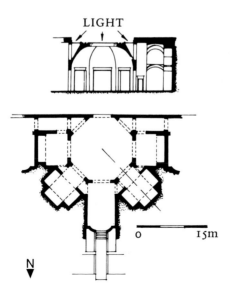

0 15m

N

virtuosity of its handling. Even if the vaulting of the vestibule be left out of account as possible but unproven, the barrel-vault of the basilica was already a notable achievement. (That it needed buttressing very soon after construction is not altogether surprising when one recalls that

examples of the former one may select for mention the suite of small rooms along the west side of the courtyard of the official wing; a small domed room in the upper storey of the domestic wing, in plan a circle inscribed in a square, with two rows, one above the other, each of eight

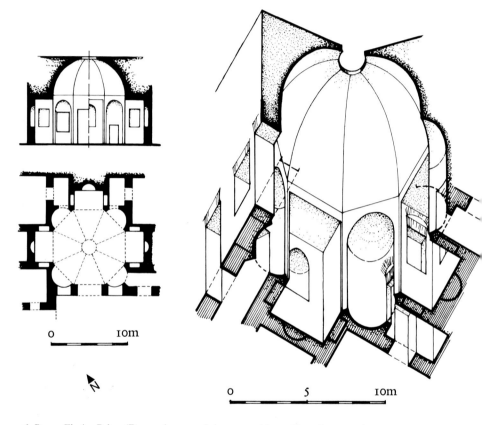

46. Rome, Flavian Palace (Domus Augustana), inaugurated in 92. Domed octagonal room.
Sections, plan, and axonometric view from below. For the façade of this room, see illustration 38

the architect's only guide was experience; it was only by working up to the limit, and at times exceeding it, that such experience could be gained.) Hardly less striking are the notable increase in the deliberate use of curvilinear features and the growing reliance for effect upon the properties of interior space. Of the many

decorative recesses, alternately curved and rectangular; and the somewhat similar but more elaborate pair of domed rooms in the north wing of the ground floor of the domestic wing [46]. The last-named in particular, with their studied avoidance of the expected (even the doors being sited with a deliberate disregard for symmetry

or axiality), are for their date astonishingly advanced; and while one may feel that some of the architect's less ambitiously elaborate ventures, such as the fountain courts adjoining the great Triclinium, were more successful, these domed rooms give us the full measure of his determination at all costs to create new and interesting interior forms. The only limitation in this respect by which he still felt constrained was that imposed by the traditional rectilinear framework of the building as a whole. Apart from the façade towards the Circus Maximus with its gently curving central portico, the whole building, whether viewed from without or from its own inner courtyard, was still clothed in a rectilinear decorum which gave scarcely a hint of the ferment within.

Side by side with this increasing use of curvilinear features we find an increasing awareness of the value of suggestion and surprise, as well as of sheer size, in the creation of impressive interiors. The suggestive glimpses afforded to diners in the great Triclinium, out into the central courtyard and across into the small garden courts to right and left, were an essential part of the total architectural effect, a lesson of which a generation later Hadrian was to show himself well aware in planning the dining halls of his villa near Tivoli. As for the element of surprise, one has only to imagine the sense of shock with which the huge, almost empty spaces of the vestibule, lit from high above, must have burst upon the visitor ushered in through the modest doorway which was the principal entrance to the palace from the world outside.

Another group of buildings well suited for the expression of the new spatial ideas was the series of large 'Imperial' bath-buildings. The Roman taste for public bathing as a social relaxation was from the outset an important factor in the development of the new architecture. Vaulted concrete was a medium ideally suited to the practical requirements of the Roman bath; and just as bath-buildings were to become one of the earliest and most influential means of dissemination through the provinces

of the new architectural ideas current in the capital, so in Rome itself these ideas took shape under the strong influence of (and themselves did much to promote) the rapid development of contemporary bathing-habits, both public and private, in and immediately after Augustan times. Foremost among the buildings in the new style were the 'Imperial' bath-buildings described in the preceding chapter. Those of Titus certainly, and very possibly those of Nero before him, were already built almost exclusively of concrete. Essentially compact, functional buildings, they offered little scope for the more elaborately fantastic curvilinear forms. They were, on the other hand, ideally suited for the development of large, dignified interiors and of the interlocking vistas by means of which the individual rooms were made to participate in the larger unity of the building as a whole. In the Baths of Titus the forms that were to dominate the great public bath-buildings of the capital for the next two and a half centuries had not yet taken decisive shape. The main cold hall (*frigidarium*) is still at one end of the central axis instead of, as functionally it belonged and as thirty years later we find it in Trajan's Baths, at the centre of the whole complex, with vistas opening out in all directions. Moreover, if Palladio's drawing [33] is right in showing this hall as essentially cruciform in plan, with a groin-vaulted central bay buttressed on three sides by barrel-vaults and on the fourth by the large apse which closed the axial vista, this all-important feature was itself still feeling its way towards its final form.[11] It was left to Trajan's architect, Apollodorus of Damascus, to take the decisive step of substituting for the lateral barrel-vaults groined vaults of a height and size equal to that over the central bay, thereby establishing an axis at right angles to that of the building as a whole and creating that deliberate sense of spatial ambivalence which one can still experience today in the frigidarium of the Baths of Diocletian, now the church of S. Maria degli Angeli. (It was precisely on the question of axis that the plans of Michelangelo and of Vanvitelli for the remodelling of this church found great-

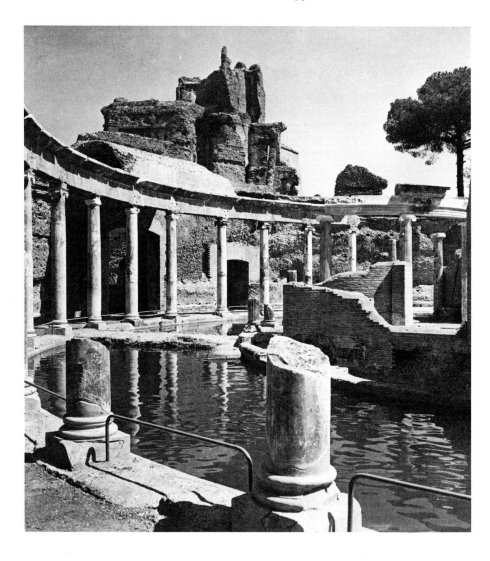

47 and 48 (*opposite*). Tivoli, Hadrian's Villa.
The island villa ('Teatro Marittimo'), 118–25 [cf. 49A, 123, and 124]

est scope for difference.) Apart from the form of the frigidarium, which we may note in passing was a variant of that used by Apollodorus himself in the central hall of Trajan's Market, and which was to play an even more important role in the development of later Roman architecture, it was principally in the greater size and elaboration of the plan as a whole and the introduction of a great many more circular, semicircular, and, in two instances, oval features that Trajan's building differed from its predecessor. With its construction the pattern for the

been fully comprehended and explored. By contrast the actual period of revolutionary experiment was, as such moments of intense intellectual or artistic activity often are, remarkably brief. By the death of Hadrian in 138 it may be said to have achieved all its immediate objectives; and it is accordingly with a brief discussion of Hadrian's work in this field that we may fittingly conclude this account of the emergence in the capital of the new architecture of the middle and late Empire.

Hadrian's Villa,[12] that imperial Xanadu in

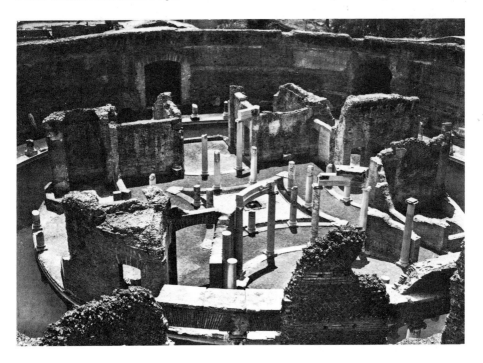

great public bath-buildings of the capital was established on lines which it was to follow with remarkably little change for the next two centuries.

The ferment of new architectural thinking which we have termed the Roman Architectural Revolution had not sprung upon the world unheralded, and it was to be many generations, indeed centuries, before its implications had

the heart of the Campagna, near Tivoli [123], is a monument that does not lend itself to easy generalizations. The product of a restless, inquiring mind, with a strong bent for architectural experiment and backed by unlimited resources, it is hardly surprising that it should have come to include a number of extraordinary buildings, of which almost the only common elements are the ingenuity with which they

A

0 10 15m

B

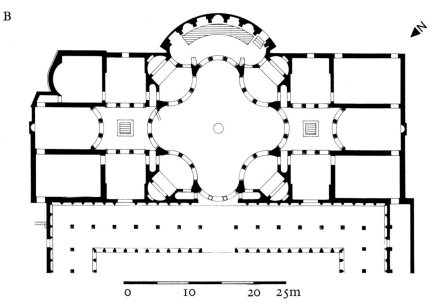

0 10 20 25m

49. Tivoli, Hadrian's Villa. Plans. (A) Island villa ('Teatro Marittimo'), 118–25;
(B) Piazza d'Oro, pavilion and south-east end of the peristyle court, 125–33

exploit the possibilities of the gently undulating site and their technical mastery of the material, concrete faced with brick or reticulate work, of which it is almost entirely built. Curvilinearity has become a commonplace. In the emperor's private island retreat, for example, the so-called Teatro Marittimo (118–25), there is hardly a straight line anywhere; instead, within the severely simple triple circle of the surrounding portico and moat, there is a bewildering medley of convex and concave chambers facing on to a miniature courtyard with a central columnar fountain, the scalloped plan of which echoes

result is in both cases a curvilinear, cruciform plan of extraordinary complexity, between the columns of which could be glimpsed a bewildering variety of matching or counterposed rooms and courtyards. The latest studies suggest that neither building was roofed;[13] but there is a small room of the same general shape in the Lesser Baths (another building of the second phase) with a correspondingly curvilinear octagonal vault which merges imperceptibly into a dome.

Apart from the semi-dome of the Serapaeum [50], a 'melon' or 'pumpkin' vault of which the

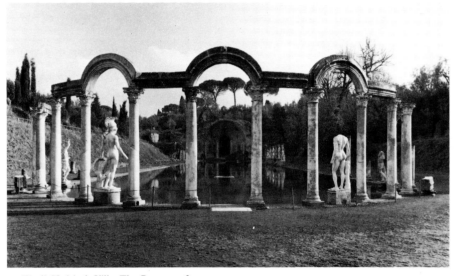

50. Tivoli, Hadrian's Villa. The Canopus, after 130

that of the façades of the surrounding chambers [47–49A]. The theme of curve and countercurve is one that we find further elaborated in the second phase of the villa's construction (125–33), notably in the central courtyards of the pavilions of the Piazza d'Oro and of the West Palace, or Accademia, the former of which is delimited by eight identical, alternately projecting and re-entrant, segments of curved colonnade [49B], the latter by a circle which is interrupted for about two-thirds of its circumference by four large convex colonnades. The

nine radiating segments are alternately concave and flattened,[14] there are no grandiose interiors – the character of the villa lent itself to virtuosity rather than mere size – but a great deal of ingenuity has been lavished on the invention of new and exciting room-shapes. In the Lesser Baths, for example, one feels that the architect's principal object has been to discard the obvious, both in the forms of the rooms themselves and in the jigsaw-like planning of the complex as a whole. At ground level it is still compressed into a rectilinear framework; but the roof plan defies

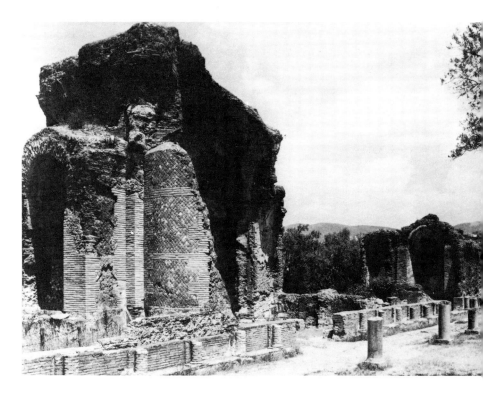

51. Tivoli, Hadrian's Villa.
Vestibule to the Piazza d'Oro, after 125

rational reconstruction. In the vestibule of the Piazza d'Oro [51] we can follow the process a stage further.[15] The plan itself is a variant of one that we have already met in the Flavian Palace, a circle inscribed in a square, with eight alternately rectangular and curved recesses; the recesses are arched, and above them the ribs of the octagonal 'pumpkin' vault merge into the uniform curvature of a dome with a central oculus. There are other examples of this inscribed form elsewhere in the villa, in the several bath-buildings, for example, or in the basement of the Roccabruna pavilion. What is altogether new and unprecedented in the Piazza d'Oro vestibule is that the outer square frame has been stripped away, and that the outside of the building follows the outline of the internal recesses. Here, for the first time, we see the principles of the new architecture pressed to their logical conclusion and the forms of the exterior dictated simply and solely by those

within. One of the last entrenched positions of traditionalism had been overturned, and the way lay open to a whole new field of architectural endeavour. There was still a long way to go before any really satisfactory solution was found to the problem of creating an exterior architecture genuinely expressive of the new interior forms. But at least the problem had been recognized and brought into the open.

There could hardly be a greater superficial contrast to the villa than Hadrian's other great monument in the contemporary manner, the Pantheon. By comparison with the villa, the prevailing note of which is one of restless experiment, the Pantheon seems the very embodiment of solid achievement; and although in this respect appearances do less than justice to the architect's originality in solving a number of formidable problems, both structural and aesthetic, for which there were no clear precedents, there is certainly no other single building which so fully and, by the very fact of its survival, so vividly sums up the achievement of the sixty years since Nero's Golden House was planned. With the building of the Pantheon the re-

volution was an accomplished fact. Architectural thinking had been turned inside out; and henceforth the concept of interior space as a dominating factor in architectural design was to be an accepted part of the artistic establishment of the capital.

Agrippa's Pantheon, rebuilt by Domitian after the fire of 80, had again been destroyed or badly damaged in 110, and it was entirely rebuilt by Hadrian between the years 118 and, at latest, 128. The dispute as to whether any part of the existing building is earlier or later than the time of Hadrian has been resolved once and for all by the study of the brick-stamps, which show that, apart from minor repairs, the whole structure is unquestionably Hadrianic.[16] It consists of two quite distinct elements, the huge domed hall, which served as the cella of the temple, and the no less huge columnar porch which in antiquity constituted almost the entire visible façade of the building towards the long narrow colonnaded precinct in front of it [52, 53]. In judging the effect of this façade one must remember that in antiquity the eye-level was a great deal lower (and the relative level of the

52. Rome, Pantheon, c. 118–c. 128. Restored view of the façade, as seen from eye-level in antiquity

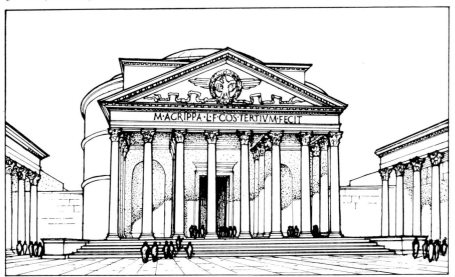

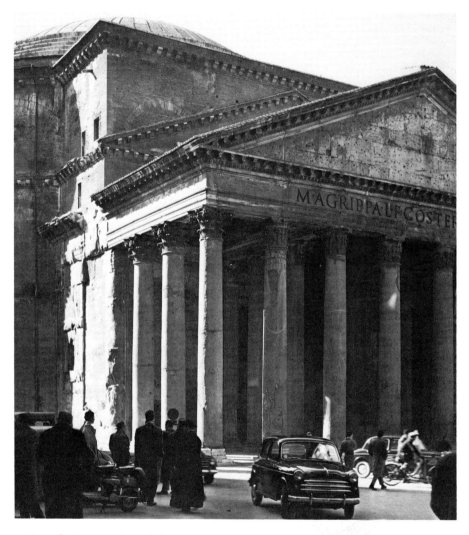

53. Rome, Pantheon, *c.* 118–*c.* 128, façade

gable correspondingly higher) than it is today. Even so the junction of the two elements is in detail so clumsily contrived that it is not surprising that scholars have been tempted to see in them the work of two different periods. In reality, however, the difference is one of function, not of date. The porch is the architect's concession to tradition. This was the sort of face which a religious building should present to the world. It could be – and still is today – forgotten the moment one stepped across the threshold into the cella.

The formal scheme of the rotunda [54] is deceptively simple – a circular drum, internally half the height of its own diameter (142 feet; 43.20 m.), surmounted by a hemispherical

54. Rome, Pantheon, *c.* 118–*c.* 128.
Axonometric view and section. The stippled area
in the section (here shown slightly exaggerated)
represents the masonry added below the
structural intrados of the dome so as to complete
the visual curvature of the coffering

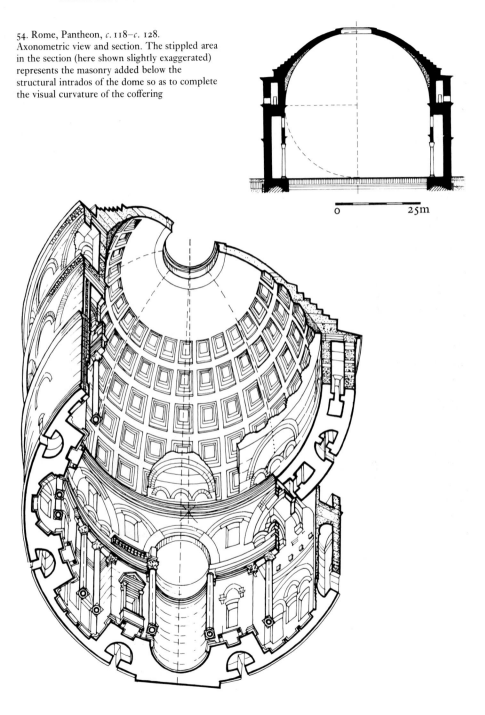

0 25m

dome, the crown of which is thus, in accordance with the precepts of Vitruvius,[17] exactly the same height above the pavement as the diameter of the building. Internally the drum is divided into two zones, and externally into three, by cornices, the uppermost zone of the exterior corresponding to the lower part of the dome. The exterior is otherwise quite plain, but the interior is more elaborate. The lower zone is considerably the taller (40 feet; 12.30 m.), and it is interrupted at regular intervals round the circumference by an apsidal recess directly opposite the door and by six columnar exedrae, alternately rectangular and curved, as well as by eight smaller aediculae projecting from the wall-faces between the exedrae. Evenly spaced around the upper zone, which is 31 feet (9.50 m.) high, are sixteen smaller, rectangular, window-like recesses. The dome is coffered, with five diminishing rings of twenty-eight coffers each, in antiquity stuccoed and perhaps gilded, and the only light comes from the great central oculus [55, 56]. Whether or not it was so intended by the architect, the rhythmic contrast (8 : 7) between the compositional schemes of the drum and of the dome does undoubtedly emphasize the visual discontinuity, thus contributing to the magical, soaring quality of the latter.[18]

There were many precedents for the essentially octagonal layout of the interior: for example, in the Augustan or early Julio-Claudian 'Temple of Mercury' at Baiae, which had already achieved a diameter of 71 feet (21.55 m.),[19] or more recently in the circular nymphaeum of Domitian at Albano (diameter 51 feet; 15.60 m.). But there were no precedents on this enormous scale – the span of the dome was not surpassed until modern times (that of St Peter's measures 139 feet; 42.50 m.) – and its successful completion was an outstanding achievement of structural engineering. The secret of its success lay in three things: the huge and immensely solid ring of concrete, 15 feet (4.50 m.) deep and 24 feet (7.30 m.) wide (enlarged during construction to 34 feet; 10.30 m.) upon which the building was founded; the tried

quality of the mortar; and the very careful grading of the *caementa*, the materials used as aggregate. The selection of specially light caementa for vaulting was already familiar building practice;[20] but here the grading runs through the building, from the heavy, immensely strong basalt (*selce*) of the footings to the very light, porous pumice of the part of the dome nearest to the oculus. By this means, and by diminishing the thickness of the envelope to less than 5 feet at the centre, the actual turning moment was kept uniform throughout at about 35–40 lb. per square inch. For this the walls of the drum, 20 feet thick, were more than adequate; indeed, it was possible to reduce the dead weight by introducing a series of cavities, both those that are visible from the interior as recesses, and a number of smaller spaces that were completely enclosed. It was the presence of these cavities that led the architect to incorporate the elaborate series of 'relieving arches' which are so conspicuous a feature of the outer face of the drum. He was determined at all costs to prevent settlement during the drying out of the enormous mass of concrete (the cavities themselves would have helped to hasten the drying process), and the whole structure, including the lower part of the vault, was further laced with horizontal courses of tiles, at vertical intervals of 4 feet (1.20 m.). There is, on the other hand, no factual basis for the elaborate series of brick arches and ribs which Piranesi claimed to have seen in the dome. The only brickwork feature of the dome is the triple ring of tiles closing the oculus. Even the three relieving arches shown internally in illustration 54 are part of the vertical inner face of the uppermost zone of the drum itself. The lowest part of the coffering is a superficial (and structurally otiose) inner skin, added to complete the required hemispherical profile of the dome.

For all the magnitude of the engineering problems involved, the result was far from being a mere technical *tour de force*. Familiarity cannot deaden the impact of the interior as one steps through the great bronze doors into the rotunda. In startling contrast to the grandiose, but

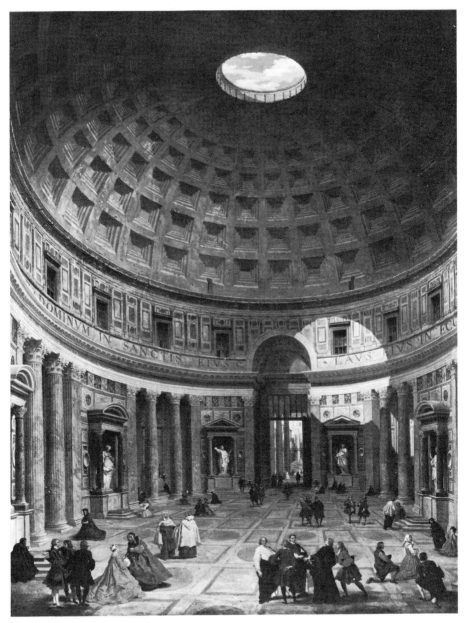

55. Rome, Pantheon, c. 118–c. 128,
one of the paintings of the interior made by Panini
before the modifications to the upper order undertaken in 1747

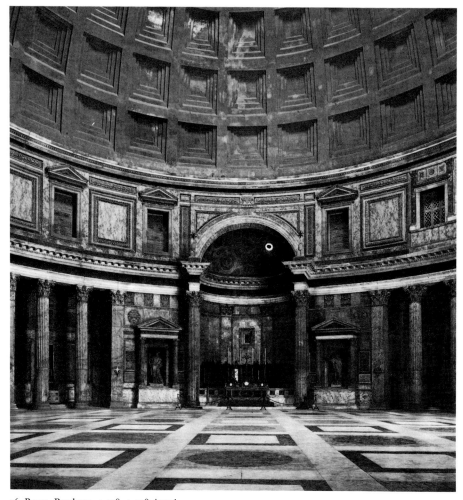

56. Rome, Pantheon, *c.* 118–*c.* 128, interior

essentially conventional monumentality of the porch, where it is the very size and solidity of the columns that rivet the attention, inside the building one is conscious, not of the solid mass of the encircling masonry, but of light and colour and of the seemingly effortless lift of the dome, soaring high above. Quite apart from the element of sheer surprise, this is due in no small part to the skilful disposition of the columnar

recesses, which, with their glimpses of heavy shadow beyond the brightly lit façade, effectively break up the solidity of the masonry drum and convey an illusion of a spatial continuum spreading beyond the rotunda itself. The illusion is furthered by the pattern of the marble veneer. Instead of an inert mass of brickwork, one is confronted with a fictitious pattern of verticals and horizontals, reassuringly evocative

of the traditional classical orders and effectively diverting the eye from the real structural problems of the building. To complete the illusion, there is the deliberate lack of orientation achieved by lighting the whole building from a single, central source. Apart from the very unobtrusive axis established by the door and apsidal room opposite it, in the horizontal plane the building is directionally neutral from floor to ceiling. The eye is almost inevitably drawn up, through the richly traceried pattern of light and shade cast by the coffering, to the light that floods in through the great central opening. Such effects have to be experienced. They can be analysed, but they cannot really be described. Few who have seen the Pantheon will, however, dispute that it is one of the great buildings of antiquity. It has also been one of the most influential. Perhaps the first great public monument – it is certainly the first on anything like this scale that has come down to us – to have been designed purely as an interior, it ranks with the Colosseum as one of the few Roman buildings that have been a continuing source of inspiration to architects ever since.

Quite apart from its merits as a building, the Pantheon is of importance also as being one of the few Roman monuments that can be experienced under something very like the conditions prevailing in antiquity. Unlike, for example, Greek architecture, which even in a partially ruined condition can still convey much of the spirit of the original, Roman concrete architecture, stripped of its marbles and mosaics, its intarsias and its stuccoes, calls for a powerful effort of the imagination if one is to recreate anything of the atmosphere of light and colour upon which so much of its effect depended. It is not at all surprising that it should be its engineering achievements, so starkly and emphatically revealed, which have come to dominate the popular conception of Roman architecture, at the expense of the many other qualities which it once possessed, but which can so rarely be directly experienced. For this reason alone, if for no other, any account of Roman building materials and practices under the Early Empire must include a brief survey of the decorative materials, and particularly of the marbles which played so large a part in determining the appearance of the finished building.

Although already in hellenistic times coloured marble was beginning to be used both for columns and pavements and as a substitute for painted plaster in interior decoration, in Italy it was still something of a rarity until the last few decades of the Republic. It was not really until the time of Augustus, with the opening of the Carrara (Luni) quarries and the ever-increasing importation of foreign coloured marbles, that marble, both white and coloured, began to be a commonplace of the monumental architecture of the capital. Employed at first chiefly as a substitute for the travertines and tufas of established architectural usage, it soon came to be valued as a material with which to clothe the bare bones of the new concrete architecture, and the rapid increase in the use of the latter was accompanied by a hardly less rapid development in the uses of marble veneering. Painted wall-plaster and floor mosaics, though still the predominant decorative materials in domestic use, early gave place in monumental architecture to floors and walls of marble and to vaults of polychrome mosaic or moulded stucco.

Of the marbles known to antiquity (the term may be taken to cover also the porphyries and granites in common use) the majority of those that were most highly prized came from the Aegean and from Egypt. Marble was a costly commodity, expensive both to quarry and to transport, and an early result of the great increase in demand created by the building programme in the capital was a reorganization of the whole system of supply, begun by Tiberius and carried to completion by his immediate successors. The essence of the new system was to concentrate production at a limited number of carefully selected, imperially-owned quarries, situated wherever possible so as to take advantage of cheap water-transport. Quarrying methods were reorganized on mass-production lines and large stocks were

built up, to be held in the form either of roughly squared blocks, equally suitable for the carving of individual architectural members and for sawing into slabs, or else of pieces, principally columns, that were already roughed out to shape and only needed the final stages of carving after receipt.[21]

The results were rapid and far-reaching. By the middle of the first century we already find most of the familiar types represented in buildings such as Nero's Domus Transitoria; and even outside Rome considerable quantities were already available for small-scale private use before the destruction of Pompeii in 79. Under the Flavian emperors large monolithic columns of imported marble, still a feature to be remarked in Julio-Claudian times, were rapidly becoming a commonplace of the monumental architecture of the capital. Some of the individual pieces were of enormous size. The columns of the Pantheon, of red and of grey Egyptian granite, were 40 Roman feet (11.80 m.) high, weighing an estimated eighty-four tons, and others are recorded nearly half as long again.[22] When one reflects that a single block of marble weighing a ton would have furnished the material for 35–45 square yards of paving or for panelling up to 100 square yards of wall-surface, it is not altogether surprising that the Roman emperors could afford to be lavish in its employment.

At first the uses made of the new material were strictly conventional, as one sees them, for example, in the Forum of Augustus – pavements made up of simple geometrical patterns of contrasting colours, and architectural wall-schemes which echo those of the free-standing orders which they accompany. Very soon, however, one can detect the beginning of a tendency towards a greater elaboration, as in the boldly curvilinear pavements and complex wall-patterns of Nero's palaces, coupled with a growing divorce of the decorative forms from the real framework of the underlying structure. In the Pantheon, for example, only the lateral recesses are functional; the columns and pilasters of the apse opposite the door are no more

than an extension of the same architectural scheme, and the whole of the upper order[23] is a superficial fiction, with no justification whatsoever in the physical structure of the building.

The use of the classical orders as a purely decorative façade was not, of course, in itself a novelty. It had, indeed, been one of the most successfully and widely used of the conventions which the Augustan architects inherited from their Late Republican predecessors, both in their monumental building and in a great deal of their domestic wall-painting. But the orders of the Theatre of Marcellus or the flanking pilasters of a pseudo-peripteral temple still reflect the essential structural realities of the building which they adorn; even the painted columns of a Second Style wall-painting appear to support a real roof. With the development of concrete, on the other hand, there began to emerge an architecture which, as we have seen, was no longer capable of being expressed in the traditional terms; and since throughout antiquity it was these traditional terms which continued to be the everyday language of classical ornament, it was inevitable that the internal veneer of such concrete buildings should come to be treated increasingly as an element almost independent of the underlying structure. It is not until late antiquity that we find this tendency pressed to its logical conclusion as a means of 'dematerializing' the structural envelope and accentuating the effects of light and space; but the seeds of the later development were already present in Hadrianic architecture.

Of all the decorative materials used by the Romans, stucco is the least durable, and although it was undoubtedly the normal medium for the covering and decoration of concrete vaults [57, 58], there are few great public monuments in which any substantial remains have been preserved. Most of what we know about the stucco ornament of Imperial Rome comes from a number of minor buildings, mainly tombs, which chance has preserved intact, and it would be unwise to deduce from these that such motifs as the free foliate arabesques of the Tomb of the Axe under the church

of S. Sebastiano found any place in the public architecture of the day. What little we do know about the employment of stucco in the latter appears to suggest two principal uses. One of these was to furnish the moulded detail of the coffering which the concrete architects inherited from the traditional repertory and applied, with great effect, to the domes, semi-domes, and barrel-vaults of buildings such as the Pantheon [56], the great public baths, and the Basilica of Maxentius [289, 290]. The other was to form the elaborate schemes of panelling,

57 (*left*). Pompeii, Forum Baths,
painted stucco decoration of vaulting

58 (*below*). Rome, Via Latina,
painted stucco vaulting in the Mausoleum
of the Anicii, second century

applicable both to barrel-vaults and groined vaults and often combined with painting or gilding, of which we can still see traces in, for example, the Sala della Volta Dorata of the Golden House, in the passages of the Colosseum and the Palatine, and in the bath-buildings of Hadrian's Villa, as well as in a number of tombs and private houses. This, the style so successfully imitated and adapted by Robert Adam, depended for its effect very largely on the delicacy of its detail, and one may reasonably doubt whether it was used to any great extent in the main halls of the larger public monuments. Both uses have this in common, that they derive from practices already current in the Late Republic, for example in the coffering of the semicircular exedrae of the Temple of Fortune at Praeneste and in the elaborately panelled stuccoes of the barrel-vaults of the Farnesina villa. This was evidently a very conservative medium. It has to be borne in mind when trying to visualize the appearance of these great concrete-vaulted interiors, but it cannot be said to have played an important part in their development.

With mosaic it was a very different matter. At Pompeii and Herculaneum it was still restricted to fountains and garden architecture, and occasionally used as a substitute for painting in small figured wall-panels.[24] In Rome, on the other hand, the development of large-scale vaulting and a rapidly growing taste for luxurious bathing establishments, both public and private, was already creating a new situation. Mosaic was an ideal decorative medium for the humid interiors of bath-buildings, and although none of the surviving examples in Rome or Ostia is as early as the first century, the statement of the Elder Pliny (who perished in the eruption of 79) that the Baths of Agrippa did not make use of mosaic because it had not yet been invented, clearly implies that in the meanwhile it had become a familiar feature of the bath architecture of his own day. Indeed, if the traces of mosaic on the dome of the 'Temple of

Mercury' at Baiae are original, it began to be applied to vaulting very soon after the time of Agrippa; and by the end of the first century it was in widespread use, not only in bath-buildings, but also in theatres (the Theatre of Scaurus), in palaces and wealthy villas (the Palatine, Domitian's villa near Sabaudia), garden pavilions (the nymphaeum in the Gardens of Sallust), and, generally, wherever there were buildings of a sufficiently opulent character with concrete vaults to be adorned. At Hadrian's Villa it has left many traces – in the two 'Libraries', for example, in one of the cryptoporticoes, in the Pavilion of the Semicircular Arcades, and on the semi-dome of the Canopus.

This is not the place for a discussion of the development of vault mosaics as such. It is important, however, to note that, although there was inevitably an exchange of patterns and ideas between the mosaics of floors and vaults, the two media were in fact quite distinct. They were handled by different groups of craftsmen (*tessellari* and *musivarii* respectively), and whereas the normal materials of the former were stone or marble, with glass confined at first almost exclusively to the small figured panels that were often inset into them, the mosaics of wall and vault were from the outset made almost entirely of glass. Quite irrespective of the designs used, the gently rounded contours, the irregular surfaces, and the play of light upon the backgrounds of white or deep, translucent blue glass, all helped to minimize the solidity of the surfaces and to accentuate the spatial qualities of this vaulted architecture. It was not until Christian times, with the invention of gold-ground mosaic, that this particular aspect of the mosaicist's craft came to full fruition. But the seeds had been sown long before; and while it was the forms of the new architecture which in the first place suggested this particular use of mosaic, in the later stages the qualities of the mosaic itself were to play a far from unimportant part in shaping the development of structure and decoration alike.

ARCHITECTURE IN ROME

FROM HADRIAN TO ALEXANDER SEVERUS

(A.D 117–235)

HADRIAN (A.D. 117–38)

The death of Trajan in 117 marks the end of an era. Rome was at the height of her power, her authority unquestioned from the Tyne to the Euphrates. But the tide had reached its peak. Trajan's successor, Hadrian, turned his back resolutely on the mirage of Oriental conquest and devoted himself instead to the benefits of peace and sound administration; and although a contemporary observer would no doubt have attributed – and rightly attributed – any immediate changes of policy to the more cautious temperament of the new emperor, it is easy for a later generation to see that his was a just assessment of the spirit and needs of a changing world.

In architecture, as in many other fields, one of the most significant manifestations of the new age was the steady decline of Italy in relation to the rest of the Empire. During the first century A.D. it would still be possible, even if somewhat misleading, to write a history of Roman architecture based almost entirely on a study of the buildings of Rome itself. This is not simply because many of the earlier emperors were avid builders who lavished their attention on the capital, nor even because it was during this period that the architects of the capital were making their great original contribution to the architectural progress of the ancient world, the contribution that is described and discussed in the previous chapter. Both of these circumstances were themselves the products of the broader historical situation whereby Italy was still the effective centre of the Roman world, and Rome the centre of Italy. That privileged status

Italy was now rapidly losing; and although it was to be a long time before the city of Rome lost its unique position, as the years passed it did increasingly find itself the first only among a number of powerful and prosperous cities, all of which might also be candidates for the benefits of imperial patronage. It is hardly surprising that, faced with this situation and confronted by the extraordinary wealth of fine building already existing in the capital, the later emperors should have been more discriminating in their architectural favours. The student of Roman architecture may be permitted a similar discrimination. Many fine and important buildings were to be built in Rome during the next two centuries; but to a degree that is not true of the first century, they are a part only of the larger picture.

Within the city of Rome the major contributions of Hadrian (117–38) to the architectural landscape were four: the completion and dedication of the Temple of the Deified Trajan at the north end of Trajan's Forum; the Pantheon (nominally a restoration of Agrippa's Pantheon but in fact an entirely new building); the Temple of Venus and Rome on the Velia; and Hadrian's own mausoleum across the river, together with the bridge leading to it, the Pons Aelius. He was also active in restoring existing buildings, notably in the Forum of Augustus and on the Palatine, where several of the more audacious enterprises of Rabirius were already in serious need of reinforcement and consolidation. Outside the city he was busy throughout his reign with the plans for his great country residence, near Tivoli; and at Ostia it is hardly an exaggeration to say that the city as we see it today is very largely his creation.

The Temple of Trajan and the Pantheon have already been sufficiently described. Both belong to the earlier part of Hadrian's reign, if indeed the former was not substantially complete before Trajan's death; and although it would be hard to imagine two buildings more profoundly different in their architectural intention and design, this is of course precisely the situation that we have already encountered in the public monuments of the previous reign, between the Baths and the Markets of Trajan on one hand and the forum and the basilica on the other. When one turns instead to the details of the architectural ornament, so often a useful indication of the training of the craftsmen employed on a given building, one does in fact find in both a strong degree of continuity with the work of the previous reign. For all its diversity, the earlier architecture of Hadrian

was in its public face a direct and logical development of what had gone before.

The clear element of continuity lends added point to the innovating tendencies that make themselves felt in Hadrian's later work. We do not know when the Temple of Venus and Rome was begun, but it was not consecrated until 135. Dedicated to the personification of Rome and to the legendary ancestress of the Roman people, it occupied the site of the vestibule of Nero's Golden House on the crest of the Velia. The roof was destroyed in the fire of 283, and the two semi-domed apses, together with the remains of the internal columnar orders of the two cellas, date from the radical reconstruction of the interior undertaken by Maxentius (305–11). The basic plan, however, with the two cellas placed back to back and facing, respectively, towards the Colosseum and down the Via Sacra

59. Rome, Temple of Venus and Rome, consecrated 135.
For the cella as restored by Maxentius in 305, see illustration 284

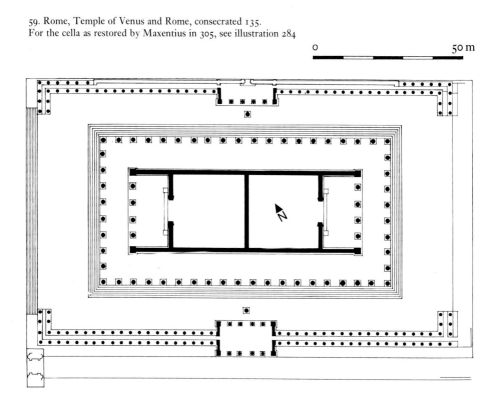

0 50 m

towards the Forum, repeated that of Hadrian's building [59].[1] This was a gigantic decastyle peripteral temple (217 by 348 feet; 66 by 136 m.) with ten columns across the façade and twenty along the sides, and set, not on a podium in the usual Roman manner, but in the centre of a rectangular temenos-like platform, above the pavement of which it was raised merely by a low encircling flight of steps. Along the two outer long sides of the platform ran colonnades of grey Egyptian granite columns, while the two short sides were open.

The design, closely modelled on classical Greek precedents, we know to have been that of Hadrian himself and to have been criticized, with more justice than prudence, by Apollodorus, with whom by this date the emperor had quarrelled.[2] The substance of his criticism is recorded, and it is revealing of the artistic personalities of both men. Apollodorus, oriental by name but Roman by training, maintained – and he was surely right – that in its setting the temple itself was too low and needed to have been placed on a tall podium. As the builders of the Temple of Jupiter at Baalbek had realized [202], a decastyle temple that was to look convincing in a Roman context needed additional height to offset its unusual breadth. Instead, Hadrian had chosen to place his temple on a low, stepped plinth, giving it the overall proportions, but neither the grace nor the setting, of a traditional Greek Doric temple.

The fact that the Temple of Venus and Rome was, as regards the temple itself, an aesthetic failure in no way lessens its historical significance. It is not only the planning that reveals the cosmopolitan interests of its imperial designer. The scanty surviving remains of the peristasis date from the time of Hadrian, not of Maxentius, and they too reveal a complete break with contemporary Roman tradition. The material is itself significant. Trajan had used predominantly the white marbles of Carrara for the architectural members of his forum and basilica and for his column. Hadrian preferred the marbles of Greece: for the porch of the Pantheon Pentelic, and for the Temple of Venus

and Rome the blue-veined marble of Proconnesus; and whereas in the Pantheon he had been content with Rome-trained sculptors for the imported materials, for the later building he imported the workmen also. The profiles of the order and the decorative mouldings and the manner of their carving all betray the direct influence of Asia Minor. Whether or not the workmen included any who had actually taken part in the building of the Traianeum at Pergamon,[3] there can be no doubt that that was the sort of enterprise in which they had been trained.

This was a major innovation. In an age when there were no hard-and-fast distinctions between planning and execution, between craftsmanship and design, it meant far more than the mere introduction of a new repertory of decorative motifs. It meant that after more than a century of virtually self-sufficient development the architectural thought and practice of the capital were suddenly exposed to a whole new world of ideas. Not since the time of Augustus had there been such an infusion of new blood.

The fourth of the major architectural tasks undertaken by Hadrian within the city was the building of a mausoleum for the new imperial family. That of Augustus, last opened to receive the ashes of Nerva, was now full, and the placing of Trajan's remains within the chamber at the foot of his column offered no precedent for general use. The site chosen by Hadrian lay on the right bank of the Tiber, opposite the Campus Martius. To give direct access to it he built a new bridge, the Pons Aelius (now the Ponte S. Angelo), dedicated in 134. The mausoleum, unfinished at Hadrian's death in 138, was completed by Antoninus Pius and dedicated two years later. It remained in use throughout the second century, the last recorded burial within it being that of Caracalla in 217.

Hadrian's Mausoleum, now Castel S. Angelo, was a considerably elaborated version of that of Augustus. It consisted of a marble-faced, podium-like base, 276 feet (84 m.) square and 33 feet (10 m.) high; a main drum, the

mausoleum proper, 210 feet (64 m.) in diameter and 69 feet (21 m.) high, the top of which was planted with a grove of cypresses; and rising from the middle of the latter, a smaller pedestal and drum crowned either by a statue of Hadrian or by a quadriga. The tomb-chamber and the ramps and stairs that led up to it and to the terrace above were contained within the body of the main drum, which was in turn faced with marble. The whole was elaborately embellished with gilded fittings and statuary. Already in the sixth century it had become a bridgehead fortress, and throughout the Middle Ages it was the principal stronghold of the popes in times of trouble, so that it is not altogether surprising that it has come down to us stripped of every bit of its superficial decoration. From drawings made in the late fifteenth and early sixteenth centuries, however, and from the *disjecta membra* that can be attributed to it, one can see that, though carved in Italian marble, it followed closely the models established a few years earlier in the Temple of Venus and Rome.[4] The innovations from Asia Minor embodied in the latter building had taken firm root, and from now on they were to be an essential ingredient in the decorative repertory of the capital.

ANTONINUS PIUS TO COMMODUS (A.D. 138–93)

The fifty-odd years that followed the death of Hadrian are a lean period in the architectural history of the capital. After a long series of lavish builders, there followed three emperors, Antoninus Pius (138–61), Marcus Aurelius (161–80), and Commodus (180–93), who were content to restrict themselves to the bare minimum consistent with dynastic prudence and the proper maintenance of imperial authority.

The military triumphs of the imperial house continued to be celebrated by the erection of triumphal arches, but with the exception of the well-known series of sculptured panels from an arch, or arches, of Marcus Aurelius, eight of which were later incorporated in the Arch of Constantine and three more are in the Con-

servatori Museum, nothing of these has come down to us. The Column of Marcus Aurelius (the 'Antonine Column', still standing in the centre of the Palazzo Colonna), modelled very closely on Trajan's Column and recording the events of the Danubian wars of 172–5, was a memorial rather than a triumphal monument. The same was true of its neighbour and immediate predecessor, the Column of Antoninus Pius, which was a fifty-foot monolith of red Egyptian granite standing on a tall sculptured base, now in the Vatican.[5]

Another, and architecturally more substantial, aspect of the public image of empire was the proper provision for the cult of the deceased and deified members of the imperial family. This was a field which even the Antonine emperors could not afford to neglect. Of the temples built by Hadrian in honour of Matidia, his mother-in-law, and by Commodus in honour of Marcus Aurelius we know nothing except their probable location in the Campus Martius. Hadrian himself was commemorated in a large temple (the 'Hadrianeum') of which eleven marble columns and the remains of the cella are still standing along one flank of the 'Borsa', in the Piazza di Pietra. It was dedicated in 145. From it, presumably from the plinth of a decorative order within the cella, comes the well-known series of rather arid, classicizing reliefs now in the Conservatori Museum, depicting personifications of the provinces of the Empire. Architecturally the principal interest of the surviving remains is the mixture of styles and motifs represented in the entablature. Side by side with elements of purely Asiatic extraction (e.g. the convex profile of the frieze) are others that come from the first-century Roman repertory, while the alien austerity characteristic of the Temple of Venus and Rome has already begun to give place to the natural Roman taste for ornamental exuberance.[6] Those of Hadrian's Asiatic craftsmen who had stayed on were rapidly being assimilated, and motifs which ten years earlier had been exotic intruders were by now becoming part of the common stock of the architectural ornament of the capital.

The well-known Temple of Antoninus and Faustina in the Forum Romanum was begun by Antoninus himself in 141 in honour of his deceased wife, Faustina. A hexastyle prostyle building of conventional plan standing on a tall podium, it owes its preservation to its conversion in the Middle Ages into the church of S. Lorenzo in Miranda, the Baroque façade of which (1602) marks the level to which this whole area had risen by the beginning of the seventeenth century [60C]. With its walls of squared tufa, once marble-faced, its entablature of Proconnesian marble, its columns of green Carystian marble, and its carving, which combines elements of both Trajanic and Hadrianic derivation (the principal source seems to have been Trajan's Forum) within the framework of a rather lifeless, academic eclecticism, it is a

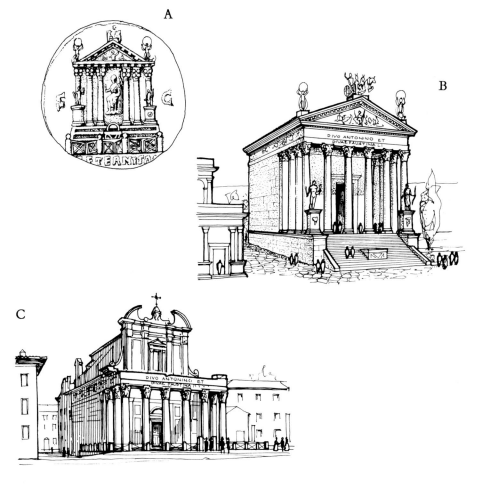

60. Rome, Temple of Antoninus and Faustina, begun in 141.
(A) As shown on a contemporary coin; (B) restored view; (C) as the church of S. Lorenzo in Miranda

typical building of its day, but not a very interesting one. Its principal interest is as a reminder of the vicissitudes, structural and aesthetic as well as historical, through which many of the familiar monuments of ancient Rome have passed before presenting themselves today, scrubbed and stripped down to whatever has survived of their classical skeletons. In a great many cases the result represents the appearance neither of the original building nor of any stage through which it has subsequently passed. Although complete restoration, as in the case of the near-by Arch of Titus, may rarely be justifiable, a building such as the Curia offers a warning of the hazards of partial restoration. In this respect the present aspect of the Temple of Antoninus and Faustina, though no more representative of the building's appearance at any stage in its past history, does at least offer a visual synopsis of that history. Furthermore, in this instance we do happen to possess the evidence for completing the classical picture. Illustration 60A shows the temple as it appears on a contemporary coin, together with all the statuary which was its principal distinguishing feature and which is so very rarely preserved. The restored view [60B] shows it as it might have been glimpsed (though never in fact in its entirety from this frontal view) between the back of the Temple of the Deified Julius and the Regia.

Apart from the restoration by Antoninus Pius of the venerable Temple of the Deified Augustus, a restoration which is illustrated on coins and which is usually interpreted as having involved the rebuilding as octastyle Corinthian of what had been originally a hexastyle Ionic building,[7] the recorded works of restoration during this period are almost all of a routine character. During the second half of the century architectural interest passes almost entirely into the domain of private rather than of public building. Some aspects of this private activity are discussed in Chapter 8. Within the private sphere belongs also the building, or rebuilding, of two sanctuaries of Oriental divinities, one on the Aventine, dedicated to Jupiter Dolichenus,

the Syrian Ba'al, shortly after 138; the other, on the Janiculum, rebuilt in the second century in honour of Jupiter Heliopolitanus, the head of the Syrian triad worshipped at Baalbek.[8] The temple is of interest, not so much because of its resemblances (in themselves fortuitous) to certain Early Christian buildings, as because it illustrates a characteristic which these individually unpretentious but cumulatively powerful Oriental cults had in common with Christianity, and which found common expression in their architecture. With a very few exceptions the older classical cults were of an essentially public character; the altar stood in front of the temple, and the sacrifices or other rituals took place in full view of all who cared to participate. The rituals of the Oriental cults were no less essentially private, privileged occasions, and their sanctuaries turned inwards upon themselves, screened by high walls from the gaze of the profane.

THE SEVERAN EMPERORS (A.D. 193–235)

The civil war that followed the murder of Commodus in 193 ended with the establishment of a new dynasty, the provincial Roman origins of which were even more strongly marked than those of its predecessor. Its founder, Septimius Severus (193–211), was a tough, able soldier of African extraction, whose wife, Julia Domna, was the daughter of the hereditary high priest of the great sanctuary of Ba'al at Emesa in Syria; and although by an ingenious process of retrospective auto-adoption he contrived to present himself officially to the world as the legitimate heir and successor to the Antonine emperors, he was well aware that dynastic considerations called for a certain display of architectural munificence. After the lean years of the later second century the list of building undertaken in Rome by Severus himself and by his successors, Caracalla (211–17), Elagabalus (218–22), and Alexander Severus (222–35), is a lengthy one; and although, architecturally speaking, the forty-odd years of Severan rule may be classed as an age of consolidation and

achievement rather than of important new experiment, the work of these years could not help reflecting the wider changes in the political and social structure that were taking place throughout the Roman world. If the architecture of the Severan age is primarily one of fulfilment, it is also in some important senses one of transition.

A first charge on the architectural resources of the new regime was the restoration and modernization of existing monuments. Among the buildings recorded as having been restored

61. Fragments of the Severan marble map of Rome, showing part of the Aventine Hill with the Temples of Diana Cornificia, restored under Augustus, and of Minerva; also an early-second-century bath-building, the Balnea Surae

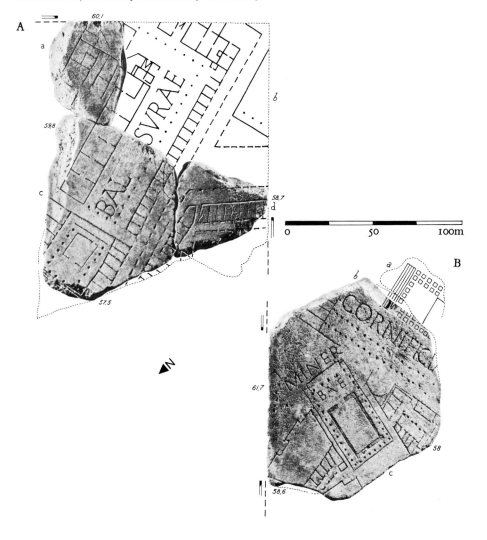

by Severus himself and his immediate family are the Temple of the Deified Vespasian; the Pantheon (where the work can have involved little more than the repair of the existing ornament); the Porticus Octaviae, the surviving pedimental brick porch of which is entirely his work; and Vespasian's Temple of Peace and the buildings lying between it and the Temple of Vesta and the House of the Vestals, all of which had been damaged in a recent fire, in 191. An important by-product of this last-named work was the preparation of a detailed map of contemporary Rome, which was carved on 151 slabs of marble and affixed to the wall of one of

Not least of the services of the marble plan is the graphic portrayal of the innumerable private houses, apartment-houses, shops, and other commercial buildings about which the literature and the archaeological and epigraphic record can preserve only a tantalizingly incomplete and haphazard record. One recognizes in it all the types of building familiar from second-century Ostia; and although a few private houses of the old-fashioned, Pompeian type still survived, their comparative rarity shows how profoundly the face of the capital had changed during the last 100–150 years. Now and then one of the lesser buildings escapes from its anonymity. An

62. Fragment of the Severan marble map of Rome, showing three old-style atrium-peristyle houses, rows of shops and street-front porticoes, a flight of steps leading up to a pillared hall (warehouse?) with internal shops or offices, and a porticoed enclosure with a central garden

the halls adjoining the Library of Peace. Though sadly fragmentary, enough of it has been preserved to make it a document of unique value for our knowledge of the vanished monuments of the ancient city [61, 62].[9]

example of presumably Severan date is the headquarters of the guild of tanners, the Coraria Septimiana, known from inscriptions to lie near the Ponte Rotto. We also know the names and locations of many of the wealthy properties. One

of these, the Horti Variani, had belonged to the father of Elagabalus, and at the time of the latter's death was being developed as an imperial residence. Its surviving remains include a small amphitheatre, the Amphitheatrum Castrense; a full-sized circus for chariot racing; a bath-building, restored in 323–6 by the empress Helena, which is now destroyed but which was recorded by Palladio; and a spacious, arcaded audience hall with large square windows, subsequently converted by Constantine into the church of S. Croce in Gerusalemme. The Amphitheatrum Castrense, with its two-storey façade of traditional type carried out entirely in

keep up with demand. (The Regionary Catalogue of A.D. 354 lists no fewer than 952 bathing establishments in the capital.) Septimius Severus himself is credited with a large bathbuilding, the Thermae Septimianae, in the Aventine district, and Alexander Severus, besides renovating the Baths of Nero in the Campus Martius, is said to have erected lesser baths throughout the city. Dwarfing all these, however, were the Thermae Antoninianae of Caracalla, dedicated in 216 and still in sheer bulk alone one of the most impressive buildings that have come down to us from antiquity [63–5]. The layout of Caracalla's Baths followed

63. Rome, Baths of Caracalla, 212–16, before the modern adaptation of the great circular caldarium as an auditorium for open-air opera

brick-faced concrete (cf. the theatre at Ostia), is a typical example of an architecture that stands midway between the early Empire and late antiquity but is difficult to classify as belonging to either. In such a case the transition was almost imperceptible.

The Severan emperors were active in the provision of public baths. With the steady increase in population and a rising standard of living, supply was evidently hard put to it to

essentially the model established a century before in the Baths of Trajan, the principal innovation being that of the surrounding enclosure. The latter, nearly 500 yards square and enclosing an area of almost 50 acres, combined the practical function of water storage with provision for all the subsidiary social amenities proper to a great bath-building. The central bath block stood in the north-eastern half of the enclosure, and except for the vast circular bulk

64. Rome, Baths of Caracalla, 212–16, north façade of the central block

of the main caldarium projecting from the centre of the south-west side, it was contained within a simple rectangular perimeter, 234 yards long and 120 yards wide (214 by 110 m.). It was a model of tight, rational planning, based on two identical bathing circuits laid out symmetrically about the shorter axis, with a hardly less important transverse axis running at right angles down the centre line of the building. At the intersection of the two axes stood the great three-bay, vaulted frigidarium. At one end of the shorter axis lay the main caldarium, a vast, circular, domed hall with a span (115 feet; 35 m.) not much smaller than that of the Pantheon and far taller, with large, scalloped windows in the drum; at the other end lay the *natatio*, or swimming pool. At the two ends of the longer axis were two identical *palaestrae*, or exercise yards, surrounded by terraced porticoes. The hot rooms occupied the whole of the south-west long side, with large arcaded windows facing the afternoon sun, while the more secluded north-east side housed the changing rooms, latrines, and other offices. Invisible service corridors, stairs, and galleries gave access to the furnaces and cisterns.[10]

The Baths of Caracalla are the embodiment of the concrete architecture of the earlier Empire at the moment of full maturity. One can, of course, detect in it problems and aspirations still to be resolved. The great circular caldarium, for example, with its moments of indecision between circular and octagonal planning belongs to a tradition that still had a long development before it; but the large windows in the drum already represent an important step forward in the direction that was to be followed by the monuments of the later third century.[11] Another problem still unresolved was that of devising an architecture of the exterior consonant with that within. On three sides the main bathing block is little more than a gigantic masonry box; only the south-west façade, with its long rows of uniform windows leading up to the powerfully projecting bulk of the central caldarium, faces up to and answers the problem

of presenting to the world outside a front that was both expressive of what lay within and at the same time interesting in itself. The interior on the other hand was, within its terms of reference, a thoroughly satisfactory solution to the architectural problem, smoothly functional and yet eloquent of the ideals described in the previous chapter. The formal extravaganzas of Hadrian's Villa would have been out of place. In their place we have elusive vistas and an adroit exploitation of the spatial ambivalence of intersecting axes, contrasting in the hot wing with a deliberately contrived self-sufficiency (in a smaller building one would call it intimacy), each room detached from its neighbours and facing inward upon itself except on the one side where it was wide open to the afternoon sunlight and to the gardens beyond. The colouring, too,

and the use of light was subtle and assured. One notes, for example, the effective contrast between the coarse texture and plain black and white colouring of the floor mosaics, the warmly tinted marble veneers on the walls, and the vivid polychromy of the stuccoes or mosaics on the vaults; or again the alternating pools of shadow and light that gave depth and quality to the long axial vistas. The style is one that is out of tune with modern taste – or perhaps it would be truer to say that it has so often been perverted by its imitators and would-be imitators into a cold, meaningless grandiosity that it is hard for modern eyes to assess it dispassionately. Above all it needs to be thought of in terms, not of the overpowering lumps of masonry that have survived, but of its mastery of soaring space, light, and colour. Viewed imaginatively in these

65. Rome, Baths of Caracalla, 212–16. Plan

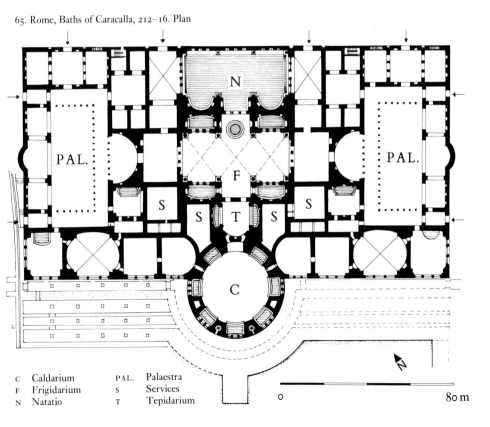

C	Caldarium	PAL.	Palaestra
F	Frigidarium	S	Services
N	Natatio	T	Tepidarium

0 80 m

terms it comes to life as an architecture full of vigour and resource, admirably suited to the needs of its day and an eloquent expression of the robust assurance of the Roman Empire at the height of its power and wealth.

The same qualities of resource and of high technical competence are characteristic also of the Severan work on the Palatine. This was directed principally towards the development of the southern corner of the hill, extending in this direction the already existing Flavian Palace; and in addition to the modification of the so-called stadium and the completion of a bath-building that had been projected but barely started by Domitian, it involved the building of a whole new wing, terraced out upon the massive arched substructures which are so conspicuous a feature today of the view of the Palatine from the Aventine and the Circus Maximus. The substructures in particular, though still awaiting detailed study, can be seen to represent an extraordinary economy of materials and effort. All too little has survived of the buildings that stood upon them at the level of the main palace, but that little suffices to show in places an almost frightening disregard for the disposition of the walls and vaults beneath; the architect of this wing was very sure both of his materials and of his own ability to use them.

The most singular of the Severan buildings on the Palatine was the Septizodium, a lofty decorative façade dedicated by Septimius Severus in 203, of which the plan is known to us from the marble map and of which the eastern corner was still standing to its full height until demolished for its materials in 1588 [66]. It took the form of an elaborate columnar screen, three orders high, and in plan consisting of three apsed recesses flanked by two shallow rectangular wings, the free-standing equivalent of the stage-building of a contemporary theatre. It was probably equipped as a fountain and the name[12] suggests a symbolic association with the seven planets. Architecturally its only function was as a screen concealing the buildings behind. The nearest analogies to it are the nymphaea that were used for precisely this purpose in many cities of Asia Minor during the first and second centuries A.D.

One other detail of the Severan work on the Palatine is worth recording in passing, if only because of its long-term consequences: Alexander Severus is credited with introducing here the type of paving in red and green porphyry which bears his name (*opus alexandrinum*) and which was to be the inspiration and material source of the pavements of countless Roman churches in the later Middle Ages.[13]

The official religious foundations of the Severan emperors were few but important; and although they seem to have been cast in a somewhat conservative architectural mould, in other respects they represent a significant advance towards the beliefs and aspirations of late antiquity. Alexander Severus undertook a major restoration of the Iseum in the Campus Martius, Caracalla built a new and splendid temple on the Quirinal in honour of Serapis, and Elagabalus a no less magnificent temple on the Palatine to house the cult-image of the Ba'al of Emesa, together with an adjoining garden and shrine of Adonis. None of these divinities, it will be noted, was a member of the traditional pantheon; and although their choice reflects the particular Eastern connexions and sympathies of the reigning dynasty, it is nonetheless symptomatic of the religious tendencies of the age. Even Septimius Severus's dedication of a temple to Hercules and Dionysus[14] sounds less conventionally classical when its recipients are disclosed as the romanized versions of Melqarth and Shadrap, the patron divinities of Severus's own native city, Lepcis Magna.

The location of Septimius's building is not known, and it may well have been of a domestic rather than a public character. The Temple of Sol Invictus Elagabalus occupied the site of what had been the Aedes Caesarum on the east spur of the Palatine, opposite Hadrian's Temple of Venus and Rome. The platform is still prominent landmark and the foundations of the temple itself have been partly excavated, beside and beneath the church of S. Sebastiano al Palatino. From these remains and from repre-

Septizonium

66. Rome, Septizodium, dedicated in 203. Drawn by Martin van Heemskerk between 1532 and 1536

sentations on coins[15] it can be seen to have been a large (200–230 by 130 feet; 60–70 by 40 m.) hexastyle peripteral building standing within a rectangular porticoed enclosure, with a monumental entrance facing on to the Clivus Palatinus. After Elagabalus's death it was rededicated to Jupiter the Avenger (Juppiter Ultor) [67].

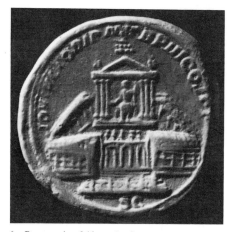

67. Rome, coin of Alexander Severus, depicting Elagabalus's Temple of Sol Invictus, A.D. 218–22, after its rededication to Juppiter Ultor

Caracalla's Temple of Serapis is to be identified with a gigantic building on the western edge of the Quirinal, near the Piazza del Quirinale, of which considerable remains were still preserved and were recorded in the fifteenth and sixteenth centuries.[16] It stood within a rectangular enclosure, and the most singular feature of the design, dictated presumably by the desire for strict orientation, was that it was the rear (west) wall which dominated the composition, flanked by the ramps of a grandiose double stairway which led down the steep slopes to the Campus Martius, 70 feet below. The temple itself faced towards the higher ground and, if Palladio is to be believed, it was unique among Roman temples in having a façade of twelve columns. It was certainly of gigantic proportions, the heights of the shafts

being recorded as 60 Roman feet (17.66 m.) with comparable capitals and entablature (just over 8 English feet (2.47 m.) and nearly 16 feet (4.83 m.) respectively).[17] The alleged Egyptian affinities of the plan may be questioned. The drawings and the scanty surviving remains show the temple itself at any rate to have been, apart from its size, a building of conventionally classical type. The most puzzling feature of the surviving remains is the strongly 'Asiatic' character of the ornament, very similar both in choice of motifs and in treatment to that of the Hadrianeum, from which it would be hard on this evidence to separate the present building by more than a decade or so. The difficulty is all the greater in that it differs markedly in this respect from other known Severan monuments, which in their choice and treatment of traditional motifs reveal a decided bias towards the rich exuberance of the Flavian period. This is not altogether surprising in that the largest single enterprise of Septimius Severus's reign had been the restoration and extension of the palace, where Flavian ornament was predominant; and it must have been workmen trained on this site who moved on to build the Baths of Caracalla.[18] One can only conclude that at least one of the workshops employed by the Severan emperors was eccentric in this respect, and preferred for its models the austerer grandeurs of the 'Asiatic' type.

Two other Severan buildings in the capital call for brief mention. One is the camp of the Equites Singulares, the Severan imperial bodyguard, extensive remains of the headquarters building and barrack blocks of which have come to light beneath the church of St John Lateran. The plan is distinctively military, but the methods of its construction and the manner of its detailing are indistinguishable from those of its civilian neighbours, an interesting anticipation of the meeting and mingling of military and civilian architectural forms which is so characteristic of the later third century. The second building is the well-known arch in the Forum Romanum (A.D. 203) [15]. Except for the plain inscribed panel running the full length of

the attic, the design of the arch itself is traditional, but both the form of the four great panels depicting the story of Severus's Eastern campaigns and the style and manner of their carving represent a whole-hearted renunciation of the traditional classical formulae (as still embodied in the panels of the Arch of Marcus Aurelius barely twenty-five years earlier) and look instead decisively forward towards late antiquity.

PRIVATE FUNERARY ARCHITECTURE
IN THE SECOND CENTURY

Of the very large body of private building that figures on the Severan marble plan of Rome, a great deal was of relatively recent, second-century date. To some extent it must have provided the element of continuity that was lacking in the official programme. For example, had it not been for a large and continuing private demand, the slump that took place in the production of bricks after the Hadrianic boom (a slump of which the brick-stamps offer clear evidence) might well have taken on disastrous proportions. As it was, although a certain number of the smaller producers were forced out of business, there was an ample margin of organized production upon which Severus and his successors could base their great new programme of public works. There was also a large reservoir of skilled building labour upon which to draw.

Building had ceased to be a luxury for the wealthy few. An ever-increasing proportion of the private building both of Rome and Ostia was in fact in the hands of a new and rapidly growing middle class, a great many of whose members were of freedman stock, the sons and grandsons of enfranchised slaves, most of whom came originally from the Eastern provinces. They were intelligent and adaptable; business, trade, and the minor ranks of officialdom were increasingly in their hands. They could afford to build or to rent houses and apartments equipped with the latest luxuries, and their tombs throng the urban cemeteries. The former are described

later. The latter are in their own way no less revealing than the domestic architecture, displaying the arts of second-century Rome in some of their most attractive and unexpected aspects.

The manifestations of Roman funerary architecture are so diverse and so full of personal idiosyncrasies as almost to defy brief analysis. If this is less true of second-century Rome than of many other periods and places, the merit lies very largely with the requirements and taste of this new middle class. Already in the first century A.D. (e.g. in the cemeteries beneath S. Sebastiano)[19] one can detect the emergence of a type of unpretentious family tomb which, for all its variations of detail, followed broadly standardized lines. This was a small rectangular, vaulted structure, built in reticulate work or, increasingly as time passed, in brick, and equipped internally with recesses for the ash-urns of the dead. The interior was often gaily painted or stuccoed; but apart from giving a certain prominence to the principal burial, usually by framing it within a small decorative aedicula in the middle of the rear wall, there was at first very little concession to architectural complexity.

The subsequent development of this commonplace architectural type is a copybook example of the familiar evolutionary cycle from classical simplicity to baroque exuberance. Once launched, the process was remarkably rapid. One can follow every stage of it, from bud to full-blown flowering, in the tombs of the Vatican cemetery between (in round figures) the years 120 and 180. The initial stimulus was of a practical nature, namely the gradual shift which was taking place about this time from cremation towards inhumation. To provide for the new rite the lower parts of the walls were marked off as a continuous plinth, within which were housed the large curved or segmentally arched burial recesses (*arcosolia*); the ash-urns continued to occupy the upper part. Within this framework there came into operation what seems to be an innate propensity of classical forms to proliferate and to recombine in certain remarkably stereotyped aclassical patterns. No sooner had the aediculae spread to the lateral

walls than they began to disintegrate and multiply and to coalesce into a continuous architectural framework of running pedimental entablatures and colonnettes. At first the schemes were relatively simple and coherent; but they very soon began once more to disintegrate into elaborate split-pedimental fantasies, of which the forms were worked up into an ingenious counterpoint of curved and straight,

from the other, were it not that in this case one can document the whole process as one of predominantly organic development from within. This is the way that, divorced from function, classical ornament is apt to behave. To the student of the sixteenth and seventeenth centuries the phenomenon needs no further explanation.

One must not imagine that a development of this sophistication took place solely upon the

68. Rome, Vatican cemetery, Tomb of the Caetennii, mid second century, interior

concave and convex, plain and decorated, and the colour schemes and materials into contrasting zones of plain colour and polychromy. The Tomb of the Caetennii ('Tomb F') in the Vatican cemetery [68, 69] will serve to illustrate this final stage. There are many formal analogies with the decorative schemes portrayed on the walls of Pompeii a century earlier, or again with the façades of Petra [213], so close indeed that one might well be tempted to suspect reminiscences from the one or cross-influences

walls of these crowded urban cemeteries, although it is here that we can best observe it. In the second century at any rate there was a parallel but architecturally more ambitious line of development of which a few examples have come down to us in the more spacious cemeteries of the suburbs. Built free-standing, sometimes in the form of a low gabled tower, the interiors of these suburban mausolea are rarely preserved in any detail (a partial exception, with fine stucco-work vaults, is the pair of tombs

69. Rome, Vatican cemetery,
Tomb of the Caetennii,
mid second century.
Axonometric view

0 4 m

70 (*above*) and 71 (*opposite*). Rome, Via Appia, Tomb of Annia Regilla, wife of Herodes Atticus, third quarter of the second century. Detail of moulded brick entablature and exterior

beside the Via Latina) [58],[20] but such of the exteriors as have come down to us are remarkable for the exceptional quality of the brickwork [70, 71]. Capitals and entablatures, doorways and window-frames, were built up in moulded terracotta, normally pale in colour, contrasting with the rest of the wall-faces, which were carried out in a brickwork that was specially selected for its decorative qualities and was not uncommonly even treated with a deep crimson slip and picked out along the joints with a hairline of gleaming white plaster. All these

devices were freely imitated on the façades of the urban cemeteries, and in a more restrained manner in the domestic and utilitarian architecture also of the cities [78]. Although the more elaborately decorative forms seem to have dropped out of use after the second century, these mausolea were undoubtedly an important factor in developing the taste for brick as a building material in its own right which characterizes so much later Roman building.

The subsequent history of the interior architecture of these tombs can be briefly stated. Just

when the baroque schemes described above had reached a point of such complexity that it is hard to see how they could have developed further, they were rendered functionally obsolete by the virtual abandonment of the rite of cremation. The whole elaborate paraphernalia of niches and orders was dropped, never to be revived. In its place we get tombs like that of Quintus Marcius Hermes in the Vatican cemetery (*c*. 180–200), the interior of which, with its two zones of plain arcosolia, is of an almost aggressive architectural simplicity. Simple, broadly planned interiors were to remain characteristic of Roman funerary architecture for a long time to come, as we see them, for example, in the Hypogeum of the Aurelii a few decades later, in the catacombs, or even in the Late Roman imperial mausolea. The emphasis had shifted emphatically to the symbolic representational content of the painting or mosaic that now tended to cover every inch of the smooth, stuccoed surfaces, or to the elaborate carving of the marble sarcophagi which are so popular in the funerary art of later antiquity.

OSTIA

No description of classical Rome is complete without some reference to the remains of Ostia. Not only was Ostia the harbour town of Rome and connected with it by the closest possible ties, but its abandonment in the early Middle Ages resulted in the preservation of the evidence for many aspects of classical architecture of which all trace has vanished for ever in Rome itself. This is particularly true of the everyday commercial and domestic buildings which in Rome were torn to pieces in the Middle Ages for their materials or else lie buried deep beneath the buildings of the modern town. The pages that follow give some account of the development of the city as a whole and something of the story of its principal public monuments. The apartment-houses, which strike such an impressive note of modernity, are discussed later.

THE EARLY IMPERIAL CITY

The main outlines of the town plan of Ostia had already been established early in the first century B.C., when Sulla enclosed the city within the circuit of walls which, except along the sea front, was to remain the effective limit of urban development throughout antiquity. These walls enclosed an irregular trapezoidal area of some 160 acres, one long side of which fronted on to the lowest reach of the Tiber. Near the centre of the Sullan city lay the 'castrum', the fortified military colony established here by Rome at the end of the fourth century B.C. This was a rectangular walled enclosure, approximately 220 by 140 yards in extent and divided into four equal quarters by two intersecting streets.[1] It was the roads leading from the gates of the castrum which determined the physiognomy of the later town [72]. That from the east gate, the eastern decumanus, was a prolongation of the major axis, running parallel with the river and dividing the eastern half of the Sullan town into two almost equal and roughly rectangular halves. The north-east quadrant, between the eastern decumanus, and the river, was early declared public property and developed on strictly controlled rectangular lines. The rest of the town grew up as best it might about the lines established by the road to Laurentum and by the pair of roads leading to the sea-front (the western decumanus) and to the Tiber mouth (the Via della Foce), which left the south and

72 (*opposite*). Ostia, the central part of the city, the street plan of which was determined by the lines of the roads radiating from the four gates of the four-square late-fourth-century B.C. settlement, the 'castrum', here indicated in heavy dotted lines

1. Capitolium	13. Horrea Epagathiana
2. Temple of Rome and Augustus	14. House of Diana
3. House of the Lararium	15. Theatre
4. Circular Temple	16. Piazzale of the Corporations
5. Basilica	17. Barracks of the Vigiles
6. Forum Baths	18. Neptune Baths
7. Via della Foce Baths	19. Seat of the Augustales
8. House of the Charioteers	20. House of Fortuna Annonaria
9. House of the Triple Windows	21. Precinct of the Oriental Gods
10. Schola of Trajan	
11. Macellum	H Horrea (warehouses)
12. House of Cupid and Psyche	

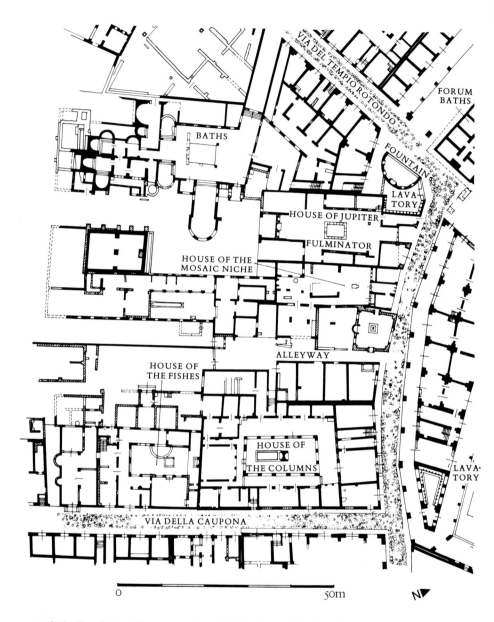

73. Ostia. Plan of a typical quarter, to the south of the forum, including private houses,
a medium-sized bath building (*balneum*), streetside porticoes, a fountain, and two public lavatories,
and along all the main street frontages shops (*tabernae*) and in many cases staircases leading directly
to apartments on an upper storey

west gates of the castrum respectively, and all three of which swung to left or right immediately on leaving the line of the early walls. There was, in short, a clear contrast between those areas (the castrum, the north-east sector, and to a lesser degree the south-east sector) which were available for orderly, rectangular development and those (the whole area west and south of the castrum, between it and the sea) in which development was determined by the prior existence of irregularly disposed topographical features [73].

It was within this framework that the whole of the subsequent development of Ostia took place. By the end of the Republic several of the main sanctuaries had been established. Rather surprisingly there was still no forum, or at best only a very small one; but a pair of very late Republican or Augustan temples, one of them perhaps the original Capitolium, constituted a formal civic nucleus facing on to the main decumanus where later the forum was to be. The remains of several pre-Imperial commercial buildings include a formally planned market quarter (the 'Magazzini Repubblicani') with rectangular blocks of shops built of reticulate work about a framework of tufa piers. On three sides they were fronted by porticoes of stuccoed tufa columns, the earliest archaeologically attested example of this very common feature of later urban planning.

The first century of the Empire was marked by a change in the tempo rather than in the pattern of development. The only major monument attributable to Augustus (and it must be remembered how much of the early city was buried or swept away in the second century) is the theatre, built in its original form by Agrippa (i.e. before 12 B.C.) [74]. It was laid out on an open site between the eastern decumanus and the river with, behind it, a large (410 by 260 feet; 125 by 80 m.) rectangular, double-colonnaded portico enclosing a garden. The quadrangle behind (the *porticus post scaenam* or 'Piazzale of the Corporations') was an integral part of the theatre complex and was intended to serve as a covered retreat for the audience, in accordance

with the best Vitruvian precepts;[2] but in the absence at this date of a forum or public basilica, it is very likely that it also served from the first as a commercial meeting-place – as it certainly did in the later second century, when the outer colonnade was broken up into sixty-one small rooms, the mosaics of which reveal them as the offices (*stationes*) of the merchants and shipwrights of Ostia itself and of its principal overseas clients and customers. The double portico, with its inner row of tall Ionic columns and outer row of Doric columns, is an adaptation of a familiar Italo-hellenistic model; and although in general at this date Ostia lagged well behind the capital in its use of materials (the theatre was built entirely of tufa), the Ionic columns offer an interesting early example of brick (in this case tiles cut to shape) used as a building material in its own right and faced with stucco.[3]

The first, and for some time the only, building at Ostia to reflect the new Augustan architectural dispensation in the capital was the Temple of Rome and Augustus, a substantial hexastyle prostyle building of Tiberian date, the façade of which was built of Italian marble and carved by sculptors who were brought in from Rome for the purpose. At the same time the space in front of it was cleared to form the nucleus of the later forum. With this exception, the new building of the Julio-Claudian and Early Flavian period at Ostia continued to follow traditional lines. New street-front porticoes were added both to private houses and to commercial buildings, preparing the way for what was to be one of the most distinctive and attractive features of the later architecture of the city. These porticoes, both here and in Rome, have been compared with the colonnaded streets of the Eastern provinces, and there is indeed a family resemblance. But there is also an important difference: whereas in the colonnaded streets of Syria and Asia Minor it was the street that was planned as a unit, to which the buildings adjoining it had to conform, the streetside porticoes of Ostia and of the western provinces always remained formally part of the buildings of which they were the frontage.

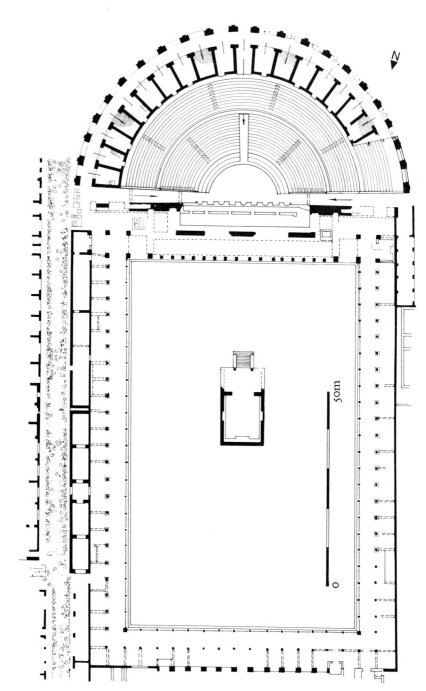

74. Ostia, theatre and Piazzale of the Corporations. Before 12 B.C., with substantial later modifications. Plan. The Piazzale did double duty as an annexe to the theatre and as a centre for commercial activities

Colonnaded streets in the Eastern manner are not found in the West before late antiquity.[4]

The most important commercial buildings of this early period are three of the large public warehouses (*horrea*) that were used for the storage of grain and other commercial commodities prior to their reshipment up-river. These were large, enclosed, rectangular buildings with storage rooms opening off the four sides of a colonnaded or porticoed courtyard (e.g. the possibly Tiberian 'Horrea of Hortensius' [75]), the central area of which might also

baths of first-century date, made possible by the construction of an aqueduct in the thirties, it was not until the early second century that the town received its first large, up-to-date public bath-building.

OSTIA IN THE SECOND AND THIRD CENTURIES

The overall impression conveyed by the first-century remains of Ostia is one of a cautiously progressive conservatism. In some respects,

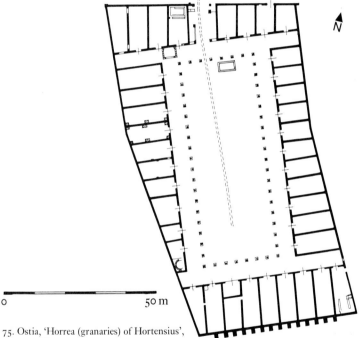

75. Ostia, 'Horrea (granaries) of Hortensius', c. 30–40. Plan

0 50 m

contain similar but outward-facing blocks (e.g. the Claudian 'Grandi Horrea'). In Rome we find this plan already well established in the Republican Horrea Galbae and in the Augustan Horrea Agrippiana near the forum. The regular type of private house at Ostia throughout the first century continued to be the old-fashioned atrium-peristyle house; and although there are the recorded remains of at least three small

notably in its poorer-class domestic architecture, Ostia had lagged far behind Rome, where overcrowding had long ago necessitated a drastic new approach to the problems of urban housing. In a great many other ways, however, the better-class domestic and commercial quarters of the capital must have looked very much like this before the great fire of A.D. 64. At this date the wave of prosperity that followed the

building of the Claudian and Trajanic harbours had still to make itself felt in Ostia. The revolution in building methods for which the reconstruction of the capital after the Neronian catastrophe offered such scope did not reach Ostia until about thirty years later. When it did come, however, it came in no uncertain manner. If the surviving remains of the first-century town afford a tantalizing glimpse of the streets and buildings of pre-Neronian Rome, second-century Ostia offers a picture of its successor that is almost embarrassingly rich.

The detailed stages of the rebuilding need not concern us. Before his death in 96 Domitian seems to have put in hand the modernization of several city blocks between the castrum and the theatre; and in the forum area he had added to the limited facilities available by rebuilding what is usually identified as the curia and by building opposite it a large basilica of conventional Early Imperial type, with one long side open to the forum square and an internal ambulatory. It was under Trajan, however, that the reconstruction of the town really gathered momentum, to be continued on an even larger scale under Hadrian and completed under Antoninus Pius. Trajan's work lay chiefly in the district between the castrum and the sea. By Hadrian's death in 137 the whole of this western quarter and the whole quarter between the castrum and the river had been rebuilt; with a few exceptions (the theatre, the Claudian horrea, and a few minor, mainly religious buildings) the same is true of the north-east quarter, between the eastern decumanus and the river. Antoninus Pius was concerned mainly with completing what Hadrian had begun, although he seems to have initiated at least one major public building, the Forum Baths [80A]; and private enterprise was still actively at work throughout his reign, in buildings such as the House of Diana [76], the Schola del Traiano, the Horrea Epagathiana [77B, 78], and the House of Fortuna Annonaria [128A]. After the middle of the century the tempo dropped rapidly. Later emperors were active sporadically in the field of public works, notably Commodus, who rebuilt the large Claudian

horrea, and Septimius Severus, who rebuilt (or completed rebuilding) the theatre and the barracks of the Vigiles and restored a number of warehouses and bath-buildings. The last important public building in the excavated area, the round temple west of the basilica, dates from the reign of Alexander Severus (222–35), or possibly Gordian (239–44), who had family connexions in the district. By that date Ostia was already launched on the decline from which it never recovered.

What was the cause of this outburst of building activity during the first half of the second century? First and foremost it was the sudden access of prosperity and the explosive growth of population that followed the re-organization of the harbour facilities of the capital city at a moment of already rapid growth and material development. Of the factors that shaped it, unquestionably the most important was the availability of the new building techniques and materials which had been developed during the first century A.D., and which were now becoming available at increasingly advantageous prices as a result of the reorganization of the brickyards undertaken by Trajan and Hadrian. Hardly less important must have been the sheer force of example of a wealthy and powerful neighbour. Ostia lacks the great imperial monuments of the capital, but in all other respects it was following the models established by the recent and still continuing rebuilding of central Rome.

From the wealth of surviving buildings, we can here select for description only a very small representative sample. The commonest of all Ostian building types, repeated with little or no variation in a very wide variety of contexts, was the *taberna*, the Roman version of the simple one-roomed shop which has served the artisan and the retail trader in Mediterranean lands at all periods. In its developed Roman form (as in illustration 76) this was a tall, deep, barrel-vaulted chamber, open in front almost to its full width. It could be closed by means of a series of sliding panels of a type of which the ashes of Pompeii have preserved the exact imprint. Inside there was a wooden mezzanine, for

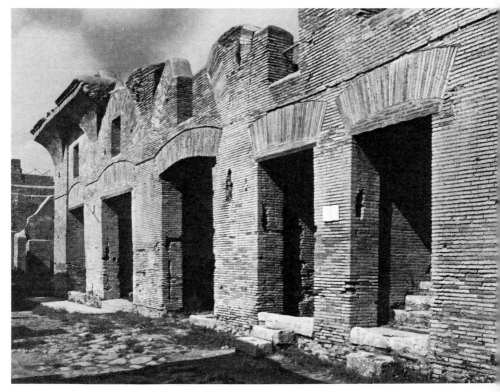

76. Ostia, House of Diana, mid second century. South façade,
with shops along the street frontage and stairs leading to the upper storeys [cf. 128c].
The small windows above the entrances to the shops lit wooden galleries
accessible by steps or ladders from within the shops

storage or for lodging, accessible by wooden steps and lit by a small window over the door. An architectural unit so simple and so flexible could be adapted to almost any context ranging from a single row of shops fronting directly on to the street to the intricate multi-level complexity of Trajan's Markets in Rome. Tabernae might be ranged along a street-front or grouped around a courtyard to form a market; or they might be part of the frontage of an apartment-house, just as today one finds their modern equivalents everywhere built into the façades of the palaces of Renaissance Rome. But whereas in Rome the great majority were carved out of existing properties, as they had once been in

Pompeii, at Ostia they were regularly an integral part of the buildings to which they belonged.

The apartment-houses of Ostia are described in the next chapter. In terms of the new building technology, the combination of shops and multi-storeyed dwellings was the logical answer to population pressures, increased land values, and a steadily-rising standard of living among the professional and mercantile classes. From casual references in classical writers we know that Ostia was not the only harbour city where this was happening;[5] nor were the resulting architectural solutions confined to domestic architecture. The palazzo type of apartment-house, built around a central courtyard, needed

little modification to serve as the barracks of the local fire brigade [77A], as the headquarters and social centre of one of the prosperous trade associations (*collegia*), or as a multi-storeyed private warehouse for the storage of retail goods [77B, 78].[6] The public granaries and warehouses of the type already established in the first century A.D. lent themselves to a very similar development, with ramps instead of stairs leading to the upper storeys.

Only three of the city's temples of the Imperial Age were conspicuous public monuments: the Tiberian Temple of Rome and Augustus, the centre of the imperial cult; facing it down the enlarged forum, the Hadrianic Capitolium, a very richly marbled brick construction, of which the unusually tall podium was presumably dictated by a wish to dominate the multi-storeyed houses of the neighbourhood [79]; and a large circular temple, of unknown

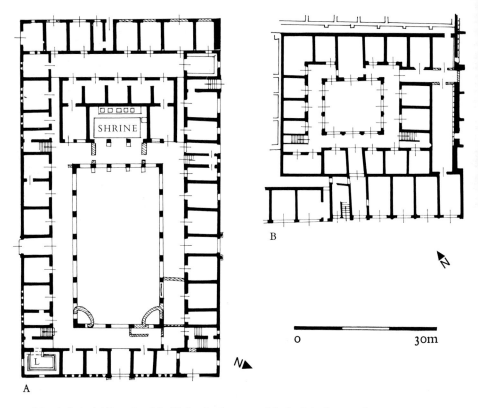

SHRINE

B

A

77 (*above*). Ostia. (A) Barracks of the Vigiles, headquarters of the fire brigade, 117–38; (B) Horrea Epagathiana, multi-storeyed warehouse, *c.* 145–50. Plans

78 (*opposite, above*). Ostia, Horrea Epagathiana, *c.* 145–50. West façade, showing the main entrance, stairs to the upper storeys (*foreground*), and, beyond the entrance, four shops

79 (*opposite*). Ostia, Capitolium, *c.* 120. Originally faced throughout with marble, the brickwork structure illustrates the use of 'bonding courses' of tiles and of relieving arches over the internal recesses of the cella

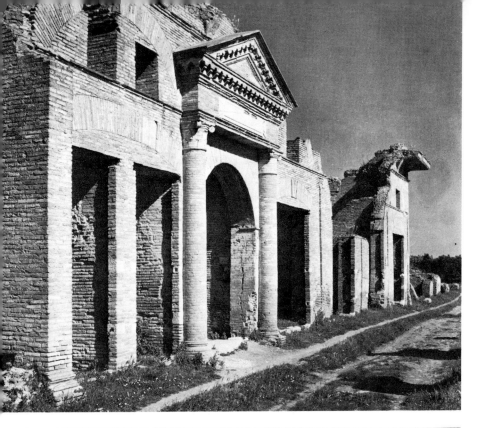

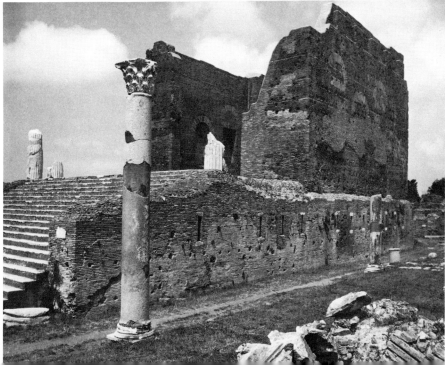

c Caldarium
f Frigidarium
l Lavatory
s Services

80. Ostia, bath-buildings.
Plans. (A) Forum Baths, c. 160;
(B) Neptune Baths, 117–38.
Note the shops and arcade
along the main street frontage
of the Neptune Baths

dedication and late Severan date, with a deca-style porch.[7] As one might expect in a harbour town, the Oriental cults were widely and variously represented from an early date. None of their buildings are of any architectural distinction, but the large triangular enclosure that housed the temples and orgiastic rites of Cybele, Attis, and Bellona offers an unusually clear picture of the buildings and fittings appropriate to such a cult. Of the bath-buildings three at least were large public thermae, all built within the first sixty years of the second century with the help of imperial money. The Hadrianic Baths of Neptune [80B] and the Antonine Forum Baths [80A] offer an interesting contrast in design. The former represent a logical development of the latest Pompeian type, as represented there by the Central Baths, with the bathing block occupying one side of a rectangular, colonnaded palaestra and shops along the main street-frontage. The Forum Baths were more adventurous in design, combining a frigidarium wing of conventionally rectilinear form with a range of interestingly diverse polygonal and curvilinear hot rooms, stepped out so that the large southward-facing windows might take full advantage of the afternoon sun. The free, functional planning closely resembles that of the so-called Heliocaminus baths at Hadrian's Villa, built a few years earlier. Across the street is a finely preserved public lavatory.[8]

In Chapter 4 we have discussed in general terms the characteristics and aims of the new architecture and, in some detail, some of its manifestations in the monumental architecture of the capital; and in describing the Markets of Trajan, we caught a glimpse of it at a rather more prosaic, though still basically monumental, level. It remains to ask briefly what was its impact upon the architecture of daily life as so fully and vividly exemplified by the buildings of second-century Ostia.

In terms of planning the answer is simply and briefly stated. Pressure of population and the rise in land values made for tighter, more economical planning, the most conspicuous manifestation of which was a tendency to build upwards all those types of building that lent themselves to such a development. Shops with apartments over them, apartment-houses of three, perhaps in places even four or five, storeys, commercial buildings of two and sometimes three storeys became the regular rule.

The formal changes are less easily summarized. The element common to all may perhaps most simply be stated as a decisive movement away from those architectural usages, however time-honoured, which no longer had any meaning in terms of the contemporary concrete medium, and an ever-increasing readiness to treat the brickwork facing as a material in its own right.[9] In positive terms this meant a steady drift away from the use of the columnar orders and towards an architecture which could be viewed from without principally as an orderly alternation of solids and voids. In this context the introduction and widespread adoption of window glass proved to be an event of the first importance. In urban architecture it was increasingly the patterns constituted by the wall-surfaces, the doors and the windows which were left to tell the architectural story [81].

81. Rome, Trajan's Market, c. 100–12.
The seven large windows of the semicircular room on the corner must have been glazed

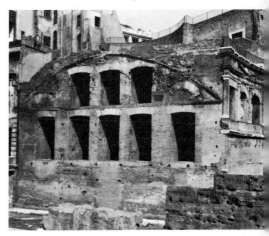

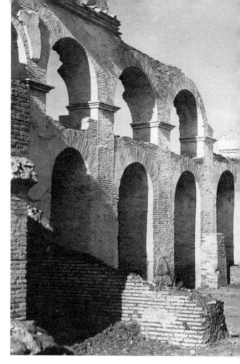

82. Ostia, House of the Charioteers,
shortly before 150. Central courtyard

83. Ostia, House of the Lararium,
second quarter of the second century.
The ground floor was organized as a market
building, with shops opening off the central
courtyard; the upper floors were residential.
The house takes its name from the small
domestic shrine (*lararium*) visible centre left,
opposite the main entrance

These changes were not applied in any doctrinaire spirit, nor were the traditional practices abandoned overnight; but we do find the latter increasingly relegated to certain well defined spheres within which traditionalism still had a claim to speak as the accepted architectural language. The marble colonnade, for example, still had connotations of grandeur and was felt to be proper for such buildings as temples, major civic monuments, and the porticoed exercise yards of bath-buildings; and, more generally, the classical orders remained an important constituent element of most interior decorative compositions, whether in private houses or in large public buildings. On the other hand, instead of the columns and architraves of the familiar classical system the courtyards of apartment-houses [82, 83] and commercial buildings and the street-front porticoes [84] now invariably used plain brickwork piers and arches, and the street frontages [76, 85, 86] were hardly less uncompromisingly 'modern'. At Ostia one can study the impact of the new Roman architecture, not in the context of court or temple, but as it affected the everyday surroundings of the man in the street [87]. One is made vividly aware how far the Romans of the second and of the third centuries had already progressed towards producing an architecture of which many of the essential concepts were to remain valid right down to our own times.

84. Ostia, south-western decumanus, looking towards the Porta Marina, showing the piers of a streetside portico and a fountain fronting a block of shops with staircases leading to the upper storeys. Second quarter of the second century

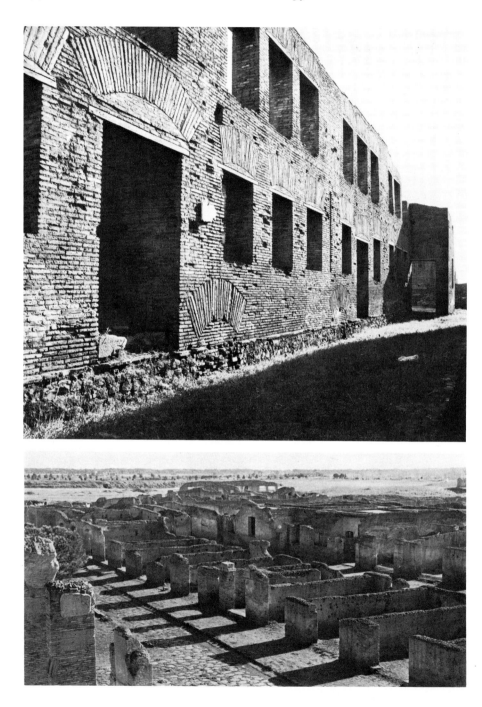

85 (*opposite, above*). Ostia, House of the Triple Windows, third quarter of the second century

86 (*opposite*). Ostia, row of shops (Regio IX, insula 15), mid second century

87 (*above*). Ostia. Façade of an insula with a cookhouse on the ground floor

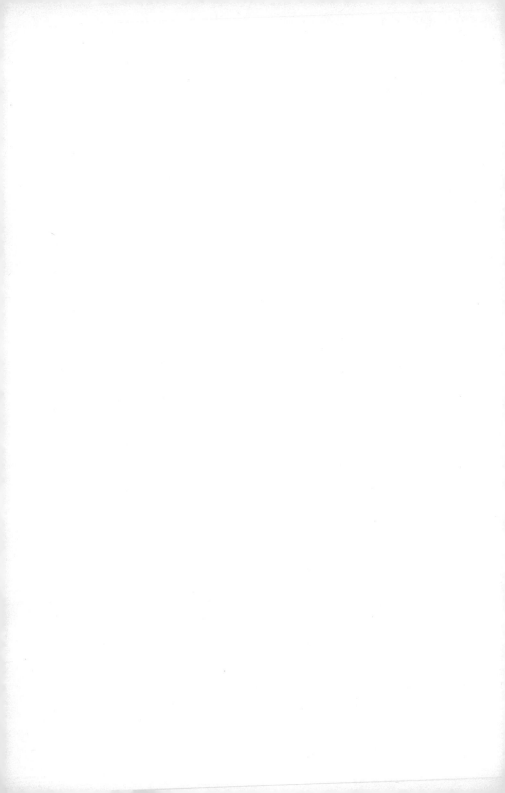

ITALY UNDER THE EARLY EMPIRE

CAMPANIA

When, in 42 B.C., the future emperor Augustus united the lowlands beyond the river Po, the former province of Cisalpine Gaul, to the rest of the Italian peninsula, he was completing a process of unification begun many centuries before when Rome first began to establish her hegemony over her Latin neighbours in the west-central coastlands. The Roman military colonies both within and beyond the limits of Italy had long been centres for the diffusion of Roman ideas and Roman habits. But it was barely half a century since the Social War had given the greater part of the peninsula parity of rights and duties with the capital, and within the formal unity of the twelve administrative regions of Augustan Italy there were ethnic, linguistic, social, and cultural differences as extreme as any with which modern Italy has had to contend. Architecture was no exception. Each region had its own problems and its own traditions; and although outside the immediate periphery of Rome it was Campania which had made by far the most important direct contribution to the Early Imperial architecture of the capital, the experience gained elsewhere in Italy, notably in the north, was undoubtedly an important factor in shaping the architecture of many of the newly emergent provinces. Before turning to the latter, it is necessary to glance briefly at some of the cities and monuments of provincial Italy.

The impact of the Greek architecture of South Italy and Sicily upon that of Rome already belonged to a remote past. There are very few important monuments of the Imperial Age in Magna Graecia. The centres of wealth and influence had long shifted elsewhere. By contrast, Campania was at the peak of its prosperity during the last century of the Republic and

under the Julio-Claudian emperors. An inexhaustibly rich soil supported a population in which Greek, Samnite, and Roman elements mingled to create and to enjoy the solid, middle-class prosperity to which Pompeii and Herculaneum bear such eloquent witness; Puteoli had not yet been supplanted by Ostia as the gateway for the rich trade with the eastern Mediterranean; and since the early years of the first century B.C. the shores of the Bay of Naples had become the fashionable playground of the wealthy Roman. This was fertile ground for the dissemination and development of new ideas.

It is the relative completeness of Pompeii that inevitably strikes the modern visitor. What is not so immediately apparent is that in A.D. 79, when the eruption of Vesuvius overwhelmed the city, it was still in the full tide of reconstruction after another, and only relatively less disastrous, natural catastrophe, the earthquake of 62.[1] Very few of the public buildings that one now sees had been completely repaired; some were still in ruins, many more, including almost the whole of the forum area, were still in the hands of the builders. It is above all the fact that so much of the town incorporates work from the last fifteen years of its existence that gives the remains a special interest in the present context. By comparison, the changes of the previous fifty years were relatively modest and had mostly taken place within the framework of a well established local Campanian tradition.

The immediately pre-eruption domestic architecture of Pompeii and Herculaneum, the excavation of which has done so much to shape the familiar picture of Roman living, is described in the following chapter. Change was in the air. The evidence of Herculaneum, which in such matters was the more progressive of the two cities, suggests that another few decades of existence might well have seen the introduction

of a local version of the Ostia-type apartment-house. Many of the older houses were in fact already being broken up into smaller units; upper storeys had become a commonplace; and at Pompeii the arcaded streetside Porticus Tulliana just north of the forum shows that at least one aspect of the post-Neronian architecture of the capital was making itself felt in the years just before 79. But the scene was still dominated by the old-style atrium-peristyle houses of the later Republic. Here too things were changing; but the most immediately obvious innovations lay not so much in the architecture as in the styles of painted ornament, which reveal a steady evolution away from the architectural illusionism of the so-called Second Style towards decorative schemes that subsist in their own right, almost unrelated to the underlying architectural facts.[2]

It is, however, in the public monuments that we can better see the extent (and the limitations) of the city's response to the changing conditions of the first century A.D. Moreover, apart from the special circumstances of the earthquake, what was happening at Pompeii was happening in innumerable other small towns up and down the length of Italy, and, farther afield, in the provinces. There were certain public buildings which any town of substance was expected to have. In this respect Pompeii, with its characteristic mixture of traditionalism and innovation, of Republican and Early Imperial building types and techniques, will serve admirably as an introduction to the municipal architecture of Italy and the western provinces during the first century A.D.

The list of public monuments at Pompeii is in itself instructive. Apart from minor wayside and domestic shrines the religious life of the community was taken care of by nine temples. Two of these, the Doric temple in the so-called Triangular Forum and the Temple of Apollo, date from the earliest days of the city's history; and three others are certainly pre-Imperial, the Capitolium and the temples of Jupiter Meilichius and of Venus, of which the first-named, sited at the head of the forum, became the

official religious centre of the Roman colony which Sulla established at Pompeii in 80 B.C. The other four were all post-Republican foundations, and the dedications are characteristic of the times – two, the temples of Fortuna Augusta (3 B.C.) and Vespasian, being associated with the imperial cult, and a third, that of Isis, being a private benefaction in favour of one of the most influential of the Oriental mystery religions, for which Puteoli's many Eastern connexions made Campania receptive ground. Between them these three temples represent the two most powerful and consistent trends in contemporary religious practice, the one very early developing into a formal state religion embodied in the person of the reigning emperor and his divinized predecessors, the other as an essentially individual response to the spiritual problems of the age. (It is significant in this respect that the Temple of Isis is one of the very few buildings that had been completely rebuilt and redecorated before the eruption.) The fourth of the Imperial Age dedications, the public Lararium, a shrine to the city's tutelary divinities, was a propitiatory foundation undertaken immediately after the earthquake.

Of the city's other public buildings the basilica, the curia (the meeting place of the city fathers) and its associated offices, and the comitium (the voting precinct of the city assembly) were, as one would expect, grouped around the forum [88, 89]. These were all in origin Republican buildings, as also were the principal places of public entertainment, of which the larger, open-air theatre was created well back in the pre-Sullan, Samnite period, while the amphitheatre and the covered theatre (*theatrum tectum*) were both built in the early years of the Sullan colony. Other Republican buildings were the Samnite-period gymnasium and two of the city's three public bath-buildings. Among the buildings added during the last century of the city's history were a vegetable market, the Forum Holitorium; the palaestra, a grandiose open-air exercise yard with enclosing porticoes and a central swimming pool; and the headquarters of the guild of

88. Pompeii, forum.
Plan

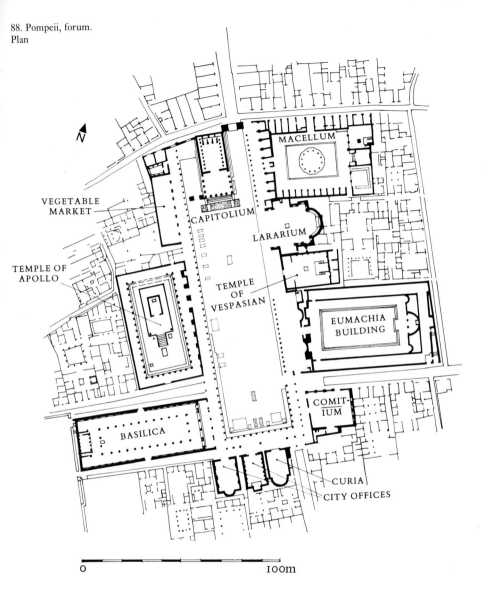

fullers, the most influential of the city's commercial corporations, built for them during the reign of Tiberius by their wealthy patroness, the priestess Eumachia. The prominence of the last-named building, which occupies a large, central site beside the forum, is a noteworthy anticipation of the position which we find these guild headquarters acquiring later, in second-

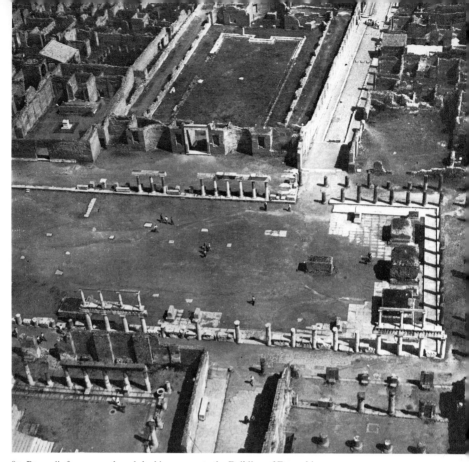

89. Pompeii, forum, south end, looking across to the Building of Eumachia.
The whole area was still under reconstruction in 79 after the earthquake of 62

century and third-century Ostia. The palaestra, an Augustan building, replaced the old Samnite-period gymnasium near the theatre and it represents an initiative that was not generally followed outside Campania, where we meet it again at Herculaneum. It has been aptly described as a hellenistic gymnasium without the actual gymnasium block. In ordinary Roman practice this function was taken over by the large public bath-buildings which regularly incorporated swimming pools and porticoed courtyards for athletics. Here at Pompeii, where the existing bath-buildings were situated too near the crowded centre for any such development, a solution more in accordance with Greek practice would not have seemed out of place.[3]

Finally, to complete the catalogue of the public monuments of the Imperial Age, there is the forum area itself, the tufa porticoes and pavement of which were already in process of replacement in travertine at the time of the earthquake and were still incomplete in 79. We are reminded that no less than the individual buildings, the streets and piazzas of the old-established Italian towns were the product of a long and often piecemeal growth.[4] That, despite this haphazard development, the civic centres of Roman towns should so often have achieved a unity and a dignity which may not unfairly be compared with that of their medieval successors

is a tribute both to the vitality of the civic institutions of the Roman town and to the essential good manners of the architectural tradition through which they found expression.

Almost without exception the public buildings of Pompeii were badly damaged in the earthquake. At least two of the most important, the Capitolium and the basilica, were still lying in ruins in 79, presumably awaiting a more radical rebuilding than was possible in the period immediately following the disaster. A few, such as the Temple of Apollo and the amphitheatre, had needed little more than patching and buttressing, and others, such as the theatre and the Forum Baths, though still far from completely restored, were partially back in service. Many more, however, were still in the builders' hands, and although wherever possible the restorers incorporated what was still serviceable of the earlier structures, the majority would on completion have been substantially new buildings.

The picture which these buildings convey of architectural practice at Pompeii during the decade before its final destruction is, broadly speaking, one of the widespread adoption of the building techniques of contemporary Rome, coupled with a rather cautious conservatism towards the new ideas that were accompanying these techniques. The extensive re-use of earlier building materials led to a variety of unusual, makeshift practices; but the dominant facing material in the new work is brick, the most noticeable difference from Rome being that, wheareas a really up-to-date (and perhaps imperially financed) building such as the Central Baths [92] might have large square windows spanned by flat arches of brick, with brick relieving arches above them in the Roman manner, timber lintels were still the regular practice in the houses and shops. One of the most valuable lessons to be learned from Pompeii and Herculaneum, and one that can all too rarely be documented archaeologically, is that timber was still far more widely used in the everyday architecture of the ordinary Italian town than one might be led to suspect by the

remains that have come down to us, which in the nature of things tend to be those of the more solidly constructed public buildings. Not only were the door-frames, architraves, balconies

90. Herculaneum, streetside portico with timber-framed superstructure carried on brick columns, before 79

[90], and roofs of wood, but much of the superstructure too was often timber-framed, as it had been in Republican Rome.[5]

Although the upper part of the seating of the theatre, which had been radically modernized in the time of Augustus, was still in ruins in 79, the stage-building, with its triple system of alternately rectangular and curved re-entrant features and counter-projecting aediculae, seems to have been completely remodelled after 62 to conform with the increasing elaboration of contemporary theatrical design. Another monument to be influenced by contemporary trends was the Building of Eumachia [89]. The main

lines of the plan, a rectangular porticoed enclosure, are simple enough; but the façade that opens on to the forum portico is enlivened by two shallow, curved recesses, and not only do the lateral porticoes end in small apses, but there is also a larger, central apse, screened by a pair of columns, at the far end of the main axis. The handsome, carved marble door-frame, on the other hand, and the continuous scheme of decorative wall-panels, with alternately triangular and curved pediments, are both inherited from the original Tiberian building, the latter being copied also in the adjacent Temple of Vespasian. The most elaborately 'contemporary' of the forum buildings was the Lararium [88], which consisted of an open courtyard flanked by two rectangular, barrel-vaulted recesses, leading up to a spacious apsidal feature, which in turn was broken out into a shallow central apse with, on the diagonals, two smaller, rectangular recesses; the altar stood in the centre. The contours of the wall-features are further enriched with pilasters, recesses, and projecting plinths, and although the building can have been only partially vaulted, the architectural intention clearly derives from the centralized vaulted architecture of the capital. Similar wall-recesses coupled with shallow

plinths can be seen in the curia, where they may almost certainly be interpreted as the structural basis for shallow aediculae of plaster, or even of veneer marble, one of the standard devices for breaking up the wall-surfaces of later Roman architecture. The brick piers of the adjoining hall are on the other hand functional, being intended to support the wooden cupboards housing the contents of the tabularium, or city record office.

Another contemporary feature is to be seen in the adjoining macellum, the meat and fish market [88]. The plan of the market itself, a rectangular porticoed enclosure with offices at the far end and a circular pavilion (*tholos*) in the centre, follows well-established models, e.g. already in 8 B.C. at Lepcis Magna in Tripolitania [243]. To judge from the recent discovery of a market building of this type at Morgantina in Sicily, dating from the second century B.C. [91], the form may well have originated in South Italy, spreading thence to North Africa, Greece (Corinth), Asia Minor, and the capital, where the old macellum just north of the forum had a central tholos in Varro's day (i.e. before 27 B.C.). The Macellum Liviae, built by Augustus on the Esquiline, and Nero's Macellum Magnum on the Caelian, followed similar models.[6] The

91. Morgantina, market building, *c.* 160 B.C.

92. Pompeii, Central Baths, inner façade of the main wing, towards the palaestra, 63–79

Pompeian building incorporated three rows of single-room shops (*tabernae*), one facing inwards and forming part of the market, and two facing outwards on to the adjoining streets. This use of valuable street frontages and courtyards for the incorporation of individual shops into other buildings, both public and private, was a natural consequence of increasing urban congestion and rising land values. Already widespread in the latest phase of Pompeii, it is one of the characteristic features of the architecture of Ostia [cf. 73]. Another striking example at Pompeii is the Central Baths [92, 93] which, when finished, would have been the most up-to-

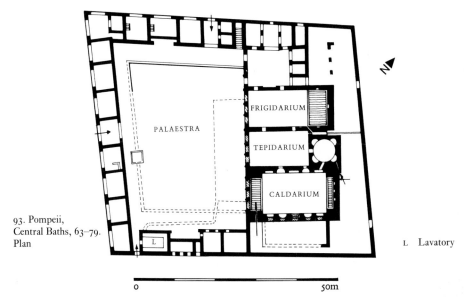

93. Pompeii,
Central Baths, 63–79.
Plan

L Lavatory

0 50m

date building of the city. Here there were shops on two adjacent frontages, backing on to the quadrangular exercise yard which occupied rather more than half the available space; along the corresponding third side were the smaller offices of the baths themselves, the bathing suite proper being concentrated along the fourth, a simple but effective arrangement reminiscent of that of the traditional hellenistic gymnasium. The brickwork detail, however, was thoroughly contemporary, particularly in the façade of the main block, with its severely effective alternation of half-columns and large square windows, and in the lofty recesses, alternately curved and rectangular, which occupy well over half the wall-surface of, and give life and movement to, the interior of the main hot room. The opening of doors and windows in the curved features is another striking innovation. Together with the still incompletely excavated Suburban Baths at Herculaneum, this building offers a vivid glimpse of how much greater the transformation might have been if the earthquake and the eruption had happened even twenty-five years later than they did.[7]

To what extent does the fantasy architecture of the latest stages of Pompeian wall-painting (as distinct from the often demonstrably realistic architectural landscapes which it incorporates) represent a decorative style in real architecture that has not survived elsewhere in more tangible form? It is not easy to generalize; there is a natural tendency in such cases for painters to mannerize and to exaggerate, nor is it always the minor art that is copying the major. With the improved excavational techniques of the last half-century, however, it has become increasingly clear that there was a very substantial element of real, three-dimensional practice behind a great many of the features portrayed. When therefore one finds, for example, a painting illustrating a façade, the two projecting wings of which terminate in the two halves of a broken pediment, it is reasonable to assume that this was already an accepted feature of the architectural repertory.[8] Again, allowing for an element of painterly exaggeration, it seems very likely that the slender, candelabrum-like col-

onnettes, elaborately figured or foliated finials, brackets, balustrades, pergolas, and other, often at first sight purely fantastic, architectural details of the so-called Third Style [e.g. 94, 95] echo the verandas and balconies, the windows, the sun-terraces, the decorative wall-schemes in gilded metal work, the draperies and hangings, that one would have found in real life in the wealthy villas of Baiae and of Rome itself.

It may well be that some of the characteristic elements of the Third Style derive ultimately from other sources – for example, from the decorative innovations attributed by Vitruvius to the Asiatic Greek architect, Apaturius of Alabanda, or from the sort of dream architecture recorded as having graced the shipboard pavilion of Ptolemy IV of Egypt.[9] That the luxurious courts of the late hellenistic monarchs should have left their mark in such a field as this it is very easy to believe. It does not follow, however, that such alien manners and motifs reached the walls of Pompeii direct. The processes of borrowing and assimilation are likely to have been complex; and just as some of the hellenistic elements demonstrably present in Second Style Campanian painting can be shown to have taken definitive shape in the real architecture of Late Republican Italy, so there is every reason to believe that a great many of the Third Style motifs are based on contemporary architectural forms in local use. Once again we are reminded how much of our knowledge of ancient architecture is based on the bare bones, stripped of their flesh and blood. The value of Pompeii and Herculaneum lies not only in the actual surviving buildings, but also in the glimpses that one can catch on their walls of many other aspects of classical architecture which might otherwise have been irretrievably lost.

Although by the first century A.D. Campania was fast losing the privileged position which it had held during the last two centuries of the Republic as a centre of creative Italo-hellenistic architectural experiment, the remains of the cities buried in 79 do not by any means exhaust the wealth of fine classical monuments of the Early Empire which it has to offer. The seaside

94. Pompeii, 'Third Style' architectural wall paintings in the House of Lucretius Fronto, mid first century. Note the views of seaside villas in the two lateral panel pictures

95. Pompeii, painting of a seaside villa with projecting wings and porticoed façade from the House of Lucretius Fronto, mid first century

villas are described in the next chapter. Here it must suffice to mention a few only of the more important of the other buildings.

Besides possessing, at Pompeii, the earliest all-masonry amphitheatre known, Campania can boast also two of the largest and best preserved of those of later date, at Capua (560 by 455 feet; 170 by 139 m., in size second only to the Colosseum) and at Pozzuoli (490 by 370 feet; 149 by 116 m.). The former, in its present form probably a late Julio-Claudian monument, but extensively remodelled under Hadrian, the latter a Flavian building, they may be compared with the approximately contemporary North Italian amphitheatres of Verona (500 by 405 feet; 152 by 123 m.; it is estimated to have held some 25,000–28,000 spectators) and Pola in Istria (435 by 345 feet; 132 by 105 m.). The known earlier amphitheatres of Italy had all been either partially recessed into the ground and only in part built up above it (e.g. Sutri, Lucera, Syracuse, Terni; cf. also Mérida, in Spain), or else, like those of North Italy (e.g. probably Piacenza) and of Rome itself, were built of timber on masonry footings. With the construction of the Colosseum and of these four amphitheatres the form reached its full maturity. That of Pozzuoli is remarkable also for the quality of its brick-and-reticulate masonry (only the outer ring, now largely robbed, was of stone) and for the elaboration of the service corridors and other substructures, in which one can make out all the details of such features as the lifts for raising the wild beasts to the floor of the arena above.[10]

The Verona amphitheatre[11] (which owes its preservation in part to an endowment for its maintenance established in the thirteenth century – a remarkably early instance of such civic enlightenment) has a great deal in common constructionally with the Colosseum, including a very similar use of dressed stone for the essential framework of the building, concrete playing a lesser and structurally secondary role. Of the three orders of arched openings of the outer face, the uppermost were not the arches of an encircling gallery but were windows that rose

clear above the seating. The same is true of Pola, where little more than the outer ring has survived, the windows in this case being rectangular openings in an otherwise plain attic. Both at Verona and at Pola the pilasters of the façade are restricted to the two lower orders and are carved in very shallow relief, thus emphasizing the pattern of the arches rather than that of the orders themselves. This is exactly the opposite of the effect sought by the builders of the closely contemporary amphitheatres of Nîmes and Arles [143, 142], who went out of their way to accentuate the rhythmical pattern of the classical framework, by carrying the projection of the pilasters of the façade up through the corresponding entablatures; and it may not be altogether fanciful to detect in the attitude of their Italian colleagues the dawning of a new sensibility, based on the more strictly functional simplicity of the concrete medium in which they were increasingly having to work.

The macellum, or market building, at Pozzuoli (Puteoli)[12] is a fine example of the type already noted at Pompeii, though of later date, the columns being of imported granite and Carystian marble [96]. The paved courtyard, 125 feet (38 m.) square with a central pavilion, is surrounded on four sides by a portico, with shops opening both inwards and outwards. In the middle of the east side the colonnade is interrupted by the four larger columns of the façade of a pedimental shrine dedicated to the divinity under whose protection the market was placed, and the two eastern angles were occupied by public lavatories. The integration of temple and portico into a single façade is a device which we have already met in Vespasian's Templum Pacis in the capital, where it may well in fact be derived from earlier Campanian models.

Little has survived of the luxurious villas for which Baiae was once famous, but the thermal establishments that crowded the southern slopes behind and above the present village have fared better.[13] The remains of one of these can still be seen, terraced impressively up the hillside; and there are no less than four circular

L Lavatory

SHRINE

THOLOS

96. Pozzuoli (Puteoli),
market, second century.
Plan

N

0 30m

halls, housing thermal springs, which were the architectural speciality of the place. The earliest of these, the so-called Temple of Mercury, consists of a masonry drum, circular internally and supporting a dome with a central oculus and, half-way down the curve of the dome, four square windows. The drum, which enclosed a circular pool, now buried, has a diameter of no less than 71 feet (21.55 m.), and the inner face of it is interrupted by four small apsidal recesses, alternating with two large and two small rectangular openings, a formula which suggests that the immediate inspiration for this grandiose hall is to be sought in the very much smaller, circular rooms[14] of the early bath-buildings at Pompeii, to which the suite of rooms adjoining the rotunda, securely buttressing it against the hillside, bears a very close resemblance. The masonry is a good early reticulate, and the materials of the dome, which tapers to a mere 2 foot (60 cm.) thickness near the crown and was decorated with mosaic, are laid radially, in the Republican manner. Even if this latter were a conscious archaism, adopted because it was thought to give greater strength, the building can hardly be later than the early Julio-Claudian period, and it represents a remarkable architectural achievement for so early a date.

The Temple of Mercury, with its evident anticipations of the Domitianic rotunda at Albano and ultimately of Hadrian's Pantheon, offers an unusually clear instance of a type of building that was evolved first in Campania and only later taken over by the architects of the capital. Its subsequent development locally can be studied in the very similar 'Temples' of Diana and Venus at Baiae itself, and in the 'Temple of Apollo' near by, on Lake Avernus, all three of which are probably of second-century date. That of Diana is now deeply buried, but the visible superstructure is octagonal, with eight large windows at the spring of the dome and, below them in the interior, the usual alternation of apsidal and rectangular recesses and doorways. The dome (diameter 95 feet; 29.50 m.) is featureless. In the Temple of Venus [97] the octagonal drum is propor-

97. Baiae, 'Temple of Venus', second quarter of the second century. The interior was faced with marble up to the base of the windows and with mosaic from that point upwards

tionately taller, with buttresses at the outer angles; the dome (diameter 86 feet; 26.30 m.) was of the same general type as the semi-dome of the Canopus at Hadrian's Villa, with eight concave 'melon' or 'pumpkin' segments alternating with eight narrow, flat segments, and there were shallow balconies externally and internally at window level. The Temple of Apollo beside Lake Avernus was the largest of the three, with a circular drum rising from an octagonal base. Though only about 20 feet less in diameter than the Pantheon (or St Peter's), the drum was pierced with windows.

Another category of monument well represented in Campania is its tombs, in the neighbourhood of Capua, outside the gates of Pompeii, and elsewhere. The variety is great, but through it, despite vagaries of personal taste that often baffle systematic analysis (the Pyramid of Cestius in Rome is a striking example of this), one can detect certain consistent strains of development. Two of these merit brief mention. One is that which derives from the simple, drumlike form set on a square podium of which the Tomb of Caecilia Metella, beside the Via Appia, is the classic example. The other is that represented by the well-known mausoleum of Saint Rémy (Glanum) in Provence [146], a tower-like structure crowned by some sort of open pavilion or canopy with a pyramidal or conical roof. The first of these was an Italian innovation of the first century B.C., and wherever one finds it, whether in the wilds of the Dobrudja at Adamklissi, in Pamphylia at Attaleia [193], or in Africa near Tiddis, it derives more or less directly from Italy. The second has a mixed ancestry, one line going back to the famous Mausoleum of Halicarnassus, another probably to the tower tombs of Syria; but it early became acclimatized in Italy and the West, where it took on characteristics of its own, as in the often needle-thin tower-tombs of Africa.

What one sees in the Campanian tombs is a gradual elaboration of (principally) the first of these types, at first by the introduction of relatively simple decorative schemes that accentuate the basic architectural framework, and later by the elaboration of these schemes in a

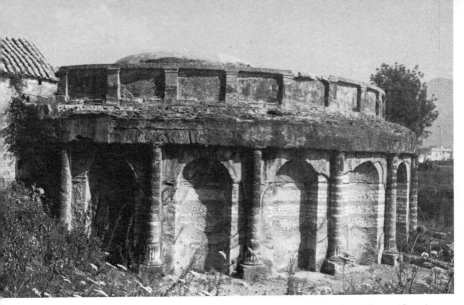

98 (*above*). Santa Maria Capua Vetere (Capua),
mausoleum ('Le Carceri Vecchie')
beside the Via Appia,
probably first half of the second century

99. Pozzuoli (Puteoli),
tomb beside the Via Celle, second century.
Axonometric view

0 5 m

manner which deliberately sets out to disrupt it,
merging them with elements drawn both from
the tower-tombs (e.g. in the Tomb of the
Istacidi at Pompeii) and from such other local
tomb types as the columbarium, the exedra, etc.
To the first category belong the mausolea of
Marano and another near Pozzuoli, the square
bases of which are divided into panels by
pilasters; or the 'Carceri Vecchie' near Capua
[98], the scalloped outline of which may echo
the structural niches that were incorporated in
so many of the earlier Roman mausolea (the
Mausoleum of Augustus, the Tomb of the
Plautii, etc.). Outstanding examples of the later,
baroque phase are a tomb beside the Via Celle
near Pozzuoli [99], which might almost be a
work of Borromini, and the remarkable tomb
known as 'La Conocchia' near Capua [100].

100 (*opposite*). Santa Maria Capua Vetere (Capua), mausoleum ('La Conocchia')
beside the Via Appia, second half of the second century

NORTHERN ITALY

In Northern Italy our knowledge of the architecture of the Roman period suffers greatly from the lack of any major excavated site comparable to those of the south and centre. There is no northern Pompeii, no Ostia. Aquileia, which might have furnished a key to the archaeology of the whole of the northern Adriatic as well as much of the Danube basin, has yet to be tackled on a scale commensurate with the problems involved: scattered buildings, part of one of the cemeteries, the tantalizing remains of the river port – there is little more. Velleia was too unimportant and too remote to offer more than a modest reflection of what was happening in its wealthier neighbours. We are dependent almost entirely on what we can learn from chance excavations and from the study of those individual buildings which happen to have come down to us.

Another serious gap in our knowledge is the almost total lack of any surviving buildings of the Republican period, serious because it was in Northern Italy that Rome learned a great many of the lessons which she was later to apply so successfully elsewhere. It was, above all, in the cities and towns, great and small, of Cisalpine Gaul that she adapted and perfected the system of planning and the types of building which enabled her with so sure a touch to launch Gaul and the other provinces of the West upon the path of urban development. But although we can catch glimpses of this at Aosta, at Brescia, and at Velleia, most of the evidence is lost for ever beneath the flourishing modern cities which everywhere attest the vision and good sense of their Roman founders.

In Tuscany and Umbria Rome had still been dealing with people who had much in common with herself. Once across the Apennines things were different. Over a large part of the Po basin the dominant element was Celtic, closely related to the Celtic peoples of what is now France and of large parts of central Europe. Until absorbed into Italy in 42 B.C. this was in fact the province of Gallia Cisalpina and, as was to happen later in Gaul proper, Roman urban civilization, modelled on that of Central Italy, found itself on congenial soil. By the time of Augustus all except the Alpine fringes had become Italy in fact as well as in name. Virgil came from Mantua, Livy from Pavia, Catullus from Verona. Despite this early and enduring romanization, however, North Italy also had, and throughout the Roman Empire continued to have, certain affinities with the provinces beyond the Alps, affinities with which the facts of history and geography had endowed it. As time passed these were to play an increasingly important part in shaping the wider architectural development of the later Empire.

When we turn to the architecture of the Augustan Age we find that it is the Alpine fringes rather than the established cities of the plains that have left the most substantial traces. The monument of La Turbie above Monte Carlo was erected in 7–6 B.C. to commemorate Augustus's subjugation of the Alpine tribes. It consisted of a huge cylindrical drum with twenty-four recesses framed between as many Tuscan columns, the whole capped by a conical crown and standing on a square plinth. It is a grandiose version of the familiar type of Late Republican and Early Imperial mausoleum of which that of Caecilia Metella on the Via Appia is the best known example, a type which by a simple extension of ideas lent itself admirably to a memorial monument of this sort; and, if rightly restored, it affords a striking example of a method of architectural planning that was common throughout antiquity, whereby the major dimensions are all related in some simple proportion to some basic unit, in this case a module of 4 Roman feet. The arch at Susa, built two years earlier in Augustus's honour by a

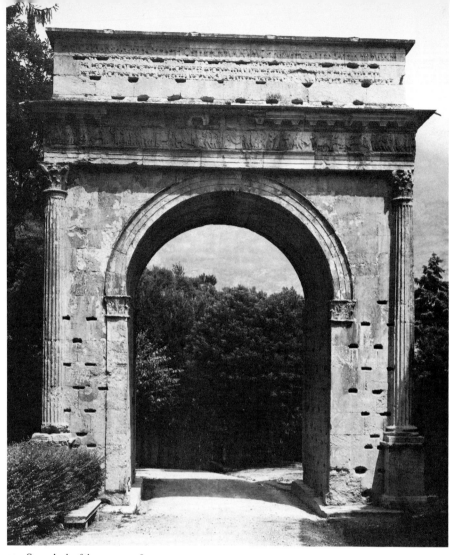

101. Susa, Arch of Augustus, 9–8 B.C.

group of the same tribes, is an interesting example of the commemorative arch at an early stage of its development as an independent monumental type [101]. Three-quarter columns on the plinth at the four angles and a long straight entablature crowned by a plain attic frame a simple arch with shallow pilasters and archivolt. The pilaster capitals are of a type characteristic of the Republican colonies in the North, whereas the architectural form belongs to the new, Imperial Age; and the naïve, lively carving of the frieze (the subject at one time or another of much misdirected erudition) is patently the work of a local craftsman doing his best in an unfamiliar medium. For all its crudities, the arch embodies all that was vigorous and actual in the contemporary art of North Italy.

We find very much the same qualities expressed in the architecture of Aosta (Augusta Praetoria). Founded in 24 B.C. and the last military colony to be established on Italian soil, it is also the one that has retained the most of its Roman physiognomy and buildings. Sited at a crossroad on the important trans-Alpine route across the St Bernard passes, it is one of the very few Roman towns where the rectangular grid of streets, comprising sixteen equal rectangular blocks, each of them measuring 590 by 460 feet

monuments of Aosta, all probably of Augustan date, include the walls and gates, an arch, a theatre, an amphitheatre, and the remains of a temple framed on three sides by the substructures of a monumental double portico which is very similar to the cryptoportico at Arles,[15] discussed in a later chapter. The gates are of the familiar Italian and Gaulish type, discussed further below, in which the actual gateway and the arcaded parapet walk above it are flanked by projecting towers and the former opens into a

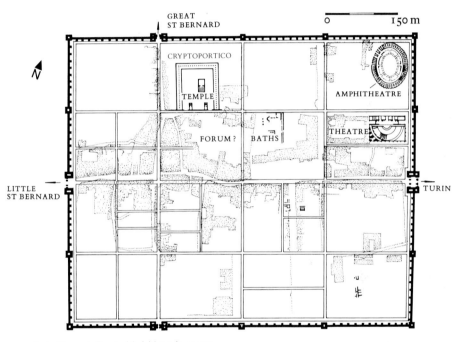

102. Aosta (Augusta Praetoria), laid out in 24 B.C.
Plan of the Roman town in relation to that of the early-nineteenth-century town

(180 by 140 m.) and most of them further subdivided into four, is matched by a perfectly rectangular perimeter of walls [102]. The rectangular grid is a commonplace of Roman urban design. On the other hand, the regular outline of the walls, found also at Turin (Augusta Taurinorum, founded c. 25 B.C.), is rare elsewhere, and must in this instance reflect the influence of contemporary military planning. The surviving

rectangular inner courtyard; the towers in this case are square and the single carriageway is flanked by two smaller footways. The arch is a somewhat clumsy building, the archway being crowded into place between the inner pair of the four half-columns of the façade, all four of which stand on a continuous plinth that encircles all four faces of each pier, truncating the pilasters of the archway. The attic has not

survived, but the order was mixed Doric-Ionic, a hellenistic feature that was quite early abandoned by the Augustan architects of Central Italy;[16] and the capitals of the archway pilasters are of the same Republican type as those of the arch of Susa. Of the amphitheatre one can say little more than that the masonry had the same robust, rather crude finish as that of the theatre. The latter is unusual in that the cavea is fitted into a rectangular perimeter, the street façade of which, with its massive buttresses and four ranges of arches and windows, makes up in strength for what it lacks in elegance. The stage-building with its shallow, very tentatively curved recess framing the central door, illustrates

much the same stage in the development of Roman theatre design as the roughly contemporary theatre at Arles [142]. It has been suggested that this may have been an odeum, or covered theatre and concert hall, rather than the usual open building.

At Turin the Porta Palatina [103], largely built of brick, illustrates what is essentially the same type of gate as that of Aosta, but in more elaborate form. The central carriageway is double; the towers are sixteen-sided; and the gallery above, together with its framing pilasters and entablature, is repeated twice. But these are inessential embroideries upon the same basic theme. At Como, for example, and at Avenches

103. Turin (Augusta Taurinorum), Porta Palatina, probably early first century. Restored view.
Of the two towers, which were built of brick, only the lower parts survive

(Aventicum) in Switzerland (which is Flavian) the towers are octagonal; in the Porta Venere at Spello (Hispellum) in Umbria, another fine Augustan building, they are decagonal; at Asti (Hasta) sixteen-sided; the 'Torre di Ansperto' at Milan has twenty-four sides; at Fano (A.D. 9–10) and in the Gaulish gates of the same type (Nîmes, Autun [135]) the towers are rectangular with rounded fronts. Circular towers are not recorded in this context, but they are found in the contemporary type of gate (Arles, Fréjus, Vindonissa) in which the actual gateway stands at the back of a recessed forecourt.

The most extensive excavations in North Italy are those of the little town of Velleia statuary, bronzes, and objects of domestic use attest the prosperity which it enjoyed under the Early Empire. Without these finds one would hardly have guessed at such material well-being merely from the architectural remains; and yet the history of Velleia must be that of countless small towns in Italy and the provinces. Its early growth, terraced down a shelving hillside, seems to have been shaped by topographical convenience rather than any coherent plan, but under Augustus the centre of the town was remodelled by the creation of a rectangular forum together with the appropriate municipal offices [104, 105]. At the upper end stood a basilica; at the opposite end a temple and on

104. Velleia, forum and basilica, early first century, from the air. In the left foreground the amphitheatre

(Veleia) in the Apennine foothills, south of Piacenza. Created in the first place to be the administrative and commercial centre of a vast area of mountain and forested uplands, the excavated remains of inscriptions, municipal either side of it, flush with the cella and of roughly the same size, a row of large rooms, which no doubt housed the curia and other municipal buildings. Rows of shops occupied the two long sides, fronted by porticoes with

105. Velleia, forum, early first century. Plan

columns of stuccoed brick. The basilica was a large rectangular hall measuring 114 by 38 feet (34.85 by 11.70 m.) internally, open along one long side towards the forum and structurally plain except that at either end a screen of two columns marked off a rectangular annex of the same width as the main hall. Like the paving of the forum, the basilica was owed to the munificence of a wealthy local citizen, and in it were found eleven statues of members of the Julio-

Claudian family and the famous bronze tables recording the details of Trajan's charitable foundations. The blocks immediately adjoining the forum were rebuilt to conform with the new rectangular scheme, but the rest of the town, including a small amphitheatre and a bath-building, retained its old, irregular layout. Numerous streetside porticoes, giving shelter in winter and shade in summer, anticipate medieval and later North Italian practice in cities such as Bologna and Padua.[17]

The scheme of the forum at Velleia is one that we find repeated, at every level of elaboration, all over Italy and the Western provinces. An even more elementary version is that represented at Martigny in the Valais, the first roadside hamlet on the far side of the Great St Bernard, which was a native centre, Octodorus,

by 55 m.), with shops down two sides and what may have been a very simple basilica or covered market across the north end.

At the other end of the scale we have the forum of Brescia (Brixia), as remodelled by Vespasian.[19] This was a long, narrow open space measuring 130 by 456 feet (40 by 139 m.) and flanked by colonnades, the rhythm of which was emphasized by a slight projection of the trabeation above each column, a characteristic late-first-century innovation that is repeated, for example, in the flanking order of the Forum Transitorium in the capital and in the amphitheatre at Nîmes [143].[20] The composition was dominated by the Capitolium, which was terraced above and separated from the rest of the open area by the line of the city's main transverse street – a disposition commonly

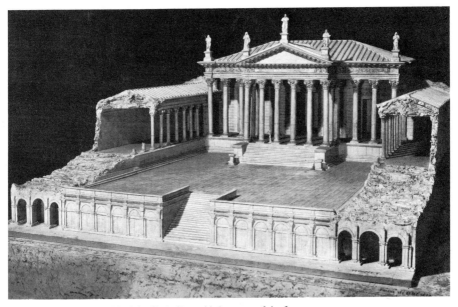

106. Brescia (Brixia), model of the Capitolium, third quarter of the first century

refounded by Augustus beside the road under the name of Forum Augusti Vallensium.[18] Later rebuilt in more elaborate form by Claudius, it was at first a simple rectangular enclosure, comprising an open space, 148 by 180 feet (45

adopted in the Western provinces, notably in Gaul (cf. Augst [134], Saint Bertrand-de-Comminges, etc.).[21] The building itself [106] is noteworthy for its almost Palladian plan, the hexastyle, pedimental porch of the central one

of the three cellas projecting boldly forward from, and dominating, the rest of the columnar façade. At the opposite end, facing up towards the Capitolium, lay a basilica. This was a free-standing rectangular building, occupying the full width of the forum, on to which it opened through three symmetrically placed doors, set within a scheme of fluted pilasters which appears to have been carried uninterruptedly right round the building. Similar, but plain, pilasters on the inner face suggest there was an internal ambulatory colonnade. Parallel with the main forum and alongside it there seems to have been another, similar monumental enclosure dominated by a theatre. The details are uncertain; but the broad lines of the layout are clear enough to serve to illustrate what, to judge from the scattered remains of monumental buildings dating from the Early Empire, must have been happening in the centres of many of the cities of North Italy. A somewhat special case, rather better documented than most, is that of Assisi. Here the ground sloped too sharply for the normal longitudinal layout and the forum was sited along the slopes, with the still surviving temple terraced directly above it in the middle of one long side. In this case we do not know where the other public buildings were.

(In parenthesis, it should be remarked that the development of this characteristic forum type, although it may contain certain echoes of contemporary military practice, was in itself essentially a civil phenomenon. In certain specific instances, e.g. at Aosta, it is probably right to detect the direct influence of contemporary military design. But such borrowings were not usually so explicit, nor was the flow of ideas by any means all in one direction; as the camps of the legionary and auxiliary troops came to take on a more permanent character, they in turn borrowed much from contemporary civil practice. In the frontier areas the exchange must in fact have been close and continuous, and the results no doubt filtered gradually through to other regions. But except in this very generalized sense it is mistaken to claim, for example, the Forum and Basilica of Trajan as a military layout, on the grounds of its undoubted formal resemblances to the headquarters complex of a large legionary fortress. Both were products of an organic and closely interrelated evolutionary development, in which it was the new cities of North Italy and the neighbouring provinces that played a determining role.)

Of the scattered individual monuments only a few call for detailed comment. The Temple of Rome and Augustus at Pola, built between A.D. 2 and 14, was one of a pair flanking a much larger temple (the Capitolium?) on the north side of the forum. It was tetrastyle Corinthian, the frieze being carved with an acanthus scroll which, like that of the Maison Carrée at Nîmes [137], reflects the style introduced into Italy by the sculptors of the Ara Pacis. Of several fine bridges, that which carries the Via Aemilia across the river at Rimini is a handsome Tiberian (A.D. 22) structure of five equal arches built of dressed stone, with decorative aediculae on the outer faces of the piers. It still stands, parapets and all, very much as on the day it was built [107]. Another impressive early bridge was

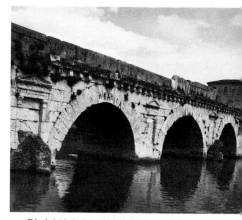

107. Rimini (Ariminum), bridge, A.D. 22

that which carried the Via Flaminia at a height of about 100 feet over the river Nera at Narni. It was unusual in that the arches, which have strong, simple archivolt mouldings, were almost exactly semicircular and, being of different spans, had to spring from the piers at different

heights. As in the Pont du Gard [136], projecting bosses were left in the faces of the piers to facilitate maintenance.

The most numerous and varied group of surviving North Italian monuments is that of the arches and city gates, of which those at Aosta, Susa, and Turin have already been described. From the outset they were used for a variety of purposes: as city gates, as entrances to fora or similar enclosures, as free-standing bases for commemorative statuary, or even as funerary monuments. The earliest dated member of the northern series, at Rimini, was one of a pair built in 27 B.C. to mark the completion of the restoration of the Via Flaminia; its fellow stood near the Pons Mulvius, outside Rome. The type originated very simply as a pedimental frame in low relief enclosing an arch, as we see it still in the early (pre-Augustan?) Porta Santa Ventura at Spello or the Porta Tiburtina in Rome [2]; but at Rimini one can already see signs of the disintegration of this basic type in favour of a looser decorative grouping of its constituent elements. The proportions of the archway have widened, and the pediment no longer rests on the flanking columns but is poised uneasily between them. The Arch of the Sergii at Pola, a funerary monument dating from the last decades of the century, represents another strain, being essentially a richer version of the arch at Susa, with paired instead of single half-columns flanking the arch and an entablature and attic that repeat the articulation of the façade below. The Claudian Porta Aurea at Ravenna (A.D. 43), now destroyed but known from Renaissance drawings and surviving details, was an altogether more elaborate structure. It had a double carriageway beneath twin pediments, the whole framed between three pairs of half-columns, of which the two outer pairs were more widely spaced to make room for decorative aediculae and richly carved medallions. Of the superstructure, presumably an arcaded gallery as in the city gates already described, there is no record. The elaborate quality of the ornament is characteristic of much Julio-Claudian work in Italy.

Less florid in detail but even more elaborate in conception are the two partially surviving city gates of Verona. The present façade of the Porta dei Leoni masks an earlier structure, probably Early Augustan, which is known chiefly from Renaissance drawings. This was an eminently sober, dignified monument, very like the Porta Palatina at Turin [103], with plain stone archways set in a facing of brick and a mixed Doric-Ionic order (as at Aosta) over the lower of the two arcaded galleries. The elaboration of its successor, rebuilt probably after the troubles of A.D. 69, shows how far architecture had travelled in the hundred-odd years that intervene. The scheme of the lower part is still essentially the same, but the carriageways are now framed by half-columns and by pediments of which the horizontal member is omitted, and the arches of the gallery are set in elaborately carved aediculae; at the same time the upper gallery has been entirely remodelled, with four spirally fluted colonnettes on projecting plinths framing a large curved statue recess in the centre between two narrow, plain wings. The roughly contemporary Porta dei Borsari [108] is closer in layout to the earlier models, but a great deal of the decorative detail is quite extraordinarily baroque in character – spirally fluted columns, contrasting curved and triangular pediments, pilasters springing from brackets, aediculae alternating with simple projecting columns or pilasters, and, perhaps the most striking feature of all, the contrasting rhythms of the two galleries, which are so devised that the aediculae of the upper gallery are poised, on brackets, above the voids between the aediculae of the lower gallery. For all the other features referred to one can find individual parallels in Italy already in the early first century A.D., but for the last-named one has to turn to the eastern provinces, whence these baroque façades drew much of their inspiration.[22]

With the latest of the Early Imperial arches in North Italy, that of Trajan at Ancona (A.D. 115), and the almost exactly contemporary arch at Benevento in Central Italy (114) we return to a more sober, classical manner [109]. The first

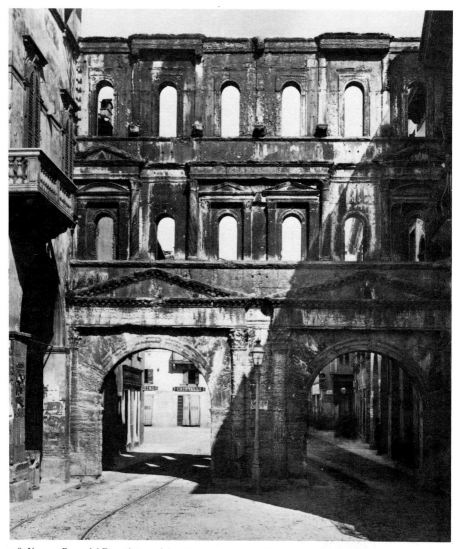

108. Verona, Porta dei Borsari, one of the city gates, formerly flanked by projecting towers, probably third quarter of the first century

impression conveyed by the two monuments could hardly be more dissimilar – Ancona with its tall, graceful lines and very simple ornament consisting of little more than framed decorative panels and applied bronze wreaths, and the robust, rather pedestrian solidity of Benevento, overloaded with symbolic and allegorical relief sculpture in the grand manner. But both can, in fact, be seen to derive very closely from the Arch of Titus in Rome; and we have the Arch of the

109. Ancona, Arch of Trajan, 115

Gavii at Verona to show that this return to a more formal classicism was felt outside the narrow circle of monuments that were directly inspired from the capital. In the North, no less than in Rome itself, the reigns of Trajan and Hadrian mark the end of an epoch.

Since it was through provincial, and particularly through northern, Italy that many of the architectural forms and practices of the capital first reached the European provinces, we may usefully conclude this chapter with a few remarks on one or two of the building types in question. Some, like the theatre and the amphitheatre, call for no explanation beyond that given elsewhere in describing the individual monuments. Others have connotations that may vary greatly according to the context, and a knowledge of the formal background is necessary if one is to appreciate the full architectural significance of the several variant forms.

In the first place, the centre of every Roman city, the forum. Throughout antiquity this retained something of its original character as an open space available for all the manifold communal activities of urban life in Mediterranean lands: market-place, place of political assembly, law court, a setting for public spectacles, the natural meeting-place for private citizens doing business, and, since all these activities were in some degree under divine protection, a focus for the religious life of the community. It was, in short, the piazza, a flavour that it never wholly lost. As time passed, however, and urban life grew more complex, special provision came to be made elsewhere for many of these activities, in basilicas, market-buildings, theatres, amphitheatres, sanctuaries. Some of these buildings might be adjacent to the forum, others not. There was no regular rule about their location, and they came into being as local circumstance demanded. In Rome, for example, the cattle market had at a very early date moved to a more convenient site beside the river, whereas gladiatorial displays were still held in the Forum Romanum right down to the very end of the Republic. In this chapter we have caught a few tantalizing glimpses of the emergence during

the late Republic of the forum as an explicit architectural form, a form which was to have a long history in provincial Italy and in the western provinces. In Rome itself the Forum Romanum, crowded with venerable monuments and heavy with tradition, did not lend itself readily to such radical experiment; but with the creation of the successive Imperial Fora we can watch the emergence and development of a comparable and, in its own way, no less influential architectural model. In Trajan's Forum the two currents were to meet and merge in what, very appropriately, later antiquity was to regard as the quintessential expression of the Roman forum.

Of the many individual types of Roman building that were regularly associated with the forum, by far the commonest was the basilica. In strict architectural usage the term denotes a columnar hall with clerestory lighting, a type to which some at any rate of the great Republican basilicas of the Forum Romanum belonged, and to which a great many of the later buildings of the same name did in fact conform. A great many, on the other hand, did not; nor was the term *basilica* by any means confined to large public halls erected alongside the forum. At Velleia, for example, already in Augustan times we see a building which has few of the architectural characteristics of the ancestral type but which stood beside the forum and was certainly called *basilica*. At the same time we find the name *basilica* used in a variety of contexts that have nothing whatever to do with the forum or public affairs: the halls flanking the stage-building of a theatre; one of the rooms of a bath-building; the audience hall of a private villa; a cloth market; the headquarters of the Roman silversmiths; a covered exercise yard for troops; the private meeting-place of a religious cult. Not all of these were basilican even in the architectural sense; it is quite clear that in course of time the name came to be applied to any large covered hall, regardless of its architectural form. The variety of possible usage is bewildering, and in view of the widespread discussion that there has been about the classical origins of the

Christian basilica (a discussion which has frequently confused the type of building and the name) the fact of this variety is important. There can be little doubt, however, that in antiquity the term *basilica* would, unless further specified, have called to mind the great halls that played so large a part in public life and affairs, and it may conveniently and properly be so used in the present context.

The Capitolium, a symbol of Roman majesty *in partibus*, is another type of monument which, though ultimately derived from Rome, from the state Temple of Jupiter, Juno, and Minerva on the Capitol, is found everywhere in a bewildering variety of architectural forms, some copying or adapting the plan of the parent building with its three separate cellas, some indistinguishable architecturally from any other temple, and many adopting local variants of their own – a single cella divided by columns into nave and aisles (Mérida, Cuicul) or with three separate apses (Thugga, Timgad); three almost identical temples, side by side (Baelo in Spain, Sufetula); or even a double cella (Lambaesis). The only secure common denominator is the dedication. Usually (though not invariably, e.g. Timgad) the Capitolium stood at or near the city centre, and in most cases it is probably a justifiable assumption that its erection signified some event in the city's progress towards full Roman status.

Like the basilica, the Capitolium found its way occasionally to the eastern provinces, a notorious example being the central temple of the colony, Aelia Capitolina, that was established by Hadrian in 137 on the site of Jerusalem. But it was far commoner in the West, particularly in the provinces adjoining the western Mediterranean, to which the conception of the old Capitoline divinities came easily.

A common and in many respects complementary equivalent of the Capitoline cult was that of the reigning emperor, usually accompanied by that of the goddess Roma. This was widely adopted from Augustan times onwards in the East, where it was a simple extension of hellenistic practice; but although the direct worship of the living ruler was for a long time prudently avoided in Rome itself, the same result was achieved in the thinly disguised form of the official cult of the emperor's deified predecessors, and this practice was widely followed also in the West. Where Sabratha in Tripolitania had its Capitolium, its neighbour Lepcis had a temple of Rome and Augustus established under Tiberius.

Some of these temples of the imperial cult, like that of Claudius at Colchester, were official foundations, others were established by private individuals; and once again the architectural forms adopted were very diverse. They might take the form of separate temples, as in Rome itself, at Pompeii, at Terracina, at Ostia, and in innumerable cities of the provinces, or they might be annexed to other buildings, as to Vitruvius's basilica at Fano or the basilicas of Lucus Feroniae and Sabratha. A distinctive and important architectural type was that established by the Caesarian 'Kaisareia' of Antioch and Alexandria, discussed in a later chapter, a type which struck echoes in Rome itself, possibly in the Imperial Fora, almost certainly in buildings such as the Porticus Divorum.

Yet another category of building for which Rome offered an obvious standard model for any who wished to use it was the curia. Buildings based more or less directly on the senate house in the Forum Romanum are not uncommon, particularly in the African provinces. On the other hand, many cities were content with models of their own devising, and in the eastern provinces we still find examples of the equivalent Greek type, the bouleuterion, with its seating arranged like a theatre. One such that was restored in traditional form in Roman times can be seen at Nysa on the Maeander.

There were these and other standard building types available for use, but it is a mistake to attach too much weight to them. Such stereotypes clearly were congenial to the Roman mind; and yet one is constantly being astonished by the flexibility with which they were adapted to local circumstances. It seems likely that they were just as often selected by the free choice of

the local inhabitants, wishing to be more Roman than the Romans, as by an imposition of ideas from above. This is a question that has to be studied case by case. For the present it is sufficient to remark that Late Republican and Early Imperial Italy did furnish architectural prototypes that were freely and widely copied, particularly in the western provinces. They are less common in the eastern half of the Empire, which had well established traditions of its own.

DOMESTIC ARCHITECTURE IN TOWN AND COUNTRY

THE TOWNS

As late as the first century B.C. the atrium-house with or without a peristyle garden was the standard residence of the well-to-do Roman, whether in Rome or in Campania. The weight of tradition was considerable. Even so potentially disruptive a force as the very great increase in wealth among the upper classes had found an outlet principally in the introduction of new and costlier materials and furnishings; and although space too was beginning to become an important consideration (as one can see if one compares a wealthy Late Republican town house in Rome, such as the House of Livia on the Palatine, with its Pompeian equivalent) the difference still amounted to the compression of familiar architectural forms rather than to the emergence of any that were radically new.

With the establishment of the Empire the seeds of change took firmer root. Populations continued to grow rapidly and the pressures on space were no longer confined to the big cities but were felt even in prosperous country towns like Pompeii. Wealth was no longer the prerogative of a small ruling class, but was beginning to spread to a new and growing middle class, whose tastes and rapidly rising standards of living demanded comparable living conditions. Abroad horizons were widening, bringing fresh and fruitful exchanges of ideas; and at home the development of new building materials and techniques provided the means of putting these ideas into effect. The stage was set for a new and altogether more complex chapter in the story of Roman domestic architecture.

The development that followed defies concise, tidy analysis. The cross-currents were too many and, as the range of possible choice increased, one must reckon also on the irrational factor of personal taste. Within the compass of a general survey the most that one can hope to do is to indicate some of the broader trends that were already beginning to make themselves felt even before the destruction of Pompeii and Herculaneum in A.D. 79.

One of the most insidious of these trends was the steady drift of the wealthy classes away from the town house, or *domus*, to the *villa* established in the less congested areas of the suburbs, or even in the open countryside near the town. At Pompeii, as land values rose, many of the older houses began to be split up into apartments or put to commercial use. By the time of the eruption wealthy town houses like that of the Vettii were rapidly becoming the exception. Pompeii, it is true, was not altogether typical. At a time when Italy was fast losing its position of commercial privilege with respect to the provinces, wealthy householders of Pompeii had also to contend with the results of the earthquake of A.D. 62. In Rome it might still be convenient to retain one's family residence near the centre, as Nero's father had done beside the Via Sacra, or the Flavian family on the Esquiline; but it was only in his properties outside the city that the wealthy owner could find real scope for his architectural ambitions.

Within the towns the inevitable result of population pressure was to set a premium on forms of planning which were economical in ground space, or which offered scope for development upwards. The older houses did not disappear overnight. As late as the beginning of the third century one finds a few of them still depicted on the Severan marble plan of Rome [62]. But in new building the relaxed sprawl of the old atrium-peristyle house no longer made economic sense. The most conspicuous casualty of the new planning was the atrium. Once the physical and social centre of the Italic house, it had already begun to lose its predominant role

during the later Republic, as more and more aspects of daily life moved to the lighter, more secluded setting of the peristyle. One solution, favoured by the more conservative-minded architects and patrons, was to multiply the columns around the atrium so as to create in effect a miniature peristyle. This was Vitruvius's *atrium corinthium*, as we see it in the house of the same name at Herculaneum. But by A.D. 79 there were other, radical alternatives. With the addition of increasingly substantial upper storeys and galleries, in many cases the atrium was reduced to little more than a passageway and a light-well, finally disappearing altogether. In its place the peristyle now became the architectural as well as the social centre of the town house.

One can follow these processes very clearly in a pair of houses at the southern edge of Herculaneum [110–13]. This quarter was developed in late Julio-Claudian times, with well-to-do houses terraced out across the line of the

110. Herculaneum, the southern garden verandas of the House of the Mosaic Atrium and the House of the Stags terraced out over the old city wall, shortly before 79

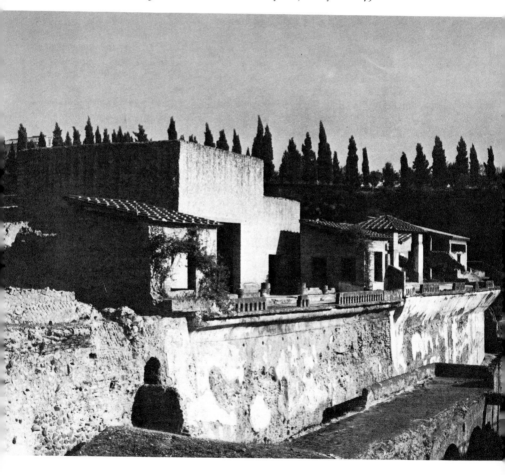

old town wall so as to take advantage of the view towards the sea. In one of these houses, the House of the Mosaic Atrium,[1] the traditional forms were still partially observed in the north wing, which was laid out across the main axis of the building. It consisted of a central atrium, shorn of its lateral rooms, preceded by a porter's lodge, entrance corridor, and kitchen, and at the far end, instead of the traditional tablinum, it had a winter dining-room of the rather unusual, basilican type described by Vitruvius as an *oecus*

aegyptius.[2] The central garden, on the other hand, was built in the new manner [113]. Piers and a half-columnar order of brick framed the large square windows of a corridor which ran round three sides of it, in place of the open colonnade of a traditional peristyle; and on the fourth side there was a range of living-rooms fronted by a narrow corridor of which the wall towards the garden was a mere framework of timber and glass.[3] At the south end another range of rooms opened on to an outer portico,

111. Herculaneum, House of the Mosaic Atrium (*left*) and House of the Stags (*right*), shortly before 79. Elevation and restored view of the south façade, built out over the old city wall

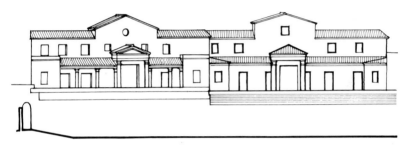

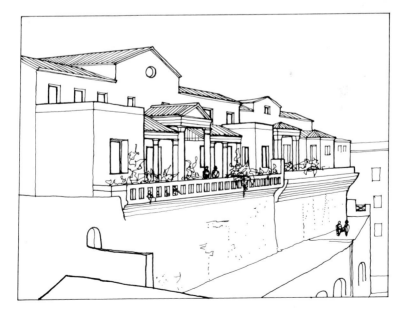

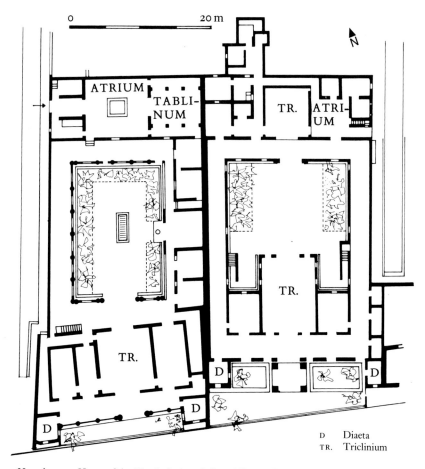

112. Herculaneum, House of the Mosaic Atrium (*left*) and House of the Stags (*right*), shortly before 79. Plan

which faced towards the sea; two small living-rooms (*diaetae*) projected at either end, framing a long, narrow terrace; and in the centre, facing outwards towards the sea and inwards across the garden, was the principal summer dining-room and reception hall of the private wing, a room which within the context of the domestic architecture that was now taking shape it is convenient to refer to as a *triclinium*.[4] Throughout the building there were upper storeys over the smaller rooms.

In the neighbouring and closely contemporary House of the Stags[5] one sees this development carried one stage further. The rudimentary atrium, which was roofed right over, has here become little more than an entrance lobby and passageway; and the semblance of an earlier, more traditional layout which determined the different orientation of the north wing of the House of the Mosaic Atrium has been abandoned altogether in favour of a symmetrical layout about the axis of

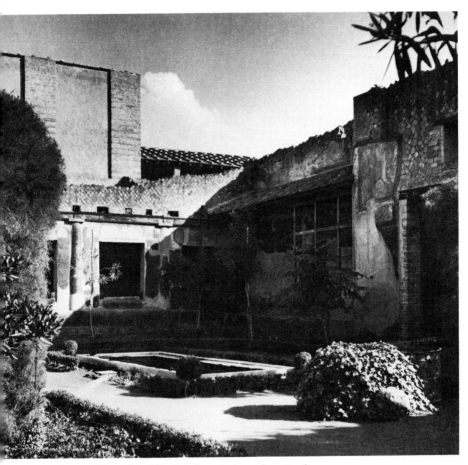

113. Herculaneum, House of the Mosaic Atrium, the internal courtyard, showing on the right the glass-fronted passageway, shortly before 79

the garden courtyard. The inner triclinium faces axially down the garden; the corridor around the sides of the garden has shed all pretence of being a traditional columnar peristyle; and the terrace wing at the south end is symmetrically disposed about a large outer triclinium, its terrace garden flanked by the same two small projecting diaetae with large panoramic windows for day-time relaxation and repose. The terrace wing is clearly a product of special circumstances; the site was such that the owner could here, in his town house, indulge in one of the panoramic terraces currently fashionable in the villas of the suburbs, as in the Villa of the Mysteries and the Villa of Diomede at Pompeii. But the symmetrical layout about a central courtyard and the emergence of the triclinium as the most important room in the house are both features that had a long development before them, not least because they brought the Italian house back into line with the developed peristyle houses of the other Mediterranean provinces.

One more example, this time from Pompeii. The House of Loreius Tiburtinus[6] [114, 115] was still in process of modernization and re-decoration at the time of the eruption. The

length of the north end of a large garden beyond, and which was the nucleus of a plan for the main living-rooms that closely resembles that of the terrace of the House of the Stags.

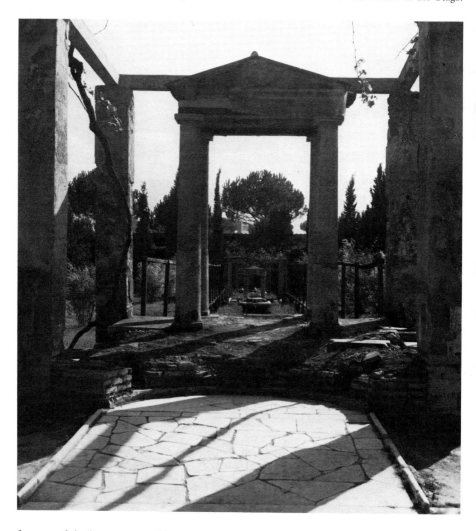

forepart of the house, grouped in two storeys around a spacious atrium, was still that of the early building. The miniature peristyle, on the other hand, was now little more than an intimate extension of the terrace which occupied the full

Terrace and garden were formally linked in an elaborate T-shaped scheme of pergolas, tempietti, statuary, and fountain basins, and whether from the luxurious central triclinium, from the open-air dining-room at the east end of

0 25m

N

114 (*opposite*) and 115. Pompeii,
House of Loreius Tiburtinus, 62–79.
View from the house down the axis of the formal garden
with section and restored axonometric view

the terrace, or from the diaetae at the west end, the eye was led out across the garden to the mountains beyond.

With the destruction of Pompeii and Herculaneum in 79 we lose the best source for our detailed knowledge of the single-family town house in Central Italy; and the individuality of the latest Pompeian houses is a warning against trying to establish any too-rigid sequence of onward development on the basis of the much

smaller number of post-Pompeian examples known to us. Houses like that excavated on the Esquiline in the eighteenth century [116] or the

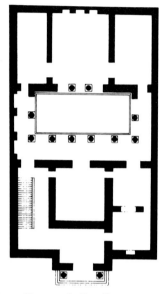

116. Rome, House on the Esquiline, probably first or second century. Plan, after Lanciani

late-second-century House of Fortuna Annonaria at Ostia [128A] are a logical product of the sort of processes that we have been describing.[7] The standard private house of the second and third centuries at Ostia is the peristyle-house, consisting of a portico accessible more or less directly from the street and enclosing three or four sides of a garden or courtyard, with rooms opening off the portico. But this no longer represents the main stream of urban architectural development. With the second century (and indeed in Rome itself since the middle of the previous century) the focus of interest shifts decisively away from the domus, the old-fashioned town house, to the insula.

The term *insula* requires definition. Its modern usage, to define the city block, the area delimited by four streets, is a convenient but inaccurate convention. In antiquity it meant an apartment-house, occupied by a number of families, in contrast to the *domus*, which was essentially a single-family unit. It might occupy an entire block, but more often than not it was only one of several buildings which together comprised an insula in the larger sense of the term. It came into being as a result of population pressures and the rise of a new and prosperous middle class; and its importance may be measured by the fact that when the regionary catalogues were drawn up in the fourth century there were 46,000 insulae in Rome and only 1,790 domus.[8]

The essential architectural quality of the insula was its height in proportion to the area which it covered. This element of height was in itself nothing new. It had long been a feature of the tenement-houses of old Rome. But these were notorious fire-traps and liable to collapse upon their inmates. It was not until the Early Empire that the new building materials and techniques made it possible to rationalize the experience of the past into a type of building that was convenient, economical of space, structurally sound, and, at any rate by ancient standards, fireproof. Echoes of the new fashions had reached Pompeii and Herculaneum before 79. But it was the rebuilding of Rome after the great fire of 64 which established the brick-and-concrete insula as the norm for urban domestic architecture; and it is the houses of Ostia, where the full impact of the new fashion was not felt until a generation later, which tell us what this new architecture was like.

Although it is the broad uniformity of the finished product that immediately impresses the modern visitor, it was in fact the innate flexibility of design which made the insula such a successful building type. The simplest plan was probably also the oldest. Already in Late Republican Pompeii one finds upper storeys added over a row of shops along the street front, and it is not impossible that the type had originated in Rome and had been introduced to Pompeii by the Sullan colonists. At Ostia one sees insulae of this elementary type along the main cardo,

between the forum and the river, or again along the main decumanus, in front of the Neptune Baths. The same idea, but without the shops, is found in the so-called Casette Tipo (Region i, 12 and 13),[9] which were laid out on a single occasion in a series of uniform blocks, symmetrically disposed; and, in a more elaborate version, in the garden houses (iii, 9), which consisted of two large apartment blocks laid out on a common plan in the middle of a large garden. In contrast to the inward-looking Pompeian house, the widespread adoption of window glass enabled many of the individual rooms at Ostia to be lit from the outside, and it was no doubt similar considerations which determined the most elaborate and most strikingly individual development of the type in which the apartments were arranged around a central courtyard in the manner of a Renaissance *palazzo* [82]. The courtyard was regularly arcaded, and it ranged in scale from what, in the House of Diana (ii, 3. 3), was hardly more than a monumental light-well to the spacious central *cortile* of the House of the Muses (iii, 9. 22). There were individual staircases to the upper storeys; window-glass was common in the better-class blocks; and although water had to be fetched from a common tap, many apartments had provision for individual sanitation, with chutes for garbage disposal. Heating was by means of braziers. If one makes allowance for the perishable fittings, of which, unlike Pompeii, there are only scant remains, these apartment-houses represent a standard of middle-class living unequalled until quite recent times.

The external appearance of these buildings [76, 85] was severe, relieved by an occasional string-course or by projecting 'balconies'[10] and dependent on the quality and texture of the brickwork (which was regularly exposed and even, on occasion, picked out in a crimson slip with white pointing) and on the rhythm of doorways, arches, and windows. This was essentially a practical, functional architecture and, combined with the regular incorporation of shops at street level, it strikes a singular note of modernity. That there was any real architec-

tural continuity between classical and later medieval or Renaissance Rome is very doubtful. But the solutions arrived at are often extraordinarily similar. The necessary complement to a visit to the ruins of Ostia is a walk in the streets of old Trastevere.

SUBURBS AND COUNTRYSIDE

Outside the city things were very different. Town house and country house had long parted company. What had started as a community of peasant farmers had gradually evolved into the highly stratified society of the Late Republic and the Augustan Age. We have a great deal still to learn about the detailed impact of this social revolution upon the countryside of Italy; but one of the immediate results of the widening of the range of the social scale was inevitably to diversify the pattern of living. At one extreme there were now the great landowners with estates up and down the length of Central Italy, and even farther afield. Though very far from being extravagantly wealthy by contemporary standards, Cicero, for example, had more than a dozen scattered properties in Latium and Campania. Some of these wealthy property owners still preferred to live close to the land; and we have the examples of such agricultural specialists as Cato, Varro, and Columella to show us how much they might contribute to the well-being of their estates. But (and this was increasingly true of the Late Republic and the Early Empire) the vast majority now used some of their estates as part-time country residences, and their standards of comfort and luxury were those of the town rather than of the country. At the other extreme, side by side with the freedmen and slaves cultivating the properties of absentee landlords, there were innumerable little men, both smallholders and tenant farmers, living close to the soil and cultivating the land on which they lived.

It is against such a background that one has to view the architecture of the Italian countryside under the Early Empire. If the result is at first sight bewildering in its variety, it can neverthe-

less be seen to fall very roughly into three broad categories: there were the country residences of the rich, corresponding roughly to the country villas of Renaissance Italy; there were the *villae* *rusticae*, with which one may compare the long-established *fattorie* and *casali* of the Roman Campagna, centres of substantial agricultural estates, run by bailiffs but often including a

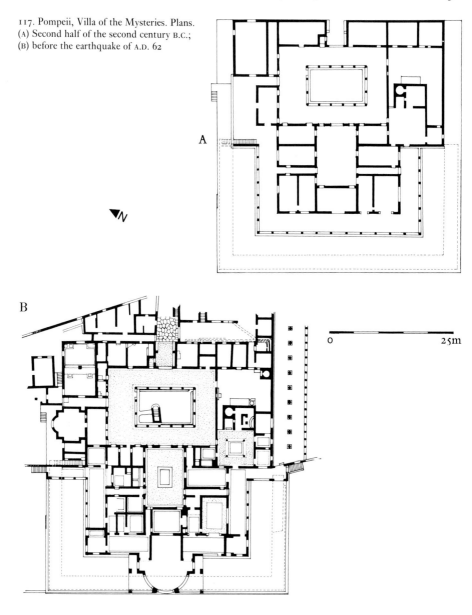

117. Pompeii, Villa of the Mysteries. Plans.
(A) Second half of the second century B.C.;
(B) before the earthquake of A.D. 62

lodging for the visits of the landowner himself; and at the lower end of the scale there were the modest farmhouses of the smallholders and tenant farmers. That one will, in practice, find infinite gradations between the several categories is the inevitable fate of any such classification. It will serve none the less as a basis for discussion.

In the age of Augustus one can still distinguish two main types of wealthy country residence. One was the relatively compact platform-villa, a long-established type characteristic of (though not confined to) the Roman Campagna and southern Latium. The other was the far more loosely integrated seaside villa with spreading porticoes, best known to us at this early date from the coastlands of Campania.[11] The two types had already met and mingled – not altogether surprisingly when one recalls that they represent ultimately a fusion between the same two traditions, between the old compact Italic atrium-house and the familiar type of hellenistic house built around a central colonnaded courtyard. Within the town the result was the essentially inward-looking atrium-peristyle house. In the countryside there had, on the other hand, from a very early date been a contrary tendency to open up the house outwards. Already in its earliest form the Villa of the Mysteries, the best known of the 'suburban' villas of Pompeii, was surrounded on at least three sides by a terraced portico [117A]. In this case the peristyle on the north-east (upper) side of the building was a later addition, of the late second century B.C.; and it was later again, towards the middle of the first century A.D., that the south-western wing was transformed by the addition in the centre of a large, projecting, semicircular veranda flanked by a pair of comfortable diaetae at the two corners [117B]. Here, in the successive transformations of the Villa of the Mysteries, we catch a vivid and instructive glimpse of the impact of the two conflicting trends in the Late Republican and Early Imperial domestic architecture of the countryside: on the one hand the development of a compact platform-villa, grouped around a peristyle court-

yard but already beginning also to look outwards; and, on the other, the emergence of a type of country residence of which the dominating factor was increasingly the outer façade, which frequently took on a quasi-monumental character in relation to the landscape of which it was a closely integrated part.

The platforms of the well-to-do Republican villas are a commonplace of the landscape from the Sabina right down to southern Latium and Campania. Many continued to be content with the simple rectangular plan, built upon a single level around a central courtyard. Such, for example, were the well-known villas of the country around Pompeii or the recently excavated San Rocco villa in northern Campania [118].[12] But long before the end of the Republic one can discern a tendency to terrace the villa platform outwards so as to catch the breeze in summer and to enjoy the views which so many of those villas were manifestly sited to command. From this it was only a short step to increasing the number of terraces and developing the plan about an axis running up and down the slope of the hillside. Around Terracina and Gaeta there are multiple-terraced villas of this sort which must go back at least to the second century B.C. An unusually well documented example is the Late Republican villa of which Hadrian incorporated the substantial remains into his own great villa near Tivoli.[13] This was laid out at two levels, of which the lower platform contained a garden with a typical Republican nymphaeum, while the upper housed the villa proper, along the axis of which, stretching back from the façade, lay an atrium opening on to a tablinum, beyond this a second tablinum facing on to a large peristyle, and beyond this again, cut into the hillside, a stepped, semicircular exedra.

The second type of Early Imperial villa, with its more informal layout, is less immediately recognizable on the ground. From the frequency of its representation, however, in the wall-paintings of Pompeii and Herculaneum [94], and from the regular association of such representations with seaside landscapes, we may

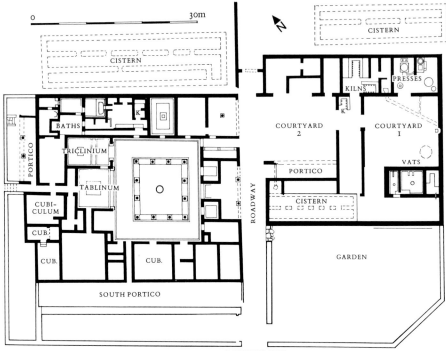

118. Francolise, San Rocco villa, early first century. Plan. On the left, the residential block, of which the portico and cubicula of the north-west façade enjoy superb views across the Ager Falernus. On the right, the *villa rustica*, with extensive facilities for pressing oil, threshing, and making tiles

reasonably deduce that it was originally developed locally, presumably when, in the closing decades of the first century B.C., the Campanian coastlands began to take the place of Formia and Gaeta as the fashionable seaside resort of the wealthy Roman. In this setting, with its distinctive landscape and strong Greek traditions, one can readily understand the adoption of a layout that relied less on the formal qualities of the architectural design than on the relation of the buildings to the natural scenery around them.

One of the few such villas to have been fully and systematically explored is not in Campania at all but at Val Catena on the island of Brioni Grande in the northern Adriatic [119].[14] Although of slightly later date and not all built on a

single occasion, the layout of the buildings, strung loosely around the shores of a narrow coastal inlet, very closely resembles that depicted in the Campanian landscapes. The main residential block lay along the southern shore, facing north. It consisted of a large, rectangular, single-storeyed block some 230 by 260 feet in extent, grouped around two peristyle courtyards, with a portico and terrace along the façade, facing the head of the inlet. To the east of it, stretching along the southern shore, lay a formal garden, partly terraced out into the water, and a private anchorage sheltered by a protecting mole. The coast of the northern side of the inlet was more irregular, an irregularity that was deliberately exploited in the layout of the quays and buildings along it. The principal

features on this side were an improved anchorage near the point; towards the centre an elaborate suite of baths and sunny, southward-facing rooms, and beside it, a rectangular ⊔-shaped portico, also facing south; and, directly opposite the main block but facing south-east at a slight angle to it, a quayside portico 475 feet (145 m.) long. At the head of the inlet, facing down it and linking the residential block to the long portico, was a large, concave feature, consisting of three small shrines placed symmetrically at the centre and two extremities of a curved Doric portico, and, behind and above them, a second portico carried on a covered passageway, or cryptoportico.

The whole layout is of extraordinary interest and variety, qualities that are repeated in the treatment of the individual groups of buildings, notably in the complex of living-rooms and baths on the north side of the inlet. This was grouped around a curved, re-entrant courtyard which occupied the greater part of the frontage. The curve of the façade repeats on a slightly smaller scale that of the harbourside terrace in front of it, and along the whole length of it ran a portico, interrupted only at the head of the curve by four large columns, which must have carried a gable projecting from the building behind. The gable marked the position of a large, open or partially open triclinium, with views both outwards across the water and inwards, through the arches or windows of a projecting, curved inner wall, on to a peristyle garden behind. Opening off the portico to either side of the central room, on the oblique axis of the curve, there were two smaller chambers (*diaetae*). The long portico follows a simpler, but no less effective, plan. This was the *ambulatio*, where the owner of the villa and his close friends might take their exercise or sit and enjoy the view from one of the seats placed in the small rectangular or curved recesses along the rear wall. A square central chamber might serve as a more intimate dining hall; and if the owner wished seclusion, there was a small private suite at the south-west end of the portico.

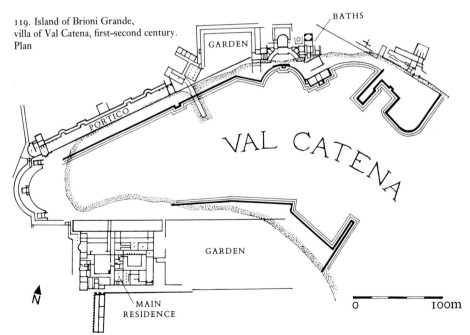

119. Island of Brioni Grande, villa of Val Catena, first-second century. Plan

With this example before one, it is obvious that a painting such as that from the House of Lucretius Fronto at Pompeii [95] is no flight of fancy, but depicts real architecture, the sort of building that the artist had seen many times along the neighbouring coasts, possibly even an actual country property belonging to the owner of the house. Here is the same porticoed façade as at Val Catena, the same curving setback on the central axis, in this case with a circular pavilion in the centre, perhaps to house a fountain. For the convex porticoed feature at the ends of the two wings one may compare the Damecuta villa on Capri, described below. The projecting wings themselves, to be seen on another Campanian painting, from Stabiae, recall the ⊔-shaped portico at Val Catena, or that of another Dalmatian villa, at Punta Barbariga near Pola, where the summer quarters were grouped around a ⊔-shaped peristyle, which opened westwards directly on to the sea. There are several other Campanian paintings, now in Naples, illustrating the broader layout of these seaside, or lakeside, villas, with their long, low porticoes and deliberately informal grouping, to which it was essentially the setting of trees, rocks, and water that gave unity and meaning. This was architecture in a landscape; a highly sophisticated landscape, it is true, but not for that reason any the less deeply felt or less skilfully handled.[15]

For an actual Augustan example of one of these Campanian seaside villas one may turn to the island of Capri. Though better known as the refuge to which Tiberius retired during the last ten years of his reign, the whole island had in fact been acquired fifty years before by Augustus, of whom·it was a favourite summer resort, and to whose hand may certainly be attributed the so-called 'Palazzo a Mare'.[16] This lay along the open crest of the low cliffs, between 100 and 150 feet above sea-level, half a mile to the west of the Marina Grande, in the middle of the north coast of the island; and although the many structures then surviving suffered greatly in the early nineteenth century and one can now make out very little of the detail of the individual

buildings, the broad layout can be traced from the series of terraced platforms strung out along the cliff-top for a distance of well over 600 yards. The main residential block lay towards the east end, with a bath-building just behind it, and a short distance to the west, at the same general level, there is the platform of what may have been a long ⊔-shaped portico, facing out to sea across a garden laid out at a slightly lower level. Beyond this again the terraces drop gently westward, with a slight shift of alignment, and near the west end, built into and down the face of the cliff, are the remains of the so-called 'Bagni di Tiberio', a separate waterside block of apartments with its own enclosed pool, or miniature anchorage. A rather larger harbour lay just outside the villa proper, to the east, and scattered throughout the whole area are the cisterns so essential for the amenities of a summer villa. To judge from what has survived, it was not a particularly elaborate or luxurious example of its type. Strung out along the cliffs, however, against a backcloth of wooded mountains, it belongs unmistakably to this fascinating class of villas, in which, as perhaps in no other domestic architecture of the ancient world, landscape and buildings were so unmistakably and indissolubly two parts of a single whole.

Slightly later than the Palazzo a Mare, and far better preserved, are two other Capri residences, the Villa Jovis (the name is ancient) and the Damecuta villa, both of which bear the unmistakable stamp of the sombre personality of Augustus's successor, Tiberius.

The Villa Jovis [120, 121] is magnificently situated on the rocky eastern summit of the island, perched on a cliff that drops a thousand feet sheer to the sea below.[17] The site did not lend itself to spacious treatment; and the suspicious temper of the emperor forbade the luxury of development on lines that would have made it readily accessible from without. Despite these restrictions, however, the architect succeeded in planning a residence that was no less a part of its setting than the seaside villas just described, incorporating several of their most characteristic features. In such a position the

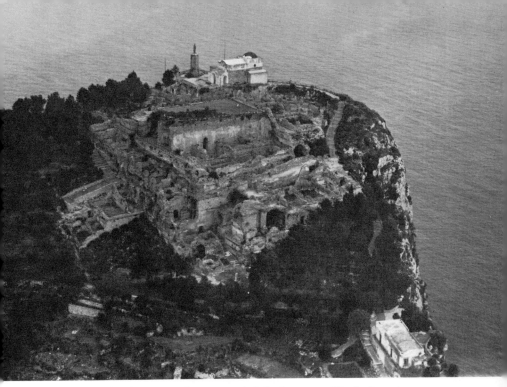

120. Capri, Villa Jovis, the private, mountain-top retreat built by the emperor Tiberius (14–37)

collection of every drop of rainwater was an urgent necessity, and the core of the villa was a rectangular courtyard measuring 100 by 100 feet (30 by 30 m.), suspended over a network of massive, vaulted cisterns. Built around and against this nucleus, at a number of different levels connected by staircases and ramps, were four distinct wings. The entrance, with a columned vestibule and guardroom, was at the south-west angle. Along the south side, separated from the main block by a corridor, lay a suite of baths; along the west side, built up against the sheer outer face of the cistern block, were the lodgings of the emperor's entourage, three almost identical storeys of simple, cell-like rooms, each opening on to a long, narrow corridor; and along the north and east sides, cut off from the rest of the building and carefully shielded against any unauthorized access, were the quarters of the emperor himself. In the buildings of the east wing, a suite of rather larger rooms backing on to a projecting hemi-

cycle, one may recognize the audience hall and reception rooms necessary to an emperor even in retirement. To the north, almost completely detached beyond a suite of four rooms occupied by the emperor's personal servants and body-guard, lay the emperor's private apartments. Very modest in scale but richly appointed, they opened on to a sheltered terrace, with steps leading up to a belvedere offering magnificent views over the greater part of the island and the Bay of Naples. From the entrance to the private apartments a corridor, with a ramp and flights of steps, led down to a long, narrow terraced walk, set on the lip of the steep northern slopes, some distance from, and 60–70 feet below, the level of the main block. This was the ambulatio of the villa, just like that of the Val Catena villa, with recesses for seats and, in the centre, a vaulted dining-room with a small suite of private rooms opening off it. Other related structures are a signal tower and lighthouse, situated on an eminence a hundred yards to the south of the

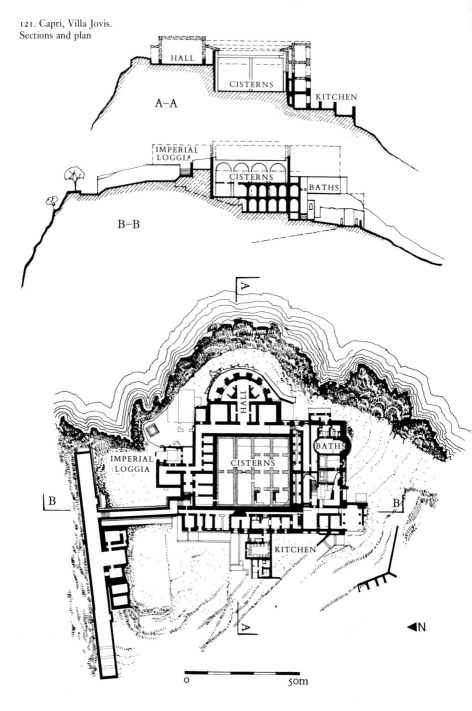

121. Capri, Villa Jovis.
Sections and plan

main block; below, and projecting from the western wing, a large kitchen; and, somewhat detached from the rest, a group of massive foundations sometimes identified as those of the observatory of the emperor's private astrologer, Thrasyllus. To the west, terraced down the slopes, are traces of gardens.

Few Roman buildings that have come down to us convey such a vivid impression of the personality of the unknown architect and of his skill in wedding the unusual terms of his commission to the potentialities of a magnificent but difficult site. Here, on a waterless mountain-top, throughout the summer months the emperor could conduct affairs of state or retire into absolute seclusion, enjoying the beauties of nature and as safe as human ingenuity could contrive, and yet maintained by an ample staff and surrounded by every comfort. A modern housewife might criticize the location of the kitchen, but by contemporary standards it was unusually large and well appointed. The planning was as sensitive as it was skilful. The diversity of interest resulting from the loose, spreading layout of most of these luxury villas was here achieved within the limitations of a compact, tightly organized plan by means of a skilful play of levels. On such a site a more relaxed plan might well have spelt architectural confusion.

The site of the Damecuta villa, 500 feet above sea-level on the broad, shelving promontory that slopes gently downwards from Anacapri, towards the north-west corner of the island, lacked the rugged grandeur of the Villa Jovis but offered far greater scope for the development of the individual buildings.[18] The remains, being more accessible, have suffered far more than those of the Villa Jovis, and, apart from the huge cisterns on the upper part of the site, the principal features now visible are those along the brow of the cliffs that slope steeply towards the north-west. Here the central feature is an ambulatio of the familiar pattern, following the line of the cliff edge, with alcoves for seats on the landward side. At the south-west end are the substructures of what appears to have been a residential block, of which the most con-

spicuous feature is the curved projection of the central part of the seaward façade, with the footings of a porticoed loggia running around the outer face, and at the opposite end of the ambulatio, below the rock platform of a medi-eval tower on the site of what was perhaps a belvedere, there is an isolated suite of small but luxuriously fitted rooms, terraced into the cliff face and approached only by a narrow ramp and steps. As in the Villa Jovis, this must be the emperor's private suite. That the same architect was responsible for the two buildings one can hardly doubt. The main difference is that here he was free to develop his plan upon more conventional lines, more closely resembling those of the Augustan Palazzo a Mare. The baths, the service buildings, and the lodging for the emperor's retinue were scattered over a considerable area within the grounds, which every analogy suggests were elaborately planted and landscaped.

To follow the story up in the same detail is impossible within the compass of a general review of Roman architecture. Nor is it neces-sary. If one makes allowance for the rapid increase in luxury during the first century A.D., for the impact of the new building materials and for the innumerable cross-currents inevitable within a society in a state of rapid evolution, the story is in its essentials one of the development of architectural themes that were established under Augustus and his immediate successors.

One important current somewhat paradoxi-cally leads back to Rome. The Roman taste for landscaping and for gardens was, it seems, one of the many introductions from the hellenistic world that took steady root and throve on Italian soil. Already by the end of the Republic it had manifested itself in a wide variety of related forms: within the towns by the addition of the peristyle to the old atrium-house and by the creation of such monumental formal gardens as the Porticoes of Pompey and of Livia;[19] in the open countryside by the creation of the land-scaped country villas of southern Latium and Campania and, within a generation or two, on the Adriatic coast too, and in North Italy; and thirdly, as the city centres grew more and more

crowded, by the development of the villae suburbanae and the parks (*horti*) of the wealthy upper classes. By the middle of the first century B.C. Rome was already ringed around by such private properties, very much in the manner of the belt of Renaissance villas and parks which formed an almost continuous ring around the city right down to 1870. Some of these estates were subsequently built over: the gardens adjoining the Baths of Agrippa and the Mausoleum of Augustus were probably carved out of what was left of the horti of the Republican Campus Martius. Others, such as the Gardens of Lucullus, of Sallust, and of Maecenas, survived as parks and private residences; and belonging wholly neither to town or country, they were the natural meeting-point of the two divergent architectural traditions. For example, the great hemicycle of the Early Augustan villa suburbana beneath the Farnesina[20] finds its closest contemporary analogies in Campania. They were, moreover, a natural field for fantasy and experiment. We have already suggested that the garden pavilions, fountain-buildings, and grottoes of those parks may have had a lot to do with shaping the new spatial conceptions that characterize the palace architecture of the later first century A.D. Last but not least, like the English eighteenth-century parks which in many ways they so closely resemble, they were the embodiment of the cultured ideals of the age. It is to the pages of Cicero or Pliny that we have to turn for a glimpse of the intellectual conventions which lay behind the 'gymnasium' porticoes and garden terraces (*xystoi*), or of the literary conceits which shaped the precursors of the 'stadium' of the Domus Augustana and the 'Academy' of Hadrian's Villa.[21]

In course of time a great many of these properties fell into imperial hands, and as they did so they offered an irresistible outlet for the more frivolous architectural whims of the reigning emperor. Both Caligula and Nero were active in this field, and under the latter a combination of circumstances gave a new and dramatic twist to the resulting development. Nero was born at Antium (Anzio), and one of his earliest architectural ventures was to re-

model the villa of his birth.[22] Too little has come down to us (and that little too ill studied) to convey any coherent picture of the whole, but it was undoubtedly a luxurious seaside estate of a type familiar from innumerable earlier examples. Another early venture (it was in occupation by A.D. 60) was the villa at Subiaco.[23] This too was built around the nucleus of an earlier building, but in this case the site was completely transformed by damming the valley below the later monastery to create an artificial lake, so creating a landscaped 'seaside' villa within the setting of an upland Apennine valley. Yet another contributory circumstance was Nero's inheritance of a property on the Velia and his decision to link the imperial estates on the Palatine and on the Quirinal and Caelian Hills into a single residence, the Domus Transitoria. It was from these ingredients that the idea of the Golden House took shape – a landscaped villa of which the central feature was an artificial lake, and at the same time a villa suburbana and its surrounding parkland transplanted to the heart of Rome. Here, on a scale never to be repeated, was embodied the Roman vision of *rus in urbe*.

This determination to have the best of both worlds, to enjoy all the advantages of an advanced urban civilization within a setting of the rustic amenities that Italy was so well equipped to offer, is perhaps the most consistent single characteristic of all this wealthy country architecture of the Early Empire. It cut right across the traditional formal proprieties of peristyle and portico, of town and country, of nature and art. When Tiberius or Caligula remodelled the upper terrace of Pompey's great platform-villa at Albano [122],[24] with its magnificent views out across Lanuvium towards the sea, the scheme adopted was essentially that of the House of the Stags at Herculaneum [112], with a central pergola and garden flanked by two diaetae; but the conventions of conservative, rectangular planning were thrown to the winds. The diaetae were angled so as to take full advantage of the summer and winter sun, and the rooms behind were fitted in around the hemicycle of the north-east façade in a manner

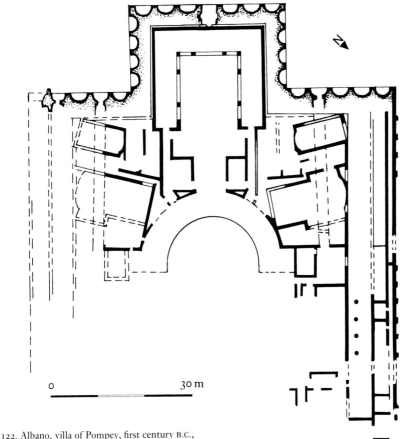

122. Albano, villa of Pompey, first century B.C., remodelled in the first century A.D. Plan

0 30 m

which in the context must surely reflect the latest models among the villae suburbanae of the capital. From this sort of thing it was only a short step to the octagon of the Golden House.

Half a century later the Villa of Pompey became part of Domitian's great estate at Albano.[25] The latter's country house beside the Lago di Paola, near Monte Circeo,[26] seems to have been a seaside portico-villa of conventional type. That at Albano, on the other hand, was comparable both in scale and character to the Golden House and Hadrian's Villa, a palace in all but name. The park stretched from Castel Gandolfo to Albano and from the lake to beyond

the Via Appia, and besides incorporating several earlier landscaped villas it was dotted with buildings of its own, among which one can still identify a theatre, a 'stadium', 'gymnasium' terraces and promenades, waterside jetties, and an abundance of pavilions and fountain-buildings. The main residence occupied one end of the three descending terraces on the seaward side of the crest and, though never adequately explored, it must have been a building of considerable pretensions, at least three storeys high and making full use of the latest building methods and materials, as we see them in the buildings of Rabirius on the Palatine.

All these traditions and trends were caught up and consummated in Hadrian's great villa at Tivoli [123, 124]. The architecture of most of the individual buildings was strictly contemporary. The layout, on the other hand, with its deliberate juxtaposition of conflicting axes that follow the natural lie of the ground,[27] stems straight from the landscaped villas of the previous century, and the themes of the individual buildings and groups of buildings belong to an

123 and 124 (*opposite*). Tivoli, Hadrian's villa, between 118 and 134, model and plan

TR. Triclinium

even earlier tradition, that of the wealthy Late Republican villa – the terraced 'gymnasia' with their libraries and sculpture galleries, the theatres, the belvedere tower ('Roccabruna'), the covered portico for exercise (the 'Percile'), the bath-buildings, the pavilions and *al fresco* dining halls. The names given to many of these buildings[28] were not the whims of a much travelled emperor, nor were they in any significant sense copies of the famous places and monuments whose names they bear. They were traditional conceits, to which Hadrian's own well-known philhellenic tastes were no more than a contributory factor.

The country residences of the emperor and of the very rich were one aspect only of the rural scene, albeit one which increasingly tended to become identified with the more progressive trends in contemporary architecture. Side by side with these great estates there were innumerable smaller properties for which the peristyle-villa long remained the established norm. Many of the early buildings remained in active use, remodelled and modernized but still recognizably grouped around their original courtyard nucleus. The Tuscan villa of Pliny the Younger, for example, still possessed an atrium, *ex more veterum*.[29] For another thing, over large parts of the Mediterranean world, from Spain to Syria, the peristyle-house was the standard form of better-class domestic architecture both in town and country; and with the steady breaking-down of regional barriers Italy was bound to be influenced increasingly by provincial practice. In the absence of systematic excavation we do not know nearly as much as we should like to know about the lesser country houses of Roman Italy (far less than we know, for example, about their Romano-British equivalents), but it is almost certainly true to say that among villas of any architectural pretensions the peristyle-house remained by far the commonest type right down to late antiquity. There were of course also innumerable smaller, simpler buildings in everyday local use; but about these we are even worse informed. For the present they must be held to fall within the province of the

archaeologist and the social historian rather than of the historian of classical architecture.

Under the later Empire the interest of the Italian villa in suburb or country shifts increasingly away from landscape and large-scale planning and towards the architectural treatment of the individual buildings. Here, while most villa owners seem to have been content with relatively minor adaptations of the traditional schemes, a certain number did follow the lead of Domitian and of Hadrian in exploring their development in terms of the new concrete architecture. One such experiment was that embodied in the 'Grotte di Catullo', a very large platform-villa built, probably early in the second century, at the northern tip of the peninsula of Sirmione, on Lake Garda [125].[30] The plan was symmetrical about its longer, north-south axis and consisted of a rectangular central block, 590 feet long and 345 feet wide (180 by 105 m.), with two small rectangular blocks projecting at the two ends. That at the north end was built up on enormous substructures to carry a terrace, offering magnificent views out over the lake, and although the terrace itself has gone, the plan suggests a version of the familiar theme of a triclinium looking out across a terrace with a pair of flanking diaetae and perhaps a pergola. The other living quarters faced inwards on to the very large garden courtyard which occupied the centre of the main block. The layout, though based on the peristyle-villa, was monumental in conception and was clearly the product of the same sort of architectural thinking as that embodied in the ceremonial wing of the Domus Augustana.

The 'Grotte di Catullo' represent an experiment that was not followed up widely, if at all. A more representative picture of second-century enterprise is offered by the wealthy 'suburban' villa of Sette Bassi, outside Rome near the sixth milestone on the Via Latina [126, 127]. This was the product of three successive building campaigns undertaken in rapid succession between about 140 and 160.[31] The first of these was conventional in plan and consisted of a compact residential block occupying the south side of a

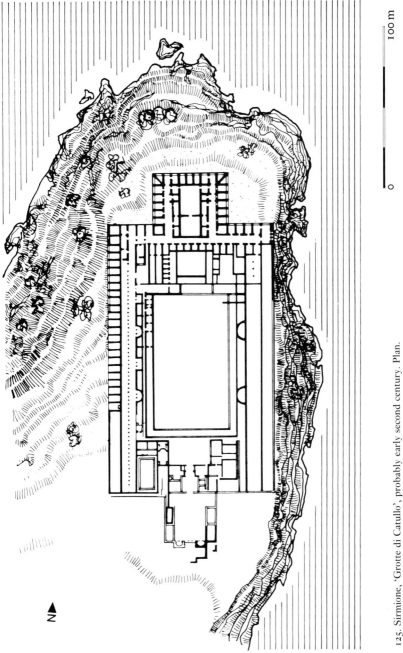

100 m

0

125. Sirmione, 'Grotte di Catullo', probably early second century. Plan. The surviving remains at the north end are those of the huge substructures on which the main living quarters were terraced out towards the lake

N

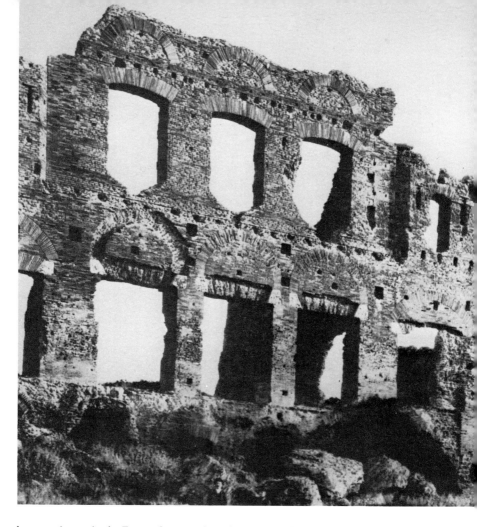

large garden peristyle. Except for a number of smaller upper rooms the whole building occupied a single level, and the exterior at this stage was very simple. Very soon after completion a second wing was added, along the west side of the entrance peristyle. This involved terracing out on substructures and, although smaller, the added wing was more ambitious in design. The southern half of the new west façade was occupied by a projecting hemicyclical veranda, with a portico enclosing a fountain court, and the outer face of the supporting terrace was crowned with a decorative motif of shallow

segmental arches carried on travertine brackets, akin to the 'balconies' (*maeniana*) of Ostia and of the façade of Trajan's market hall overlooking the Via Biberatica. The third stage was the most elaborate of all. This involved the building of a new wing across the north end of the area immediately west of the the existing building and the addition of a vast cryptoportico, over 1,000 feet long, enclosing the whole area west and south of the residential complex as a formal, terraced garden. The new north wing was monumental both in scale and in intention. The whole length of it was built up on terraced

126 (*opposite*) and 127. Rome, Via Latina, Villa of Sette Bassi, *c.* 140–60, façade (now fallen), and restored views of villa, looking north-westwards, and of north façade

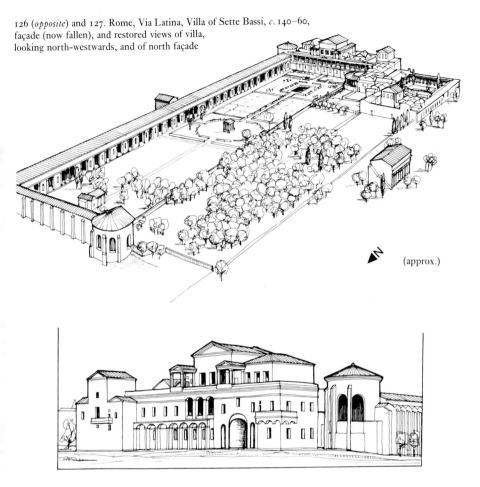

N (approx.)

substructures to counteract the natural west-ward fall of the ground, and the *piano nobile* was divided almost equally between, at the east end, two suites of rooms (one of them a bath-building) opening off an arcaded courtyard, and at the west end two very large, lofty reception halls. The latter rose clear of all the surrounding structures and occupied the full width of the building between the pair of corridors which ran down the north and south façades at this level; and although there was no attempt at formal symmetry, the large triple windows and gabled roofs of these halls, towering high above the continuous roof-line of the corridors, did in fact provide a most effective focus for the whole composition at the point where the natural fall in the ground gave it the maximum of emphasis.

For all its debt to the villas of the previous century – the garden, for example, is patently a sophisticated version of the 'stadium' motif – this was a strictly contemporary building. The arcaded courtyards, the windows, the brick mouldings and bracketed 'balconies', all of these came straight from contemporary urban prac-tice. So did the decorative use, without any stucco surfacing, of such elements as window-

frames and relieving arches and of the masonry facing itself, in this case a very early and effective use of *opus mixtum*, in which the brickwork alternated with bands and panels of small tufa blocks. Among the many features that looked forward to later practice (at Spalato, for example) were the high lighting of the main halls and the corridors along the main façades.[32] The small inner 'peristyle' of the early block, with its principal living-room looking out across a small arcaded garden courtyard on to an elaborate fountain structure, was already moving towards a type of plan that was common in fourth-century Ostia. Perhaps the most striking anticipation of late antique and medieval practice was the use of slender, sloping buttresses to support the plunging outer faces of the cryptoportico and of the circular towers at the angles of it.

The most obvious distinguishing characteristic of the Sette Bassi villa is its application of up-to-date building techniques and masonry finishes to introduce an element of taut monumentality within the hitherto rather relaxed sprawl of the landscaped country residence. Domitian seems to have set the fashion in his villa at Albano, and tower-like residential blocks two and three storeys high are a feature of several other wealthy second-century villas on the periphery of Rome – the Villa of the Quintilii on the Via Appia, for example, or the 'Mura di S. Stefano', near Anguillara.[33] In other respects the wealthy domestic architecture of the Central Italian countryside seems to have been content to exploit the existing models. The Horti Variani of Elagabalus were still an elaborately landscaped villa suburbana of which the known buildings include a circus, an amphitheatre (the Amphitheatrum Castrense), a bath-building (the Thermae Helenae), and the great audience hall which Constantine converted into the church of S. Croce in Gerusalemme.[34] The Villa of Maxentius, with its more compact articulation of residence, circus, and mausoleum, does, like so much of Maxentius's work, suggest the impact of new ideas.[35] In the event, however, these were stillborn. The representative monuments of the immediately pre-

Constantinian age, which will be discussed in a later chapter, are the great villa of Piazza Armerina and Diocletian's palace at Spalato.

THE LATE ROMAN TOWN HOUSES OF OSTIA

It remains to make brief reference to the rather surprising re-emergence in late antiquity of the *domus* as a significant feature of the metropolitan city scene. Once again it is Ostia that furnishes the evidence. For nearly two centuries such single family residences as had been built at Ostia were almost invariably of the peristyle type, built around a colonnaded or arcaded courtyard. Good examples are the second-century House of Fortuna Annonaria [128A][36] and the somewhat later, more orthodoxly planned House of the Columns [73].[37] There was invariably one main reception room, the *triclinium*, and the first-named had also one centrally-heated room – the earliest example in domestic use yet recorded from Ostia. But these were the exceptions. Right down to the middle of the third century the standard urban residence even of the well-to-do was the apartment-house, or *insula*.

Under the later Empire, however, as land values dropped, there was a marked shift of emphasis away from the insula and back to the domus. The late antique private houses of Ostia follow no regular plan, preferring to adapt themselves wherever possible to the structures of already existing buildings. But they do have a great many distinctive features in common with each other – a courtyard, usually containing an elaborate fountain; opening off the courtyard, often up several steps, the main living-room of the house; central heating in one or more rooms and in several cases private lavatories; a lavish use of coloured marbles on walls and floors; and a marked taste for apses and for triple-arched columnar screens of a type widely used in late antiquity as an alternative to (and no doubt originally developed from) the 'arcuated lintel' convention. In the already existing House of Fortuna Annonaria [128A] the innovations were aimed mainly at the enlargement and

128. Ostia. Plans of houses and apartment-houses.
(A) House of Fortuna Annonaria, late second century,
remodelled in the fourth century;
(B) House of Cupid and Psyche, *c*. 300;
(C) House of Diana, *c*. 150 [cf. 76];
(D) Garden House, 117–38

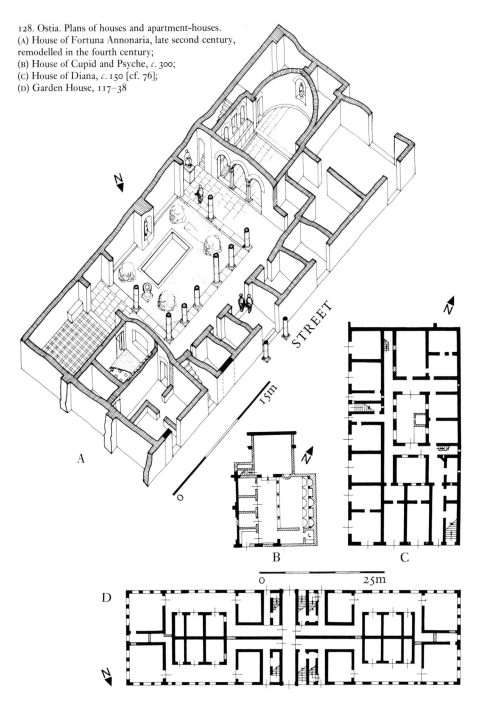

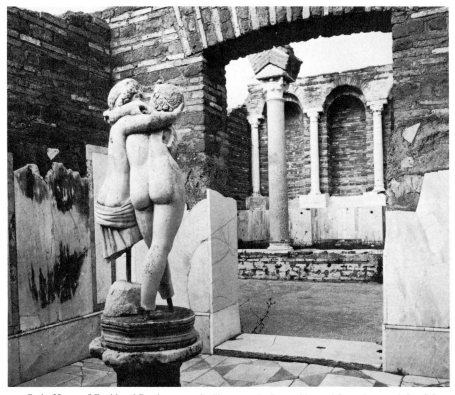

129. Ostia, House of Cupid and Psyche, *c.* 300, looking towards the corridor and fountain court [cf. 128B]

embellishment of the triclinium by the addition of a large apse, a fountain (with latrine behind) along the south wall, and a triple-arched screen towards the courtyard. The House of Cupid and Psyche [128B, 129][38] rather unusually had an upper storey over the western range of small rooms. Even so more than half the available floor space was taken up by the luxuriously marbled, centrally heated triclinium and by the large central corridor, one side of which was an arched columnar screen looking out across the garden courtyard to the elaborate fountain that occupied the whole of the east wall.

These houses represent something quite new in Italian domestic architecture. Analogies have been sought in North Africa,[39] but the closest parallels would seem to lie rather with the contemporary houses of Syria, as revealed by the Antioch excavations. With their intimate association of triclinia and fountain courtyards and their seemingly deliberate avoidance of symmetry, buildings such as the early-third-century house at Seleucia [210] or the late-third-century House of Menander at Antioch[40] do indeed have a great deal in common with these late Ostian houses. At a time when the old regional barriers were everywhere breaking down, nothing is in fact more likely than that Ostia, with its many Oriental connexions, should have drawn upon the experience of the wealthiest and most influential city of the Roman East.

THE ARCHITECTURE
OF THE ROMAN PROVINCES

CHAPTER 9

GAUL AND THE EUROPEAN PROVINCES

Within the confines of Italy it is still possible to speak of 'Roman architecture' and to understand thereby an architecture which reflects that of the capital so closely that the term is intelligible without further qualification. There were indeed diversities of local taste and practice, but these were no more than one would expect to find as a result of the very considerable differences that still existed in Italy under the Early Empire, in historical and social traditions as well as in climate, materials, and building practices. As Roman political authority expanded, however, Rome found herself the political mistress of a kaleidoscopic variety of peoples covering every shade of the civilized spectrum. It was her great achievement that, after an initial period of exploitation and misrule under the Late Republic, she did succeed in welding this heterogeneous assortment into a body politic within which all the participants could feel themselves to be in some real sense Romans. But this took time. Under the Early Empire there was still a wide gulf between the superficial unity of the political framework and the extraordinary diversity of cultures, social habits, and languages contained within it. Any study of classical art in the wider setting of the Empire is almost bound, therefore, to find expression in a dialogue between those elements that accompanied the uniting of a large part of the civilized world upon a basis of peaceful, day-to-day exchange and those that derived instead from the individual traditions and propensities of its very diverse constituent peoples.

Of the many cultural boundaries that one can draw within the Roman Empire, by far the most important is that which separated the Greek-speaking provinces of the eastern Mediterranean, including the eastern Balkans and Cyrenaica, from the Latin-speaking West. The difference is one not merely of language (there were indeed substantial areas in the west, in Southern Italy and Provence, where Greek long remained the common language of the educated classes) but also of recent history. The eastern part of the Roman Empire corresponds closely in extent with the hellenistic kingdoms established after the death of Alexander, and throughout these territories Rome was dealing with peoples who either boasted a far longer native tradition in the arts than she did, or else had at the very least undergone the same hellenistic experience as herself. In matters of the arts she was dealing here with her equals or superiors. In the European West she was, on the other hand, for the most part confronted by civilizations which, whatever their potentialities, were substantially inferior to her own. Even here the process of romanization can be seen in the long run to have been one of give and take; but in the early stages it was Rome that was the dominating member of the exchange.

Within the Latin-speaking half of the Empire there were regional and local differences hardly less far-reaching than those between East and West – differences of geographical orientation, inwards towards the Mediterranean or outwards towards the Atlantic, the Rhine, and the Danube; differences of cultural background, between those territories that already had enjoyed some measure of urban life under Greek or Carthaginian rule and those that the Romans found still organized upon a purely tribal basis; and differences of historical circumstance, between those which settled down rapidly under civilian rule to enjoy the fruits of the Roman Peace and those in which Roman civilization was, and long remained, dependent upon the presence of the army. When one recalls the great differences also of climate and of natural resources (over much of Northern and Central Europe, for example, timber was still available for building in almost unlimited quantities) it is hardly surprising that the resulting provincial architecture should be seen to cover a very wide range of local practice.

Nevertheless, by comparison with the provincial cultures of the eastern half of the Empire those of the European provinces during the first two and a half centuries of our era do display the wider unity of a civilization which in almost all its manifestations stemmed more or less directly from Italy. It is this wider unity which must be held to justify the devotion of the greater part of this chapter to the architecture of a single region, Gaul. Roman Gaul is broadly representative of what was happening all along the northern frontiers of the Empire. It was unique only in the degree to which it succeeded in making Roman civilization its own.

THE IBERIAN PENINSULA

Spain[1] was the only western province with an early flowering in any way comparable to that of Gaul. Spaniards were among the first provincial citizens to take their place as equals within the Empire; Seneca was born at Córdoba, Quintilian at Calahorra (the Roman Calagarris), near Zaragoza, and the first two non-Italian emperors, Trajan and Hadrian, were both of Romano-Spanish stock, from Italica near Seville. Then as now, however, Spain was a land of strong contrasts. Despite the fact that large parts of it had been under Roman rule since 206 B.C., Augustus two hundred years later had to engage in long and bitter fighting before the entire peninsula was finally subdued; and although it had valuable resources, particularly in minerals, romanization was never as broadly based as it was in Gaul. Even if one makes allowance for the continuous occupation since Roman times of most of the major cities and the consequent destruction of most of the finer monuments, one can hardly fail to be struck by the limitations of the Hispano-Roman architectural tradition.

The finest monuments are significantly those of the Early Empire, from Augustus to Trajan. By contrast the two preceding centuries of Republican rule have in themselves left little tangible mark on the archaeological record. There must have been fortifications and public works of a specifically Roman character during this period; and the establishment of military colonies, of which Italica (206 B.C.) was the first, had undoubtedly helped to spread urban life on the Mediterranean model. But although there is at present little to show how much of all this was based directly on Italian models and how much was evolved locally within the framework of the established Graeco-Punic building tradition, there can in fact be little doubt that, as in Provence and in Punic Africa, the real long-term significance of the Republican Roman presence in Spain was that it prepared the ground for the outburst of building activity that took place under Augustus and his immediate successors. To cite a single example, Mérida, the military colony of Augusta Emerita founded in 25 B.C., by 18 B.C. already possessed a fine theatre and by 8 B.C. an amphitheatre; and the other known structures of Mérida that are attributed to the Augustan or the immediately following period include three aqueducts, a circus, and a magnificent sixty-arch bridge across the river Guadiana.

130. Segovia, aqueduct, variously dated to the early first and to the early second century. It still carries the city's water supply

A characteristic of this early work, and one which continued for a long time to make itself felt in Spanish provincial building, was the fine tradition of opus quadratum stone masonry. The workmanship varied with the quality of the stone locally available. In the great aqueduct at Segovia, nearly 900 yards and 128 arches long and nearly 100 feet high at its highest point [130], the blocks were left rough, giving an air of solid strength to the unusually tall, slender

piers.[2] The builder of the aqueduct of Los Milagros at Mérida, on the other hand, employed smaller courses of stone, using them as a facing around a core of concreted rubble and alternating them with narrow bands of brick, very much as in a lot of Gaulish work. The aqueduct at Tarragona, another impressive but more conventionally proportioned structure, over 200 yards long and 250 feet high, used a coarse mason's drafting, whereas the builders of the bridge at Mérida chose a heavy bossing, akin to the decorative *bugnato* of Renaissance practice. Another justly renowned bridge is that built in 106 by Trajan over the Tagus at Alcántara [131]. This was a structure of deceptively simple-looking proportions (the six arches are, in fact, of four different spans) with an arch spanning the carriageway over the central pier and a small bridgehead temple. An unusual feature of the dedicatory inscription is that it names the architect, Gaius Julius Lacer. One is reminded of another Trajanic bridge-builder who was also an architect, Apollodorus of Damascus.[3]

For a graphic vision of what Romanization meant in the Iberian peninsula we now have the excavations at Conimbriga in Lusitania, near

Coimbra in north-central Portugal. Here, in the middle of what had been a pre-Roman promontory settlement, the existing buildings were levelled to make way for a civic centre built in the new Roman manner. This in its turn was swept aside a century later, but the foundations and in places the substructures present a picture that is clear in its essentials [132A, B]. A central paved piazza, measuring 125 by 83 feet (38.10 by 25.35 m) – a strict application of the Vitruvian precept (V. 1, 2) that the dimensions of a public place should be in a ratio of 3:2 – was framed on the south and west by porticoes; shops opened off the west portico, and, facing them, along the east side of the paved open space, were a severely simple, three-aisled basilica and a small rectangular chamber with a vestibule, which in the context must surely have housed the curia. At the north end the ground dropped, and here a cryptoportico formed the substructure of an upraised transverse portico and, axially beyond it, the square cella of a temple. The layout, a concise architectural expression of the three fundamentals of Roman civic life, official religion, orderly government, and commerce, is in effect that of the forum at Velleia, except that, as at Iader

131. Alcántara, bridge over the Tagus, 106

(Zadar) in Dalmatia, the basilica is displaced to one side. It also recalls Velleia, and countless other pre-existing urban centres throughout the Empire (we shall be meeting well documented North African examples at Thugga (Dougga) and Sabratha), in the readiness of Roman

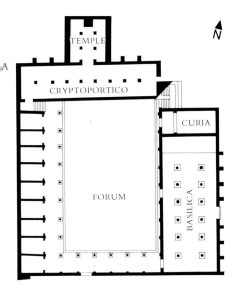

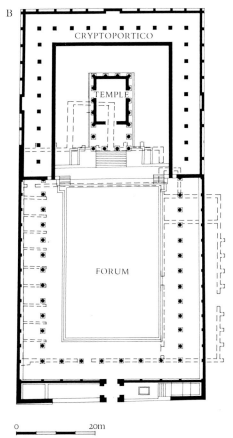

132. Conimbriga. (A) and (B) Forum,
(A) late Augustan (c. A.D. 1–14), and, replacing it
(see dotted outline), (B) late Trajanic

0 20m

architects to impose an order and a symmetry which were as alien to what was there before as the Via Nazionale was to nineteenth-century Rome or the boulevards and expressways of modern Brussels.

When the site was redeveloped towards the end of the first century A.D. the shops, the basilica, and the curia were eliminated, presumably to be resited independently, and their place was taken by an enlarged forum, enclosed symmetrically on three sides by porticoes and dominated on the fourth side by the temple, now rebuilt as a free-standing tetrastyle,

pseudoperipteral Corinthian building, set within a raised temenos and framed on three sides by double porticoes. This was a thoroughly conventional scheme, little more than an opulent restatement of its predecessor, and it was one that would have been at home in any of the western provinces; we shall meet something very like it at Sabratha in Tripolitania. By contrast, the other major public building to be excavated, the South Baths [132C, D] did undergo a substantial and significant architectural development. The original Augustan building, a compact, interconnecting suite of hot and cold

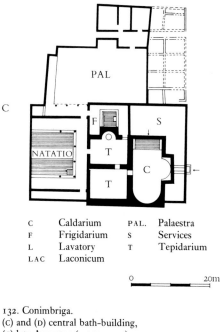

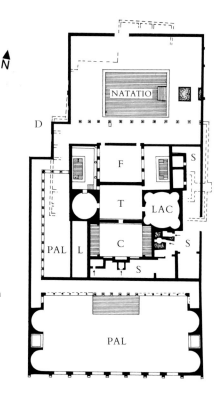

C	Caldarium	PAL.	Palaestra
F	Frigidarium	S	Services
L	Lavatory	T	Tepidarium
LAC	Laconicum		

0 20m

132. Conimbriga.
(C) and (D) central bath-building,
(C) late Augustan (c. A.D. 1–14)
and, replacing it (see dotted outline),
(D) late Trajanic (c. A.D. 105–15)

rooms with an open-air cold plunge and a small palaestra, was closely based on Pompeian models. Its Trajanic successor, on the other hand, was not only larger and richer, but it embodied quite a different type of layout, planned symmetrically about its north–south axis, in this conforming, as we shall see, to contemporary Gallo-Roman practice. The Conimbriga excavations are significant not least because they document so clearly two of the three main formative influences on the Romano-provincial architecture of the Iberian peninsula: Italy, particularly in the earliest stages, and Gaul. The third was, of course, Roman Africa.

Other buildings that deserve passing mention are the Temple of Rome and Augustus (A.D. 16) at Barcelona, a peripteral building of which the scanty remains suggest a close relationship to the Maison Carrée at Nîmes; the mid-second-century Capitolium at Baelo (Bolonia) near Cádiz, which consisted of three distinct temples placed side by side, as at Sbeitla (Sufetula) in Africa [274]; a growing number of residential villas, some of them very wealthy and reflecting both in their plans and in their mosaic decoration the influence of North Africa; the elegant but strangely old-fashioned arch of Licinius Sura, one of Trajan's generals, at Bara; the small four-way arch at Capera; and the amphitheatre at Italica, the fourth largest (540 by 460 feet; 165 by 140 m.) in the Roman world and the scene of countless *venationes*, the Roman precursors of the bull-fight of today. But the list of outstanding monuments is short; there is little in the later Imperial architecture of the peninsula that might not have been found in any African city. Architecturally, as in much else, Spain in the second and third centuries A.D. seems to have been something of a backwater.

GAUL, BRITAIN, AND THE GERMANIES

Among the provinces of the Roman West, Gaul occupied a unique position, a position which it owed in part to the wealth of its natural resources and its geographical situation at the crossroads of North-Western Europe, in part to the accidents of history which had endowed it with a vigorous, sensitive people, capable of absorbing and putting to good use the best that classical civilization had to offer. The Mediterranean coastlands and lower valley of the Rhône had had the additional advantage of long contact with the Greek colony of Massilia (Marseille), and so it is not altogether surprising that some of the finest of the surviving monuments of the Early Empire are to be found in Provence and in the immediately adjoining districts of central and southern Gaul.

As in Spain, the results of this early exposure to classical ways did not at once make themselves felt in a specifically Roman form. The territory of Gallia Narbonensis (corresponding roughly to the modern Provence and Languedoc) was annexed in 121 B.C., but there is little or nothing in the way of monumental architecture to show before the great Augustan reorganization in the years following 19 B.C. For

a picture of provincial life during the preceding century we have to turn instead to the little city of Glanum near Saint Rémy-de-Provence. Glanum had originally been established as a Massiliote trading-post, and the principal excavated remains of the pre-Imperial town are those of its private houses. These are well planned, solidly built, rectangular structures, the rooms of which open upon a central columnar courtyard, very different in detail from the houses of contemporary Pompeii, though the standards of comfort and building practice are in no way inferior. They offer an at present unique picture of the solid foundation of Greek culture and craftsmanship upon which the Roman Imperial achievement in southern Gaul was based [133].

Between 58 and 51 B.C. Caesar conquered and annexed the 'Three Gauls', which, together with Narbonensis and the military frontier provinces of Upper and Lower Germany, henceforth comprised the whole of present-day France and Belgium, and parts of the Rhineland, the Netherlands, and Switzerland. The years that followed, under Caesar himself and his heir and successor, Augustus, were ones of rapid and enlightened progress. Retired legionaries were settled in the colonies of Arles

133. Saint Rémy (Glanum), courtyard house, first half of the first century

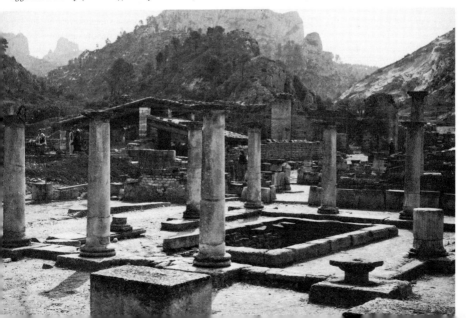

(Arelate), Béziers (Baeterrae), Fréjus (Forum Julii), Narbonne (Narbo), and Orange (Arausio), and, in the newly conquered territories, at Lyon (Lugdunum), at Nyon (Noviodunum) on the Lake of Geneva, and at Augst (Augusta Raurica) on the upper Rhine; the native cities of Nîmes (Nemausus) and Vienne (Vienna) received municipal charters; and all over Gaul new towns arose along the great trunk roads and on the sites of, or replacing, the old tribal capitals. The Romans were notoriously reluctant to think of the administration of their empire in terms of any but the urban civilization with which they were themselves familiar, and wherever an appropriate urban system did not exist it had to be created. How well they planned is shown by the subsequent history of their foundations. Even in Britain, where for a time in the Dark Ages city life was virtually obliterated, the Roman urban legacy, beginning with London itself, is still strong. In Gaul the Roman roads and towns became the essential framework of all subsequent progress. Before turning to individual monuments it will be well therefore to cast a brief glance at the towns themselves for which this essentially urban architecture was created.

In many cases the very success of these foundations has obliterated almost all trace of their beginnings. Of one of the earliest and greatest of the Gallo-Roman cities, the veteran colony of Lugdunum (Lyon), founded in 43 B.C. by Lucius Munatius Plancus, the only substantial monuments now visible are the aqueducts and the fine Early Augustan theatre and the adjoining odeion, or concert hall [141]. Of the river port that brought the city its wealth and of the great sanctuary dedicated to Augustus at the confluence of the Rhône and the Saône by the representatives of all the Gauls, there is now hardly a trace. From the records of chance finds we know that both the circuit of the city walls and the layout of the streets were irregular. The former was normal practice in Gaul, even in conjunction with the most rigidly rectilinear of street plans (e.g. Fréjus, Nîmes, Autun). The irregularity of the street plan is, on the other

hand, unusual and must indicate the existence already of a substantial Gaulish settlement on the site of Plancus's foundation.

Plancus's other colonial foundation, Augusta Raurica (Augst), the predecessor of the modern Basel, is in this respect more characteristic of Early Imperial practice. Here the nucleus of the colony was laid out in a neat grid of rectangular insulae, each measuring 165 by 195 feet (50 by 60 m.), along the crest of a ridge of high ground between two valleys. The surviving buildings offer a vivid picture of the monumental centre of a typical Gallic city; and although none is actually as early as the original foundation, they are precisely the sort of building which these formal quadrangular layouts were from the outset designed to accommodate. It is easy to dismiss such 'gridiron' planning as unimaginative, but one cannot deny the extraordinary convenience and practicality of a standard layout within which these towns could, over the years, develop the complex of public and private buildings appropriate to their status, without ever losing that sense of organic unity which, one and all, they so markedly possessed. Hardly less convenient was the possession from the outset of a definitive layout of streets and drains.[4]

The group of public buildings which came in time to occupy the centre of the colony of Augst included a basilica and forum, two large temples, a theatre, and a spacious public market [134]. The basilica, the forum, and one of the temples formed a single architectural complex, occupying three complete insulae and divided into two unequal parts by the main street of the town. On the west of the street, facing it and framed on three sides by a monumental portico, stood the Capitolium, a large hexastyle peripteral building of conventional classical type standing on a tall podium. Across the street, to the east, the line of the lateral porticoes was continued to form the long sides of the rectangular open space of the forum proper, the far end of which was closed by the massive bulk of the basilica. Originally an aisled building with two large, shallow apses at the two ends, it was

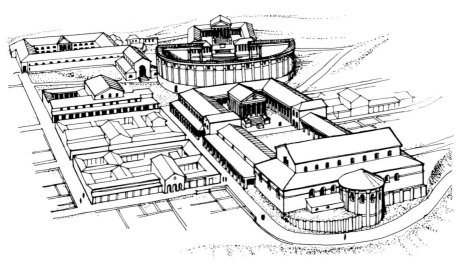

134. Augst (Augusta Raurica), restored view of the centre of the town, looking northwards, mid second century with later modifications. To the left of the forum a public bath-building and, beyond it, the market complex

later converted by the suppression of the apses into a grandiose rectangular hall, 210 feet long and 90 feet wide (64 by 28 m.), with an internal ambulatory and galleries above it. Rows of shops or offices (*tabernae*) faced inwards along the two long sides of the forum and outwards along the exterior both of the forum and of the temple precinct, those of the latter carrying a second storey. Streetside porticoes along the two long sides gave an exterior unity to the whole complex, interrupted only by the passage of the transverse street, which was itself interrupted by two porch-like structures through which only foot traffic was able to enter the actual forum.[5]

The whole complex appears to date from just before the middle of the second century A.D., and its plan, with its formal conjunction of a forum and a large official temple facing each other across the line of a transverse street, is one which we have already met in Republican Brescia, and which was widely adopted in the western provinces. We meet it again, for example, in Roman Paris (Lutetia) and at Saint

Bertrand-de-Comminges (Lugdunum Convenarum), at Virunum in Austria, at Zadar (Iader) in Dalmatia, and perhaps in a modified form, omitting the temple, in Britain also, at Caerwent, Caistor, Silchester, and Wroxeter.[6] An unusual feature of the basilica at Augst is the circular, tower-like structure added in the third century against the middle of the steeply plunging east side of the basilica. It contained five tiers of seats arranged as in a miniature theatre and was evidently the *curia*, the meeting-place of the 100 decurions who constituted the city council. The similarly placed exedra of the basilica at Alesia probably served the same purpose.

Of the rest of the central group of buildings, the theatre, just to the west of the Capitolium precinct, was sited on a slightly different orientation so as to take full advantage of the head of an oblique re-entrant on the western side of the ridge. Originally an Augustan or Julio-Claudian building, it was remodelled in 73–4 to serve as an amphitheatre, and then reconverted once more into a theatre and enlarged *c.* 120–50.

Beyond and to one side of it, terraced out above the steep western slopes, stood the market. This consisted of porticoes, with shops opening off them, enclosing three sides of a rectangular open space measuring 160 by 100 feet (49 by 31 m.); a monumental entrance, together with what may be the offices of the market officials, occupied the fourth side; and opening off the north-east angle there was a covered market hall. The latter comprised two rows of shops facing each other across an elongated rectangular hall, with stairs leading up to a second storey, which was presumably served by a wooden gallery. The second temple stood in the angle between the market and the theatre, on the summit of the prominent isolated spur of Schönbühl. Originally a large open sanctuary containing two small square shrines of typically Celtic form,[7] it was replaced, probably towards the middle of the second century, by a large (80 by 60 feet; 24 by 18 m.) hexastyle peripteral temple of purely classical type, enclosed within a monumental double portico. Temple and portico were laid out on the axis of the theatre, the stage-building of which was deliberately, and uniquely, left open in the centre so as to afford a vista down the axis. There is no means of telling whether (as often in Gaul) there was any ulterior religious significance in this relationship.

To complete the picture of the Roman city one may mention two large public bath-buildings, one established about the middle of the first century A.D. and still reflecting Pompeian models, the other probably built a few years later. The former was subsequently modernized and the latter rebuilt on a more ambitious plan, both during the course of the second century. There was also an important sanctuary in the valley to the west comprising, in its fully romanized form, a triple shrine, in plan somewhat resembling the Capitolium at Brescia, set within a large porticoed enclosure, beside the entrance to which stood a bath-building. The dedications, to the local divinity Sucellus as well as to Aesculapius and Apollo, confirm that it was in origin a native healing-sanctuary, associated with a spring. Another vivid glimpse of the lively syncretism of Gallo-Roman religious life is afforded by a small temple to the east of the town. Dedicated to the Asiatic Mother Goddess, Cybele, the forecourt was a simple classical building, whereas the temple at the far end of it was of the purely native, square type described later in this chapter.

The picture revealed in the preceding paragraphs must, broadly speaking, be typical of what happened to many of the early foundations in other parts of Gaul. Apart from such obvious necessities as city walls and aqueducts and a certain number of prestige monuments (such as, in Britain, the Temple of Claudius at Colchester, begun within a decade of the Roman landing), the public buildings established at the actual moment of foundation were probably few, and even they must normally have been conditioned by the materials and building skills that were available locally. The important thing was that the initial plans did allow for the expansion which almost inevitably followed once city life had taken root.

Typical also is the picture of an architecture that stems unmistakably from Italy, much of it almost certainly from North Italy. It was not long since most of Italy north of the Apennines had itself been part of Gaul,[8] and history and geography alike suggest that it was the experience gained in the Republican foundations in the plains and foothills of Gaulish North Italy which shaped the pattern of Rome's civilizing mission in transalpine Europe. This was the immediate source of the sort of planning which we see at Augst and (still on Italian soil, but part in fact of the same Augustan programme in and beyond the Alps) at Aosta [102]. The closest parallels for the gates of Nîmes or Autun are with Aosta, Turin, and Verona [103, 108]; and the basilicas, the podium-temples, the theatres and amphitheatres, the market buildings, all of these derive more or less directly from Italian models. The masonry techniques, discussed below, are another link with North Italy.

In course of time the net came to be spread

more widely. At Augst, for example, the forum-basilica scheme derives ultimately from the sort of thing one sees at Velleia a century earlier [105], but the two apses of the basilica, as first constructed, strongly suggest the more immediate influence of the Basilica Ulpia. The market hall too looks like a provincial version of that in Trajan's Market. Contacts with other provinces grew more frequent. Provence in particular began quite soon to look farther afield; and in common with the whole Empire Gaul saw a gradual breaking down of the old regional boundaries. But Italy long remained the principal outside source of Gallo-Roman architectural inspiration.

The typical monumental building materials of Roman Gaul were dressed stone and a version of the omnipresent Roman concrete which may conveniently be referred to by the conventional name of 'petit appareil'. The former needs no introduction. As in Spain, and as one can see at Glanum, it was a heritage from the pre-Roman past of Provence which acquired fresh standing from the Augustan monuments of Rome itself. The 'petit appareil' was a coursed and mortared rubble, similar in composition and general consistency to the concrete of Late Republican Italy, but with a facing of small squared stones [138] instead of the opus incertum or opus reticulatum of metropolitan practice.[9] The closest relevant parallels are with the stone-using parts of North Italy. The mortar was very variable in quality, but at its best this Gallo-Roman work came very near to having the strength of the finest Roman Imperial concrete, of which it may be regarded as a close collateral relative. The principal innovation of the later Empire was the introduction of bands of brick, each of several courses, which bear a superficial resemblance to the bands of brick found in association with some Italian reticulate work (e.g. at Hadrian's Villa) but which in fact frequently differ in running right through the core,[10] serving as levelling courses and to some extent as a guarantee against settlement. They are not found before the early second century. Brick-faced concrete in the Roman manner is not found outside the military areas before late antiquity. Another material in common use was timber, during the earlier stages of the occupation even in public architecture and throughout antiquity for domestic and utilitarian building. It was often supplemented by mud brick or adobe, as until modern times in many parts of France and Britain.

Although much of the best Early Imperial work is, not surprisingly, to be found in Provence, the military colonies and tribal capitals in the Three Gauls and subsequently in Britain and the Germanies had their share of fine early buildings that were designed with an eye to prestige as well as to the practical needs of the inhabitants. One of the first requirements of such foundations was a defensive wall, and from the outset the city gates were designed to impress. One common type, with many parallels in North Italy,[11] is that which one sees at Nîmes and at Autun [135], in which an elaborate multiple arch, flanked by projecting rounded towers and crowned by an arcaded gallery, opened on to a rectangular inner courtyard. Another, more distinctive form is found in Provence at Fréjus (Forum Julii) and at Arles. Here the actual gate is set at the base of a large incurved courtyard flanked by two almost free-standing, circular towers. Nîmes, it is worth recalling, was not primarily a military settlement but a romanized tribal capital that had received colonial status; and Autun (Augusto-dunum), another tribal capital replacing the old hilltop fortress of Bibracte, was not founded until 16 B.C., thirty-five years after the conquest. The city wall was already fast becoming a symbol of status rather than a strict military necessity.

Another immediate requirement for each new town was an abundant water supply. At Nîmes, for example, the fine spring that existed within the circuit of the walls was not in itself sufficient, and between 20 and 16 B.C. Agrippa built an aqueduct that brought to the town the waters of a group of springs near Uzès, 31 miles distant. In accordance with normal Roman practice the channel was, wherever possible,

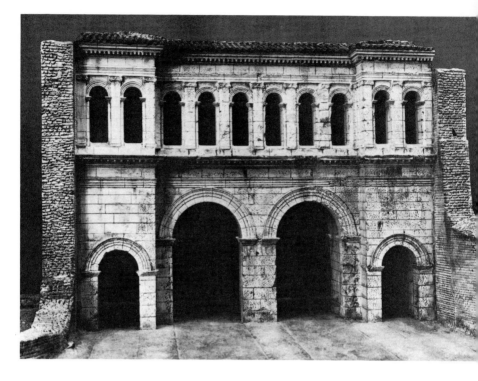

trenched or tunnelled below ground, or carried on a low wall, and was skilfully sited along the contours so as to afford a steady, gentle drop, calculable over the whole distance as about 1 in 3,000. At one point, however, it had to cross the gorge of the river Gardon, and here can still be seen one of the most impressive of all monuments of Roman antiquity, the Pont du Gard [136]. Built throughout of squared stone, it is 295 yards (269 m.) long and carried the water channel across the valley at a height of 160 feet (49 m.) above the stream. The harmonious lines of the structure are based (as in so many ancient buildings) upon an extremely simple set of numerical proportions: 4 units for the central arches, 3 for the lateral arches, 1 for the arches of the uppermost tier, and 6 for the height of the whole structure. The bosses left projecting from the inner faces of the upper arches were to carry centering, in the event of repairs. Just inside the

walls of Nîmes one can still see the *castellum divisorium*, a large circular basin with a settling tank and a series of sluices and outlets by means of which the water could be allocated as required to the municipal water system.

The aqueduct bridge, with its elegant arches and often grandiose proportions, is such a familiar and conspicuous symbol of Roman engineering skill that is worth remarking, in passing, that the Roman engineer was perfectly familiar with the other ways of transporting water across an obstacle. He was even ready as a last resort to pump it uphill;[12] and there are numerous examples of all dates where it was carried across a valley in a sealed pipe. In Gaul itself there were several fine instances of the latter along the course of the Mont Pilate aqueduct, one of the four aqueducts which served second-century Lyon with some 2,700,000 cubic feet of water daily, or again

135 (*opposite*). Autun (Augustodunum), model of the Porte Saint-André, after 16 B.C. The gateway was flanked by semicircular, projecting towers

136 (*below*). Pont du Gard, carrying the aqueduct of Nîmes over the river Gardon, late first century B.C. The bridge is 160 ft (49 m.) high

where fresh water was carried across the bed of the Rhône at Arles in a battery of lead piping. We shall meet another fine example at Aspendos in Asia Minor [198]. The reason such systems were not used more often is that they were expensive both to install and to maintain. By comparison manpower under the early Empire was abundant and cheap.[13]

Gaul is poor in surviving road bridges. There certainly were permanent bridges even over such major rivers as the Rhine and the Saône, with masonry piers founded, where necessary, on iron-shod wooden piles. In such cases the superstructures were almost certainly of timber. Smaller bridges were arched in masonry. A well preserved example, the carriageway of which is spanned by two ornamental arches, can be seen at Saint Chamas (Bouches-du-Rhône). The fast-flowing Rhône was crossed at Arles by a bridge of boats.[14]

The civic centres of the Early Imperial foundations have almost all been overlaid by later buildings, although it is a reasonable assumption that most of them, as at Augst, replace earlier, simpler versions of the same planning models. From the rather unsatisfactory accounts of the excavation of the 'Basilica' at Saint Bertrand-de-Comminges (Lugdunum Convenarum) on the upper Garonne it seems clear that the original building, a long narrow hall with transverse columnar partitions (an elaborate version of the basilica at Velleia), was early, perhaps even Augustan; but it is far from clear that its function was not from the outset commercial, as it undoubtedly was under the later Empire, when a series of tabernae were opened up around all four sides of the main hall. The basilica at Alesia, like those of Augst and of Paris, is unlikely to be earlier than the second century, after the Basilica Ulpia in Rome had

constituted a new model that was widely imitated in the western provinces. At Glanum there is a very simple version of the familiar scheme, with a forum and a basilica across one end of it, but lacking the axial temple. In this instance there was no room for a more expansive development; the other public buildings were ranged along one side of the street leading up the valley. They include the bouleuterion of the pre-Roman town, a finely built assembly hall with rising steps for seats on three sides. The basilica was a plain rectangular hall with an internal ambulatory colonnade, open on one side towards the forum.

At Arles there are the vaulted substructures of a monumental double portico enclosing three sides of a rectangle, across the fourth side of which ran one of the main streets of the town. Each arm consisted of two parallel, barrel-vaulted corridors separated by massive stone piers carrying segmental arches, and the vaults were lit by windows splayed downwards from

the open space in the centre. In late antiquity, probably under Constantine, the northern side was interrupted by the footings of a temple set obliquely across it; and beside them, shovelled in after some civic disaster, was found a mass of Early Imperial official sculpture and inscriptions. This was almost certainly part of the forum, and similar vaulted substructures (cryptoporticoes) are recorded at several other Gallic sites, notably at Reims (Durocortorum) beneath the porticoes of what is probably the forum; and in a very elaborate form at Bavai (Bagacum), north of Reims, beneath the porticoes of the early-second-century forum. A very similar structure at Aosta, in North Italy [102], encloses a precinct containing one large and two smaller temples; as at Arles the fourth side faces on to a street.[15]

About the religious architecture we are rather better informed. Two of the best-known surviving monuments, the Maison Carrée at Nîmes [137] and the Temple of Augustus and Livia at

137. Nîmes (Nemausus), Maison Carrée, c. A.D. 1–10

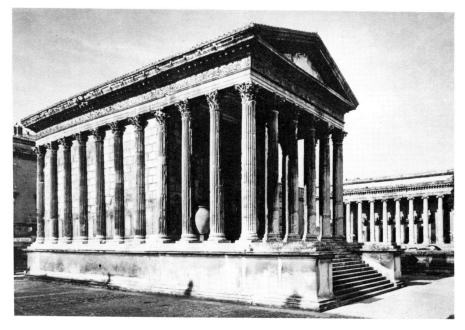

Vienne, were both official foundations, erected during the lifetime of Augustus, and both in design and in execution they are purely classical buildings. Both are hexastyle, standing on tall podia, the former being pseudo-peripteral, the latter peripteral *sine postico* in the Late Republican Roman manner. The direct contemporary influence of the capital on the Maison Carrée is evident in such details as the design of the Corinthian capitals and the channelled masonry of the cella, both the work of an architect who knew and had probably worked on the Temple of Mars Ultor, while the handsome acanthus scrollwork of the frieze derives from that of the Ara Pacis. The temple at Vienne is slightly more provincial in its detail (e.g. in the profile of the column-bases, which are of the form that was current in Late Republican Italy and in the earliest monuments of Provence), but the overall design is once again that of metropolitan Roman architecture *in partibus*.[16]

At Narbonne we catch a vivid glimpse of the way such influence might be brought to bear. The remains of the Capitolium indicate a very large temple (the linear dimensions of the ground plan, 158 by 108 feet; 48 by 36 m., are twice those of the Maison Carrée), the effect of size and height being deliberately enhanced by its situation at the far end of a long, narrow enclosure surrounded by a double portico; the superstructure was octastyle pseudoperipteral, with a triple cella, and it was built throughout of imported Carrara marble. The wreck of a Roman ship has been identified off the coast of the French Riviera near Saint Tropez, the cargo of which consisted of roughed-out columns, capitals, and other architectural members of the same material and dimensions;[17] and since these are unparalleled elsewhere in Gaul or Spain, there can be little doubt that this is a shipment to Narbonne that never reached its destination. As we have already seen in the case of Augustan Rome, the introduction of new materials and techniques almost inevitably meant the introduction of foreign craftsmen and fresh artistic traditions. Here at Narbonne, in

what must have been one of the most admired buildings of its day, we have the same story all over again.

These officially inspired classical temples were only one side of the coin. If there were clear and powerful classicizing influences at work from Italy, there was also a strain of vigorous Gallic conservatism which, as it came to acquire the means of monumental expression, was to play an important part in the creation of a more specifically Gallo-Roman architecture. Apart from the formal establishment of such official provincial and municipal cults as those of the emperor and the Capitoline triad, the romanization of religion was virtually limited to the easy assimilation of Roman names and attributes by local divinities, whose sanctuaries continued to play a large and active part in the daily life of the native Gaulish population. Many of these sanctuaries were in the open countryside, associated with springs or other natural features. They often stood within or beside a large enclosure, suggestive of pilgrimages or gatherings for popular festivals; and annexed to these enclosures were shops, covered halls, porticoes, inns, theatres, and other buildings. The sanctuary of Sanxay (Vienne), in a forest clearing twenty miles south-west of Poitiers, was a small town in itself.[18] Another striking example is the late-fourth-century pilgrim shrine of Nodens at Lydney in Gloucestershire, with its temple, its dormitory portico for the sick, and its well appointed inn and bath-building.

The actual temples vary in detail, but the basic form is remarkably constant and consists of a square, circular, or octagonal tower-like cella with a single doorway and, in all but the simplest, an external portico with a low roof running right round the building. There are countless examples of such temples in Gaul, Britain, and the Rhineland, of all periods from the first to the fourth centuries A.D., and of every degree of elaboration, from simple rustic chapels to great tribal or provincial sanctuaries. The simpler ones continued to be built of timber, the native material. At the other end of

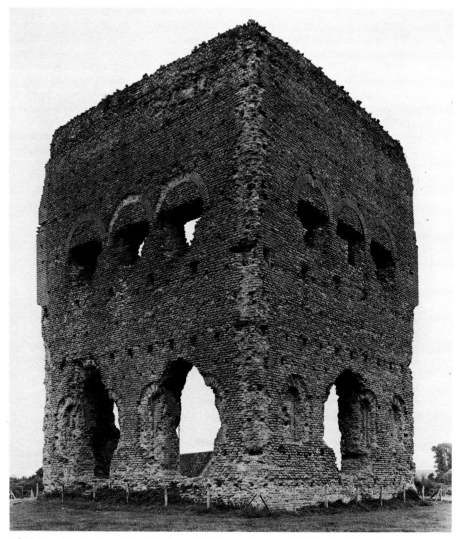

138. Autun (Augustodunum), temple of square Celtic type known as 'the Temple of Janus', second century. Of the horizontal rows of holes, the larger carried the timbers of an outer gallery [cf. 139A] and the smaller were for scaffolding

the scale we find such notable monuments as the 'Temple of Janus' at Autun, 43 feet (13 m.) high and built of 'petit appareil' masonry with brick details [138], or the second-century Temple of Vesunna, patron divinity of Périgueux (Vesunna Petrucoriorum), the cella of which was a cylindrical tower of fine 'petit appareil' masonry, again with brick details. Both had wide external porticoes and stood within monumental rectangular enclosures.

In Provence, as one might expect, such native temples disappeared early. Unfortunately we do not know the original form of the shrine of the spring-god, Nemausus, who gave his name to Nîmes; but the surviving Early Augustan temple of Vernègues (Bouches-du-Rhône), another water shrine, is a purely classical building. In the Rhineland, on the other hand, we have the Altbachtal sanctuary at Trier (Augusta Treverorum) [139A], which comprised no less than seventy temples, big and little, mostly square but a few circular, embrac-

139. Trier (Augusta Treverorum).
Plans and elevations of (A) Temple 38 in the Altbachtal sanctuary, second century;
(B) Temple of Lenus-Mars, in its latest, classicizing form, third century

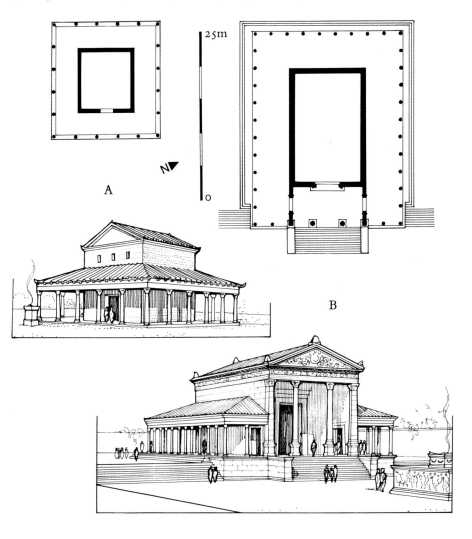

ing with little apparent change the whole period from the first to the fourth centuries. A similar conservatism is characteristic of many country areas, notably in northern Gaul and Britain. Elsewhere the progress of romanization brought changes. In the Augustan colony of Augusta Raurica, as we have seen, the temples of the hilltop sanctuary of Schönbühl were of native type until replaced by a monumental classical structure at some date in the later second century. Such classical replacements must have been a great deal commoner than can now be documented; the Temple of Lenus-Mars at Trier [139B] illustrates just such a development. Hardly less frequent was the assimilation of classical and native types, of which it must suffice to cite the examples of Périgueux and Autun, already described, or even more strikingly the pilgrimage sanctuary (c. A.D. 200) of Champlieu, in the open countryside of the Forest of Compiègne, half-way between Senlis and Soissons [140]. Here the temple stood in the

140. Champlieu, Gallo-Roman sanctuary, c. 200. Plan

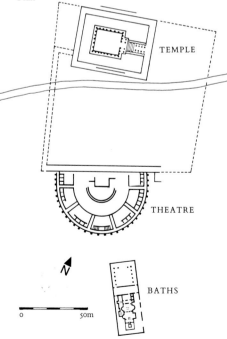

TEMPLE

THEATRE

N

BATHS

0 50m

centre of a rectangular, porticoed precinct, part of a larger enclosure, also porticoed, along one side of which was a theatre, with a bath-building just beyond it. The temple itself was square, but it stood on a podium in the classical manner; it had a small porch, half the width of the façade and probably gabled; and each of the four faces was elaborately carved with two angle-pilasters and six half-columns, just as if this were a pseudo-peripteral classical temple. The whole was gaily coloured. Architecture and sculpture alike, it represents a lively fusion of classical and native elements in the service of a simple but vigorous provincial culture.

The theatres of Gaul include some of the earliest known examples outside Italy. Typologically, if not in point of time, pride of place goes to that of Fréjus, where it was only the substructures of the cavea and of the façade that were of solid masonry ('petit appareil'), the upper part being of timber and the columns of the stage-building of stone, or timber, faced with painted stucco. An inscription of Claudian date found at Feurs (Loire), recording the reconstruction in stone of an originally timber theatre, suggests that many of the stone theatres of Gaul may have had similar beginnings, that of Fréjus being unusual chiefly in that it was never subsequently brought up to date. There are, however, several stone theatres that are almost certainly of Augustan or early Julio-Claudian date. Much of the surviving sculptural detail at Arles, for example, notably the mixed Doric-Corinthian entablatures of the three external orders of the cavea, is undeniably early. At Lyon the original form of the theatre is unfortunately largely obscured by later alterations [141], but the surviving column bases are of a very distinctive type which went out of use in Rome well before the end of the first century B.C. Few of these South French monuments are closely dated epigraphically, but there is a growing body of evidence to show that the broad lines of the subsequent Early Imperial development were laid down under Augustus.

In terms of the stage-building this development seems to have taken the form of an

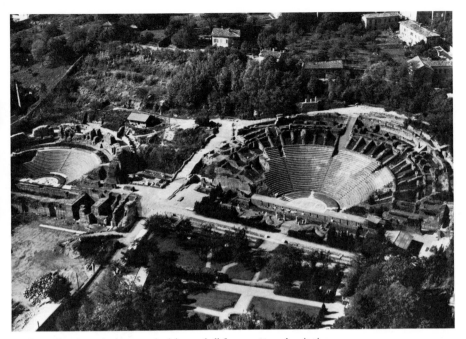

141. Lyon (Lugdunum), theatre and odeion, or hall for concerts and recitations. Both are Hadrianic (117–38), the former enlarging and embellishing a building of the end of the first century B.C.

evolution from simpler towards more complex forms, followed (but not before the second century) by the substitution of marble for the original local materials. At Fréjus the rear wall (*scaenae frons*) of the stage is simply a straight wall, the three symmetrical doors of which were framed in some way by a screen of columns. At Arles [142] the outer extremities of the wall are straight, but the central door stands within a projecting porch at the back of a shallow, curved exedra, as in the roughly contemporary theatre at Aosta. It is only at Orange and Vienne that we meet what was thereafter to be the standard monumental type in the provinces, in which the central exedra is matched by two others, often rectangular, framing the two lateral doors and creating the elaborate play of curving and rectilinear, projecting and re-entrant features which is so characteristic and striking a feature of Roman theatrical architecture [cf. 249].

Both at Vienne and at Orange [163B] the theatres were built up against steep rocky hillsides and, contrary to the usual practice, the public had to reach its seats from above. That of Vienne retains traces also of a common but rarely preserved feature of these theatres, the curving portico at the head of the cavea, and, overlooking the cavea from the centre of this portico, there was a small temple, as in the Theatre of Pompey in Rome and in several of the North African theatres.[19] The theatre of Orange is remarkable chiefly for the almost total preservation of the structure, though very little of the ornament, of the stage-building. The external appearance of the latter would have been lightened in antiquity by the monumental portico that once stood against the base of it and by the rhythmical repetition of the vertical staves that were contained in the two surviving series of brackets to support the awning (*velum*)

over the interior. But the range of blind arcading that occupies the middle register is far too shallow to be effective, and the total effect is decidedly bleak. Here, as in many other fields, use is demonstrated by that of the Flavian colony of Aventicum (Avenches), or again at Xanten (Vetera), where the small earth-and-timber amphitheatre of the Claudian fort was

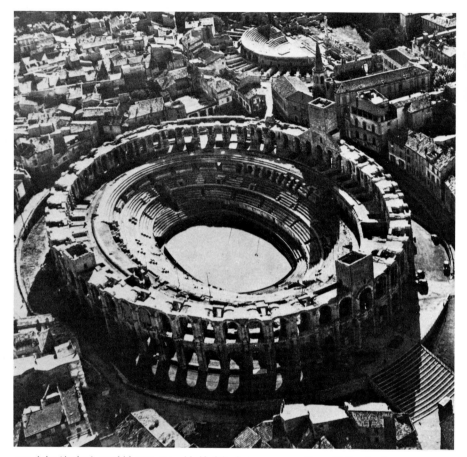

142. Arles (Arelate), amphitheatre, second half of the first century A.D. Beyond it lies the theatre

Roman architects had yet to produce an effective integration of the visual demands of interior and exterior.

Many of the early amphitheatres of Gaul were, and in some cases they remained, largely of timber, as in North Italy. The evidence for this comes mainly from the military zones; but that they were by no means restricted to military replaced by the far larger timber construction on masonry footings which served the Trajanic colony. Of the stone-built structures by far the best preserved are those of Arles [142] and Nîmes [143], which resemble each other so closely that they must be almost contemporary, that of Arles being perhaps the later by a decade or two. In the absence of any direct evidence of

date one can only compare them with the monuments of the capital, from which they bear every indication of being closely derived. The most significant and effective innovation upon their Italian models was the introduction of a repeated vertical accent by the carrying of the projection of the pilasters and demi-columns of the façade straight up through the entire building, entablatures and all. This is not at all the line of development followed in the roughly contemporary amphitheatres at Verona and Pola, but one can see something very like it in the late-first-century forum at Brescia, and it would appear to establish the two Provençal amphitheatres as later than the Colosseum, where the overriding emphasis is still upon the horizontal continuity of the four encircling cornices. Both buildings should probably be attributed to the Late Flavian or Trajanic period. The no less clear reminiscence of the Theatre of Marcellus in the vaulting of the upper galleries must be an archaism, attributable to the architect's lack of confidence in his materials. It must be remembered that there had been no technical advances in Gaul comparable to those that had recently taken place in the concrete of the capital, a fact which helps to explain the singular absence of monuments that are obviously attributable to the later first century. If it is at times tempting to label every Early Imperial building in Gaul as Augustan, this is in part at any rate because both the canons of provincial architecture and taste and the means of expressing them had been so firmly and decisively established in the Augustan era.

Bath-buildings were another aspect of Roman material civilization which, not surprisingly, had a great appeal in northern climates, and they spread rapidly and widely throughout the northern provinces. It is unfortunate that, apart from tantalizing fragments at Paris (in the Hôtel de Cluny) and Poitiers (Limonum), the only major installations surviving in the great cities are the somewhat uncharacteristic 'Imperial'-type baths of Trier and Arles, which are described in a later chapter. But there are a great many of the smaller public baths in both

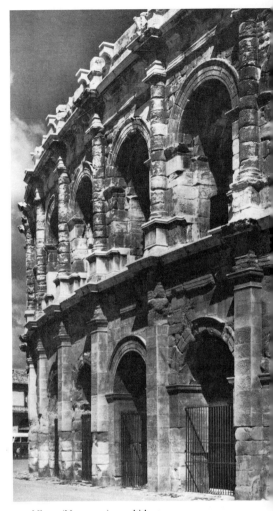

143. Nimes (Nemausus), amphitheatre, second half of the first century A.D.

town and countryside, and although no two plans are exactly alike one can distinguish two fairly consistent lines of formal development. One of these, with a solid block of bath-rooms grouped irregularly along one side of an open palaestra, derives from the same tradition as the baths of Pompeii, and no doubt it represents the form in which Roman-style bathing first

reached Gaul. The other, which seems to be a peculiarly Gallo-Roman development, is distinguished by a straight axial sequence of frigidarium, tepidarium, and caldarium, usually accompanied by a palaestra and often by one or more circular rooms of varying purpose.[20] A third type, functionally distinct from the other two, is that found in the numerous spas of Roman Gaul. Many of these took shape around sacred springs, and, like healing-sanctuaries

The bath-buildings of this third group are distinguished by the high proportion of rooms with large central plunge-baths fed directly from the springs. Typical surviving or recorded examples are those of Évaux (Creuse), Royat (Puy-de-Dôme), Badenweiler in the Rhineland [145C], and Les Fontaines Salées (Yonne, near Vézelay). At Amélie-les-Bains (Pyrénées-Orientales) the plunges are accompanied by small individual cubicles.

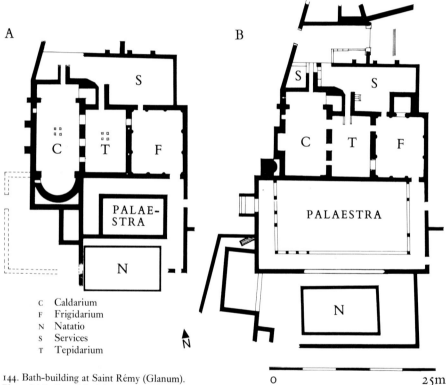

144. Bath-building at Saint Rémy (Glanum).
Plans: (A) In its original form, second half of the first century B.C.;
(B) as reconstructed in the second half of the first century A.D.

throughout the Roman world, they offered a unique combination of religious, curative, and social amenities. In Britain the Temple of Sulis Minerva and the bathing establishments of Bath (Aquae Sulis) were part of just such a complex.

A good example of the 'Pompeian' type of bath-building is to be seen at Glanum, built at some date after 45 B.C. and remodelled, with an enlarged palaestra, in Flavian times [144]. At Saint Bertrand-de-Comminges, in Aquitania,

the North Baths [145A], though of second-century date, still have much in common with the Central Baths at Pompeii [93], whereas the baths adjoining the forum are a good example of the second type. The latter might be very simple, as in the bath-building attached to the festival sanctuary of Champlieu, described above [140], or it might be elaborated in a number of ways, often of considerable architectural character and pretension. To mention only

a few of the more striking, we have the baths of Canac, just outside Rodez (Aveyron), which were developed symmetrically almost as if a miniature version of the 'Imperial' type; at Drevant (Cher) and at Verdes, near Beaugency (Loir-et-Cher) [145B], both single bathing-suites with a number of supplementary features, which again were developed symmetrically about the main block; and those of Vieil-Évreux (Gisacum), in Normandy, and of Allonnes, near

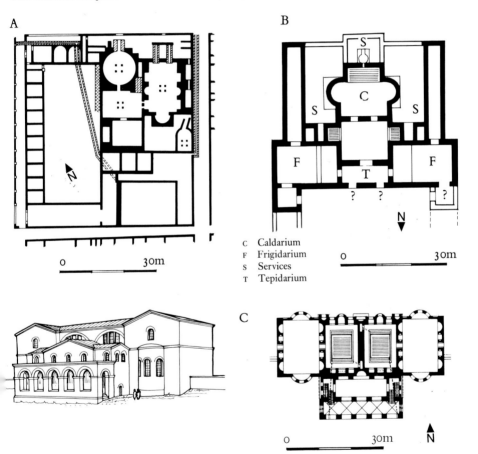

C Caldarium
F Frigidarium
S Services
T Tepidarium

145. Bath-buildings in Gaul and the Rhineland.
(A) North Baths at Saint Bertrand-de-Comminges (Lugdunum Convenarum), second century. Plan;
(B) Verdes, date uncertain (second century?). Plan; (C) Badenweiler, thermal baths,
original form of the buildings, probably first half of the second century. Restored view and plan

Le Mans, two schemes which incorporated a pair of separate but identical suites of bathing-rooms within a single large, symmetrical complex. One has only to compare such buildings with any comparable series of bath-buildings in Asia Minor or North Africa (or indeed, after the initial stages, in Italy itself) to appreciate the individuality of this Gallo-Roman architecture.

The only other early group of public monuments that calls for brief mention is that of the monumental arches of Provence, which are closely related to those of northern Italy, differing chiefly in the generally greater wealth of their architectural forms and sculptural decoration. The earliest members of the series, at Cavaillon (Cabelio) and at Carpentras (Carpentorate), are followed closely (c. A.D. 10–20) by that at Glanum [146], a more elaborately articu-

lated version of the arch at Aosta. The arch at Orange [147], long thought to be very early, is now known to be of Tiberian date (soon after A.D. 21).[21] Even so, it is the earliest surviving triple arch to have been built as such (the Parthian Arch of Augustus in the Forum Romanum is rightly characterized as three single arches placed side by side), and it is remarkable for the virtuosity alike of its architectural forms (which, it must be remembered, were designed to be viewed as the basis for a monumental group of statuary) and of the relief carving with which it is covered. A feature that deserves remark is the breaking back of the horizontal cornices of the pediments of the tetrastyle façades on the two ends, in a manner which is reminiscent of the painted architecture of the Third Pompeian Style.[22] A closely related

146. Saint Rémy (Glanum), arch and monument of the Julii.
The arch dates from c. A.D. 10–20, the monument probably a little earlier

147. Orange (Arausio), monumental arch, built shortly after 21

monument is the Mausoleum of the Julii at Glanum [146]. The nearest parallels to the architectural form, a four-way arch standing on a tall, sculptured podium and crowned by a circular pavilion with a conical roof, are again with Italy (Aquileia, Sarsina, Nettuno), whereas the sculptured panels look as if they derive from some well-known hellenistic painting.[23] Whether or not it is legitimate to see in this the continuing influence of Massilia, the individuality and skill of this distinctive school of sculpture offers yet another proof of the extraordinary creative vigour of Augustan Provence.

For the domestic architecture in the early Gaulish towns we are virtually dependent on the excavations at Glanum and Vaison. Within their limitations – both were country towns of quite modest importance – they afford a valuable picture of middle-class domestic life in Gaul under the Early Empire. They are, moreover, complementary, the former rooted in its own strongly hellenistic traditions, the latter a small but prosperous tribal capital developing on lines which have much in common with Italian practice. The houses of Glanum [133] are built around peristyle courtyards, as at Delos and like the later houses at Pompeii; and although these are mostly so small as to resemble a columnar atrium, the resemblance is here at most one of assimilation, not of derivation.[24] The atrium as

such was never common north of the Alps and, when found, is invariably of the developed, columnar form. A good Gaulish example is that of the House of the Silver Bust at Vaison [148], which in other respects too, with its somewhat informal layout, large garden peristyles, and bathing suite, offers a vivid picture of a well-to-do Italianate town mansion of the later first

148. Vaison-la-Romaine (Vasio),
House of the Silver Bust,
later first century. Plan

A Atrium
L Lavatory
P Peristyle

149. Vaison-la-Romaine (Vasio), street and streetside portico, later first century.
On the left the entrance to the House of the Silver Bust and, beyond it, a row of shops

century A.D. The shops along the street frontage and the streetside porticoes [149] are other typical features of Gallic city architecture that have obvious Italian analogies.

Between the extremes of such wealthy mansions and the simple one-room tabernae of the artisan, such as we see clustered beside the main streets of the roadside settlements of the Three Gauls, or in Britain at St Albans (Verulamium) and at Silchester, there was a variety of detailed practice which defies brief analysis. The materials and building techniques were local, timber predominating in many areas, but over all was spread with varying intensity the familiar veneer of Roman domestic life – tiled roofs, painted plaster on the walls, window-glass, floors of concrete or mosaic, private or communal bath-buildings, mass-produced household vessels of bronze, fine pottery, or glass, and, pervading all, a degree of civic order which distinguishes the most modest of road-stations from the haphazard agglomerations of the pre-Roman period.

Outside the towns romanization, though no less thorough, was slower in coming. A few of the wealthy villas are demonstrably early, among them being the great country mansion of Chiragan on the upper Garonne, with its astonishing series of marble portraits and other early sculpture, and the first-century residence

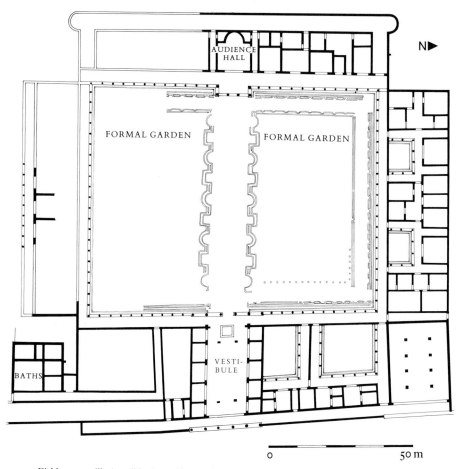

150. Fishbourne, villa (possibly the residence of the last native king, Cogidubnus), third quarter of the first century. Plan

at Fishbourne, near Chichester [150]. At first, however, such wealthy country houses were the product of special circumstances. Over most of Gaul, Britain, and the Germanies the architectural pattern of the Roman villa was one which evolved slowly within the established social framework of town and country; and it was because, in consequence, it was able to put down deep roots that it became one of the most individual and enduring aspects of the Romano-

provincial civilization of the north-western provinces.

The essence of the villa system in the provinces was that the house was not merely a country residence (as it had become in parts of Central Italy); it was also the centre of a working estate. One of the many startling results of the systematic aerial survey of Roman sites in Picardy undertaken by Roger Agache has been to reveal the extent and variety of the outbuild-

ings which regularly accompanied the residential block, graphic evidence of the intensity of the agricultural economy of which they were the product. None of these is quite so large as the great estate centre at Anthée, near Namur [151A], the residence of which was, incidentally, by no means exceptionally luxurious; but a

expect they reveal a wide variety of planning, materials, and local historical circumstance. In Britain, for example, much of the finest work belongs to the fourth century, by which time in some other, more exposed parts of the northern frontier villa-building had virtually ceased.[26] But through all the variety of plans and styles

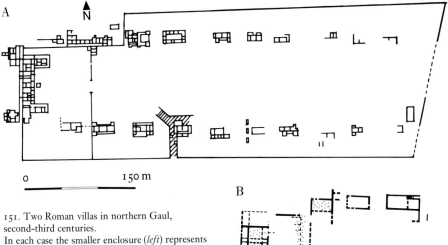

A

150 m

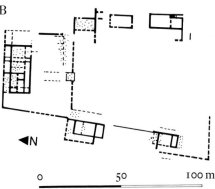

B

151. Two Roman villas in northern Gaul, second-third centuries.
In each case the smaller enclosure (*left*) represents the residence and garden, and the outer enclosure (*right*) the working farm buildings. (A) Anthée, near Namur, evidently a large villa, the centre of an intensively cultivated estate; (B) Cachy, near Amiens, a typical small residential working farm

50 100 m

number are of the same order of size, and the pattern, that of a smaller, residential enclosure at the head of a larger, working farmyard, ranges all the way down the scale to what in later times would be considered a small manor house. A good example of the latter is the villa of Les Champs Suzanne at Cachy, south-east of Amiens [151B].[25] A great many of these villas have been excavated and studied, notably in Britain and the Rhineland, and as one would

one can detect an architectural evolution which in its broad outlines is remarkably consistent, and which is the product of a long process of mutual assimilation between native farming traditions and building practices and the more advanced material civilization of the south.

The earliest villas were simple, rectangular, barn-like houses, normally timber-framed and subdivided internally into living quarters, storage, and stabling. In many cases they can be

seen to have replaced even simpler pre-Roman farmhouses, as in Britain, for example, at Lockleys, near Welwyn, and at Park Street, near St Albans, in Hertfordshire, and in the Rhineland at Mayen and at Köln-Müngersdorf. From such simple beginnings it was a short step to the addition of a linking portico or corridor along one long side and the progressive relegation of stabling, storage, and the other practical requirements of the farm to separate buildings within the outer farm-enclosure; the corridor was commonly flanked by a pair of projecting rooms (one of which might house part of an added bath suite), and although this remained in essence a tradition of single-storeyed building, there was a growing tendency to add towers, cellars, and even partial second storeys. An early stage of this development, c. 100, is well illustrated at Ditchley, Oxfordshire [152] and, rather more elaborately, at Köln-Müngersdorf

[153]. From the corridor-villa with outhouses it was a natural step to bring order into the complex by grouping the several buildings round one or more courtyards, and from this point of view the courtyard-villa may be regarded simply as a corridor-villa writ large. At the same time, however, porticoes and courtyards lent themselves to treatment in ways that were quite specifically classical; and with the spread of such luxuries as window-glass, painted wall-plaster, mosaic pavements, and central heating, it is small wonder that one should find an ever-increasing assimilation also of the external forms and something of the planning of Mediterranean classical usage. One sees this, for example, in the great residential villa at Nennig, on the upper Mosel [154].[27] The basic plan, with two tower-like wings flanking a porticoed façade, stems from the local Romano-provincial tradition; but the architectural detail, the two

152. Ditchley, Roman villa and its dependencies, set within a rectangular, ditched enclosure, revealed by air photography, c. 100

153. Köln-Müngersdorf, villa, in its fully developed form,
third century. Restored view and plan

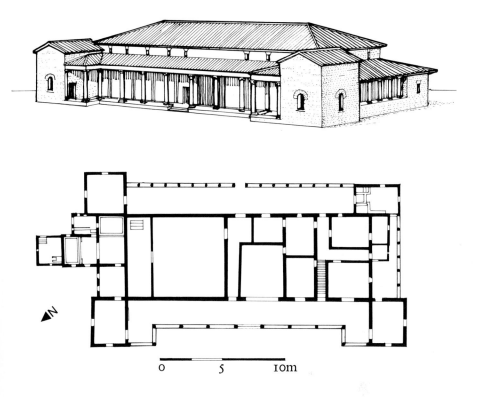

o 5 10m

storeys of the frontal portico, the grouping of
the rooms of the main wing around internal
peristyle courtyards, and the convergence of the
whole scheme upon a great central triclinium,
all of these represent the influence of more
directly classical ideas. At a less ambitious level
one can see the same forces at work in a building
such as the villa at Chedworth, in Gloucester-
shire [155], which started in the early second
century as three separate half-timbered wings
grouped around the head of a small valley, and
which was only later developed into a single
unitary plan, with inner and outer courtyards, a
large new triclinium, various other reception

rooms, and an up-to-date new bathing suite.

At its best this was a domestic architecture of
considerable pretensions and some elegance,
and it was rooted in standards of solid material
comfort which were not to be seen again in
Europe before the nineteenth century. These, it
should be remembered, were the country
houses of the world of Ausonius and Sidonius
Apollinaris, the world within which the Visi-
gothic and Frankish chiefs acquired the far-
from-negligible veneer of classical culture
which they were to carry forward into the
Middle Ages.

It will have been remarked that although

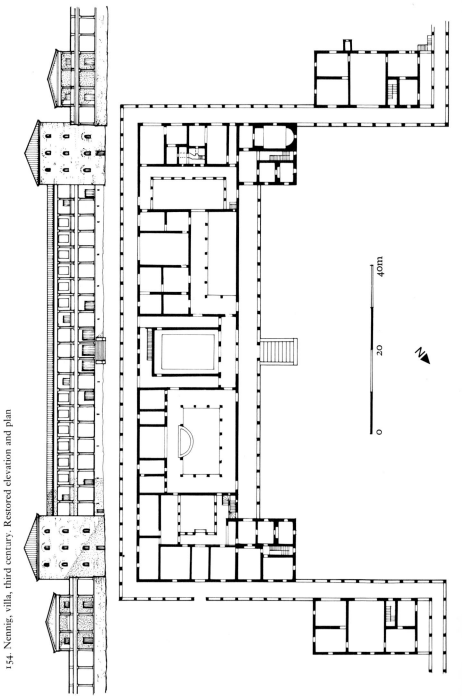

154. Nennig, villa, third century. Restored elevation and plan

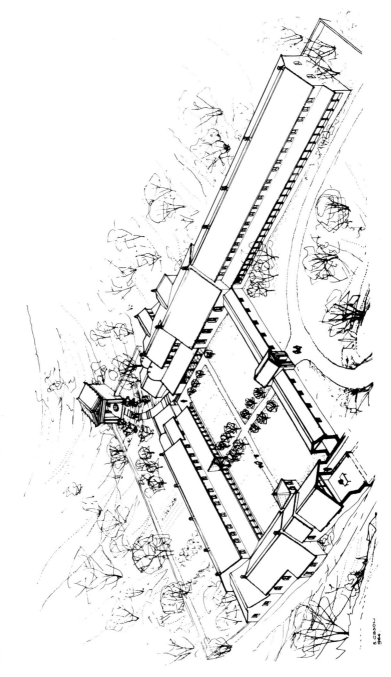

155. Chedworth, restored view of the villa, looking north-westwards, c. 300

Britain and the Germanies were frontier provinces, little or nothing has been said in this, or indeed in any other, chapter about military architecture. The fact is that, by comparison with the hellenistic world and with Byzantium, the Roman Empire added little to the science of military architecture as such. Works like Hadrian's Wall were essentially police barriers, the legionary and auxiliary fortresses of the frontiers police posts and supply bases directed against an enemy who was dangerous only in the open field. Along the eastern frontiers the potential threat was more sophisticated; but although one might have expected the germs of later military thinking to have taken shape in Syria, there is in fact remarkably little evidence of any such development. As late as the third quarter of the third century the Aurelianic walls of Rome or the roughly contemporary walls of Nicaea, in Bithynia [18, 178],[28] show little effective advance on the best hellenistic work.

Architecturally the real significance of the military stations of the frontier zones was that they were centres for the dissemination of Roman material culture and the outward forms of Roman life. As the garrison towns became established on a permanent basis, there was inevitably an increasing interdependence between the forms and practices of civil building and of the comparable branches of military building. A great many of the architects practising in the frontier provinces must have received their training in the army. But the revival of interest in military architecture as such was a product of the crisis of the third century and belongs to the history of late antiquity.

CENTRAL AND SOUTH-EASTERN EUROPE

To the north and east of Italy lay the provinces of the Danube basin and the Balkans, an area populated then as now by peoples of widely differing ethnic and cultural backgrounds. Outside the Greek colonies of the Black Sea coast and the cities along the northern fringes of mainland Greece itself this was a relatively backward area, with no previous tradition of monumental architecture. Along the upper and middle Danube, in the provinces of Noricum, Pannonia, and Moesia, the architecture of the Roman age was essentially a provincial derivative of that of northern Italy, developed under the strong influence of the great legionary fortresses and of the civil settlements that grew up beside them. Along the lower Danube, in Lower Moesia and northern Thrace, the army was still an important factor, but here, apart from the curious island of Latin speech which still persists in the modern Rumania, the classical background was Greek. The eastern shores of the Adriatic were another provincial extension of Italy, this time, however, with fewer military overtones. The one region which, to judge from the vigour of its native pre-Roman culture, might have thrown up a Romano-provincial civilization with a distinctive personality of its own was the trans-Danubian province of Dacia, but here Roman rule was too short-lived for its results to come to full fruition. Over most of the area the surviving monuments are rare, and it will here be possible to refer to a few only of the more important sites and buildings.

Within the area of the upper Danube basin the earliest stages of romanization are graphically illustrated by the excavations on the Magdalensberg, ten miles north-east of Klagenfurt, in Carinthia, the hilltop fortress capital of the pre-Roman kingdom of Noricum and the first capital of the Roman province.[29] The forum is a long, narrow open space terraced into the steep southern slopes near the brow of the hill [156]. Here, scratched on the plastered walls of the pre-conquest buildings, one can see the records of the Italian traders from Aquileia and the south whose activities did much to pave the way for the formal annexation of the kingdom in 15 B.C. Adjoining the forum are a well equipped bath-building; a complex with an audience hall heated in the Roman manner, which appears to have been the meeting-place of the provincial assembly; and the porticoed precinct and substructures of a large prostyle tetrastyle temple, built in part of white marble from the recently

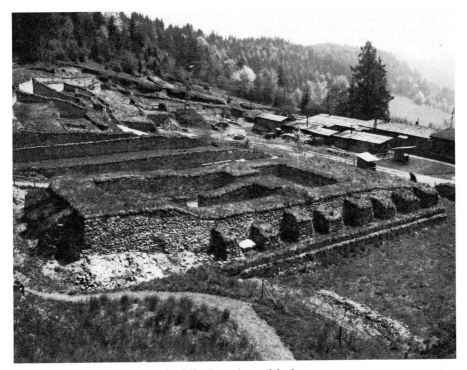

156. Magdalensberg, unfinished temple of Claudius and part of the forum. The site was abandoned in 45 in favour of Virunum on the plain below

opened quarries on the Drau just above Villach. The temple was still under construction when, in A.D. 45, the town was abandoned in favour of the more convenient site of Virunum on the plain below. The forum of Virunum followed more conventional lines; it was a large rectangular enclosure of which the western part was occupied by the porticoed precinct of an official temple, the eastern half by a porticoed piazza with a long, narrow basilica at the east end, and the other two sides by ranges of small halls – a layout clearly derivative from the same North Italian models as the early fora of Gaul and of Dalmatia.

The Magdalensberg and Virunum lay in long-settled country just across the border from Italy. Over most of this region the decisive event was the advance of the Roman army to the Danube. As happened everywhere along the northern frontiers, from the Atlantic to the Black Sea, the legionary and auxiliary fortresses were the inevitable focus of the local economy, and alongside them grew up the civil settlements which in the second and third centuries were to become the established social and cultural centres of provincial life. Two of these frontier towns have been systematically excavated, Aquincum, just above Budapest, and Carnuntum, twenty-five miles below Vienna. The patterns are broadly similar – a loose, near-rectangular network of paved streets separating rather large insulae, some neatly divided into long narrow plots, others bearing evident traces of development over a considerable period of time. Only in the centre was space at a premium, and even here there is little or no trace of any tall

building. The third-century houses were solidly built, single-storeyed structures of stone and timber, a recurrent type having the living rooms opening off a central corridor behind a wide timber porch. The standards of comfort and decoration derive from Rome: window-glass, painted wall-plaster and moulded stucco, an occasional floor mosaic, and regularly one room with central heating; but apart from a single peristyle-house at Aquincum and near it a market building of Italian type, with shops around the four sides of a rectangular porticoed courtyard (and of course such direct importations as aqueducts, bath-buildings, and amphitheatres), there is surprisingly little evidence

of the influence of Mediterranean building types. This was in every sense of the word a thoroughly provincial architecture.

Two buildings call for brief individual mention. One is the civil amphitheatre at Carnuntum, the extraordinarily irregular plan of which must be due to the piecemeal replacement in masonry of what was originally an all-timber structure. The other is identified as the palace of the provincial governor at Aquincum.[30] It was a rectangular, courtyard building, with round towers at the angles of the main, east façade [157]. Along the north side of the courtyard lay the private residence and bath-building, along the south side storerooms and workshops, and

157. Aquincum, ceremonial wing of the Governor's Palace, mid second century. Plan

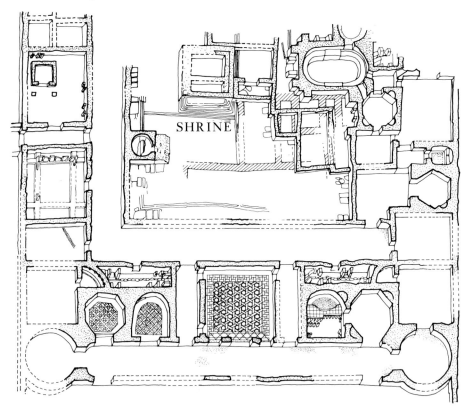

in the centre a small prostyle classical temple for the imperial cult. The mosaic-paved state rooms opened off a corridor that ran the full length of the east front, with in the centre a square audience hall and, to right and left, symmetrical suites of heated rooms, each with an attached latrine. There are obvious affinities here with later palace design, a tradition which the residences of the Roman officials in the provinces must have done much to shape.

Along the lower Danube Roman authority was not fully established until the campaigns of Trajan in the early second century. Here the Romans at first came to terms with, and then in A.D. 46 they annexed, the kingdom of Thrace, a kingdom which in many of the externals of its way of life may be regarded as an outlier of the hellenistic world. Its architecture is best known from the excavated site of Seuthopolis, 45 miles north-east of Plovdiv, founded in the late fourth century B.C. and substantially abandoned after less than a century of occupation. Apart from the royal palace enclosure, the remains are those of any outlying provincial hellenistic city, orthogonally planned, with strong city walls, an agora, regular insulae, and large, well-appointed courtyard houses. The normal building materials were stone and mud brick, but kiln-baked brick was already known and used, notably in the magnificent painted tumulus graves which are a more familiar aspect of this wealthy Thraco-hellenistic society.[31]

This was clearly a local tradition of some substance and, together with the old Greek colonies of the Black Sea coast, it must have been a far from negligible factor in shaping the patterns of urban culture that grew up in the rear of the legionary fortresses along the lower Danube. Serdica (Sofia), with its orderly gridded plan, its rectangular circuit of walls (only at one corner, where they skirted marshy ground, was the symmetry broken), its central forum and its rows of warehouses, patently reflects the predominantly western military planning tradition of legionary cities such as Ratiaria, Oescus, and Novae, although even here one notes the presence, beside the forum, of a covered,

theatre-like bouleuterion in the Greek tradition, while the second-century city wall, erected between 170 and 180, was built of alternating bands of solid brick and of mortared rubble faced with small coursed stones, upon a socle of dressed stone masonry. Nicopolis-ad-Istrum, near Velico Turnovo, founded by Trajan after 106, embodies the same mixture, this time, however, preponderantly Greek with Roman overtones. The forum, or agora [158], located at the intersection of the two main streets of a tidily gridded layout, consisted of a square paved open space framed by Ionic porticoes and flanked along the north side by a stoa-like basilical hall and on the east and south sides by shops or offices; in the middle of the west side was a monumental entrance passageway, erected between 146 and 161, set between a rectangular hall, identified by the excavators as a bouleuterion, and a small covered theatre, the stone seats of which were carried on brick vaults.[32] The covered theatre would have been well placed to serve also as an additional place of assembly for public business.

Space precludes any extended treatment of the many other important excavations in this area. One can only mention the fine stadium at Philippopolis (Plovdiv); Marcianopolis, another Trajanic foundation, 15 miles west of Odessos (Varna), with the substructures of what was probably a wooden amphitheatre; the fine 'Imperial'-type bath-building at Odessos itself, built probably soon after the city received a new aqueduct in 157; two large public bath-buildings at Oescus, near Pleven; and several mineral-spring establishments, notably one near Stara Zagora (Augusta Traiana) [159] of which the dedicatory inscription gives the names of several of the rooms. Among the many villas may be mentioned that of Madara, a wealthy second-century peristyle villa that was occupied right through into Byzantine times; Chatalka, a residential estate centre near Stara Zagora, a complex which offers many points of comparison with the similar Gallic villas; and Ivailovgrad, near the Turkish frontier, notable for its wealth of 'marble-style' sculpture and its

158. Nicopolis-ad-Istrum, agora, founded after 106
and nearing completion by the middle of the century

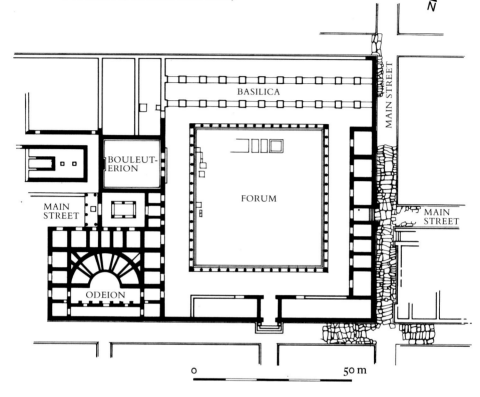

mosaics. There are also several fine subterranean mausolea, brick-vaulted and in some cases painted. This is unquestionably one of the richest of the still relatively unfamiliar areas of Roman provincial archaeology.[33]

The other significant pre-Roman building tradition in this area was that of the old Greek colonies of the Black Sea coast, and many aspects of the architecture of the province reflect its position as a meeting place between the forms introduced by the settlements that accompanied the Roman armies of the Danube and those which were the result of the coastal cities' long-established commercial and cultural ties with Asia Minor and the Aegean. Outstanding among the latter was a 'marble-style' architecture of typically second-century Asia Minor type. The marble came from the quarries of Proconnesus (Marmara); and the carving of the capitals and other architectural members, freely copied in the excellent local limestones, is indistinguishable from that of north-western Asia Minor – or indeed of Pamphylia, or Tripolitania. At Nicopolis-ad-Istrum most of the building is in the local Hotnitsa limestone, but the repertory of architectural ornament is securely 'marble-style', or 'Asiatic', and there is an inscription recording the presence of a group of monumental masons (lithoxooi) from Nicomedia in Bithynia. Among the many scattered

159. Stara Zagora (Augusta Traiana), thermal baths, 161–9.
A dedicatory inscription refers to a shrine to the Nymphs of the Spring,
a hot bath (*loutrōn*), two changing-rooms (*apodyteria*), and a frigidarium.
The conventional bath suite along the north side was added later

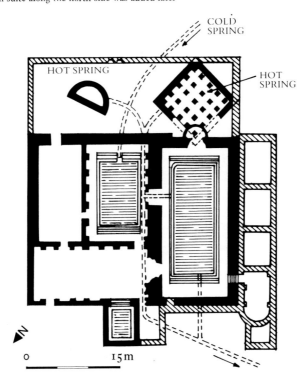

examples of the work of the Proconnesian marbleworkers at Costanza (Tomis) are the remains of a building dated to 161–2, and their influence can be seen as far inland as Philippopolis and Oescus, and sporadically even further afield.[34] Another significant link with the same area is the use of a rubble-concrete masonry faced with courses of small squared blocks of stone and laced with bands of coursed brick, notably in a Severan bath-building at Histria and in a fine harbourside warehouse-building, also Severan, at Costanza. As we have seen, kiln-baked brick had a long history of architectural use in this area, both for walls and for vaulting, and it is by no means improbable that

it was from Thrace that it first entered the architecture of western Asia Minor in the second century A.D. as a vaulting medium. In a great many respects the classical architecture of this region right down into Byzantine times may be regarded as a lively provincial outlier of the region of which Constantinople is the natural centre.

The Roman architecture of the Illyrian coast reflects its geographical position no less clearly. There is a persistent substratum of provincial late Greek building practice, represented by the frequent remains of pre-Roman fortification walls and, more generally, by a fine tradition of cut-stone masonry. As one would expect, this is

strongest as one approaches the modern Albania and the Greek frontier. Upon this basis was established a pattern of small-town Roman municipal architecture, the surviving remains of which indicate a close dependence upon North Italy. Towards the north-western end, in Liburnia, Aenona (Nin) has yielded a Capitolium with tripartite cella, Asseria (near Benkovac) the remains of a handsome, elaborately articulated,

an amphitheatre and a large bath-building, are overshadowed by those of the later, Christian city and by Diocletian's residence near by at Split (Spalato). The most distinctive of the earlier buildings is a peristyle, tetrastyle temple, the plan and ornament of which bear a significantly close resemblance to those of the Augustan temple at Pola.

The best preserved and best recorded re-

160. Asseria, archway-gate, 112. Restored view

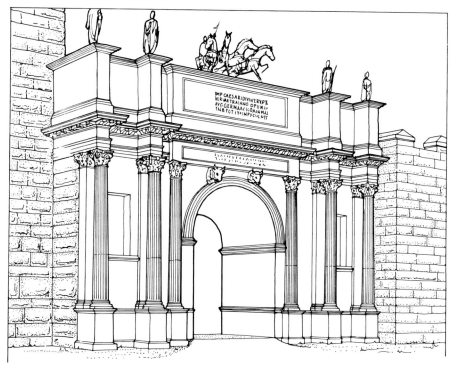

Trajanic archway-gate [160] and a rectangular, porticoed forum with a long, narrow, aisleless basilica, and Zadar (Roman Iader) a forum complex with a free-standing temple, transverse street, and two-storeyed porticoes, all very reminiscent of the forum at Augusta Raurica.[35] The remains of Roman Salona, which include

mains from the south-eastern part of the territory are those of Doclea in Montenegro, near the Albanian frontier. These include a temple of Diana, distyle *in antis* against the rear wall of a square, porticoed enclosure; a second temple, very similar but smaller and free-standing; a large public bath-building, of rectilinear design

throughout except for one or two apsidal exed-
rae; a peristyle-house; and a forum and basilica
[161] laid out in accordance with the familiar
North Italian pattern. The basilica is remark-
able for the use of arcading in place of the flat
architraves of normal classical practice in the
two transverse screens, an anticipation (if the
Doclea building is rightly dated to the early
second century) of the monumental use of this

(and some imported marble) with the coursed,
mortared rubblework faced with small squared
blocks of stone which seems everywhere to have
been the local equivalent of the Roman opus
reticulatum and brick-faced concretes, and
which in this derives presumably from North
Italy. The buildings were mostly timber-
roofed; but just across the border of Albania,
at Butrinto (Roman Buthrotum), there is a

161. Doclea, forum and basilica,
early second century, with later modifications.
Plan

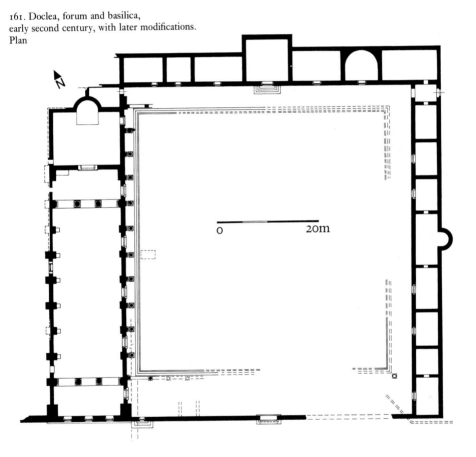

feature both in Spalato and in the Severan
buildings at Lepcis Magna.[36] The masonry of
the Doclea buildings is characteristic of this
whole region, alternating dressed local stone

shrine of Aesculapius with a vault of radially
laid bricks, which must in the context reflect
the influence of Asia Minor and of northern
Greece.

GREECE

CORINTH

Roman Greece was a poor country, rich only in the memories of its own glorious past. Architecturally its principal resources were its splendid building materials and its fine traditions of craftsmanship, both in the handling of masonry and in the carving of architectural ornament. Philhellene sentiment found sporadic outlet in the endowment of Athens with some handsome new buildings. But for the rest it would almost certainly be true to say that in Roman times the architectural significance of Greece was felt as much outside its own boundaries as within them. One cannot, however, for that reason disregard the architecture of Roman Greece altogether. Not only was classical Greece the ultimate source of a great deal that was still vital to the architecture of the West, but also it was still a source of contemporary inspiration; and the very fact that the native tradition had long ago lost its own initial impulse makes it easier here than in any other part of the hellenic world to detect the currents that were beginning to flow in the other direction, from west to east, and to distinguish between those elements in the contemporary architectural scene that were little more than the conventional repetition of traditional lessons and those that were new and charged with significance for the future.

For a representative picture of Roman building outside Athens we are fortunate in possessing an unusually full and carefully documented picture of the heart of Corinth, the capital of the province of Achaea (southern Greece).[1] Corinth, sacked and ruthlessly depopulated by Mummius in 146 B.C., had been refounded in 44 B.C. The period immediately following its refoundation was not one for ambitious building schemes, and the original colonists seem to have been content with re-establishing the agora (the

Greek equivalent of the Roman forum) on its old site and with refurbishing the few earlier buildings that were still standing, notably the main sanctuaries and the great fourth-century South Stoa. It was only under Augustus that the city centre began to take on a more distinctive shape; and since, thanks to the skill of its American excavators, we can follow most of the essential features of its subsequent development, it is worth describing in some detail, not only as a representative cross-section of the architecture of Roman Greece, but also as a typical example of the sort of processes of growth and adjustment which lie behind the seeming monumental unity of so many of the complexes of provincial Roman architecture that have come down to us in other provinces.

In hellenistic times the agora had been an irregularly shaped open space, some 500 feet in length, delimited on the south long side by the great South Stoa and on the north side by the Fountain of Peirene and by a second but smaller stoa, the North-west Stoa, built up against the steeply scarped slopes of the hill that carried the Temple of Apollo. It was traversed obliquely by the line of the road from Kenchreai to the port of Lechaion, and across the west end, terraced above it, ran the Sikyon road. The first act of the new settlers was to rehabilitate the two stoas and the fountain, the town's chief water-supply; and at the same time, in place of the characteristically Greek informality of the gently sloping central area, to divide the site into two level terraces, of which the upper one seems from the outset to have been intended primarily to serve the administrative requirements of the provincial capital, leaving the lower one free for the ordinary day-to-day business of the city. As was the normal practice, the agora was closed to traffic. Its principal entry lay up steps from the Lechaion road.

The subsequent development of the site [162] took place by stages. The reign of Augustus saw the first monumental layout of the Lechaion road and the adjoining basilica; the building of the Temple of Hermes (D) and the Pantheon (G), the first two of six temples which by A.D. 200 formed an almost continuous row across the along one side of the Lechaion road; the addition of a monumental forecourt to the Fountain of Peirene; the building of the Julian Basilica, closing the east end of the lower agora, and of the South Basilica and the bouleuterion, both opening off the South Stoa; the establishment of a row of shops along the front of the

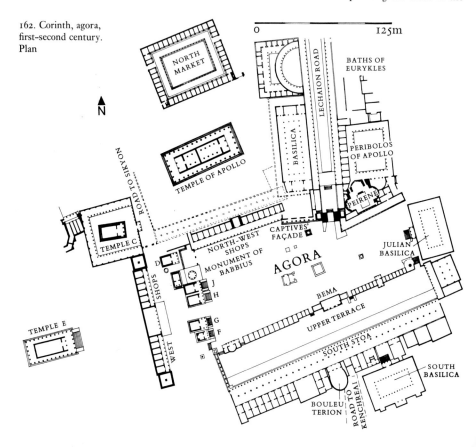

162. Corinth, agora, first-second century. Plan

west end of the lower agora; the addition of a new and more ambitious façade to the Fountain of Peirene; and the beginning of the rebuilding of the South Stoa and the addition to it of the first of a long series of administrative buildings. The immediate successors of Augustus, Claudius in particular, were no less active. To this period belong the establishment of a portico terrace between the upper and the lower agora, with a monumental tribunal, or *bema*, in the centre, serving as an official platform for the appearance of the governor; the addition of one new temple (F) and the rebuilding of another (G) along the western terrace; and, dominating the whole from the higher ground to the west, a large temple (E) which is probably to be iden-

tified as the Capitolium. In front of this last building, forming a low façade to the temple precinct, was a row of shops (the West Shops) symmetrically disposed about a central propylon. To the same Early Imperial phase of building activity belong the Roman theatre (on the site of its Greek predecessor) and, just to the north of the Temple of Apollo, a market building which was in the form of a rectangular peristyle enclosure with some forty shops opening off its four inner porticoes.

Most of this building was done in the local limestone (*poros*) and faced with fine stucco, which as late as the middle of the first century A.D. were still the normal monumental building materials at Corinth. There were, however, already significant signs of change. The Temple of Tyche (F), a handsome tetrastyle Ionic building, and the monument of Cnaeus Babbius Philinas, a circular octastyle tempietto with a low conical roof, both date from the reign of Tiberius and both make liberal use of a blue marble and of white Attic marble for the finer work, the detail of the ornament in both cases clearly revealing the influence of the classical buildings of Athens, notably of the Erechtheion. A few years later the Pantheon (G) was rebuilt wholly or partly in Attic marble. The bema is another structure of which the marble detail harks back to earlier Attic models.

Under the Flavian emperors there was a decided change. The year 77 was marked by a serious earthquake, which badly damaged many of the older buildings. In the subsequent rebuilding of the city centre, marble was the material used regularly for the orders, for the facing of wall-surfaces, and for all decorative detail. To this phase belong the rebuilding and enlargement of the basilica beside the Lechaion road, the construction of colonnades down both sides of the street itself, and the building of the shops and of the peristyle courtyard (the 'Peribolos of Apollo') across the street from the basilica, and of the monumental archway at the point where it entered the agora; the replacement of the old North-west Stoa by a line of concrete-vaulted shops; the rebuilding in marble of the Capitolium and of the pronaos of the Temple of Hermes (D); the building of a large new temple (C) and its enclosing colonnaded precinct beside the Sikyon road, just above the historic fountain of Glauke; and the building, near the theatre, of an odeion, or covered concert hall. During the second century the irregular layout of the north side of the lower agora was tidied up by the addition of an elaborate columnar façade (the Captives Façade) linking the North-west Shops to the propylaea; a large bath-building and latrine were built beside the Lechaion road, north of the Peribolos of Apollo; more public offices and a lavatory were added to the South Stoa; and the Fountain of Peirene was twice remodelled, under Hadrian and again later in the century, on both occasions with elaborate marble facings. In the seventies of the century the odeion was rebuilt by the Attic millionaire, Herodes Atticus. The last two decades of the century saw the line of temples at the west end of the lower agora completed by the addition of twin temples (H and J), dedicated respectively to the emperor Commodus, personified as Hercules, and to Poseidon.

By the year 200, then, not long after the Greek traveller and writer Pausanias visited Corinth and described its monuments, the centre of the city had assumed substantially the form which it was to retain with only minor alterations throughout the later Empire. The processes of building and rebuilding that have just been described are exceptional only in the detail in which they can be documented. The same sort of thing was happening in innumerable cities, large and small, up and down the length of the Empire. We shall be glancing at another, Lepcis Magna in North Africa, in a later chapter.[2] If the Roman agora at Corinth had a certain logic and coherence, it was because, despite all changes of materials, style, and architectural usage, the original plan was soundly conceived, and because the successive additions to it were all made within the framework of a single developing, but fundamentally conservative, tradition.

The basis of this tradition was Greek. We see this in the building materials and techniques. Concrete makes only a limited and grudging appearance, and then chiefly in contexts which more or less directly derive from Late Republican and Early Imperial Italy – in the cores of the temple podia, in the substructures of the theatre and odeion, in the vaulting of the Northwest Shops, and in the second-century Baths of Eurykles. We see it again in the decorative detail and in the continued use, throughout the first century, of the Ionic and of an evolved Doric order, with direct Attic influence still clearly manifest. Above all we see the native Greek heritage in the planning, orderly but flexible, balanced but never giving way to the demands of an over-rigid symmetry. The organization of the commercial quarters in particular is characteristically Greek. The formal grouping of the shops in orderly units stems straight from the tradition of the great hellenistic stoas. This is neither the dense concentration of the bazaar quarters of the Orient (as we see it, for example, at Dura, in Syria),[3] nor the haphazard mingling of shops and houses characteristic of so much of Pompeii, of Ostia, and (as we know from the Severan marble plan) of Rome itself. This is Greek planning, although – an important reservation – the immediate antecedents of some of it may well lie in hellenized South Italy rather than in Greece itself. The formal precedents for the North Market at Corinth, for example, go right back to buildings such as the late-fourth-century B.C. porticoed market square behind the North Stoa along the harbour front at Miletus; but it is to Campania and Magna Graecia (at Pompeii, and already in the second century B.C. at Morgantina in Sicily) that one looks for parallels in the immediately preceding period. From South Italy such market buildings had already spread to Rome itself and to North Africa (at Lepcis Magna as early as 8 B.C.), and this may very well also be the immediate source of the North Market at Corinth and, in Athens, of the Market of Caesar and Augustus. In such matters it is natural and proper to compare and to contrast the Greek and Roman architectural traditions, but one has also to remember the extent to which the two traditions had already met and merged.[4]

That the early architecture of Corinth did incorporate elements derived directly from Italy is abundantly clear. Reticulate masonry, a rarity in Greece, appears in a mausoleum beside the Kenchreai road. The limited use of concrete has already been noted. Italian precedents presumably determined the use of the Tuscan order in the original poros temple of Hermes, as well as the form of the Augustan façade of Peirene, with its engaged Doric order framing a row of arches and carrying an engaged upper, Ionic order. More generally one can detect the influence of Rome in the paving of the agora in marble[5] and in the predominance of certain stereotyped architectural forms, such as that of the temple set on a tall podium, with steps on the front only, instead of the uniformly-stepped *krepis* of the ordinary Greek temple – contrasting types of which the Temple of Tyche offers an early and rare conflation. To the same category of Roman architectural innovations one may assign the several bath-buildings, one of the most popular and widespread of Western importations to the hellenistic East, and the as yet unexplored, third-century (?) amphitheatre, a type of building which was, by contrast, always something of a rarity in the Greek-speaking world.

Two of these typically Roman building types, the basilica and the theatre, are worth describing and discussing in rather greater detail. Although the actual remains of these buildings are not particularly well preserved at Corinth, the archaeological documentation is unusually clear. Their architectural history will serve to illustrate many features that are liable to recur wherever buildings of this sort are found in the eastern half of the Empire.

Of the two, the basilica is in the context the less important, since such buildings were never common in the Roman East.[6] The fact that Corinth possesses no less than three is as clear evidence as one could wish of the strength of the Italian influences at work under the Early

Empire. The earliest and architecturally the most important of the three is that built towards the end of the first century B.C. beside the Lechaion road. The elongated plan [162], with its ambulatory colonnade and its entrance and tribunal at the two ends of the long axis, clearly relates it to the basilica at Pompeii and no less clearly distinguishes it from the contemporary basilicas of Rome and Central Italy, which were regularly laid out parallel to, and in very close association with, the adjoining forum. The latter was the disposition adopted by the basilicas of Ephesus and of Smyrna, of Berytus in Syria, and of Cyrene, in all of which the façade towards the adjoining open space consists, in the Roman manner, of a colonnade. In this respect (as indeed in a great many others) it was the stoa that was the normal East Roman equivalent of the Western basilica. The Lechaion road building is of interest, therefore, as illustrating the very close links that united the newly refounded city with Campania and southern Italy. This type of basilica seems, on the other hand, to have had little influence on later architecture elsewhere in the Roman East. At Corinth itself two more basilicas were added some fifty years after the first, both of which adopt the commoner transverse layout. Since, however, they differ markedly from those of the capital in being architecturally independent entities, accessible only up a tall flight of steps and through a single door, they may perhaps be regarded as somewhat eccentric local variants of the parent type.

The Roman theatre at Corinth occupied the same natural sloping site as its Greek predecessor, but unlike, for example, that of Roman Ephesus it was a completely new building. The superimposition of the two structures does, however, serve to illustrate some of the main differences between the Greek and the Roman theatre. These differences were well summarized by Vitruvius, writing in the early twenties of the first century B.C.; and although in practice often obscured by the historical development of the Roman from the hellenistic theatre and, particularly in the Greek-speaking

part of the Empire, by the subsequent interaction of the Roman and native traditions, they are in fact clear enough in their broad outlines [163].

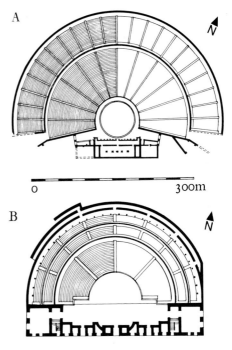

163. Typical Greek and Roman theatres. Plans.
(A) Epidaurus, mid fourth century B.C.;
(B) Orange (Arausio), first century A.D.

One of the basic differences between the Greek and the Roman theatres lay in the relationship between the seating and the stage-building. In the former the 'orchestra' (orchaestra) still retained its originally circular shape, except for that part of it which might be encroached upon by the stage, and the seating (koilon, Latin cavea) enclosed substantially more than half of the circle so described; the two lateral entrances to the orchestra (parodoi) were open passages and met at an obtuse angle, separating the seating from the stage-building. In the Roman theatre orchestra and seating

were both semicircular, and the parodoi, now vaulted and known as *confornicationes*, faced each other directly across the front of the stage and carried an extension of the seating across to meet two lateral projections of the stage-building. This important development had already taken place when the Large Theatre at Pompeii was rebuilt, soon after 80 B.C., and thereafter in the typical Roman theatre stage and seating were part of a single, organically planned structure, enclosed within a single continuous perimeter.[7]

A second and hardly less fundamental difference between the Greek and the Roman theatre lay in the size and elaboration of the stage-building. There is much that is still controversial about the exact nature and chronology of the transition from one to the other; but since on any reckoning this took place in Republican times, it need not here be discussed further, beyond remarking that the context of the development was one that was not limited to Italy but was widely manifest also in the late hellenistic architecture of the eastern Mediterranean. This is an important reservation when one comes to consider the impact of the Roman theatre on the provinces of the Roman East; but even if it means that the Roman contribution consisted primarily in giving formal shape and direction to tendencies that were in themselves of considerably wider application, there can be no doubt of the distinctively and unmistakably Roman character of the finished product. The classical Greek and earlier hellenistic theatres had seen the introduction of substantial stage-buildings, but these were independent structures, consisting essentially of a rectangular building (*skene*, Latin *scaena*) placed tangentially to the theoretical circumference of the orchestra; in front of it, projecting forward from the scaena between two rectangular wings (*paraskenia*), was the stage itself, upon which part, but part only, of the action took place. Now, in the Roman version, besides the linking of the stage-building to the cavea, the stage itself was deepened and raised, cutting off a part of the orchestra; the façade of the stage-building

(*scaenae frons*) was heightened and given an elaborately articulated decoration of super-imposed columnar orders framing three symmetrically placed doorways and constituting a formal backdrop; and the whole stage was covered with a timber roof, which sloped forwards and upwards from the summit of the scaenae frons and was supported at either end by the parascaenia. The formula was in detail capable of widely varying interpretation; but a glance at the three best-preserved of the innumerable theatres of the Roman world, at Orange [163B], at Aspendos [197], and at Sabratha [249], will suffice to show that these were variations on a single, immediately recognizable theme. Another feature that distinguishes the Greek from the Roman theatre is the provision of shelter for the audience between performances, or in the case of rain. In the Greek theatre this novelty took the form of a separate building (e.g the Stoa of Eumenes at Athens). In the Roman theatre colonnades were very commonly incorporated as organic elements of the design, in the shape either of a roofed ambulatory round the top of the cavea (*porticus in summa cavea*) [197] or of a colonnaded court behind the scaena (*porticus post scaenam*) [74], or both [e.g. 247A].[8]

The subsequent evolution of the Roman theatre, though in detail complex, is in its broad outlines simple enough. It may be said to develop along two main lines, both of which are well illustrated by the remains at Corinth.

Formally it was the stage-building that was the centre of architectural interest. In this respect, it is customary to classify the stage-buildings of the Roman world as belonging to an 'Eastern' or to a 'Western' group, of which the former is distinguished by its continued emphasis upon the rectilinear façade of the stage-building, articulated about its three monumental entrances and variously enriched with columnar aediculae or continuous orders, whereas the latter is developed in depth, with an elaborate alternation of re-entrant and projecting features, which tends increasingly to throw emphasis upon the decorative screen at the

expense of the wall behind it. The choice of terms to indicate this difference is not a happy one, since (to quote only the most glaring exception) the theatres of Roman Syria are almost exclusively of the so-called 'Western' type. Provided, however, that one makes full allowance for the complex interaction of what were, after all, two closely related and con-

three deep, curved re-entrants, framing in reverse a pair of apsidal exedrae that open off the portico beyond, the stage-building is little more than a slender supporting background for the columnar screen. At the other end of the scale stands the approximately contemporary (Hadrianic) but in many respects extremely conservative theatre at Stobi in Macedonia [164].[9]

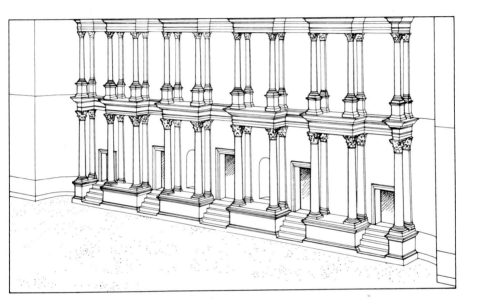

tinuously developing branches of a single tradition, the classification itself, which is well exemplified in the difference between the theatres of Aspendos and of Sabratha, is sound enough. The distinction seems to lie between those provinces (Greece and Asia Minor) which had a long and essentially Greek theatrical tradition of their own, and those which derived their theatrical architecture mainly from southern Italy and from Rome. In this respect the theatre at Corinth clearly reflects its many western contacts. The remains of the Augustan stage-building are rather scanty, but the form of the second-century marble scaenae frons can be reconstructed almost in its entirety. With its

164. Stobi, theatre, second century A.D. Restored view of stage building and plan

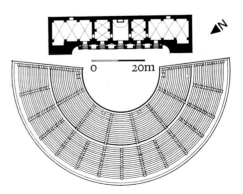

Here not only did the seating occupy a segment of well over 180 degrees, in the Greek manner, but it was still separated by open parodoi from the stage-building, and the façade of the latter consisted of little more than a straight wall with five equally spaced doors framed between a uniform series of simple bi-columnar aediculae.

The other principal line of development within the Roman period was one of function. The standards of theatrical spectacle were everywhere declining. Already in the first century there are literary references to the staging of gladiatorial contests in theatres, and during the second and third centuries a great many theatres were in fact adapted to serve these and similar purposes, particularly in the eastern half of the Empire, where amphitheatres were exceptional. At Corinth the adaptation dates from the early third century and took the form of cutting back the stage and the front rows of seating to form an arena, with a high surrounding wall to protect the spectators and with openings for the introduction of the wild beasts used in the ever-popular hunting displays. Another and unusually well preserved example of such a transformation can be seen at Cyrene. The Hadrianic theatre at Stobi, referred to in the previous paragraph, was actually built to serve the double purpose, with an arena which could, when required, be converted by the addition of a temporary wooden stage. This tendency was not confined to the East. At the other end of the Roman world small theatre-amphitheatres are characteristic also of the remoter parts of Belgic Gaul and of Britain.[10]

Later again, the arena of Corinth was converted into a *colymbēthra*, a tank for aquatic displays. The practice is thought to have originated in the East, where there is evidence for some such installation at Daphni, the fashionable suburb of Antioch, as early as the beginning of the second century. It achieved widespread popularity – and notoriety – in late antiquity. The theatre at Ostia is one of many that were converted to such purposes. The well-known 'bikini' girls of the Piazza Armerina mosaics presumably represent performers.

For more cultured tastes there were still the small covered theatres, or *odeia*, which were used for readings, lectures, and concerts, and which were commonly, as at Corinth, closely linked architecturally with their larger neighbours of conventional, open design – at Athens, for example, at Naples and Pompeii, at Lyon [141], at Vienne, and at Syllion in Pamphylia. In plan many of these odeia (e.g. in Greece at Nicopolis and at Buthrotum) were simply theatres in miniature; in others, as at Pompeii, at Epidauros, and at Termessos in Asia Minor, the curved seating was enclosed within a rectangular outer wall, which carried the roof. This latter form closely resembles, and may well derive from, such hellenistic buildings as the *bouleuterion*, or council hall, of Miletus. At Gortyna in Crete a circular bouleuterion was in fact converted into an odeion, and many of the so-called odeia of the Greek-speaking world (e.g. at Aphrodisias and Ephesus, or at Ptolemais in Cyrenaica) may well in fact have been bouleuteria, or even have done double duty as places of civic assembly and of cultural entertainment. Limitations of size alone prevented the roofed rectangular form from being more widely adopted in northern climates, as it was at Aosta [102]. The largest known building of the sort is at Athens, built by Herodes Atticus, who was responsible also for rebuilding the odeion at Corinth. This was a building of ordinary theatrical shape, seating some 3,000 spectators. As was customary in odeia, the stage-building was of simple, severely rectangular design. After a fire in the early third century it, too, was converted into a miniature arena.

To conclude this picture of the monuments of Roman Corinth, it may be noted that the external influences, though predominantly Italian, did not all come from the West. The formal colonnading of the Lechaion road early in the first century A.D. almost certainly reflects the city's commercial activities in the Levant. By the second and third centuries this striking architectural form had become almost as common in Asia Minor as it was in Syria, but at this early date it was only in the cities of coastal Syria

that one would have found the necessary models. The flourishing architecture of Roman Asia Minor does in fact seem to have had surprisingly little impact upon that of Corinth. A possible exception is the Captives Façade, a scenic columnar façade which was designed to bridge an awkward hiatus in the northern frontage of the lower agora, and which may have served as a background for dramatic performances in the agora.[11] Even in this instance, however, the fact that four of the columns of the upper façade were replaced by caryatid figures, a recurrent and typically Attic motif, suggests that the immediate inspiration may have lain nearer home, and only at second-hand in the cities of western Asia Minor, where this type of decorative columnar screen was first developed.

ATHENS

It was in such relatively new foundations, or refoundations, as Corinth that the springs of provincial life still flowed. Athens by contrast was a backwater. She had suffered grievously in the sack of 86 B.C. and during the Civil Wars, and did not revive fully until the time of Hadrian.[12] Moreover, even had she wished to do so, she could never escape from the shadow of her own rich past. Students from all over the Roman world might flock to her university;

philhellene emperors and private citizens might endow her with new and splendid buildings; but there were no living traditions other than those of an ever-lively intellectual curiosity and of a craftsmanship which was equally at home in moving a venerable monument, block by block, from one site to another, in turning out reproductions of old masters or decorative sculpture in the classical manner, or in producing the magnificent (and within its limited range strikingly original) series of Attic figured sarcophagi.

Against such a background of impoverished versatility it is not altogether surprising that the monuments of Roman Athens should present a bewildering variety of faces. If we except the activities of such Roman architects as the Decimus Cossutius who was called in when Antiochus Epiphanes between 174 and 164 B.C. undertook the construction of the Olympieion, the great Temple of Olympian Zeus, the Roman series begins, characteristically, with the munificence of a Roman private citizen, Appius Claudius Pulcher, friend and correspondent of Cicero, who between 50 and 48 B.C. gave money for the building of the Inner Propylaea at the sanctuary of Eleusis. This, with its mixed Doric and Ionic order, its beautifully carved, figured Corinthian capitals [165], and, on the inner face, its caryatid maidens copied from those of the Erechtheion, was a little masterpiece of in-

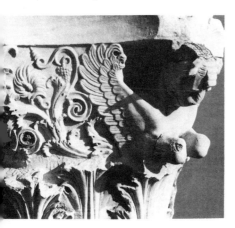

165. Eleusis, figured Corinthian capital
from the Inner Propylaea, c. 50–40 B.C.

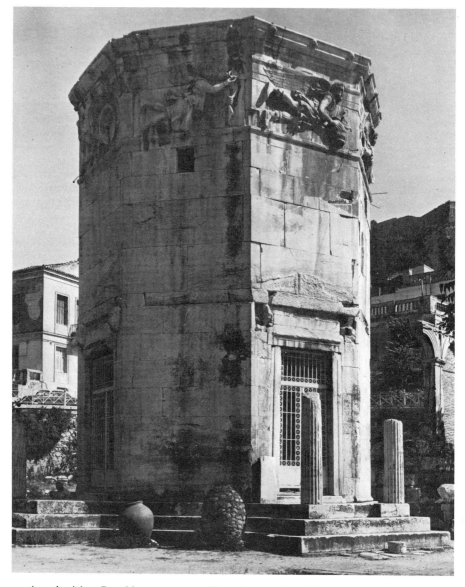

ventive eclecticism. Roughly contemporary (the exact date is disputed) is the 'Tower of the Winds' [166, 167], the elegant octagonal monument built to house the water-clock, or Horologeion, of Andronicus of Cyrrhus, the graceful lotus-and-acanthus capitals of which were copied and re-copied right through Christian times and survived to inspire a further long series of copies in neo-classical England and Scotland. To the same genre of monuments

belonged the little Temple of Rome and Augustus on the acropolis. This was a small circular building, little more than a tempietto, and it too drew freely on the decorative detail of the Erechtheion. The extraordinary influence of the latter building upon the architectural ornament of the Augustan Age may in part be explained by the fact that it had recently had to undergo a substantial restoration after a fire. Its ornament was part of the repertory familiar to the Attic craftsmen of the day.[13]

Beside these buildings, which illustrate at its best the characteristically Attic mixture of antiquarianism and inventiveness, the Market of Caesar and Augustus was a rather prosaic

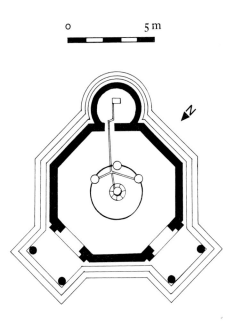

o 5 m

166 (*opposite*) and 167. Athens, Tower of the Winds, or Horologeion of Andronicus, towards the middle of the first century B.C., with plan

building.[14] Built from money given by Julius Caesar and Augustus and dedicated between 12 and 2 B.C., it consisted of a paved rectangular piazza, some 270 by 225 feet (82 by 69 m.), enclosed on all four sides by Ionic porticoes, off

the two shorter sides of which opened individual shops, as at Corinth, and off the two longer sides inner porticoes which were designed to shelter temporary stalls. Incorporated into the south portico was a fountain-building, and just outside the east entrance lay the offices of the presiding market official, a large public lavatory, and the Tower of the Winds. The main entrance, off-axis on the short, west side, faced the Agora, and consisted of a conventional Doric tetrastyle propylon, much of the detail of which was obviously inspired by fifth-century classical models. From this, and from the use of certain archaizing structural devices, it seems very likely that some of the workmen had been employed in transporting and reassembling on a new site in the Agora the fifth-century B.C. Temple of Ares from Acharnai in northern Attica. There are at least two other well attested examples of this practice about this date, elements of the temples of Athena at Sounion and of Demeter at Thorikos being used for making the porches of new temples in the Agora.[15] Nothing could better illustrate the cult of the classical in Athens of the Early Roman period, or the economies to which the city was driven by its poverty.

Unquestionably the most original and important monument of the Augustan period was the great odeion built as an adjunct to the Gymnasium of Ptolemy by Agrippa, about 15 B.C., on a dominating site in the middle of the south side of the Agora, overlooking the Panathenaic Way [168].[16] From the outside it consisted essentially of a lofty rectangular, gabled hall, towering above the sloping roof of a concentric outer structure, of which three sides were occupied by an outward-facing gallery and the fourth, towards the north and at a lower level owing to the slope of the ground, by the rectangular stage-building. The main entrance to the seating and to the gallery lay at the south end, at gallery level; a small porch in the middle of the north side gave independent access to the stage-building. Except for a shallow lobby at the south end the entire central structure was occupied by the seating and stage of the lecture hall, which

168. Athens, Odeion of Agrippa, *c.* 15 B.C.
Axonometric and restored views

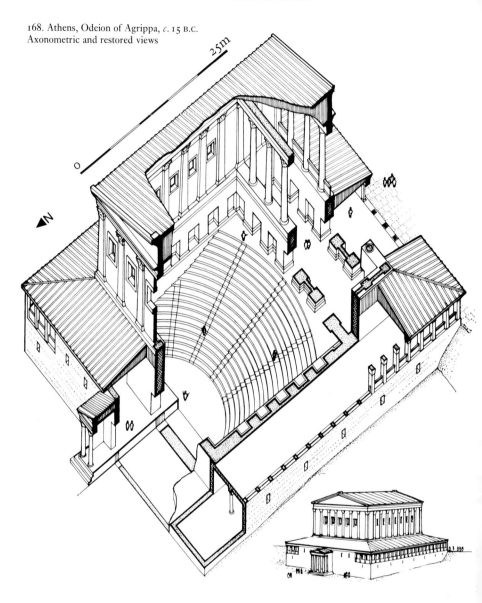

was almost exactly square (82 feet; 25 m.) and only very slightly less (76 feet; 23 m.) from orchestra to ceiling. The stage was narrow and severely rectilinear, and the orchestra and seating gently segmental in plan, the latter being pitched at an unusually shallow angle so that the back row fell level with the floor of the lobby and the outer gallery. When full it seated about 1,000 spectators. Except for whatever statuary there may have been and for the painted stucco

of the walls, decoration seems to have been concentrated on the stage front and orchestra, both of which were elaborately treated in polychrome marble; the carved ornament of the former once again reflects the classicizing tastes of the day, being copied straight from fifth-century models.

Above the level of the gallery roof the walls of the odeion were treated, both internally and externally, as an almost independent structure. Along three sides the roof was carried on a series of massive rectangular piers, which projected inwards and outwards from a comparatively thin curtain wall to form the pilasters of a Corinthian order, eight along the north façade and ten along the east and west sides. Along the south façade and above the partition wall between hall and lobby there were, instead, open colonnades, each consisting of six columns placed between the two corresponding piers of the outer walls; the capitals of the outer colonnade were Corinthian [169], those of the

169. Athens, Odeion of Agrippa,
c. 15 B.C. Capital

inner colonnade of the same lotus-and-acanthus form as those of the Tower of the Winds. There were presumably rectangular windows in the curtain wall between the pilasters, but the bulk of the light came, most effectively, from behind and above the spectators, through the colonnades and so forwards and downwards towards the stage.

Although completely out of scale with its setting, this was by any standards an impressive building, and to the Athenians who watched it going up there was much about it that must have seemed very strange. The workmanship and detail were unmistakably Attic, but for the building itself there were no local precedents. The restoration of the historic Odeion of Perikles some fifty years earlier[17] had been carried out on traditional lines; and although we know all too little about it, we do know that it was notoriously bad for vision on account of the many supports for its tent-like roof. Agrippa's Odeion did have a great deal in common with a building such as the second-century B.C. Bouleuterion at Miletus, notably in its division both internally and externally into two storeys and in its external treatment of the upper storey as a virtually independent unit, with an engaged classical order of its own; but even at Miletus the roof was supported by uprights, with an open central span of only 50 feet. The only comparable buildings at this date were in Italy. In particular, the Covered Theatre at Pompeii, with a span of 90 feet (27.60 m.), offers so many points of resemblance that it is hard to believe that the architect of Agrippa's Odeion did not have it, or some building very much like it, in mind when planning his own building. Another Italian building with which the odeion presents a certain analogy is the Basilica Aemilia, with its external galleries that seem to have been designed primarily for the viewing of spectacles in the adjoining forum. The siting, too, a dominating mass set axially at one end of a large open space, follows a typically Italian pattern and one that had few, if any, precedents among the more freely grouped monuments of classical and hellenistic Greece. The elaborate use of poly-

chrome marbling is yet another detail that suggests contemporary Western contacts. The Odeion of Agrippa was an intruder to Athens, the broadly late hellenistic architectural language of which was strongly coloured by the recent Italo-hellenistic experience of south-central Italy.

In an earlier chapter[18] we have already noted the many motifs in the architectural ornament of Augustan Rome which appear to be derived directly from Attica, motifs which include not only revivals from the great monuments of the past, notably from the Erechtheion, but also derivations from such near-contemporary masterpieces as the figured capitals of Eleusis. The fact that a few years earlier Agrippa had been intimately concerned with the largest building project of contemporary Athens does much to explain this phenomenon and indicates how readily men and ideas were passing between the two cities. It also shows that this was a two-way traffic. The flow of materials and craftsmanship from east to west was matched by a flow of architectural ideas from west to east. It is the former of which the results are the more immediately distinctive and which tend, therefore, to attract more notice. It is the latter, on the other hand, which were the more important in the long run, and which constitute the essential element in the gradual romanization of the architecture of the hellenistic East.

During the greater part of the first century A.D. there was little building of importance in Athens. The only substantial exception was the rebuilding of the Theatre of Dionysus under Nero, between 54 and 61. The form of the seating was left untouched on this occasion; and although the stage-building was modernized, this seems to have been on very conservative, strictly rectilinear lines, the scaenae frons probably closely resembling that of the theatre at Stobi [164].[19]

The second and early third centuries were, by contrast, a period of relative prosperity, a prosperity to which the exportation of fine building materials and Attic architectural craftsmanship continued to make an important contribution. To the resulting urban expansion Hadrian gave shape by building an aqueduct and formally adding a whole new quarter to the east of the old city. The many remains of private houses, bath-buildings, and gymnasia that have been recorded in this area show that Hadrian's was no mere empty gesture.[20] The principal monument within it was the Olympieion, which was now finally completed and dedicated in 132, some 700 years after the project was first conceived by Peisistratus and 300 after it was redesigned by Cossutius on lines that were followed with very little change in the finished building. In the ancient world such projects, if they were not brought rapidly to completion, were apt to hang fire, sometimes for decades, sometimes for centuries (one recalls the Didymaion near Miletus, begun by Alexander the Great and finally completed by Caligula), and they must have been an important factor in ensuring the continued vitality of traditional building practices and motifs.

The other surviving early-second-century monument of the new quarter, the arch which divided the new from the old city [170],[21] is one of those singular creations which do not fit neatly into any category. A product of much the same mixture of conservative taste and intellectual curiosity as is embodied in the Inner Propylaea at Eleusis, its curious proportions do not make sense until one restores to it mentally, not only the statues (presumably of Theseus and Hadrian) which stood in the central aediculae of the upper order, but also the strong vertical accent of the columns that flanked the lower archway, standing on independent pedestals and bracketed out from the entablature, in obvious imitation of those of the façade of Hadrian's Library [171, 172]. The scheme is then revealed as an elaborate interplay between two superimposed architectural schemes, on the one hand the projecting columns, which are made to seem to carry the architectural framework of the upper storey, and on the other the deliberately muted structure of the arch proper. The effect is enhanced by the deliberate displacement of the one relative to the other. The

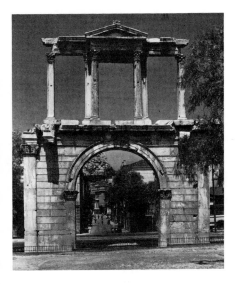

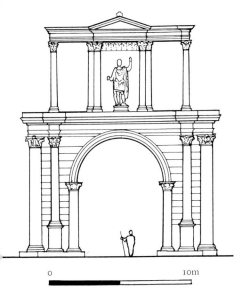

170 (*top*) and 171. Athens, Arch of Hadrian, probably erected in 131, view from the east and restored elevation

0 10m

intention was akin to, though more elegantly contrived than, that of the great fountain-building at Miletus [192]. It betrays the working of a thoroughly baroque mentality operating within the conventions of a rather formal classicism.

The Stoa and Library of Hadrian occupied a rectangular site adjoining, and of roughly the same dimensions as, the Market of Caesar and Augustus.[22] In plan it was a very close copy of Vespasian's Templum Pacis in Rome, a porticoed garden enclosure symmetrical about the longer axis, with a range of large rooms along the side facing the single entrance and with small exedrae opening off the porticoes of the two long sides; a long pool ran down the centre of the garden. The only difference of substance from the parent building was that the principal room, being a library, not a temple, did not call for the gabled pronaos that breaks the line of the inner portico of the Templum Pacis. The façade, of which the left half and one column of the tetrastyle central porch are preserved to cornice height [172], was an extended and in detail simplified version of that of which part is still standing in the Forum Transitorium. One must envisage it crowned by a plain attic serving as a background for a row of statues placed above the columns. In detail it illustrates a nice balance of influences. The green cipollino columns from Euboea and the hundred columns of Phrygian pavonazzetto which once carried the inner porticoes belong, as does the idea of an almost free-standing columnar screen, to the architecture of contemporary Rome. So does the raising of the order on a base, to give added height, with the difference, however, that the base here is not an engaged plinth but a free-standing pedestal, a device which was already widely popular in the Roman East but which was found only sporadically in the West before Christian times. The decorative drafting of the masonry is another convention which had only a limited vogue in Early Imperial Rome,[23] but which was at home in Asia Minor. Very little of all this was native to Athens, any more than it was to Lepcis Magna, where we shall be

172. Athens, part of the façade of the Library of Hadrian, 132

meeting the same scheme in slightly developed form some seventy years later.[24] The significance is wider. Already in the more sophisticated provinces we can detect the beginnings of the break-down of the old regional differences and of the emergence of an architecture which was, in the fullest sense of the term, Imperial Roman.

The period immediately following Hadrian's work in Greece was dominated architecturally by the figure of Herodes Atticus, the wealthy patron of the arts whose benefactions included the restoration in Pentelic marble of the stadium at Athens for use in the Panathenaic games of 143–4; the building of the odeion and the rebuilding of the Peirene Fountain at Corinth; the erection of a handsome fountain-building beside the Altis at Olympia; and, towards the end of his life, the construction of the odeion which today, consolidated and restored but not re-roofed, still serves as an open-air theatre and concert hall for the city of Athens. Enough has survived of the nymphaeum at Olympia to permit a reliable reconstruction of most of its features, including the statuary, the display of which, with its ostentatious references to the munificence of its donors, was one of the primary functions of such buildings.[25] It consisted of a raised semicircular exedra and basin, the curved inner façade of which incorporated two tiers of recesses set within gabled aediculae, within which stood statues of members of the imperial family; flanking the exedra at the same level were statues of Herodes himself and his wife; in front of it, at a lower level, a long rectangular basin; and at either end of the latter, framing the whole composition, a pair of elegant, conical-roofed circular tempietti. The elements were all familiar; indeed, an apsidal nymphaeum and a small tempietto-like fountain building (the latter notable for its use of a brick dome, one of the earliest known in Greece) figure independently among the monuments that were added to the Agora at Athens at just about this date, following the completion of the Hadrianic aqueduct in 140. It was precisely in the manipulation and recomposition of such familiar forms that this mid-second-century Greek architecture was most at home.

The Odeion of Herodes, though carried out in a more sober vein, was a building of the same eclectic spirit. The square outline and basic simplicity of the stage-building are those of the traditional odeion; but it seated 5,000 people, and the roofing without internal supports of a semicircle of radius 125 ft (38 m.) was in itself a remarkable engineering achievement.[26] The internal arrangements are those of a theatre, the orchestra and seating, before restoration, following the old Greek layout, whereas the scaenae frons was a simple version of that of a Roman theatre, with what appears to have been a single columnar order, or series of aediculae, framing the three doorways and the eight statuary-recesses that constituted the main decoration at stage level. Above this rose the double row of round-headed windows which are such an impressive and unusual feature also of the severely monumental outer façade. The layout of these, it will be observed, forms a characteristic counter-rhythm to that of the lower order.

Athens was sacked by the Herulians in 267; but even before this date there had been no building of importance in the city after the end of the second century, and very little elsewhere in southern Greece, until late antiquity, to which the brief spell during which Thessalonike (Salonica) was an Imperial capital served as an effective curtain-raiser. The Indian summer of Athens came even later, in the fourth and fifth centuries.

OTHER ROMAN SITES

Outside Corinth and Athens the only major site of the Roman period to have been systematically excavated is that of Philippi in Macedonia.[27] The city was founded by Philip of Macedon, but the visible remains are almost entirely those of the Roman military colony, established here in 42 B.C. and reinforced twelve years later, shortly after the battle of Actium. The agora, terraced into the gentle slopes at the foot of the

acropolis, offers an unusually complete picture of a Graeco-Roman city centre that was laid out afresh, on monumental lines, in the second century A.D. It was grouped symmetrically about its shorter, north-south axis around a rectangular, marble-paved open space, about 50 by 100 yards in extent. Along the north side the terrace wall of the Via Egnatia and the rocky cliffs of the acropolis formed a back-drop to the orators' platform (*bema*), which stood against the centre, flanked by a pair of small temples and long, narrow fountain basins. The other three sides were laid out as multiple stoas, with colonnaded frontages towards the central space and, opening off the inner colonnades, shops, offices, and, on the east side, a public library. Facing each other across the central area at the north ends of the two short sides were two temple-like buildings, distyle *in antis*, one of which contained low stepped benches round the three inner sides of the cella and was evidently the *bouleuterion*. The whole complex, which replaces an earlier, less spacious layout, appears to have been built between 161 and 179.

Other excavated buildings at Philippi include a large bath-building of scrupulously rectilinear design, an unusually complete public lavatory, and the Roman theatre, built on the site of its Greek predecessor and, like so many theatres in the eastern provinces, remodelled in the third century to serve as an amphitheatre. The material in common use is the bluish local marble, and the motifs and workmanship both indicate close links with the workshops of Bithynia and western Asia Minor. The same is true of the rather scanty Early Imperial remains of Thessalonike.[28] Evidently the position of both cities upon the Via Egnatia, the principal land route from Italy to Asia Minor, had already

gone far to establish the community of style and building practice which is such a marked feature of later Imperial and Early Byzantine architecture throughout this whole area.

Scattered throughout Greece there are innumerable other Roman monuments, but most of them have received little serious study. One that deserves brief mention is a nymphaeum (so named in a fragmentary inscription) which was excavated some years ago at Argos in the Peloponnese.[29] It was a circular building of the Corinthian order, with eight columns and a conical, scale-patterned roof. It dates from the second half of the second century and was thus roughly contemporary with the similar, but smaller, pavilions of the Nymphaeum of Herodes Atticus at Olympia and the little domed pavilion in the Agora at Athens.

In conclusion it should be remarked that Greece and the Greek islands were the source of more than half of the precious marbles that were widely used in Roman times for decorative paving, wall-veneers, columns, and statuary throughout the Mediterranean area. Among those quarried for export were the splendid white marbles of Attica, the red marble (*rosso antico*) and green porphyry of Laconia, the green-veined cipollino of Carystos, in Euboea, and the handsome verde antico of Thessaly. From the Aegean came Parian, the most prized of statuary marbles; Chian, both a black variety and the variegated brown and grey porta santa; the multicoloured breccia de' settebasi of Skyros; and africano and a soft, translucent grey marble from Teos, on the Asiatic coast. The shipments were often accompanied by Greek workmen and they played an important part in the dissemination of Greek motifs and Greek craftsmanship, wherever these are found.

ASIA MINOR

BUILDING MATERIALS AND TECHNIQUES

Asia Minor shared with mainland Greece the heritage of a rich classical past. There were, however, also important differences. In the first place, the classical backgrounds were in detail very different. Whereas in mainland Greece the native Greek element in the Roman architecture was dominated by the prestige of the monuments of classical Athens, in Asia Minor, if there was any single authoritative monumental tradition, it was the Ionic tradition of which the work of Hermogenes is the embodiment; and the hellenistic kingdoms, notably Pergamon, had been active creative centres when Athens was already a venerable pensioner. Then again, despite a century of piracy, civil war, and gross misrule, Asia Minor was still a country of rich resources. Ephesus was one of the great cities of the Roman world, and the map of Asia Minor is dotted with the names of cities great and small which enjoyed a prosperity in Roman times such as they have never had before or since. As a creative force Greece was spent. Asia Minor, on the other hand, was still a live and active exponent of the hellenic tradition. Situated, by temperament and tradition as well as by the facts of history and geography, midway between the two extremes of Rome and the Ancient East, it was to be an increasingly powerful force in shaping the development of the architecture of the later Roman Empire.

Asia Minor is a land of fine building-stones and marbles, and in Roman times it was still, for the most part, a land of plentiful timber. These were the natural and obvious materials for monumental architecture. There were many cities – Hierapolis on the Maeander, for example, or Assos and Alexandria Troas – which remained true to this tradition right down to Byzantine times. As late as the sixth century it

was still to dressed stone that the architects of Hagia Sophia in Constantinople and of the church of St John at Ephesus instinctively turned for the piers of their great vaulted monuments.

From Augustan times onwards, however, dressed stone found itself competing with a material which closely resembles, and patently derives from, the concrete of Roman Italy.[1] It did not have the strength and hydraulic properties which Roman engineers derived from their use of the dark volcanic sands of Latium and Campania; but in other respects it was very similar, consisting of rubble laid in horizontal beds in a thick lime mortar and brought to a finish with a facing of finer materials [173]. To outward appearances it is the facing that distinguishes it from the parent material. Such distinctively Italian facings as opus reticulatum are very rare. Instead, we find the local materials used in whatever way suited them best. At Miletus, for example, where the river boulders and pebbles are by nature intractable, much of the facing is extremely coarse [174]; and in parts of Cilicia the volcanic basalt lent itself most readily to a sort of opus incertum. Wherever the stone permitted, however, it was customary to dress it into small rectangular blocks, which were laid in courses very much in the manner of the 'petit appareil' of Roman Gaul, of which indeed it is the almost exact equivalent. The courses of the facing, unlike the facing of Roman concrete, normally coincide exactly with those of the core. Corners, doors, and windows were regularly turned with larger blocks.

The earliest datable example of this technique is in the superstructure and abutments of the aqueduct of Caius Sextilius Pollio at Ephesus (between A.D. 4 and 14) [175], and by the middle of the century it was already firmly established, at any rate in the cities of the west

coast. At Miletus, for example, one can watch the increasing sophistication of its use in a series of monuments ranging from the Baths of Cnaeus Vergilius Capito (Claudian), through the Humeitepe Baths and the aqueduct and substructures of the great nymphaeum (both Trajanic), to the mid-second-century Baths of Faustina, in which for the first time it begins to be used in combination with brick, another and later Roman innovation. Its early and widespread use in bath-buildings is no accident. It was precisely in buildings of this sort, in terraced platforms, and in the great vaulted substructures of such buildings as theatres and amphitheatres that concrete had first proved itself as a monumental building material in Italy; and it was such buildings that were among the earliest and most distinctively Roman contributions to the established hellenistic repertory.[2]

Whereas, however, in outward appearance it is the facing that immediately distinguishes this masonry from Roman concrete, structurally there was another and profounder difference;

173 (*opposite*, *left*). Ephesus, Baths of Vedius, mid second century [cf. 190B].
Detail of the coursed rubble masonry, showing the core and the typical facing of small squared blocks

174 (*opposite*, *right*). Miletus, Baths of Capito, mid first century. A coarser version of the masonry
shown in illustration 173, with massive stone details and vaulting carried out in smaller stones.
The shape of this dome was visible externally beneath a rendering of waterproof concrete

175 (*below*). Ephesus, Aqueduct of C. Sextilius Pollio, between 4 and 14.
The arches were of dressed stone, the abutments and superstructure of mortared rubblework

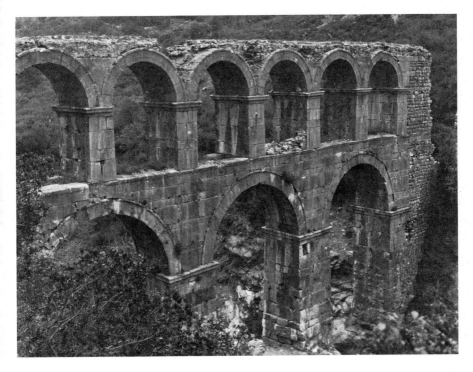

the mortar lacked the strength needed for the creation of vaulting in the fully developed Roman manner. Up to a certain span barrel-vaults, domes, and semi-domes could be constructed, as they had been in Late Republican Italy, by selecting elongated slabs of stone and laying them radially as if they were so many bricks. One can see vaulting of this sort in every one of the Milesian buildings referred to in the previous paragraph [cf. also 174 and 183]. Like the vaulting of Republican Italy, however, the finished product stood more by virtue of the disposition of the materials than because of the inherent strength of the mortar itself. It is altogether exceptional to meet a mortar (as one does occasionally in Cilicia, where there were supplies of volcanic sand similar to that of Italy) which had the almost monolithic strength of that used in the best Roman concrete.[3]

An immediate and architecturally very important result of this lack of suitable materials was that the sort of concrete building which was being undertaken in Rome during the second half of the first century A.D., and which has been

described in detail in Chapter 4, could have no immediate and direct counterpart in Asia Minor, or indeed anywhere else in the Roman East. As unquestionably the most progressive architecture of its day, it was bound in the long run to make itself felt all over the Roman world; but its impact could not take the obvious form of direct imitation. What did happen in Asia Minor (to confine the inquiry for the moment to the technical problems of vaulting, which was in practice the principal limiting factor) was that a substitute material had to be found, one which might .not have all the properties of Roman concrete, but which could be used with a greater freedom than either the dressed stone or the mortared rubble which were its only local alternatives. The material chosen was brick.

Although brick was regularly used in Asia Minor in classical times, it is poorly represented in the archaeological record. Crude, sun-dried brick was common both in Greek and in Roman architecture; but its remains are rarely preserved outside the dry climates of the Near East. Kiln-baked brick is, by contrast, virtually inde-structible; for that very reason, however, classical buildings have everywhere been ruthlessly pillaged by later generations in search of building materials. In Asia Minor climate and the building robbers have both been active, and as a result actual surviving examples of Roman brickwork, and *a fortiori* of Roman brick vaulting, are decidedly rare.

Of the two materials, although crude brick had long been known and used in Asia Minor, in the total absence of surviving examples it is impossible to prove that it was also used for vaulting. It was, however, undoubtedly so used both in Roman Egypt and in Roman Syria; and since at least one of the relatively few surviving fired-brick vaults of Asia Minor, that beneath the basilica at Aspendos, in Pamphylia [176], is of a very distinctive form for which all the precedents are in the mud-brick architecture of the Near East, there is a good case for regarding the use of brick vaulting as having first taken shape in Asia Minor under the influence of, and using the characteristic materials of, her eastern neighbours.[4]

176. Aspendos, pitched brick vaulting in the substructures of the basilica, end of the third century

With fired brick we are on firmer ground. There can be no doubt that this was introduced to Asia Minor from the West, either directly from Italy or else from Thrace, probably early in the second century A.D., certainly in time to be used in the upper storey of the Library at Ephesus [187]. How it was used, we may illustrate by reference to two of the principal monuments of Roman Pergamon. One of these is the Kızıl Avlu, or Serapaeum,[5] of which some of the secondary buildings are of the usual mortared rubble faced with small squared blocks, but of which the great central hall [181] is constructed entirely of brick. At first sight this bears a remarkable resemblance to the brick-work of Rome, but the resemblance is in fact only skin-deep. Instead of being built in the Roman manner of concrete or mortared rubble faced with brick, the masonry is here of mor-tared brick throughout. That this was no mere local eccentricity is shown by such other surviv-ing examples as the second-century superstruc-ture of the Harbourside Baths at Ephesus [177] and the upper parts of the pressure-towers of

177. Ephesus, Harbour Baths,
part of the late-second-century bath-building.
The substructure is of dressed stone,
the superstructure of solid brick. The lines of holes
are those of the pegs for fastening the slabs
of fine marble veneer-panelling

the third-century aqueduct at Aspendos [198]. This was regular practice in the brickwork of Roman Asia Minor; and, as we shall see, it was this form and not its metropolitan Roman counterpart which was taken over by the archi-tects of Constantinople.

The other Pergamene monument to make extensive use of brick is the Temple of As-klepios Soter, built largely in the thirties of the second century [182].[6] This temple was the centrepiece of one of the great prestige monu-ments of its day, and the materials and methods used in its building acquire added significance from the fact that it was almost certainly directly modelled on the Pantheon, built a decade or so earlier. Instead, however, of the carefully graded, brick-faced concrete of the Pantheon, the drum was built of fine ashlar and the dome of brick, laid radially and reinforced at the spring by an outer ring of mortared rubble (which, with a fine facing of small squared blocks and heavy ashlar quoins, was the material of the adjoining, semi-subterranean rotunda [183]). One could hardly ask for a more graphic illustration of the blend of ideas that went to make up this provincial architecture: a Roman design carried out in a building tradition of which the immediate antecedents were local, but which in matters of vaulting was prepared to assimilate and to adapt a material, kiln-baked brick, which also was derived from Rome. When one reflects that the mortared rubble, too, is a translation into local terms of an earlier phase of Roman concrete construction, one realizes how closely interwoven were the various traditions that went to make up the architecture of Roman Asia Minor.

One other use of brick calls for a brief remark, in which bands of brickwork alternate with wider bands of mortared rubble. This is another characteristically Asiatic usage which makes its first appearance during the second century A.D., and which was ultimately to be taken over by the architects of Constantinople, the *locus classicus* of its use being the great Theodosian land walls of that city. A fine Roman-period example is that of the city walls of Nicaea in Bithynia, built

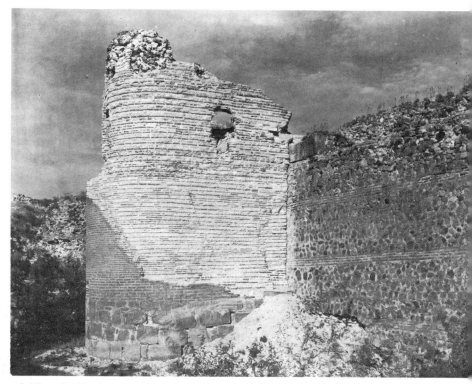

178. Nicaea (Iznik), city walls, between 258 and 269.
Tower, of brickwork, and (*right*) curtain wall of alternate bands
of brickwork and rubble masonry

between 258 and 269 [178]. Once again the
resemblance is to the 'petit appareil' masonry of
the European provinces rather than to the
superficially similar brick-and-reticulate opus
mixtum of Central Italy. The brickwork is not
merely part of the facing but runs right through
the core, to which it was presumably designed to
give strength and cohesion, preventing settle-
ment within the rather loosely mortared rubble
mass.[7]

THE CENTRAL PLATEAU

Asia Minor is a large country and in many parts
of it communications are difficult. In describing
the monuments of the Roman period, it will be

convenient to distinguish three main areas: the
central plateau, the valleys and plains of the
western coastal belt, and the southern coastal
plains of Pamphylia and Cilicia.

Of the three, the central plateau, accessible at
only a limited number of points from the coast
and from the sources of classical civilization, is
in the context by far the least important. Had
more been preserved of such flourishing centres
as Iconium (modern Konya), one might have
been able to form a clearer impression of the
architecture of the provinces of Galatia and
Cappadocia; but what little there is leads one to
suspect that it was in every sense of the word
provincial. The only exception is Ancyra, the
modern Ankara, which as capital and principal

179. Ancyra (Ankara), Temple of Rome and Augustus (*temp*. Augustus, 27 B.C.–A.D.14).
The cella and (*foreground*) footings of the peristasis

road-centre of Galatia occupied a privileged position. Here there are the substantial remains of at least two important monuments. One is the Temple of Rome and Augustus [179], on the walls of which was carved the best preserved text of the will and testament of the emperor Augustus, the *Res Gestae Divi Augusti*. This was a large, octastyle, pseudo-dipteral temple, of which the surviving detail of the cella is so very close in layout and style to the manner of Hermogenes that it has even been thought to be a building of the second century B.C. The outer order was, however, Corinthian, and there are several details that are hardly credible as hellenistic work. It was the product of a conservative but (as we have already seen from its influence upon the Temple of Mars Ultor in the Forum Augustum in Rome) still very live tradition.

The other major surviving monument of Ancyra is a very large bath-building, remarkable chiefly for the size and number of its hot rooms.[8] This appears to date from the reign of Caracalla (211–17) and was laid out on a grandiose rectangular plan, symmetrical about its shorter axis. At the west end there was a projecting apse, and at the east, as one entered, a large piscina (natatio). In front of it was a huge colonnaded peristyle. The baths were built throughout of mortared rubble faced with small squared blocks, alternating with courses of brick. Brick was used also for the vaulting of drains and staircases, and some of the smaller rooms may have been vaulted, although the main roofs must have been of timber. Architecturally as well as socially this was as thoroughly Western a building as the temple was native hellenistic.

Antioch-in-Pisidia, founded as a Roman colony soon after 25 B.C. to control the wild mountain tribesmen of the south-western extremity of the central plateau, illustrates an earlier and elsewhere very little documented phase of this process of westernization. It had been a hellenistic foundation, and traces of a rectilinear street-plan may date from this period. Otherwise the surviving remains are Roman; and since the colony does not seem to have maintained its early promise but to have soon settled back into a comfortable mediocrity, the initial architectural impact of the Roman foundation is unusually clearly documented.[9]

The principal excavated monument is the temple identified as that of Augustus, perhaps in association with the local divinity Mên. It occupies a commanding site, framed by the broad hemicycle which constitutes the rear wall of a large terraced platform. Around the hemicycle ran a two-storeyed portico, Ionic above and Doric below; and the centre line of the temple was projected downhill by Tiberius to form a grandiose axial approach. This was characteristically Roman planning, and the temple itself, in startling and significant contrast to that of Ancyra, was a building in the Roman manner, standing on a lofty podium, with a tetrastyle porch at the head of a frontal flight of steps. The lavish ornament, though drawn from the late hellenistic repertory, incorporates several of the motifs that contemporary architects in the West were busy making their own (notably the friezes of acanthus scrollwork and of bulls' heads and garlands). By selection, if not by actual workmanship, this was a very Roman building.

Other monuments are the fine Augustan aqueduct, built throughout of squared stone; a theatre, unexcavated; a large vaulted platform of mortared rubble masonry faced with ashlar, which served as the basis for a later building; and a monumental arch of the early third century. This last, a nightmare blend of Early Imperial motifs and of others derived from the contemporary marble architecture of the coast, is a typically provincial product of baroque taste misunderstood.

THE WESTERN COASTLANDS

The western coast was the traditional heart of classical civilization in Asia Minor, and throughout the Roman period, together with the adjoining province of Bithynia along the southern and eastern shores of the Propontis, it remained the vital creative centre. In a great many respects the Roman architecture of Ephesus and Pergamon, of Aphrodisias, Tralles and Hierapolis in Caria, of Cyzicus and Nicaea in Bithynia, remained remarkably true to its hellenistic antecedents. But within a somewhat conservative framework of ideas, there was also a spirit of lively experiment; and it was precisely because in certain aspects of planning, decoration, and technique the resulting innovations were coupled with a strong traditionalism, and because the basic artistic vocabulary was in consequence so familiar, that the art of this region was to be such a powerful factor in influencing the taste of late antiquity. One has only to measure the monuments of Ephesus against the rather arid antiquarianism of much of the contemporary architecture in Athens to appreciate the vitality and vigour of the former.

In architecture, as in so much else, it was the cities of Asia which were the repositories of the living hellenistic tradition.

Of the three principal excavated sites – Ephesus, Miletus, and Pergamon – the most important in Roman times was Ephesus, capital of the province of Asia and the main port for the whole of south-western Anatolia. The centre of the town beside the harbour had been laid out on orderly lines by Lysimachus soon after 300 B.C., but the steep hillsides overlooking the centre defied orderly planning, and although one of the most exciting of all ancient sites to visit, Ephesus is also, archaeologically speaking, one of the most elusive.[10] The very exuberance of the creative fancy displayed makes its architecture far less susceptible to orderly classification than that of other, more orthodox centres. Roman Miletus lacked this progressive spirit. Its remains betray all the conservatism of a city which had passed its prime, not only in its planning, which clung rigidly to the four-square layout established by Hippodamos in the fifth century B.C., but also in the quality of much of the detail. At Pergamon, the third of the excavated sites, the main development in Roman times took place on new ground, across the plain at the foot of the acropolis on which were clustered the principal monuments of the hellenistic city. Outside these three towns we catch only occasional glimpses of the city plan. At Aphrodisias, which stood on level ground, apart from the fine theatre built into the slopes of the prehistoric tell, the heart of the city seems to have been an area of public monuments and large colonnaded open spaces, loosely interrelated within a rectangular layout which resembles that of the centre of Miletus. At Knidos, too, the terraced plan of the Roman city conformed closely to that of its hellenistic predecessor. The plan of Nicaea, with two broad intersecting avenues which divided the city into four roughly equal quadrants, was particularly admired.

When one turns to the individual monuments one is made aware from the outset of the influence of two architectural currents that were in detail very different. There were some fields in which local hellenistic traditions continued for a long time to predominate. There were others in which, for lack of native models, the architects were bound to look to Italy for inspiration. The history of architecture in western Asia Minor during the first three centuries of our era is very largely the history of the development and mutual assimilation of these two traditions.

Religious architecture belonged decisively to the former category. The cities of the province of Asia were already well provided with fine temples built in durable materials; and in the absence of any compelling alternative it was almost inevitably to the great sanctuaries of the hellenistic age that the architects of the succeeding period turned in planning such new building as was called for.[11] The most popular model seems to have been typified by the buildings of the second-century B.C. architect Hermogenes. We have already remarked this in the case of the Augustan temple at Ancyra. Except for the omission of the opisthodomos, the Temple of Titus (the so-called Temple of Domitian) at Ephesus followed the same plan.[12] The excavations at Aphrodisias have not yet established the date or structural history of the Temple of Aphrodite; but this too was certainly an octastyle Ionic building, and the fragmentary remains of the cella wall, incorporated in the structure of the Christian apse, are of the same distinctive masonry. Yet another building in the same general tradition is the Temple of Zeus at Aizani in Phrygia [180],[13] which was completed about A.D. 125, and which bears a close relationship to the last and most ambitious of the series, the great Temple of Hadrian at Cyzicus.[14] The latter, completed in 139 but damaged soon afterwards in an earthquake, was re-dedicated in 167. Only a scrub-covered mound of rubble now marks the site, but half of the columns were still standing when it was seen, described, and drawn by Cyriacus of Ancona in the fifteenth century. From him we learn that the podium measured some 100 by 200 feet (a double square); that it was a

180. Aizani, Temple of Zeus, completed *c.* 125

peripteral octastyle building of the Corinthian order, with fifteen columns down either flank; and that the cella walls and columns stood some 70 feet high, 10 feet higher than those of the Temple of Jupiter at Baalbek. Even allowing for a margin of error in the calculations of Cyriacus, it was unquestionably a gigantic building. It was also very elaborately ornamented with figured friezes, vine-scroll columns, richly carved doorways, and a bust of Hadrian in the pediment (recalling the *imago clipeata* of Antoninus Pius in the pediment of the Outer Propylaea at Eleusis); and at some point in the building which cannot now be precisely identified, colonnades carrying architrave-moulded arches in place of the traditional flat architrave – the first clearly attested example of the use of this motif in monumental architecture. We shall meet it next at Lepcis Magna in North Africa.

Another outstanding temple was that of Zeus Philios and of Trajan (the 'Traianeum') at Pergamon.[15] This occupied a magnificent site on the old citadel, facing out across the theatre and framed on three sides by the porticoes of a rectangular courtyard. The temple itself was hexastyle peripteral, of the Corinthian order, and it differed from those just described in being raised up on a podium in the Roman manner; the cella had two columns *in antis* and the masonry was drafted, with smooth pilasters at the angles. Striking features of the building were the fine openwork acroteria, based on such hellenistic models as those of Hermogenes's Temple of Artemis Leukophryene at Magnesia; and the large, staring Medusa heads of the frieze, alternating with triglyph-like fluted motifs. The frieze is unquestionably the source of the similar motifs used at Side in the earliest buildings of the new, marble style which swept Pamphylia under Hadrian (117–38); and there is good reason for the belief that the architect of Hadrian's Temple of Venus and Rome in the capital had worked on the Traianeum.[16] It was evidently a much admired and influential building.

The little streetside Temple of Hadrian at Ephesus was a modest building, being a private rather than a public dedication. It is remarkable chiefly for the fact that the outer corners of the façade are carried on rectangular piers, instead of on columns, and that the central span of the façade, mouldings and all, is arched up into the pediment. This device, the 'arcuated lintel' or 'Syrian arch', is one of a number of Syrian

architectural motifs that quite early found their way into Asia Minor. It derives ultimately from ancient Mesopotamia and seems to have made its first appearance in a classical context in southern Syria in the time of Augustus. Another possibly Syrian intruder, the colonnaded street, is discussed below.[17]

Still in the classical tradition, but very different in detailed treatment, was the grandiose temple behind the Library at Ephesus, which must date from the second half of the second century.[18] This was another octastyle Corinthian monument but, most unusually for a building of this size, it was prostyle and, even more unusually, vaulted. The architectural ornament was very elaborate, and it stood on a tall podium against the rear wall of a rectangular precinct, a typically Roman disposition that is rare in Asia Minor. The probable identification of this building as a temple of the Egyptian Gods, or Serapaeum, is of particular interest when one contrasts it with the very nearly contemporary Serapaeum at Pergamon.[19] The former, for all its unusual features, is still

essentially a temple of traditional classical type – one of the last to be built in western Asia Minor. The latter was as unclassical in plan as it was in materials [181]. It consisted of a lofty hall, 170 feet long and 85 feet wide (52 by 26 m.), with what appear to be galleries and a large window at the east end; the hall was flanked symmetrically by a pair of almost square courtyards, each colonnaded on three sides and opening centrally towards the east into a domed rotunda; and the whole complex formed the eastern extremity of a huge rectangular enclosure, nearly 200 yards in length, beneath which the river Selinus flowed in two vaulted tunnels. Whether or not this elongated, axial layout reflects Egyptian models, the whole architectural concept could hardly be more remote from the conventions of religious architecture which we have just been describing. We are reminded once again that this was just the sort of context in which new architectural ideas most readily made themselves felt. The third-century Serapaeum at Miletus, though a far more modest building designed in a superficially classical style, is

181. Pergamon, central hall of the Kızıl Avlu, or Serapaeum, beginning of the third century

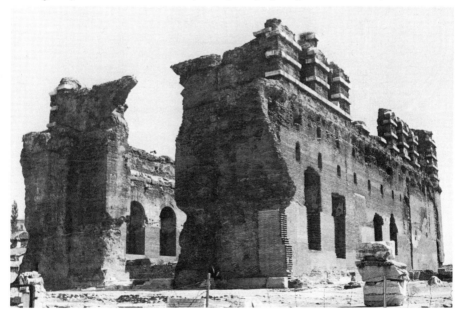

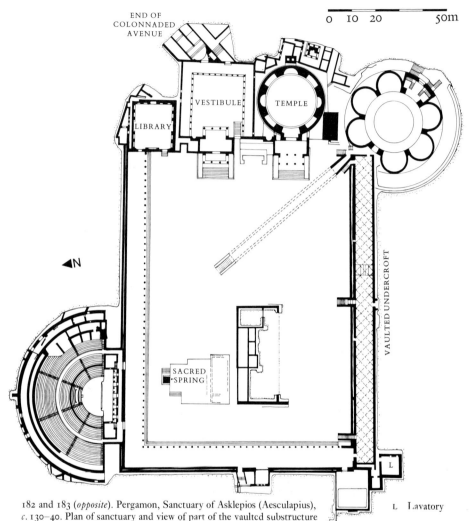

182 and 183 (*opposite*). Pergamon, Sanctuary of Asklepios (Aesculapius), *c.* 130–40. Plan of sanctuary and view of part of the vaulted substructure of the rotunda at the south-east corner

L Lavatory

another instance of this – a basilican hall with rectangular pedimental porch and, where a church would have had an apse, a square, internal, canopied naos.[20]

The Temple of Asklepios Soter at Pergamon has already been described. It too was part of a much larger complex, which in its present form dates largely from the later years of the reign of Hadrian [182]. The sanctuary was grouped rather loosely around and within a large rectangular enclosure, 405 by 345 feet (124 by 105 m.), surrounded on three sides by porticoes, of which that on the south side stood on a vaulted substructure. There was a substantial theatre, of which the rectilinear scaenae frons repeated the scheme of the nymphaeum at Miletus and the Library at Ephesus [192, 188]. Along the east side lay, from north to south, a plain rectangular

library; a tetrastyle propylon, balancing the pronaos of the adjoining temple; the temple itself; and, set obliquely to the south-east corner, an even larger rotunda (diameter 87 feet; 26.50 m.), the timber roof of which presumably had a central oculus and rested on a cylindrical drum, rising above and buttressed by six apsidal

Once again the corresponding building at Miletus was of more modest dimensions. Its most noteworthy feature was the porch, which faced on to the same piazza as the bouleuterion, the market gate, and the nymphaeum and was a tetrastyle structure with an arcuated lintel.[21]

Another field in which the continuity of

chapels, with a cryptoportico beneath [183]. In the open central area there were various buildings associated with the cult, including the sacred spring. Leading to the sanctuary was a colonnaded street. The classical detail is rich and varied, mainly a very elaborate Ionic, but including some Composite capitals, a form which begins to be found in Asia Minor during the second century.

established local tradition was bound to make itself felt strongly was that of the monumental architecture associated with the city's day-to-day public and commercial life. At Miletus the main squares, markets, and council building of the hellenistic city continued to serve, little changed, throughout Roman times. Even at Ephesus the hellenistic agora, when it was radically rebuilt in the third century A.D.,

retained its hellenistic form of a colonnaded square, with shops opening off the surrounding porticoes. The early-second-century agora at Aphrodisias, another building in the hellenistic manner, seems to have been a large, rectangular space, formally enclosed on three sides by double porticoes; in the middle of the fourth side stood what has been tentatively identified as an odeion, but which may well have served also as a council building. The mid-second-century council house (the 'Gerontikon') at Nysa in the Maeander valley was a theatre-like building of just this sort, with open rectangular parodoi separating it from the wall which in a theatre would constitute the scaena.[22]

There were, of course, certain innovations. One of these was the widespread adoption of the colonnaded street. Originating possibly in Syria, where there is some evidence to suggest that it had already reached Palmyra in the later first century A.D., it was very soon copied and acclimatized in Asia Minor. What is perhaps the earliest surviving example in the cities of the west coast (the published accounts are not explicit on this point) is that which ran towards the harbour at Ephesus from the Agora. Others of relatively

184. Pergamon, Sanctuary of Asklepios (Aesculapius), Corinthian capital of the thirties of the second century

early Imperial date can be seen at Pergamon [184] and at Perge (both Hadrianic), and at Hierapolis, of which the last-named is unusual in that some stretches of it are not actually colonnaded, but take the form of an ordinary street with engaged semi-columnar Doric façades. The best known and most elaborate of the colonnaded streets of Asia Minor, the

185. Ephesus, theatre, restored and enlarged in the second half of the first century, and the Arkadiane (colonnaded street), fourth century, looking towards the site of the ancient harbour. At the far end of the Arkadiane can be seen the bulk of the Harbour Baths

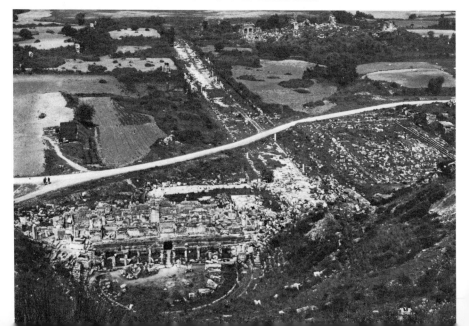

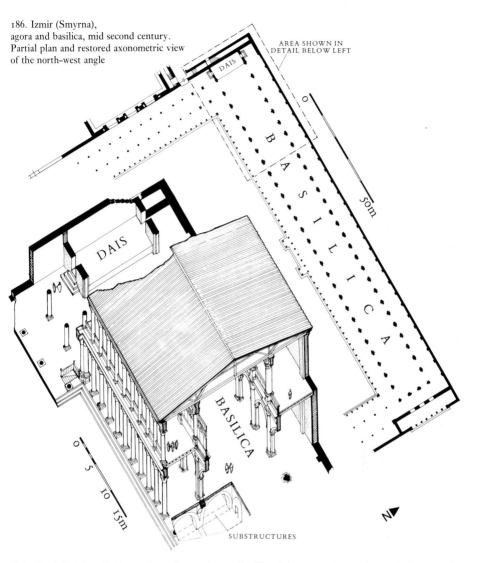

186. Izmir (Smyrna),
agora and basilica, mid second century.
Partial plan and restored axonometric view
of the north-west angle

AREA SHOWN IN
DETAIL BELOW LEFT

BASILICA

50m

DAIS

DAIS

BASILICA

SUBSTRUCTURES

N▼

Arkadiané [185] at Ephesus, is as it stands a creation of the fourth century A.D.[23]

Two public buildings that deserve special mention are the agora at Smyrna and the Library of Celsus at Ephesus. The former was a very large complex, dating from the mid second century A.D. and still incompletely excavated [186]. It consisted essentially of a long, narrow basilica (about 525 by 90 feet; 160 by 27 m.) which occupied the north side of an open, rectangular piazza, 425 feet (130 m.) wide and of uncertain length, enclosed on two (and probably three) sides by two-storeyed triple porticoes. The southern façade of the basilica was colonnaded and symmetrically disposed about a central porch, just as if this were a traditional

stoa. Internally, on the other hand, the emphasis was longitudinal, with a monumental entrance and shallow internal lobby at the east end, and at the west end what appears to have been some sort of tribunal. Instead of columns, the internal supports were composite, cruciform piers, of which the taller members were treated as half-columns carrying a normal longitudinal entablature, and the shorter ones as piers carrying arches at a lower level between the columns. At the east end this internal arcading turned immediately inside the porch to form an ambulatory; at the west end it ran straight through to frame the tribunal. On the side facing the agora there was an upper gallery, facing outwards, and on this side at any rate the central hall of the basilica was lit, not by clerestory windows, but by grilles in the rear wall of the outer gallery. Both in its planning and in its detail this is an unusual and highly sophisticated building, in which the several elements of undoubtedly Western derivation (the basilican plan, the

arcading, the Composite capitals) have been skilfully assimilated and adapted into what, constructionally and decoratively, is still a developed hellenistic tradition. We can now document an earlier stage of this assimilation at Ephesus, where the Augustan basilica, which occupied the whole north side of the Upper Agora (the 'Staatsmarkt'), was a building essentially similar in plan, symmetrical about its own longer axis but open through a continuous colonnade towards the Agora and far simpler in detail than its two-storeyed counterpart at Smyrna. In this instance the convergence of the two traditions, that of the monumental Greek stoa and that of the Republican Italian basilica, appears to be reflected in the terms of the dedicatory inscription which, if correctly restored, refers to it in Latin as *basilica* and in Greek as βασιλικὴ στοά.[24]

The Library at Ephesus [187],[25] begun towards the end of Trajan's reign and completed by *c.* 120, was built by the son and grandson of a

187. Ephesus, Library of Celsus, *c.* 117–20. Before the re-erection of the façade

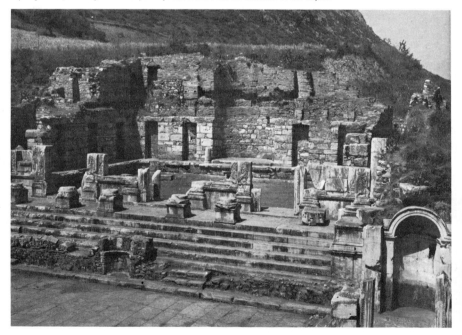

188. Ephesus, Library of Celsus, *c.* 117–20.
Plan (*left*) and restored view of the interior,
showing galleries for access to the cupboards
in which the books were stored. The narrow
ambulatory corridor, a protection against damp,
also provided access to the burial vault
of the founder's father beneath the central apse

wealthy and distinguished citizen, Caius Julius
Celsus Polemaeanus, who had been consul in
Rome and who was accorded the unusual
honour of being buried within the city limits, in
a vaulted chamber beneath the Library apse.
This handsome building was a lofty rectangular
hall, wider than it was long (55 by 36 feet; 16.70
by 10.90 m.), with a small central apse in which
no doubt stood a statue of Celsus himself [188].
Round three sides ran tiers of rectangular
recesses to house the cupboards for the books.
Two orders of columns carried the balustraded

galleries which served the upper rows of cupboards, and both these and the mausoleum were reached by stairs which were built into the thickness of the lower walls, and which served the additional purpose of protecting the books from damp. There may have been a square oculus in the centre of the flat ceiling. The richly

ments, a widespread late hellenistic device which took on a new lease of life in contexts such as this; and the pedestal bases which gave added height to the columns of the lower order, a recent innovation with a long history before it in late antique and Early Christian architecture.

The amphitheatre was an Italian building

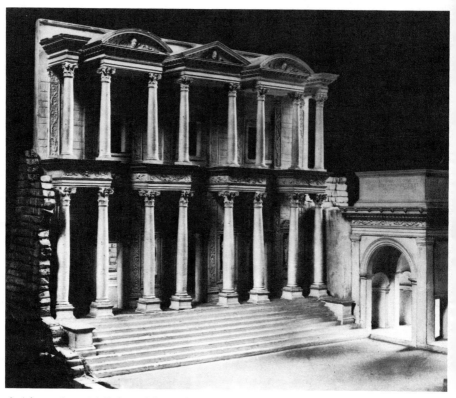

189 (*above and opposite*). Ephesus, Library of Celsus, *c.* 117–20.
Restored model (on the right the Arch of Mazaeus and Mithradates, 4–3 B.C., the south entrance to the Agora) and restored façade

carved façade [189] illustrates Ephesian decorative architecture at its best, a deceptively simple scheme of bicolumnar aediculae, of which those of the upper storey are displaced so as to straddle the spaces between those of the lower storey. Other characteristic features are the alternation of curved and triangular pedi-

type that never took root in the eastern Mediterranean. The surviving examples at Pergamon, Cyzicus, and Anazarbos in Cilicia are unusual; the normal practice in the Greek-speaking East was to adapt theatres, as at Corinth, or stadia, as at Aphrodisias and at Laodiceia-ad-Lycum. On the other hand, the western coastlands were

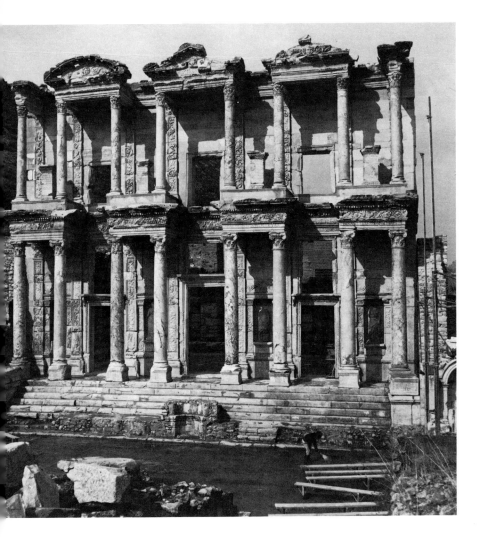

already well endowed with theatres and the majority of these were remodelled in Roman times. It will be sufficient here to describe two representative examples.

At Ephesus[26] the magnificent auditorium, built up against the steep hillside and seating some 24,000 spectators, though restored and enlarged in the second half of the first century A.D., was in plan still essentially a Greek building [185]. The stage-building too, restored under Domitian (81–96), was Greek in its structural independence of the seating, but in other respects it was . a Roman building of 'Eastern' type, with a rectilinear scaena wall and, framing the five doors, a scheme of two columnar orders which so closely resembles that of the theatre at Aspendos [197] that it is tempting to regard it as the model for the latter

building. Subsequently, about A.D. 200, a third order was added, of a rather weak, half-hearted design and set slightly back from the lower two. In the absence of projecting parascaenia it is doubtful whether the stage could ever have been roofed.

The theatre at Miletus[27] was far more radically romanized. Here the seating as well as the stage-building was enlarged and re-designed, being extended upwards and outwards on vaulted substructures and forwards, across the parodoi, to meet the stage-building. The latter had a façade of the three orders in the usual Roman manner, with parascaenia and a roof. The only unusual features were that, instead of the triple recessing of the usual 'Western' type, there was here a single shallow and unusually wide, curved, central recess, across the front of which the columnar façade was carried on four independent columns; and that the grouping of the aediculae of the several orders displayed the same deliberate ambivalence as we have already observed in the Library of Celsus at Ephesus.

The importance of the bath-building as a medium for the introduction of Roman building practices and techniques has already been stressed. The baths of Asia Minor were not, however, mere slavish copies of those in Italy. Quite apart from the many technical adaptations and modifications which they underwent to suit local materials and building traditions, there were also important differences of social usage. The most important of these was undoubtedly the established position of the hellenistic gymnasium. The gymnasium and the bath-building had already met and come to terms in Italy.[28] Now in Asia Minor architects were faced with much the same problem, with the difference that the Roman bath-building of the Early Empire was a more developed and architecturally more aggressive type than its predecessor in Late Republican or Augustan Pompeii. There were, of course, other factors at work to complicate the picture; climate, for example, as we are reminded by the baths at Ankara, or the many small differences of local

190 (*opposite*). Ephesus, bath-buildings (gymnasia). Plans. (A) Harbour Baths, partial plan, probably late first century, several times remodelled; (B) Baths of Vedius, mid second century; (C) East Baths, early second century, remodelled *temp.* Severus (193–211)

habit and fashion which must be held to account for much of the almost infinite variety of detailed layout that one encounters in the bath-buildings of the Roman provinces. In the present context, however, it is not the detailed functioning and internal arrangement of these buildings that matters, but the factors which affected their broad architectural development; and of these the limitations imposed by local materials and the influence of the Greek gymnasium were unquestionably the two most important.

It is, characteristically, at Ephesus that we find the latter problem most vigorously and successfully handled [190].[29] The best excavated and documented of these buildings is that built by the wealthy Ephesian friend of Antoninus Pius (138–61), Publius Vedius Antoninus. This occupied a rectangular site to the north of the stadium, some 250 by 425 feet (76 by 130 m.), with the long axis running east and west. At the west end an area of just under two-fifths of the whole was occupied by the bath-building proper, and an equivalent area at the east end by an open palaestra enclosed by four colonnades. Projecting from the east end of the former and from the west end of the latter, and so defining a monumental corridor of H-shaped plan, were, respectively, the swimming pool of the baths and a very richly decorated rectangular exedra opening off the west portico of the palaestra. The latter (the 'Kaisersaal' or 'Marmorsaal'), a recurrent feature of these buildings, had an open columnar façade and an elaborate scheme of two decorative orders, niches, and statuary round the three inner walls. The monumental corridor, here H-shaped and barrel-vaulted in mortared rubblework or brick about a framework of stone arches carried on projecting piers, is another feature that recurs, in a variety of plans, throughout the Ephesian

C Caldarium
F Frigidarium
L Lavatory
M 'Marmorsaal'

series. One meets it again, in a less obviously utilitarian guise, in the Baths of Faustina at Miletus. The actual bathing block, like all the Early Imperial Ephesian series, was of rigidly rectilinear design and calls for little detailed comment. The main caldarium, here at the western extremity of the central axis, appears to be a translation, in terms of the local materials and vaulting techniques, of the typical frigidarium plan of the bath-buildings of the capital. It has been suggested, very plausibly, that the curved outer surfaces of the vaulting were visible externally, as they certainly were at Miletus.

The Theatre Baths, dated on rather tenuous grounds to the early second century, reveal a broadly similar disposition, except that the relative orientation of the bath-building is here reversed, the caldarium range backing directly on to the palaestra; the monumental corridor, here ⊔-shaped, lies beyond the bathing block and beyond this again a further range of rooms, of which the central one appears to be the equivalent of the Marmorsaal – an unusual disposition that was not repeated.

More important and informative is the vast complex which occupied the whole of the north side of the Arkadiané. This comprised three distinct elements: at the west end the towering bulk of the Harbour Baths [185, 190], in its present form a building of the later second century; in the centre, axial to the baths, a large porticoed enclosure with two rooms of the Marmorsaal type facing each other on the cross-axis [191]; and at the east end, still on the axis, a huge open space (220 by 260 yards) enclosed by multiple porticoes ('the Porticoes of Verulanus') which are convincingly identified as *xystoi*, or

191. Ephesus, Harbour Baths, Marmorsaal, second-century marble decorative wall-facing. Restored view

covered running-tracks of the traditional late hellenistic type, as described by Vitruvius. The whole complex, except for the baths, seems to have been laid out during the reign of Domitian (81–96), and it is thought to occupy the site of the hellenistic gymnasium referred to by Strabo. It is a plausible conjecture – but no more – that the surviving bath-building replaces an earlier, less ambitious structure of Domitianic date. The East Baths, near the Magnesia Gate, embody yet another variant of the same broad design [190]. In this case the bath-building is ascribed to the early second century, the palaestra-gymnasium to a reconstruction of the reign of Severus (193–211). The latter resembles that of the harbour complex in layout, the hall opposite the Marmorsaal being in this instance clearly identifiable as a finely decorated lecture hall, with raised benches round the three inner sides.

The dedicatory inscription of the Vedius foundation refers to it as a *gymnasion*, and there is comparable epigraphic evidence from the harbour complex. Even without such aid, however, there could be no doubt about the double parentage of these buildings: from the hellenistic gymnasium and from the Roman bath-building.[30] What is no less clear is the progressive change in the relative importance of the two elements. In the Domitianic complex the palaestra and exercise grounds occupy two-thirds of the total area; a hundred years later, in the East Baths, only just over one quarter. Architecturally too the bath-building comes increasingly to dominate the complex, though never to the exclusion of its other functions. The hellenistic gymnasium had been a great deal more than just a place for athletic exercise. It was a centre also not only for education and the arts, but also for the youth organizations and other select quasi-aristocratic clubs which played so large a part in the city's social life. In Italy some of these activities found themselves channelled elsewhere, others were quietly and naturally incorporated into the public bath-buildings. The development in Asia Minor followed broadly similar lines. Some of the

manifestations, such as provision for the imperial cult in the Marmorsaal of the Vedius building, might be new; but even here there is a suspicious resemblance in plan and situation to the *ephebeion*, the schoolroom of the old hellenistic gymnasium.

At Miletus one can see something of the same process at work.[31] The earliest of the series, the baths built by Cnaeus Vergilius Capito during the reign of Claudius (41–54), were built on the site of a hellenistic gymnasium, of which part was retained to form the colonnaded palaestra of the bathing block; and although the Humeitepe Baths (*c.* 100) embody a rationalization of the same sort of plan whereby the gymnasium element is reduced to the bare minimum of a porticoed palaestra, the Faustina Baths (mid second century) quite obviously reflect the contemporary Ephesian development – all the more obviously because the irregular shape of the site involved the dismemberment of the complex into its constituent elements. The bath-building itself, a loosely organized circuit of barrel-vaulted halls, illustrates the norm of Asiatic usage far more closely than the neat, symmetrical layouts of Ephesus. It also incorporates early examples of the use of brick barrel-vaults, side by side with others of mortared rubble. It is indeed in their constructional details that the main interest of the Milesian bath-buildings lies, forming as they do a well dated early series of structures in the Roman manner, built partly in squared stone, partly in faced rubblework, and vaulted in mortared rubble [174]. The Baths of Capito, in particular, with their numerous apsidal recesses and a domed circular room with small apses in the four corners, constitute a direct link with the early bath-architecture of Campania. It is interesting to observe that, as in the Hunting Baths at Lepcis Magna [251], the curve of some at any rate of the vaults was visible externally as well as from within. This is an aspect of the architecture of Roman Asia Minor which it is hard to document in detail, but it is certainly one in which these buildings broke fresh ground, accustoming the eyes of their con-

temporaries to outlines that were neither the pitched roofs nor the flat terraces of traditional classical architecture.

Three other bath complexes of western Asia Minor call for brief mention.[32] One is that of the Upper Gymnasium at Pergamon, of which the West Baths are of early (mid-first-century) date and the colonnaded palaestra and East Baths Hadrianic (117–38), both being additions to, or developments of, an already existing gymnasium of characteristically hellenistic type. Along the north side of the palaestra were ranged an odeion and two exedrae of the Marmorsaal type. The construction throughout is in mortared rubble with carefully dressed stone facings. At the other end of the constructional scale are the great baths built over the mineral springs at Hierapolis, a huge complex of scrupulously rectilinear vaulted halls carried out almost exclusively, vaults and all, in dressed stone. In this case the familiar rectangular exedrae are two, facing each other across the outer palaestra; one of them may have contained a library. The layout of the baths at Aphrodisias (Hadrianic, 117–38), which were built partly of squared stone and partly of mortared rubble, appears to have followed the lines of the harbour complex at Ephesus; at the west end, symmetrically disposed about the long east–west axis, the massive bathing block; in front of it a small but very richly decorated porticoed enclosure; and in front of this again, stretching the full length of the adjoining agora, a very much larger, elongated enclosure measuring 695 by 225 feet (212 by 68 m.), which is of earlier date (A.D. 14–28) but which now presumably served as a palaestra.

By comparison with public architecture the domestic architecture of Roman Asia Minor has received little attention from excavators. A notable exception is that of the large townhouses, with fine paintings and mosaics, overlooking the avenue that leads up from the Agora and the Library at Ephesus towards the upper town and the Magnesia Gate.[33] Though perhaps multi-storeyed rather by the accident of their location, terraced up the steep slopes on either side of the street, than as representative of a consistent urban tradition, they remind us how fragmentary our knowledge is of this important aspect of architectural practice in a country where, by contrast to the western provinces, well-to-do residence outside the towns seems to have been altogether exceptional.

Before leaving the cities of western Asia Minor a further word must be said about the marble ornament which was such a characteristic and so historically important a feature of this whole school of architecture. Marble was, and had long been, a material that was in plentiful supply, in a great many cases (e.g. Ephesus, the cities of the Maeander valley, Aphrodisias) drawn from local quarries. Already in hellenistic times there was a well established tradition of decorative craftsmanship; and although the Roman period saw a notable expansion in production, resulting in a great deal more marble being available at proportionately lower prices,[34] there was no break in this tradition. The architectural ornament of Roman Asia Minor was firmly rooted in hellenistic practice.

To appreciate the strength of this hellenistic tradition one has only to compare the detail of a building such as the Traianeum at Pergamon with that of the almost exactly contemporary Temple of Venus Genetrix in Rome [34]. The latter marks the culmination of a century of vigorous Western development which had seen the introduction of many new motifs and the radical transformation of many old ones. In Asia Minor, although there was a steady stylistic development in the direction of the more summary, coloristic style characteristic of the later second century, the basic decorative vocabulary underwent remarkably little change; what changed was the way that vocabulary was used. The importance of this fact in determining the decorative repertory of the 'Imperial' architecture of the second and third centuries will be discussed later in this chapter. It is the other side of the coin that concerns us here. Whereas in Rome the taste for decorative innovation found expression in the exuberant detail of individual mouldings and motifs, here

in Asia Minor it was channelled into more strictly architectural forms, of which the elaborate columnar façades to which we have already had occasion to refer many times in the present chapter were the most striking and characteristic expression.

The architecture of these façades was essentially baroque, in the sense that it relied for its effect upon the recombination of the familiar elements of the classical orders in unfamiliar and often highly artificial schemes. In this respect it closely resembled that of the stage-buildings of the Roman theatre. Both were the product of a movement that originated in the luxurious atmosphere of the hellenistic courts and was already widely influential in late hellenistic times. The early stages of this development are difficult to document in detail, since they seem to have been very largely carried out in ephemeral materials; but, as we have seen in an earlier chapter, they are very fully reflected in the wall-paintings of Pompeii, many of which, allowing for the exaggerations and distortions of the medium, do present a lively picture of this vanished court architecture.

The next stage (and it is important to remember that this was not necessarily a single event, but a series of related events) was the monumentalization and partial rationalization of this fantasy architecture to meet the requirements of everyday public building. In the case of the Roman theatre we are fortunate in being able to document the moment of transition, from the Theatre of Scaurus to the Theatre of Pompey. What seems to have happened in western Asia Minor, and particularly in, and within the sphere of, Ephesus, is that with the resumption of large-scale building under the Early Empire the same conventions were reinterpreted and widely applied, not only to stage-buildings but wherever a columnar façade of this sort might be thought to lend a note of opulence to the public architecture of the city. At Ephesus alone we find such elaborate columnar schemes used in gateways, in the ceremonial halls ('Marmorsäle') of the great bath-gymnasium complexes, in the façade of the Library and in the scaenae frons of the theatre.[35]

The earlier gateways at Ephesus were soberly conceived and executed.[36] The West Gate of the agora was a severely simple Ionic building, with a broad flight of steps leading up to a columnar façade between two projecting distyle features. In elevation the Harbour Gate retains the simple Ionic structure, but the plan, though still rectilinear, was more complex, with three openings alternating with four distyle projections. As late as c. 160 we still find much the same basic scheme in the West Market Gate at Miletus, except for the addition of an upper storey with small pediments on the outer wings and a larger broken pediment in the centre. Only in the gateway-arch at the south end of the marble-paved street leading down from the theatre at Ephesus do we escape this relatively sober note. The openwork treatment of this (as a setting for statuary?), and the deliberate disproportion of the upper order spanning the arch of the lower, are reminiscent of, though less successful than, the Arch of Hadrian at Athens [170].

With the theatre at Ephesus and the Library we pass to more characteristic examples of the Asiatic columnar façade. The latter building, with its subtle proportions and deceptive simplicity of line [189], illustrates the dignity of which, at its best, this style was capable. At the other extreme, crowded with detail and often seeming to court eccentricity for its own sake, are the 'Marmorsäle' of the great bath complexes. The Harbour Baths at Ephesus [191] had a lofty colonnade across the front and two alternately projecting and re-entrant columnar orders along the three inner walls, each elaborately carved and diversified with contrasting rectilinear and curvilinear features and ingenious broken pedimental schemes, and the whole carried out in rich polychrome marble; to complete the effect one must imagine the gleaming white of pavements and statuary and the more sombre tones of the painted or gilt timber coffered ceilings. With buildings of which one can only study the effect in restorations it is hard to judge at what point opulence shades off into vulgarity. In some of

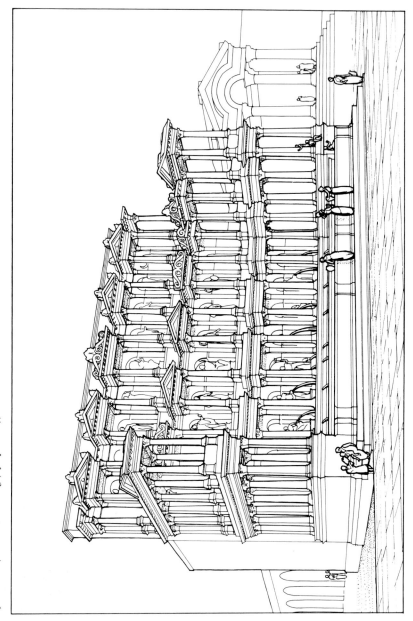

192. Miletus, fountain-building (nymphaeum), *c.* 100. Restored view

the provincial replicas, e.g. that at Side in Pamphylia,[37] one is left in little doubt of the answer – deeply satisfying though such a building was, no doubt, to local civic pride. At its best, however, this was a style in which wealth was tempered with sophistication, and it was one that was admirably attuned to the spirit of its age.

The nymphaeum erected at Miletus in honour of the emperor Trajan's father[38] was a decidedly pedestrian building [192], but it will serve to illustrate the characteristics of the large group of scenographic fountain-buildings of which it was one of the earliest monumental examples. These were essentially elaborate columnar façades, put up to close a vista or simply to mask what lay behind – in this case to complete the monumental frontage of the piazza opposite the bouleuterion and the West Gate of the agora. Except as purely scenic decoration the detail is architecturally meaningless; it bears no relation whatsoever to whatever is hidden by the screen. As such it became a favourite device of civic planners in the smaller cities, notably those of southern Asia Minor, where it became almost a symbol of status, comparable to the possession of a colonnaded street. Outside Asia Minor it was less common. An outstanding example is the Septizodium in Rome, erected to screen the utilitarian buildings at the south end of the Palatine [66]. Another closely comparable building is the Captives Façade at Corinth (p. 263), which was designed to mask an awkward gap in the north façade of the agora.

PAMPHYLIA AND CILICIA

The cities of southern Asia Minor, though rich in buildings of the Roman period, are architecturally far less important than those of the western coasts and valleys. Not only was theirs a later flowering, but when it came it was largely derivative. Few areas had suffered more from the political disorders of the Late Republic, and it was only under Augustus and his successors

that urban life once more gathered momentum. The strain of classical hellenism had never been very robust, and the principal architectural legacy from the past seems to have been the buildings erected in Pamphylia under Pergamene domination in the second century B.C., among them the well preserved city walls of Attaleia (Antalya) and Perge and, possibly, the two-storeyed stoa beside the agora at Aspendos. This was a tradition of fine dressed masonry, and it remained the basis of local building-practice throughout antiquity. Superimposed upon it was the new Roman-period architecture.

The architecture of Roman Pamphylia falls into two clearly distinguishable phases. During the first, corresponding to the period from Augustus to Trajan (27 B.C.–A.D. 117), the materials were local and the sources various. A small tetrastyle pseudo-peripteral temple at Side [195A] is built of limestone; it stands on a podium and is as Western in plan as the Temple of Augustus at Antioch-in-Pisidia. The same may be said of a large cylindrical mausoleum standing on a square basis overlooking the harbour at Attaleia [193]. On the other hand,

193. Attaleia (Antalya), mausoleum overlooking the harbour, first century

both in its plan and in the detail of its ornament, which is still purely hellenistic, a small fountain-building at Side, built in 71 [194], is a modest

194. Side, fountain-building, as erected in 71.
Restored view. It was later remodelled
with a larger basin

version of what we may imagine the predecessors of the elaborate monumental nymphaea of Ephesus and Miletus to have been. Another monument which is still in the hellenistic manner, but which may well in fact be Augustan, is the fine South Gate at Perge [196].[39]

By the twenties of the second century this 'Romano-Pamphylian' architectural tradition was fast disappearing as a monumental building style, to be superseded by one based on the new material, marble, which had now for the first time become available in large quantities. The overwhelming majority of the marble used architecturally in Pamphylia came from the quarries of Proconnesus (Marmara), and the techniques and styles were those of western Asia Minor. At Side this is most strikingly evident in the smaller and slightly earlier (Hadrianic?) of the two hexastyle peripteral temples ('N 1') overlooking the harbour, the details of which (notably the frieze) derive straight from the Traianeum at Pergamon. The larger of the two ('N 2'), with Composite instead of Corinthian capitals but otherwise very similar, is perhaps a

decade or two later. Both in plan [195B] and in detail these temples bear a very close resemblance to that of Antoninus Pius (138–61) at Sagalassos, about 60 miles inland, another and well dated example of what one may conveniently refer to as the Imperial 'marble style' architecture. As we shall see, Pamphylia is only one of a number of Mediterranean provinces upon which it had a deep effect.[40]

By the middle of the second century this was the only style in monumental use in Pamphylia. At Side alone we meet it in a range of buildings that includes three colonnaded streets; a city gate modelled on that of Perge and, facing it, a monumental nymphaeum, both of the early third century; a theatre, among the decorative motifs of which is the same distinctively Pergamene frieze motif as in Temple N 1; a square porticoed piazza behind the stage-building, which (like the Piazzale of the Corporations at Ostia) was also a place of business, with rows of offices or shops; a large porticoed enclosure of uncertain purpose, the principal feature of which is an extremely elaborate late-second-century 'Marmorsaal';[41] a small third-century temple on a tall podium, with a semicircular cella and a gabled porch, of which the central opening was three times as wide as the other two and arched as in the Temple of Hadrian at Ephesus [195C]; a small circular temple with a conical roof, added in the third century to the piazza behind the theatre in honour of the city's guardian divinity, or Tyche; and, perhaps as late as the early fourth century, a grandiose funerary temple and precinct in the north-west cemetery. All of these, except possibly the nucleus of the theatre cavea, which is of traditional Greek shape, were essentially new buildings, and they illustrate not only the overwhelming impact of the new material and style, but also the solid basis of middle-class urban prosperity upon which its rapid diffusion rested.

The other cities of Pamphylia tell the same story. At Perge the transformation of the South Gate into a nymphaeum [196], with an elaborately carved, two-storeyed marble order applied to the curving walls of the inner courtyard and enclosed on the north side, towards the

195. Side. Plans of temples. (A) Small temple beside the theatre, first century;
(B) Temple N1, second quarter of the second century; (C) apsidal temple, third century

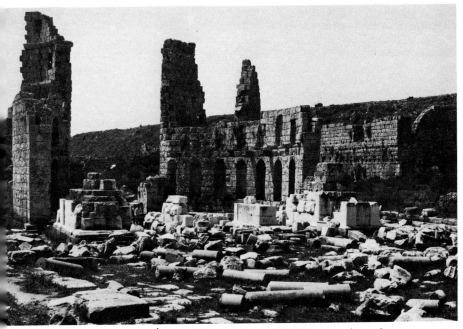

196. Perge, South Gate (second century B.C.? Augustan?), remodelled into a nymphaeum between 117
and 122. Across the entrance to the nymphaeum the piers of a triple arch of the same date

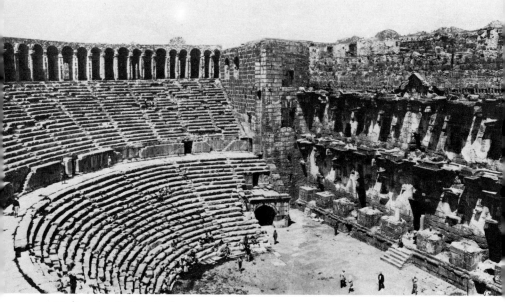

197. Aspendos, theatre, 161–80

great axial colonnaded street, by a monumental triple arch, can be closely dated by its statues and their inscriptions to the years between 117 and 122.[42] The arch, like the nymphaeum that was built a few years later at the far end of the colonnaded street, facing down towards the South Gate, was built partly of marble and partly of the fine white limestone from the near-by Pisidian mountains; and although within a generation limestone had been almost entirely displaced as the material in which to carve the finer decorative detail of monumental public architecture, dressed stone did, of course, continue to be used everywhere for the walls and vaults that accompanied the fine marble detail. At Perge, as at Side, this was the basic material of the large Roman-type theatre; of the stadium, with its ingeniously stone-vaulted substructures; of the market, a *macellum* of the familiar South Italian type with a central circular pavilion, or *tholos*; and of the two well preserved public bath-buildings. The latter, each in plan a loose agglomeration of rectangular halls, are

noteworthy for the unusually clear traces of their brick barrel-vaulting.

At Aspendos[43] the outstanding monument is the theatre, outstanding because alone of its kind it has preserved intact its stage-building [197]. Built by an architect named Zeno, between 161 and 180, this is a good example of the traditional 'Eastern' type, and it could well have been copied directly from the stage-building at Ephesus. The narrow wooden stage projected at the level of the central steps, which are modern; the vaulted gallery around the head of the cavea is a later addition. On the hill above lay the agora, flanked on one side by a two-storeyed stoa of late hellenistic type and on the other by a basilica of the third century A.D.; it was closed at one end with a two-storeyed columnar screen. The basilica was a long, narrow building with a single apse at one end and a square, tower-like vestibule at the other. Analogy with the Hadrianic basilica at Kremna in Pisidia suggests that this vestibule served the purposes of the imperial cult.

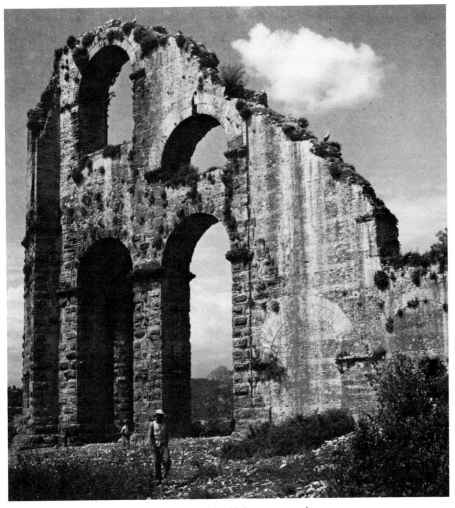

198. Aspendos, one of the two pressure-towers of the third-century aqueduct

The most singular building at Aspendos is the aqueduct [198]. Contrary to the normal Roman practice of letting water follow a gentle gradient, it was here carried under pressure across the broad valley to the north of the town, the total distance being divided into three segments by means of pressure-towers. These two towers, built partly of solid brick and partly of mortared rubble with brick courses about a framework of dressed stone, are fine examples of a sort of masonry which, as we have remarked above, was to play an important part in the transition from Roman to Byzantine architecture. Another portent of the future is the pitched-brick barrel-vaulting of two cisterns below the basilica [176], a characteristically Byzantine feature for which all the precedents lie in the mud-brick architecture of Egypt and

Syria.[44] Here we have a rare surviving example of the sort of Roman-period building which was the intervening link between the two traditions.

Coastal Cilicia, the 'Rough Cilicia' (Cilicia Tracheia) of antiquity, was not in itself an important creative centre, but it will serve to illustrate a common phenomenon in the Roman East, namely that the strength of direct Italian architectural influence tended to be in inverse proportion to that of the hellenistic traditions which it found established locally. In Cilicia a century of organized piracy, which it took a special expedition under Pompey the Great to suppress, was symptomatic of the void which Rome was called upon to fill. The surviving Roman-period remains are plentiful, and a decade of systematic excavation at Anemurium (Anamur) has provided a valuable framework of

199. Anemurium,
bath-building and adjacent palaestra
with an elaborate mosaic floor,
second-third centuries

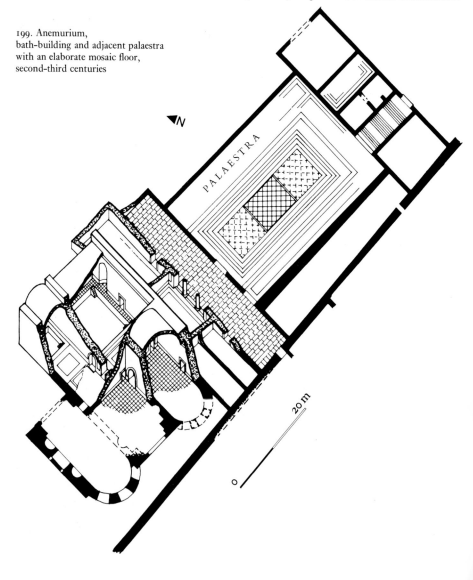

reference.[45] The finer materials were imported, and almost without exception such classicizing refinements as porticoes, mouldings, marble veneers and paving, stuccoes and mosaics were borrowed. But they were applied to buildings of which the constructional traditions were as distinctive as they were robustly effective. The ubiquitous building material is a stout mortared rubble masonry, competently roofed with barrel-vaults, half-domes and even full domes, constructed around an inner face of stones laid radially upon a wooden framework, while the outer faces normally conformed to the shapes of the inner faces, and there are even examples of tombs of which the outer faces of the roofs were decorated in mosaic. The bath-palaestra complex at Anemurium [199] will serve to illustrate the rather simple but functionally effective public architecture to which this sort of building lent itself.

That this building tradition reflects the direct influence of late Republican and early Imperial Italy can hardly be doubted. At Elaeusa (Ayaş) there is even a small bath-building faced with *opus reticulatum*, alternating with courses of brickwork; and some of concreted rubble work, both here and at Korykos, is of such a high quality that one suspects the use, either accidental or deliberate, of the volcanic sands that were available a short distance along the coast. It was not until the second century A.D. that, in common with the whole eastern coastline of the Mediterranean, cities such as Seleucia (Silifke), Elaeusa (Ayaş), Korykos, and, in the adjoining 'Flat Cilicia' (Cilicia Pedias), Soloi-Pompeiopolis, Tarsus, and Anazarbos came under the influence of the 'marble style' architecture of western Asia Minor; and even so the impact was far less marked than in Pamphylia. Culturally as well as geographically Cilicia belonged quite as closely to the North Syrian coastlands and to the great metropolis of Antioch as it did to the rest of Asia Minor. At Diokaisareia, for example, and at Soloi-Pompeiopolis the brackets projecting from the columns of the colonnaded streets to carry statuary are a Syrian feature of which Palmyra

and Apamea offer many examples [233], and the 'windswept' Corinthian capitals of the streets at Pompeiopolis seem to point in the same direction. This was a typical small-town, provincial architecture and one which, for all its derivative nature, took root and flourished. The outlying provinces of the Empire were rich in such local architectures. They may have contributed little to the main stream of architectural history, but cumulatively they represent a far from insignificant part of the Roman architectural achievement.

THE CONTRIBUTION OF ASIA MINOR TO THE ARCHITECTURE OF THE EMPIRE

Seen within the larger perspective of the Roman Empire as a whole, the architecture of Asia Minor emerges as a broadly conservative tradition, but one which was prepared to adapt itself to changing times, and itself to absorb and to adapt those extraneous elements which met its own particular social, political, or cultural requirements. Although its strength lay in its solid foundation of hellenistic taste and practice, this was no sterile traditionalism. We see this very clearly in its treatment of the new ideas which came in from Italy, the largest single source of outside inspiration, particularly under the Early Empire. Some, which answered an immediate need, were adopted as they stood. Such were the roads and bridges, the aqueducts, cisterns, and other hydraulic works of which the engineers of Rome were the acknowledged masters. A few, such as the amphitheatres and basilicas of Western practice, took only precarious hold. Many others (the bath-building is an outstandingly successful instance) were adapted and absorbed into the steadily developing provincial tradition of which the cities of the western coast were the vital centres, the Anatolian plateau and the southern coastal provinces the peripheral recipients. Other currents were at the same time flowing in from the East, bringing in such diverse elements as the colonnaded street, the sanctuaries of the Oriental gods, and the brickwork vaulting-systems of Egypt and Babylonia.

Roman Asia Minor, in common with most of the Roman world, was the recipient of many outside influences, but the local tradition was vigorous and consistent enough to absorb them and give them new direction. Right through into late antiquity Asia Minor, for all its essential conservatism, was a vital creative centre.

At the risk of over-simplifying a picture of which the very essence is its complexity, one may perhaps select two facets of the resulting tradition as outstandingly important for the history of classical architecture as a whole. One was its translation of the techniques and aspirations of the concrete architecture of the West into terms which were both meaningful and structurally practicable under the very different conditions prevailing in the Aegean world. This was one of the essential preconditions of Early Byzantine architecture, which, in this particular respect, can be seen to be firmly rooted in the Middle Imperial architectural practice of the Roman provinces bordering on the Aegean and the Sea of Marmara. The other, and even more influential, manifestation of this Asiatic tradition was that embodied in its use of the familiar orders of the classical architectural system. Here Asia Minor occupies a somewhat paradoxical position as both a guardian of tradition and an innovator; a guardian in respect of the time-honoured elements of the system and the detail of their decoration, an innovator in the manner and spirit of their use. While the architects of Italy were busy exploring new materials and new spatial forms, their colleagues in Asia Minor were taking the traditional classical elements and recombining them to produce novel visual effects. Both in their very different ways were helping to shape the development of Roman architecture towards the new forms and aspirations of late antiquity.

Finally we may emphasize once more the significance of Asia Minor's predominant position in respect of the supply and handling of what in the second and third centuries A.D. became the monumental building material *par excellence* of a large part of the Roman world – marble. Even in Rome the results of this fact are evident in the architecture of Hadrian and his successors. In many places, as in Pamphylia and in parts of North Africa, the impact was such as radically to reshape the building traditions of the earlier Empire; and everywhere, throughout the Mediterranean basin, the new style left its mark on the most influential buildings of the age. If the emergence of an 'Imperial' architecture, broadly uniform wherever it is found, is rightly regarded as one of the characteristics of the later Roman Empire, it owes much to the quarries and to the marble-workers of Asia Minor.

THE ARCHITECTURE OF THE ROMAN EAST

If within the Greek world the study of the architecture of the Roman age is complicated by an essential duality of direction between the native hellenic tradition and that which derived from Rome herself, when we turn to the eastern coastline of the Mediterranean world and to the lands that lay beyond it the duet becomes a trio, if not indeed a chorus of mixed voices. Both the Achaemenid Persians, who were masters of the whole area from the sixth to the fourth centuries B.C., and the hellenistic Greeks, who succeeded them as a result of the whirlwind conquests of Alexander the Great, found themselves ruling over peoples who counted as many millennia of civilized life as their masters, Iranian or Greek, could count centuries. Alexander and his successors did manage to impose on their Oriental subjects some of the superficials of hellenism, and even in certain favoured areas some of its realities. But the centuries which followed the establishment of the hellenistic kingdoms were in the main characterized by a resurgence of the time-honoured habits and customs of the ancient East. In dealing with the hellenic world Rome had been confronted by an essentially kindred civilization, of which her own was indeed in many respects a direct offshoot. In the eastern provinces, on the other hand, she found herself face to face with a multitude of local cultures which, however receptive to the superficials of classical life, spiritually had little in common with Greece and Rome. Here and there, as in the Greek foundations of north-western Syria, hellenism had struck deep roots. Elsewhere Rome found herself face to face with an older and more intractable world.

In studying the architecture of the Roman East we have, then, to bear in mind not only the familiar dualism of Greece and Rome, but also the deep-seated antithesis between East and West, between the classical and the Oriental

worlds. Not that the contrast often presents itself in such simple, uncomplicated terms. For centuries the ideas of the ancient East had been filtering through to the Western world. Even in Rome, and as early as the first century A.D., they were beginning to be an important factor in shaping, for example, the architecture of the ruler cult and of the mystery religions. Again, the art of Arsacid Parthia, for all its anti-classical tendencies, had roots in a past to which hellenism had contributed many of the formative ideas and a great deal of the formal vocabulary. All these currents had already met and mingled their waters. Now for the first time, however, all three moved forward as a single stream. If one views the architecture of Roman Syria within the larger context of the history of Mediterranean architecture, it is the fact that the architectural traditions of Greece, of the Orient, and of Rome were here meeting and developing on common ground that may be considered to have been foremost in giving shape and purpose to its special contribution.

Politically the history of Rome's eastern frontier is one of continuous rivalry and occasional open warfare with the successive rulers of Iran. By the middle of the second century B.C. the Arsacid Parthian dynasty, originally the product of a nationalist reaction against the Graeco-Iranian hellenistic kingdom of the Seleucids, had successfully established its authority over the whole vast territory that lay between the great westward bend of the Euphrates on the west and the Kushāna Kingdom of the Indus valley on the east. Here, and here alone along the many thousand miles of her frontiers, Rome was faced by a major civilized power with whom she had to come to terms. Like the Romans themselves, the Parthian (c. 240 B.C.–A.D. 226) and Sassanian (from A.D. 226) rulers of Persia had their moments of

weakness and of strength, upsetting the uneasy balance; but such moments of open, dramatic warfare were the exception. Most of the time both parties were content with a state of peaceful coexistence, during which the frontier between them was as much a zone of mutual influence and profitable exchange as it was a barrier. Along it, as the effective instruments of such a policy, lay a chain of client principalities in varying degrees of dependence upon one or other of the great powers. Armenia, Cilicia, Commagene, Emesa, Hatra, Judaea, Nabataea, Osrhoene, Palmyra, Pontus – these are some of the buffer states, great and small, which at one time or another owed allegiance to Rome, to Parthia, or successively to both.

It was only in exceptional circumstances and under an exceptionally gifted ruler that one of these border communities might aspire to a genuinely independent policy; and in course of time most of them came to be absorbed by Rome or by Parthia. In the fields of thought, religion, and the arts, on the other hand, they have a significance that far transcends their political importance. Not only were they the heirs to a civilization far older than that of either of the contending powers, but they had a community of culture, belief, and commercial interest that made little of the political boundaries of the day. The average citizen of third-century Dura or Palmyra would have felt far more at home in Parthian Hatra than in Roman Antioch, let alone in Rome itself. These frontier cities were not only a medium of fruitful exchange between East and West: they were the homes of people who had themselves an important contribution to make to the rapidly evolving civilization of the worlds on either side of them.

This whole region passed formally within the Roman orbit when, in 64 B.C., as a result of the conquests of Pompey the Great, Rome fell heir to the tattered remnants of the great Seleucid Empire. There is no need to follow in any detail the successive stages of the organization of the province of Syria (which in the present context may be treated as including also the provinces of Judaea and Arabia). More important are the facts of geography. Central and southern Syria may be regarded as being divided broadly into three zones: an often very narrow coastal belt of which the natural outlet was towards the west by sea, through the ports of Phoenicia; a frontier zone of varying extent, which faces eastwards across the desert; and between the two a belt of hills and mountains, comprising the greater part of the modern Lebanon and Palestine. Within this mountain belt the upland of the Bekaa, between the formidable twin ranges of Lebanon and Anti-Lebanon, formed a well defined unit, across which the route from Damascus to Sidon and Tyre formed one of the two main outlets for the immensely profitable trans-desert caravan trade through Palmyra. (The other outlet lay slightly to the north, through Emesa (Homs).) Palestine seems on the whole to have shared Lebanon's tendency to look either westwards or inwards upon itself, rather than eastwards across the Jordan to the relatively poor, marginal territories of Nabataea (corresponding roughly to the western fringes of the Arabian desert, from Damascus to the Gulf of Aqaba) and the cities of the Decapolis. The natural outlet of this latter region was northwards, through Damascus.

It is only at the northern end of the Syrian coastline, in the modern Syria, that there was a rich hinterland beckoning eastwards as well as westwards. Here the great bend of the Euphrates swung to within a hundred miles of the Mediterranean; and from here, cutting obliquely across the west-east pattern of sea, mountain, and desert, ran the age-old route down the Euphrates to Seleucia, the successor of Babylon, near the modern Baghdad, and the rich commerce of the Persian Gulf. This was the site chosen, with rare historical foresight, by Seleucus I for his new capital of Antioch, founded in 300 B.C.; and it was almost inevitable not only that Antioch should be chosen to be the administrative capital of the Roman province of Syria, but that it should also become the commercial and cultural, and in Christian times the spiritual, metropolis of the whole Roman

East. Together with the neighbouring Seleucid foundations of Apamea, Laodiceia, and the seaport of Seleucia, Antioch had been the no less unquestioned focus of hellenization in Syria, and the loss of the monuments of these cities is a gap in our knowledge comparable to the loss of their great Egyptian contemporary and rival, Alexandria.[1]

In partial compensation for the disappearance of ancient Antioch and of its twin capital of Seleucia-on-the-Tigris, the cultural metropolis of hellenistic and of Parthian Mesopotamia,[2] we have the evidence of Dura, which was successively a hellenistic, a Parthian, and a Roman stronghold on the middle Euphrates, and of Hatra, a Parthian and for a brief while Roman outpost in northern Mesopotamia. Together with the caravan city of Palmyra, they offer a vivid picture of the debatable country that lay on the eastern fringe of the Roman world, belonging wholly neither to it nor to Parthian Iran. Another area rich in classical architecture, though mostly rather late and of a rather modest, provincial character, is the Djebel country of northern Syria, north and south of the road from Antioch to Aleppo. To the north and north-east, beyond the Euphrates, lay the alternative land route to Mesopotamia, through Edessa and Nisibis to the upper Tigris, but of the Roman architecture of this region we know virtually nothing. Finally, beyond the Mesopotamian frontier to the east lay lands as richly varied as those which we have been describing, but which from the point of view of the classical world may be referred to simply as Parthia.

JUDAEA:
THE BUILDINGS OF HEROD THE GREAT

The initial impact of Imperial Rome upon the architecture of Syria was far greater and more immediate than it had been on that of Greece or Asia Minor. One important reason for this was that, outside the great hellenistic foundations of the north,[3] there does not seem to have been any very widely diffused stratum of provincial architecture that was whole-heartedly Greek in character. There were, of course, individual Greek monuments, just as there were certain individual Greek motifs which entered the *lingua franca* of local usage: the common use of the Ionic order, for example, well into the Roman period, and many of the architectural mouldings in later use. But the example of Dura[4] spells out the resilience of time-honoured local habits and building practices. Despite borrowings from Greece, as from Persia before it, there were many parts of the hellenistic East where the tradition with which the Romans were confronted was still in many essentials that of a native, local architecture.

Another important factor was the presence along the eastern frontier of a string of client principalities, some of whose rulers had close personal connections with Rome and all of whom were, in the last resort, dependent on Roman favour and patronage. Outstanding among these was Herod the Great, king of Judaea from 37 to 4 B.C. Architecturally as well as politically he dominated the earliest phase of Roman rule in this area. He was a prodigious builder, not only in his own kingdom and the several territories annexed to it, but also up and down the whole Syrian coast and as far afield as the Dodecanese, Pergamon, and Nicopolis in Epirus. The list of his work includes the foundation of the important harbour town of Caesarea (the name is significant), the refoundation of the ruined city of Samaria, which he doubled in size and renamed Sebaste (the Greek equivalent of Augusta), and the creation of several lesser urban centres: the port of Anthedon, rebuilt and named Agrippeion; Antipatris and Phasaelis; and Gaba, near Carmel, a settlement of discharged cavalry veterans, reminiscent of a Roman *colonia*. He rebuilt several of the Hasmonean residential fortresses in the Judaean desert, including Alexandreion, Hyrcania, and Masada, and founded another, Herodion, which was also to be his burial place. He built temples in honour of Rome and Augustus at Sebaste, at Caesarea, and at Paneion on the slopes of Mount Hermon. At

Jerusalem he rebuilt the Temple, doubling the size of the temenos around it; he built the citadel called Antonia; and he built a palace for himself, defended by three huge towers and incorporating halls named after Augustus and Agrippa (*Kaisareion* and *Agrippaion*). Outside Judaea his recorded benefactions in Syria and Phoenicia include stoas, temples, and agoras at Berytus and Tyre; fountains and a monumental peristyle at Ascalon; theatres at Sidon, Damascus, and Caesarea; an amphitheatre at Caesarea; gymnasia at Tripolis, Damascus, and Ptolemais; a bath-building at Ascalon; an aqueduct at Laodiceia (Latakieh); and the paving of the great axial street at Antioch. After half a century of trouble during which there had been very little significant building, such an ambitious, far-flung programme was bound to leave its mark.[5]

Herod's buildings have been the subject of a great deal of excavational activity during the last two decades, and although, pending full and accessible publication of all this work, generalization is a hazardous business, some of their basic characteristics do seem to have been securely established.[6] Both in their planning and in their approach to the problems of construction they seem to have leaned heavily upon contemporary Roman experience, freely interpreted in terms of local materials, building skills, and traditions. The use of a form of concrete became common. Vaulted substructures made possible the levelling of hill-top platforms at Hyrcania, Masada, and Herodion (this last with a ring vault) and the creation of the large, level temenos of Jerusalem, Samaria, and Caesarea. Aqueducts, the viaduct crossing the central valley of Jerusalem, and the staircases up to the Temple were carried on arches. Opus reticulatum, always a rarity in the East, was used at Paneion and again at Jericho. On the other hand, a small but beautifully constructed dome on the Herodion, whether or not it was inspired by comparable domes in Campania, is executed in the traditional hellenistic manner in dressed stone. The accompanying detail, too, which includes pavements of mosaic and of opus sectile and mouldings and 'First Style' wall

schemes of painted stucco, may in the context reasonably be regarded as derived predominantly from local late Hellenistic sources.

The surviving Herodian remains at Jerusalem itself are tantalizingly fragmentary: of the Temple itself nothing; rather more of the vast temenos, a near-rectangle measuring 480 (470) by 315 (280) m., i.e. 525 (514) by 344 (306) yards, embodying gates and open staircases and incorporating huge ashlar blocks, up to 40 feet (12 m.) long; of the palace only foundations remain, although the base of one of the three towers is still standing to a height of 65 feet (20 m.).[7] At Samaria, on the other hand, though sadly robbed and overlaid by later buildings, enough was found of Herod's Temple of Rome and Augustus to show that it consisted of a rectangular temenos 165 by 205 feet (50 by 63 m.) internally, terraced out from the crest of the hill and enclosed on three sides by porticoes; and dominating the fourth side at the head of a long flight of steps, the temple itself, which was of the Corinthian order and seems to have been peripteral on three sides, with a plain back wall.[8] The layout is one for which there are several parallels in the Early Imperial architecture of central and southern Syria, including Baalbek. Whether it derives from hellenistic Syrian models or from contemporary Roman practice (as the very unusual omission of the colonnade on the fourth side of the temple might suggest), or indeed from the convergence of both traditions, is a question that cannot be answered on the evidence now available.

In Caesarea the theatre was built of concrete, with stone seating. The stage-building, as rebuilt in the second or third century, was of typically Roman design, with a curved central exedra flanked by the rectangular recesses and adorned with a decorative screen of imported marble and granite columns. The Herodian stage-building is described as having had a shallow, rectangular niche in the centre, with wide, curved niches at the sides and projecting wings with columns, and as having 'more in common with (late) hellenistic design than with the deep recession of the Roman scaenae frons'.

The Herodian floor of the orchaestra was of stucco, painted to simulate marble. It was later again converted into a tank for aquatic shows.[9]

The remains at Jericho are those of a luxurious winter palace complex, picturesquely landscaped on both sides of a wadi [200]. It comprised a residential wing on the north bank with a long, porticoed façade facing out across the wadi towards a sunken garden; a large (c. 300 by 140 feet; 90 by 42 m.) open pool, and a lofty artificial mound, which incorporated a square structure, possibly a pavilion, built of concrete

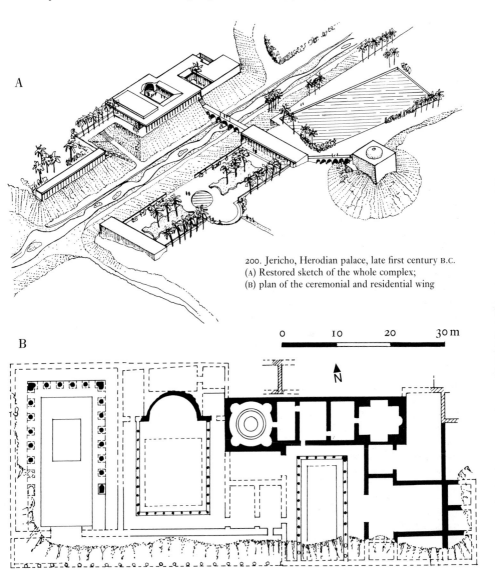

200. Jericho, Herodian palace, late first century B.C.
(A) Restored sketch of the whole complex;
(B) plan of the ceremonial and residential wing

0 10 20 30 m

upon a footing of squared stone. The north wing, built partly of concrete, partly of mud brick, and detailed throughout in painted stucco and coloured stones and marbles, included a grandiose reception hall, with an internal colonnade supporting a timber roof of 43 feet (13 m.) span; a peristyle courtyard with an axial apse; a five-room bath suite; and, opening off a second, Rhodian peristyle, a T-shaped triclinium. The sunken garden, formally planted, was composed about a façade with decorative niches and a terraced hemicycle in the centre, all carried out in opus reticulatum, and it was

framed between a pair of raised, flanking porticoes. Water was in lavish supply. Here in all essentials, six miles from the shores of the Dead Sea, was a landscaped villa in the contemporary Italian manner.[10]

The same Italian influences are evident in the small but spectacularly situated residence (the 'Hanging Palace') at the northern tip of Masada [201]. This was built of dressed stone faced with stucco and consisted of three platforms terraced down the knife-edge northern extremity of the plateau. The upper platform comprised a rectangular suite of nine rooms, including cubicula

201. Masada, 'Hanging Palace', before 4 B.C.

paved with black-and-white mosaics and front-
ed by a semicircular colonnaded terrace, which
looked directly out over the middle platform,
60–70 feet below. A circular pavilion stood on
the middle terrace and, behind it, a covered
colonnade. The lower terrace, 40–45 feet lower
again, was entirely occupied by a belvedere,
with four porticoes enclosing an open central
area. The walls of the belvedere, inside and out,
consisted of a series of structural piers linked by
a vestigial curtain wall, of which almost the
entire intercolumnar space was occupied by
lofty rectangular windows – an extreme form of
a typically late hellenistic device, the germ of
which is already present in the bouleuterion at
Miletus, but for which the closest recorded
parallels are to be found in Italy, e.g. in the
House of the Mosaic Atrium at Herculaneum
[113]. On the plateau above were storerooms
and cisterns, a large public bath-building in the
Roman manner, and a second, larger palace (the
'Western Palace') with a throne room and
reception halls as well as living quarters grouped
around a central court with a portico. The
military aspect of this fortified residence is
emphasized by the extensive storage facilities,
and by the double wall with towers that sur-
rounds the plateau. This was a late hellenistic
architecture with strong Italian overtones – just
what one would have expected from a patron of
Herod's known tastes and upbringing.[11]

A more strikingly original plan is that of
Herodion, the circular perimeter of which, with
towers at the four points of the compass, was
landscaped into the summit of an artificially
heightened hill-top. Internally it was precisely
oriented, with a peristyle and a garden occupy-
ing the eastern half and a residential wing, with
reception hall and bath-building, occupying the
western half. Down the hill there was a second
palace complex, which included an open
swimming-pool with a circular island at the
centre.[12]

The foregoing account will doubtless require
modification as more is excavated and accessibly
published,[13] but the picture that is emerging is
already clear and broadly consistent. This was

an architecture which, though inevitably shaped
by local practices, leaned heavily upon ideas and
techniques brought in from the classical world,
from Italy as well as from the hellenistic East.
Although the fine masonry and the mud brick
with its stucco detail are, in the context, a local
tradition, the reticulate work and the concrete
were both Italian innovations. The agora, the
gymnasium, the stoa, and the porticoed en-
closure belong to the stock-in-trade of hellenis-
tic town planning, but the bath-building and the
amphitheatre are distinctively Western inno-
vations; perhaps also the *peripteros sine postico*
plan of the temple at Samaria and, more
generally, the widespread use of terracing on
vaulted substructures. About the theatres it is
difficult to be precise. The theatre had never
really taken root in hellenistic Syria outside the
big cities,[14] and in the absence of a local
tradition those of provincial Roman Syria are
almost exclusively of the so-called 'Western'
type. Herod's building at Caesarea appears to
represent a rather different tradition, the im-
mediate inspiration of which has yet to be
determined.

Herod is often credited also with having built
the first colonnaded street, at Antioch; but what
in fact Josephus tells us[15] is that he paved the
great central avenue (*platea*) and alongside it he
built a stoa of equal length. For the moment it
represented no more than the monumental-
ization of one of the *viae porticatae* of later
Republican Rome; only when doubled sym-
metrically down both sides of the street did it
become the fully-fledged colonnaded street so
beloved by the town planners of the Roman
East. But there was no more prestigious centre
than Antioch and in this, once again, it was
Herod who took the essential first step.

After the Jewish revolts and the reduction of
Judaea to the role of a small, second-class
province, it was not really until late antiquity,
under Constantine and in the context of Chris-
tianity, that this area once again came to occupy
the centre of the architectural stage. An early
group of synagogues in Galilee, dating from the
late second and third centuries, has often been

claimed as ancestral to the Christian basilica; but they are singularly isolated both in place and time, and the connexion is very doubtful. They should be regarded rather as one of the innumerable borrowings of this versatile and symbolically neutral architectural type for other purposes, without wider significance.

BAALBEK AND THE LEBANON

For a more comprehensive vision of the historical development of classical architecture in the Syrian coastlands one has to turn from Judaea to the cities and dependencies of Phoenicia, corresponding roughly to the modern Lebanon. Here not only do we have the great sanctuary of Jupiter Heliopolitanus at Baalbek, but there are many well preserved lesser sites and, in recent years, a growing body of material from the coastal cities, which together enable us to view the buildings of Baalbek in increasingly sharp perspective.[16]

The complex origins of the religious architecture of the Roman East are closely bound up with the historical development of the cults themselves. At Baalbek the cult, originally that of a typical triad of native agricultural divinities, had already undergone considerable modification in hellenistic times, probably under the influence of Ptolemaic Egypt. The great god of the storm, Ba'al, had been equated with Zeus, and whether by an act of formal syncretism or by a process of natural assimilation, the youthful god of regeneration and rebirth (Adonis, Echmoun or Tammuz) took on the character and attributes of a divinity who was at this time acquiring ever-increasing popularity as a god of personal regeneration and rebirth after death, namely the god known to the classical world as Dionysus or Bacchus. It is typical of the practical good sense of the Romans that they should have chosen to promote this long-established sanctuary, rather than, as in Gaul or Asia Minor, a conventional shrine of Rome and Augustus, to serve as a focus for the religious loyalties of central Syria.[17]

The only specific reference to this enormous enterprise in ancient literature, a statement by the seventh-century Antiochene historian, John Malalas, that it was built by Antoninus Pius, is certainly mistaken.[18] An inscription on one of the columns of the façade of the great temple proves that the latter was already standing to capital height in A.D. 60, and it must in fact have been planned quite soon after the foundation of the Roman Colonia Julia Augusta Felix Heliopolitana c. 16 B.C.[19] It was not the first monumental sanctuary to occupy the site. Excavations undertaken in the sixties, as yet substantially unpublished, have shown that the platform of the great courtyard rests on the remains of an ancient tell, and built into this tell there had been at least three substantial previous sanctuaries, the first of which is thought to be as early as, or earlier than, the sixth century B.C. All three had followed the same orientation as the present building and seem to have been centred upon the area occupied by the later altar; and adjoining the façade of the third was a tower-like altar closely comparable to those of Machnaka and Kalat Fakra, which are described below. Whether the pre-Roman sanctuary included a temple proper or was simply a monumental temenos with altars is at present an open question.[20] The altars were certainly an essential feature, so much so that provision was made to keep those of the hellenistic sanctuary accessible during the early stages of work on its Roman successor. Like many of the great shrines of the ancient world, Baalbek was a long time building, and even so it was never fully completed. A study of the decorative detail shows that the great altar was finished soon after the middle of the first century A.D., the courtyard around it, after several changes of plan, not until nearly a century later. About the middle of the second century the 'Temple of Bacchus' was added (it is perhaps to this building that Malalas's sources were referring); and over the next hundred years there were added a monumental forecourt and propylaeon, dated by inscriptions and coins to the time of Caracalla (211–17) and Philip the Arab (244–9) [202].

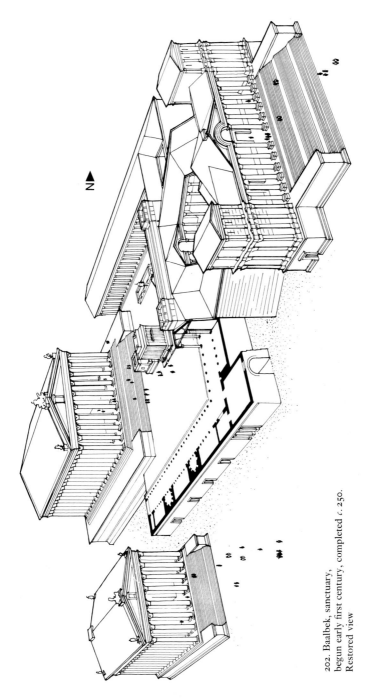

202. Baalbek, sanctuary,
begun early first century, completed c. 250.
Restored view

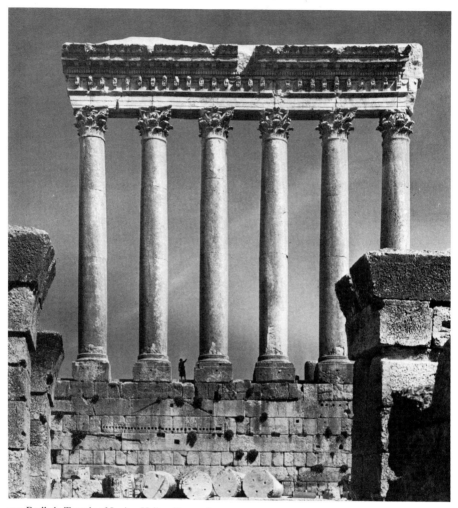

203. Baalbek, Temple of Jupiter Heliopolitanus, first century,
the six standing columns of the south peristasis

The Temple of Jupiter was, by any standards, a very large building, and it was made to seem even larger by its elevation on a podium which towered 44 feet (13.5 m.) above the great court, at the head of a grandiose flight of steps. The temple itself, built throughout of the superb, honey-grey local limestone, was decastyle, with nineteen flanking columns and a deep columnar porch. Its columns rose another 65 feet (19.90 m.) from floor to capital [203], and the gable was thus nearly 130 feet above the floor of the great court. The cella, which faced east, was removed in its entirety when in the Middle Ages the whole sanctuary became an Arab fortress, but the plan of the footings and the analogy of other known early temples in the

area alike suggest that there was a raised sanctuary (*adyton*) at the west end, a simpler version of that found later in the Temple of Bacchus. In front of the temple stood a porticoed courtyard, the central open space of which measured 320 by 280 feet (97 by 86 m.), and on the axis of this courtyard, between the façade of the temple and the original propylon, stood two square, tower-like structures, the larger of which rose no less than 55 feet (17 m.) above the pavement of the courtyard, from which the flat platform-roofs were accessible by stairs. These were artificial 'high places', designed for the sacrificial rites of the sanctuary. The larger of the two is sited so close to the main entrance to the courtyard that the temple must at first have been invisible to the visitor entering the sanctuary on the conventional central axis. Only when he turned and moved to right or left would the towering bulk of the great temple façade have broken upon him in all its immensity.

It is customary to refer to the element of sheer size at Baalbek as if it were a characteristically Roman innovation, and rather a vulgar one at that. In fact, although the height was indeed exceptional, the dimensions of the actual temple (158 by 259 feet, or 48 by 88 m., at the stylobate) fall well short of such classical Greek giants as the temples of Artemis at Ephesus (180 by 374 feet; 55 by 114 m.) and of Zeus Olympios at Akragas (173 by 361 feet; 52.75 by 110 m.), or the hellenistic Didymaion, near Miletus (167 by 358 feet; 51 by 109 m.). In Rome itself it had no equal until Hadrian's Temple of Venus and Rome (217 by 348 feet; 66 by 136 m.).[21] The plan, which closely resembles that of Herod's temple at Samaria, may or may not reflect hellenistic models. It would certainly have looked very familiar to Roman eyes, and some of the detail is specifically Roman. The earliest capitals of the temple (the design was modified in the course of the work) are based on models to be found in Augustan Rome, notably in the Temple of Castor. Another characteristically Roman trait, rare in the East, is the use of shell-heads that splay downwards, not upwards, in

the decorative niches. Again, much of the decorative carving of the great altar-tower is purely Roman in character, in significant contrast to the work of other squads engaged on the same building, whose sharply outlined, rigidly geometric carving is no less clearly the product of a markedly conservative Oriental tradition. The entablature of the Temple of Jupiter, 13 feet high, exhibits an even more complex parentage. The proportions and relative scale of the ornament are those of a mid-first-century Roman monument, whereas the detail of some of the mouldings, such as the foliate ornament of the sima and the maeander below it, are patently hellenistic in origin; a curious, corkscrew-like horizontal moulding is paralleled only on the great temple of Shamash at Hatra in Mesopotamia and on a few Judaean monuments;[22] and the frieze, a boldly conceived design in which the forequarters alternately of bulls and lions project above foliate brackets, as if supporting the load of the cornice, must have been designed expressly for the temple, since the bull and the lion are the attributes of Ba'al-Hadad (Jupiter) and of Atargatis-Allat (Venus), the two senior members of the local triad. The bracket itself must in the context be a Persian legacy, comparable to the twin-bull capitals of Persepolis and Susa and, nearer home, of Sidon.[23] This motif too is repeated at Hatra.

The Temple of Bacchus was smaller than its gigantic neighbour (115 by 217 feet; 35 by 66 m.), but it was still by any ordinary standards a large building. In plan it differed principally from its predecessor in the proportionately far greater area that was reserved for the cella, an emphasis which was presumably due to the requirements of the cult. The architectural ornament, though based on that of the earlier building, is extraordinarily elaborate, the interior of the cella in particular [204] being a masterpiece of disciplined opulence, in which the soaring dignity of the main architectural lines stands out in vivid and effective contrast to the intricacy of the secondary detail. It is instructive to contrast it with the rather dry, Attic sobriety of the nearly contemporary façade

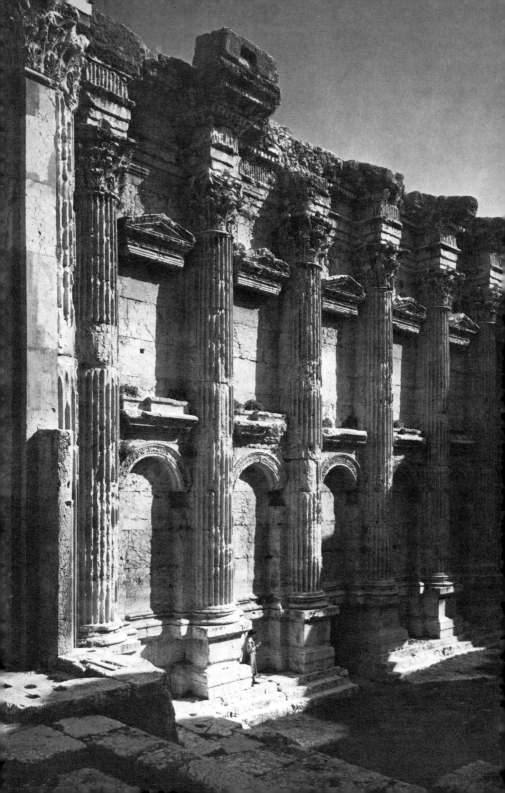

204 (*opposite*). Baalbek, Temple of Bacchus, mid second century, north side of the interior of the cella

205 (*below*). Baalbek, Temple of Jupiter, part of the forecourt, as rebuilt in the second century

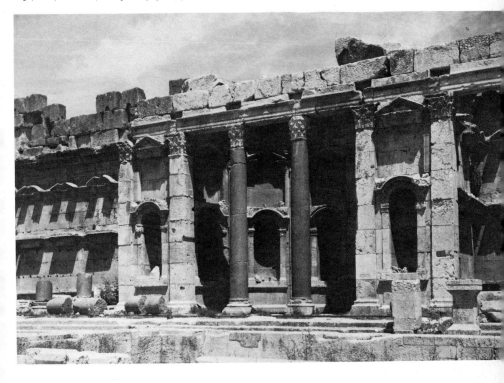

of Hadrian's Library at Athens [172]. The spirit of Baalbek is far closer to that of the Severan Forum at Lepcis Magna [253], where the doorways of the tabernae serve very much the same purpose in giving height and scale to the main decorative order. Other refinements are the receding planes of the wall surfaces (which, one asks, is wall and which pier or recess?) and the ingenious, if not wholly successful attempt to link the architecture of the adyton with that of the cella as a whole. In the treatment of the walls it may not be altogether fanciful to see the Syrian architect's answer to the increasing illusionism and emphasis on the properties of space that characterize so much of the contemporary architecture of the Roman West.

The great courtyard in front of the Temple of Jupiter [205] seems to have been planned from the outset on broadly the same lines as what one sees today, although the present building represents a major reconstruction undertaken to comply with the more sophisticated requirements of second-century taste. Opening off the three porticoes there was a series of alternately rectangular and semicircular exedrae, within and between which every inch of wall-surface was occupied by tall pilasters and, between the pilasters, giving height and scale, two tiers of decorative aediculae. The contrast between the rectangular and the curved exedrae was accentuated by differences of detailed treatment. The former had flat timber roofs, and the wall

decoration consisted of two continuous and closely interlocking orders of aediculae projecting from the wall to form a virtually independent columnar screen. The latter had semidomes, and their wall-pattern resembles, with minor embellishments, that of the Temple of Bacchus. In both there was an elaborate interplay of curvilinear and rectilinear forms. The columns of the main porticoes and of the exedrae were of red granite from Assuan and grey granite from the Troad (the transport alone of these up from the coast, each weighing over 10 tons, was a remarkable feat), and the vanished colonnettes of the aediculae were presumably of imported marble. Once again one is led to admire the subordination of the wealth of detail to the grandeur of the total effect, to which the repetition of the columns and aediculae lent scale and movement and the contrast of the granite and the local stone a welcome note of colour. When the colonnades were still standing as a frame and a foil for the elaborate detail within, the whole overshadowed by the towering bulk of the great temple, this must have been a building to impress the most jaded taste.

The hexagonal forecourt is now so ruinous that it is hard to judge the effect of the unusual plan.[24] The details were closely modelled on those of the great court, but the proportions were quite different, dwarfing the central space and heightening the eventual impact of the court beyond. In front of it lay the propylon, the last of the additions, dating from the reigns of Caracalla and of Philip. Here too, though there was little new in the detail save the arching of the architrave over the central opening (new perhaps to Baalbek but already a well established feature of the temple architecture of southern Syria),[25] and the moulded pedestals which gave added height to the twelve granite columns and to the gilded bronze detail of the entablature, one can nevertheless detect a subtle change in the spirit of the composition as a whole. The towers which flank and dominate the façade, while looking back to the Early Imperial monuments of the Hauran and of the

Decapolis, and ultimately perhaps to the Temple of Jupiter at Damascus, also herald a long line of such symmetrical schemes in the architecture of Christian Syria.[26] While the temples and the great court are still firmly rooted in the classical world, here one is conscious of having already stepped across the threshold of late antiquity.

The last in date of the surviving monuments of Baalbek is the little third-century Temple of Venus which stood across the street from the main sanctuary in an enclosure of its own. After the grandeurs of the Temple of Zeus it strikes a welcome note of elegance and refinement. The plan, an ingenious combination of a circular cella with a rectangular pronaos, had no close precedent [206]. It stood on a tall podium, and from the front it might easily be mistaken for a typical temple building of southern Syria.[27] The circular cella speaks a very different language. It was roofed with a shallow stone dome, and it may have been the need to buttress this which first suggested to the architect the idea of an outer colonnade of which the entablature should be composed of five horizontal arches, their crowns tangential to the base of the dome and their two extremities projecting outwards to rest on the columns of the peristyle. The result was a plan that was partly scalloped and partly circular, a contrast of which the architect took full advantage, balancing the concave surfaces of the podium and entablature and of the niches in the cella wall against the convex surfaces of the cella itself and of the bottom steps of the podium so as to create an elaborately receding play of curve and counter-curve. Among the many refinements may be mentioned the uniquely five-sided Corinthian capitals and bases. This is a building to delight the fancy of any Baroque architect.[28] The buildings of the great sanctuary, whether they look forward or backward, are essentially buildings of their own time and place. Here is one that eludes such classification – a monument to the sophisticated taste alike of the architect and of his public, and a reminder that great architecture, whatever the extent to which it may be conditioned by circumstances,

206. Baalbek, Temple of Venus, third century. Plan and axonometric view

is the product of the individual genius of its creator.

Baalbek was two and a half centuries building. The first impression that it conveys is almost inevitably one of a powerful continuity, extending often to the most trivial details, such as the abacus ornament of the capitals right through the series. Nevertheless there were, as we have seen, also important innovations of content and style, above all innovations of planning; and although in the presence of the temples one is conscious first and foremost of their overwhelming influence upon the temple architecture over a large area of central Syria, it is pertinent to ask to what extent they themselves were shaped by forces that were more widely at work in this region in late hellenistic and Roman times. How much of all this is the legacy of traditional native practice, and how much the product of successive waves of alien classical influence, both hellenistic and Roman?

To such questions the many lesser sanctuaries of Lebanon offer at any rate a partial answer. Although few are closely dated and many, particularly the later ones, exhibit the strong influence of Baalbek, there are also several which, whatever their absolute date, clearly illustrate a stage of development prior to that of any buildings now preserved at Baalbek. The characteristic monument of these early sites is a tower-like 'altar'. In its earliest recognizable architectural form this has simple but distinctive 'Egyptian' mouldings (a flattened torus near the base and at the top a flaring sima above a plain torus). In at least one instance, at Machnaka in the mountains above Byblos, an altar-tower of this type can be seen to incorporate a yet earlier structure in the form of a plain box of dressed stone slabs; and the hellenistic altar was itself subsequently given more conventionally classical form by the addition of an outer ring of slender Doric columns with an entablature and an openwork parapet

above. On another early site with a long history, Kalat Fakra near the head of the Adonis river, the development took the form of loosely grouping the successive altars within the periphery of a single 'high place'. Four of them have survived – one with typical Egyptian mouldings

207. Kalat Fakra, altar, first century B.C. or A.D. with 'Egyptian' mouldings and crenellated ornament

and a crowstep-ornamented parapet [207]; a small columnar structure of a type which recurs on several other sites (Hossn Sfiri, Hossn Suleiman, Niha), and which appears to be a miniature version of the latest phase of Machnaka; a large tower with internal staircases and terraces, the detail of which includes Egyptian mouldings and a gallery with Phoenician volute capitals; and a small altar of conventional Roman shape.[29]

The group of Kalat Fakra serves very well to illustrate both the range and the extraordinary conservatism of this Lebanese architecture. The Phoenician volute capital goes back with little change to the beginning of the first millennium B.C. in Phoenicia and Palestine; the crowstep parapet, which we shall meet again at Damascus, Petra, and Palmyra, had a comparable background in Mesopotamia, and it remained in use throughout the area right into Arabic times.

At Kalat Fakra the capitals and the Egyptian mouldings were still in use as late as A.D. 43, the date of the tower. By then Roman Baalbek was already taking shape; and there – as no doubt happened on many other sites – the earlier altars were superseded and replaced. Even so, tradition was strong enough at Baalbek to impose on an otherwise classical layout the architecturally incongruous element of the great altar-towers, to the form of which the tower at Kalat Fakra offers an obvious parallel.

It is to such local factors that we must look also for the explanation of the very distinctive interiors of these Lebanese temples. In the later, more elaborate versions, as in the 'Temple of Bacchus' at Baalbek, or Temple A at Niha [208], the sanctuary proper (*adyton*) consists of a raised, canopied platform occupying the whole of the far end of the cella.[30] But this can be seen to have developed from an altogether simpler type in which the cult-statue stood within a simple canopied aedicula set in the rear wall at the head of a flight of steps.[31] The essential features were the canopy and the steps. Unlike the simple, rather intimate room which housed the cult-statue of a Greek temple, this was the throne room of the divinity, where he received his worshippers in audience. The conception is one that we find expressed in very similar terms throughout southern Syria, at Gerasa for example, or at Petra. The architectural language of these temples is classical, but it is used to express an idea altogether alien to the traditional temple of Mediterranean lands.

The smaller sanctuaries of the Lebanon do, therefore, help us greatly to appreciate the strength of the native Semitic traditions that still underlay the classical veneer even in a countryside so readily accessible from the Mediterranean coast. They also illustrate the surprising persistence of Achaemenid Persian architectural influences. The hellenistic legacy is less unexpected, although it is well to remember that part of this may well be due to the diffusion in Roman times of classical ideas previously established in the cities of the coast. Among the hellenistic legacies we may number the location

of several of these temples within a monumental porticoed temenos; the frequency of the Ionic and, less commonly, Doric orders; and possibly, but less certainly, the long, narrow shape of most of the lesser temples, which are pre- dominantly prostyle or *in antis*. The upper temple at Kalat Fakra [209] is of particular interest in this connexion, as illustrating the influence of first-century Baalbek or else of some common hellenistic model.[32] Although

208. Niha, interior of Temple A, late second century. Restored view

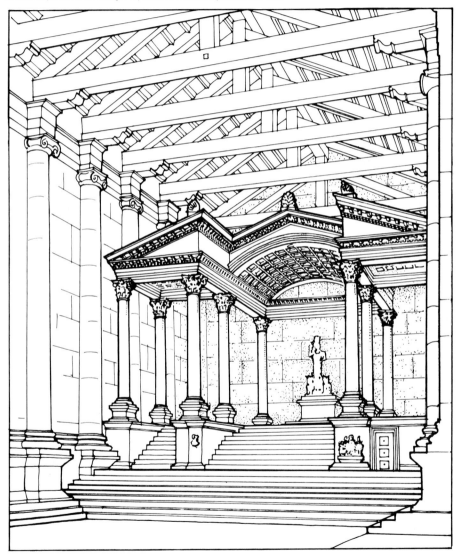

209. Kalat Fakra, temple, late first or second century.
Restored view, looking north-westwards

the building in its present form can hardly be earlier than the second half of the first century, the altar in the forecourt is still of the traditional type, with Egyptian mouldings.

The wave of fresh architectural ideas from the classical world which had followed the re-establishment of peace and prosperity under Augustus, and which found such vigorous expression in the planning of first-century Baalbek, was of relatively short duration. Further exploration of the coastal cities would doubtless modify this impression in detail. But just as in Rome itself the architects of the Julio-Claudian period were largely engaged in assimilating and exploiting the innovations of the previous generation, so too in the Lebanon the rest of the first century A.D. seems to have been devoted primarily to working out the new ideas in terms of local practice and to the creation of the distinctive Romano-provincial style of which Baalbek was the focus and the continuing inspiration.

Once again, as in southern Asia Minor, it was the advent of marble which upset the balance of the local Early Imperial style; and if in the Lebanon the results may at first seem less startling than in Pamphylia, this is partly at any rate because the facts of geography limited its direct impact upon those monuments with which we are most familiar. Even at Baalbek the granite columns of the great courtyard bear witness to the fascination of the new materials, and the entablatures which they carried, though still carved in limestone, bear the unmistakable imprint of the new stylistic repertory. In the coastal cities the results were immediate and far-reaching. At Tyre the only well preserved first-century monument is an elaborate triple arch spanning the landward end of Alexander's causeway, and this is a characteristically Early Imperial structure of sandstone faced with stucco. The later buildings – the colonnaded street, the baths, the great temple of Hercules-Melqarth – all had columns of imported marble

or granite, with Proconnesian marble capitals and entablatures that follow familiar 'marble style' models. The same is true of the colonnaded street and nymphaeum at Byblos, the only substantial monuments of the period yet uncovered there. The remains of Berytus lie deep beneath the modern Beirut; but the long series of Proconnesian marble capitals recovered casually and now housed in the National Museum would alone suffice to show that, from the second century onwards, the prevailing architectural style was in this respect based on that of western Asia Minor; and it is possible that in this case chance has preserved the remains of the actual building which set the fashion. The exact nature of this building, which came to light in digging the foundations of the modern parliament house, is disputed; but it certainly included a handsome Corinthian order, now partially re-erected in front of the museum, with columns of reddish limestone breccia and the remaining elements of Proconnesian marble, an interesting feature of which is the instructions for assembly carved on each individual block. A fragmentary inscription records that it was built 'with its columns and marbles' by Berenice, sister of Agrippa II and for a time mistress of the emperor Titus.[33] This is just the sort of wealthy context in which one might expect to find the forerunner of what in the second century was to become normal municipal practice.

NORTH-WEST SYRIA

It is sad that so little should have survived of the cities of northern coastal Syria, and in particular of Antioch. Here, if anywhere, one would have seen the monuments which set the pattern for the lost buildings of hellenistic Syria. Here again one would have seen, written large, the successive waves of Roman influence, the pattern of which, with its strong Western bias, was already established in the list of buildings for which Julius Caesar was responsible in Antioch itself; a bath-building and aqueduct, a theatre, an amphitheatre, and a monumental centre, the Kaisar(e)ion, for the cult of Rome and its rulers – a programme which neatly foreshadows that undertaken by Herod twenty years later.[34] Here, finally, one would have seen something also of the reverse architectural currents which under the later Empire began to flow from East to West and which are at present most tangibly represented by the magnificent series of floor-mosaics from the city and its suburbs.[35]

Of all this building we have to be content with the remains of several of the smaller baths and of a number of houses. In plan the former [224B] ring changes on a few simple rectangular, octagonal, apsed, and occasionally circular forms, comparable at their most elaborate to the Hunting Baths at Lepcis Magna [251] and no doubt derived from the same sources.[36] We do not know how they were roofed. Among the private houses and villas it is clear that the single-storey peristyle-house was the dominant type. Some of these were of considerable wealth and elaboration, grouped loosely about a number of minor courtyards. The most obvious common characteristic is the emphasis on the triclinium, which opens between columns or piers on to a courtyard, often accompanied by an elaborate fountain and usually laid out with a firm disregard of axial symmetry. An early-third-century house like that at Seleucia, the port of Antioch [210],[37] will serve as an example

210. Seleucia-Pieria, near Antioch.
Plan of a Roman house, early third century.
The lighter lines indicate patterned mosaic floors

TRICLINIUM

FOUNTAIN

N

0 10 15m

of the sort of building which may well have inspired the late antique houses of Ostia. Of the rich monumental architecture of the city there is hardly a trace. From the pages of Malalas and other writers we know that this architecture existed; we can be sure of its importance; but when it comes to details we have to accept the fact of a gap at the heart of our subject.

To fill that gap we have sadly little from the other cities of northern Syria.[38] What we do have, instead, is the often outstandingly well preserved remains of the innumerable small country towns and villages which occupied the higher ground inland from the coastal plain, midway between Antioch and Aleppo.[39] This was the countryside which supported the great classical cities, and it conveys an extraordinarily vivid picture of what, under fortunate circumstances, Roman civilization could mean to the humble dweller in the provinces – a picture all the more remarkable in that a great many of the surviving buildings date from the fifth and sixth centuries, a time when over much of the Roman world civilization was crumbling fast. The late date of so many of the actual buildings does not matter greatly in the present context, since those architectural forms that are not specifically Christian seem to have changed very little since Early Imperial times; and although much of the architecture of these grass-roots communities is of greater interest to the social than to the architectural historian, it does inevitably reflect many aspects of contemporary urban practice.

The basic architectural forms were extremely simple and were determined by an abundance of good building stone and a tradition of fine craftsmanship in handling it. Except for the apses and semi-domes of bath-buildings and churches, the buildings were uniformly rectilinear, with gabled, or occasionally flat, roofs and a clearly marked tendency to build upwards rather than outwards. Towers and two-storey, or even three-storey, buildings are a commonplace. Another regular feature is the portico, sometimes conventionally classical in its detail, far more commonly translated into an open framework of alternately vertical and horizontal squared monoliths. A few buildings stand out as representative of a somewhat wider classicism. One such is the temple of Burdj Bakirha (A.D. 161), a modest prostyle building which, with its podium and rudimentary adyton, would not have been out of place in the Lebanon. Another is the small third-century private bath-building at Brad (Roman Barade), the curvilinear plan and vaults of which derive unmistakably from metropolitan practice [211C] and look forward in their turn to the small bath-buildings that were one of the more distinctive legacies of Roman to Early Muslim architecture in Syria.[40] It must represent the taste of some wealthy city-landlord. Such intrusive buildings were, however, exceptional. The great majority ring the changes on the very simple range of building forms that constitute the constructional repertory of this whole local group.

Domestic architecture bulks large, thanks to its use of exactly the same architectural vocabulary and durable materials as the public buildings. Most of the surviving houses date from the fourth to sixth centuries, but they repeat forms that were already established on the spot in the Early Empire. The basic unit was a rectangular building, one room thick, subdivided by transverse partitions, or rows of posts, and almost invariably opening along one long side, usually the south side, on to a portico. In what is probably rightly regarded as its primitive local form, the roof was flat and the span no larger than could be achieved with the poor local timber. The village houses at Taqle [211A] illustrate a developed and modestly prosperous version of the type (fourth to fifth centuries) with the dwelling-rooms in an upper storey over the stable. As early, however, as the first century A.D. the introduction of the classical gabled roof with tiles made possible the development of the more spacious, better built versions which characterize the wealthier houses from the Early Empire onwards, as at Banaqfur in the first century [211B] or Benabil in the second. These were regularly two storeys high, with a double portico along the façade, and they normally opened on to a square courtyard, around which

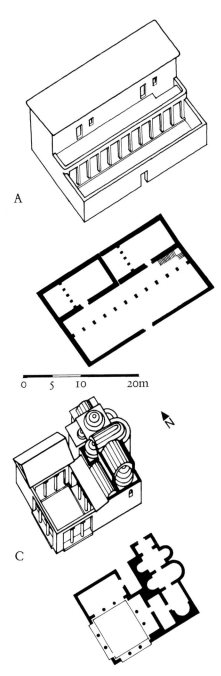

0 5 10 20m

N

211. Buildings in North Central Syria.
Elevations and plans.
(A) House at Taqle, fourth century;
(B) house at Banaqfur, first century;
(C) bath-building at Brad, third century

might be grouped storage-towers, and other
service buildings. The type remained in use,
little changed, into late antiquity.

The public buildings, including the earliest,
pre-basilican churches, both in plan and in
general appearance represent a closely related
development. Such, for example, were the
bazaars, rows of small shops opening off the rear
wall of a portico and regularly two storeys high.
The resemblances to the hellenistic stoa can
hardly be accidental, and one of them, at
Babisqa (A.D. 536), is in fact so named. Very
similar in form were the inns (*pandocheia*). Yet
another related type of public building was the

andron, consisting of a gabled hall with one or more porticoed annexes. This seems to have been an all-purpose community meeting-place, and one such hall, at Me'ez, dates from as early as A.D. 29. Even such an alien type as the bath-building was in time assimilated to local practice, as we see at Serdjilla (A.D. 473) and Babisqa (fifth to sixth centuries).

As seems to have happened so often in the classical world, it was only in commemorating the dead that this very homogeneous practical architecture found scope for real individuality. Tall paired columns (Sermada, A.D. 132); tetrapylon monuments crowned with pyramidal roofs (Dana, Brad, second to third centuries) or, later, domes (Tomb of Bizzos at Ruweiha, sixth century); gabled sarcophagi perched on lofty plinths in the manner of Asia Minor; gabled tempietti (Babutta, first century; Ruweiha, 384); rock-cut tombs and façades; square towers with tall pyramidal roofs (Rbe'ah, second century), following a type which was widespread in Syria (Hermel) and Cilicia (Diokaisareia) and which was echoed as far afield as Italy and North Africa – these are some only of the forms that were in recurrent use over many centuries. They illustrate once again the difficulty of fitting into neat, orderly categories a funerary architecture in which so large a part was played by quirks of personal taste.

DAMASCUS

Damascus, well watered and situated at the focal point of central Syria, has paid the price of a long and prosperous history in the almost total loss of its classical monuments. Little more can be made out than the outline of a typically hellenistic, gridded street plan; superimposed upon it a pair of Roman colonnaded streets, one of them the 'street called strait' of the Acts of the Apostles; the probable positions of the agora and the theatre; and, on the site of the Ummayad Mosque, the scanty remains of the city's principal shrine, the Temple of Jupiter Damascenus. This stood near the west end of a symmetrical porticoed temenos (now the outer wall of the mosque), which in turn was enclosed within a vast outer enclosure, measuring some 325 by 450 yards and encircled by double colonnades. Begun presumably under Augustus, the temple and temenos were well advanced by A.D. 15–16.[41] The principal surviving elements belong to the temenos, and these offer a glimpse of an architecture which, though classical in intention and in much of its detail (notably the handsome Corinthian order of the propylaea),[42] still embodied many traditional features, including 'Egyptian' mouldings and merlon parapets. Among the several anticipations of later Romano-Syrian practice we may note the towers at the outer corners of the façade, the rectangular columnar exedrae facing on to the courtyard and, more generally, the characteristic relationship of propylaea, temenos, and temple. This was one of the great monuments of the Early Imperial East, and had more of it come down to us no doubt the later story of Roman architecture in central and southern Syria would be much easier to read.

SOUTHERN SYRIA:
PETRA AND THE DECAPOLIS

The picture conveyed by this rapid survey of the architecture of coastal Syria and its immediate environs, though often deficient in detail, is in its broad lines clear and consistent. About the hellenistic cities, the main source of pre-Roman classical influence, we are sadly ill-informed; but even in this, the area of closest and most continuous contact with the rest of the Mediterranean world, we see that in the countryside outside the cities native traditions and ideas were still powerful. The balance varied sharply in accordance with historical, geographical, and social circumstances, but Persian, hellenistic, and native Semitic traditions were still factors to be reckoned with in Roman times. The pattern of Roman influence, sketched at Antioch by Caesar, took substantial shape under Augustus, notably at the hands of Herod, whose example may well have been followed by the rulers of other client princi-

palities along the frontiers.[43] It was based on the introduction, both from the Greek world and from Italy, of a number of new building types, and even building techniques, and these, at various social levels and in varying degrees, seem for the next hundred years or so to have constituted the principal Roman contribution to an architecture which in many respects was still firmly rooted in its own recent past. The next turning-point came early in the second century, and in this case the medium was a new material, marble, and the main source of inspiration the Romano-provincial architecture of western Asia Minor.

It is against such a background that one has to view the development of Roman architecture along the frontiers of Syria, southwards and south-eastwards towards the Red Sea and the Arabian desert, and eastwards towards Mesopotamia.

With the tangled political history of the first of these areas under the Early Empire we need not concern ourselves in any detail. For a time in the early first century B.C. the whole region east of Jordan and south of Damascus had been part of the kingdom of the Nabataeans, who continued to rule the southern part as client kings until its annexation by Trajan in A.D. 106. Of the rest, the village-dwellers of the mountains and plains of the Hauran, although retaining close cultural and commercial ties with the Nabataean kingdom, were until A.D. 93 part of the domain of Herod and his successors; whereas the strip of country immediately to the east of the Jordan, the principal area of prior hellenization, was in 63 B.C. organized into a loose confederation of ten cities, the Decapolis, which long retained a considerable measure of independence within the framework of the newly constituted province of Syria. The whole area is very rich in remains of the Roman period, the outstanding surviving sites being those of Petra, the capital of the Nabataean kingdom, and of Gerasa (Jerash), one of the cities of the Decapolis. Throughout the period the main source of classical influence was probably Damascus.

Petra, romantically situated in an almost impregnable basin within the mountains of Edom, is best known for the rock-cut tombs which honeycomb the surrounding cliffs. The monuments of the town itself have received far less attention. They included an aqueduct, a central colonnaded street, a theatre, a large peripteral Corinthian temple, a small prostyle, hexastyle temple, a streetside nymphaeum (akin to, but smaller than, that of Gerasa), bath-buildings, and, at the west end of the street, an elaborate triple arch leading into the temenos of Qasr el-Bint (Qasr Fira'un), the large temple which is the principal monument still upstanding within the city.

The chronology of the monuments of Petra is controversial. The traditional view, followed by many modern scholars, is that the great majority of the very distinctive architecture of Petra antedates the Roman annexation of the province of Arabia in 106, having taken shape under King Aretas II, who ruled in the late first century B.C., and his immediate successors. On this view the architecture is late hellenistic in date as well as in character, based on models established in the late hellenistic courts of Egypt and of Syria, models which are thought also to have inspired the Palazzo delle Colonne and other similar buildings in Cyrenaica.[44] The same evidence can also be interpreted as indicating that the great majority of the actual buildings now visible within the town date from after the annexation, and that a substantial part of the tomb series, including the most elaborately classicizing façades, are a great deal later than supporters of the traditional view would maintain. It is this latter reading which the present writer believes to be, on balance, the more probable and which is followed in the paragraphs that follow. But it must be emphasized that those who prefer to follow the traditional, early chronology will find themselves in good company.[45]

Although the rock-cut tombs of Petra are in detail very varied, they fall into a well defined typological sequence. This is based on the form of the façade, which is quite independent of that of the actual tomb-chamber, and is charac-

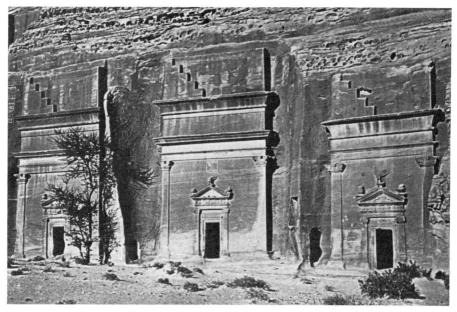

212. Hegra (Medaein Saleh), rock-cut Nabataean mausolea
of the third quarter of the first century

terized by the use of a shallow, almost two-dimensional relief as a means of representing real, three-dimensional architectural schemes. The basic native form is that of the rock-cut tower, a form of tomb-architecture which was widespread in the hellenistic and Roman East, and which is vividly represented, for example, in the cemeteries of Palmyra. The ornament is very simple, the two principal recurrent forms being the 'crowstep' crenellation (later simplified into a V-shaped crowning motif of two outward-facing stepped triangles) and the 'Egyptian' cornice, both motifs which we have seen to be characteristic of late hellenistic Lebanon, and which had a long currency at Petra. The second stage is characterized by the introduction of such classical elements as angle-pilasters and simple capitals[46] and doorways with derivative classical mouldings, which include small pedimental gables and Doric triglyph friezes; and in the more elaborate versions there is an added, attic-like upper storey, which

portrays the truncated upper part of a similar tower-tomb, just as if it were part of a separate building set back from, and looking across, an independent façade [212]. All of these forms are represented in a series of rock-cut tombs at Hegra (or Egra), the modern Medaein Saleh, in the northern Hejaz, which was an important road station and police post on the trade route southwards from Petra; and since they are all found more or less indiscriminately throughout the thirty dated tombs at Hegra, which range from A.D. 1–75, they may be accepted confidently as representing forms that were already current at Petra by the beginning of the first century A.D.[47]

There is, on the other hand, no trace at Hegra of the third typological stage of development, whereby the classicizing elements already present on a small scale in the doorways were taken and applied to the whole façade, thus creating the typical 'temple' tomb, with two or, in more elaborate examples, four pilasters, or columns,

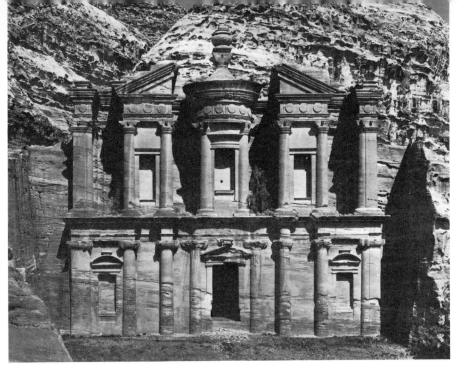

213. Petra, rock-cut mausoleum of ed-Deir, possibly early second century. The façade is 151 ft (46 m.) wide and 125 ft (38 m.) high

supporting a full-scale classical frieze and a pediment. It would seem that as late as 75 temple tombs were not a familiar feature of the funerary architecture of Petra. Whether they had come into use before 106 is, in the context, a question of less importance, since there is no hint of any sharp break in the development; but on the evidence at present available it is likely that many of the more elaborate temple tombs of Petra are those of the wealthy Romano-Nabataean burghers of the second-century city.

The final stages of the development followed a predictable course. The only substantial additions to the repertory were the broken pediment and the circular pavilion with a conical roof. The distinctive Nabataean capitals, the urn-like finials, the Doric friezes with large discs in the metopes, the quarter-columns on the inner faces of the angle-pilasters, all these were inherited from the previous phase. What was new was the scale and elaboration of the development of these motifs. This was 'baroque'

in precisely the same sense as the Third Style painted architectural schemes at Pompeii a century earlier, or such contemporary phenomena as the marble façades of western Asia Minor, the stucco tomb interiors of Rome, and the adyton architecture of the temples of the Lebanon. These can all be seen to have obeyed an inner evolutionary logic, which was at the same time shaped also by precedent. Decorative schemes that were first developed in the court architecture of the hellenistic age might find themselves repeated almost verbatim, in another medium and in an entirely different context, two centuries later. The resemblance of these tombs to the hellenistic prototypes is often uncannily close; but it is the product of an evolution far longer and more complex than many scholars have been prepared to allow for.

Viewed in this perspective, the tomb façades of Petra can be seen to be the late, eccentric manifestations of a long-established tradition. The façade of the tomb known as ed-Deir [213]

will serve to illustrate two of the most tell-tale aspects of this phenomenon. In the lower storey the doors and windows are theoretically credible as the details of an inner wall glimpsed between the columns of the façade, as we see them already in the columnar tombs of the preceding, classicizing phase. The upper storey, on the other hand, is carved in the round and might well be taken to derive directly from the real architectural scheme of which it is a representation – until one looks at the windows, which reveal it as a retranslation into three dimensions of a bas-relief decorative scheme that had already begun to lose touch with its sources. Its vitality lies entirely in its response to its own very specialized local problems. The other significant characteristic is that this tomb and its fellows are out of all proportion to the models from which they derive. This explains why no photographs can do justice to the sheer size of the façade of ed-Deir, 150 feet long by 125 feet high (46 by 38 m.), larger than the west front of Westminster Abbey. It is enormously impressive; but for all the sophistication of the basic tradition, there is also more than a touch of the barbaric about its manifestations at Petra.

Of the buildings within the city only two, the arch and the standing temple, call for brief notice. The arch, recently partly restored, is a monument of Roman type, with the three archways framed by pilasters and semi-columns on one side and on the other by columns placed on free-standing moulded plinths.[48] As in many outlying Syrian arches, however, the proportions are altogether unclassical, and a great deal of the detail too (e.g. the pilaster capitals and the fine zoomorphic Ionic capitals of the columns, and the quarter-columns adjoining the outer pilasters) is of typically Nabataean derivation. The Roman arch of Si' in the Hauran (c. 150–75) and the East Arch at Bostra offer many points of resemblance. The temple, Qasr el-Bint or Qasr Fira'un [214, 215], faced northwards across the west end of a long, narrow temenos. In front of it stood a square altar. The date of the temple is controversial. The discovery of an

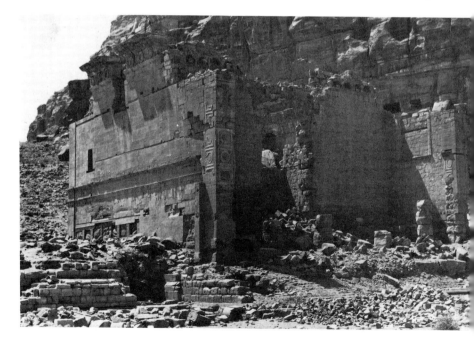

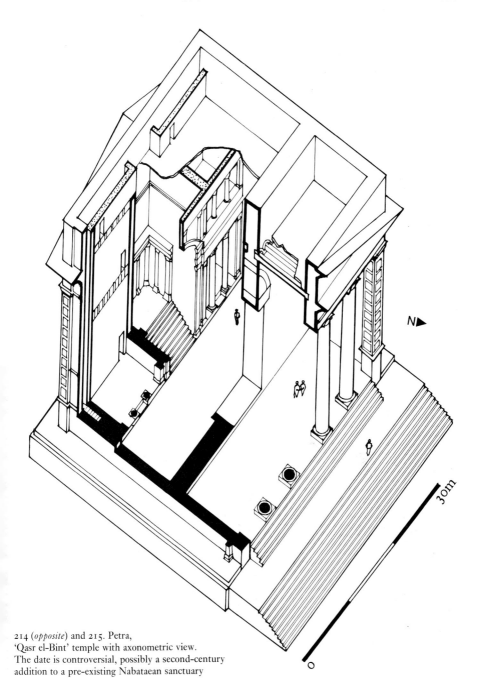

N▶

30m

214 (*opposite*) and 215. Petra,
'Qasr el-Bint' temple with axonometric view.
The date is controversial, possibly a second-century
addition to a pre-existing Nabataean sanctuary

inscribed statue-base of King Aretas IV (9 B.C.–A.D. 40), apparently in position against the south wall of the temenos, has been widely hailed as indicating a date for the temple not later than the beginning of the first century A.D.[49] In reality all that has been demonstrated is that the temenos itself was in existence by that date. With the examples of Baalbek and of several of the lesser Lebanese sanctuaries before one,[50] it is difficult to exclude the possibility that the actual temple is an addition to a pre-existing open-air temenos, of which the principal feature had been an altar. Whatever its date, it presents an even more extraordinary mixture of classical and Oriental elements. In classical terminology it may be described as tetrastyle in *antis*, standing on a wide podium with frontal steps; the façade may well have been of conventional pedimental form, and the encircling entablature, with its console cornice and Doric frieze, was of classical derivation. In plan, however, the building was almost exactly square (105 feet; 32 m.) and in elevation, if one includes the podium, very nearly cubical, the ceiling of the cella being no less than 60 feet (18 m.) above the inner pavement level. The cella was divided from the pronaos by a massive cross-wall with a huge central doorway, and was itself further subdivided into a narrow transverse hall which ran the full breadth and height of the building, and a triply divided sanctuary, or *adyton*, of which the two lateral compartments were two storeys high and colonnaded, framing the lofty central recess that housed the cult-statue. Stairs led up to the galleries and to the roof, which was terraced. How exactly the superstructure was finished we do not know, but analogy suggests the likelihood of a frontal gable backing against a tall enclosing parapet-wall. An interesting feature of the construction is the extensive use of timber string-courses and tie-rods, no doubt intended as a precaution against earthquakes.

Many features distinguish this remarkable building from conventional classical practice, and almost without exception these can be seen to stem from architectural forms and usages that had wide currency also in the non-Roman East.

The square plan, for example, is almost certainly attributable to the influence of the square, box-within-a-box type of temple, of which there is a fine example, ascribed to the first century A.D., at Khirbet et-Tannur, barely 50 miles north of Petra.[51] The broad cella can be documented in north Syria from the Bronze Age onwards and in the Roman period it was the standard plan for the many small temples at Dura and at Hatra, in Mesopotamia, in several cases combined with a tripartite adyton.[52] The tripartite sanctuary was used widely both within pagan Roman Syria and beyond the frontiers, and it has long been recognized as the source of this typical feature of the Christian churches of Syria.[53] Good late-second-century examples in the Hauran are the Tychaeon (Temple of Tyche) at es-Sanamen (A.D. 191) [223] and the temple at Slem, 20 miles north of Bostra. Yet another typical feature of Syrian temple design is the flat, terraced roof.[54] The evidence for this is most clearly displayed in the temple at Dmeir (A.D. 149) near Damascus. This curious building has two identical façades, superficially pedimental with an arch framed between the two inner pilasters, but in reality consisting of two pairs of angle-towers, each framing a central vaulted porch. One of these towers contained a staircase, and all four rose above the pediments and must have been connected along the flanks of the temple by a parapet enclosing the flat roof over the cella.

The plan of Dmeir is obviously eccentric in a number of respects; but the terraced roof can in fact be seen to be a feature of many more conventionally classical temple buildings in Syria, among them the temples referred to above, at Slem and at es-Sanamen. In the former the two angle-towers, both of which contained staircases, were at the front and flanked a distyle porch, the pilasters and columns together constituting a gabled façade; above this the outer angle-pilasters rose clear to carry a second, horizontal entablature, which ran right round the building, enclosing the terrace. At es-Sanamen the towers were at the back, over the lateral chapels, and the porch was

of conventional prostyle form. The dispositions vary greatly in detail; but once the fact of these flat roofs is accepted, they can be recognized with confidence on a great many other sites – in the Lebanon possibly even in the Temple of Bacchus at Baalbek, almost certainly in a dozen lesser temples; in the Hauran in the Temple of Zeus at Kanawat; in the Temple of Bel at Palmyra [232]; in the temples of Zeus and of Artemis at Gerasa; and in the mountains of Moab, east of the Dead Sea, in the temples at Dhat Ras, Mhayy, and Qasr Rabbah, of which the two last-named are noteworthy also as possible precursors of the scheme of the third-century entrance portico at Baalbek. The function of these terraces must have been liturgical. It is by no means unlikely that in some measure they correspond to, and took the place of, the tower-like altars of earlier practice.

At Gerasa one is, superficially at any rate, in a very different world. Although there had certainly been a native community here, probably on the hill to the north of the 'forum' opposite the Temple of Zeus, it was formally refounded as a city under the name of Antioch-on-the-Chrysorhoas by Antiochus IV of Syria (175–164 B.C.); and while it would probably be easy to exaggerate the impact of this event on the externals of daily life, the contacts established then, and subsequently as one of the cities of the Decapolis, did undoubtedly predispose Gerasa to the acceptance of the classical forms that dominate the surviving remains.[55]

For a time the establishment of Rome in Syria seems to have made remarkably little difference. Excluded as it was from the territories of Herod and his successors, the Decapolis may well have become something of a backwater. The first certainly attested enterprise under Roman rule is the rebuilding of the temple and temenos of Zeus. The actual temple was again rebuilt in the mid second century; but we know that its predecessor, already building in A.D. 23 and still not complete in 70, was of the Ionic order, and that the site and layout, with the temple at the head of a long flight of steps leading up from a porticoed forecourt, are those

of the earlier building. They recall Herod's temple at Samaria, and allowing for the difference of site the Early Imperial sanctuary at Baalbek. Another early building at Gerasa, also known to have been Ionic, was the temple thought to have been dedicated to the Nabataean divinity Dushara, later demolished to make way for the Christian cathedral.

Apart from these rather scanty traces of earlier work, the city as one sees it today is a product of the 150 years following the middle of the first century A.D. The first step in its creation was the layout of a new and far more ambitious street plan and the establishment around it of a new circuit of walls and gates, of which at least one, the North-West Gate, was complete by 75. The walls enclosed a polygonal area on both banks of the River Chrysorhoas, the main town being terraced up the sloping spurs on the west bank. The axis (cardo) of the new layout was a colonnaded street running northwards from the 'forum', and this was crossed at right angles by two transverse colonnaded streets (decumani), which were carried across the river on bridges. Both the cardo and the decumani were designed and partly carried out in the Ionic order, as also were the porticoes that were added at about the same time around the 'forum' [216]. The latter was an irregular oval space just inside the South Gate, between the probable site of the hellenistic city and its principal sanctuary, the Temple of Zeus, and it may well in fact have been a market for the caravans coming in from the south. Yet another first-century building (under construction in the reign of Domitian, 81–96) is the great South Theatre, beside the Temple of Zeus, a building of typically 'Western' type[56] and one of the earliest surviving theatres in Syria. The emphasis on the Ionic order in almost all these early buildings confirms the evidence from the Lebanon that this was the dominant order in late hellenistic Syria. It also indicates that, although economically and socially Gerasa was at this time very closely linked with the Nabataean kingdom, architecturally its contacts were with the classical world.

The real turning-point in the history of

Gerasa was its incorporation in 106 within the newly annexed province of Arabia. The first act of the new government was to lay out a network of fine roads – the only Trajanic monument as yet identified at Gerasa is, appropriately enough, the North Gate (115) [235B],[57] facing down the road to Pella and to the cities of the coast – and within a short time the tide of romanizing prosperity was in full flood. The emperor Hadrian spent part of the winter of 129–30 at Gerasa; and although the solemn

was converted into a circular piazza with an elaborate tetrastyle monument in the centre; the Temple of Artemis and its precinct were rebuilt and enlarged, with a solemn processional way leading up to them; the precinct and propylaea of the adjoining 'Cathedral' Temple were remodelled and, between the two, there was added in 191 a richly adorned fountain building. Other buildings of the later Antonine period were the North Theatre (c. 161–6); the great West Baths; a new temple, Temple 'C';

216. Gerasa, oval piazza, third quarter of the first century. Foreground, part of the South Theatre, *temp.* Domitian (81–96)

addition on this occasion of a new city quarter seems to have proved a somewhat empty gesture (the new South Gate and the archway delimiting it are the only monuments that were certainly completed), the next few decades saw a transformation of the already existing town. The Temple of Zeus was rebuilt and ready for dedication in 163. In the middle of the town the central and southern sections of the cardo were widened and converted to the Corinthian order, and later again one of the major intersections

and, a mile outside the town, the festival sanctuary of Birketein, with ritual pools and a festival theatre.

The central monument of all this was the temple of the city's protecting divinity, Artemis, which today still dominates the whole site. It was a large (74 by $131\frac{1}{2}$ feet; 22.60 by 40.10 m.) Corinthian building, hexastyle peripteral in plan, with a deep porch and standing on a very tall (14 feet 2 inches; 4.32 m.) podium. Stairs beside the main door indicate a terraced roof

behind the conventionally gabled porch, and within the cella the floor rose steadily westward to the adyton and to the statue recess high in the rear wall; height was obviously an important consideration. The temple stood near the centre of a rectangular temenos, 395 feet wide and 530 feet deep (121 by 161 m.), which was enclosed on three sides by porticoes and on the fourth side by the rear wall of a propylaeon, consisting of a portico running the full width of the building at the head of a grandiose flight of stairs

monumental courtyard, which faced westward on to the cardo, its curiously splayed, trapezoidal plan being evidently designed to give an uninterrupted view across the street to the main propylaea. At this point the temple complex was terraced high above the west side of the street, the terrace wall being masked by a two-storeyed façade of shops; and in the centre of this façade stood the propylaea proper, a huge tetrastyle porch of which the rear wall was in effect a triple arch with square doorways and flanking aedi-

217. Gerasa, monumental approach to the Temple of Artemis, third quarter of the second century

and flanked by pavilions, or low towers – very much as at Baalbek half a century later. The workmanship of the temple itself is fine but far from elaborate. For its effect it relied instead on its magnificent situation and on the mounting height and growing architectural tension of the approach up the processional way. This started at a bridge across the river, from which a sloping ramp led up to a triple gateway. Beyond this lay the east propylaea, consisting of a short stretch of colonnaded street leading in turn to a

culae [217]. From this arch seven flights, each of seven steps, led straight up to the forecourt, the whole of the far end of which was occupied by a magnificent flight of twenty-seven steps, over 100 yards wide, leading up to the propylon of the temenos proper. It was not until one entered the temenos that the actual temple, glimpsed from afar, would have been fully visible – again one thinks of Baalbek or, in a very different context, the approach to St Peter's in Rome before the opening up of the Via della Con-

ciliazione – but the whole progress up the processional way had been building up to this moment.

The rebuilt Temple of Zeus was a somewhat larger (octastyle) version of that of Artemis, which it otherwise very closely resembled in plan, differing mainly in the greater elaboration of its detail, with pilasters along the inner walls of the cella and deep aedicula-framed recesses along the outer faces, between the columns. These decorative aediculae, a regular feature of the second-century architecture both of Gerasa and of the Hauran, are yet another indication of a close relationship with the architectural world of Baalbek. Temple 'C' was a much smaller building and far less conventional in plan. Built on what had been a cemetery area, it consisted of a rectangular, porticoed temenos, 65 feet wide by 50 feet deep, of which the temple occupied the middle of the fourth side, its tetrastyle porch projecting into the central space; the cella was T-shaped, with a square inner sanctuary opening off a transverse hall. On the analogy of the hellenistic Heroon at Calydon in Aetolia it has been identified as the commemorative shrine of some distinguished citizen; but in the context it seems far more likely to have been a superficially classicized version of the sort of T-shaped temple that one meets at Dura and at Hatra, and indeed, in slightly more elaborate form, in the temple of Qasr el-Bint at Petra. Even at this moment of enthusiasm for the externals of classicism, the native element did not lie far below the surface.

The West Baths are chiefly remarkable for the fine quality of the stone vaulting, which includes three instances of hemispherical vaults over square rooms [218], possibly the earliest surviving example of this feature in Syrian architecture.[58] In view of the exaggerated claims sometimes made about the Oriental origins of this particular architectural form, it is worth emphasizing that formally identical spherical vaults were being built at this time in many parts of the Empire, in Italy in concrete, for example, and in Egypt in mud brick. It was already a commonplace of Imperial architec-

218 (*above*). Gerasa, West Baths, third quarter of the second century. Hemispherical vault of dressed stone

219 (*opposite*). Gerasa, fountain building, 191. The hemicycle was vaulted with light volcanic *scoriae*

ture, and it is the materials and techniques that constitute the main point of interest. In this case there can be no doubt that in their planning, laid out symmetrically about a typically tripartite frigidarium, the baths derive closely from Western usage, worked out in terms of local building practices. Another obvious intruder from Mediterranean lands is the nymphaeum beside the cardo, built in 191 [219]. The central, semicircular exedra and the two wings were both faced with a double order of columns, framing alternately rectangular and curved recesses; the lower order was veneered with green Carystian marble, imported from the Aegean, and the exedra was vaulted with a semi-dome of light volcanic *scoriae*.[59] That fountain-buildings of this sort were being erected also in the coastal cities we know from the nymphaeum at Byblos, a typical marble style structure of about the same date. The closest formal parallel (without the semi-dome) is the great Severan nymphaeum at Lepcis Magna in Tripolitania [260]. Another, and even more elaborate, example

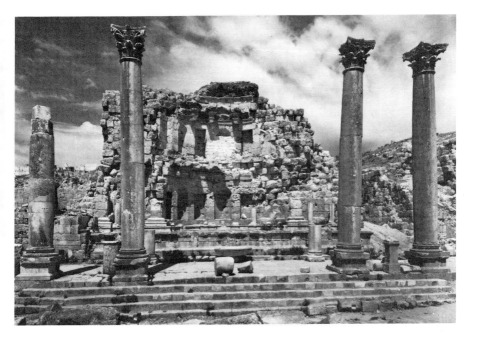

within the Decapolis was the great nymphaeum beside the main street of Philadelphia (Amman). Yet another was that of Pella, which was sufficiently remarkable to be recorded on the city's coinage.[60]

THE HAURAN

The wave of prosperity which led to this outburst of building in second-century Gerasa was part only of the tide of material well-being which flowed over the whole province of Arabia during the hundred years following its annexation until checked by the military disasters and political anarchy of the mid third century. We have seen something of the results of this already at Petra. We have still to glance at the remaining district of southern Syria, the Hauran.[61]

Here, somewhat paradoxically, it is the buildings of the period before the annexation of the province that matter most in the wider context of the history of architecture in the Roman Empire. As in the comparable country districts of northern Syria described above, Roman civilization, once established, struck deep; but it was in every sense of the word a provincial civilization. Except for the capital, Bostra (Bosra), very few of the native villages rose under Roman rule to be more than small country towns. Their architecture is of the greatest interest to the social historian, but its impact outside the province was slight. There was, however, one important respect in which the Hauran differed from north Syria, and that was in the very considerable innate artistic talent of its people, the Nabataeans. Under the stimulus of contact with the mature civilizations of the hellenistic East they had already developed a fine architecture of their own; and although the forms were derivative the spirit and the technical skills were strikingly individual, and they were quite vigorous enough to leave their mark on the architecture of Roman Syria as a whole.

The outstanding monument of this early period is the great sanctuary of Si', the ancient

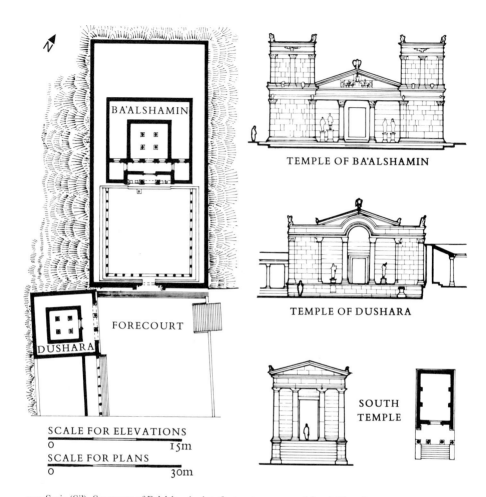

220. Seeia (Si'), Sanctuary of Ba'alshamin, late first century B.C., and South Temple, late first century A.D. Plans and elevations

Seeia, in the mountains north-east of Bostra, near Kanawat [220]. This is dated by inscriptions to the last few decades of the first century B.C., at a time when the Hauran had recently been attached to the territories of Herod the Great. As built then, it consisted of a processional way leading up to a triple gate at the entrance to the first of two long, narrow, rectangular precincts, which served as the sett-

ings (*theatra*) for sacred spectacles. The first of these had colonnaded terraces on either side and at the far end on the left, facing inwards, stood the Temple of Dushara. The plan of this was very simple, a square cella within a square enclosing wall, of which the façade was open in the centre, with two columns set *in antis*. The cella was roofed, the outer corridor open, and the dominant feature of the façade was the

carrying of the otherwise horizontal entablature up to form an arch over the central pair of columns. From the outer courtyard a single, very elaborately sculptured doorway led into the inner temenos, which had porticoes on three sides, and on the fourth side, facing the entrance, the Temple of Ba'alshamin. This was similar to its fellow, but rather more elaborate, the façade in this case being capped by a low pediment and framed between two low towers. The roof of the cella (as presumably also that of the Dushara Temple) can be seen to have been carried on four internal columns. At some later date the sanctuary was enlarged by the addition of an outer courtyard, containing a temple of more or less conventional prostyle tetrastyle form (the South Temple) and entered by an outer monumental archway.

One could hardly ask for a more vivid illustration of the complexity of the influences that were at work upon the Syrian frontiers. Though this architecture of Si' was a direct product of the more settled conditions established by Roman rule, the form of the two early temples was as alien to classical thinking as the divinities in whose honour they were built. The square-in-square plan, though widely distributed in Nabataea (e.g. at Khirbet et-Tannur, and at Sur and Saḥr in the Lejja, a northern outlier of the Hauran), has long been recognized as probably of Iranian origin, an identification confirmed by the excavation at Surkh Khotal in Afghanistan of just such a temple, built in the late first or early second century A.D. by the great Graeco-Buddhist king Kanishka.[62] Though the square, enclosed form was subsequently given up in the Hauran in favour of columnar temples of classical derivation, the proportions of many of the latter (e.g. Maiyamas and Brekeh; cf. Qasr el-Bint at Petra) clearly reflect its continuing influence. The plan of the sanctuary as a whole, with its enclosed, axial layout, seems on the other hand to derive from the same hellenistic sources as the sanctuaries of central Syria; and this was certainly true of much of the architectural detail – the colonnades, the quasi-classical orders, the door-frames, the telltale orthostat-and-capstone socle of the triple gate – even if in the process it was often so elaborated and transformed as to be barely recognizable. Side by side, however, with the classical egg-and-dart, the kymation, the key-pattern, and the palmette sima, there are other motifs that closely resemble the earliest architectural mouldings of Palmyra, which have been convincingly interpreted as following contemporary Parthian models.[63] Notable among the latter is the variety and range of vine-scroll patterns. The crowstep and the 'Egyptian cornice', characteristic of the Phoenician coastlands and of early Petra, are conspicuously absent. In their place we have inverted foliate column bases of Persian type. The first specific indication of the influence of Petra can be seen in the use of 'Hegra'-type capitals in the later, prostyle temple, which can hardly be earlier than the last years of Nabataean independence, and in the quarter-columns of the possibly even later (c. A.D. 150?) outer gate, which must derive from those of the rock-cut façades of Petra. In the earlier phase the sources of classical inspiration must have lain elsewhere, in Herod's northern territories. Rather unexpectedly, they do not seem to have included the Ionic capital. Those of the earlier buildings are all of a distinctive type which, like the earliest capitals of Palmyra, derives from a free hellenistic version of the Corinthian capital.

The architecture of Si', though somewhat barbaric, was fertile of new ideas. No less than three of its characteristic features were to make themselves felt far beyond the frontiers of Nabataea. One was the central arching up of the architrave (the 'arcuated lintel' or 'Syrian arch'), of which this is the earliest known example in a classical context; another was the framing of the façade between two equal towers. Both of these were devices with a long and important history of classical and medieval Christian usage before them.[64] Less momentous in its results, though hardly less far-travelled, was the little ring of acanthus leaves inserted between the shaft and base of a classical column. Originally perhaps a Ptolemaic Egyptian device,

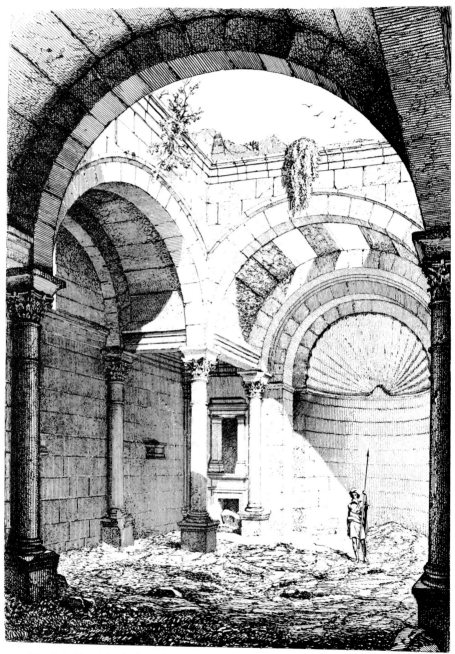

221. Mismiyeh, 'Praetorium', 160–9. Drawing by De Vogüé

this was picked up at Gerasa (e.g. the Hadrianic Arch), entered the repertory of the marble-workers of Asia Minor, and is found as far afield as Rome (Temple of Venus Genetrix), Nîmes (the Fountain Building), and Lepcis Magna (the Severan Basilica).[65] It is not impossible that the vine scroll too first entered the classical architectural repertory through this door. Within its limitations this was an architecture of ferment and considerable creative power.

Locally, too, it established the essential pattern of building for the next hundred years. When, after the creation of the new province, prosperity flowed in, and with it the more conventionally classical architectural types of Roman Syria, the newcomers found already established the building practices and craftsmanship which were to distinguish Romano-Nabataean architecture from that of any other province of the Empire. Over a large part of the area the local building stone was a hard volcanic basalt, an intractable material in the handling and carving of which the Nabataean craftsmen had acquired an extraordinary skill. In the absence of suitable timber, the ordinary method of roofing was to build a series of transverse arches and to lay long slabs of stone from one arch to the next. One sees this everywhere, in the houses, in the temples (beginning with the third temple at Si'), and in such public buildings as the late-second-century basilica at Shakka, the forerunner of countless local Christian churches of the same distinctive form. An alternative, which may well go back to Achaemenid Persian models, was to lay the slabs upon a close-set system of columnar supports, as in the two earlier temples at Si'. Both, as one sees e.g. in the 'Praetorium' at Mismiyeh [221], were well established local building types. Another form of roofing, which had no local precedents and must derive directly from Roman practice, was the concrete vault, built of light volcanic *scoriae*. This is found sporadically as early as the late second century, e.g. over the entrance hall of the 'Palace', a large public building, at Shakka (cf. the nymphaeum at Gerasa, A.D. 191);[66] but it does not seem to have gained wide currency until the emperor Philip (241–5) built the city of Philippopolis (Shehba) on the site of his birthplace and endowed it with a grandiose bath-building in the Roman manner, with suites of rectangular, barrel-vaulted halls grouped symmetrically about two circular, domed caldaria [222]. Elsewhere in the Hauran

222. Philippopolis (Shehba), bath-building with vaulting of light volcanic *scoriae*, 241–5

(e.g. at Shakka) domes were achieved over square rooms by laying courses of converging slabs across the angles, and it is suggested that the domes themselves were not spherical but of a pointed elliptical profile, as in the still preserved church of St George at Zor'ah (515) and no doubt also in the similar but grander cathedral church of St George at Bostra, built three years earlier. Together with concrete vaulting one notes also the introduction of a new type of masonry, with a facing of coarse opus quadratum about a core of mortared rubble.

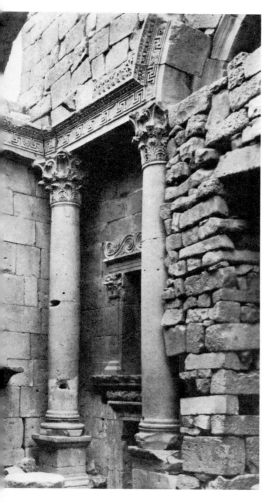

The analogy with the faced rubblework of Asia Minor is clear, and in the context of such buildings as the baths at Philippopolis and at Bostra, it too must derive ultimately from Roman concrete, once again presumably by way of the cities of the coast.

Side by side with this technical mastery of their difficult material the Nabataeans showed also an extraordinary skill and taste in carving it, the crisply cut detail being made to stand out in sharp, incisive contrast to the plain surfaces of the buildings as a whole [223]. Some of the most effective items in their repertory were carried over from the pre-Roman period, notably the ubiquitous key pattern, but the choice and treatment were, within the limitations of the medium, scrupulously classical. The normal order was Corinthian, but there are examples of both Ionic (e.g. a streetside colonnade at Bostra; the temple at Hebran, 155) and of a sort of Composite (the temples at 'Atil, 151, and Slem). A characteristic feature, shared with the developed mid-second-century architecture of Baalbek and Gerasa, is the importance of the decorative aedicula, often though not invariably incorporating an upward-splaying shell-head niche ('Atil, Hebran, es-Sanamen, Shakka, etc.; cf. illustration 221). In the Hauran we find rectilinear aediculae already in the temple at Suweida,[67] a building which has been ascribed to the first century B.C., before Si', but which is in fact far more likely to represent the mutual assimilation of native and classical traditions under Herod's successors. It was a quasi-Corinthian peripteral building, with a cella that was almost square and eight columns down the flanks, six across the façade, and seven across the back. (This last feature, otherwise unique, was repeated a century or so later in the peripteral temple at Kanawat, the Corinthian columns of which were raised on high moulded pedestals.) The ornament of the third century

223. Es-Sanamen, Tychaeon, 191.
Note the 'arcuated lintel' (*top right*)
and the remarkably conservative nature
of the architectural ornament, including the use
of almost hellenistic models for the capitals

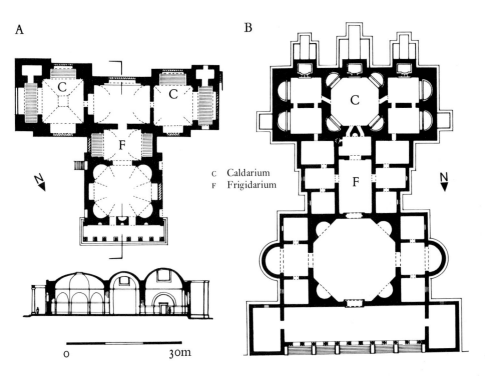

224. Bath-buildings in Syria. Plans. (A) Bostra, South Baths, probably third century;
(B) Antioch, Bath C, rebuilt in the fourth century following the second-century plan

reveals a development towards a drier, more academic style; but it includes very few new motifs, and there is scarcely a hint of influence from the 'marble style' ornament of the Syrian coastlands. It is only under the somewhat artificial conditions represented by Bostra and Philippopolis that one finds any trace of actual marble imports, and then only for veneering.

Apart from the more elaborate, terrace-roofed and peripteral buildings mentioned in the previous section, the temples were mainly quite small buildings, some with and some without the 'Syrian arch' façade, and either prostyle (the unfortunately fragmentary Der el-Meshkuk, of 124; Brekeh; Maiyamas) or *in antis* ('Atil, 151; Mushennef, 171; and, in rather eccentric form, Hebran, 155). For other public buildings one has to look principally to Bostra

and Philippopolis. Bostra, laid out by Trajan to be the capital of the new province, had a grid of fine colonnaded streets, with several arches and gates, of which the East Arch, with its Nabataean capitals, may well be Trajanic. A street-corner fountain-building was an ingenious adaptation of that at Gerasa to an angled site, with a 'Syrian arch' frontal. The South Baths [224A], constructionally very similar to the probably roughly contemporary baths at Philippopolis, are of patently Western derivation. The entrance hall, for example, with its apsidal recesses in the four angles of a circle or an octagon inscribed within a square, is of a characteristically Italian form, found already in the bath-building of Herod's winter palace near Jericho and still current in 'Bath C' at Antioch [224B]. The concrete vaulting, on the other

hand, though inspired by Western models, can be seen to have acquired a physiognomy of its own, incorporating at least one very unusual form, a domical vault 30 feet square with a central oculus, as well as an octagonal dome, 45 feet in diameter, which is of such a daringly shallow pitch that it would have been quite impossible to construct without the use of the light volcanic materials available locally. A large street-front cryptoportico may also probably be attributed to Western influence. The handsome second-century theatre, with its triapsidal stage-building and a colonnade at the head of the cavea, is yet another monument of basically Western design. The somewhat austere treat-

ment of this building was carried to its logical conclusion a century later in the theatre at Philippopolis, which was even more compactly planned and omitted both the exedrae and the columnar screen of the scaenae frons.

Bostra was not only the seat of provincial government but, in accordance with common practice along the eastern frontiers, it was also the garrison town of the legion III Cyrenaica. Two of the surviving monuments probably reflect this circumstance.[68] One is the 'Basilica', a large, well-lit hall, which was part of a larger complex of (probably) third-century date [225]. It was, exceptionally, timber-roofed in the conventional manner; it had a single, concrete-

225. Bostra, 'Basilica', probably third century. Elevation and plan

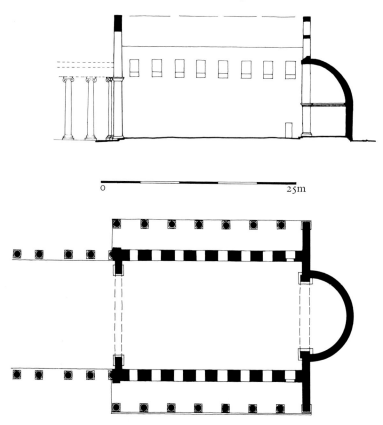

0 25m

vaulted apse at the far end, and it opened off the end of a longitudinally colonnaded forecourt, or street. There were external porticoes along the two flanks, below the windows. The whole scheme is very suggestive of a ceremonial audience hall, comparable to the Constantinian Basilica at Trier. For less ceremonial occasions there was the hall incorporated in the 'Palace'. This was a large rectangular building (120 by 160 feet; 36 by 48 m.) of second-century date, the two main wings of which faced each other across an internal porticoed courtyard. The porticoes were of two storeys and the rooms of three, except for a monumental, trilobed hall (*triconchos*) which occupied the full height of the *piano nobile* in the middle of one side. This large and obviously official building can hardly be other than the residence of the military governor, with a domestic wing on one side and on the other an official wing for the conduct of the day-to-day business of the province. There are many points of comparison with the third-century Palace of the Dux Ripae at Dura [229] and, two centuries later again, but still expressing the same duality of function in not dissimilar terms, the Palace of the Dux at Apollonia in Cyrenaica.[69]

Finally, a word about the domestic architecture which, as in north Syria (and for much the same reasons), varied remarkably little over the centuries and which today constitutes a very high percentage of the surviving remains. The layout of the individual houses varies greatly, but it can almost always be seen to be based on combinations of the same two constructional units, small rectangular rooms, the width of a single large roofing-slab, alternating with larger rooms that were roofed with the help of one or more transverse arches, the latter because of their greater height frequently corresponding to two storeys of the former. Three and even four storeys were not uncommon, with a flat, terraced roof, and in such cases the ground floors were used for stabling and storage, the upper floors as living-rooms. A characteristic feature is the use of external, corbelled stone staircases [226]. Porticoes, as in north Syria, are found

occasionally, but they were not native to the tradition. The houses faced inwards, and anything up to half a dozen might open off the same irregular, enclosed courtyard. Exceptionally, as at Medjel in the southern Hauran, this scheme was fitted into a neat, rectangular plan, like a Roman insula and perhaps copying urban practice. Usually, however, the grouping was more casual, about a haphazard network of irregular open spaces, alleyways, and courtyards, which might be those of any Oriental country today. Umm el-Jemal [226] and Busan offer examples that have been published in some detail.[70]

THE MESOPOTAMIAN FRONTIER LANDS: DURA-EUROPOS AND HATRA

Dura, the Greek Europos, was successively a Greek, a Parthian, and a Roman town. Founded by Nicanor about 300 B.C. and settled with colonists from Macedon, on the break-up of the Seleucid Empire it passed in about 140 B.C. to the Parthians, and except for a brief interlude under Trajan it remained in Parthian hands until, in the sixties of the second century A.D., it was occupied by Rome. Septimius Severus, c. 200, made it an important garrison town. Fifty years later the pendulum swung again. In 256 it was besieged by Shapur, captured and sacked, and then abandoned to the desert. The emperor Julian hunted lions among its ruins. Though never a city of the first rank, its position as one of the few readily defensible sites along the great natural highway that led up the Euphrates, from Seleucia-on-the-Tigris and the Persian Gulf to Antioch, gave it a considerable strategic importance in moments of crisis between East and West, and in times of peace a stake in the valuable caravan trade up and down the river and across the desert to Palmyra and Hatra. To us its unique importance is that, alone among the cities of the frontier, it has been excavated on a scale and by methods which permit a real vision not only of what it was but also of how it grew to be what it was, and of the social and cultural forces that determined that growth.

226. Umm el-Jemal, house, third-fourth century.
Elevation, plan, and section

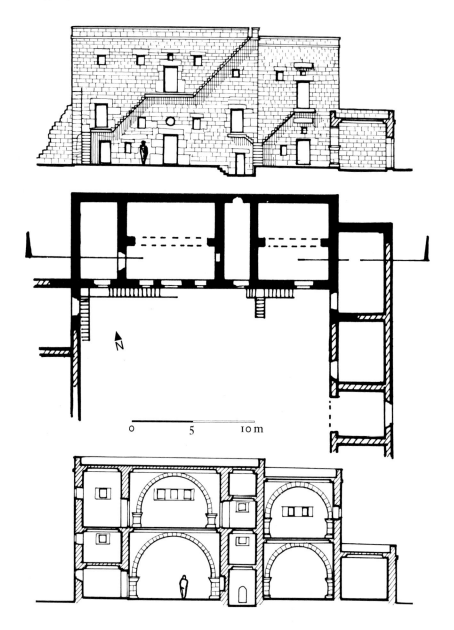

The first and most powerful impression left by the remains of Dura is how remarkably shallow and ephemeral was the architectural impact of Greece. Apart from the continuing use of certain simple members such as columns and door-frames, the only really durable legacy of the hellenistic foundation was the town plan, laid out on strict Hippodamian lines with a regular network of streets intersecting at right angles to delimit a series of uniform insulae, each twice the length of its breadth (230 by 115 feet; 70 by 35 m.), in accordance with normal Seleucid practice. The original builders of the city made extensive use of Greek building materials and methods, including stone socles for their walls, and by virtue of their superior construction these walls tended to survive and to be incorporated into later structures even when these reverted, as they soon did, to the normal local practice of building in mud brick and plaster. The last enterprise to be planned on Greek lines was a rebuilding of the sanctuary of one of the city's patron divinities, Artemis, or, as she was known locally, Nanaia.[71] This was undertaken after the Parthian occupation, and it was to have been a small peripteral temple in the Greek manner; but in fact it was never completed, and shortly before 32 B.C. its place was taken by a new and more ambitious building of purely Oriental type, one of at least eight such temples to be built during the next two centuries. The story of Seleucid Greek architecture in Mesopotamia is told in miniature in the agora.[72] This was planned to occupy eight insulae beside the intersection of the two main streets, with a double row of uniform shops facing outwards and inwards along one side and, along two at any rate of the other three sides, a single row of similar shops, facing inwards across the open central area and fronted by colonnades; alone among the buildings of Dura it had a pitched roof, tiled in the Greek manner. In fact only one half of this scheme was ever finished; soon there began the process of piecemeal rebuilding and encroachment which by the second century A.D. was to transform the whole layout, open space and all, into a maze of narrow

alleyways and tortuous, shop-fronted dwellings. In its last phase, under Roman rule, a little order was established by the erection of streetside porticoes along the most important frontages and by the opening up of a small market square, with shops grouped around it. But in all essentials the city centre had long reverted from its Greek beginnings into a busy Oriental bazaar quarter [227].

Apart from the rather scanty remains of the official residences, the majority of the buildings from the period prior to the installation of a Roman garrison are private houses and temples. The former were flat-roofed and mostly single-storeyed buildings, with the rooms grouped irregularly around a small courtyard. This was essentially a local, Mesopotamian pattern, closely analogous to the contemporary houses of Hatra, the centre of a Parthian (and for a brief while in the third century a Roman) client principality, in the desert 180 miles to the north-east of Dura and 60 miles south-west of Mosul. The temples, too, find their closest analogies in the lesser sanctuaries of Hatra.[73] The standard plan is that of a transverse hall, with the cult-statue set in a smaller chamber opening off the middle of one long side, opposite the entrance. Often, though not invariably, the central shrine is flanked by two subsidiary chapels, an arrangement which was widely copied in southern Syria,[74] and which is one of several pagan themes that were to play an important part in the architecture of the Christian period. The T-shaped sanctuary of the Temple of Dushara at Gerasa may well reflect the same tradition. At Dura and at Hatra the central shrine is regularly set within a courtyard, around which were loosely grouped smaller shrines, altars, treasuries, and residences for the priests.

These temples might come to incorporate classicizing elements such as, for example, the tetrastyle porch that was added in the third century A.D. to the Temple of Bel (or the Palmyrene Gods) at Dura [228], where a pre-existing tower of the city walls prevented the addition of the usual second flanking chapel.

227. Dura-Europos, bazaar quarter occupying the site of the hellenistic agora, mid third century.
Bottom left, part of a market building of classical type

228. Dura-Europos,
Temple of the Palmyrene Gods,
built into an angle of the city walls.
(A) Plans, first and early third centuries;
(B) restored view, early third century

But such features were as superficial as the classical names that were given to many of the divinities worshipped. Whatever the classical veneer, these were essentially native Semitic gods, from Babylonia, Mesopotamia, Arabia, northern Syria, and Phoenicia, and their temples and forms of worship were just as distinctively native to this Mesopotamian frontier-land. Only the Jewish and Christian communities stood aloof, adapting the architecture of existing houses to serve their special requirements.[75] The Mithraeum, too, for all the Iranian origins of the cult of Mithras, may be considered as somewhat apart from the rest, having been introduced by the Roman garrison and consisting at first only of a single room within a private house. This was later rebuilt and enlarged, but the architectural forms remained those proper to the rituals of this most cosmopolitan of cults, with little or no reference to local religious usage.[76]

The installation of a Roman garrison by Septimius Severus involved the expropriation of nearly a quarter of the area within the walls and the building of barracks and officers' quarters, a headquarters building (*praetorium*) fronting on to a colonnaded street, a parade ground, several bath-buildings, a small amphitheatre for the recreation of the troops,[77] and an official residence for the commander of the Euphrates frontier zone, the Dux Ripae.[78] The last-named, added only a decade or two before the city's destruction, was a building of some pretensions [229]. The residence proper occupied one side of a shallow rectangular courtyard finely situated on the low cliffs overlooking the river and flanked by two short, projecting wings. The central feature of the layout was an apsed dining hall; the commander's private suite lay at one end, and opening off the other end there was a small bath-building.[79] Behind the residential wing there lay a large peristyle surrounded by service rooms, servants' quarters, a stable, and a suite of reception rooms; and behind this again a second peristyle with two monumental entrances and a single large hall opening off it, which together were clearly intended for public ceremonies and for the

exercise of the commander's judicial functions. As in the case of the residence of some other high officer near the praetorium, and of the praetorium itself, the whole layout represents an alien, imported architecture, the analogies for which lie in the West. Local materials and building techniques imposed certain features such as the flat roofs and the arches of the façade (very reminiscent of twentieth-century Italian 'colonial' architecture in Libya), but that was all. Even the unit of measurement was the Roman foot, instead of the local Semitic cubit. The roofs of Dura were normally flat, carried on timber rafters, which must have been imported for the purpose down-river. Ceilings were of plaster, laid on a framework of rushes and sometimes curved to imitate vaulting. Here and there, too, the excavators found evidence of vaulting both in mud brick and fired brick, used in the age-old Mesopotamian manner, with the bricks pitched on edge across the line of the vault instead of being laid radially as in normal Roman work. The chances against the survival of such vaulting are heavy, and it must have been far more common in Syria than the recorded examples would suggest. From Syria it spread to Asia Minor, to become (in fired brick) the standard vaulting technique of Constantinople.[80]

Dura offers us a vivid picture of the busy Mesopotamian world that lay neither wholly within nor wholly outside the Roman frontiers. Its buildings, as such, have little to do with the contemporary development of classical architecture. They do, on the other hand, afford a valuable illustration of what often underlay the superficially classical forms of those parts of Syria that were in more immediate contact with the Roman world; and the paintings on their walls and their sculptures foreshadow much that was to become the common artistic language of later classical antiquity. This was where the classical world and Iran met on common ground, and it was here that many of the religious and artistic ideas for which the architecture of late antiquity was the vehicle first took shape.[81]

229. Dura-Europos, Palace of the Dux Ripae
(residence of the commander of this sector of the Euphrates frontier),
first half of the third century. Axonometric view

PALMYRA

Palmyra, situated in the heart of the Syrian desert at a point almost equidistant from Damascus and Emesa on the one hand and the Euphrates near Dura on the other, was the fortunate possessor of an abundant water supply. It was the far-sighted exploitation of this fact, coupled with the establishment of stable rule in Syria by the Romans, which made possible Palmyra's meteoric career as a great merchant city. By setting up and policing a system of regular caravan routes, she was able to offer to the merchants engaged in the fabulously rich luxury commerce between the Roman world and Asia a safe and direct outlet to the ports of Phoenicia. For a brief moment in the third century A.D. the virtual eclipse of Roman military power in the East enabled Odenaethus of Palmyra and his wife Zenobia to exercise *de facto* rule over Syria and much of Anatolia and Egypt. But this was a fleeting and, in the event, disastrous moment of glory. The city was captured and sacked by Aurelian in 272, and henceforth its only importance was as a legionary fortress within the new frontier system established by Diocletian.

The architectural language of Palmyra is a mannered, but in its essentials orthodox, provincial classicism, strikingly and surprisingly different from that of Dura when one remembers how many and close were the links between the two cities. The difference is only in part to be explained by Palmyra's closer and more continuous political connexions with Rome and by its abundant supplies of a fine building stone. In part also it was the product of a very different historical background. Dura, for all that it was an official Seleucid colony, rapidly took its place within an older world in which local Semitic influences were strong enough to absorb and to orientalize the Macedonian settlers. As a city Palmyra was, on the other hand, a creation of very recent date, and, in so far as there was any pre-Roman tradition of monumental architecture, it must have been that of the great hellenistic city through which all its

commerce ran, Seleucia-on-the-Tigris.[82] Our only knowledge of the earliest architecture of Palmyra comes from deposits of architectural mouldings, capitals, and other details found in contexts that can be dated (in round figures) to the second half of the first century B.C.[83] These reveal a late, fanciful, hellenistic architecture that had absorbed a large number of alien, non-classical elements, for which (in the absence of comparable excavated material from Seleucia itself or from the trading stations of the Persian Gulf) the closest parallels are with such far-flung outposts of hellenism as Aï Khanoum, Gandhara, and Matura, in India. The architecture of pre-Roman Palmyra was that of a western outpost of an orientalized but still recognizably hellenistic East, and it started with a bias towards classical forms and solutions.

During the early years of the first century A.D. there was a sharp change of orientation. This is clearly reflected in the earliest of the surviving monuments of the city, the great sanctuary of Bel [230]. Like Baalbek, it was a long time building. In its finished form the temple stood within a quadrangular enclosure surrounded on all sides by colonnaded porticoes, of which that on the west side, opposite the temple doorway, was considerably taller and incorporated a monumental entrance; within the courtyard, on either side of the axis, stood the altar and a large basin for ceremonial purification. The temple [231] was dedicated in A.D. 32. The three lower colonnades of the precinct were added towards the end of the first century, the west colonnade under Hadrian or Antoninus, the propylaea under Marcus Aurelius or Commodus.[84]

In its original form the temple stood upon a stepped platform in the Greek manner, which was altered to the present low podium when the surrounding precinct was laid out in its definitive form. Viewed from ground level, from the outside, it was a fairly conventional, octa-style, peripteral building of classical type, except that the entrance was placed in one of the long sides, slightly off-axis, with a complex door-frame inserted between two of the columns of the peristasis, and that the classical

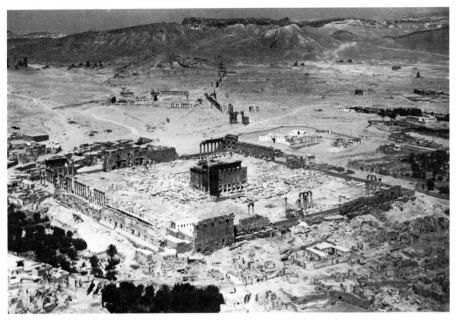

230. Palmyra, from the air. In the foreground, the Sanctuary of Bel. Left distance, tower tombs

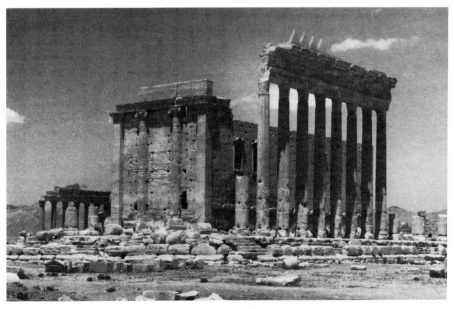

231. Palmyra, Temple of Bel, dedicated in 32, from the south-east

cornice was capped by a parapet of crowstep merlons in the old Persian manner [232]. But the resemblance to a classical temple was only skin-deep. Behind the conventional triangular pediments, instead of a pitched roof there were terraces, accessible from within by turreted staircases set in three of the four angles of the cella; while inside, two small inner shrines (*thalamoi*)[85] faced each other down the length of the cella-building from the heads of two tall, opposed flights of steps. Each is framed between the projecting shoulders of the staircase wells,

and cut into the flat lintel above is a shallow, saucer-like false dome, carved in the one case with a representation of Bel at the centre of the firmament. There is much about this curious layout that awaits explanation, but a great deal is doubtless due to the anomalies inherent in the attempt to express the requirements of the local cult within the framework of an orthodox classical architecture. The remarkable thing is that already as early as the twenties of the first century A.D. the prestige of Rome should have reached so far as to make the attempt worth

232. Palmyra, Temple of Bel, dedicated in 32, (A) restored view and (B) plan

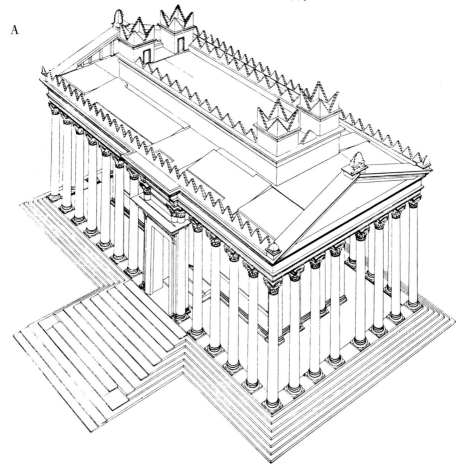

A

making. Like the Temple of Jupiter at Baalbek, this building affords graphic evidence of the architectural impact of the new political situation; but whereas at Baalbek the dominant new classicizing influence seems to have been that of metropolitan Rome, at first or second hand, at Palmyra the immediate source of inspiration was the late Seleucid and early Roman-period architecture of Antioch.[86]

The subsequent history of Palmyrene architecture follows a predictable course. A study of the Corinthian capitals[87] shows that when the Temple of Bel was built in A.D. 32 the immediate models, though tending towards an orthodox Vitruvian classicism, still retained elements of the freer, more fanciful treatment of the hellenistic age. By the end of the first century, however, orthodoxy was as firmly established here as it was at Baalbek; and although the figure sculpture of Palmyra remained to the end obstinately 'oriental' in spirit, the architecture of the great age of Palmyrene prosperity was no less firmly linked with that of the rest of Roman Syria.

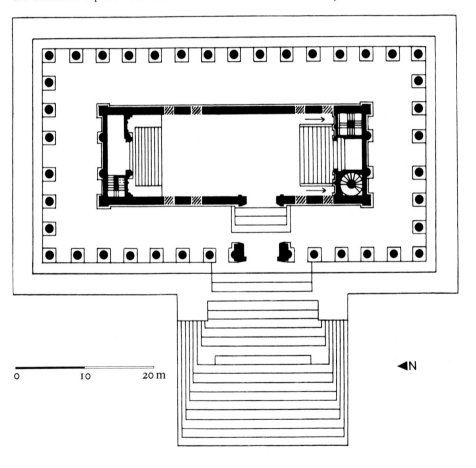

0 10 20 m

◄N

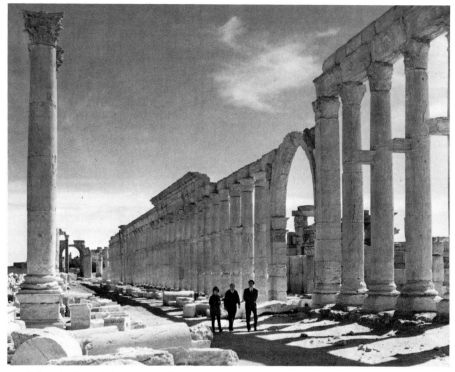

233. Palmyra, colonnaded street, second century

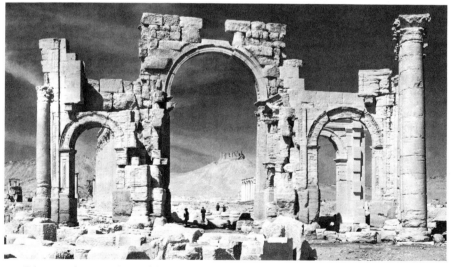

234. Palmyra, arch, 220, and part of the second-century colonnaded street

The feature of Palmyra that first strikes the eye and the imagination of every visitor is its colonnaded streets [233] – so much so in fact that it is worth recalling that Palmyra was in no way exceptional in this respect among the cities of the Roman East, nor was it necessarily one of the earliest. It is possible that the colonnades of the north-east street at the west end of the town date from the end of the first century;[88] but the main axial street, 35 feet (11 m.) wide and about three-quarters of a mile in length, was not started until the second century; the central

the red granite columns had been transported all the way from Aswān; and, at the east end of the second, central section, by a fine triple archway. The tetrakionion monument recalls the very similar monument at Gerasa, a city with which the oval colonnaded piazza at the south end of the shorter, but unusually spacious (70 feet; 22 m.), transverse street at the west end of the town offers another link. The archway [234, 235A], built in 220, was wedge-shaped in plan, a simple but effective device of which the Roman world seems to have made surprisingly

A B

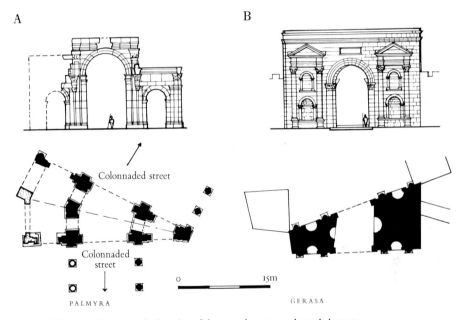

235. (A) Palmyra, arch, 220, at the junction of the second-century colonnaded street and the very wide processional avenue to the sanctuary, projected but never completed; (B) Gerasa, north gate, 115

section was added in the third century, and the easternmost section, leading to the Temple of Bel, though planned was never completed. It falls into three sections, the changes in direction of which were masked, respectively, by a grandiose monument consisting of four square platforms set in a square and each carrying a tetracolumnar pavilion (*tetrakionion*) of which

little use. (The only comparable monuments that come to mind are the north gate at Gerasa [235B] and the elegant arch on the harbour-frontage at Ephesus.)[89] At two points recent excavations have revealed fountain-buildings in the form of apses with flanking recesses fronted by tetracolumnar façades that spanned the lateral porticoes. A striking feature of the whole

complex was the rows of brackets projecting from the columns on either side, to carry statues, a practice for which one can find parallels elsewhere in Syria (Apamea) and in Cilicia (Pompeiopolis, Diokaisareia), though nowhere on such a large scale. However upsetting to the classical purist, it offered an orderly and not unattractive alternative to the clutter of civic statuary at ground level with which most classical cities were content.

The theatre and the agora were both second-century foundations which suffered badly when the city was hastily refortified in the third century. The former was a conventional building of rather academic 'Western' type, the most notable feature being the sector of colonnaded street which followed the outer curve, providing a ready-made alternative to the porticoes for the shelter and refreshment of spectators which regularly accompany theatres elsewhere. The latter, a square porticoed enclosure of Hadrianic date, was more unusual in that it incorporated, along the east side, a basilican hall, a type of building which never achieved the same popularity in the eastern half of the Empire as it did in the west. In this case it may have been, in whole or part, a kaisareion, associated with the imperial cult.[90]

Other surviving monuments are the temples of Nabô and of Ba'alshamin; the remains of a number of houses; a public bath-building; the towers of the cemeteries; and the military headquarters established by Diocletian at the west end of the city.

The Temple of Nabô faced south but was in other respects a temple of conventional Romano-Syrian type, a hexastyle peripteral building of the Corinthian order set on a lofty podium in the centre of a trapezoidal, porticoed temenos.[91] In front of the steps stood the great altar, a square, box-like structure with surrounding columns, closely comparable to those found on some of the Lebanese sites, and beyond this again a monumental propylaeon. The cella was of simple rectangular plan, with a raised platform at the north end and traces of a stair, leading presumably to a terraced roof. The

two flanking walls were crowned with stepped merlons. The temple itself dates from the second half of the first century A.D., while the precinct colonnades, which most unusually were of the Doric order, were added on various occasions during the second century. The Temple of Ba'alshamin, externally a building of more or less conventional classical design, prostyle tetrastyle with a deep Corinthian porch and pilasters along the sides and back, is a relatively late addition to a much older sanctuary. The earliest feature of this, certainly in existence by A.D. 17, was a near-rectangular open temenos at the north-east end of the complex. This nucleus was extended and progressively classicized by the addition (before 33) of a portico, which in 67 was converted into a large peristyle courtyard; by the enclosure of one corner of the early temenos to form a rather rudimentary, roofed temple; and finally (c. 130) by the conversion of the original temenos into a Rhodian peristyle. The present temple building dates from 130, while the peristyle courtyard to the south-west of it was added between 137 and 179. An unusual feature of the second-century temple is the inclusion of a large window in each of the side walls of the cella, a wholly unclassical feature which reminds us that, like the temples of Lebanon and southern Syria, this was thought of as the audience hall and dwelling-place of the divinity. The elaborate adyton, based on Lebanese models, incorporated a receding apsidal central feature with oblique doorways leading into a pair of angle chapels.[92]

The bath-building, a Diocletianic addition, is remarkable principally for the surprising conservatism of its layout, around a central peristyle court. One room was octagonal, all the rest rectangular. The better-class houses, the only ones yet explored, were also of typically hellenistic peristyle design.[93] The tower-tombs strike a grimmer, more personal note. Though of little architectural interest in themselves, they remind us that the roots of this idea, which in one form or another spread to almost every corner of the Roman world, lay in the ancient East. Other tombs, many of them elaborately painted and

carved, took the form of hypogea or of pedimental classical temples.[94]

Under Diocletian what was left of the city became a garrison town, with the troops quartered alongside the native population within a greatly reduced circuit of walls. The so-called 'Camp of Diocletian', at the south-west end, is the *principia*, or headquarters building, of the garrison. Like the contemporary camp at Luxor, it was laid out around two colonnaded streets, which intersected at right-angles and led up to an open space, dominated on the west side by a wing of military offices and, in the centre, the 'Chapel of the Standards'. Although the evolution of this building is evident, stemming from the typical military encampments of the earlier Empire, of which that at Lambaesis will serve as an appropriately monumental example, there is also much here in common with such contemporary civil buildings as the palace at Antioch and Diocletian's residence at Spalato. In the starkly militaristic climate of the late third century it is hardly surprising that in many respects the distinction between monumental military and civil architecture was becoming increasingly hard to draw.[95]

THE NORTH AFRICAN PROVINCES

EGYPT

Despite their manifold diversity, the countries of the ancient East presented a certain fundamental unity in their reaction to the stimulus of classical culture. The same cannot be said of North Africa. Here we are confronted by the heirs to three distinct ancient civilizations, all of which in differing manners and degrees continued to make themselves felt throughout the Roman period. In Egypt the hellenistic Greek culture of the Ptolemies had overlaid, but even at its most sophisticated had never succeeded in eradicating, the stubborn traditionalism engendered by two millennia of Pharaonic rule. In Cyrenaica the enduring substratum of provincial taste was hardly less tenacious of its metropolitan Greek origins. The whole of the rest of North Africa, west of the Greater Syrtis, had for many centuries been part of the commercial empire ruled by Carthage; and although the fact of Punic rule did not leave so immediately distinctive a mark on the outward forms of architecture and the other arts, it did constitute the basis of a broad unity of thought and taste that extended along the whole central and western seaboard, from Tripolitania in the east to the Atlantic coastlands of Morocco in the west.

Roman Egypt, from the moment of its annexation after the death of Cleopatra, occupied a singular position among the provinces of the Roman Empire. The fact that it was ruled by a viceroy responsible directly and solely to the emperor may be explained very simply by the anxieties and fears of the last years of the Republic, when there had been a real danger of the effective centre of the Roman world shifting eastward, as it was to do three and a half centuries later under Constantine. But it also reflects Roman awareness that this strange country, the roots of whose civilization ran so deep and nurtured a plant so oddly resistant to many of the blandishments of classical civilization, was in some way different from all other regions of the ancient East of which Rome found herself heir. If one compares the architecture of Upper Egypt in the classical period with that of almost any other province of the Roman Empire, one cannot but be impressed by its staunch preference for the tried forms of tradition, expressed in the time-honoured building materials of the country, dressed stone and mud-brick. The inhabitants of Philae, wishing to honour Augustus, might erect in 13–12 B.C. a more or less conventionally classical building, a prostyle tetrastyle temple with a shallow porch and a mixed Corinthian-Doric order. (Illustration 236 shows a similarly classicizing building, the Hadrianic Temple of Serapis at Luxor.) But the adjoining 'kiosk' of Trajan, a century later, was still very largely native Egyptian in style [237]; and as late as 296 the near-by Arch of Diocletian, with its slightly parabolic arches and boldly blocked-out mouldings, had absorbed the external forms, but hardly anything of the spirit, of conventional classicism.[1]

Romanization did, of course, make itself felt in a great many fields. Two small nymphaea of classical type flank the processional approach at Dendera; a house of the Roman period at Edfu had a private bath-building in the Roman manner; and the Diocletianic camp at Luxor, for all its almost literal incorporation of the Pharaonic temple buildings (one of the temple halls, which was later used as a church, became for a while the chapel for the legionary standards), was itself laid out on a four-square classical plan, with intersecting colonnaded streets and a tetracolumnar monument at the intersection. Locally, within and beyond the frontiers, the Romans left a substantial legacy of

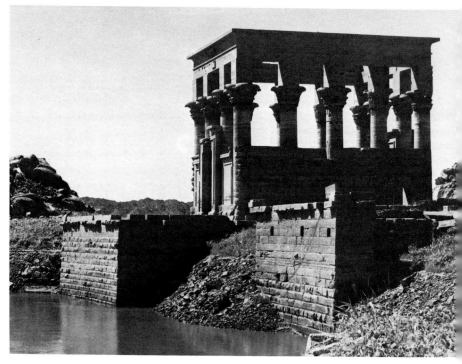

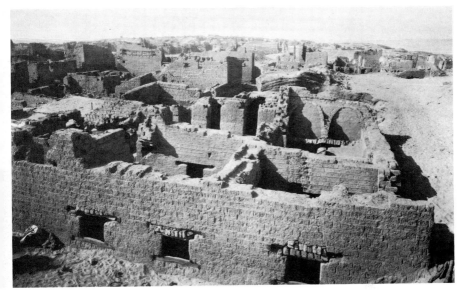

236 (*opposite, above*). Luxor, Temple of Serapis, 126

237 (*opposite, below*). Philae, 'Kiosk' of Trajan, *c.* 100

238 (*above*). Karanis, House C65, built of mud brick with timber details
and (*top right*) pitched brick vaulting

architectural forms and building practices to the flourishing Christian and pagan civilizations of late antiquity. But in terms of the architecture of the Roman world as a whole Upper Egypt was, and remained, a backwater.

The one group of buildings that deserves mention – not because it was in any way unusual, but because its excavation was, for once, well observed and documented – is that of the small townships of Karanis and Soknopaiou Nēsos in the Faiyûm. The mud-brick houses, with their scanty use of timber and even scantier use of stone, afford one of the very few surviving examples of a building material and of building techniques which have all too rarely come down to us but which were in fact in widespread use in many parts of the Mediterranean Roman world. In particular, the barrel-vaults and shallow saucer-domes, many of them carried out in a pitched-brick technique requiring a bare minimum of timber shuttering, anticipate one of the most distinctive features of Early Byzantine building practice [238].

In the hellenistic cities of the Delta things must have been very different. Here the almost total loss of the remains of Roman Alexandria constitutes a gap in our knowledge hardly less serious than that of its great sister metropolis in the east, Antioch. There are descriptions of the city and of such individual monuments as the Pharos, the library, and the great first-century synagogue; but such literary descriptions afford notoriously slippery ground for the student of architecture and can at the best be used to supplement the picture to be gained from the surviving monuments. The *disjecta membra* of

the classical city show that for a time the architecture of Roman Alexandria retained a decided flavour of the rather mannered hellenism of the previous age. But there are hints of influence from Italy, as, for example, in the introduction of the ubiquitous Roman-style bath-building or in the high podium of a small Ionic tetrastyle temple in the suburb of Ras el-Soda.[2] Subsequently, in the later Empire, the capitals and other architectural members preserved in the museum and elsewhere include a high proportion of 'marble style' decorative material, most of it in Proconnesian marble. In this respect Alexandria was evidently subject to the same all-pervading influences as the coastal cities of southern Asia Minor and Syria and the rest of the North African littoral.

One of the most influential of the lost buildings was the Kaisareion, erected by Caesar in 48–47 B.C. a few months before the lost building of the same name in Antioch. It seems to have been a large, inward-facing temenos surrounded by porticoes, and it has been plausibly argued that it derived from some such monument as the temple enclosure, classical in its details but in its layout still essentially Pharaonic, which was erected c. 240 B.C. by the garrison of Hermoupolis Magna in honour of Ptolemy III and Berenice.[3] The Alexandrian building in its turn seems to have exercised a powerful influence on the architectural forms adopted elsewhere in the Roman world, including the capital, for the purposes of the newly instituted ruler cult. At Cyrene a building identified as a gymnasium of the second century B.C. was remodelled and rededicated to Augustus as a *Caesareum*, or *Kaisareion* [239, 240]. If this gymnasium is correctly equated with the *Ptolemaion* of several local inscriptions, the transformation was both simple and logical. It comprised a rectangular open space, some 170 by 265 feet (51 by 81 m.), surrounded by Doric porticoes, with a series of chambers opening off one long side, which were later rebuilt as a basilica of which the whole of one end was occupied by a large semicircular exedra.[4] (The temple in the middle of the open area is a later, second-century addition.) Comparable forum-

239 and 240 (*opposite*). Cyrene, Caesareum, a hellenistic building adapted to its Roman purpose in the late first century B.C., air view and plan. The basilica is a modification of the first century A.D., the central temple an addition of the second century

basilica complexes are known from several other sites within the Greek-speaking world, and at least one of these, at Palmyra, seems to have been associated with the imperial cult and may be tentatively identified as the Kaisareion of local epigraphy. Other well preserved examples are at Kremna, in Pisidia, and at Smyrna [186].

In more general terms one may suspect the influence of the same tradition in Rome too, not only in such direct manifestations of the ruler cult as the Porticus Divorum of Domitian [20] but also perhaps even in the planning of the Imperial fora. All these were porticoed monuments, enclosed and inward-facing, and the allocation of the post of honour in the first such forum to a temple of Venus Genetrix, divine ancestress of the Julian family, came as near to expressing the sentiments of the ruler cult as contemporary opinion in Rome would have permitted. There were, of course, other influences at work as well. But it would have been natural for Caesar, in planning his forum, to have drawn upon his own recent experience in Alexandria and in Antioch. If so, this, one of the most widely diffused schemata of Roman Imperial architecture, appears as an ultimate product of the hellenistic influences that had shaped so much of the architecture of the previous century. It is significant of the subsequent shift in the architectural centre of gravity within the Roman world that the known later Kaisareia, all of them in the eastern provinces, should have incorporated basilicas, a specifically Western type of building which, in the context, must almost certainly reflect the prestige of the last of the Imperial fora in Rome, the Forum of Trajan and the Basilica Ulpia.

The life and art of Egypt seem to have exercised a peculiar fascination on Roman minds at all levels and in all periods. Some of the resulting products, such as the famous Bar-

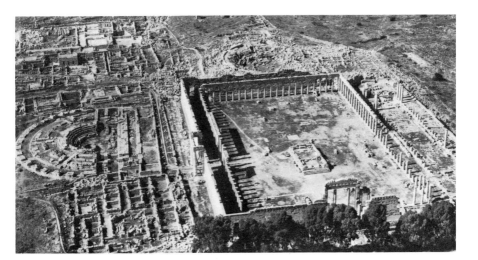

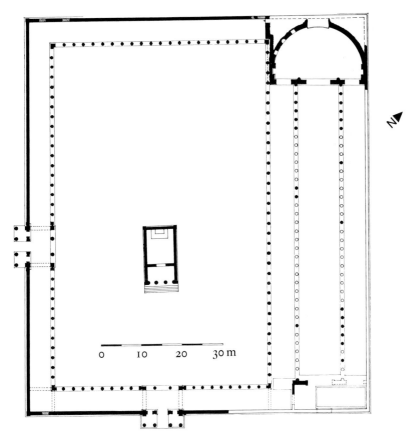

berini mosaic at Praeneste (*c.* 80 B.C.), with its lively scenes of Egyptian life and fauna displayed within a framework of rich Nilotic landscape, are of a quality that must reflect closely the decorative tastes of the Ptolemaic court; and although many more bear the stamp of an artificial convention comparable to the 'chinoiserie' of a later age, it was a convention of a remarkable durability and resilience, which continued to make itself felt in painting, stucco-work, and mosaic throughout the Roman period. There was also a lively commerce in Egyptian obelisks, sphinxes, fountain basins, and ornamental statuary. Augustus set the fashion by transporting two large red granite obelisks from Heliopolis, one of which he erected on the axis of the Circus Maximus, the other as a sundial in the Campus Martius. In all no less than forty-two such obelisks are known to have been imported by successive emperors. This commerce owed much to the popularity of the cults of Isis and Serapis, whose sanctuaries in Rome, Benevento, and elsewhere have yielded a rich haul of architectural sculpture and statues, both originals and copies.

Finally we may note the development of an important export trade in such highly prized Egyptian building stones as the red granite of Syene (Assuan), the imperial porphyry of the Jebel Dokhan in the eastern desert, and the grey granite ('granito del foro') from the near-by quarries of Mons Claudianus. The Flavian Palace, the Basilica Ulpia, the Pantheon, the great court at Baalbek, the Severan forum and basilica at Lepcis Magna, are a few only of the great monuments of the Empire for which the vast monolithic columns, weighing up to 300 tons, were shipped all over the Mediterranean basin. As a source of luxury building materials the quarries of Egypt were second only to those of Greece and of Asia Minor.

CYRENAICA

Roman Cyrenaica, unlike Egypt, was a poor province, richer in history than it was in fine contemporary monuments; and although much of Cyrene itself has been excavated as well as considerable areas of Ptolemais and Apollonia, there are few Roman buildings that are of more than local significance. One such, the Caesareum at Cyrene, has been described above. Its retention of the Doric order is characteristic of the staunch conservatism of that city. As late as the time of Hadrian Doric was employed for the reconstruction of the Temple of Apollo, destroyed a few years earlier during the great Jewish revolt.[5] Used monumentally, Corinthian makes its first certain appearance in the large public bath-building erected by Trajan within the sanctuary of Apollo (or possibly in its restoration by Hadrian, after the same revolt). The capitals of this are typical 'marble style' importations from Asia Minor; but although such importations constitute one of the stylistic sources of the series of small Corinthian temples and other public buildings erected at Cyrene in local stone during the course of the second century,[6] they do not seem to have been as numerous or to have made the same impact as in most other coastal provinces of the eastern and central Mediterranean. Throughout its later history Cyrene maintained close commercial and sentimental ties with Athens. The bulk of the imported marble (Cyrenaica itself has no supplies) is Attic, and it would not be surprising if further research were to reveal architectural links, too, with Athens and with mainland Greece.

Ptolemais, a hellenistic coastal foundation, and Apollonia, the port of Cyrene, were more up-to-date in their tastes and artistic connexions. In their domestic architecture in particular they seem to have been more open to the influence of hellenistic Alexandria, an influence which received fresh impetus from the prosperity that followed the Augustan Peace. The most significant monument in this respect is the so-called 'Palazzo delle Colonne' at Ptolemais [241]. This was a wealthy private residence, occupying the greater part of an elongated rectangular insula.[7] The whole building was terraced upwards on substructures to counter the natural slope of the site, and the

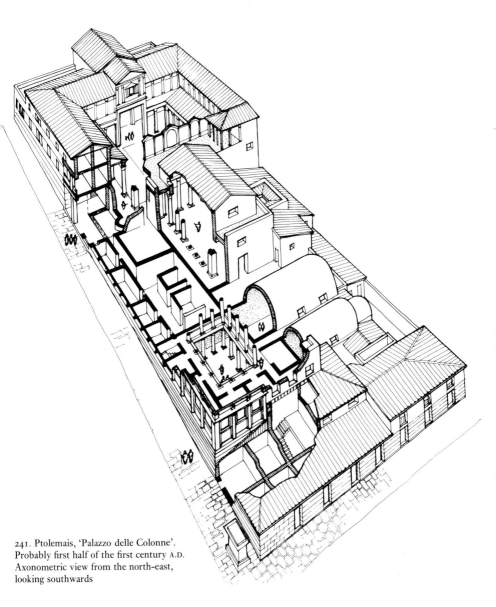

241. Ptolemais, 'Palazzo delle Colonne'.
Probably first half of the first century A.D.
Axonometric view from the north-east,
looking southwards

main residential quarters too were developed in
elevation, with rooms and colonnades of very
differing height and a second storey over the
main peristyle – an echo presumably of the

vertical development imposed by the crowded
urban conditions of Alexandria. The plan is
essentially that of a typical late hellenistic
peristyle-house, with a large room (the *oecus*)[8]

for domestic use opening off the middle of the south side, and opposite it (in this case) a second and larger oecus for more public occasions, the roof of which was supported on an internal ambulatory colonnade in a manner reminiscent of the similarly derived Second Style architectural schemes of Late Republican Italy. Other rooms and offices were grouped around a second, smaller peristyle, and a bathing-suite was added later at a lower level, behind the shops that occupied the northern frontage. The architectural ornament was lavish, with pavements of mosaic and of shaped marble tiles (*opus sectile*) and richly carved architectural schemes carried out in the soft local stone and surfaced with stucco. Among the characteristic motifs it must suffice to notice the heart-shaped angle piers; the free interchange of Doric, Ionic, and Corinthian elements, and the juxtaposition of orders of different heights; the columns that spring from a calyx of acanthus leaves (a Ptolemaic motif that found its way also into Syria and sporadically elsewhere);[9] the arch springing from the two ends of an interrupted horizontal architrave;[10] the façade in the form of a false portico, with Ionic half-columns carrying a Doric architrave and framing large rectangular false windows (the scheme recalls that of Herod's palace at Masada and the House of the Figured Capitals at Utica); and the broken pediments framing independent pedimental aediculae within the setting of a miniature columnar screen in a manner that clearly foreshadows the marble columnar screens of Asia Minor. All this has very close affinities with the decorative architecture portrayed in the wall-paintings of Pompeii. Whatever its date, the Palazzo delle Colonne may be regarded as exemplifying the sophisticated late hellenistic domestic architecture from which so many elements of the decorative taste of Roman Italy and the Mediterranean provinces were more or less directly derived.

In Cyrenaica, too, this seems to have been a specifically domestic style, to be contrasted with the more conservatively classical style of public architecture. It was widely represented in the province. Several other Early Imperial houses of the same general character, though less elaborate, have been identified at Ptolemais; at Cyrene itself the first-century nucleus of the rich 'House of Jason Magnus' falls within the same general category, though the planning is more relaxed; and there are remains of similar workmanship both at Teuchira (Tocra) and at Apollonia. At the other extreme stands the building at Ptolemais which has been variously identified as an odeion and a council hall (*bouleuterion*), the stage-building of which was absolutely plain except for the conventional three doors, which opened directly on to the orchestra. Whatever its original function (and could it not have served both purposes?), it was later converted to theatrical use by the addition of a wooden stage, and later again (as frequently elsewhere in late antiquity) by the waterproofing of the whole orchestra to provide for aquatic displays.[11] The magnificently situated Greek theatre at Cyrene was similarly converted by the elimination of the stage and the deepening of the rock-cut orchestra to form the arena of a small amphitheatre. Cyrene had in all no less than four theatre-like buildings (two are visible in illustration 239), some of which must certainly have been designed as places of public assembly. Hippodromes at Cyrene and at Ptolemais remind us that Cyrenaica was famed for its horses. Ptolemais possessed in addition two other theatres and, unusually for an Eastern province, an amphitheatre.

TRIPOLITANIA

West of the Great Syrtis one enters a world very different from Egypt and Cyrenaica. Here the Greeks never succeeded in establishing a foothold; from Tripoli to Cádiz and across the sea to Sardinia and western Sicily Rome was heir not to Greece but to Carthage, and the language, where it was not Punic or Berber, was Latin. If Cyrenaica was essentially a part of the hellenistic East, Roman Africa (as it is convenient to term the whole of this territory, from Tripolitania westwards) belonged no less decisively

to the Western world. Thirteen centuries of Arab rule have overlaid but have not succeeded in entirely cancelling this distinction.

Roman Africa is almost embarrassingly rich in monuments. Not only did classical civilization strike deep, but the circumstances of the country's subsequent history have favoured the survival of many of its ancient cities and buildings. And yet, with a few notable exceptions, these buildings are more remarkable as documents of a vanished civilization than for any great artistic originality. The architecture here remained to the end largely derivative.

Why was this? There can be no single answer, but one of the most important reasons lies undoubtedly in the historical background of the territory and its peoples. At the time of the first Greek and Phoenician colonies, the indigenous inhabitants of North Africa were still to all intents and purposes in the Stone Age; and whereas the Greeks in Cyrenaica brought with them a vigorous, proselytizing art of their own, the Phoenicians were a people singularly devoid of any artistic talent. As craftsmen they were skilful, borrowing freely from others, and as merchants and middle-men they carried their wares all over the western Mediterranean; but as creative artists they had little of their own to offer. If the remains of the art and architecture of the Phoenician colonies in the west are only now beginning to be recognized and discussed, it is largely because of their essentially derivative, colourless character. This is particularly true of the later pre-Roman period, when the distinctively Oriental influences had dwindled and the primary source of contemporary inspiration was the hellenistic art and architecture of South Italy and Sicily. The subsequent advent of Roman rule has almost inevitably tended, in consequence, to obscure the local contribution to a mixed civilization of which so many of the externals were obstinately and uniformly classical. And yet, as any student of the history, language, and institutions of Roman North Africa is at once made aware, this was as much a 'Romano-Punic' or 'Romano-African' civilization as that of Gaul was 'Gallo-Roman'. To disregard this fact is to dissociate the art of Roman North Africa from the setting of daily life and thought within which it was created and by which it was conditioned.

Two cities about the early development of which we happen to be unusually well informed are Lepcis (or Leptis) Magna and Sabratha, two of the three cities from which the territory of Tripolitania took its name. Both were in origin Carthaginian trading-stations (*emporia*). Excavation has shown that Sabratha was the site of a seasonal, harbourside trading post as early as the fifth century B.C. Lepcis was founded even earlier; but although the site of the Punic settlement is known, on the west bank of the sheltered wadi-mouth which constituted the harbour, the earliest extant remains are of the Augustan Age, when the quarter immediately inland from the primitive nucleus was laid out on a neat rectangular grid around an open space, the forum, and along the axial street which struck inland on a gentle curve, following the line of the higher ground to the west of the wadi. Individual buildings within the forum area were later rebuilt or embellished. But the subsequent establishment of a new and far more magnificent forum on another site meant that the Old Forum retained to an unusual degree the broad lines of its Early Imperial physiognomy right through pagan antiquity. Better than any other similar complex in North Africa, it offers a picture of the Roman architecture of the province in the earliest, formative stages of its development.

The oblique alignment of the north-east side of the Old Forum must derive from that of some building, or buildings, of the Punic city [242]. The rest is strictly rectangular. Along the north-west side stood three temples. The smallest of these, the North Temple (*c.* 5 B.C.–A.D. 2), served as the model for its larger neighbour, which was built between A.D. 14 and 19 and dedicated to Rome and Augustus. Both made use of the magnificent silvery-grey limestone which was to remain the characteristic building stone of Lepcis for over a century; both were peripteral on three sides only, in the Italian

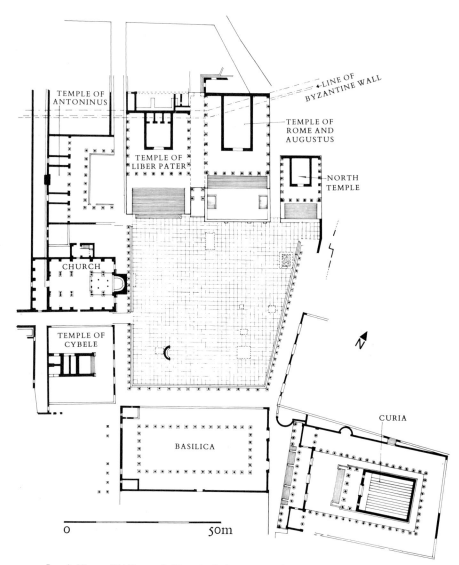

242. Lepcis Magna, Old Forum. Laid out in the last quarter of the first century B.C.
and developed principally during the first century A.D. Plan

manner; both employed an order with highly distinctive Ionic capitals, and instead of the customary columns at the outer angles of the façade there were heart-shaped angle piers. All of these are recurrent features of the Early Roman architecture at Lepcis, and the proximate source of the capitals and angle piers (not to be confused with the similarly shaped but inward-facing angle piers of everyday hellenistic practice) is probably Late Punic rather than

Italian. For all the superficial classicism of these buildings, it was in part at any rate a classicism at one remove from source. The Temple of Rome and Augustus is of interest also for its elaborate vaults and twin cella, and for the design of the podium, which rose sheer from the forum paving, with twin flights of steps incorporated in the flanks, just as in the Temple of Venus Genetrix in Rome. Similar platforms are a feature of a number of North African temples (e.g. Althiburos and Gigthis in Tunisia; Sabratha; Timgad), and in this instance the survival of two carved ships' prows (*rostra*) establishes beyond dispute that the purpose was to furnish a platform for orators. Another feature common to many Early Imperial monuments in Tripolitania is that the architraves seem to have been of wood.

Alongside the Temple of Rome and Augustus, with the pavement of the lofty podium carried across the street between the two on arches so as to form a single platform, was the Temple of Liber Pater, or Dionysus, the Punic Shadrap. This was the earliest building of the whole group, being built originally of the soft quaternary sandstone which, faced liberally with stucco, was the pre-Augustan building stone of Lepcis. Opposite the two, some time before the middle of the century, was added a basilica (the 'Basilica Vetus'), a building which, though sited transversely so as to balance the bulk of the two main temples, internally was of the longitudinal South Italian type found at Pompeii and at Corinth, the main entrance lying in a small secondary piazza opposite the curia. Then, and not until then, in A.D. 53–4, the central area of the forum was given monumental form by the addition of limestone porticoes on three sides and a pavement of magnificent limestone slabs. This was followed, along the south-west side, by an enclosed precinct and temple of Cybele (71–2), by a temple of Trajanic date which was later converted into a church and, tucked into the western corner, by a small porticoed shrine in honour of Antoninus Pius (153). The curia, the meeting-place of the municipal council, lay just outside the forum

proper, opposite the entrance to the basilica, on an earlier alignment. A temple-like building set within a porticoed enclosure upon a raised platform, it seems in origin to have been of Early Imperial date. As at Sabratha, the seating followed the canonical model of the Roman senate house, with two longitudinally facing tiers of low steps.

The Old Forum at Lepcis Magna, like the agora at Corinth, is an excellent example of the sort of monumental unity which sound basic planning and the use of congruous materials enabled Roman architects to achieve, often over long periods of piecemeal growth. Moreover, though derived exclusively from South Italian classical sources, either directly or else through Late Punic imitations, this was an architecture that reflected admirably the solid civic qualities of the local mercantile aristocracy. The donors of these buildings bore names like Iddibal, Balithon (Ba'alyaton), and Bodmelqart. The dedicating magistrates were still the Punic *sufetes*, and the dedicatory inscriptions were written in Neo-Punic script as well as in Latin. More than a century later the Lepcis-born emperor Septimius Severus spoke Latin with a strong Libyan accent, and his sister spoke it so badly that she had to be sent back to her native city.

Such a society responded rapidly to the opportunities of the Augustan Peace. Lepcis grew apace. Before the end of Augustus's reign another 275 yards of the axial street towards the south-west had been incorporated as the basis for the street grid of a whole new quarter, and before A.D. 27–30 almost another 400 yards south-westwards again, bringing the limits of the city to the point where the Arch of Septimius Severus later stood. The monuments that mark the stages of this rapid growth are a market building (8 B.C.) and a theatre (A.D. 1–2), both built on the outskirts of the area hitherto developed, and a porticoed façade, the Chalcidicum, built in A.D. 11–12 to mask one of the resulting irregularities of plan [244]. The market [243] is an outstanding example of the Pompeian type of macellum, with a central pair

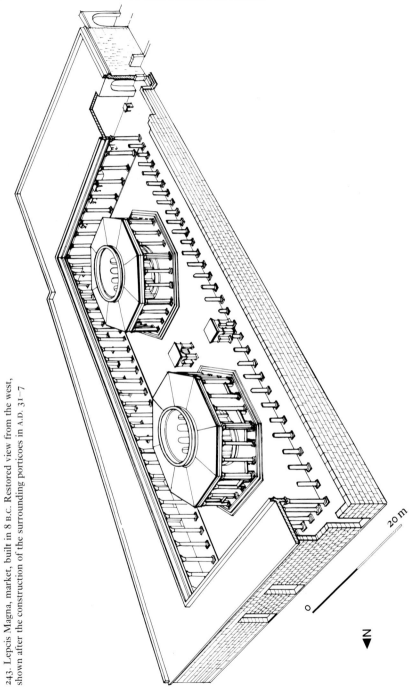

243. Lepcis Magna, market, built in 8 B.C. Restored view from the west, shown after the construction of the surrounding porticoes in A.D. 31–7

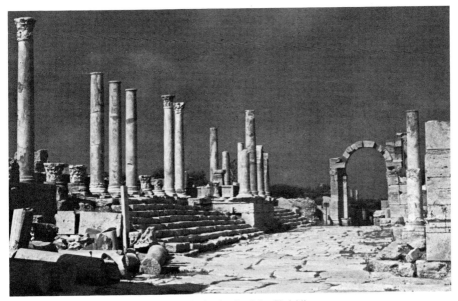

244. Lepcis Magna, main street, showing (*left*) the façade of the Chalcidicum, 11–12, remodelled in marble in the second century, and beyond it the Arch of Trajan

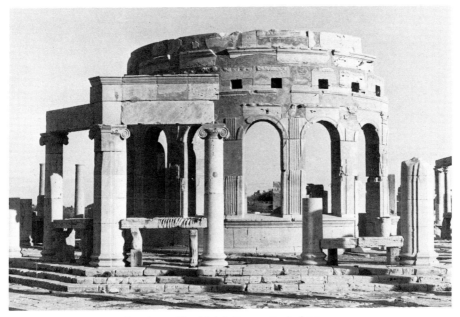

245. Lepcis Magna, octagonal market pavilion (*tholos*), Romano-Punic, 8 B.C. Its counterpart was rebuilt on a circular plan in the early third century

of pavilions enclosed within a rectangular open space, around which, between A.D. 31 and 37, was added an encircling portico. The south-east pavilion was rebuilt in marble two centuries later, but its fellow [245] is still the original Augustan structure, of fine grey limestone, with a circular, windowed central chamber and an octagonal portico; as in the early temples of the Old Forum, the angle piers of the octagon are heart-shaped. There were no separate shops, the market benches being ranged between the columns of the pavilions and along the outer walls of the porticoes.

The theatre [246, 247A], despite later additions and modifications, is another building that has retained a great deal of the Augustan structure, including the splendid sweep of the original grey limestone seating. The columnar orders of the stage-building were replaced in marble in the later second century, but the plan of it, a large, boldly curved, apsidal recess flanked by two similar but slightly smaller recesses, is original, affording valuable evidence of the early development of this characteristi-cally Imperial Roman architectural scheme. Other noteworthy features are the small tetra-style temple (dedicated to Ceres Augusta) at the head of the cavea, as in several other North African theatres;[12] the porticoed foyer beyond the stage-building,[13] as for example at Ostia and at Corinth; the colonnade around the head of the cavea, a feature repeated at Timgad, Thugga, and Cherchel; and the flooring of the orchestra, replaced in marble during the second century but originally, as in Herod's theatre at Caesarea, of gaily patterned, painted stucco.

The architectural models established at Lepcis under Augustus were maintained with remarkably little change throughout the first century A.D. The ornament grew fussier, and the Corinthian order tended to displace the Ionic; but as late as Trajan the building material in fine monumental use was still the local grey lime-stone. Then quite suddenly, under Hadrian, the marbles of Greece and Asia Minor (and oc-casionally of Italy) were introduced, and with them came craftsmen trained in the workshops of the Aegean world and of Rome. The impact

246. Lepcis Magna, theatre. The limestone seating is of A.D. 1–2,
the partially re-erected marble stage colonnade of the second half of the second century.
The lower columns on the left are not in their original position. The front rows of seating,
in front of the balustrade, were reserved for magistrates and local dignitaries

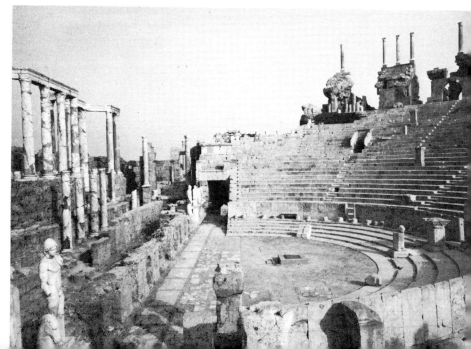

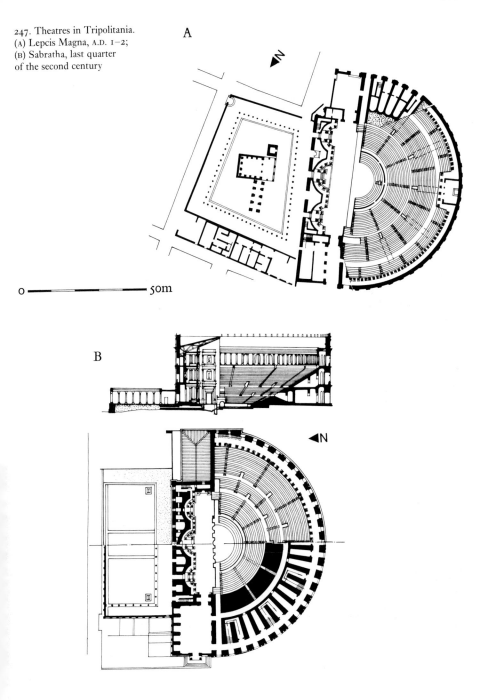

247. Theatres in Tripolitania.
(A) Lepcis Magna, A.D. 1–2;
(B) Sabratha, last quarter
of the second century

A

B

0 ▬▬▬▬▬▬ 50m

was startling. The first building to have used columns and other architectural members of marble was the Hadrianic Baths [253], a large, symmetrically planned complex of the 'Imperial' type, derivative from the great public bath-buildings of Rome, though with only a very limited use of their characteristic concrete vaulting. Within a few decades the new materials and style had swept the field. After the time of Hadrian there was not a single new building of substance that did not make extensive use of imported marble, and a great many of the existing buildings were correspondingly remodelled – the porticoes and the two main temples of the Old Forum, the curia, the market, the theatre, and the Chalcidicum, to enumerate only those already named above. Almost overnight the buildings of Lepcis lost the individuality conferred by local materials, techniques, and styles. The columns were now imported ready-made, and the bases, capitals, entablatures, and other fittings were carved to standard classical designs and, at first, by the foreign workmen who have left their signatures upon them. In course of time the establishment of local workshops came to give them a certain individuality of style, but it was only within the wider framework of an Imperial art that was as much at home in Asia Minor or the Syrian coastlands as it was in Tripolitania. Much of the new architecture was rather dull, but it was ostentatiously expensive and it satisfied the pretensions of an age of material progress and civic prosperity.

The monuments of pre-Severan Lepcis – and to those already mentioned must be added half a dozen lesser temples, as many honorary arches, an aqueduct and cisterns, port installations, an amphitheatre, a circus, several smaller bath-buildings, a monumental exercise ground (*palaestra*), and sundry streetside porticoes, fountains, and public lavatories – jointly and severally offer a glimpse of what must have been happening in innumerable other cities, great and small, along the coastlands of North Africa. Not that one can often document the early phases of their growth in anything like the same

detail. At Sabratha, for example, the local building stone was a friable sandstone that could only be used beneath a thick coating of stucco, needing constant attention; already in late antiquity there was very little left of the first-century city and its monuments. Lepcis was fortunate in this respect; and since it was also wealthier than the average North African city, its early expansion was correspondingly more rapid. Architecturally, however, the only important respect in which it seems to have differed from most of its neighbours was that, like the recently refounded Carthage, it developed within the framework of an orderly city plan. In most of the older North African cities, such as Hippo Regius (Bône), Tipasa, Thuburbo Maius, Thugga, and Gigthis, the Roman-period town plan reflects rather the impact of two quite distinct patterns, the tidy symmetry of the Roman monuments superimposed upon the more or less haphazard growth of the pre-existing town.

It is again to Tripolitania, to Sabratha, that one must turn for a well documented example of the processes of transition. One's first impressions of the old town adjoining the harbour are dominated by the neat rectangularity of the forum, but excavation has shown this to be in fact a drastic rationalization of what had previously been an irregular open space serving the late pre-Roman city as an occasional marketplace. In plan, or from the air [248], the pre-existing layout is still clearly visible in the picturesque commercial and domestic quarter between the forum and the harbour, and again on either side of the main road leading inland from the forum towards the main east-west coast road. Only as one approaches the latter do the individual city blocks assume the more regular shape of those to the south of it. A really strict rectilinear plan was adopted in the late second century for the new quarter laid out to the south-east of the old city, towards the theatre. Here at Sabratha, as in the neighbouring city of Gigthis, the contrast leaps to the eye. Elsewhere, where the existing physiognomy of the town was already more developed, as for

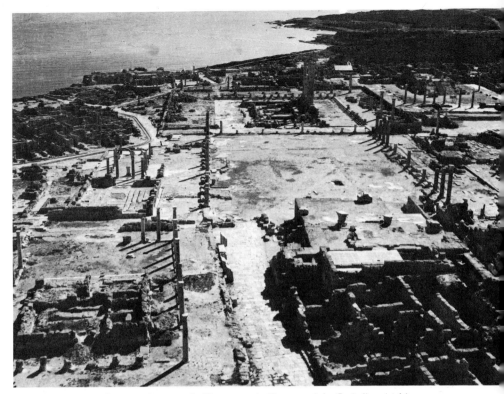

248. Sabratha, forum, first-second century, looking eastwards. Foreground the Capitolium (*right*) and Temple of Serapis(?); middle distance Basilica (*right*) and Curia; far end (*left to right*) the Seaside Baths, the East Forum Temple, and the Antonine Temple

example at Thugga, the individual monuments had for the most part to develop piecemeal as best they could within the framework of the existing urban scheme.

As originally laid out in stuccoed sandstone towards the middle of the first century A.D. the forum at Sabratha consisted of an elongated rectangular open space, flanked along the two sides by shops and enclosing near the east end a large, gaily painted temple dedicated to Liber Pater. Along the western half of the south side, behind the shops, there was a basilica. In contrast to that of Lepcis this was of the Central Italian 'Vitruvian' type,[14] symmetrical about the shorter axis and incorporating, opposite the

main door, a rectangular, apsed tribunal, which served as a chapel for the Imperial cult. The only other monumental building was a small temple, of pre-forum, possibly Augustan date, standing in a colonnaded enclosure, just off the north-west corner. The temple, free-standing within the enclosure, was a small, box-like structure, wider than it was long, set on a low podium at the head of a flight of steps. Despite the widespread adoption of classical names and other outward forms, native religious traditions were still strong, and (as we shall see later in this chapter) temple architecture is one of the few fields in which Roman North Africa did in fact display a certain originality.

249 (*opposite*). Sabratha, theatre,
reconstructed stage-building,
last quarter of the second century

During the course of the next three centuries all the forum buildings, with the single and presumably deliberate exception of the Temple of Liber Pater (which was rebuilt and enlarged in traditional materials), were rebuilt wholly or partially in imported marble. The innovations included the building at the west end of a large new temple, the Capitolium, presumably here, as normally elsewhere, symbolizing the city's achievement of some advance in civic status; the suppression of the rows of shops in favour of, in the western half, two longitudinal porticoes with imported columns of red Egyptian granite and, on three sides of the eastern half, an elaborate double portico of traditional hellenistic type, with an outer Doric colonnade and an inner Ionic colonnade at twice the spacing;[15] the addition of a municipal council hall, or curia, along the north side opposite the basilica; the rebuilding in more conventionally classical form of the early temple at the north-west corner; and the construction on either side of the main street, just outside the forum to the south, of two new and typically 'marble style' temples, one dedicated to Marcus Aurelius between A.D. 166 and 169, the other added a few years later. The Capitolium, the vaults of which were perhaps used as strongrooms, was of conventional classical plan except for the vertical front of the podium, forming a platform for orators, and for a pair of square projecting chambers on either side of the porch. The two marble style temples were both prostyle buildings standing in the Italian manner on lofty podia against the rear wall of a rectangular enclosure, the two flanking porticoes of which ended in apses against this rear wall. The Temple of Hercules, the Punic Melqarth, in the east quarter (A.D. 186) was of the same form.

The outstanding single monument of Sabratha is, of course, the late-second-century theatre, outstanding not so much because it was in any way unusual in its own day as because the discovery and accurate restoration to its full height of the façade of the stage-building has made it possible to appreciate the visual subtleties of one of these elaborate columnar façades in a way that is quite impossible from even the best paper restorations [247B, 249]. All that is missing is the coffered wooden ceiling, cantilevered forward over the stage, and the facing of marble veneer that covered the wall surfaces behind the columns. Rather surprisingly (for Sabratha, though prosperous, was not a very large town) it is one of the largest theatres to have come down to us in Africa, with a maximum diameter of 304 feet (92.60 m.) against the 290 feet (88.50 m.) of Lepcis, and second only to that of Hippo (c. 325 feet). The plan of the stage-building closely resembles that of Lepcis, from which this theatre differs principally in the greater elaboration of the substructures of the cavea, incorporating an outer ambulatory corridor and embellished externally with a triple order in low relief, both features that go back to the Roman tradition represented by the Theatre of Marcellus.

The domestic and commercial architecture is unusually well preserved and would repay far more detailed study than it can receive here. The irregular insulae of the old town present all the confusion and diversity of plan of a quarter that was continuously occupied for many centuries, with shops, dwelling-houses, workshops, and magazines jostling for position along the narrow streets. Shallow roadside colonnades here and there gave shade to the buildings behind, supporting the projection of the upper storeys to which the remains of staircases bear frequent witness. The ground floors were regularly of squared stone masonry, the upper storeys of timber and mud-brick, and the rarity of roof-tiles suggests that the roofs were flat in the Oriental manner. Interiors and exteriors alike were faced with stucco, and in the better-

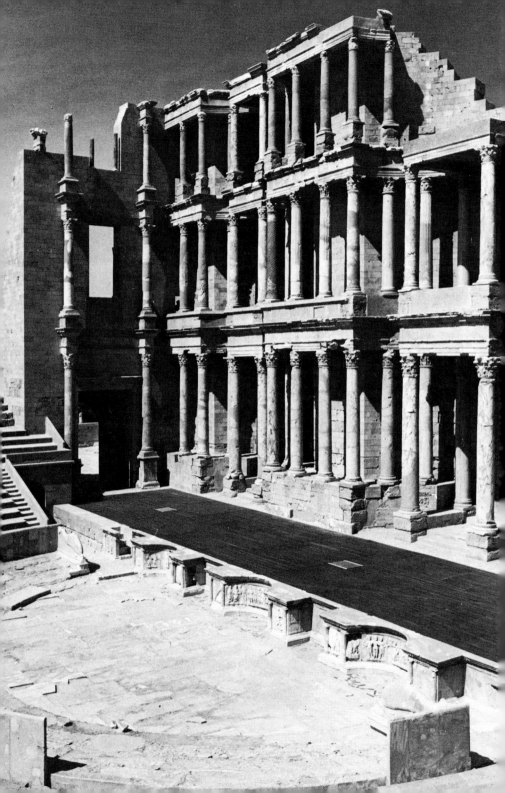

class houses one finds the abundant remains of painting (including painted plaster vaults), ornamental stucco mouldings, mosaic floors, and even marble veneer. The rectangular insulae of the new quarter (c. 180–90) repeat the same schemes, but in a more orderly, planned manner. The random columnar porticoes of the old quarter have become neat rows of columns fronting one or more sides of the insulae. On the outskirts of the town are the remains of several rich peristyle-villas.

A regular feature of the town houses of Sabratha, as elsewhere in North Africa, was the incorporation of large cisterns for the storage of rainwater for domestic use. There was also a public supply brought in by aqueduct, but this was normally directed only to the public fountains (which were intended for practical use as well as for decoration) and to the bath-buildings. Attached to the latter, and flushed by their outflows, were public lavatories, which were of communal character, with accommodation for as many as sixty persons at a time

on long stone benches, and which were often lavishly ornamented with marbles and statuary (cf. illustration 250, in the Hadrianic Baths at Lepcis). Sewage, domestic waste, and rainwater alike were collected and discharged through large sewers laid beneath the paving of the streets. Domestic plumbing was confined to the more luxurious private houses. At Sabratha, for example, there was an exquisite, mosaic-paved little bath-building (the 'Oceanus Baths') attached to a rich suburban seaside villa near the eastern limits of the town. The general public used the large, irregularly planned baths overlooking the harbour; and between these two extremes there were numerous medium-sized establishments that were available on payment or were reserved for members of certain privileged groups. At Lepcis the 'Hunting Baths' [251] seems from its decoration to have belonged for a while to the merchant association engaged in supplying exotic wild beasts to the amphitheatres of the Roman world. Fortunately for its credibility as a classical building erected

250. Lepcis Magna, Hadrianic Baths, public lavatory

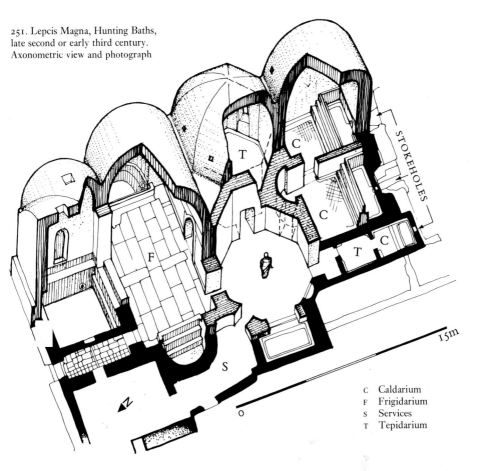

251. Lepcis Magna, Hunting Baths,
late second or early third century.
Axonometric view and photograph

STOKEHOLES

c Caldarium
f Frigidarium
s Services
t Tepidarium

15m

0

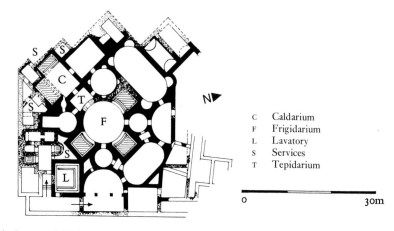

C Caldarium
F Frigidarium
L Lavatory
S Services
T Tepidarium

o 30m

252. Thenae, baths, second-third century. Plan

probably in the early third century, it is exceptionally well preserved, nearly up to the crown of its concrete vaults. Concrete was not a material native to North Africa. It could be used, however, and on this occasion was used, to produce a building that patently derives from the concrete architecture of metropolitan Rome, but does so with a logic of application and a frankness of statement that are rare in the capital. Its parentage must be sought in buildings such as the Lesser Baths of Hadrian's Villa, but the plan of the interior has been rationalized into an orderly scheme, eliminating the purely extravagant in favour of a simple but effective juxtaposition of contrasting geometrical room-shapes; and the exterior was simply a candid restatement of the shapes within.

To the conservative citizen of Lepcis, nurtured on the sober splendours of the Hadrianic Baths, the Hunting Baths must have seemed a quite extraordinary building. And yet, within the field of bath-building (for which the vaulting offered many practical advantages), this sort of architecture had a considerable vogue in North Africa. The actual vaults are rarely preserved; but with the example of the Hunting Baths before one, they can be confidently restored in imagination.[16] An outstanding example of the type is the bath complex at Thenae

in Tunisia [252], grouped around a central, domed frigidarium, buttressed by four radiating barrel-vaulted chambers, with smaller domed rooms in the four angles of the cross.[17] Outside North Africa, too, such exposed vaulting was far commoner than one's knowledge of conventional classical architecture might lead one to expect. The vaults were certainly visible, for example, in the Baths of Capito at Miletus, or again at Bostra and Philippopolis. In this the early Arab bath-builders were simply following classical practice. In Rome itself we lack unequivocal evidence, but the balance of probability is that even in the great Imperial bath-buildings the outer curvature of the domes was candidly displayed. The artistic implications of this for a building such as the Baths of Caracalla are considerable.

Lepcis, already one of the wealthiest cities of North Africa in its own right, had the good fortune to be the birthplace of the emperor Septimius Severus (193–211). During his reign the city was embellished with a whole new monumental quarter, comprising an enclosed harbour, a bath-building, a colonnaded street, a forum and basilica, and a piazza dominated by a monumental fountain-building [253]. Another Severan enterprise was the building of a four-way (quadrifrons) arch.

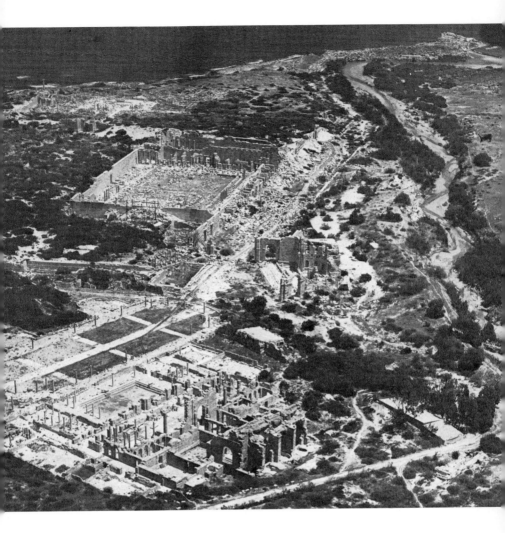

253. Lepcis Magna, air view showing, in the foreground, the Hadrianic Baths;
in the middle distance, the Severan Nymphaeum, Colonnaded Street, Forum, and Basilica;
and beyond them (*left*) the Old Forum and (*right*) part of the silted-up Severan Harbour

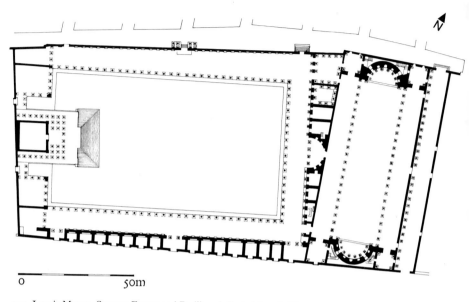

254. Lepcis Magna, Severan Forum and Basilica, dedicated in 216. Plan

Except for the arch, a hurriedly erected and very over-decorated structure, of interest more for the content and quality of its sculpture than for its architectural design, these were all buildings of real distinction. The harbour was an irregularly circular basin nearly 400 yards in diameter, with a lighthouse and a signal-tower on the extremities of the two moles; along the wharves stood ranges of warehouses, fronted by porticoes and two temples. From the waterside a colonnaded street, nearly 450 yards long and measuring 70 feet (21 m.) across the central carriageway, led up to a piazza adjoining the Hadrianic Baths. On the south-east side of this street was a bath-building (as yet unexcavated) and on the opposite side the great Severan forum and basilica. The principal building material throughout was a hard yellow local limestone, used in large dressed blocks and liberally supplemented with imported marbles and granites. For the more utilitarian structures and for the relatively few curved features, a

concreted rubble was used, faced with courses of small squared blocks and laced with brick or timber.

The forum [254] consisted of an open rectangular space measuring nearly 200 by 330 feet (60 by 100 m.), at the middle of the south-west end of which, framed by open columnar halls, stood a large temple dedicated to the Severan family. The temple, which stood on a double podium at the head of a spreading flight of steps, was a towering octastyle building of solid Proconnesian marble with red granite columns [255]. The same note of opulence was reflected in the colonnades that enclosed the remaining three sides, with columns of green Carystian marble and gleaming white Pentelic capitals and bases. Along the south-east side an elongated, wedge-shaped block of tabernae faced on to the Colonnaded Street, and another on the north-east side masked the change of direction as one passed from the forum into the basilica. The latter [256, 257] was a huge colonnaded hall,

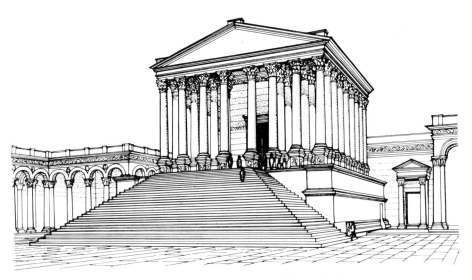

255. Lepcis Magna, temple in honour of the Severan family, *c.* 216. Restored view

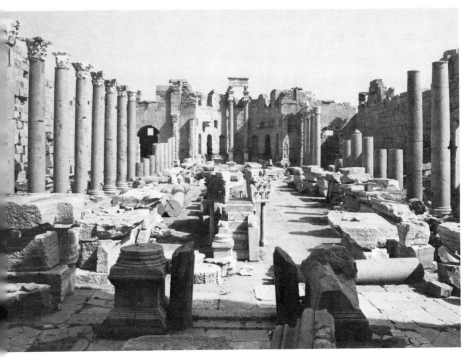

256. Lepcis Magna, Severan Basilica, dedicated in 216

with apses at the two ends of the central nave. This has a span of 62 feet (19 m.) and there were galleries over the lateral aisles, giving a total height from floor to ceiling (assuming a shallow clerestory) of well over 100 feet (30 m.). A pair of bracketed orders encircled each apse (the curious central feature in each case is an afterthought, of Severan date) and (another afterthought) there was an enclosed street with a decorative flanking order along the north-east façade. Yet another decorative order fronted the range of tabernae within the portico that faced the temple, across the forum [258]. This was a rich, elaborate, and highly individual architecture. Among its many distinctive features we may note the liberal use throughout of inde-

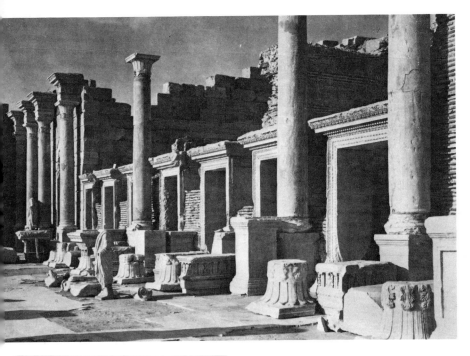

257 (*opposite*). Lepcis Magna, Severan Basilica, dedicated in 216. Restored view

258 (*above*). Lepcis Magna, north-east portico of the Severan Forum, early third century

259 (*left*). Lepcis Magna, lotus-and-acanthus capital from the Severan Forum, early third century, made of Pentelic marble by an Attic workman

pendent pedestals to give added height to the orders; the graceful lotus-and-acanthus capitals of forum and street [259], and the substitution in both of arches for the horizontal architraves of traditional classical practice; the use both in the nymphaeum and in the basilica of small rings of acanthus foliage between base and column; and throughout the complex, an em-phasis on height and elegance and on the qualities of fine masonry, set off by an elaborate use of coloured marbles and of rich, deeply carved architectural ornament.

That all this was the work of a single architect it is hard to doubt. Some of the site was ground reclaimed from the wadi that ran through the middle of the town, but much of it had to be

adapted to the irregularities of pre-existing street frontages, and the unity of plan could only be achieved by a number of adjustments which bear the mark of a clearly defined architectural personality. Such, for example, were the angle-chapels of the basilica and the wedge-shaped blocks of tabernae between the forum and basilica, and between the forum and the Colonnaded Street. The piazza is a copy-book exercise in the resolution of such problems. Faced by the divergent orientations respectively of the street leading up to the theatre, of the street (also colonnaded) that flanked the Hadrianic Baths, and now of the Colonnaded Street, the original intention was to build a circular colonnaded piazza at the point of junction. While still under construction this safe, but somewhat neutral, device was scrapped in favour of the bolder scheme of establishing a new dominant axis by building a huge, eye-catching fountain-building symmetrically across the angle between the two colonnaded streets [260].

A lesser architect (and, be it admitted, almost any architect trained in Rome) would have met such problems head-on by imposing an orderly, symmetrical plan upon the ground, as for example in the great Imperial fora of the capital. The architect of Lepcis had the more sensitive approach that makes a virtue of the problems posed by the site. One can see the same hand at work in the harbour, in the subtly receding planes of the steps and wharves of the east mole and in the contrast between the stepping up of the colonnades and the gentle slope of the mole itself. This was architecture in the grand manner, but it was interpreted with a light touch.

That the architect was a newcomer to North Africa there can be no doubt, and everything points to him having come (like many of his assistants, who left their signatures on the masonry and architectural detail) from the Greek-speaking world, probably from north-western Asia Minor. The pedestal bases, the distinctive masonry formula of the outer wall of

260. Lepcis Magna, Severan Nymphaeum, beginning of the third century, viewed from the north-east end of the second-century palaestra

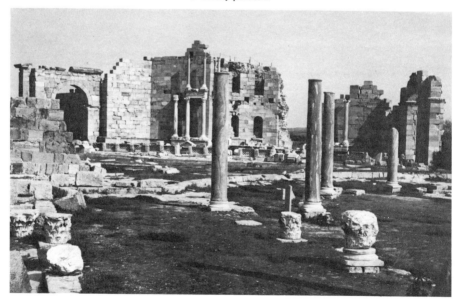

the forum and basilica, the Colonnaded Street, the screen-like fountain-building, the carved ornament, all these were typically and characteristically 'Asiatic'. The lotus-and-acanthus capitals were Attic in design and in materials, and the little acanthus ring between base and column, ultimately an Egyptian and Syrian feature, is found in Asia Minor. The arcaded colonnades, anticipating by a century those of Diocletian's palace at Spalato, had themselves been anticipated in Hadrian's great temple at Cyzicus. The only features that are unequivocally Western are the basilica and the temple. Here the architect's commission must have been to follow Roman models, notably the Forum and Basilica of Trajan; but the architectural vocabulary, materials, and methods that he used in carrying out his commission were those of his own background and training.

In all this the Severan building programme at Lepcis may be regarded as a logical extension and culmination of the artistic and commercial contacts built up in Tripolitania over the previous three-quarters of a century. Formally, like so much of this 'Imperial' or 'marble style' architecture, a building such as the Severan basilica was in consequence thoroughly conservative in spirit, a final flowering of the same Romano-hellenistic tradition as the Basilica Ulpia itself. But Severan Lepcis was also a portent for the future. The product of imperial patronage, its almost total disregard of the old regional frontiers foreshadowed the great imperial foundations of the later third and fourth centuries, which pushed these same tendencies to their logical conclusion, creating an architecture that was neither 'Eastern' nor 'Western', but truly Empire-wide in scope. For all their essential conservatism the Severan buildings at Lepcis had within them the seeds of the new creative impulses that were to come to fruition in the architecture of late antiquity.

TUNISIA, ALGERIA, MOROCCO

Lepcis and Sabratha were both cities that acquired their Roman shape within the setting of an already existing urban civilization. For a comparable vision of Roman city-life in areas where only the barest rudiments of such had existed before, we have to turn to the territories that lie to the west. Here Timgad (the ancient Thamugadi) and Djemila (Cuicul) will serve to present a picture of this other, but no less characteristic, aspect of Roman achievement in Africa.

Timgad, on the high plains of Algeria about 70 miles south of Constantine, was founded by Trajan in A.D. 100 as a colony of military veterans. Lambaesis, the new permanent camp of the Third Legion, lay only 15 miles to the west, and Timgad itself was sited so as to control one of the passes from the wild mountain country to the south. Such colonies had, however, another role. They were from the first intended also to be centres for the diffusion of Roman civilization in the one form that the Romans really understood, that of the Graeco-Roman town of Mediterranean lands. Apart from the military precision of its plan, this was the consideration that dominated the architecture of Timgad. As so often in the frontier provinces, the original foundation must have relied heavily upon the building experience and skills of military architects, active or retired, to which the remains of Lambaesis itself, a city in all but name and function, bear eloquent testimony.

The site chosen was on gently rolling ground within easy reach of an abundant water supply. The layout [261] was a textbook example of orderly rectangular planning, based on a square of 1,200 Roman feet (about 1,165 English feet, or 355 m.) subdivided in each direction into twelve equal city blocks (insulae), of which in the event the westernmost row was, for some reason, never built. The only deviation from strict symmetry was that the main north-south street (cardo) stopped at the geometrical centre of the town, where it joined the main east-west street (decumanus). Beyond this point the ground began to rise, and here, dominating the rest of the town, were sited the principal public buildings. The total area was not large (about 25

261. Thamugadi (Timgad), air view, showing the regular chequerboard layout
of the original foundation (100) and the irregular development of the following half-century

acres), and busy suburbs soon grew up beside
the roads leading out from it. By the end of the
second century the population is estimated at
12,000–15,000 persons.

Apart from the forum complex, a theatre, and
one or more of the smaller bath-buildings (and
possibly an open market-square, later built
over), the entire available space was given over

to the houses of the settlers. These at first were solid, undistinguished, single-storey structures, occupying a single insula or part of an insula and facing inwards on to a courtyard. Shops of the familiar taberna type occupied the better street frontages, and along the two main streets there were in addition streetside colonnades [263]. These were discontinuous at the street junctions, in the Ostian manner; but being columnar and uniform throughout their length, rather than arcaded and carried on piers, the effect is very like that of the colonnaded streets of the

with courses of small squared blocks and re-inforced with larger squared blocks, which was the regular African equivalent of the variously faced concretes of metropolitan practice.[19] Timber was evidently still available in quantity from the mountains, and vaulting was the exception.

The theatre, which is estimated as having seated between 3,500 and 4,000 persons, is a building that might have been found in any one of dozens of smaller African cities.[20] The forum too [262] followed familiar lines, but in this case

262. Thamugadi (Timgad), forum, 100. Plan

Eastern provincial cities.[18] The building materials throughout were dressed limestone for the principal architectural features, and for the rest a version of the mortared stonework, faced

the stereotypes allowed for more variety of local interpretation. An almost square central space (140 by 165 feet; 43 by 50 m.) was entirely enclosed by Corinthian colonnades, except at

one point where the podium of a temple was carried forward, so as to form a platform for public orators. (It is a singular fact that this is the only temple for which the original layout of the city made any provision.)[21] The basilica, which occupied the greater part of the east side, was a plain rectangular hall, 50 feet (15 m.) wide, with decorative pilasters down the two long walls; at the south end there was a raised tribunal, and opening off the east side a range of public offices. At the west end of the forum a smaller rectangular hall, lavishly veneered in marble and divided internally by steps and a columnar screen, was the meeting-place of the town council (*curia*), and there was a second, rather smaller hall, of unknown destination, at the north-west corner, beside the temple. Columnar exedrae and shops occupied the two long sides, those along the north side being in part at any rate terraced out over the shops and the large public lavatory which occupied the lower frontage, facing on to the main street.

This was the destined centre of the city's administrative life, and much of its commercial and social life too, and it followed a pattern which, though derived in almost all essentials from Italian practice, was almost infinitely adaptable to suit local circumstances. The ingredients were the open, paved piazza, usually colonnaded; the basilica, either a plain timber-roofed hall (as here and at Cuicul and Madauros)[22] or colonnaded internally (as at Tipasa, Sigus, and Thubursicu Numidarum);[23] the curia, a smaller but luxuriously equipped chamber, often with a forecourt or internal vestibule;[24] an official temple or temples; other municipal offices, such as a treasury or an archive building; a tribunal for speeches or public appearances; and assorted fountains, exedrae, statues, and shrines. At Timgad these ingredients found expression in a plan which escaped monotony by making effective use of a gentle rise in the ground level; and because the main lines of it must go back to the city's foundation, it offers an unusually clear picture of what were then held to be the essential requirements of the civic centre of one of the smaller provincial African towns.

The Trajanic colony prospered and expanded rapidly, and in the course of the second and third centuries it acquired a number of additional monuments and amenities. These included a Capitolium and one or two lesser temples, several monumental arches, two market buildings, a public library, and several fine public baths.

The Capitolium dates probably from the latter part of the second century. It was finely situated just outside the south-west corner of the early town so as to face obliquely across towards the city centre, and by local standards it was a very large, commanding building. The temple itself, which stood against the rear wall of a large porticoed precinct, was hexastyle Corinthian and peripteral on three sides, and it was very tall in proportion to its width, with the columns, themselves over 30 feet from pavement to capital, standing on a vaulted platform at the head of two flights of no less than thirty-eight steps; the cella was subdivided into three chapels, one for each member of the Capitoline triad. In all of this the Capitolium of Timgad was an almost aggressively Roman building, so Roman in fact that one suspects it of copying some well-known monument in one of the coastal cities, perhaps even the lost Capitolium of Carthage.[25]

The 'Arch of Trajan' [263] belongs to a group of monuments which was equally Roman in origin, but which was rapidly becoming acclimatized in a no less distinctively African form.[26] Arches are found in North Africa in large numbers and of every degree of complexity, from simple archways framed between shallow pilasters, as at Verecunda (Marcouna) near Lambaesis, up to the elaborately adorned four-way (*quadrifrons*) arches of Lepcis and Tébessa. At Timgad alone there were three other such arches: a single archway framed on each face between four free-standing columns, erected in honour of Marcus Aurelius between 166 and 169 across the Lambaesis road; another in 171 across the Mascula (east) road; and the North (Cirta) Gate, completed in 149, each pier of which carried an inner pilaster and an outer half-column. One can establish a classification

263. Thamugadi (Timgad), 'Arch of Trajan', late second century, and streetside colonnades

of these North African arches in terms of the number of arches, the number and disposition of the framing elements, and the use, or not, of free-standing columns, but elaboration is as often an index of means and taste as of chronology. The 'Arch of Trajan' at Timgad is certainly earlier than Severus, but probably not much earlier, since the closest parallels are with the probably Severan arch at Lambaesis and that of Macrinus (A.D. 217) at Diana Veteranorum (Zana). The most singular element of its design is the segmental pedimental feature that frames the aediculae above the lateral arches.

Market buildings (*macella*) were another feature of the Italian repertory that had reached Africa from Sicily or South Italy at an early date – perhaps already in Punic times. The market at Hippo Regius [264A] consisted of two distinct elements, a rectangular, colonnaded outer courtyard for temporary markets, and, opening off one side of it, an inner courtyard on the Pompeian model, with permanent stalls around three sides and a circular pavilion in the middle. Similar macellum buildings, with or without outer courtyards or pavilions and often containing a statue or shrine of Mercury, the god of

commerce, are known from half a dozen other African sites, where they clearly played an important part in the daily life of the community.[27] Of the two at Timgad, the Market of Sertius, built in the third century just outside the 'Arch of Trajan', was a building of some pretensions [264C]. Beyond an irregular forecourt it consisted of an enclosed rectangular courtyard, colonnaded on three sides and equipped with stalls along the inner face of the façade. Across the far end a taller colonnade carried the gabled façade of an apsidal hall with seven radiating stalls round the curve. After the sober rectangularity of the Trajanic city the apse strikes a refreshingly different note. But the real surprise, amidst all the banalities of provincial classical detailing, is the tall, narrow arcading of the inner façade, resting on independent square entablature blocks as if on so many detached architectural brackets.

The East Market, within the old town, was another relatively late building, and it had an even more unusual plan.[28] Behind an outer portico, with a range of market stalls on either side of a central semicircular vestibule, were a pair of small, partly intersecting, apsidal inner

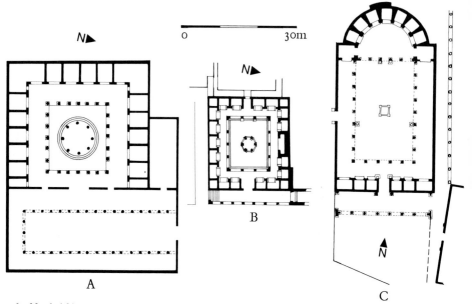

264. North Africa, market buildings. Plans. (A) Hippo Regius (Hippone),
date uncertain; (B) Cuicul (Djemila), Market of Cosinius, mid second century [cf. 269];
(C) Thamugadi (Timgad), Market of Sertius, just outside the west gate
of the original settlement [cf. 261], third century

courtyards, set side by side, facing forwards, and ringed with stalls. In this case the architect was faced with the problem of inscribing an elaborately curvilinear design within the framework of a pre-existing insula; and even if the result suggests enthusiasm rather than experience, it is interesting and significant that he should have tried. Much the same situation confronted the architect of the library, the gift of a wealthy third-century citizen.[29] In this case the solution adopted was to inscribe the library proper, an elongated apsidal hall, between two rectangular chambers at the far end of a shallow rectangular forecourt, porticoed on three sides and itself flanked by small reading rooms or offices. Around the curve of the central hall, framed between the marble columns of a projecting order, were the recesses that housed the cupboards for the storage of the rolls, with a larger central recess for a statue of the emperor or presiding divinity. Here and there one detects

a certain hesitancy, notably in the relation of the semi-dome to the vaulting (or timber roof?) over the first bay of the library hall; but on the whole the result is a reasonably successful compromise between old and new.

By the third century the ripples of the 'new' metropolitan architecture were evidently disturbing the calm even of these remote backwaters of Empire. In Africa, as elsewhere, a very important part in the introduction of the new ideas must have been played by the bathbuildings. No less than fourteen of various dates and sizes have been identified at Timgad alone, and it was a poor town indeed that did not boast three or four. No two are exactly alike, but amidst an almost infinite variety of plan one can distinguish two broad trends, both of which, as it happens, are well represented at Timgad. The North Baths, built in the third century, was a compact rectangular structure [265B] measuring 200 by 260 feet (60 by 80 m.), symmetrical

265. Thamugadi, (Timgad), bath-buildings. Plans.
(A) South Baths, mid second century;
(B) North Baths, third century

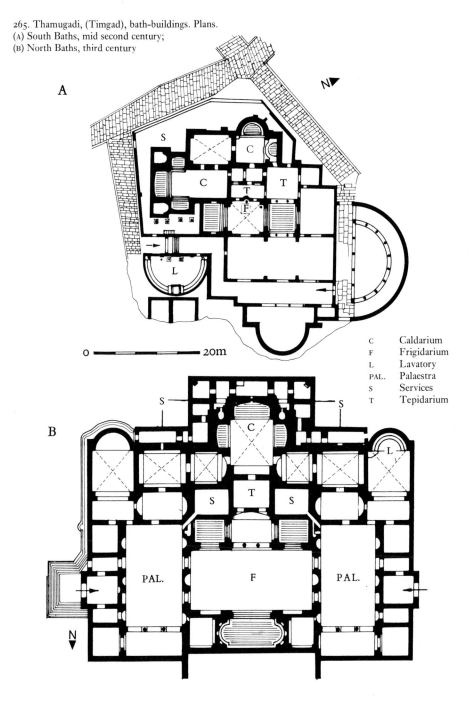

C Caldarium
F Frigidarium
L Lavatory
PAL. Palaestra
S Services
T Tepidarium

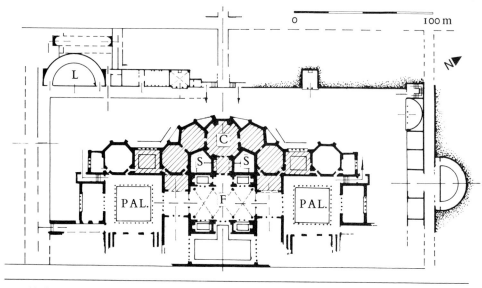

0 100 m

266. Carthage, Antonine Baths, 143–62.
Plan. Of the shaded areas very little more than
the vaulted substructures is now standing

c	Caldarium	PAL.	Palaestra
F	Frigidarium	s	Services
L	Lavatory		

about its shorter axis and patently derived from
the great public bath-buildings of Rome. The
Hadrianic Baths at Lepcis (123) was probably
the first of these 'Imperial' bath-buildings in
Africa, and it was followed twenty years later
(143) by the great Antonine Baths at Carthage
[266], with its highly original and ingeniously
planned ring of interlocking hexagonal caldaria.
This was an enormous prestige monument, 650
feet long and lavishly equipped with mosaics
and imported marbles, and it must have made a
great impression throughout the African pro-
vinces. Other known examples of the type are at
Cuicul (183) [267], at Utica, at Uthina, at
Caesarea (Cherchel) (of Severan date), the
Licinian Baths at Thugga (temp. Gallienus,
259–68), the late 'Large' Baths at Lambaesis,
and an unfinished mid-fourth-century(?) bath-
complex at Lepcis.[30] The buildings at Caesarea
and Thugga will serve to give an idea of the
range of architectural possibilities inherent in
the same basic type: the former very wide in
proportion to its depth and almost osten-

tatiously rectilinear in plan, the latter a tightly
planned complex of ingeniously interlocking
curves, which made use also of columnar
arcading, as in the Severan forum at Lepcis.
The Timgad baths, though of rather sober
design, were spacious and workmanlike. They
were also the only building at Timgad to be
faced throughout in brick, and it is probably
right to detect the hand of an architect brought
in for the purpose.

The South Baths, built in the mid second
century on an irregular plot of ground just
outside the south gate, were different in almost
every respect [265A]. They were of the far
commoner type with a single circuit of hot and
cold rooms, within which functionalism might
yield· to a certain symmetry within the in-
dividual rooms, or groups of rooms, but rarely,
if ever, to a symmetrical treatment of the
exterior. In the older towns this would be lost to
sight among the houses of a crowded urban
quarter, as in the Summer Baths at Thuburbo
Maius. Usually, however, these large buildings

were wholly or partly free-standing, and in that case there were two possibilities open to the architect. He might still contrive to present a decorously monumental face to the outer world, as he did, for example, with some success in the Large Baths at Madauros. The alternative adopted by the architect of the South Baths at Timgad was to make a virtue of the irregularities of his site by deliberately laying out the rectangular framework of his building at 45 degrees to the adjoining city grid and filling in

the angles with boldly projecting apses and curved exedrae. When one reflects that the rooms of the actual bathing-suite were certainly vaulted, and that the vaults almost certainly had exposed outer surfaces, as in the Hunting Baths at Lepcis, one can imagine something of the impact of such a building upon the staid burghers of Timgad.[31]

At first glance nothing could resemble Timgad less than Cuicul (modern Djemila), 70 miles to the north-west, on the old main road from

267. Cuicul, (Djemila), bath-building, 183. Plan (cf. illustration 268, the large building near the south-west end of the excavated area)

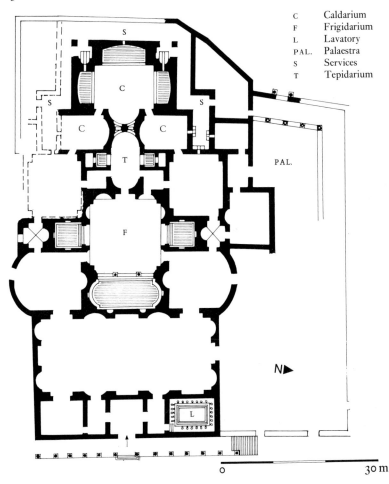

C	Caldarium
F	Frigidarium
L	Lavatory
PAL.	Palaestra
S	Services
T	Tepidarium

0 30 m

268. Cuicul (Djemila), air view, showing the original foundation (96 or 97)
laid out on a regular plan on the northern end of a steep spur and below, separated from it
by the Severan Forum, the second-century and later city

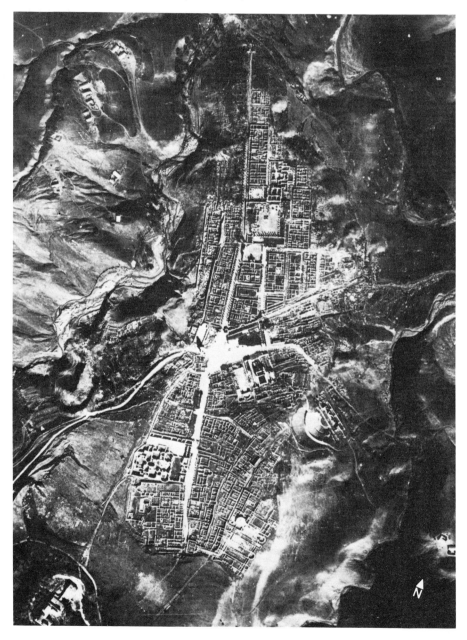

Cirta (Constantine) to Sitifis (Sétif), Timgad four-square and uncompromising on the edge of the plain, Cuicul clinging to the northern extremity of a narrow triangular plateau overlooking the heads of two plunging valleys, with only the rudiments of a formal layout [268]. Between them they represent the two everpresent poles of Roman city planning. But although the buildings of Cuicul as a result display an animation and a sense of adventure that are sadly lacking amidst the bourgeois proprieties of Timgad, one has only to scratch the surface to find out how closely the two cities resemble each other.

This is hardly surprising. Like Timgad, Cuicul was a military colony, founded only three years earlier (96 or 97) to control an important road up through the mountains of the Kabylie. Like Timgad again it prospered, and it grew rapidly in the only direction that was physically possible, southwards up the ridge. By the second half of the century the buildings outside the walls already included a theatre

(161) and a large bath-building of 'Imperial' type (183); and a few years later the expansion was given definitive shape by the conversion of the open space outside the old walls into a new and larger forum, dominated by an arch in honour of the emperor Caracalla (216) and a fine temple to the reigning Severan dynasty (229).[32]

The architectural ingredients followed a familiar pattern. Within the old town there were the main street with flanking colonnades, the forum complex, a market building, a public baths occupying the greater part of one of the rectangular insulae, numerous private houses, and (in this respect unlike Timgad) two temples. The forum square was colonnaded along two sides, and along the other two sides were a basilica in the shape of a plain rectangular hall with a raised tribunal at one end, a large Capitolium with tripartite cella, and a curia building with an internal vestibule. The Market of Cosinius [264B, 269] was a typical macellum with porticoes and stalls grouped around an open square with a central hexagonal pavilion.

269. Cuicul (Djemila), Market of Cosinius, mid second century, with remains of a central pavilion and (*left*) table of standard measures [cf. 264B]. Cf. illustration 268, in the old town, opening off the main north-south street just north of the original forum

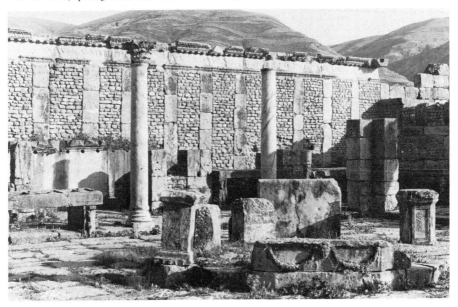

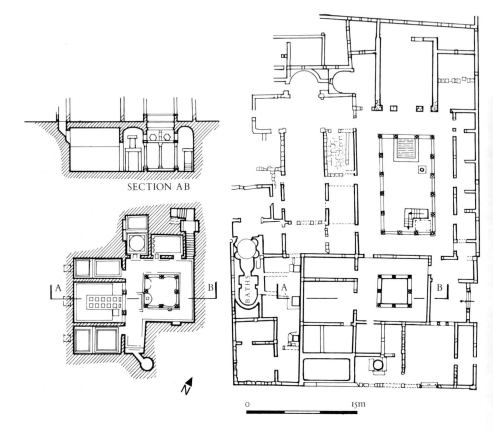

270 (A). Bulla Regia,
House of the Hunt, third century.
(*left*) plan and section of the underground
residential suite for summer use,
(*right*) plan at ground level

In it, as at Lepcis, one can see the city's official
weights and measures. Of the temples, that of
Venus Genetrix was unusual in having only the
porch and steps projecting from the rear wall of
a colonnaded precinct; the other, a long, narrow
prostyle building of unknown dedication, stood
free within a porticoed enclosure. A number of
fine peristyle courtyard-houses with handsome
mosaics are of later date, replacing the simpler
residences of the earlier settlers. Peristyle
houses of this type, usually with a principal
living-room, the *triclinium*, dominating the
courtyard and with a greater or less emphasis on
compactness of planning in accordance with

pressures on building space, were typical of the better-class town houses of North Africa. There were a great many local variants, ranging from the extraordinary houses of Bulla Regia [270A, B],

with two equally prominent residential storeys (perhaps for summer and winter use), to the more commonplace, relaxed layout of a building such as the second-century 'House of

270 (B). Bulla Regia, House of the Hunt, third century. The light-well peristyle of the underground suite

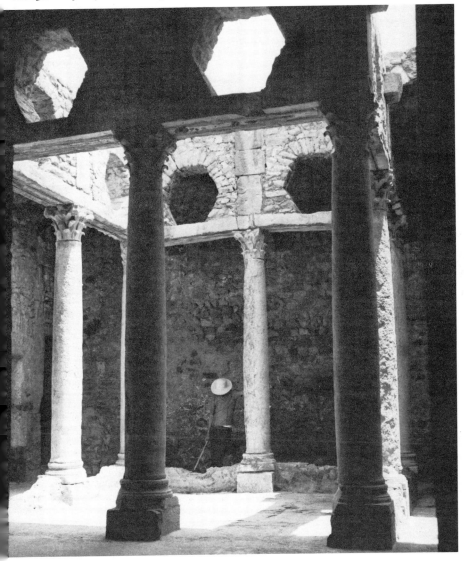

271. (A) Althiburos, House of the Muses, second century;
(B) Volubilis, House of Venus, mid third century. Plans

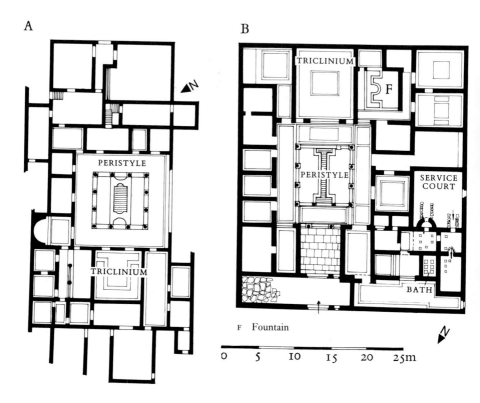

F Fountain

0 5 10 15 20 25m

the Muses' at Althiburos, in Tunisia [271A], which was free-standing in its own grounds, or that of 'Venus and her Court' at Volubilis, in Morocco [271B], built towards the middle of the third century as part of a city quarter of well-planned residential insulae. Illustration 272 shows a town house of the same general type at Tipasa, in this case terraced out so as to take advantage of a sloping, seaward-facing site and incorporating shops at ground level within the streetside porticoes. The detailed disposition varied greatly with the wealth of the owner and with local circumstance, but the basic type is remarkably uniform.[33] A feature which these

houses shared with the bath-buildings and other public architecture was the wealth of the polychrome mosaic ornament of pavements, walls, and vaults. Here at any rate was a field in which North Africa broke fresh ground, preparing the way for one of the most characteristic aspects of late antique architecture.

Apart from its magnificent setting, terraced into the steep eastern slopes, the theatre of Cuicul, of the same order and size and seating capacity as at Timgad, was a rather ordinary building. The baths of 183 [267] display far more originality – in their clever adaptation of the 'Imperial' plan to an unusually narrow site,

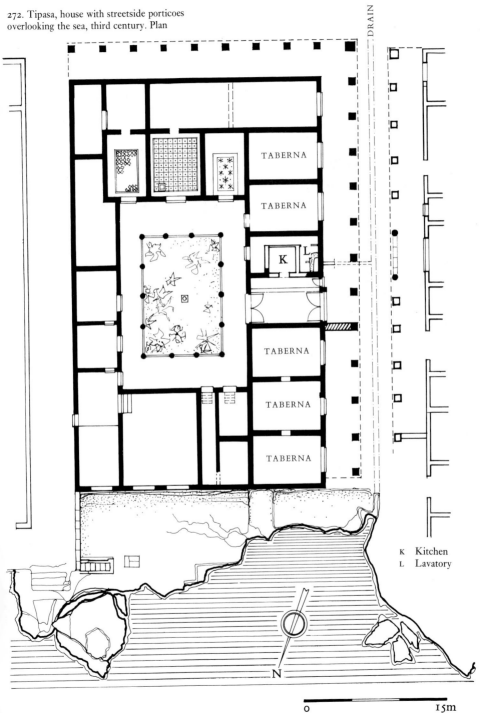

272. Tipasa, house with streetside porticoes overlooking the sea, third century. Plan

K Kitchen
L Lavatory

0 15m

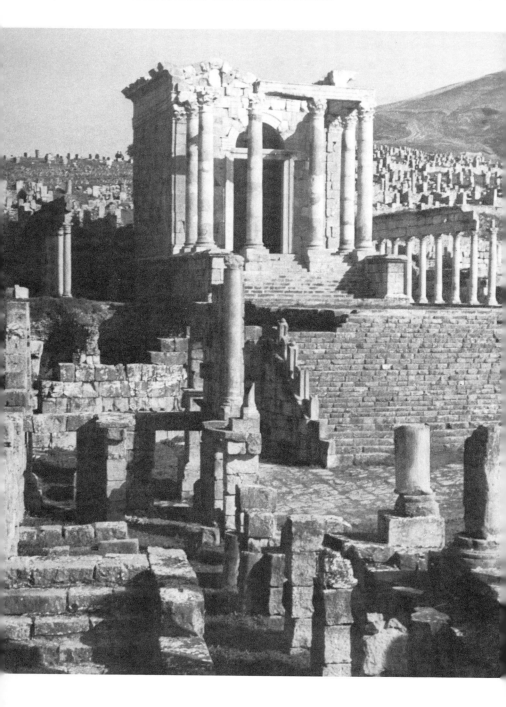

273 (*opposite*). Cuicul (Djemila),
Temple of the Severan family, 229

in the diamond-shaped scheme of oblique vistas that runs right through from the main entrance to the main axial caldarium, and in the (for the date and place) remarkably sophisticated use of internal curvilinear forms. Once again one suspects an architect brought in for the purpose. The New Forum was dominated by two buildings, the Arch of Caracalla (which narrowly escaped transport to Paris in 1842) and the Temple of the Severan Family [273]. The latter was a prostyle tetrastyle building with an almost square cella, set against the rear wall of a square enclosure with colonnades down the two long sides. The plan is that of dozens of North African temples; but the site and the raising of the temple itself on a very tall podium at the head of three flights of monumental steps give it an authority and a dignity that transcend the commonplaces of the familiar everyday formulae. This is one of those buildings which, without any particular intrinsic distinction, are nevertheless just right in their context.

One other aspect of the architectural history of Cuicul deserves brief mention. In many cities of North Africa the third quarter of the fourth century was a period of surprising building activity. Not only do we find many public monuments, including pagan temples, undergoing restoration, but even new buildings, such as a granary at Rusicade (Philippeville). Cuicul had its share of impressive Christian buildings on the south hill, but it also acquired (364–7) a large new civil basilica, a rectangular hall with a single apse at the far end on the model of the contemporary audience halls. Another basilican hall of the same general form was added at about the same date beside the Arch of Caracalla and was almost certainly a cloth-market (*basilica vestiaria*). Inscriptions refer also to a portico named after Gratian (d. 383). All this took place at a time when in many parts of the Empire civic life was going rapidly downhill. One sees that in

this part of Roman Africa urban civilization was a vigorous growth.[34]

The preceding pages have described in some detail four North African cities about which we happen to be unusually well informed. Two of these, Lepcis Magna and Sabratha, give us a picture of Roman urban life in an area where Rome was building on foundations already established by the Carthaginians. Here one can get some idea of the continuity of development of the architecture of Roman North Africa; and also (because these were harbour towns in close everyday contact with many other parts of the Mediterranean) an idea of some of the outside influences by which that development was conditioned. The other two, Timgad and Cuicul, were new foundations, involving the imposition of the outward forms of Roman life on areas in which such amenities had hitherto been few or non-existent. Their architecture was bound at first to be derivative; and because they were remote from the main creative centres, new ideas were slower to penetrate. Nevertheless, Roman civilization, once established, put down deep roots. The Christian architecture of Timgad and Cuicul lies outside the scope of this volume; but, no less than the monuments of the Antonine and Severan Age, it is a product of what had gone before, the ultimate justification of the vision and sound good sense of the Early Imperial founders of these cities.

One could continue the catalogue almost indefinitely. There are the surviving monuments of the great coastal cities, Carthage, Utica, Hippo Regius (Bône), Tipasa, Caesarea (Cherchel), cities which, like Lepcis and on a more modest scale Sabratha, were the principal exponents in Africa of a larger Mediterranean culture and the immediate source of much that we find in the often better preserved cities of the interior. Of the latter, many of which developed from pre-Roman communities (a fact that is very evident in their tortuous streets and irregular layouts), the number of those that have preserved considerable remains of their Roman-period architecture is almost embarrassingly large – Gigthis, Mactar, Madauros (the birth-

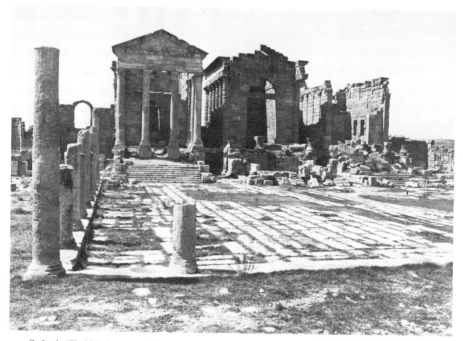

274. Sufetula (Sbeitla), forum and Capitolium,
the latter comprising three distinct temples, mid second century

place of Apuleius), Sufetula (Sbeitla) [274],
Theveste (Tébessa), Thibilis (Announa),
Thuburbo Maius, Thugga (Dougga), Volubilis,
to name only some of the more substantial.
Then again there were the small country towns
which, without ever achieving formal urban
status, did in fact take on much of the outward
appearance of their grander neighbours; one
among many hundreds that happens to have
been fully explored is Castellum Tidditanorum,
near Cirta. But although all these sites contain
many buildings of interest, to pursue them in
detail would be to lose sight of the broader
picture in a wealth of accessory detail. Instead,
the rest of this chapter will try to summarize a
few of the more general aspects of this Roman
North African architecture – its pre-Roman
inheritance, the successive outside influences to
which it was subjected, and something of its
wider affiliations.

We have already caught a glimpse of the local
pre-Imperial architectural traditions that lay
behind the earliest surviving architecture of
Lepcis Magna and Sabratha. As one moves
westwards towards the more immediate orbit of
Carthage they become very much more ap-
parent. For a long time the building materials
and techniques in everyday use, including the
widespread use of stucco for superficial detail,
remained those of pre-Roman custom. To a
more limited extent this was true also of the
architectural detail. Here, understandably, the
first casualties of increasing Roman influence
were those features that had little or no previous
history of classical usage. Such were the Phoe-
nician volute capitals and the very distinctive
'Egyptian' mouldings, both of which we have
already met in use in Syria as late as the first
century A.D.,[35] and which had found their way,
through Phoenicia, to Sicily, Sardinia, and

North Africa at least as early as the fifth century B.C. Both figure, for example, on a tower-like mausoleum of the second century B.C. at Thugga, and in the cornice (in this instance with Doric columns and capitals) of the Medrecen, a great circular, tumulus-like mausoleum of one of the Numidian kings, perhaps Micapsa (d. 118 B.C.), not far from Lambaesis.[36] In Africa neither form seems to have survived long, if at all, into the first century A.D. The Ionic capital continued to be used at Lepcis, throughout the century. In Tunisia, on the other hand, where the impact of Italy was stronger and more direct, its place was commonly taken by capitals which seem to be more or less close copies of the Italic Tuscan order, introduced in the early first century B.C. As late as the time of Trajan the capitals of the forum at Thubursicu Numidarum (Khamissa) and those of the streetside colonnades of Timgad [263] were of this type.

As was often the case in the Roman world, it was in the field of religion, in temples and tombs, that the results of the native influence were strongest and most persistent. Among the very large number of Roman-period temples that have come down to us in Africa one can distinguish two main groups. One is the typical forward-facing temple of the Republican Italic tradition, normally prostyle or pseudo-peripteral and regularly standing on a podium at the head of a flight of steps. This sort of temple is found with almost monotonous regularity throughout the territory, either standing alone or else placed against the rear wall of a sanctuary enclosure, which was usually, though not invariably, rectangular and very often colonnaded (illustrations 275, 276, at Thuburbo). They vary greatly in size and elaboration, from simple, box-like shrines (e.g. Thibilis) to large temples that are peripteral on three sides (Gigthis

275. Thuburbo Maius, Capitolium, 168

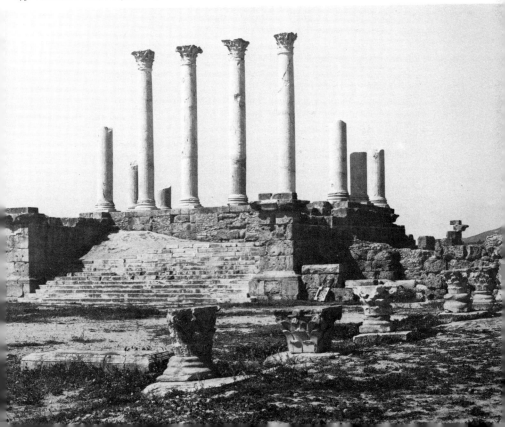

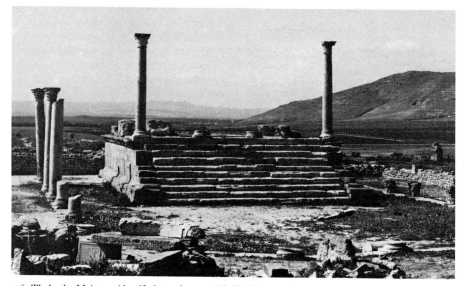

276. Thuburbo Maius, unidentified temple, second half of the second century

[277B], the Capitolium at Timgad) or even, exceptionally, on all four (Cirta, the Temple of Caelestis at Thugga); but although the names of most of the divinities worshipped (e.g. Mercury, Saturn, Apollo, Caelestis) thinly conceal those of the old native gods, the externals of the cult have been almost totally classicized. The Italic origins of this distinctive type are emphasized by its total absence from Cyrenaica.

The other recurrent group is most readily defined as consisting of a sacred enclosure with a small inner shrine opening off it, at the same level or at most up one or two steps. Good examples of such temples are those of the Cereres at Thuburbo Maius [277A], the temple at Sufetula that was later converted into the Church of Servus, and the Temple of Saturn at Thugga. To the same group belong the Romano-Punic temple at Nora in Sardinia and one recently excavated at Lixus in Morocco.[37] In at least one case, at Thugga, the Roman-period sanctuary is known to overlie a Punic *tophet*, and there can be little doubt that such buildings expressed in classical terms a type of

shrine that was already familiar in Punic Africa. It must go back to the very old Semitic tradition of a 'Holy of Holies', which was not so much a temple as a repository for sacred objects, set apart from the open sacred precinct within which the actual religious rituals took place.

With the passage of time the distinction between the 'Punic' and the 'Roman' types, never very sharply drawn, became increasingly blurred – as in very similar circumstances it did in Gaul. The substitution of the columns of an open exedra (Sufetula, Thugga) for the doorway of the primitive enclosed cella (Temple of the Cereres at Thuburbo Maius; cf. the Temple of Mercury in the same city, and perhaps also the North-west Forum Temple at Sabratha) was already a step in this direction. A further step was to set the cella on a podium, while still leaving it projecting beyond the rear wall of the enclosure, as at Cuicul in the Temple of Venus Genetrix, at Theveste, at Thugga in the mid-second-century Temple of Minerva, and in a temple dedicated in 162 to a group of divinities at Lambaesis [277C]. It only remained to bring

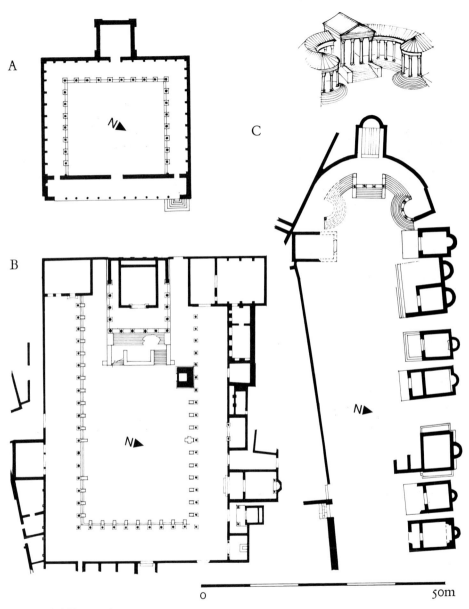

277. North Africa, temples.
(A) Thuburbo Maius, Temple of the Cereres, first century. Plan;
(B) Gigthis, Temple A (Capitolium?), second century. Plan;
(C) Lambaesis, temple dedicated in 162 to Aesculapius and a group
of other divinities. Restored view and plan

the cella within the framework of the precinct and the resulting building was indistinguishable from a 'Roman' temple within its precinct, a fact which no doubt goes far to explain the wide popularity of this type of sanctuary throughout the territory. The temple at Lambaesis, with its porch tightly framed between the convex inward projections of a concave portico, is also, for Africa, an unusually bold example of baroque planning. It bears a family resemblance to the elaborate Sanctuary of the Nymphs near Zaghouan [278], at the principal source of the great aqueduct that supplied Carthage.[38]

Outside the field of religion, few of the ideas that shaped the architecture of Roman Africa were other than Italian. Already in Punic times the influence of Magna Graecia and Sicily had been strong, and with the annexation of the province of Africa in 146 B.C. Rome and Campania also came directly into the picture. In the present state of knowledge it is not easy to assess the impact of Republican Italy in any detail; but some at any rate of the building types that were common later, e.g. the Italic podium temple and the macellum, are presumably a legacy from this Republican phase. More generally, the widespread acceptance of classical forms and ideas as the natural medium of architectural expression paved the way for the rapid development that followed the establishment of the Augustan Peace.

During the first century A.D. the materials and building techniques were still very largely those of the preceding phase, and wherever, as at Lepcis, one can view the architecture of this period in a sufficiently broad perspective, it can be seen to have retained and developed a considerable individuality of detailed expression. This had the makings of a genuinely Romano-African architecture. But the building types – the basilicas and the state temples, the theatres and the aqueducts – these were all essentially Italian; and with the establishment of military colonies and the founding of other new settlements the relationship received fresh emphasis. There is more than a grain of truth in the view that a city such as Timgad was in conception a small Italian town transplanted to the frontiers.

By the early second century horizons were beginning to widen. Italy and the western provinces continued to be Africa's natural outlet (a more detailed study would reveal many points of contact with Mediterranean Spain), and the new concrete architecture began to make steady inroads on the entrenched positions of provincial architectural conservatism. At the same time, however, an entirely new situation was created by the wholesale adoption of marble as the building material *par excellence* for monumental use. The main supplies of fine marbles and granites came from the Aegean and from Egypt, and with them came new traditions of craftsmanship and architectural decoration. Within a generation local materials and styles disappeared from monumental use in the coastal cities and their place was taken by an opulent, but for the most part rather dull, 'marble style' architecture, of which the norms were no longer provincial but Empire-wide. The Antonine Baths at Carthage and the Severan buildings of Lepcis Magna together epitomize the convergence of these two currents, from Italy and from the eastern Mediterranean. Though never a creative centre in its own right, throughout its history Roman Africa showed itself ready to receive and to put to good use the architectural creations of others, and its surviving remains are an unrivalled exemplar of what the Empire could mean in this respect.

278. Zaghouan, Sanctuary of the Nymphs,
at the source of the aqueduct that supplied Carthage.
Restored view

LATE PAGAN ARCHITECTURE
IN ROME AND IN THE PROVINCES

CHAPTER 14

ARCHITECTURE IN ROME

FROM MAXIMIN TO CONSTANTINE

(A.D. 235 - 337)

With the murder of the last emperor of the Severan dynasty, Severus Alexander, in 235 the Empire entered on a period of anarchy, civil war, and external disaster from which it was only finally rescued by the energy and ability of the great soldier emperors of the last two decades of the century. Beset on every side by revolts and by incursions from beyond the frontiers, their treasuries strained to the utmost by the requirements of their troops, the successive emperors had neither the time nor the resources to indulge in ambitious building projects. Under Aurelian (270–5) the tide of adversity was temporarily stemmed; and although the city wall which bears his name was a matter of urgent necessity, his great Temple of the Sun on the edge of the Campus Martius was a monument in the best tradition of imperial patronage. But Aurelian was assassinated in 275, and the only architectural event of note during the next decade was the disappearance of several venerable monuments in a fire which swept the north end of the Forum Romanum in 283. It was not until 284 that Diocletian finally succeeded in restoring the authority of the central government and ushered in the last great building phase of Rome before, in 330, Constantine transferred the seat of government to his new capital of Constantinople.

Of Aurelian's two great enterprises, the walls, which with relatively minor variations were to remain the defensive circuit of Rome down to 1870, were begun in 270 or 271 after the incursion of a horde of Germanic tribesmen into the Po valley had shown that even the capital of the Roman world could no longer afford to disregard its own defences. It was a vast undertaking. The total circuit is over 12 miles (about 19 km.) in length, and despite a virtual mobilization of the building industry[1] the wall took about ten years to build. It was $11\frac{1}{2}$–13 feet (3.5–4 m.) thick at the base and in its original form $25\frac{1}{2}$ feet (7.8 m.) high, with a continuous open wall-walk, protected by a parapet and merlons. Square towers projected at intervals of 100 Roman feet (97 English feet, or 29.6 m.). In addition to numerous posterns there were eighteen principal gates, each with one or two stone arches, flanked by two-storeyed semicircular towers and surmounted by a windowed gallery to house the mechanism of the portcullis [279]. Only the actual gateways were of stone. Elsewhere the material throughout is concrete faced with brick, almost all of it re-used material.

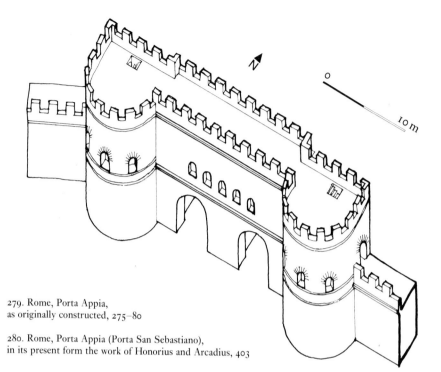

279. Rome, Porta Appia,
as originally constructed, 275–80

280. Rome, Porta Appia (Porta San Sebastiano),
in its present form the work of Honorius and Arcadius, 403

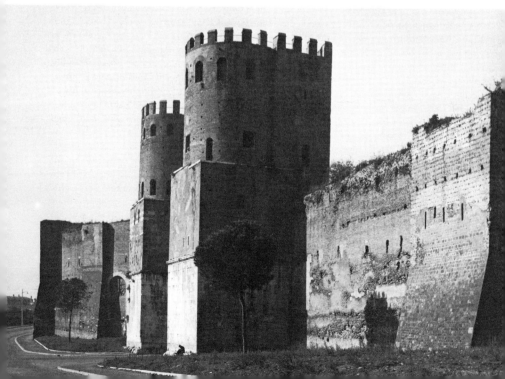

Evidently the organization of the state-owned brick industry had broken down completely since Severan times. At various later dates, notably under Maxentius and again under Arcadius and Honorius in 403, the walls were heightened and most of the gates strengthened or rebuilt [280].

No other single Roman monument so aptly symbolizes the changed role of Rome within the Empire. Hitherto the military architecture of the frontiers had impinged very little upon the civil architecture of the Mediterranean provinces. Now for the first time we find the architecture of the frontiers transported to the capital. Furthermore Rome was only one of innumerable European cities which found themselves faced suddenly with the need to defend themselves in grim earnest against the menace from the north. The tide had turned and was everywhere beginning to flow in reverse. As for the Aurelianic walls of Rome, the very fact of their building must have made an immense impression upon contemporary thought and taste, and it can be no accident that the clean, functional lines of their towers and gates foreshadow so much that is most characteristic of the late architecture of the capital.

Aurelian's other great enterprise, the Temple of the Sun (Sol), was no less symptomatic of its age. It reflects the same broadly monotheistic trend of religious thinking, Eastern in origin, as was manifest also in Christianity. Even the dedication recalls such nearly contemporary monuments as the Christ-Helios mosaic of the Vatican cemetery and the Sol Invictus coinage of Constantine himself. The occasion for the temple's foundation and the funds for its building were furnished by Aurelian's reconquest in 273 of Zenobia's short-lived Oriental empire of Palmyra. Of the classical buildings nothing is now visible. They lay just to the east of the modern Corso, beneath and near the church of S. Silvestro, and our knowledge of them is derived almost entirely from a plan and drawing made by Palladio in the sixteenth century, when quite a lot must still have been standing [281].

Palladio's plan shows a circular temple in the centre of a large rectangular enclosure (413 by 284 feet; 126 by 86.4 m.), the single entrance to which lay at the north end, in the middle of one short side, and was itself approached through the vestibule set in the middle of one of the two apses of what he shows as an elongated forecourt with opposed apsidal ends. It is difficult to judge the credibility of such a plan out of its architectural context (which alone could explain, for example, the ninety-degree shift in the conventional relationship between forecourt and inner precinct), but most of the detail is plausible enough. The inward-looking inner precinct (which must have been porticoed, though it is not so shown in Palladio's plan) and the central position within it of the temple, both have good Syrian precedents, including the great Temple of Bel at Palmyra itself [230, 231]; the columnar exedrae opening off the inner precinct might well have been borrowed from Vespasian's Temple of Peace; and the circular temple, the scale of which can be judged from the eight porphyry columns (height $22\frac{1}{2}$ feet, or 6.88 m.) which Justinian took from it to use in his church of Hagia Sophia, would have been as symbolically appropriate to its purpose as, a century later, were the cruciform plans of Early Christian architecture. The plan of the forecourt, on the other hand, and the double demi-columnar order with broken pediments which adorned it patently derive from Trajan's Forum, and the scanty surviving remains of the architectural decoration echo that of the Baths of Caracalla, where Aurelian is known to have undertaken repairs after a fire. For all its unusual features, Palladio's plan is perfectly credible as an early manifestation of that same far-ranging eclecticism of which the Imperial foundations of Constantine were shortly to offer so many striking examples.

The work of Diocletian (284–305) was, by contrast, broadly conservative in its taste. His Curia, or senate house, rebuilt after the fire of 283, followed very closely the time-honoured lines and proportions of its Domitianic and Julian predecessors. Internally it was a plain

281. Rome, Aurelian's Temple of the Sun (Sol), 275–80. Plan, after Palladio

rectangular hall, with low steps for the seating of the senators running down either side towards the dais of the presiding magistrate and with a coffered timber ceiling, the height of which, half the sum of the length and breadth, still observed the Vitruvian prescription for the acoustics of such a building. The unusual proportions were deliberately emphasized by contrasting the severely plain upper walls, lit on three sides by single windows just below ceiling height, with the three pairs of columnar aediculae and the rich polychrome marbling of the lower walls and floor. From the outside, as one sees it today [15], it looks bleak and strangely out of proportion, but one has to remember that in antiquity, flanked by the Basilica Aemilia and the Secretarium Senatus (now Pietro da Cortona's church of SS. Luca e Martino), one saw little more than the pedimental façade, dominated by the three large windows which were yet another legacy from its historic predecessors. The severity of the pediment as one sees it today, constructed of brick with small travertine consoles, was lightened in antiquity by a facing of stucco which once covered the entire façade. Traces of this, imitating drafted masonry, can still be seen just below the horizontal entablature. A singular feature of the cornice is the progressive angling of the consoles as one approaches the corners. One meets this in painting at a very early date, but I know of no earlier example in real architecture.

Diocletian's great bath-building on the high ground north-east of the Viminal was begun in or soon after 298 and completed in 305–6. It followed closely the scheme established by the Baths of Caracalla, from which it differed principally in the more uniform distribution of

0 50m

the secondary structures around the perimeter (one of the angle rotundas survives as the church of S. Bernardo) and in the greater simplicity and tighter planning of the huge (785 by 475 feet; 240 by 144 m.) central block [282]. In particular one may note the opening up of the vista down the whole length of the long axis, a tantalizing alternation of light and shade viewed between receding pairs of columns; the neat, efficient planning of the service courtyards; the alternation of enclosed rectangular and curvilinear spaces along the shorter axis; and, most strikingly of all, the substitution of a rectangular, cross-vaulted caldarium with four projecting apses for the great domed rotunda of the Baths of Caracalla. If the latter building had marked the coming of age of this most ambitious of all Imperial building types, the Baths of Diocletian certainly represent its full maturity.

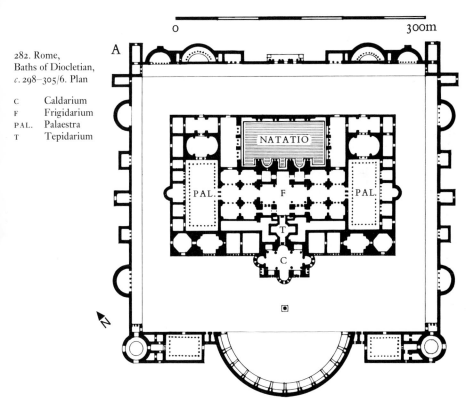

0 300m

282. Rome,
Baths of Diocletian,
c. 298–305/6. Plan

C Caldarium
F Frigidarium
PAL. Palaestra
T Tepidarium

283. Rome, Baths of Diocletian, *c.* 298–305/6.
The central hall remodelled as the church of Santa Maria degli Angeli

From the outside, the baths relied for their effect almost exclusively on the marshalling of the masonry masses.[2] The interior on the other hand was as rich and varied as the exterior was simple. At one extreme we have the three tiers of elaborate columnar exedrae ranged along the stage-like buttresses and re-entrants which constituted the façade of the frigidarium towards the swimming-pool (*natatio*), and which are the subject of one of the best known of Piranesi's prints; and at the other, the grandiose simplicity of the great triple-vaulted frigidarium, converted by Vanvitelli on the designs of Michelangelo into the church of S. Maria degli Angeli [283]. Like the Pantheon this is a building to be experienced, not described. The vistas have been closed, the glow of marble and mosaic very largely replaced by paint. But for all its muted tones, one can still catch a glimpse of one of these great Roman interiors under something approaching Roman conditions.

The last of the pagan emperors of Rome, Maxentius (306–12), was another prolific builder. Nothing is now visible of the restoration of the offices of the senate (Secretarium Senatus) which was the complement and completion of Diocletian's work on the Curia itself; but at the other end of the forum, on the Velia, the surviving remains of the cella of Hadrian's Temple of Venus and Rome are almost entirely his work, undertaken after a fire in 307; and the same fire made way for the last and greatest of his architectural enterprises, the Basilica Nova, the great basilica which Constantine completed and which, despite its much diminished ruins, still contrives to dominate the whole surrounding scene. Another important group of buildings, beside the Via Appia, included a suburban residence, a racetrack, and a large family mausoleum. Maxentius is also credited with the first substantial modifications and additions to the Aurelianic walls.

The walls and outer colonnades of Hadrian's Temple of Venus and Rome seem to have escaped serious damage in the fire and Maxentius's restoration consisted principally of remodelling radically the interiors of the two identical cellas. This work, which was carried out entirely in brick-faced concrete, veneered from floor to ceiling with fine marbles, was built up against the inner faces of the Hadrianic cella walls (the excellent tufa masonry of which was long ago robbed away for re-use elsewhere) [284]. The most striking innovation, in the past often wrongly attributed to Hadrian, was the replacement of the simple transverse wall of the earlier temple by two apses, placed back to back, while along the two side walls and in the shoulders and flanks of the apse there were decorative columnar aediculae, similar to those of Diocletian's Curia and of the swimming-pool façade of his bath-building. A striking and unusual feature is the lozenge-shaped coffering in the semi-domes of the apse. Even more elaborately shaped coffering, faced with stucco, is recorded as having adorned the vaults of the central hall of the Basilica Nova.

Of the complex of Maxentian buildings beside the Via Appia [285] partial excavation of the villa has revealed an apsed audience hall fronted by a long transverse corridor, as at Piazza Armerina [312]. As so often in late antiquity the imperial residence was accompanied by a circus, which is estimated as having held about 15,000 spectators, and which offers an unusually detailed picture of one of the racecourses that played such a large part in the social, and frequently also the political, life of later antiquity. The architectural niceties were many. Here one can see, for example, the ingenious irregularities of plan which ensured a fair start for the competitors in the outer lines; the starting-gates (*carceres*) set between the traditional pair of flanking towers (*oppida*); the two turning-points (*metae*) at either end of the central barrier (*spina*), which was placed well off-axis so as to allow for the crowding of the initial lap; the imperial box, overlooking the finishing line, and a second box near the middle of the opposite side for the use of the judges and organizing officials; the entrances and exits for the ceremonial parades of the contestants; and on the central point of the spina, in imitation of the Augustan obelisk in the Circus Maximus,

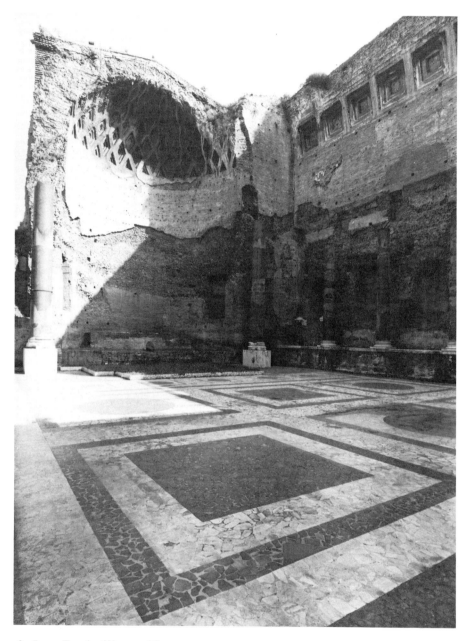

284. Rome, Temple of Venus and Rome,
cella as restored by Maxentius, 307–12

285. Rome, Via Appia (*top left*) and the Circus, the Mausoleum (*at the far end of the Circus*), and (*to the right of the Circus*) remains of the Villa of Maxentius, 307–12

the site of the Egyptian obelisk which Maxentius brought from Domitian's Temple of Isis in the Campus Martius and which Innocent X in 1651 retransported to the city to adorn Bernini's fountain in the Piazza Navona. Constructionally the building is of interest for its bold use of alternate courses of bricks and of small tufa blocks and for the large hollow jars used to lighten the mass of the vaulting that carried the seating [286], both characteristically late features which are discussed in greater detail later in this chapter.

The adjoining mausoleum was a circular, domed structure with a deep, gabled, columnar porch, set in the middle of an arcaded quadriporticus. It resembled the Tor de' Schiavi

(c. 300) beside the Via Praenestina [287, 288], and both were somewhat academic copies of the Pantheon. There were, however, significant differences. Unlike the Pantheon, of which little more than the gabled porch was visible from the long, narrow enclosure in front of it, these buildings were free-standing, to be viewed from all angles; each of them stood on a tall podium, within which were housed the funerary vaults; porch and rotunda were bound closely together by the continuous lines of the podium and entablature mouldings; and the height of the interior was increased in relation to the diameter and given greater emphasis by treating the inner face of the drum as a single decorative order. In common with many other imitations of the

286. Rome, Circus of Maxentius, 307–12, showing typical late masonry with alternate courses of brick and small squared blocks of tufa, and, incorporated in the vaulting, large earthenware jars (*pignatte*). The rows of holes are for scaffolding timbers

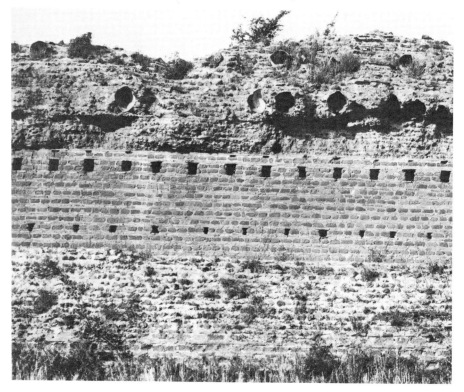

287 and 288. Rome, Mausoleum of Tor de' Schiavi, *c.* 300.
(*above*) View and plan, after Durm;
(*below*) possible alternative reconstruction of façade

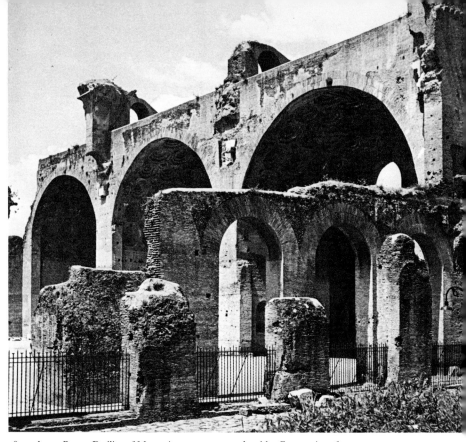

289 and 290. Rome, Basilica of Maxentius, 307–12, completed by Constantine after 312, with (*opposite*) reconstructed view of the interior as originally planned by Maxentius

Pantheon at all periods these buildings posed (and were not altogether successful in resolving) problems which, by a happy instinct or by sheer good fortune, the architect of the Pantheon had been content to let go by default. But it is symptomatic of the age that the problems should have been faced at all. Among other interesting innovations are the insertion of four circular windows into the upper part of the drum of the Tor de' Schiavi, in place of the traditional central oculus, and, even more remarkable if it can be substantiated, the possibility that the porch of the same monument was vaulted and may therefore have had a centrally-arched façade in place of the conventional flat architrave. The suggestion[3] is based on an eighteenth-century painting, which shows the

remains of large hollow jars in a concrete core at the junction of porch and drum; and although there is no other known example of the use of such a feature on this monumental scale in the architecture of pagan Rome, one hesitates to exclude such a possibility. By contrast, the arcading of the rectangular precinct which encloses Maxentius's building, with the piers and arches masked by the half-columns and entablature of an engaged decorative order, is a deliberate archaism, harking back to Late Republican and Early Imperial models.

The outstanding monument of Maxentius's reign was the basilica (the Basilica Nova) which he planned on the eastern slopes of the Velia, beside the Via Sacra [289, 290]. Left unfinished at his death, it was completed by Constantine,

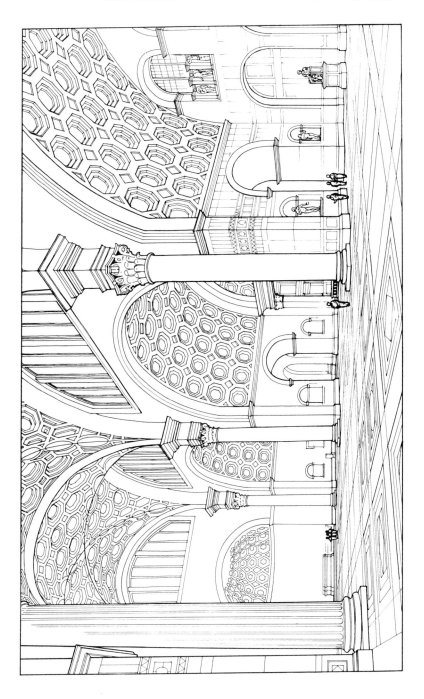

and by any reckoning it was one of the great architectural achievements of classical antiquity. In all essentials the plan was that of the central hall of one of the great 'Imperial' bath-buildings, stripped of all its surrounding structures and with the emphasis placed on the long axis by the addition of a porch at the east end and opposite it, at the west end, a shallow apse destined to house a colossal statue of the emperor. Constantine subsequently switched the axis, adding a porch in the middle of the south long side and throwing out an apse from the rear wall of the exedra opposite it.

The central nave measured 260 by 80 feet (80 by 25 m.), its three soaring cross-vaulted bays, 115 feet (35 m.) from floor to crown, springing from the bracketed entablatures of eight huge fluted Proconnesian marble columns, equally spaced, four and four, down the two long sides and framing the arches of three gigantic, inter-connected barrel-vaulted exedrae. It is the three exedrae on the north side which are still standing. Their structural function was to buttress the central nave; but at the same time they were so very much an integral part of it that, despite the inevitable bulk of the four main piers, one would have been principally conscious not of the internal subdivisions, but of the unity of the whole. This effect of spatial unity was enhanced by the virtual equipoise between the single long axis down the central nave and the three transverse axes across it.

Yet another building that is traditionally attributed to Maxentius, probably rightly though often for the wrong reasons, is the so-called 'Temple of Romulus', immediately to the west of the Basilica Nova.[4] Converted in the sixth century into the vestibule of the church of SS. Cosmas and Damian, it consisted of a domed rotunda, the entrance to which, instead of being housed in the conventional manner within a projecting porch, was flanked by two narrow, almost tangential wings, across the fronts of which two pairs of columns constituted the actual façade towards the Via Sacra. The rotunda was lit by four large windows set on the diagonal axes, and from it two doors led into the flanking halls. In its original form the courtyard

was rectangular, but very soon after its construction (the masonry of the two phases is indistinguishable) it was converted to the curved shape, decorated with columnar niches, of which the rather battered remains can still be made out through the overlay of medieval masonry. The entablatures of the two projecting façades were bracketed out over the columns, but what if anything these carried above cornice level there is nothing to show.[5] An unusual feature of the order is the placing both of the columns of the façade and of those framing the great bronze doors (which are still those of the original building) on pedestal-like plinths, of a type which had been common in the eastern provinces for two centuries, but which is almost unknown in the monumental architecture of Rome itself before this date.

Neither the coin evidence nor the very confused medieval traditions of a 'Templum Romuli' in this area in themselves justify the identification of this building as a temple to the memory of Maxentius's infant son, M. Valerius Romulus, who died in 309. On the other hand, it immediately adjoins the area which Maxentius is known to have rebuilt after the fire of 307; the masonry is very like that of the Basilica Nova; and, whether or not one places any reliance on the fragment of a Constantinian inscription shown by Panvinio in a drawing of the façade, the fact that the latter was remodelled so soon after construction would tally very well with Constantine's known interest in the frontages facing on the Via Sacra. If not the work of Maxentius, it was certainly built very soon afterwards; and in the context it is hard to suggest any other than purely aesthetic reasons for the modifications to the façade – a deliberate exploitation of the contrast between convex rotunda and concave forecourt, both framed between the projecting wings. This last flowering of pagan architecture is full of tantalizing might-have-beens.

The defeat and death of Maxentius by Constantine in 312 did not immediately spell the end of imperial munificence in Rome. That only followed when, tired of the hostility of the wealthy pagan aristocracy, Constantine found-

ed, and in 330 formally dedicated, his new capital on the Bosphorus. During the early years of his reign Constantine was as active as his predecessor had been; and while some of this activity, such as the building of the new cathedral church of Rome, was specifically associated with the requirements of the newly enfranchised Christian religion (and is discussed in another volume), there was much that belonged also, like Constantine's own complex history and personality, to the world that was passing. Besides the completion of the unfinished buildings of Maxentius, no account of the last phase of pagan architecture in Rome would be complete without a mention of Constantine's Arch, his Baths, and the two great imperial mausolea of Tor Pignattara and S. Costanza.

Constantine's Arch [291], built to commemorate his victory over Maxentius, was

291. Rome, Arch of Constantine, completed in 315

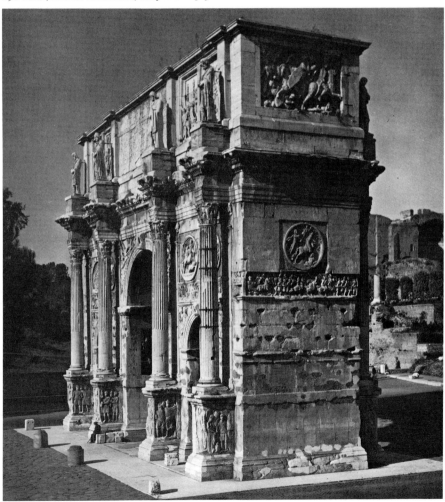

completed in 315. The design follows closely that of the Arch of Severus at the west end of the Forum Romanum, from which it differs principally in its more dignified setting and proportions, in the more telling disposition of its sculptured ornament, and in the triple articulation of the attic in correspondence with the pattern of the archways beneath. The relief panels are partly contemporary and partly, like the statues of captured barbarians along the attic, taken from a series of earlier public monuments, and together they constitute a unique repertory of the official sculptural art of the capital from Trajan to Constantine. Understandably enough they are usually discussed in terms of their more specifically sculptural qualities, and the Constantinian narrative panels in particular are praised or blamed as an illustration of the profound changes in the aims and conventions of official relief sculpture during this period. But although the narrative panels would have distressed a Roman of the old school as deeply as they did the late Bernard Berenson, there can be no serious doubt that they represent the creative main stream of one of the most vigorous currents in early-fourth-century art.

A more fruitful subject of criticism is the technical ineptitude of those elements, such as the panels of the pedestals of the columns or in the spandrels of the arches, which directly copy earlier models. Their poor quality has nothing to do with the alleged decadence of the age: it is simply that the production of large-scale relief sculpture had ceased in Rome some eighty years earlier. The narrative panels were made possible by the presence in the capital of a lively contemporary school of sarcophagus carvers, with whose work, both in scale and style, they have much in common. On the other hand, with the ever-increasing austerity of architectural exteriors and the ever greater reliance upon coloured marble, stucco, and mosaic for interiors, there was now little or no scope for relief-carving in the grand manner. This was a genre which was all but extinct in Rome by the middle of the third century,[6] and it is small wonder that the sculptors of the larger panels on the Arch of Constantine found themselves out of their depth. Their scant success is a measure, not of the artistic decadence of the age, but of the shift that had taken place in decorative taste. With the exception of its narrative panels, the Arch of Constantine is an evocation, perhaps a deliberate evocation, of an age that was already obsolescent a century earlier.

Another building which, though carried out in a strictly contemporary idiom, belonged to the age that was passing is the bath-building which Constantine built early in his reign on the Quirinal, near the Temple of Serapis. Much of this complex was still standing at the beginning of the seventeenth century [292], and the plans and drawings made by Palladio and du Pérac show that, despite the omission of several familiar features owing to the limitations of the site, it was still in all essentials one of the great Imperial series, developed symmetrically about an axial succession of swimming pool, three-bay frigidarium, quadrilobate tepidarium (flanked by service courtyards), and large, circular caldarium. Quite apart, however, from a general tendency to develop the curvilinear elements of the familiar plan (which may be no more than a reaction against the unusually severe rectilinearity of the Baths of Diocletian) there are several details which distinguish it from the earlier members of the series. In particular one may note the three apsidal plunge baths of the circular caldarium, lit by multiple windows and closely akin to the columnar exedrae of the 'Temple of Minerva Medica'; also the marked emphasis not only on the central nave of the frigidarium at the expense of the lateral exedrae but also, within the central nave, on the central bay – a deliberate exploitation of the centralizing tendencies already noted in connexion with the Basilica Nova.

Of the two imperial mausolea built by Constantine, Tor Pignattara, beside the Via Praenestina, was originally destined for Constantine himself, although in the event it was used only by his mother, Helena. It was a simple but grandiose adaptation of the circular type (diameter 66 feet 2 inches; 20.18 m.) already

292. Rome, Baths of Constantine, *c.* 320.
Plan, after Palladio

c Caldarium
F Frigidarium
T Tepidarium

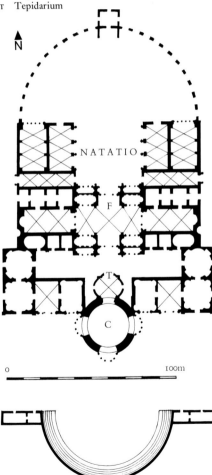

established by the mausolea of Tor de' Schiavi and of Maxentius. Instead of the gabled porch, however, it was entered by a doorway opening off the end of the nave of the adjoining martyr-church, also Constantinian, of SS. Peter and Marcellinus; and the upward-reaching tendencies of the earlier buildings were given full play by heightening the drum and opening in it eight large, round-headed windows. Corresponding to these on the outer face were eight even larger, scalloped recesses. The dome has fallen, but the spring of it can be seen to have been lightened by the use of the large, hollow jars (*pignatte*) from which the monument takes its name, and there are traces of the mosaic which once covered it. Up to the spring of the dome the walls were faced with panels of coloured marble. Architecturally the most interesting feature of this building is the scalloping of the outer face of the drum, a development which had already been foreshadowed in the Baths of Caracalla and in the annex to the 'Temple of Venus' at Baiae (p. 168). We see the same exploitation of curve and countercurve in the little 'Temple of Romulus' in the Forum Romanum; and about this date, or soon after, the scalloped window-recesses were copied in another well preserved rotunda, the 'Tempio della Tosse', which was the vestibule of a wealthy villa in the plain just below Tivoli.

The mausoleum of Helena was still in its essentials a building in the pagan tradition. That of Constantine's daugher, Constantina (now the church of S. Costanza), had already crossed the divide. In place of the soaring simplicity of Tor Pignattara, its plan, with its barrel-vaulted and arcaded ambulatory buttressing the central rotunda [293], looked forward to a long series of centrally planned churches which were inspired initially by the Church of the Holy Sepulchre. But it was still a pagan building in one important respect: neither the surviving decorative mosaics of the ambulatory nor the more elaborate figured designs of the destroyed dome mosaic owed anything to Christianity. They were made by workmen whose fathers had worked in the Baths of Diocletian, and their

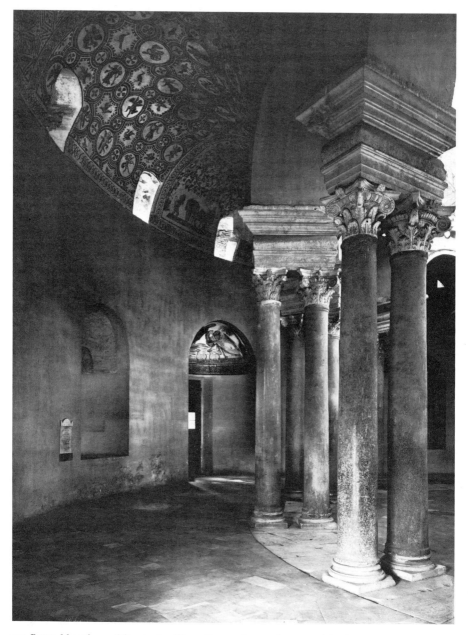

293. Rome, Mausoleum of Constantina ('Santa Costanza'), second quarter of the fourth century, showing the surviving mosaics of the ambulatory vault

great-grandfathers in the Baths of Caracalla. They offer a unique glimpse of an aspect of pagan classical architecture which elsewhere has perished almost in its entirety.

The most elaborate of the series of late rotundas in and around Rome is the pavilion in the Licinian Gardens, better known as the of nine projecting apses, continuous except at the entrance, which occupies the tenth side. The apse opposite the door is slightly larger than the rest, and the two pairs of apses on the transverse axis were open to the exterior through triple arches carried on columns. The drum, too, was decagonal, lit by ten round-headed windows,

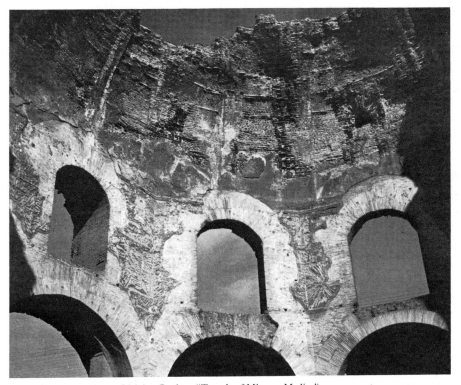

294. Rome, pavilion in the Licinian Gardens ('Temple of Minerva Medica'), showing the brick ribs incorporated in the vaulting and (below the vault) the backing for the original marble veneer. Early fourth century

'Temple of Minerva Medica' [294–6]. The gardens belonged to the emperor Gallienus (259–68), but brick-stamps show that the building is of the early fourth century, modified very soon after construction in order to buttress signs of settlement. Strictly speaking, it is not circular but decagonal (diameter 80 feet; 25 m.), with the lower parts of the walls broken out to form a ring and the transition to the dome was accomplished simply by merging the angles of the decagon inwards to form a circle. The latter was ingeniously constructed of light materials about a framework of brick ribs, and it offers an unusually clear picture of how one of these late vaults was built. The ribs were constructed of small pieces of brick, laid one upon the other in

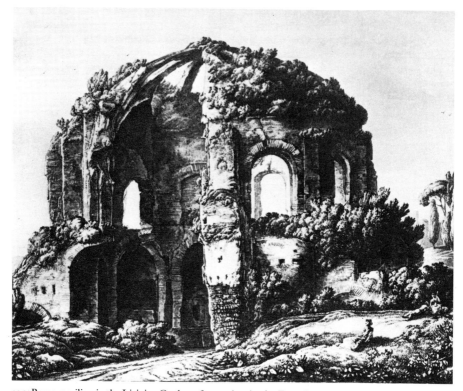

295. Rome, pavilion in the Licinian Gardens, from a drawing by Franz Innocenz Kobell, 1780, when some of the brick ribbing was still standing independently

vertical bands that were linked horizontally by numerous rather larger cross-pieces. The ribs rose concurrently with the surrounding concrete envelope, and at frequent intervals, corresponding to the upward progress of the dome as a series of concentric rings of ever-diminishing diameter, the work was capped by a continuous layer of large tiles. By this means the whole mass of the dome was partitioned into small, virtually independent compartments, greatly facilitating construction and at the same time ensuring the localization of any settlement that might take place during drying-out.

Brick ribbing similar to that just described is a feature of the vaulting of many of these late pagan buildings in the capital, in the Villa of the Gordians for example, in the Baths of Diocletian, and in the Basilica Nova. Superficially it bears a certain resemblance to the ribbing of a Gothic vault, and this resemblance has sometimes been taken to imply a close similarity not only of function but also of theoretical intention. This is certainly mistaken. That these brick ribs were developed in the first instance with any clear idea of distributing the load of the vault down certain predetermined lines can be disproved by even the most cursory examination of their relationship to the vaulting of which they are a part.[7] Many break off short before reaching the crown, others side-step to right or left or are interrupted by the tile capping of the adjoining fill. It is quite certain that they rose *pari passu*

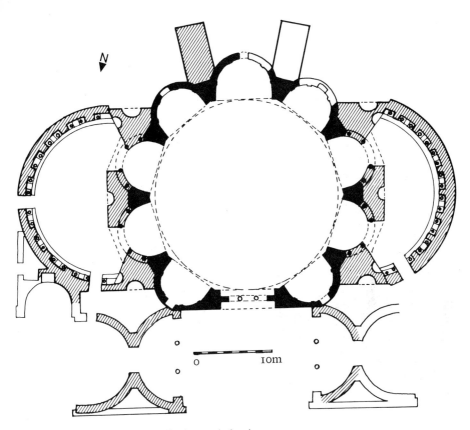

296. Rome, pavilion in the Licinian Gardens, early fourth century.
Plan. Original construction in black; added masonry shaded

with the accompanying envelope of light tufa concrete, and there can be very little doubt that their primary function was to simplify the processes of construction. This fact does not, of course, preclude the possibility that they did in practice prove to be a source of strength within the vault as a whole, or that contemporary architects should have become aware of this. Illustrations of the Minerva Medica vault prior to 1828 do in fact show several of the upper ribs still standing independently of the envelope [295]. A few years later the dome of S. Costanza is said to have incorporated eight ribs of solid brick.[8] It looks very much as if architects may indeed have been moving towards a conception

of the vault as a differentially constructed fabric within which the structural stresses might be channelled along certain predetermined lines. But if so, it was a characteristically cautious, empirical approach, based, not upon theory, but upon observation of the results of building processes that had been adopted initially for quite other reasons.

As late as the beginning of the fourth century it would be true to say that the factors principally determining the stability of a Roman vault were still the quality of the mortar and of the foundations. By this late date the former could almost be taken for granted in the volcanic regions of Central Italy. The real enemy was

settlement. Any fractioning of the unitary envelope of the vault was immediately liable to set up centrifugal pressures far greater than those inherent in the initial design. The prudent architect allowed for this; and the history of Roman concrete-vaulted architecture, from the Flavian Palace and the Pantheon onwards, is full of instances of buttressing added to remedy some such structural defect, real or imaginary. The Licinian Pavilion itself underwent substantial modification in this sense quite soon after its construction. But, whatever the constructional refinements, the essential characteristics of the vaults built in the Rome of Maxentius and of Constantine were still those of Roman concrete-vaulted architecture in its Early Imperial heyday.

If one turns to survey as a whole this last phase of architectural activity in pagan Rome one cannot fail to be struck by two things: by the complete triumph of brick-faced concrete as the standard constructional medium, and by the no less complete assurance and virtuosity with which it was handled. Except for a few monuments of purely traditional character, such as the triumphal arches, squared stone masonry is hardly found after the middle of the second century. In its superficial appearance the later brickwork, with its ever-increasing dependence on re-used materials and the occasional alternation of courses of brick and tufa, cannot compare with that of the earlier period; and although Diocletian's reorganization of the brickyards for a while reversed this trend, the results of this did not outlast the slump that followed Constantine's decision to transfer his capital to Constantinople. But one only has to glance at gigantic spans like those of the Basilica Nova to realize that this was a purely superficial deterioration. These builders were complete masters of their material; and if they were content with a rather cheaper, rougher finish than would have satisfied a more leisurely age, this was a small price to pay for the technical and organizational advances which made it possible, for example, to erect the Aurelianic walls or the whole huge complex of the Baths of Dio-

cletian, each within the span of a single decade.

Of the constructional techniques characteristic of the period there is not much that need be added to what has already been said in connexion with the individual buildings. Most of them represent no more than the taking into general use of devices that were already known, if not fully exploited, at an earlier period. Already in the second century the alternation of courses of brick and tufa had figured extensively in Hadrian's Villa and in the Villa of Sette Bassi, but it was only now promoted to occasional monumental use and did not become general until even later. Brick ribbing had been used as early as Flavian times in the barrel-vaults of the Colosseum and sporadically, though sparingly, on a number of subsequent occasions (e.g. in the Severan substructures of the Palatine). The use of specially selected light materials, such as porous tufa or even pumice, for the aggregate of the vaults already appears in a highly sophisticated form in the Pantheon. All these were familiar techniques now brought into systematic use. Perhaps the most notable innovation was the use of large jars to lessen the weight of a concrete mass at such bulky points as the spring of a vault, as in the Villa of the Gordians, the Baths of Diocletian, and the Circus of Maxentius. This is a device that was to play an important part in the Early Christian architecture of Central and Northern Italy. Other late vaulting techniques which were already current elsewhere, but which do not seem to have reached pagan Rome, are the use of interlocking tubular tiles and the employment of brick, the one a North African innovation, the other derivative ultimately from the Roman East and recorded from as near home as at Spalato, in the Palace of Diocletian.

So far as concerns the forms of architecture, this was, as in so many other fields, an age of transition. With the hindsight of later knowledge it is easy to regard it as a mere *preparatio evangelii*, paving the way for the triumph of Christianity and the emergence of the highly individualized Early Christian architecture of the following century. Such a view, however,

disregards the nature and strength of the forces of architectural change that were already at work before the time of Constantine, both in Rome and (as we shall see in the next and last chapter) in the Empire as a whole. It was the crisis of the third century quite as much as the triumph of Christianity which marks the transition of the classical world to late antiquity.

In Rome any architectural development was almost bound to turn upon the fuller exploitation of the constructional and aesthetic possibilities of concrete. The first phase of feverish, seminal experiment was long over and had been followed, since the middle of the second century, by a long period of consolidation and rationalization. Now, as the new architectural stereotypes took firm hold, there was a renewed moment of rather restless, experimental development. Broadly speaking, one might characterize it as dominated by a determination to explore the spatial possibilities inherent in such relatively newly established types as the domed rotundas and the great cross-vaulted central halls of the Imperial bath-buildings, at the expense of the inherited commonplaces of an older classicism. With this was coupled a steadily growing awareness of the formal properties inherent in the brick-faced medium as a means of developing a monumental architecture that was independent of the norms imposed by the use of the traditional orders. But there was no single, clear-cut stream of development. Rather there were a number of complementary and even contrasting streams. To the extent that it was only when these converged to supply the needs of the new religion that the overall pattern acquired shape and purpose, the conventional view of these buildings as setting the stage for Christianity is a legitimate one; but it neglects what was in the minds of the men who built them. What at the time were the aims and objectives of the architects of late pagan Rome?

In the first place, it would be naïve to disregard the fact that some of these buildings were very large. The line that separates grandeur from mere grandiosity is a delicate one, and the student of Roman architecture is at a disadvantage in that the sort of effect that the Late Roman builders were aiming at is very hard to judge on a drawing-board: it needs to be experienced, and that is precisely what in most cases we cannot now do. Nevertheless one is probably on safe ground in regarding the Basilica Nova, for example, as having been a very impressive as well as merely a very large building. There was nothing new in this exploitation of the quality of size. The Colosseum, the Pont du Gard, the Temple of Jupiter at Baalbek are among the many distinguished Roman precedents, and they all stem from a capacity which the Romans at all times possessed in abundance, the engineer's complete mastery of his materials.

Another characteristic which this Late Roman architecture shared with earlier periods is its constant striving after height. The sensibility which had put the classical temple on to a podium and the classical order on to a tall plinth found fresh expression in the handling of interior space. If we take the interior proportions of the Pantheon as a norm, the subsequent history of this characteristically Late Roman type is *inter alia*, as we have seen, one of an ever-increasing emphasis on the vertical component. In this case the technical prerequisite was the ability to pierce the drum, so as to provide lighting at clerestory level, without impairing the stability of the dome. This had already been achieved in the 'Temple of Venus' at Baiae and in the Baths of Caracalla, and by the end of the century the older form, with a central oculus, was already obsolete. The Curia of Diocletian represents the same idea. In this case the proportions were inherited; but the disposition of the inner windows just below the very high ceiling certainly suggests a deliberate exploitation of the contrast between the emphatic horizontal lines of the lower part of the hall and the soaring simplicity of the coffered ceiling above.

The central plan continued to play an important part in architectural thinking, as indeed it had done from the moment that architects started to occupy themselves seriously with the

problem of interior space. The serial grouping of the halls of bath-buildings had already made them aware that the impact of such enclosed space could be notably enhanced by putting it in direct, provocative relationship with the space beyond it; and already in the Pantheon we find a remarkably sophisticated use of the exedrae set in the thickness of the perimeter wall to give an illusion of opening outwards. But despite this, and despite the many experiments in the same sense in Hadrian's Villa, the idea was not immediately and systematically followed up, and the central-plan building *par excellence*, the rotunda, remained essentially a self-enclosed, autonomous unit. The opening up of windows in the drum in place of the single, spatially neutral central oculus was a step towards a more balanced, outward-looking treatment; but it is not really until the early fourth century, in the Licinian Pavilion, that we find a decisive break with tradition. Once again the elements of the plan, the multilobed rotunda and the curved columnar exedrae, can be seen to go back to Hadrianic precedents; but only now were they brought together in a direct, vital relationship. Through the arches of the arcaded, columnar exedrae the observer within was brought into immediate contact with the world beyond.[9] Within a generation the architect of S. Costanza had introduced the parallel idea of a continuous arcaded ambulatory around the central domed area; and soon after the middle of the fourth century, in the church of S. Lorenzo at Milan, we find the two ideas converging within a single building. The way was open for one of the most fruitful models of Early Christian architecture, leading eventually to S. Vitale in Ravenna, to SS. Sergius and Bacchus in Constantinople, and even to Hagia Sophia itself.

Right down to the end of the pagan period it was the interiors of these buildings that were the predominant consideration of forward-looking architects. Even if it be an exaggeration to say that the exteriors were simply left to take care of themselves, in very few of them does one feel that the architect was primarily concerned with this aspect of his building. The language of a more traditional classicism was still spoken on occasion, particularly in contexts where a certain conservatism was appropriate; but the more closely one examines the individual instances, the more one is made aware that this was no longer a living idiom but a dialect inherited, and even on occasion deliberately revived, from the monuments of Rome's own past. The imitation of the Pantheon and of Trajan's Forum in the gabled porches of the imperial mausolea and in the decorative orders of Aurelian's Temple of the Sun; the revival of a scheme obsolete since Flavian times for the porticoes around the Mausoleum of Maxentius (and in Diocletian's palace at Spalato); the rendering of a traditional theatrical stage-building in terms of the columnar aediculae of contemporary decorative usage in the swimming-pool façade of the Baths of Diocletian: these are a few only of the most striking instances of an almost antiquarian attitude to the use of the familiar externals of an older classicism. We shall meet it again in the architecture of the provinces during the same period.

It is easier to document this breakdown of the old exterior values than it is to define any positive and consistent trend towards a new exterior aesthetic. A ready acceptance of the functional logic of the new material was not in itself sufficient to produce a satisfactory answer, as we can see very clearly from the bleak, barrack-like elevations of three of the four sides of the central block of the Baths of Caracalla [64]. Only on the south façade of the same building do we find the succession of large windows used with some success as a frame and foil for the projecting mass of the central rotunda. It is perhaps the growing taste for these large windows (made possible by the more general use of lead-framed panes of window-glass or its equivalent) which offers the most consistent clue to the development of an exterior aesthetic in this late pre-Christian period. Grouped (as in the façade of the Curia) or spaced out in orderly lines [85], they could be used to give life and movement to the large, blank, exterior surfaces; and the scalloped

framing recesses of the Tor de' Schiavi reveal a growing awareness of their more subtle aesthetic possibilities. We see this again very clearly in a building such as the Basilica at Trier, described in the following chapter. Whereas it could be argued that the external window-pattern of the Basilica Nova, for example, is determined primarily by the lighting requirements of the interior, that of the Trier Basilica is based unmistakably on the deliberate choice of a bold pattern of rhythmically alternating voids and solids. Working essentially from the inside outwards, late pagan architecture had already arrived at its own equivalent of the older classical scheme based on column and architrave. The familiar comparison between this building and the early-fifth-century church of S. Sabina shows how far, in this respect too, Christian architecture started where pagan architecture left off.

THE ARCHITECTURE OF THE TETRARCHY

IN THE PROVINCES

The military crisis of the third century A.D. was one which shook the whole Empire to its roots. A few favoured areas, such as Asia Minor and North Africa, escaped the full blast; but even there the financial difficulties of the time meant that public building dropped to a mere trickle by comparison with the second century. Gaul, Northern Italy, the Danube provinces, Greece, and Syria were all ravaged by hostile armies; and although Roman authority was eventually re-established and metropolitan Syria, for example, went on to enjoy another three centuries of prosperous life on the classical model, never again could the citizens of the Roman Empire face the future with the same unruffled assurance as before.

Not surprisingly, the world that re-emerged from the holocaust was a very different world from that of the previous age. Nowhere is this fact more apparent than in the relationship between Rome and the provinces. Italy had long ago lost its pre-eminence over the other provinces, but in the second century Rome itself was still the unchallenged centre of the Roman world. Now it had been made painfully clear that this world was too large to be ruled with success by any single man ruling from any single capital. The solution adopted by Diocletian, a consortium of two senior and two junior emperors (the 'Tetrarchy'), despite its many internal stresses was successful in carrying the Empire over the crucial period of military, civil, and economic reorganization. For a while in the earlier fourth century the towering personality of Constantine succeeded in re-establishing once more a single central authority. Then, without drama but finally and irrevocably, the Empire once more broke into its two halves, East and West, establishing the pattern which

was to dominate the history of the northern shores of the Mediterranean for the next seven or eight hundred years.

The crucial single event in all this was the inauguration in 330 of Constantinople as the new capital of the Roman world. But one must not forget that, inspired though Constantine's choice of site proved to be, the venture as such was no novelty. Within the last forty years there had been half a dozen new capitals established, formally or *de facto*, up and down the length of the Empire by the rulers of the Tetrarchy: Antioch, Nicomedia, Thessalonike, Sirmium, Milan, Trier. All these were built very largely by local craftsmen, with local resources and with local materials; to this extent they represent the culmination of the long processes of regional development which constitute the architectural history of the several areas of which they were the capitals. But at the same time by the very circumstances of their foundation they tended to cut right across regional boundaries. Even allowing for the differences of climate and craftsmanship, of methods and materials, the formal requirements of an imperial residence or a public bath-building were very much the same in Syria as on the Danube or in Gaul. What now happened in varying degree in all these new capitals had been foreshadowed nearly a century earlier at Lepcis. The old regional barriers were everywhere breaking down. Never before or since was the Mediterranean world nearer to achieving a real *koine* of architectural usage.

Two of the Tetrarchy capitals, Nicomedia in Bithynia and Sirmium near Belgrade, have left hardly any trace above ground, and two others, Antioch and Milan, all too little.[1] About Trier and Thessalonike, on the other hand, we are quite well informed, and we can supplement

this by reference to at least two other ultra-wealthy residences of the same period, the palace at Spalato (Split) on the Dalmatian coast to which Diocletian retired in 305, and the great Sicilian country house of Piazza Armerina.

TRIER

Trier (Augusta Treverorum), strategically situated on the Moselle in rear of the armies of the Rhine, was chosen by Constantius Chlorus to be his capital when in 293 he was nominated by Diocletian to be one of the junior members of the Tetrarchy, with a military and administrative command stretching from the Straits of Gibraltar to Hadrian's Wall and from the Rhine to the Atlantic. It was the residence successively of Constantius himself, of his son Constantine the Great, and of his grandson Constantine II, and again later of Valentinian (364–75) and Gratian (375–83), and it was not until 395 that the court was formally transferred to Milan and the headquarters of the military prefecture to Arles. During this period many of the most distinguished literary and ecclesiastical figures of the age lived here, including Ausonius, Lactantius, Athanasius, St Jerome, St Ambrose, St Martin of Tours, and St Augustine. For a century it was culturally as well as politically the first city of the West.

Trier was one of the most prosperous, as well as one of the oldest, cities of northern Gaul. The principal remains of the first three centuries of its history are the rectangular street plan, related to a bridge over the Moselle; the amphitheatre, originally of earth and timber but rebuilt in stone c. A.D. 100; a grandiose second-century bath-building of the 'Imperial' type, the St Barbara Baths; a number of private houses, some with fine mosaics; and several important religious sites, including both the predominantly Celtic sanctuary of Altbachtal and the more classicizing temple and terraced precinct of Mars Lenus on the slopes across the river.[2] This was a typically prosperous Gallo-Roman city, with strong native overtones in the fields of religion and of domestic building, but with a public architecture that was essentially classical.

When Constantius chose it as his capital, the city was still suffering from the effects of a disastrous incursion of the Franks and Alemanni in 275–6. The city walls must have been built immediately after this disaster (if not indeed already before it) and many of the older monuments needed restoration. In addition Constantius now started to lay out, and Constantine completed, a palace complex occupying many insulae in the north-east part of the town. The audience hall (the 'Basilica' or 'Aula Palatina') is still standing. There are also the substantial remains of a large new bath-building (the 'Kaiserthermen'), as well as traces of a circus and of the residential quarters, on a part of which Constantine later (c. 326) founded a great double church, the first cathedral church of northern Gaul. Other monuments of the period are the grandiose north gate of the city, the 'Porta Nigra', the exact date of which is disputed, and the Constantinian warehouse of S. Irminio, near the river.

The Basilica occupies the same site as an earlier and smaller, but similarly oriented hall, which may have been part of the palace of the regional procurator, destroyed in the incursion of 275–6. The right-hand wall of the present building and most of the façade are rebuilt, having been largely demolished when the building was part of the adjoining bishop's palace; but, apart from certain details of the façade, the main lines of the Constantinian building are nowhere in doubt [297–9]. At first glance one would take this for a typical example of contemporary metropolitan, brick-faced concrete masonry. In reality it is built of solid brick, seemingly unique example in the West of a method of construction which at this date we find only in the Greek East, and a striking reminder of the ecumenical range of so much of this official Tetrarchy architecture. Constantine himself, it will be recalled, had spent much of his youth at the courts of Diocletian in Nicomedia and of Galerius in Thessalonike. With such patronage small wonder if ideas found it easy to travel.

The basic design of the Basilica was very simple: a severely plain, rectangular hall,

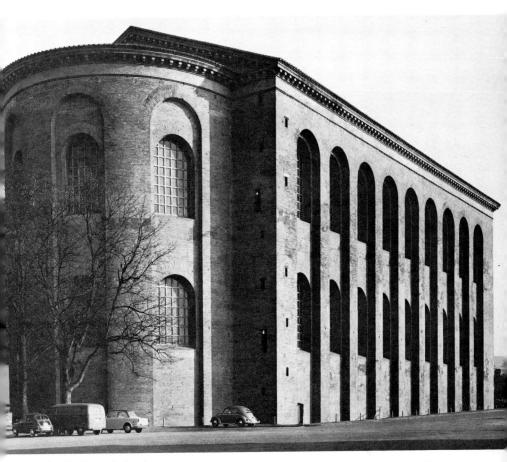

297. Trier, Basilica, early fourth century

measuring roughly 95 by 190 feet (100 by 200 Roman feet; 29 by 58 m.) and, beyond it, a projecting, flat-ceilinged, semicircular apse; an elongated, single-storeyed, transverse fore-hall, or narthex, with a central porch opening on to the middle of one end of a large forecourt flanked by porticoes; and, bulking far larger in plan than in actuality, a pair of low, porticoed courtyards flanking the main hall. The floor was of black and white marble and heated by hypocausts, the outlet ducts of which were incorporated in the lower parts of the walls and controlled from the lower of two outer service

galleries. The lofty ceiling was presumably coffered, as now restored. The lighting came from two rows of large, round-headed windows, which were continuous down the two long sides and round the apse, their rhythm accentuated internally by a framing architectural scheme in coloured marble. The intention of the whole design was to carry the eye to the apse, where the emperor sat enthroned and where a series of mosaic-ornamented recesses lent a welcome note of colour to the rather austere simplicity of the scheme as a whole. The impressive proportions of the hall were further enhanced by an

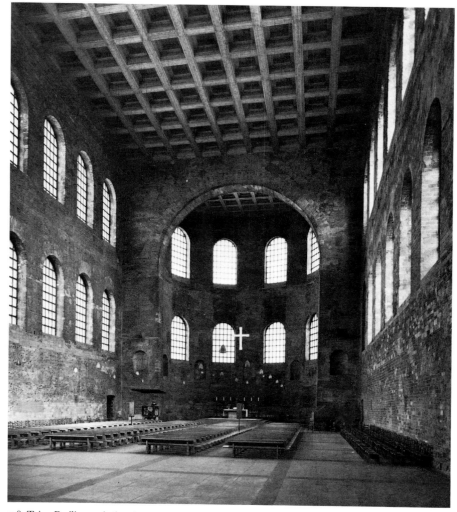

298. Trier, Basilica, early fourth century

ingenious series of optical devices. The windows of the apse are not only shorter than those of the nave, but those of the upper row spring from a horizontal line 4 feet (1.20 m.) below the springing-line of the corresponding nave windows; and in both rows the two central windows are appreciably narrower than the outer pair. In addition, the ceiling of the apse is correspond-

ingly lower than that of the nave. The combined effect of these devices, viewed through the interrupting frame of the 'triumphal arch', is that the eye, assuming a uniformity of size and proportion between nave and apse, gives to the latter a depth and height considerably greater than in fact it possesses. Even if one knows the trick (clearly visible in illustration 299A) one is

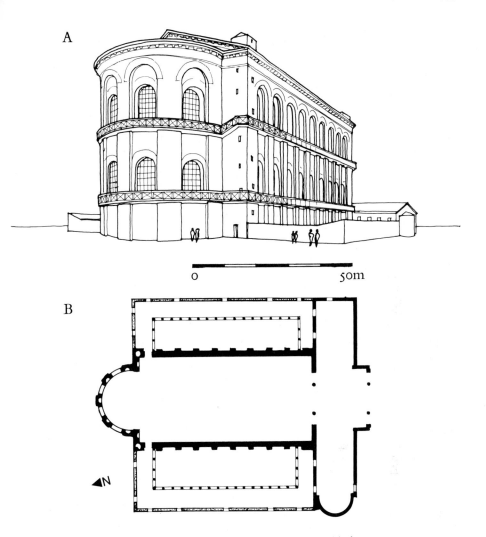

299. Trier, Basilica, early fourth century. (A) Reconstructed view of exterior; (B) plan

still deceived. There can be no doubt that the optical effect is quite deliberate, and its use in this building, unparalleled even in Rome, is a measure of the architectural sophistication of the provincial capitals of the Tetrarchy.

The exterior, which was faced with plain stucco, is dominated today by the vertical lines of the tall, narrow arches of the blind arcading which frames the two rows of windows. In antiquity this vertical emphasis was tempered by the pair of timber galleries which ran along the sides and around the apse, to service the two rows of windows. There are obvious analogies in this arrangement with the two rows of blind arcading which are such a conspicuous feature of the exterior of the contemporary horrea of S.

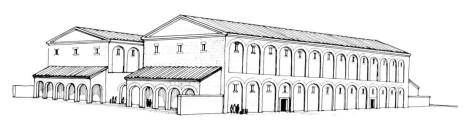

300. Trier, S. Irminio warehouses, early fourth century. Restored view

Irminio [300]. These are a pair of two-storeyed warehouses, each about 230 feet long and 65 feet wide, with the main working entrances facing inwards on to a long, narrow loading-yard between the two buildings. Internally there were fourteen transverse bays, lit by narrow slit windows, and the floor of the upper storey was carried on two longitudinal rows of stone piers.[3]
· The bath-building (the Imperial Baths, or 'Kaiserthermen') [301, 302] which occupied the southern extremity of the palace-complex was of a type already familiar in the provinces, a type for which the St Barbara Baths, built soon after the middle of the second century, offered a notable local precedent. In its broad lines the layout of Constantine's building followed that of the St Barbara Baths, which in turn were closely derived from, though by no means a slavish copy of, the Baths of Trajan in the capital. The main bathing-block (c. 450 by 400 feet) was designed to occupy one half of the elongated rectangular site, facing out across the large porticoed enclosure and low surrounding buildings that occupy the other half, in this respect conforming more closely to the model of the gymnasium bath-buildings of Asia Minor

301 and 302. Trier, Imperial Baths ('Kaiserthermen'), early fourth century, exterior of the main caldarium with (*opposite, above*) restored view and (*opposite, below*) plan

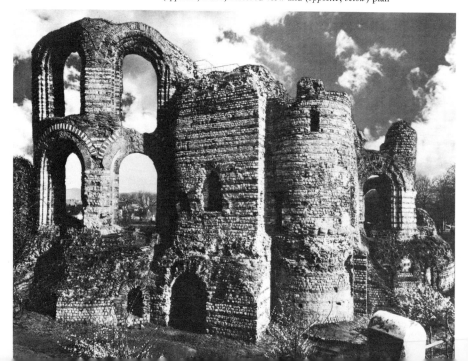

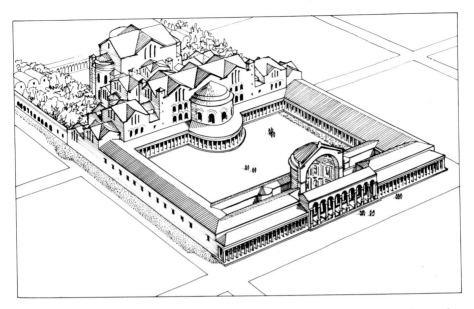

than those of Rome itself. There is no need to describe in detail the internal disposition of the bathing-suite. The principal advances of the Constantinian building upon its predecessor lay in the far greater compactness of the design of its main block, which was grouped tightly

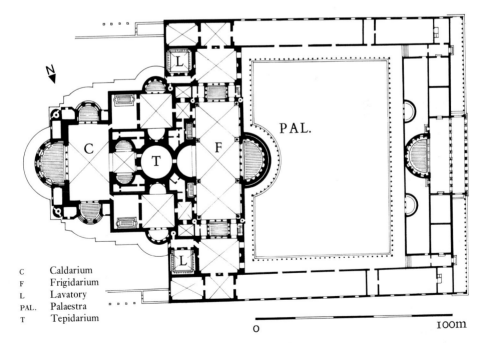

C Caldarium
F Frigidarium
L Lavatory
PAL. Palaestra
T Tepidarium

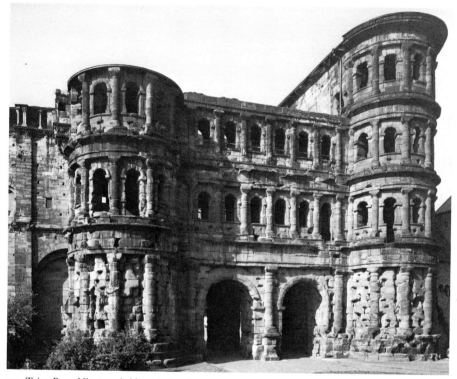

303. Trier, Porta Nigra, probably early fourth century.
Unfinished

around the main axis, and in its liberal use of lively curvilinear forms in place of the rather banal, loosely organized rectilinearity of the earlier building. Another notable feature of the design was the grouping of all the services (heating, drainage, service corridors, and storage) within a self-contained cellar range below the raised floor level of the bath itself.[4] In the event these baths were never completed as planned. Constantine's departure for the east in 316 led to an indefinite suspension of the work, and when Valentinian (364–75) undertook to complete them he did so on a much reduced scale, eliminating all except the tepidarium and the nucleus of the caldarium range, and enlarging and simplifying the forecourt so as to consist of little more than four ranges of small square tabernae opening off a huge open courtyard.

The Porta Nigra [303] is the quintessential Roman gate, designed at all costs to impress the wayfarer with the might of Imperial Rome. Such unusual features as it possesses are due simply to the fact that, like many of the late antique monuments of Rome, it represents a deliberate return to earlier Imperial models. In this case the models were first-century buildings such as the Porta Palatina at Turin [103] or, in Gaul itself, the Porte Saint-André at Autun [135], the only serious concession to contemporary military planning being the greater robustness and depth of the towers, which were carried backwards the full length of the square internal courtyard so as to flank the inner and the outer gates alike. The decoration too derives from the same models, from the arched openings and framing orders of the galleries directly

over the carriageways of the earlier gates. In this case, however, the motif has been taken and applied, incongruously but with a certain barbaric magnificence, to the whole structure, two rows of arches running right round the whole building and a third right round the towers, 144 arches in all. The extraordinarily crude finish of the masonry, sometimes cited as analogous to the sophisticated rustication of the Porta Maggiore in Rome [21], is accidental: the building was never completed. There is no independent evidence to show exactly when in late antiquity this gate was put up. On historical grounds the most likely occasion would seem to be either when the town and its defences were rebuilt after the disaster of 275–6 or else during the early years of Constantine's reign. The latter date would better explain why, like Constantine's bath-building, it was left unfinished.

THESSALONIKE (SALONICA)

Thessalonike (Salonica), strategically situated on the Via Egnatia, the main Roman land route from Italy to the Bosphorus and to Asia, was already a town of importance when Galerius (293–311) chose it to be the capital of his quarter of the Empire. At this point the Via Egnatia runs roughly east and west, and to accommodate his palace Galerius added a whole new quarter on either side of it, along the eastern edge of the existing city. To the south lay the palace proper, with a hippodrome (circus) along the eastern edge of it; to the north lay the rotunda which was perhaps destined to be the founder's tomb, and which is now the church of St George; and between the two ran a processional way with an elaborate triumphal arch marking the point where it crossed the Via Egnatia [304].

304. Thessalonike (Salonica). (A) Mausoleum of Galerius and monumental approach to it, including the arch of Galerius across the main colonnaded street to the city. Before 311. Restored views. The superstructure of the arch and the detail of the rectangular hall are both hypothetical

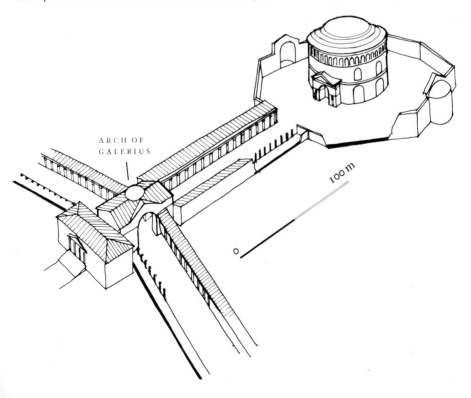

ARCH OF
GALERIUS

100 m

0

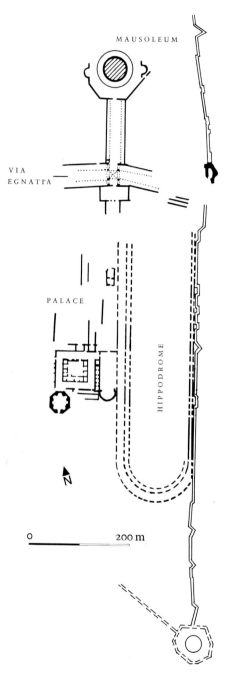

MAUSOLEUM

VIA
EGNATIA

PALACE

HIPPODROME

N

0 200 m

304. Thessalonike (Salonica).
(B) The south-east corner of Roman Thessalonike,
showing the site of the palace and mausoleum
of Galerius in relation to the hippodrome,
the Via Egnatia, and the Byzantine city walls

The location of the palace alongside the
hippodrome, a relationship first established by
the Flavian Palace in Rome, was a regular
feature of the palaces of later antiquity (Antioch,
Constantinople, Milan, Sirmium, Trier). Of the
palace itself, which lies beneath the modern
town, only scattered elements have been re-
covered. The most coherent of these is a
complex of which the central feature was a
peristyle courtyard, framed on three sides by
small rooms and isolated from the adjoining
rooms by a broad, encircling corridor; along the
east side, between the courtyard and the hippo-
drome, lay a large rectangular hall with an apse,
possibly an audience hall, and along the south
side, separated from each other by another
broad corridor, a bath suite, and a large octa-
gonal, domed hall nearly 80 feet (25 m.) in
diameter, with apsidal recesses in the eight
angles.[5] The plan is curiously episodic, suggest-
ing a series of interlocking units rather than a
tightly coordinated scheme, but this impression
may of course be due to the limited area
exposed. Another known feature of the palace
was a rectangular transverse hall which abutted
on the south side of the arch, serving as a
vestibule to the colonnaded processional way
that led up from the arch to the ceremonial
enclosure surrounding the rotunda. Viewed
from the east or west the central archway
spanned the road and may well have carried
some sort of conventional superstructure as well
as the usual group of statuary. The two lateral
archways, on the other hand, spanned the
footpaths within the flanking colonnades, pre-
cluding the normal architectural development
of such an arch. Instead, the elaborate sculp-
tural ornament, recording Galerius's victory
over the Persians in 297, was concentrated upon
the vertical faces of the piers. The piers them-

304. Thessalonike (Salonica).
Part of the palace of Galerius

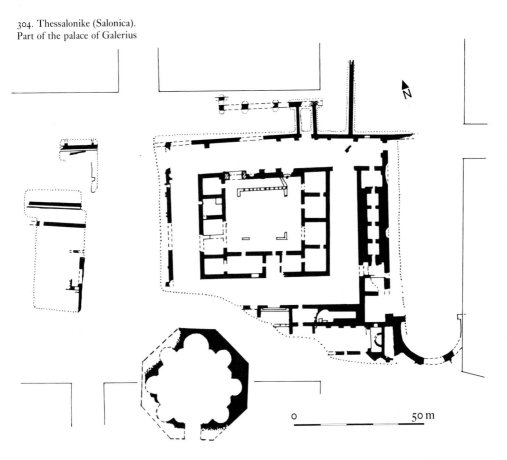

selves consisted of a marble facing about a core of mortared rubble, and the arches were of brick.

Both in plan and in elevation the rotunda [305, 306] was in effect a free-standing version of the caldarium of the Baths of Caracalla, with eight large, radiating, barrel-vaulted recesses at ground level and, directly above them, eight similar but somewhat smaller recesses housing a ring of large windows. Externally the shoulders of the dome were treated as an arcaded outer gallery, buttressing the thrust of the dome, and the essential rotundity of the monument was emphasized by the relative insignificance of the entrance porch. The decoration of the interior

was carried out in veneer marble, with two orders of pilasters and entablatures framing the recesses and, on the piers between the lower recesses, eight decorative aediculae, similar to those found in the buildings of Diocletian and Maxentius in Rome. There are the substantial remains of the original mosaics on the vaults of the radiating recesses. Those of the dome date from the conversion of the building into a church later in the fourth century, but they presumably replace an earlier series.

The plan of the building and much of its detail are unmistakably derived from Rome. Not so its construction. In the absence of the volcanic sands necessary for making Roman

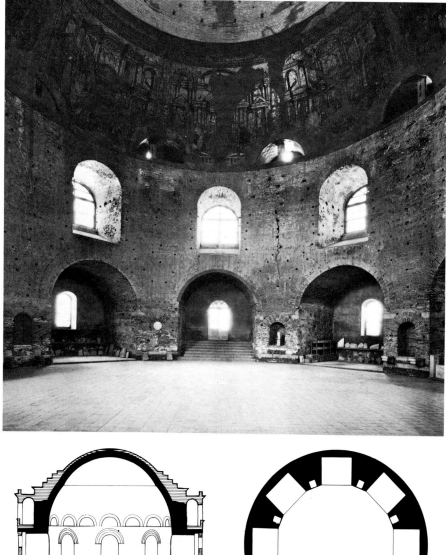

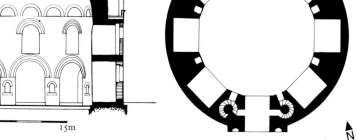

concrete, the materials and techniques are those described in an earlier chapter (pp. 273 ff.) as characteristic of Roman building in western Asia Minor and the northern Aegean. The walls are built of a mortared rubble, laced with bands of brick and faced, partly with brick, partly with

vaulting [307]. The bricks are of normal shape, but instead of being laid radially, parallel with the axis of the arch or vault, they are laid end to end along the line of curvature. In crude brick this was a technique that goes back to the Middle Kingdom in Pharaonic Egypt and at

305–7. Thessalonike (Salonica), Mausoleum of Galerius (church of St George), mainly before 311, the dome and its mosaics completed later, when it was transformed into a church. The change of curvature has here been slightly exaggerated. Interior (*opposite, above*), section and plan (*opposite, below*), and detail of vaulting

courses of small, roughly squared blocks of local stone; and the arches and vaults are of brick. For the most part the individual bricks are laid radially in the traditional classical manner, in anything from one to three concentric rings, and so one sees them also in the substructures of the hippodrome. But both in the arch and in the vaulting of the radiating recesses of the rotunda there are panels also of brickwork, 'pitched' in the manner characteristic of most Byzantine

least to the beginning of the first millennium B.C. in Mesopotamia. It called for the use of a quick-drying mortar, and it had the double advantage of needing only a very light, movable scaffolding and of being, in consequence, very flexible in its application. So far as concerns the Mediterranean world, the story of this device belongs rather to the history of Byzantine than of classical architecture. But the fact that it is found both here and at Spalato, albeit on a very

modest scale, shows that by the end of the third century it was in fact already current in the Aegean provinces; and its use at about this date, or even slightly earlier, in the substructures of the basilica at Aspendos in Pamphylia [176] gives support to the suggestion that it derives ultimately, through the later classical architecture of Asia Minor, from the familiar mud-brick forms of Syria and Mesopotamia.[6]

An unusual constructional feature of the rotunda is that, whereas the lower part of the dome, to a height of 23 feet (7 m.), is a segment of a hemisphere based on a centre situated on the level of the springing line, the upper part has a different curvature, based on a centre about $6\frac{1}{2}$ feet (2 m.) higher. By this means the builders were able to reduce the effective span from $79\frac{1}{4}$ to $62\frac{1}{2}$ feet (24.15 to 19 m.), corbelling the lower part inwards without scaffolding and making the pitch of the crown less dangerously shallow. It was neglect of some such precautions that 250 years later brought the original dome of Justinian's church of Hagia Sophia crashing to the ground. In the present instance the pattern of the later mosaics makes the change of curvature virtually invisible from the ground.[7]

SPALATO (SPLIT)

The 'palace' which Diocletian built for himself on the Dalmatian coast and to which he retired in 305 was planned on very different lines [308]. It was not really a palace at all, in the sense of being part of a larger urban complex; it was an independent self-contained country residence, enclosed on all sides within a near-rectangular (575 and 595 by 710 feet; 175 and 181 by 216 m.) circuit of defences. The walls were guarded by projecting square and octagonal towers; from gates in the middle of the two long sides and of the landward (northern) short side two axial colonnaded streets converged upon the geometrical centre of the city. A shorter length of street, the so-called 'Peristyle', flanked by open colonnades [309], continued the line of the north-south street across the intersection and led up to the residence proper, which occupied the southern extremity of the rectangle, overlooking the sea. The rest of the southern half was occupied by two large rectangular precincts, which faced each other across the 'Peristyle'. That on the left contained the emperor's mausoleum, that on the right a small temple and two small rotundas of uncertain character and purpose. There was no gate. On the southern side there was no monumental gate, only a small postern. Otherwise the walls presented an unbroken façade towards the sea [310], crowned by the arches of a gallery which ran the full length between the two corner towers, interrupted only by three small gabled pavilions.[8]

For the plan of the residential wing, which was terraced out over lower ground, we are dependent largely on that of the still only partially explored substructures. These indicate a series of rectangular suites, physically separated by corridors and doubtless no less sharply distinguished in function. An emperor in retirement still had certain official and ceremonial duties. At Spalato the public rooms occupied the middle of the palace wing. On the central axis a circular vestibule led directly into a large rectangular hall, with a second doorway at the far end on to the corridor-gallery beyond. On either side of the central suite the same corridor gave access to two more large halls, both evidently of an official character. That to the right (west) had an apse at the north end and two longitudinal rows of piers or columns, and it was presumably a basilican audience hall; that to the left was perhaps a triclinium. Beyond these, at the two ends of the block, lay the domestic and bathing suites.

There are obvious analogies between the planning of this building and that of the traditional Roman castrum, with its transverse Via Praetoria and axial Via Principalis converging upon the praetorium, originally the actual residence of the commanding officer and later the official ceremonial headquarters building. The formula was one that one would have found in countless variants all along the frontiers of the Empire, where the neat orderly planning of the military camps inevitably left its mark on the

308. Spalato (Split), Palace of Diocletian, *c.* 300–6. Plan

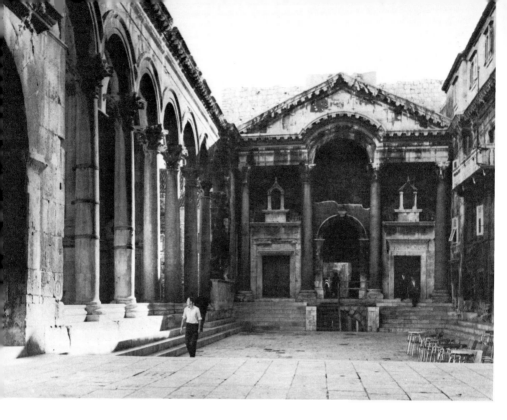

civil settlements that grew up under their protection. At Timgad, for example [261], the forum complex occupied precisely the same position in relation to the T-shaped plan of the city's main streets as the praetorium of the nearby camp at Lambaesis, the station of the Third Legion from which the majority of the new settlers were drawn. From the moment that Roman military architecture ceased to be a matter of the temporary lodging of mobile units and began to be concerned with the provision of permanent barracks and other facilities for units that might be established in one place for decades, or even for centuries, the mutual interaction of civil and military architecture had become a lively factor in the architectural development of the frontier provinces.

The crisis of the third century gave fresh substance to this relationship. Many of the frontier provinces were, culturally speaking, late starters, and it was only now that they really began to acquire an architectural voice of their own; and at the same time, from Gaul to the Levant, vast regions which for centuries had basked in comfortable security found themselves thrust into close and urgent contact with military affairs and military ways. The Aurelianic walls of Rome were symptomatic of a profound shift in the centre of gravity of the Roman world, a shift which affected every aspect of civilized life, architecture included.

The fortifying of the towns took the obvious form of surrounding them with often hastily devised, irregular circuits of walls. The villas and farms of the open countryside presented a more varied problem and the answers were correspondingly varied. In a few outlying areas, as in parts of northern Gaul, the wealthy villas were simply abandoned. Elsewhere, for example in North Africa, one can trace the

309 (*opposite*). Spalato (Split), Palace of Diocletian, *c.* 300–6. 'Peristyle' or ceremonial courtyard leading up to the entrance to the main residential wing

310 (*below*). Spalato (Split), Palace of Diocletian, *c.* 300–6. View of the seaward frontage in the eighteenth century by Robert Adam

emergence of a variety of more or less defensible building types, ranging from the well-to-do villa with massive towers that figures so largely in the later African mosaics down to the small, square, fort-like *gasr* (from the Latin *castrum*) of the Libyan frontiers. Here and there along the northern frontiers, a tendency to regroup into larger defended communities can be seen to have been accompanied by the emergence of individual fortified buildings of quasi-military character. There are a number of such villa or estate centres in the central Danube area.[9] An even more striking example is the fourth-century 'villa' at Pfalzel near Trier. This was a lofty, square keep built around an open court-yard and defended by closely spaced, project-ing rectangular towers. It may have been a country retreat for the emperor when in re-sidence at Trier. In Syria the Byzantine castle of Kasr ibn-Wardan and the early Arab *châteaux*

and hunting lodges represent a similar development.

Diocletian's fortified villa at Spalato was thus not an isolated phenomenon. As a residence it can be seen to reflect the same current of events as that which produced a whole series of fortified villas, quasi-military in plan, which began to emerge on to the provincial scene during the closing years of the third century. To what extent it established the type (as one may suspect in the case of the often-quoted fortified residence of Mogorjelo), and to what extent it merely embodied features that were already being developed elsewhere along the northern and eastern frontiers, only further work can show. The creation of an age in rapid transition, it may well have done both. At the same time, the scale and quasi-urban planning looked forward to the numerous small fortified town-ships in the Danubian and Balkan provinces

which were the late Roman and early Byzantine answer to the problem of security against the ever-present menace of marauding tribesmen from the north.[10]

Another precedent that has sometimes been cited for the building at Spalato is the city and palace of Philippopolis (Shehba) in southern Syria, the birthplace of the emperor Philip (244–9). Historically Philip's work here affords a welcome chronological link between the building activities of Septimius Severus at Lepcis Magna and those of the Tetrarchy emperors in their several capitals. But it is clear that at Philippopolis the palace (about the details of which we have very little information) was part only of a larger urban unit; and one suspects that the latter's incorporation of two intersecting colonnaded streets might have been matched in any city of the eastern provinces that underwent substantial rebuilding at this date. A far more plausible precedent is that of the palace which Diocletian built at Antioch, seemingly within the framework of a fortress begun by Valerian (254–9) on the island opposite the hellenistic city. The remains of this palace and of the adjoining new quarter lie deep beneath the silt of the Orontes, but they are described by the fourth-century writer Libanius, whose description deserves quotation:[11] 'The whole of it is an exact plan, and an unbroken wall surrounds it like a crown. From four arches which are joined to each other in the form of a rectangle [i.e. a tetrapylon], four pairs of stoas [i.e. four colonnaded streets] proceed ... towards each quarter of the heaven. Three of these pairs running as far as the wall, are joined to its circuit, while the fourth is shorter but is the more beautiful ... since it runs toward the palace, which begins hard by, and serves as an approach to it. The palace occupies ... a fourth part of the whole [island]. It reaches to the middle, which we have called an ompholos [i.e. to the tetrapylon].' Libanius adds that at the far side the wall was crowned by a colonnade offering a view over the river and the suburbs beyond. Adjoining it was a hippodrome. The plan was certainly not a neat rectangle, and the palace did not occupy the whole of the fortified enclosure. But there are obvious analogies with the plan of Spalato, and it seems not unreasonable to believe that this was indeed one of the buildings which Diocletian and his architects had in mind a few years later in planning his Dalmatian residence.

That an architect and workmen from the eastern provinces were among those employed in the building of Spalato there can be little doubt. Among the elements that can be seen to stem more or less directly from Syria or Asia Minor are the several instances of the use of the Syrian 'arcuated lintel' and the arcading of the columnar screens on either side of the so-called 'Peristyle' [309]. The whole treatment of the Porta Aurea [311] is typically Syrian, with its characteristic combination of an open arch with a horizontal lintel, the bracketing out on consoles of its decorative arcade, and the deliberate ambivalence of the receding planes of the wall surface, just as in the Temple of Bacchus at Baalbek [204]. The preference for fine, squared-stone masonry, extending even to the barrel-vaulting of the small temple, points in the same general direction. So too does the use of brick vaulting, which includes examples of the same 'pitched' brickwork as at Thessalonike and an ingenious variant of the same technique in the dome of the mausoleum, which is built up of superimposed, interlocking fans of brickwork, converging upwards towards the crown.[12] For the immediate inspiration for all these features one would have had to look east of the Aegean, to Asia Minor or to Syria. At the same time, however, there are other elements that point no less unmistakably westwards. The design of the mausoleum, for example, octagonal externally with a projecting gabled porch and circular internally, with eight alternately rectangular and apsidal recesses, falls squarely within the series of Roman imperial mausolea described in the previous chapter. Other features for which the known parallels lie in Italy rather than in the East are the circular vestibule (as in the 'Tempio della Tosse' at Tivoli) and the framing of the arches of the seafront gallery between the half-

311. Spalato (Split), Porta Aurea, *c*. 300–6. Restored view

columns of an applied decorative order, an archaism employed also in the courtyard of the Mausoleum of Maxentius and on the Porta Nigra at Trier [303]. The known precursors of the apsed audience hall also belong to the West. In the present state of knowledge it would be unwise to insist on the immediate source of any of these features: the very fact that they could meet and mingle so freely is a sufficient indication of the geographical fluidity of ideas and motifs which is so characteristic of the monumental architecture of the Tetrarchy. This is a building that belongs exclusively neither to East nor West.

PIAZZA ARMERINA

When the great villa at Piazza Armerina, with its astonishing series of nearly 400,000 square feet (35,000 sq. m.) of polychrome, largely figured mosaics, was first excavated it was widely believed to be the country retreat of Diocletian's colleague, Maximian. On balance this now seems unlikely. The date of construction may well be as much as a quarter of a century later,

N

L Lavatory

0 25m

312. Piazza Armerina,
villa, early fourth century.
Axonometric view

perhaps *c.* 320–30, and the owner is more likely to have been some very wealthy member of the pagan aristocracy who possessed estates in North Africa.[13]

Unlike Spalato, Piazza Armerina, situated in a secluded valley of south-central Sicily, did not feel the need of defences. Instead of the compact, orderly planning of Diocletian's residence, consisting of a miniature semicircular courtyard (*sigma*), with two bedroom suites and a small triclinium; to the south lay an independent ceremonial wing (IV) with a trilobed triclinium (*triconchos*) and an oval, porticoed forecourt; and projecting obliquely from the north-west corner of the peristyle there was a bath-suite (V). Not all of this elaborate complex was laid out on

313. Piazza Armerina, villa, early fourth century.
General view of the central peristyle, looking towards the entrance

we have here the relaxed, single-storeyed sprawl of the old-style Italian country villa [312]. One can distinguish five principal elements within the layout. At the west end lay the monumental triple entrance and horseshoe-shaped forecourt (I); from this the visitor turned half-right into the main body of the villa, which comprised, in roughly axial succession, a vestibule (IIa), a peristyle garden flanked by living quarters (IIb) [313], a transverse corridor (IIc), and a large apsidal audience hall (IId); accessible from the south end of the corridor was a private wing (III)

a single occasion. There are several structural abutments, indicating successive building campaigns or changes of detailed intention, and the magnificent series of decorative floor-mosaics in particular must have taken years, if not decades, to complete. But, despite any such additions and adjustments, there is a manifest unity of basic intention about the whole design which argues that it was from the outset planned in something very closely resembling the form in which it has come down to us. This is no rich man's whim, but the product of a clear-eyed, organic con-

ception of what was proper to the residence of a great aristocratic landowner.

Two traditions in particular seem to have contributed to the overall conception of the villa, as well as to its detailed treatment. One of these was that of the Italian country villa, as quintessentially interpreted in Hadrian's great villa near Tivoli. Here, at Piazza Armerina, for

status of a positive architectural rationale. Symmetry is now something to be avoided at all costs, or at best employed as a foil to emphasize the avoidance of the axial vistas of traditional classical planning. The forty-five-degree turn from entrance courtyard to vestibule, the blocking of the onward vista from the vestibule by a domestic shrine [314], the slight but sufficient

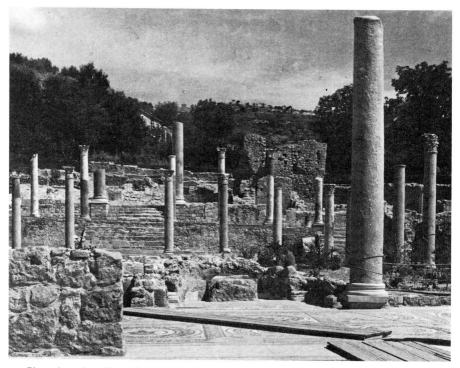

314. Piazza Armerina, villa, early fourth century.
View from the vestibule across the central peristyle towards the basilica

all the much reduced scale, one can see the same loose aggregation of quasi-independent suites of rooms, the same skilful exploitation of the terrain to produce lively juxtapositions of contrasting axes. The principal differences are that somewhere along the way the old intimate association with the surrounding landscape has been lost, giving place to an inward-turning self-sufficiency; and that what had begun as a picturesque disregard for the conventions of formal symmetry has been promoted to the

shift of axis between the peristyle (with its emphatically axial fountain pool) and the audience hall, the steady rise in level from entrance to audience hall, all these are as deliberately contrived as the studiedly casual access from the main complex to the triclinium group or to the bath suite.

The other recognizable strain in the pedigree of the Piazza Armerina villa is the wealthy peristyle-villa of North Africa. Socially as well as geographically Sicily was almost as much a

part of Africa as of Italy. Many of the great patrician families had vast estates in Tunisia and Algeria, and whoever was responsible for ordering the mosaics of the great transverse corridor (11C) must also have had a stake in the profitable business of exporting exotic African beasts to the amphitheatres of the north. The mosaics too, with the exception of those of the great triclinium, are almost exclusively the work of mosaicists brought in from North Africa. Small wonder that the architecture too should reflect African precedents. Although we know all too little about the wealthy villas of the African countryside, several lines of development were moving towards the sort of scheme adopted at Piazza Armerina.[14] One (shared with many other provinces) was the increasing dominance of the triclinium as the focal point of domestic design. Another was the breaking out into looser form of the tight rectangular perimeter of the traditional peristyle-house. Both of these (and the transverse corridor separating the triclinium from the main peristyle complex) are features of an approximately contemporary villa at Portus Magnus, near Oran in Algeria [315]. Another feature that seems to have first taken shape in

315. Portus Magnus, near Oran, villa, *c*. 300. Plan

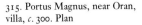

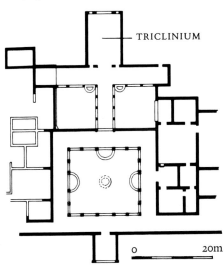

TRICLINIUM

0 20m

the residences of the provincial landed aristocracy is the triconchos. The bath-suite, too, is of a type which, originating in Italy, had found favour and been widely developed in North Africa.

How much of all this is a direct translation to Sicily of contemporary African practice (which was at every stage itself influenced from Italy) and how much it represents an individual interpretation, under more direct Italian influence, of established African schemes, only further research will show. In either case Piazza Armerina offers us a vivid glimpse of the wealthy patrician villa of pagan antiquity on the eve of its extinction as a significant building type. In the troubled centuries to come there was no longer any place for the open villas of an earlier, more expansive age. The future lay with Spalato rather than with Piazza Armerina. This is not to say that individual features of the latter did not find a place within the new order. We have already remarked on the relationship between Spalato and the square pre-Islamic and Islamic fortress-palaces of Syria, such as Kasr ibn-Wardan (564) and Mschatta (eighth century). The central feature of both is a great triconchos audience hall, and the link, directly or indirectly, must in both cases be Constantinople, where two of the commonplaces of later palace design were both foreshadowed at Piazza Armerina – the triconchos and the semicircular porticoed forecourt, or *sigma* (so-called from the Greek capital letter S, which at this date was written like a Latin capital C). The best known examples are the triconchos and sigma which Theophilus (829–42) added to the Great Palace; but as early as 447 we have a reference to a triconchos, evidently an official building, in the new capital; and the substantial remains of the palace (416–18) include a complex of circular and multilobed rooms opening off a great central sigma.[15] At Ravenna we find peristyle, apsed audience hall and triconchos associated in the large, badly excavated building just to the east of the church of S. Apollinare Nuovo. Since 404 Ravenna had been the residence of the imperial court; and although the identification of this building as the Palace of

Theodoric (d. 526) lacks any secure basis, this is undoubtedly the sort of context to which the building must belong. As a social phenomenon, then, the Piazza Armerina villa may be one of the last of its line. Architecturally, on the other hand, it foreshadows several important future developments in the history of ceremonial public building.

NORTH ITALY

By the end of the third century the effective centre of power in Italy had moved away from Rome to the Po valley. For a time, until succeeded by Ravenna, Milan was the most important city in the European West. Ausonius, writing about 388, refers to the theatre, a circus, the double walls, temples, a palace, a mint, and a bath-building erected by Maximian,[16] and the almost total loss of its late pagan architecture leaves a serious gap in our knowledge of the period. The imperial palace was a creation of the second half of the third century and one of the few surviving monuments is in fact a stretch of the city wall, together with a twenty-four-sided brick-faced tower, belonging to the extension that was made by Maximian (after 286) in order to bring within the defences a part of the new palace quarter, including the palace baths and

the adjoining circus. Another is part of a bath-building, thought to be of Constantinian date, situated just inside the Vercelli Gate and consisting of a circular, domed caldarium with a number of smaller radiating chambers. Ravenna has fared better, but it belongs decisively to the Christian world and, except for the palace referred to in the previous section, none of its buildings are secular.

Tantalizingly fragmentary though they are, the remains in North Italy tell a familiar story. In Milan, the curvilinear, centralizing forms of the Vercelli Gate bath-building are in the same tradition as the Baths of Constantine in Rome; they were to be taken up later in the century (c. 370) and given fresh coherence and monumentality in the great church of S. Lorenzo, probably the palace church of the Arian emperor and itself the head of a line that led ultimately to S. Vitale in Ravenna.[17] The external buttress-like arcading of the church of S. Simpliciano, built by the successor of St Ambrose (d. 397), is a close repetition of that of the S. Irminio warehouse at Trier and probably, though only the ground-plan of these is known, of the very similar late antique warehouses at Aquileia and at Veldidena in Austria.[18] The partly excavated villa at Desenzano [316] beside Lake Garda, with its curvilinear and polygonal

316. Desenzano, part of a rich villa, fourth century. Plan

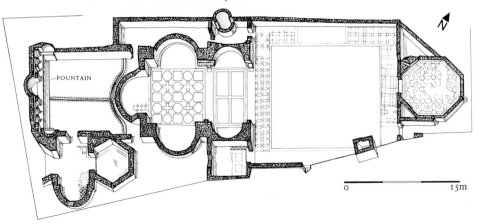

room-shapes, its elaborate fountain courts and fine polychrome mosaics, has many points in common both with Piazza Armerina and the late houses of Ostia. Most striking of all, as evidence of the wide variety of late pagan traditions which at this time were converging upon North Italy to shape the newly emergent Christian architecture, is the steady abandonment by the latter of concrete vaulting in favour of lighter materials – the large pottery vessels of Rome itself, the brickwork of the Roman East, and the interlocking tubular vaulting of North Africa.[19] The picture that can be drawn from such scattered fragments is bound to be itself fragmentary, but it is enough to show that in such matters North Italy was right in the main stream of architectural development.

CONSTANTINOPLE

With the foundation of Constantinople a page of history was turned. That the full implications of the event were apparent at the time to Constantine's contemporaries, or even to Constantine himself, we may well doubt. To most the new city must have seemed (and before Constantine's final break with the pagan aristocracy of Rome it would rightly have seemed) to be merely another of the new capitals called into being by the conditions of the Tetrarchy. In the context of the recent past it was no more than the culmination of tendencies already widely manifest during the previous half-century. We today can see that its foundation sealed the fate of the old pagan order; but it was within the framework of ideas and traditions inherited from the pagan world that the new city first took shape.

During the first half of the present century there was much controversy about the sources of Early Byzantine architecture, and in particular as to whether it should be regarded as a product of the architecture of 'the West', i.e. of Rome and of Roman Italy, or of 'the East', in the sense of new forces and traditions at work in and through the provinces of the eastern half of the Empire. The fact that we today are in a position to view the question more dispassionately and in a deeper perspective is due very largely to our greater knowledge of the architecture of the immediately preceding period. Any detailed analysis of the effective sources of early Byzantine architecture lies outside the compass of the present volume;[20] but few nowadays would dispute that it was the product of a number of convergent traditions, some derived from Rome, some from the Roman East, and some again from the other provinces, from the Aegean world, and from the new capitals along the northern frontiers. Some of these represent the deliberate choice of the city's planners, others were adopted almost unthinkingly as part of inherited attitudes and skills of the age. To this last category belong the building materials and techniques of the new city, which were those already current in the region of which Constantinople was the natural centre: dressed stone, faced rubblework, and, to an ever-increasing degree, brick, used both for vaulting and as a solid building material in its own right. At the other end of the scale there was a deliberate appeal to the traditions of the old capital, to its regional organization, its plan, and its major public buildings. The almost total destruction of the pre-Justinianic city makes it very hard to judge how significant this reference to Rome was architecturally. Many of the analogies were no doubt rather superficial. But there is also a great deal in the surviving architecture of the sixth century which derives unmistakably from pagan Rome. It is a reasonable guess that many of the public buildings of Constantine's city were indeed interpretations in local materials of the time-honoured monuments of the old capital.

Between those two extremes, and surely bulking very large in the minds of Constantine and his advisers, lay the accumulated experience of the last fifty years, gained at Antioch, at Nicomedia, at Thessalonike, at Sirmium, at Milan, and at Trier. In the late pagan architecture of these cities the old distinctions between east and west, between capital and province, and between one province and another had already

gone far towards losing their meaning. At the beginning of the fourth century the ancient world was as near as it had ever been to possessing an architecture that was truly cosmopolitan both in character and distribution; and it was this cosmopolitan tradition to which Constantinople seemed destined to be the principal memorial.

In the event, the facts of history and of geography were to operate otherwise. Constantinople was founded at the end of a long period during which the whole tendency of the age had been towards an ever-increasing unity of culture and ideals. It was to develop in an age that was moving steadily in the reverse direction. The classical world was breaking up. The division of the Empire into east and west, followed by the collapse of Roman rule in the west and the rise of Islam, drove Byzantine civilization in upon itself. Increasingly cut off from the west, it drew more deeply on its Greek heritage, while Christianity gave it a new, theocratic content. But although the architecture of Byzantium reflects the needs and aspirations of this new and very different world, it was also essentially and continuingly a product of its own historic past. That past was the architecture of the late pagan Roman Empire.

LIST OF PRINCIPAL ABBREVIATIONS

NOTE: Other abbreviated titles are given fully in
the general bibliography or in the relevant
chapter bibliography.

A.A.A.S.	*Annales Archéologiques Arabes Syriennes* (*Annales Archéologiques de Syrie*)
Acta Rom. Suec.	*Acta Instituti Romani Regni Sueciae* (*Skrifter utgivna av Svenska Institutet i Rom*)
A.J.A.	*American Journal of Archaeology*
Anz.	*Archaeologischer Anzeiger* (in *J.D.A.I.*)
Arch. Cl.	*Archeologia classica*
B.A.S.O.R.	*Bulletin of the American Schools of Oriental Research*
B.C.H.	*Bulletin de correspondance hellénique*
B. d'Arte	*Bollettino d'Arte*
Blake (1947)	Marion Blake, *Ancient Roman Construction in Italy from the Prehistoric Period to Augustus.* Washington, 1947
Blake (1959)	Marion Blake, *Roman Construction in Italy from Tiberius through the Flavians.* Washington, 1959
B.M.C.	*British Museum Catalogue* [*of Coins*]
Bull. Comm.	*Bullettino della commissione archeologica comunale di Roma*
C.I.L.	*Corpus inscriptionum latinarum*
C.R.A.I.	*Comptes rendus de l'Académie des inscriptions et belles lettres*
Crema	L. Crema, *L'Architettura romana* (*Enciclopedia classica*, III, vol. XII, *Archeologia* (*Arte romana*) a cura di Paolo E. Arias). Turin, 1959
Dura	*The Excavations at Dura Europos. Preliminary Reports.* New Haven, 1929–52
Forma Urbis	*La Pianta marmorea di Roma antica, Forma Urbis Romae, a cura di Gianfilippo Carettoni, Antonio M. Colini, Lucos Cozza, Guglielmo Gatti.* Rome, 1960
I.L.N.	*Illustrated London News*
Itinerari	*Itinerari dei Musei e Monumenti d'Italia.* Rome, Libreria dello Stato
J.D.A.I.	*Jahrbuch des deutschen archaeologischen Instituts*
J.Ö.A.I.	*Jahreshefte des Österreichischen Archäologischen Institutes in Wien*
J.R.S.	*Journal of Roman Studies*
M.A.A.R.	*Memoirs of the American Academy in Rome*
Mem. Linc.	*Memorie dell'Accademia nazionale dei Lincei*
Mem. Nap.	*Memorie della Accademia d'archeologia, lettere e belle arti di Napoli*
Mem. Pont.	*Atti della Pontificia Accademia romana di archeologia, Memorie*
Milet	Th. Wiegand (ed.), *Milet. Ergebnisse der Ausgrabungen und Untersuchungen seit dem Jahre 1899.* 18 vols. so far published. Berlin, 1906–
Mon. Ant.	*Monumenti antichi*
Nash	E. Nash, *Pictorial Dictionary of Ancient Rome*, 2 vols. 2nd ed. London, 1968

N.S.	*Notizie degli scavi di antichità*
P.B.S.R.	*Papers of the British School at Rome*
Platner-Ashby	S. B. Platner, *A Topographical Dictionary of Ancient Rome.* Completed and rev. by T. Ashby. London, 1929
P.W.	Pauly-Wissowa, *Realencyclopädie der classischen Altertumswissenschaft*
Rend. Pont.	*Atti della Pontificia Accademia romana di archeologia, Rendiconti*
R.M.	*Mitteilungen des deutschen archaeologischen Instituts. Römische Abteilung*
Scavi di Ostia	*Scavi di Ostia.* In progress. Rome, 1953–
S.H.A.	Scriptores Historiae Augustae

NOTES

21. 1. Suetonius, *Augustus*, 28. 3; the word used for brick refers to sun-dried, not kiln-baked, bricks. The *Res Gestae* (often referred to as the *Monumentum Ancyranum*, the most complete surviving copy being that inscribed on the walls of the Temple of Rome and Augustus at Ancyra, the modern Ankara) were inscribed on two bronze tablets beside the entrance to the Mausoleum of Augustus.

22. 2. For dedications by private individuals under Augustus, see Suetonius, *Augustus*, 29. 5, and Tacitus, *Annals*, III. 72. A building specifically recorded as having been paid for by Augustus himself *ex manubiis* is the Porticus Octaviae, a rectangular colonnaded enclosure adjoining the Theatre of Marcellus and replacing the Republican Porticus Metelli; presumably also the eighty-two temples claimed to have been restored in 28 B.C., the year after his own great triumph. The Temple of Castor and probably that of Concord also were rebuilt by Tiberius from the proceeds of his triumph in 7 B.C. Of the buildings that are wholly or partly lost, the plans of the Temples of Diana [61] (an adjoining fragment, now lost, is known from an old drawing) and probably of Neptune, of the Porticus Philippi and of the Theatre of Balbus are known from the Severan marble map. The Porticus Philippi adjoined and closely resembled the Porticus Octaviae. The remains of the theatre, long thought to be those of the Circus Flaminius, are now known to lie buried beneath the Palazzo Caetani (G. Gatti, *Capitolium*, XXXV (July 1960), 3–12). The library housed in the Atrium Libertatis was yet another inheritance from Caesar.

23. 3. For the chronology of the surviving Augustan buildings, see Gros, *Aurea Templa*, *passim*; also Strong and Ward-Perkins, 'Temple of Castor', 4–5. The Augustan column bases of the Temple of Saturn, *ibid.*, 5–12, plate IX, b. The Arch of Augustus in the Forum Romanum awaits publication.

4. Agrippa's work of flood-control and consolidation, though less grandiose in conception than Caesar's plans for tackling the same problems (Cicero, *Letters to Atticus*, XIII, 33a. 3), established a mean level within the Campus Martius that was little altered throughout antiquity; see Shipley (*Agrippa*), *passim*, and Blake (1947), 159–63. The detailed study of the masonry of the aqueducts by Miss Van Deman

yielded a striking picture of the variety of the work undertaken by the different contractors, many of them using a mortar that in practice proved inadequate for its purpose. The squared stone masonry of parts of the Horrea, with its engaged Corinthian columns, is in the same tradition as that of the Theatre of Marcellus.

25. 5. The present Pantheon, long thought to be in part the work of Agrippa, is entirely the work of Hadrian, who reproduced the dedicatory inscription of his predecessor; cf. below, p. 111. The Agrippan building seems to have faced in the opposite direction, with the door into the cella approximately beneath that of the present building.

6. As early as 54 B.C. (Cicero, *Letters to Atticus*, IV. 16. 14).

7. Pliny, *Natural History*, XXXVI. 38.

8. The Diribitorium in the Campus Martius [cf. 20], begun by Agrippa and completed in 7 B.C., was reputed to have the widest span of any timber roof ever built (Pliny, *Natural History*, XVI. 201). The precedents are to be sought in Campania, including the Covered Theatre at Pompeii, built soon after 80 B.C. For the roofing of the Odeion of Agrippa at Athens, and for the Inner Propylaea at Eleusis, see below, pp. 263 ff.

26. 9. This had presumably been an open-air theatre-temple complex of the old Italic type, represented near Rome by the sanctuary at Gabii (see A. Boëthius, *Etruscan and Early Roman Architecture* (*Pelican History of Art*) (Harmondsworth, 1979), 165–6); F. Coarelli, *Bull. Comm.*, LXXX (1965–7), 69 ff.

10. For the pair of apsed halls (*basilicae*) flanking the stage-building, cf. the Augustan theatre at Iguvium (Gubbio), *C.I.L.*, XI, 5820.

11. For illustrations see Boëthius, *op. cit.*, ills. 159, 144, 143.

28. 12. The background of the figure sculpture is unmistakably Attic, whereas the acanthus scrollwork, though derived immediately from the workshops of Attica, stems ultimately from hellenistic Pergamon. For the Altar of Pity, see H. A. Thompson, *Hesperia*, XXI (1952), 47–82.

33. 13. Pliny, *Natural History*, XXXVI. 102. For the masonry of the temple, see *J.R.S.*, XXXVIII (1948), 65–6, figure 10. For the caryatids and Pegasus capital, C. Ricci, *Capitolium*, VI (1930), 157–89, and G. Q. Giglioli, *R.M.*, LXII (1955), 155–9; and for Attic details in general, *P.B.S.R.*, XXX (1962), 18–25.

14. *P.B.S.R.*, 11 (1904), plate 124, b and c.

34. 15. A further reconstruction in A.D. 22 (Tacitus, *Annals*, 111. 72) seems to have involved mainly the upper order of the central hall.

16. The 'Anaglypha Traiani' (G. Lugli, *Roma antica, il centro monumentale* (Rome, 1946), 160–4; Mason Hammond, *M.A.A.R.*, XXI (1953), 127–83) show the keystones of the façade arches carved as the forequarters of chimaeras – a Greek architectural motif found also in the Forum Augustum.

37. 17. It has been suggested that this, rather than the Temple of Divus Augustus, is the building with an Ionic façade shown on a coin of Caligula; see below, p. 46. The only capital of appropriate date and scale found near the site is an engaged half-column capital of the Corinthian order (H. Kähler, *Römische Kapitelle des Rheingebietes* (Berlin, 1939), Beilage 2, 4); but, as the remains of the Temple of Saturn show (below, Note 22), a mixture of Ionic and Corinthian is not unthinkable in such a context. For the plan of the temple, see G. Carettoni, *Rend. Pont.*, XXXIX (1967), 69 ff.

39. 18. Blake (1947), 165–6. Strong and Ward-Perkins, 'Temple of Castor', 8–9.

19. A. von Gerkan (*R.M.*, LX–LXI (1953–4), 200–6) and others have proposed a date late in the first century A.D. But see Strong and Ward-Perkins, *loc. cit.*

20. Cf. the little Republican Temple of Veiovis; perhaps also Agrippa's Pantheon. The plan of Concord was dictated by the space available.

40. 21. For Quirinus, see Vitruvius, III. 2. 7; restored by Augustus and dedicated in 16 B.C. Nothing of it has survived.

22. Pseudo-peripteral: Apollo in Circo, Apollo Palatinus, Saturn (?), Divus Julius (?). Prostyle: Magna Mater. Peripteral: the restored Temple of Minerva on the Aventine [61] (see above, Note 2) and the three small temples in the Forum Holitorium, of which the northernmost is *sine postico* (for which see F. Castagnoli, *R.M.*, LXII (1955), 139–43). For the orders of Saturn and Divus Julius, see Ward-Perkins, *P.B.S.R.*, XXXV (1967), 23–8.

41. 23. Whether or not this close spacing was deliberately chosen in order to emphasize visually the sanctified detachment of the area so enclosed (so Gros, *Aurea Templa*, 108), such spacing was also a necessary result of the general abandonment of timber in favour of stone or marble for the architraves of these large buildings. See Vitruvius, III. 3. 5 on the use of timber architraves in an areostyle order; but see also V. 9. 3, where he contrasts the *gravitas* of temple colonnades with the *subtilitas* of porticoes. In such a situation practical and aesthetic considerations may well converge.

42. 24. Blake (1947), 41–4. See below, p. 98.

25. Roman brickwork was never more than a facing to the concrete core within. The flat exposed surface usually conceals a triangular or irregular profile, designed to bite into the structure behind. See below, Chapter 4.

CHAPTER 2

46. 1. The surviving remains of the upper order of the Basilica Aemilia accord well with the date of the Tiberian restoration recorded by Tacitus (*Annals*, 111. 72). Pliny (*Natural History*, XXXVI. 102) admired it greatly.

2. For the identification of the Ionic temple as that of Apollo, see O. L. Richmond in *Essays and Studies presented to William Ridgeway* (Cambridge, 1913), 203–6. See also above, pp. 36–7 and Note 17.

48. 3. For the recent excavations within the camp, principally of barrack blocks within the south-east quadrant, see the short preliminary report by E. Caronna-Lissi in *B. d'Arte*, L (1965), 114–15.

4. See below, pp. 198 ff.

5. By the second half of the century this was normal practice in building vaults of any substantial size, e.g. in the Colosseum.

6. The aqueducts were completed by Claudius; see p. 52.

7. Pliny, *Natural History*, XXXVI. 111.

49. 8. The Temple of Cybele, built on the Palatine between 203 and 191 B.C. and restored on traditional lines by Augustus (above, p. 37), was a purely classical building [14]. So too in its detail was the Sanctuary of the Asiatic Divinities at Ostia (R. Meiggs, *Ostia* (Oxford, 1960), 356–9, figure 26); but the layout, around a large enclosed precinct, is that of a cult whose mysteries had to be shielded from the eyes of the profane. The precinct was probably established under Claudius.

51. 9. Originally published by G. E. Rizzo (*Monumenti della pittura antica: Roma*, fasc. 1) as the 'Aula Isiaca di Caligola', it is now widely accepted that H. G. Beyen was right in attributing the paintings to the late Second Style, shortly before 20 B.C.; *Studia Vollgraf* (Amsterdam, 1948), 11 ff. See also G. Carettoni, *N.S.*, XXV (1971), 323–6.

52. 10. F. Castagnoli, *Bull. Comm.*, LXX (1942), 57–73.

11. E.g. the Porticus Minucia (p. 55 and Note 14, below); a portico in the Claudian harbour at the Tiber mouth (Lugli, *Tecnica edilizia*, plate XXXIII, 6).

55. 12. Blake (1959), 84. Cf. Tacitus, *Annals*, XII. 57; Pliny, *Natural History*, XXXVI. 124. For the continued importation of pulvis puteolanus from Pozzuoli, see Pliny, *Natural History*, XVI. 202.

13. For the warehouses of Ostia, see below, p. 145.

14. F. Castagnoli, *Mem. Linc.*, ser. 8, 1 (1948), 175–80. For the surviving remains, see E. Sjöqvist, *Acta Rom. Suec.*, XII (1946), 47–153.

56. 15. See below, pp. 100 ff.

16. *B.M.C.: Empire*, I, plates 43, 5–7, and 46, 6. The type probably originated in South Italy; see *J.R.S.*, LX (1970), 15–16. For the remains of a building which may have been the Macellum Magnum, and which was recorded by Pirro Ligorio, see J. S. Rainbird and F. B. Sear, *P.B.S.R.*, XXXIX (1971), 40–6.

17. Martial, VII. 34: 'quid Nerone peius? quid thermis melius Neronianis?'

18. See below, pp. 73, 292.

57. 19. See below, p. 59.

20. M. Barosso, *Atti del III Congresso nazionale di storia dell'architettura* (Rome, 1941), 75–8.

59. 21. Miss Van Deman's reconstruction of these porticoes (*A.J.A.*, XXVII (1923), 402–24; *M.A.A.R.*, V (1925), 115–25) is discussed at length in Blake (1959), 44–6. The façades consisted of a rising series of arches framed between the semi-columns of an engaged, probably Ionic order. The porticoes represent a monumental application of Nero's own town-planning regulations.

61. 22. Tacitus, *Annals*, XV. 42, where the architects, Severus and Celer, are characterized as 'magistris et machinatoribus'. Suetonius, *Nero*, 31, lists the mechanical marvels. Cf. the phraseology in Seneca, *Letters*, 90 (XIV, 2), 7 and 15.

23. Tacitus, *Annals*, XV. 43.

24. Repeating an Augustan ordinance (Strabo, V. 3. 7 (235)) which had evidently been allowed to lapse. The height was subsequently reduced by Trajan (Aurelius Victor, *Epitome*, 13. 13) to 60 feet.

CHAPTER 3

63. 1. *B.M.C.: Empire*, 11, 168, nos. 721, 722; cf. Nash, 11, 532, figure 657. For the earlier temple, see Boëthius, *op. cit.* (Chapter 1, Note 9), 46.

65. 2. A. M. Colini, *Mem. Pont.*, VII (1944), 137–61; A. Prandi, *Il Complesso monumentale della Basilica Celimontana dei SS. Giovanni e Paolo* (Rome, 1953), 373–420.

3. Boëthius, *op. cit.*, illustration 164.

66. 4. The word *templum* in Latin signifies not a building as such but an area duly sanctified by ritual procedures, perhaps best translated in the context as 'the Precinct of Peace'. Within it stood the *aedes*, the temple proper in the English sense of that word, a distinction which is well expressed by the architectural form adopted. The evidence of the scanty remains now visible is supplemented by that of

excavation (A. M. Colini, *Bull. Comm.*, LXV (1937), 7–40) and of the Severan marble map (*Forma Urbis*, 73, plate XX; cf. Nash, I, figure 536).

67. 5. The insertion of a taller, gabled porch into the line of a portico was an architectural device already familiar in other contexts, such as the gymnasia and the domestic peristyles of Campania (and presumably also of Rome itself); but used in this way, as a means of integrating the façade of an independent pedimental building into the scheme of its own columnar forecourt, as it was again a decade later in the Triclinium of the Domus Augustana [37], it appears to be a newcomer to the monumental architecture of the capital. Cf. in the second century the market building at Pozzuoli [96].

6. The superstructures were doubtless of timber on masonry footings, as described by Tacitus at Fidenae in A.D. 27 (*Annals*, IV. 62) and at Piacenza (Placentia) in A.D. 69 (*Histories*, II. 21). An amphitheatre of this type is illustrated on Trajan's Column (Lehmann-Hartleben, scene 100).

68. 7. I owe these details to the courtesy of Dr Claudio Mocchegiani Carpano, who will be publishing a full account of his work shortly. I estimate the volume of these foundations as approaching 10 million cubic feet (*c.* 300,000 cubic m.) of concrete.

8. See below, pp. 433–5. The brick arches in the vaults that span the vomitoria have been interpreted as the remains of a prior skeleton vaulting-system that enabled the workmen to operate simultaneously at several different levels; but this is certainly mistaken. They could never have stood, let alone carried a load, independently of the rest of the vault.

70. 9. For the awnings, see Durm, *Baukunst*, 687–9 and figures 754 (Pola) and 755 (Nimes).

73. 10. Reproduced by Nash, 11, figure 1280.

11. See also above, p. 56.

75. 12. E. Sjöqvist, *Acta Rom. Suec.*, XVIII (1954), 104–8. See also below, p. 366.

13. Colini, *Bull. Comm.*, LXI (1933), 264.

77. 14. Gabriella Fiorani, *Quaderni dell'Istituto di Topografia Antica*, V (1968), 91–103, for a preliminary study of the modifications to, and extensions of, the western part of the forum complex. In its original, Caesarian-Augustan form the temple backed directly against the slopes of the saddle of higher ground which at that time still linked the Quirinal and the Capitoline hills (see below, p. 86). Trajan's massive landscaping operations left it free-standing within a north-western extension of the forum area, which served to adapt the plan to that of Trajan's own forum.

15. F. Castagnoli (*Arch. Cl.*, XII (1960), 91–5) interprets the stepped feature as the base of the cult-statue within the temple. A coin of A.D. 94–6 (*B.M.C.: Empire*, 11, 241, plate 67, 7; Nash, 11, 66,

figure 753) indicates a circular columnar building of conventional type.

78. 16. Listed by Blake (1959), 124–31.

17. Many other buildings have been attributed to Rabirius (see MacDonald, 127–9), some no doubt correctly; but this is the only one for which there is specific ancient authority (Martial, *Epigrams*, VII. 56).

80. 18. Opinions as to the roofing of the large Domitianic state halls range from a belief that all had concrete barrel-vaults (so, for example, MacDonald, 56–63; Wataghin Cantino, 66–9) to the suggestion that the Aula Regia was in fact a courtyard open to the sky. The problem is one to which there can be no clear-cut, decisive answers. The writer's own conclusions are coloured by the belief that this was an ambitious, experimental architecture in which the resources of the new building methods were being pushed to the limits. The effective spans of the four halls, allowing for such features as internal supporting columns, are: basilica, 48 feet (14·5 m.); Aula Regia, 95 feet (29 m.); Triclinium, 95 feet (29 m.); vestibule, 72 feet (22 m.) from east to west, or 101 feet (31 m.) across the longer, but far more substantially buttressed, north–south span.

83. 19. Though heavily restored, much of this wing is still upstanding as a result of its incorporation into later buildings, the last of which was the Villa Mills, built by a member of the English banking family and one of the very few neo-Gothic buildings in Rome.

20. For the significance of such gardens, see below, p. 202.

84. 21. The vaulted structures within the hall, cited by Tamm, 81, appear to be later insertions.

22. Aurelius Victor, *Epitome de Caesaribus*, 41.13; cf. Ammianus, XXVII. 3. 7.

85. 23. Dio Cassius, LXIX. 4. 1.

24. For which Nero had made provision in a separate building, the short-lived gymnasium (above, p. 56).

25. *Forma Urbis*, 79, plate XXIII.

26. As shown on coins (*B.M.C.: Empire*, II, no. 471, plate XI, 189). The characteristic segmental pediments are echoed locally in the second-century mausolea of the Isola Sacra cemetery.

86. 27. Lionel Casson, *J.R.S.*, LV (1965), 31–9.

28. Ammianus, XVI. 10. 15.

87. 29. *B.M.C.: Empire*, III, 99, no. 492.

30. P. von Blanckenhagen, *Journal of the Society of Architectural Historians*, XIII (1954), 23–6.

31. A much-cited coin, showing the column crowned with an eagle, is an early, programmatic issue, struck before the column was complete; see J. B. Ward-Perkins, *Mélanges Paul Collart* (Lausanne, 1976), 348–9.

89. 32. See Ward-Perkins, *art. cit.*, 349–51, arguing

that the column of red Egyptian granite which was erected in the Campus Martius to commemorate Antoninus Pius (d. 161), and which bears an inscription recording that it was 50 Roman feet long and quarried in 105, was probably a left-over from the construction of this temple; and that the temple, though not formally dedicated until after the death of Plotina (probably in 121), was an integral part of the original project and was already substantially complete in 113.

94. 33. The only buildings in Rome specifically attributed to Apollodorus are the Baths of Trajan, the forum, and a lost odeum (Dio Cassius, LXIX. 4). But the markets and forum are so essentially complementary that it is hard to believe that they were not in conception at any rate the work of a single mind. For the bridge over the Danube, see Procopius, *Buildings*, IV. 6. 12–13; cf. Dio Cassius, LXVIII. 13; it was of timber on stone piers. It is illustrated on Trajan's Column (Lehmann-Hartleben, scene 99).

34. The military layouts sometimes cited as the model adopted by Trajan should be regarded rather as a parallel phenomenon, both being derived in the first instance from models which were originally developed in Late Republican North Italy, and which were widely copied in the new cities of the European provinces; see below, pp. 175–7.

35. See Leon, *op. cit.* (Bibliography), *passim*. The suggestion of M. E. Bertoldi (*Studi Miscellanei del Seminario di Archeologia . . . dell'Università di Roma*, III (1962), 27–31) that this is the result of a Hadrianic rebuilding of the Forum Augustum creates more difficulties than it resolves.

CHAPTER 4

97. 1. There were of course later exceptions, as for example the theatre at Ostia. With the transfer of the 'framed arch' motif, however, to the new building materials it lost the illusion of a robust functionalism which characterizes all its previous manifestations, from the Tabularium and the Temple of Fortuna at Praeneste to the Stadium of Domitian. The Early Imperial tradition was revived in the third century; see below, p. 438.

98. 2. Pliny, *Natural History*, XVI. 202.

99. 3. Boëthius, *op. cit.* (Chapter 1, Note 9), illustrations 144 and 161.

4. The spacing of the courses often, but by no means invariably, corresponds with that of the successive putlog (scaffolding) holes.

100. 5. The planks of the shuttering were not uncommonly replaced or supplemented by tiles (cf. Lugli, *Tecnica edilizia*, plate CCVI, 1–2). Good early examples of this technique, which greatly simplified

the carpentry involved, can be seen in the Domus Aurea, in the Colosseum, and in the Markets of Trajan. Arches, doors, windows, and recesses of all sorts continued to be framed in brick, the frames playing a part during the actual processes of construction similar to that of the facing of the adjoining wall-surfaces.

6. See above, pp. 59 ff.

7. In this description of the residential complex of the Golden House I have, to avoid confusion, retained the conventional terminology based on the notion of a building with two wings symmetrically disposed about a recessed central courtyard. Since the recent researches of Laura Fabbrini it is virtually certain that there was (or that provision was made for) a second recessed courtyard, to the east of the 'east' wing, and beyond this again, presumably, another wing, thus constituting a tripartite façade symmetrical about the octagon. There was also, at any rate in the central wing, an upper storey. These findings, which greatly enhance the architectural role of the octagon and of its superstructure, were reported to the Pontifical Academy in 1978 and a full publication is in preparation.

101. 8. The first known monument in Greece to break with tradition in this respect was, significantly, Agrippa's Odeion in the Agora at Athens (p. 265).

9. Varro's aviary: III. 5. 12–17; cf. A. W. Van Buren and R. M. Kennedy, *J.R.S.*, IX (1919), 59–66. The fragment of the Domus Transitoria preserved under the Temple of Venus and Rome (p. 57 [24]) already indicates an awareness of the possibilities implicit in the new architecture. For Caligula's urban villas, see above, p. 48.

10. See above, pp. 78 ff.

105. 11. For later survivals in the provinces of the same vaulting pattern, see the Cluny Baths in Paris and, in Tunisia, the Central Baths at Mactar and the Summer Baths at Thuburbo Maius.

107. 12. Cf. pp. 204–6 and illustrations 123 and 124. The successive building phases of the villa can be determined in considerable detail from the brick stamps (H. Bloch, *Bolli laterizi e la storia edilizia romana* (Rome, 1947), 102–17). Recent work is showing that there were many changes of plan during construction.

109. 13. That the walls of the Piazza d'Oro octagon cannot have carried a concrete vault is shown by F. Rakob in *Gnomon*, XXXIII (1961), 243–50. It remains a possibility that there was some sort of superstructure in lighter materials.

14. Hence the slighting reference to Hadrian's 'pumpkins' (κολοκύνται) in Dio's account (LXIX. 4) of Hadrian's quarrel with Apollodorus. F. E. Brown in *Essays in Memory of Karl Lehmann* (New York, 1964), 55–8. Although the semi-dome is wide open

today towards the Canopus [50], in antiquity it was masked by a screen wall with three large arches.

110. 15. See C. F. Giuliani in *Quaderni dell'Istituto di Topografia Antica*, VIII (1975), 3–53.

111. 16. Bloch, *op. cit.* (Note 12), 102–17. W. D. Heilmeyer's claim that the Pantheon was designed by Apollodorus and begun under Trajan (*J.D.A.I.*, XC (1975), 316–47) is right in stressing the highly professional quality of the construction and the strong element of stylistic continuity between its architectural detail and the later work of Trajan's reign. This is not the work of a gifted amateur – the emperor. But Heilmeyer's argument refines unduly on the degree of chronological precision implicit in such evidence. In the early years of Hadrian's reign, before his quarrel with Apollodorus (p. 123), it would have been very natural for him to have turned to his predecessor's chief architect; and, as we have seen above (p. 75) in connection with the reconstruction of the Forum of Caesar, workshop traditions did not necessarily dissolve overnight from one reign to the next. Hadrian's amateur status as a builder is of small relevance when it comes to assessing his influence as an exceptionally well-informed patron.

114. 17. IV. 8. 3. and V. 10. 5.

18. For the compositional scheme of the coffering, with twenty-eight ribs, see T. Kurent, 'The Modular Composition of Roman Water-Wheels', *Archaeometry*, X (1967), 29–34.

19. A. Maiuri (*B. d'Arte*, X (1930–1), 241–52) argues for an Augustan date. The construction of the dome, with an aggregate of large, irregular chunks of tufa laid radially, is still in the Republican tradition.

20. The earliest recorded example is Caligulan (p. 48).

118. 21. See J. B. Ward-Perkins, 'Tripolitania and the Marble Trade', *J.R.S.*, XLI (1951), 89–104; also in *Enciclopedia dell'Arte Antica*, IV (1961), 866–70.

22. See below, Chapter 5, Note 17.

23. The present design of the upper order dates from 1747. The original form is shown in illustration 55, and a short section has since been so restored.

120. 24. See F. B. Sear, *Roman Wall and Vault Mosaic* (Heidelberg, 1977). To wall mosaic was later added the coloured marble intarsia which found such vivid expression in the Basilica of Junius Bassus and in the fourth-century building outside the Porta Marina at Ostia (G. Becatti, *Edificio in opus sectile fuori Porta Marina* (*Scavi di Ostia*, VI) (Rome 1969)).

CHAPTER 5

123. 1. For the original design of the two identical cellas, placed back to back and separated by a simple transverse wall, see A. Barattolo, *R.M.*, LXXX (1973),

243 ff.; *Bull. Comm.*, LXXXIV (1974–5), 133 ff. The apses were a Maxentian innovation. The statement that the layout was based upon a double square (E. Muñoz, *La Sistemazione del tempio di Venere e di Roma* (Rome, 1935), 16) is only an approximation to the truth. The plan appears to have been designed in the Greek manner in terms of multiples of a basic module, in this case the diameter at ground level of a column (*c.* 6 feet; 1·87 m.). Strictly applied this resulted in 19 equal intercolumniations along the flanks, but only 9 across the façade; see A. Barattolo, *R.M.*, LXXXV (1978), 397–410.

2. Dio Cassius, LXIX. 4. 3. F. E. Brown, *Essays in Memory of Karl Lehmann* (New York, 1964), 55–8.

3. As very persuasively suggested by D. E. Strong, 'Late Hadrianic Ornament', 133.

124. 4. *ibid.*, 129 and 142–7.

5. The column-shaft was probably a left-over from the building of the Temple of the Deified Trajan fifty years earlier; J. B. Ward-Perkins, *Mélanges Paul Collart* (Lausanne, 1976), 345–52.

6. Strong, *op. cit.*, 123–6.

126. 7. But see Chapter 1, Note 17; also p. 46.

8. N. Goodhue, *The Lucus Furrinae and the Syrian Sanctuary on the Janiculum* (Amsterdam, 1975).

128. 9. The map, a remarkably accurate vertical projection at a scale of approximately 1:250 (according to Gatti, in *Forma Urbis*, 206, it was 1:240), dates from between 203 and 211. Illustrations 61–2 show three characteristic sections; cf. also illustration 20.

130. 10. There is no adequate recent survey. E. Brödner, *Untersuchungen an den Caracallathermen* (Berlin, 1951) is useful for the part which it covers, but is almost certainly mistaken in its belief that the palaestrae were roofed.

11. So also the placing of the windows in shallow, scalloped recesses, so as to admit more light; cf. Tor Pignattara, below, pp. 431, 438–9. This feature had been anticipated in Campania, at Baiae, in the annex to the 'Temple of Venus' (p. 168).

132. 12. 'Septizodium' rather than 'Septizonium' (*Forma Urbis*, 67 and plate XVII, fragments 8a and b). Cf. *C.I.L.*, VI. 1032, and G.-C. Picard, *Monuments et Mémoires Piot*, LII (1962), 77–93.

13. S.H.A., *Severus Alexander*, XXV. 7.

14. Dio Cassius, LXXVII. 16. 3.

134. 15. Reproduced by Nash, I, figures 663 (Sol Invictus) and 664 (Juppiter Ultor = *B.M.C.: Empire*, VI (1962), 134, no. 208).

16. Palladio's plan and Van Heemskerck's and du Pérac's drawings of the remains still visible in the fifteenth and sixteenth centuries are reproduced by Nash, II, figures 1160, 1165, and 1168. Frequently but mistakenly identified as Aurelian's Temple of

the Sun, which lay farther to the north (see below, p. 417).

17. The largest recorded Roman column is one of grey Egyptian granite still lying in the Mons Claudianus quarries, which measures just over 62 Roman feet (18·40 m.) and weighs an estimated 268 tons: T. Kraus and J. Röder, *Mitteilungen des deutschen archäologischen Instituts, Abteilung Kairo*, XVIII (1962), 113. The columns of the Pantheon and of the Temple of the Deified Trajan, both of mixed red and grey Egyptian granite, measured 40 and 50 Roman feet respectively (11·80 m. and 14·75 m.), those of Baalbek, of Syrian limestone, fractionally over 56 Roman feet (16·64 m.).

18. P. von Blanckenhagen, *Flavische Architektur* (Berlin, 1940), 90–9.

135. 19. G. Mancini, *N.S.* (1923), 46–75; E. L. Wadsworth, *M.A.A.R.*, IV (1924), 64–8.

138. 20. Wadsworth, *loc. cit.*, 69–72 (Tomb of the Valerii) and 73–8 (Tomb of the Pancratii).

CHAPTER 6

141. 1. See G. Becatti, *Scavi di Ostia*, vol. I. For the Sullan city, see Boëthius, *op. cit.* (Chapter 1, Note 9), illustration 123, pp. 181–3.

143. 2. Vitruvius, V. 9.

3. In Campania this practice had been anticipated at least a century earlier in the Basilica at Pompeii. For the stoa-like porticoes of similar form enclosing the Republican forum at Minturnae, built soon after 191 B.C., see J. Johnson, *Excavations at Minturnae*, I (1935), 44–51.

145. 4. For the wooden *viae porticatae* of Late Republican Rome, see K. Lehmann-Hartleben in *P.W.*, 2, 3, s.v. 'Städtebau', 2059–60. There was a symmetrically planned street with flanking arcades inside the Porta Nigra at Trier. The colonnaded street at Lepcis Magna (pp. 390–1) was an intruder from the East, the work of an architect from Asia Minor. For streetside porticoes of substantially Ostian type in the Western provinces, see below, pp. 239 (Gaul) and 393 (North Africa).

147. 5. For multi-storeyed houses at Tyre, Strabo, XVI. 2. 23. The multi-storeyed houses of Ephesus (below, p. 296) are a rather special case, being terraced up steeply sloping hillsides.

148. 6. Barracks of the Vigiles (fire brigade) (Region ii, 5, 1): P. K. Baillie-Reynolds, *The Vigiles of Imperial Rome* (Oxford, 1926), 107–15 (but it was never a private house; Meiggs, *Ostia*, 305, note 4). The House of the Triclinia (Region i, 12, 1), headquarters of the collegium of builders. The Horrea Epagathiana et Epaphroditiana (Region i, 8, 3), built presumably by

two well-to-do freedmen of these names: *N.S.* (1940), 32. Later warehouses, e.g. Region i, 8, 2; ii, 3, 2; ii, 12, 1; and at Portus.

151. 7. The gable of the Capitolium reached about 70 feet above pavement level, suggesting that some of the adjoining buildings may have approached the statutory height-limit of 60 feet established by Trajan (Victor, *Epitome*, 13. 13); see p. 61 and Note 24 thereto. For the circular temple, C. C. Briggs in *M.A.A.R.*, VIII (1930), 161–9 (but a Constantinian date cannot be accepted). For the sanctuary of Cybele, G. Calza, *Mem. Pont.*, VI (1943), 183 ff.

8. Such public lavatories were regularly situated near bath-buildings or fountains so as to take advantage of the outflow of waste water; two more can be seen in illustration 73. For a study of the Forum Baths in terms of the technical problems involved in heating them, see E. D. Thatcher, *M.A.A.R.*, XXIV (1956), 169. Of the smaller, privately owned baths (*balnea*) one in the Via della Foce (Region i, 19, 5) offers an unusually complete fourth-century example of a type best represented in North Africa and at Piazza Armerina.

9. G. Calza, *Architettura e arti decorative*, III (1923–4), 11.

CHAPTER 7

157. 1. The evidence is fully discussed by Maiuri in *L'ultima fase*.

158. 2. The so-called Third and Fourth Pompeian Styles. Though named after and best studied at Pompeii, these do in fact represent far wider contemporary trends.

160. 3. Nero's short-lived gymnasium in Rome, which appears to have been a building independent of the Thermae Neronianae, may have served a comparable purpose; see above, p. 56.

4. So too in the provinces. Cf. the agora at Corinth and the forum at Sabratha (below, pp. 255 ff. and 378–80).

161. 5. For wooden constructions and fittings, see specially the accounts of the more recent excavations here and at Herculaneum, by Spinazzola and Maiuri.

162. 6. The macella of Rome are known from the literary sources (see Platner-Ashby, s.v. 'Macellum'), from representations on coins (above, Chapter 2, Note 16), and from the Severan marble plan. For the diffusion of this type of market building in the provinces, see below, p. 395; also *J.R.S.*, LX (1970), 15–16, and the writer's account of the Market Theatre at Cyrene, forthcoming in *Libya Antiqua*.

164. 7. The discovery of a glass window still in position in the Suburban Baths at Herculaneum

reminds us how much the architecture of the Central Baths at Pompeii, with their large, southward-facing windows, owed to the recent introduction of this material. See above, p. 151.

8. The earliest surviving broken pediments in real architecture seem to be in the Doric Nymphaeum beside Lake Albano (usually attributed to the first century B.C.) and in the Palazzo delle Colonne at Ptolemais in Cyrenaica, the date of which is controversial (see below, p. 370). The ultimate source of the motif is hellenistic.

9. Vitruvius, VII. 5. The description of Ptolemy's pleasure-barge by Kallixeinos of Rhodes is preserved by Athenaeus (V. 204d–206c, ed. Kaibel, 1887); see F. Caspari, *J.D.A.I.*, XXXI (1916), 1–74.

166. 10. For Capua and Pozzuoli see A. Maiuri in *Mem. Nap.*, III (1953). The earliest of all permanent amphitheatres may well have been at Capua, where there was a famous gladiatorial school. For the partially timber amphitheatres of North Italy, S. Aurigemma, *Historia*, VI (1932), 159.

11. P. Marconi, *Verona romana* (Bergamo, 1937), 101–14; L. Beschi, 'Verona Romana, i monumenti', in *Verona e il suo territorio*, I (Verona, 1960), 456–75. Pola: A. Gnirs, *J.Ö.A.I.*, XVIII (1915), Bb. 163–76.

12. Pozzuoli: Maiuri, *Campi Flegrei*, 24–8; Dubois, *Pouzzoles antiques*, 286–314; C. De Ruyt, *Puteoli: studi di storia antica*, I (Pozzuoli, 1977), 128–39.

13. For the excavations at Baiae, see A. Maiuri in *B. d'Arte*, X (1930–1), 241–53; and XXXVI (1951), 359–64. A detailed survey, directed by M. E. Bertoldi, awaits publication.

167. 14. The circular room of the Stabian Baths, later converted into a frigidarium, was built as a laconicum; see H. Eschebach, *R.M.*, LXXX (1973), 235–42, where he documents archaeologically the inscription *C.I.L.*, X. 1, 829.

173. 15. See below, p. 226.

174. 16. For the hellenistic mixed order, see S. Stucchi, *L'Agora di Cirene*, I (Rome, 1965), 201–2.

177. 17. For similar streetside porticoes at Ostia, see p. 143.

18. Grenier, *Manuel* (see bibliography to Chapter 9), III. 1, 380–2.

19. M. Mirabella Roberti in *Storia di Brescia*, I (Brescia, 1961), 249–59; cf. G. Saletti, *Museo Bresciano Illustrato*, I (Brescia, 1838). Preserved within the platform of the later Capitolium are the substantial remains of a row of four small, apparently identical, Republican temples facing axially down what was presumably already the open area of the forum. Dating from the early first century B.C., this is an at present unique example of the models from which the fora of the Imperial age were developed.

20. A similar projection of the basal plinth appears already in Augustan times on the monument of La Turbie (above, p. 171).
21. See R. G. Goodchild, *Antiquity*, XX (1946), 70–7.
179. 22. See below, pp. 297 ff.

CHAPTER 8

187. 1. Maiuri, *Ercolano*, 280–302.
2. Vitruvius, VI. 3. 9. For the basilican *oecus aegyptius* and other similar exotic room-forms, see Maiuri in *Studies Presented to D. M. Robinson*, I (St Louis, 1951), 423–9.
3. One of the factors which made the opening-up of the old atrium-house possible was the adoption of window glass, a development said by Seneca (d. A.D. 65) to have taken place during his own life-time (*Letters*, 90. 25).
188. 4. As the Pompeian house lost its stereotyped layout, so the terms *oecus*, *tablinum*, and *triclinium* lost the precision of their earlier meanings; the distinction becomes largely one of archaeological convention. For the subsequent emergence of the triclinium as the principal room of the Roman house, see I. Lavin, *Art Bulletin*, XLIV (1962), 5; also below, p. 463.
5. Maiuri, *Ercolano*, 302–22.
190. 6. A. Maiuri and R. Pane, *La Casa di Loreio Tiburtino e la Villa Diomede in Pompei* (Rome, 1947), 5–9.
192. 7. R. Lanciani, *Mon. Ant.*, XVI (1906), 266. Becatti, 'Case Ostiensi', 23–5, figure 22.
8. R. Meiggs, *Ostia* (Oxford, 1960), 237 ff. The two fundamental articles are by G. Calza in *Mon. Ant.*, XXIII (1914), 541–608, and in *Architettura e arti decorative*, III (1923–4), 3–18 and 49–63.
193. 9. This and the following references are to the plan of the Regions and insulae of Ostia appended to *Scavi di Ostia*, I.
10. The 'balconies' (*maeniana*), carried on project-ing segmental arches [e.g. 76], do not always cor-respond with the floor levels inside the building, and many of them seem anyway too narrow to have been functional. For the regular exposure of the brickwork, see Calza, *Mon. Ant.*, XXIII.2 (1914), 577–8.
195. 11. The 'peristyle' and 'portico' villas, re-spectively, of Swoboda's classification. It should be emphasized that where, as here, the distinctions are far from clear-cut, any classification is bound to be largely a matter of convenience; and that some sort of platform (*basis villae*) is a regular feature of the seaside portico villas [cf. 95].
12. *N.S.*, XIX (1965), 237–52; *P.B.S.R.*, XXXIII (1965), 54–69. Definitive publication imminent.

13. G. Lugli, *Bull. Comm.*, LV (1927), 139–204. A fine early-first-century B.C. platform villa is currently being excavated at Sette Finestre, near Cosa.
196. 14. A. Gnirs, *J.Ö.A.I.* between VII (1904), Bb. 131–41 and XVIII (1915), Bb. 99–158.
198. 15. Punta Barbariga: H. Schwarb, *Schriften der Balkankommission*, 11 (1903). Campanian paintings of architectural landscapes: the fundamental publication is still that of M. Rostowzew, *R.M.*, XXVI (1911), 1–186.
16. Maiuri, *Capri*, 66–9.
17. *ibid.*, 29–56.
201. 18. *ibid.*, 56–65.
19. Porticus Pompeii: *Forma Urbis*, 104–6, tavola XXXII; cf. Propertius, *Elegies*, II. 32, 11–16. Porticus Liviae: *Forma Urbis*, 69–70, tavola XVIII; cf. Pliny, *Natural History*, XIV. 11.
202. 20. G. Lugli, *Mélanges d'archéologie et d'histoire de l'École française de Rome*, LV (1938), 5–27; now convincingly identified by H. G. Beyen (*Studia Vollgraf* (Amsterdam, 1948), 3–21) as the town house of Agrippa and Julia (19–12 B.C.).
21. Grimal, *Jardins*, *passim*. Varro, while criticizing the fashion for gymnasia and other hellenizing fancies in the villas of his day (*On agriculture*, 11. intr.), had a 'palaestra' in his own villa at Tusculum (III. 13). For the 'hippodrome' of Pliny's Tuscan villa, see *Letters*, V. 6. 32–3. Cicero's villa at Tusculum had a favourite terrace known as 'the Academy'.
22. Blake (1959), 40–1.
23. *ibid.*, 41–2. Nero was dining here in 60 (Tacitus, *Annals*, XIV. 22).
24. Lugli, *N.S.* (1946), 60–83.
203. 25. Lugli, *Bull. Comm.*, XLV (1917), 29–78; XLVI (1918), 3–68; XLVII (1919), 153–205; XLVIII (1920), 3–69.
26. Lugli, *Forma Italiae: Regio I*, vol. 1, 2, 65–76 and map 3; G. Jacopi, *N.S.* (1936), 21–50.
204. 27. Bloch, *op. cit.* (Chapter 4, Note 12), 117–83 and especially 182–3. To the first phase of the construction (A.D. 118–25) belong certainly the nucleus of the East Palace and the complex of buildings associated with the Stadium. Pending the publication of more detailed studies of the individual buildings by Friedrich Rakob and his collaborators and by various members of the Istituto di Topografia Antica, it is premature to speculate further about the layout of the villa as a whole and about the many changes of plan which it underwent during the twenty-odd years of its construction.
206. 28. The names actually attested (S.H.A., *Hadrian*, XXVI. 5) are those of four buildings in Athens (the Lyceum, the Academy, the Prytaneum, and the Stoa Poikile), the Vale of Tempe in Thessaly, and the

great Sanctuary of Serapis at Canopus in Egypt; also 'the Underworld'.

29. *Letters*, V. 6. 15.

30. There is no adequate publication of this important building.

31. T. Ashby, *P.B.S.R.*, IV (1907), 97–112; N. Lupu, *Ephemeris Dacoromana*, VII (1937), 117–88; Bloch, *op. cit.* (Note 27), 256–68.

210. 32. There is a solitary example of this high lighting at Pompeii, in the triclinium of the House of the Menander, rebuilt between 62 and 79; A. Maiuri, *La Casa del Menandro* (Rome, 1933).

33. Villa of the Quintilii: T. Ashby, *Ausonia*, IV (1909), 48–88. Le Mura di S. Stefano: T. Ashby, *R.M.*, XXII (1907), 313–23; cf. *P.B.S.R.*, XXIII (1955), 66, plates XVII, XVIII; XLV (1977), 227–51.

34. Nash, s.v. 'Amphitheatrum Castrense' (I, 13–16), 'Sessorium' (II, 384–6), and 'Thermae Helenae' (II, 454–7).

35. Limited excavation within the area of the residence has disclosed, incorporating or replacing the remains of three earlier periods, an audience hall and a long transverse corridor, both reminiscent of Piazza Armerina; G. Pisoni Sartorio and R. Calza, *La Villa di Massenzio sulla Via Appia* (Istituto di Studi Romani, 1976).

36. See above, p. 192 and Note 7.

37. Reg. iv, 3. Becatti, 'Case Ostiensi', 114–17, figure 14.

212. 38. Reg. i, 14. Becatti, *loc. cit.*, 105–7, figure 4.

39. E.g. the triple-arched windows of one of the houses of a mosaic from Thabraca (reproduced by Becatti, figure 51).

40. Doro Levi, *Antioch Mosaic Pavements* (Princeton, 1947), figure 26.

CHAPTER 9

214. 1. In Latin usage *Hispania* or *Hispaniae* ('the Spains') covered the whole Iberian peninsula. It comprised the three provinces of Baetica in the south, Lusitania in the south-west, south of Oporto, and Tarraconensis, covering the whole of the north and north-east.

216. 2. The projecting string-courses had a practical as well as an aesthetic purpose, namely to support scaffolding during construction or repairs. The aqueduct still serves Seville.

3. *C.I.L.*, II, 761. For Apollodorus's bridge see below, Note 14; also above, Chapter 3, Note 33.

220. 4. Cf. the inscription on the original Porta dei Leoni at Verona (above, p. 179), in which the four commissioners charged with refounding the city on its present site record that they built and completed the

city wall, the gates, and the sewers (*murum, portas, cluacas fecerunt: C.I.L.*, V, 3434). These and a water supply were the first priorities of good city planning.

221. 5. The exclusion of wheeled traffic from the forum area was regular Roman practice.

6. R. G. Goodchild, *Antiquity*, XX (1946), 70–7; also *J.R.S.*, LX (1970), 7–11.

222. 7. See below, pp. 227–8.

8. Gallia Cisalpina was not formally incorporated into Italy until 42 B.C.

223. 9. Occasional uses of opus reticulatum (e.g. in the aqueducts of Lyon) represent quirks of local taste, copied directly from Italy.

10. But by no means invariably. Mr R. M. Butler, to whom I owe this observation, cites Carcassonne, Nantes, Rennes, Sens, Toul, Bavai, and Jublains as instances of town walls where the tile-courses do not penetrate the full width of the core. In the aqueduct of Los Milagros at Mérida in Spain (p. 216) the tile-courses appear to be continuous through the core.

11. See above, p. 173. For the priority accorded to the building of a city wall, cf. above, Note 4.

224. 12. In Rome, for example, the buildings on the Capitol must have been supplied in this way. A part of the water supply at Lincoln may have been similarly pumped from a spring at the foot of the hill; F. H. Thompson, *Archaeological Journal*, CXI (1954), 106–28; but see Wacher, *Towns of Roman Britain*, 125–32.

225. 13. For the syphons on the 45-mile-long Hadrianic Mont Pilate aqueduct (Aqueduc du Gier) at Lyon, see Grenier, *Manuel*, IV, 129–36. Arles, *ibid.*, 85. The second-century B.C. aqueduct at Alatri in Central Italy was already of this type (*C.I.L.*, X. 1, 5807; cf. *P.B.S.R.*, XXIII (1955), 115–23).

14. Two bridges over the Danube are illustrated on Trajan's Column: a bridge of boats (Lehmann-Hartleben, scene 4) and Apollodorus's bridge below the Iron Gates, which had masonry piers and a timber superstructure (*ibid.*, scene 99); cf. also scene 131, an all-timber bridge over a lesser river. Vitruvius (V. 12. 2–6) describes how to lay foundations below water, using wooden coffer-dams (*arcae*).

226. 15. See Grenier, *Manuel*, III, 305–22. Although much has been made of Vitruvius's recommendation (V. 9. 5–9) that public porticoes be used for the storage of commodities such as fuel and salt, the vaulted substructures must in most cases have been primarily a matter of constructional convenience, as a means of providing a level, upstanding platform for one of the city's major civic monuments. See the writer's comments in *Les Cryptoportiques dans l'architecture romaine* (École Française de Rome, 1973), 51–66, in which there are also detailed accounts

of the cryptoporticoes of Arles (with a highly imaginative reconstruction of the complex) and of Reims; also of Coimbra (Aeminium) and of Conimbriga in Portugal.

227. 16. I am indebted to Pierre Gros for advance information about his detailed study of the Maison Carrée, now published; see Bibliography, s. v. Amy, R., and Gros, P. He dates its completion to the very beginning of the Christian era. The identification and chronology of the temple at Vienne are based on the readings of what are interpreted as two successive dedicatory inscriptions, of which only the holes for the pegs of the bronze letters have survived; see Grenier, *Manuel*, III, 396–7. If correctly read, these show the temple to have been dedicated to Rome and Augustus, before the latter's death in A.D. 14, and rededicated shortly after A.D. 41 to the Deified Augustus and to Livia. It used to be thought, on similar evidence, that the Maison Carrée too was rededicated in A.D. 1–2, after being built originally by Agrippa between 19 and 12 B.C. (*ibid.*, 147–9), but this is not correct.

17. F. Benoit, *Rivista di.studi liguri*, XVIII (1952), 219–44.

18. A remarkable example, revealed by air-photography at Ribemont-sur-Ancre, north-east of Amiens, is nearly half a mile (750 m.) in length; R. Agache and B. Bruart, *Atlas d'archéologie aérienne de Picardie* (Amiens, 1975), 110–11. The square Gallo-Roman temple (Augustan), with two rectangular forecourts, stands at the head of an elongated monumental enclosure, splayed slightly outwards, with a theatre (Neronian) and a bath-building (Trajanic) on the central axis and flanked by other large buildings.
231. 19. See below, Chapter 13 and Note 12 thereto.
234. 20. The 'Reihentyp' of Krencker's classification (D. Krencker and E. Krüger, *Die Trierer Kaiserthermen* (Augsburg, 1929), 177). For the two types, cf. the South Baths at Conimbriga in Portugal (pp. 217–18), where the Augustan bath-building, of derivative Pompeian form, was replaced under Trajan by a more elaborate, axially-disposed 'Reihentyp' complex.
236. 21. This account follows the chronology proposed by P. Gros, *Gallia*, XXXVII (1979), 55–83. H. Rolland had suggested an early Augustan date for the arch at Glanum, but this is far too early.

22. Amy, *L'Arc d'Orange*, plates 6 and 64. To be distinguished from the 'arcuated lintel' of contemporary Syrian practice. See below, Chapter 12 and Note 64 thereto.
237. 23. G. Brusin and V. de Grassi, *Il Mausoleo di Aquileia* (Padua, 1956). Sarsina: A. Aurigemma, *Palladio*, I (1937), 41–52. Nettuno: G. Giovannoni, *Roma*, XXI (1943), 378–9. Cf. the destroyed 'Three Monuments' of Terni, *N.S.* (1907), 646–7.

24. Cf. the fine terraced town house at Aix-en-Provence described by Benoit in *Gallia*, V (1947), 98–122. This had a large inner peristyle and a small entrance peristyle of 'Rhodian' type, i.e. with one portico taller than the rest, as regularly at Delos and in Cyrenaica.
241. 25. At Anthée the overall length of the two enclosures was 650 yards (600 m.) and the area enclosed by the residence and farm buildings was of the order of 25 acres; Grenier, *Manuel*, II, 845. Among the most completely documented of the large villas of the Somme area are the villa at Estrées-sur-Noye, 7 miles south of Amiens (Agache and Bruart, *Atlas*, 60; 440 yards (400 m.) long); and the two villas at Warfusée-Abancourt, 13 miles east of Amiens (*ibid.*, 131; 330 and 440 yards (300 and 400 m.) long respectively). For Cachy, 9 miles south-east of Amiens, *ibid.*, 40. These and many others are further discussed in R. Agache, *La Somme préromaine et romaine* (Amiens, 1978), 279–387. For the large villa of similar plan at Odrang in the Mosel area, near Trier, see Wightman, *Roman Trier*, 143–5.

26. The wealthy villas of Gallia Belgica, for example, virtually come to an end after the third century. But in many other regions (e.g. in the district around Metz and again in the south-west; evidence conveniently summarized in chapter 4 of Percival, *The Roman Villa*) villas were reconstructed or continuously occupied right through the fourth century.
242. 27. Wightman, *Roman Trier*, 145–8. The villa of Montmaurin (see Bibliography) is a good example of the residence of a wealthy late Roman landowner in south-western Gaul.
246. 28. A. M. Schneider and W. Karnapp, *Die Stadtmauer von Iznik* (*Nicaea*) (*Istanbuler Forschungen*, IX) (Berlin, 1938).

29. Conveniently summarized in *Enciclopedia dell' Arte Antica*, IV, 772–5. Detailed interim reports annually in the local review, *Karinthia I*. For the forum at Virunum, see *J.R.S.*, LX (1970), 13, figure 13; Alföldi, *Noricum*, 87–90, figure 6.
248. 30. The building here illustrated, which replaced a Trajanic structure, is dated by the excavators to the mid second century; Mócsy, *Pannonia and Upper Moesia*, 111 and note 119, with bibliography.
249. 31. Seuthopolis, near Koprinka, the capital city of Seuthes III, excavated and then submerged by a dam: see P. Dimitrov and M. Čičicova, *The Thracian City of Seuthopolis* (*B.A.R.*, Supplement 38) (Oxford, 1978). The remarkable contemporary painted tomb at nearby Kazanlăk, found and preserved intact, has a corbelled brick vault, as did one of those at Koprinka. Hoddinott, 93–7 (Seuthopolis) and 97–103 (tombs at Kazanlăk and Koprinka).

32. For the latest state of the excavations of the forum at Nicopolis-ad-Istrum, see T. Ivanov, 'L'Agora de Nicopolis ad Istrum, d'après les nouvelles recherches', *Arheologiya*, XIX (1977), 16–29 (in Bulgarian, with a French summary).

250. 33. A great deal of this material has been excavated since the Second World War, and most of it awaits definitive publication. Short accounts of most of the sites here referred to will be found in R. Hoddinott, *Bulgaria in Antiquity* (London, 1975), which also lists (p. 18) the Bulgarian archaeological periodicals that contain interim reports of some of them. For Chatalka, see D. Nikolov, *The Roman Villa at Chatalka, Bulgaria* (B.A.R., Supplement 17) (Oxford, 1976). For the Stara Zagora baths, see *idem, Arheologiya*, X (1968), 43 ff. Several other mineral spring establishments have been recorded, one of them, near Haskovo, yielding traces of pre-Roman use. The Ivailovgrad villa is also referred to under the name of Marina.

251. 34. See Gabriella Bordenache, 'Attività edilizia a Tomi', *Dacia*, N.S. IV (1960), 255–72, notably the remains of two buildings dedicated in A.D. 116–17 and in 161–2 respectively.

252. 35. I am indebted to Prof. John Wilkes and to the excavator, Prof. M. Suić, for information about this as yet rather inaccessibly published site.

253. 36. Sticotti's account of this building is careful and his arguments for dating it appear convincing; but one would welcome independent evidence of so notable an innovation at this early date.

CHAPTER 10

NOTE. For the architecture of Greece prior to the Roman period, see A. W. Lawrence, *Greek Architecture* (*Pelican History of Art*), 3rd ed. (Harmondsworth, 1973).

255. 1. For the individual buildings at Corinth referred to in the pages that follow, see the following volumes of *Corinth*:

I, 1 (1932). Topography, the Lechaion Road, the Propylaea, the Julian Basilica.

I, 2 (1941). Northwest Stoa and Shops, the Captives Façade, the Peribolos of Apollo, Temple E.

I, 3 (1951). The Lower Agora, including the buildings along the West and Central terraces. Temples E–K. The Market.

I, 4 (1954). The South Stoa and its Roman successors.

I, 5 (1960). The Julian and South Basilicas.

I, 6 (1964). The Springs of Peirene and Glauke.

II (1952). The Theatre, the Odeion.

See also individual articles in *Hesperia*.

The conclusions of the earlier excavators are currently the subject of a wide-ranging general revision at the hands of C. K. Williams; the broad picture stands unchanged, but there will be considerable modifications of detail. I am indebted to Susan Walker for the information that the Captives Façade is now believed to be Severan; and that fresh epigraphic evidence shows the long-accepted attribution of the second marble phase of Peirene to the munificence of Herodes Atticus to be mistaken. From her own observations she tells me that the accepted restoration of the three great exedrae that characterize the final major reconstruction of the fountain court at Peirene (G. P. Stevens, *A.J.A.*, XXXVIII (1934), 55–8) as having been concrete-vaulted is also mistaken. They presumably had flat timber ceilings at two levels.

257. 2. See below, pp. 371 ff.

258. 3. See below, p. 349 and illustration 227.

4. For similar market buildings in North Africa, see pp. 373–6, 395.

5. The Greek agora had been gravel-paved, as was that of Athens right through the Roman period. For the use of Italian-type mouldings at Corinth, see L. T. Shoe in *Essays in Memory of Karl Lehmann* (New York, 1964), 300–3. For the Italian origin of the colonists, Pausanias, II. 1. 2.

6. Only four certain examples seem to have been recorded from Asia Minor, at Aspendos, Ephesus, Kremna, and Smyrna. In mainland Greece, see the recently discovered North-West Basilica in Athens, a rectangular building of Hadrianic date, with an internal ambulatory colonnade and an external portico fronting on to the north-west corner of the Agora; see *Hesperia*, XL (1971), 261–5, and XLII (1973), 134–8.

260. 7. In the matter of access to the seating, the Theatre of Marcellus in Rome [4] and those at Lepcis Magna and Sabratha in Tripolitania [247], all of them built on level ground with access to the seating by way of staircases incorported in the substructures, are more characteristic of normal Roman practice than the theatre at Orange [163B]. At Orange, built up against a steep, rocky hillside, not only were the *confornicationes* suppressed, but the seating could only be reached by external staircases discharging into the portico at the head of the *cavea*. At Verona, in a somewhat similar setting, the *confornicationes* were retained, but here too access to the seating was by way of an external staircase which entered the *cavea* halfway up.

8. For the *porticus post scaenam*, see Vitruvius, V. 9. 1.

261. 9. B. Saria, *Anz.* (1938), 81–148.

262. 10. For theatre-amphitheatres, used for hunting spectacles (*venationes*), see Dio Cassius, LXXVIII. 9. 7 (θέατρα κυνηγετικά), and Richard Stillwell in

Corinth, 11, 7; and for their adaptation for aquatic displays (κολυμβήθρα), see John Chrysostom, *In Matthaeum Homiliae* (ed. Migne, *Patrologia*, 1860), VII, 7; also G. Traversari, *Gli Spettacoli in acqua nel teatro tardo-antico* (Rome, 1960).

263. 11. As suggested to me by Professor H. A. Thompson. It lies directly opposite the bema.

12. See Pausanias, I. 20. 7.

265. 13. The 'Tower of the Winds' (so-named after the appropriately oriented representations of the eight principal winds on the upper frieze) or 'Horologion of Andronikos': Travlos, 28–37; H. S. Robinson, *A.J.A.*, XLVII (1943), 291–305. The nineteenth-century observatory at Oxford embodies a close replica of this building. For the water clock, see D. J. de Solla Price, *A.J.A.*, LXXII (1965), 345–55. The Temple of Rome and Augustus: Travlos, 494–5.

14. Travlos, 28–37. This now became the city's commercial agora. For its possible South Italian connections, see above, p. 258.

15. *A.J.A.*, LXVI (1962), 200; Agora *Guide*³ (1976), 140.

16. H. A. Thompson, *Hesperia*, XIX (1950), 31–141; Travlos, 365–77. For the identification of the adjoining building as the Gymnasium of Ptolemy, see *A.J.A.*, LXIX (1965), 177; *Hesperia*, XXXV (1966), 41. Lecture halls of comparable size were added in the Roman period to the old gymnasia of Epidaurus and Pergamon.

267. 17. Travlos, 387–91. Its roof, burnt in 86 B.C., was restored by Aristobarzanes Philopator (65–52 B.C.), the work being entrusted to a mixed team of architects, one Greek and two Italians, Gaius and Marcus Stallius. Like Decimus Cossutius (p. 263) the latter probably came from Campania (the name Stallius is South Italian), a region whose architects seem already to have acquired a reputation as specialists in such work.

268. 18. See above, p. 25.

19. For the successive stage-buildings, see Travlos, 548.

20. Aqueduct (begun in 125 and completed in 140): Travlos, 242. Houses: *ibid.*, 392–401. Bath-buildings: *ibid.*, 180–90. The façade of the aqueduct reservoir was still standing in the mid fifteenth century, when it was seen by Cyriacus of Ancona. It consisted of a tetrastyle Ionic propylon of which the central opening was arched. It is significant for local taste that this followed the older, hellenistic tradition of an arch flanked by two independent architraves (see above, p. 236 and Chapter 9, Note 22), not the arcuated lintel as represented, for example, in the Temple of Hadrian at Ephesus.

21. Travlos, 253–7. The inscription on the west face reads 'This is Athens, the ancient city of Theseus';

that on the east face 'This is the city of Hadrian, not of Theseus': *Inscriptiones Graecae*, II², 5185. The central compartment of the upper order was divided into two by a transverse slab of marble, presumably to house statues of Theseus and of Hadrian respectively. The arch was most probably completed in time for the dedication ceremony of the Olympieion in 132. A few years later a pair of arches, identical both in design and in dimensions, were set up at Eleusis by the Panhellenes, in honour of Demeter and of Antoninus Pius.

269. 22. M. A. Sisson, *P.B.S.R.*, XI (1929), 50–72; Travlos, 244–52.

23. See above, p. 32.

271. 24. See below, pp. 388–9 and illustration 258.

25. At first sight the plan suggests that this building carried a semi-dome, and it is commonly so restored; e.g. by R. Ginouvès in J. Des Gagniers and others, *Laodicée du Lykos: le nymphée* (Quebec-Paris, 1969), 138. But although some of these apsidal nymphaea certainly were vaulted (e.g. Gerasa [219]), a fact which may be rightly interpreted as a lingering legacy of the origins of such buildings in caves dedicated to the Nymphs, it is equally certain that some did not (e.g. the Severan Nymphaeum at Lepcis Magna [260]). On balance, the very considerable height of the walls implied by the quantity of statuary displayed within the building at Olympia, coupled with the failure of the excavators to find any trace of fallen vaulting, suggests that it belonged to the latter group, without a semi-dome. For the programmatic nature of the statuary displayed in such buildings, cf. the nymphaeum built by Plancia Magna within the South Gate at Perge (below, pp. 300–2).

26. That it was roofed seems certain. The nineteenth-century excavators found the marble seating badly calcined by fire, and a thick layer of ashes and carbonized wood covered both stage and seating; see Travlos, 378. Timbers of the necessary size were available – at a price. Pliny (*Natural History*, XVI. 200) records one in Rome, a left-over from the roofing of the Augustan Diribitorium, which was 100 Roman feet (nearly 30 m.) in length and 1½ Roman feet (45 cm.) in section. Begun after 160, the Odeion of Herodes was in use when seen by Pausanias in 176.

27. Recently, however, Roman-period architecture has begun to attract more attention in its own right, e.g. at Nicopolis and at Argos, where R. Ginouvès has published a valuable pioneer study of Roman brick-work in Greece (*Le Théâtron à gradins droits et l'odéion d'Argos* (Paris, 1972), appendix pp. 217–45). A wall built of solid brick and dated to the second century is reported from the harbour buildings at Kenchreai (*Archaeology*, XVIII (1965), ill. p. 194), suggesting the influence of contemporary Asia Minor.

272. 28. Notably the mid-second-century monument, now dismantled, known as 'Las Incantadas', which incorporated a Corinthian façade with a much smaller order of pseudo-caryatid figures above it. P. Perdrizet, *Monuments et Mémoires Piot*, XXXI (1930), 51–90; Lucia Guerrini, *Arch. Cl.*, XIII (1961), 40–75.
29. G. Roux, *B.C.H.*, LXXVIII (1954), 160–2.

CHAPTER 11

273. 1. See J. B. Ward-Perkins in D. Talbot Rice (ed.), *The Great Palace of the Byzantine Emperors* (Edinburgh, 1958), II, 52–104, discussing many of the buildings referred to in this chapter. A provincial variant of opus caementicium; cf. Pliny, *Letters*, X. 39, describing the walls of the new gymnasium at Nicaea as 'caemento medii facti nec testaceo opere [i.e. brick facing] praecincti'. This whole correspondence (*Letters*, X. 37–40) offers a vivid glimpse of provincial architectural practice in relation to that of Rome.
274. 2. Ephesus, aqueduct of Pollio: *Forschungen*, III (1923), 256–63; Keil, *Führer*[5], 133–4. Miletus, bath-buildings: below, Note 31. Miletus, nymphaeum: below, Note 38. For the early influence of metropolitan Roman architecture in Asia Minor, see J. B. Ward-Perkins in *Proceedings of the X International Congress of Classical Archaeology* (Ankara, 1978), II, 881–91.
275. 3. Simple vaulting was very common in the coastal cities of Cilicia. The harbour mole at Elaeusa (Ayaş) is of a strength which suggests that suitable volcanic sand may have been imported.
276. 4. *Great Palace*, II, 90–5. The *locus classicus* for this sort of vaulting is Karanis in Egypt; see below, p. 365 and illustration 238.
277. 5. E. Boehringer in *Neue deutsche Ausgrabungen im Mittelmeergebiet und im vorderen Orient* (Berlin, 1959), 136–8. For the masonry, *Great Palace*, II, 85 and plate 30. A full report is said to be in preparation.
6. Th. Wiegand in *Abhandlungen der deutschen Akademie der Wissenschaften zu Berlin, Phil.-hist. Klasse* (1932). Temple and sanctuary (for the latter see below, pp. 284–5 and illustration 182), long thought to be mainly the work of Antoninus Pius, are now shown to have been begun by Hadrian, *c.* 131, and well advanced before his death in 138; C. Habicht, *Alterthümer*, VIII, 3 (1969): *Die Inschriften des Asklepieions*; cf. M. Le Glay, 'Hadrien et l'Asklépieion de Pergame', *B.C.H.*, C (1976), 347–72.
278. 7. The immediate source may well have been the provinces of the lower Danube, where similar masonry, with alternating bands of mortared rubble and of brickwork, was in widespread use (see p. 249).
280. 8. *Anz.* (1932), 233–49. Adjoining it was a colonnaded street.

9. D. M. Robinson, *A.J.A.*, XXVIII (1924), 435–44; *Art Bulletin*, IX (1926), 5–69.
281. 10. Since 1967, a period of intensive excavation, consolidation and publication has brought into much sharper focus our picture of the architectural development of what was probably the most influential single architectural centre in the Greek-speaking world. The overall impression conveyed is one of a vigorous continuity of local development, a development within which the language of traditional classicism was continuously being reinterpreted to meet the requirements of contemporary taste.
11. Several of the great hellenistic foundations (e.g. the Didymaion near Miletus) were still being completed in Roman times, closely following the original designs. G. Gruben, *Athenische Mitteilungen*, LXXVI (1961), 155–96 suggests a similar history for the great Temple of Artemis at Sardis. Such situations did much to ensure the survival of traditional motifs and styles of craftsmanship.
12. *J.Ö.A.I.*, XXXVII (1932), Bb. 54–61. Keil, *Führer*[5], 124–7, figure 67. For the dedication to Titus rather than to Domitian, see M. Wegner, *Das römische Herrscherbild: Die Flavier* (Berlin, 1966), 26.
13. R. Naumann, *Der Zeustempel zu Aizanoi* (Berlin, 1979).
14. G. Perrot, *Revue archéologique* (1864), 350–60; B. Ashmole, *Journal of the Warburg and Courtauld Institutes*, XIX (1956), 179–91, and *Proceedings of the British Academy*, XLV (1959), 25–41.
282. 15. *Alterthümer*, V (1895).
16. D. E. Strong, *P.B.S.R.*, XXI (1953), 131–3.
283. 17. *J.Ö.A.I.*, XLIV (1959), 264–6; Keil, *Führer*[5], 118–20. The dedicatory inscription shows that it was almost certainly begun in the final years of Trajan's reign and dedicated, after his death, to Artemis, Hadrian, and the People of Ephesus, in A.D. 117–18 or 118–19; see E. L. Bowie, *Zeitschrift für Papyr. Epigraphie*, VIII (1971), 137 ff., and M. Wörrle, *Anz.* (1973), 470–7. For the 'arcuated lintel', see D. F. Brown, *A.J.A.*, XLVI (1942), 389–99. It derives ultimately from ancient Mesopotamia; see also below, Chapter 12, Note 64. To be distinguished from the somewhat similar hellenistic device of resting an independent arch on the two ends of an interrupted trabeation (Crema, 142–3).
18. *J.Ö.A.I.*, XXIII (1928), 265–70. Keil, *Führer*[5], 105–8.
19. See above, Note 5. The apse dates from its conversion to a church.
284. 20. *Milet*, I. 7, 180–210.
285. 21. *Milet*, I. 7, 229–61.
286. 22. Ephesus, agora: *Forschungen*, III. 1 (1923), 1–168; Keil, *Führer*[5], 94–8. Aphrodisias, odeion: *I.L.N.* (27 February 1965), 23. Nysa, Gerontikon: W.

von Dienst, *Nysa ad Maeandrum* (*J.D.A.I.*, Ergänzungshefte, x) (1913); K. Kourouniotes, *Archaiologikon Deltion*, vii (1921–2), 1–68 and 227–41.

23. I owe to Caroline Williams the observation that the early dates commonly cited for some of these streets do not stand up to critical examination. At Diokaisareia in Cilicia, for example, there is no architectural evidence for a Tiberian street of this type; and the Lechaion road at Corinth was probably first colonnaded on one side only in Claudian times, and only by the end of the first century was it colonnaded symmetrically on both sides. The broad, open avenues (*plateiai*) of hellenistic planning lent themselves to such piecemeal development. For the Arkadiané, see *Forschungen*, I (1906), 132–40; Keil, *Führer*[5], 71–3.

288. 24. Smyrna: R. Naumann and S. Kantar in *Kleinasien und Byzanz* (*Istanbuler Forschungen*, xvii) (1950), 69–114. Ephesus: W. Alzinger, *Augusteische Architektur in Ephesos* (Vienna, 1974), 24–37; cf. *J.Ö.A.I.*, l (1972–5), Beiblatt, 270–9. The bilingual dedicatory inscription records its construction by C. Sextilius Pollio, the builder of the aqueduct (above, p. 273), i.e. between 4 and 14.

25. *Forschungen*, v, 1 (1953); V. M. Strocka, *Proceedings of the X International Congress of Classical Archaeology* (Ankara, 1978), 11, 893–900. Celsus was almost certainly dead by A.D. 114, and his grandson who completed the building, had already held high local office in 90. The Library and the almost exactly contemporary Temple of Hadrian (above, p. 282) show a marked stylistic advance on such other, earlier Trajanic monuments in Asia Minor as the Nymphaeum at Miletus (*c.* 100) [192] and the Trajanic fountain building at Ephesus itself (before 114), and Strocka suggests that one of the workmen had been employed in the Trajanic building programme in Rome. There are interesting library buildings also at Nysa (Von Dienst, *loc. cit.*) and in the Asklepieion at Pergamon (Wiegand, *op. cit.* above, Note 6).

291. 26. *Forschungen*, 11 (1912). Keil, *Führer*[5], 87–93. There was also a small second-century theatre, or odeion, near the Magnesia Gate, Keil, *Führer*[5], 130–2. For the so-called 'Eastern' and 'Western' types of theatre, see above, pp. 260–2. For the theatre at Aspendos, below, p. 302.

292. 27. F. Kraus, *Bericht über den VI Internationalen Kongress für Archäologie* (Berlin, 1940), 387–93.

28. See above, pp. 56, 85, 160.

29. Maccanico, 'Ginnasi romani'; also Keil, *Führer*[5], 56–61, 74–86, and 141–2. For a restored drawing of the Vedius Baths, showing exposed barrel-vaults, see Miltner, *Ephesos*, Abb. 68.

295. 30. To the younger Pliny, writing as governor

of Bithynia (*Letters*, x. 39), the terms *gymnasium* and *balineum* appear to be interchangeable.

31. A. von Gerkan and Fr. Krischen, *Thermen und Palaestren* (*Milet*, i. 9) (Berlin, 1928).

296. 32. *Altertümer von Pergamon*, vi (1923), 80–92. Hierapolis: Krencker and Krüger, *op. cit.* (Note 20 to Chapter 9), 288–95. Aphrodisias: G. Mendel, *C.R.A.I.* (1906), 159–78.

33. Pending a definitive publication, see V. H. Strocka, *Die Wandmalereien der Hanghäuser in Ephesos* (*Forschungen*, viii, 1, 1977), and interim reports in *J.Ö.A.I.*

34. J. B. Ward-Perkins, *J.R.S.*, xli (1951), 89–104.

297. 35. In theatrical architecture the stage building of the theatre at Aphrodisias (*c.* 40–30 B.C.) is still firmly rooted in hellenistic forms.

36. West Gate of the agora: *Forschungen*, iii (1923), 18–39; Keil, *Führer*[5], 73–4; the Gateway-arch: *J.Ö.A.I.*, viii (1905), Bb. 69. Miletus, West Market Gate: *Milet*, i, 7, 69–155.

299. 37. Mansel, *Ruinen von Side*, 109–21; see also below, p. 300.

38. *Milet*, i. 5 (1919).

300. 39. Side: Mansel, *op. cit.*, 90–1, Abb. 71–2 (temple) and 66–74, Abb. 48–57 (fountain). Perge, South Gate: Lanckoronski, i, 60–1. Attaleia, mausoleum: *ibid.*, 11–12.

40. Temples at Side: Mansel, *op. cit.*, 77–86. Sagalassos: Lanckoronski, 11, 130, 145–9.

41. *Anz.* (1975), 49–96.

302. 42. *Anz.* (1956), 99–120; cf. *Anz.* (1975), 49–96 for the nymphaeum at the head of the axial street and for the *macellum*.

43. Lanckoronski, i, 85–124. For the aqueduct: Ward-Perkins, *P.B.S.R.*, xxiii (1955), 115–23; also above, p. 225.

304. 44. See above, p. 276 and Note 4.

305. 45. I am indebted to Professor James Russell for information about this important site and for permission to reproduce illustration 199, based on a survey by Thomas D. Boyd. For a well illustrated interim account, see *Antike Welt*, vii, 4 (1976), 2–20.

CHAPTER 12

309. 1. A picture of the topography and architecture of Roman Apamea is beginning to emerge from the Belgian excavations, although it is heavily overlaid by late antique building and the architecture mostly awaits detailed study. For useful general accounts, see the two *Colloques Apamée de Syrie*, 1965–8 and 1969–71, ed J. and J. C. Balty (Brussels, 1969 and 1972). The town was divided into four roughly equal quadrants by a broad, north-south colonnaded avenue crossed at right-angles by somewhat narrower col-

onnaded avenue. As at Palmyra, the colonnades of the former were added piecemeal, starting at the north gate in 116/17 and reaching the central crossroads *c.* 166. The theatre, of normal Syrian type, is ascribed, on rather slender evidence, to the second half of the second century.

2. Seleucia is described by Roman writers as a great city, with a population of 600,000, and as having retained a great deal of its classical culture. See Pliny, *Natural History*, VI. 122, and Strabo, XVI. 2. 5.

3. Antioch and its harbour-town of Seleucia Pieria, Apamea, and Laodiceia; also no doubt Damascus. Paradoxically, it is the Greek colonial foundations on the periphery, outside the Roman frontiers, that are just as likely to yield buildings of specifically Greek type; e.g. the little ashlar-built distyle *in antis* temple built by Seleucus III on the island of Failaka, off Kuwait (K. Jeppeson, *Kuml. Årbog for Jysk Arkeologisk Selskab* (1960), 153–98).

4. See pp. 347–52.

310. 5. For Herod's activities as a builder, see Josephus, *Jewish War, passim*, and especially I. 401–25 (=I. 21.1–11) describing his work at Jerusalem (401–2; cf. V. 161–83), Samaria (403), Paneion (404–6), Jericho (407), Caesarea (408–15), Antipatris, Anthedon, and Phasaelis (416–18), Herodion (419–21), other cities in Syria and Phoenicia (422), and other Greek sites (423–5). For Gaba, *ibid.*, III. 36. Cf. also Josephus, *Antiquities*, XV, *passim*, and especially 8.1.5; 9.5–6. Some scholars credit him with building the vast temenos over the tombs of the patriarchs at Hebron, though this is not mentioned by Josephus. For the life and personality of Herod, see A. Schahil, *König Herodes: der Mann und sein Werk* (Berlin, 1969).

6. In trying to summarize this work, none of which have I seen and much of which is accessibly published only in Hebrew, I am very deeply indebted to the generous advice and help of Dr Yoram Tsafrir.

7. Most accessibly published in articles (various authors) in *Jerusalem Revealed, Archaeology in the Holy City, 1968–1974* (Jerusalem, 1975).

8. *Samaria-Sebaste*, I (London, 1942), 123–9.

311. 9. A. Frova and others, *Scavi di Caesarea Maritima* (Milan, 1965), publishing the cavea, but not the stage-building, of the theatre. For the painted stucco floor of the orchaestra, cf. the Augustan theatre at Lepcis Magna; and for its conversion to aquatic shows see above p. 262. See also L. I. Levine, *Roman Caesarea, an Archaeological and Topographical Study* (*Qedem*, V. 2) (Jerusalem, 1975).

312. 10. E. Netzer, 'The Hasmonean and Herodian Winter Palaces at Jericho', *Israel Exploration Journal*, XXV (1975), 89–100, amending and extending previous accounts by J. L. Kelso and D. C. Baramki and

by J. B. Pritchard in *A.A.S.O.R.*, XXIX–XXX (1955), 1–49 and XXXII–XXXIII (1958), 1–58. It identifies an earlier, pre-Herodian palace complex, built mainly of mud brick faced with painted stucco; and it demonstrates clearly that in the Herodian buildings the distinction between stone, concrete, and mud brick is one of function, not of date. Josephus (*Jewish War*, I. 407) records that, as at Jerusalem, the complex included halls named *Kaisareion* and *Agrippaion*.

313. 11. Y. Yadin, *Masada, Herod's Fortress and the Zealots' Last Stand* (London, 1966). The closest parallels for the handsome polychrome mosaics of the entrance hall of the upper palace are with Delos. M. Avigad and others, *The Archaeological Survey of Masada, 1955–1956* (Jerusalem, 1957), is still useful.

12. V. Corbo, 'L'Herodion di Gebel Fureidis', *Studium Biblicum Franciscanum, Liber Annuus*, XIII (1962–3), 219–77; XVII (1967), 65–121; E. Netzer, *Israel Exploration Journal*, XXII (1972), 247–9.

13. I owe to Dr Y. Tsafrir the following references to important articles in Hebrew: on Herodion, E. Netzer in *Qadmoniot*, XXIII–XXIV (1973), 107–10; on Cypros (another fortress-palace in the desert above Jericho; cf. Josephus, I. 417), E. Netzer in *Qadmoniot*, XXX–XXXI (1975), 41–53. See also preliminary notes of recent excavations at Antipatris by M. Kochavi in *Israel Exploration Journal*, XXV (1975), 246, and XXVI (1976), 52.

14. Hellenistic Dura, for example, did not have a theatre. An interesting outlier is described by F. Wetzel and others in *Das Babylon der Spätzeit* (*Ausgrabung der deutschen Orient-Gesellschaft in Babylon*, VIII (1957), 3–22; cf. Colledge, *Parthian Art*, figure 27). There was also a theatre at Seleucia, the piers of which are said to have been of baked brick; C. Hopkins (ed.), *Topography and Architecture of Seleucia on the Tigris* (Ann Arbor, 1970), 26–7. We know nothing of the theatres referred to by Josephus at Sidon and Damascus. Several of the early sanctuaries of the Hauran have porticoed forecourts containing seating, which were designed for the viewing of sacred spectacles and were known as *theatra*; e.g. Si' [220], Sûr, and Saḥr (Butler, *South Syria*, 379 ff., 428–30, ill. 371 and 441–3, ill. 337, respectively); cf. the antechamber to the Temple of Atargatis at Dura (attributed by F. Cumont, *Fouilles de Doura-Europos* (Paris, 1926), 183–5 to Artemis; but see *Dura, Third Season*, 11–13), which served a similar purpose. There is no architectural relationship whatsoever between these and the contemporary classical theatres, although in course of time their place was sometimes taken by buildings of conventional classical type; e.g. in the popular festival sanctuary of Maiumas at Birketein, near Gerasa (Kraeling, *Gerasa*, 159–67).

15. *Jewish War*, I. 422.

314. 16. The pages that follow owe much to the Emir Maurice Chehab, Director of the Department of Antiquities of the Lebanon, and his assistant, the late H. Kalayan, for allowing access to the results of the recent work, much of it still unpublished.

17. It is nowhere stated in the sources that this was an official enterprise, but the scale of it hardly leaves room for doubt. It is significant that the patron divinities of a number of other Syrian cities, including the Tyche of Antioch, appear on the coffering of the Temple of Bacchus. For the character of the cult and its date, see H. Seyrig, *Syria*, XXXI (1954), 80–96, especially 96, note 1.

18. (XI), 280. 12, ed. Schenk (Stuttgart, 1931), 50, cf. 494.

19. *Bulletin du Musée de Beyrouth*, I (1937), 95 ff.

20. The evidence for von Gerkan's contention (*Corolla Ludwig Curtius* (1937), 55–9) that the present podium is that of an earlier hellenistic building is not conclusive. It is more likely that the podium and peristasis are those of the Early Roman building, of which the forecourt in the original, simpler version was planned to extend back to the seventh column along either flank; that the podium was then re-planned (though never in fact completed) so as to afford a wide platform all round the existing temple (or conceivably, though less probably, to carry the peristasis of an even larger, dodecastyle temple); and that the forecourt in its re-designed, second-century version was at first meant to be extended so as to enclose the temple on all sides, but that this plan too was modified during construction, cutting it short along the line of the existing façade, as one now sees it. See also D. Krencker, *Anz.* (1934), 268–86.

317. 21. The building most closely comparable to Baalbek in size and proportions was Hadrian's temple at Cyzicus, which measured about 155 by 300 feet (47 by 92 m.) at stylobate level and was slightly taller from base to capital; see above, pp. 281–2.

22. The 'Tomb of Absolom' at Jerusalem (Durm, *Baukunst*, figure 833) and a stray architrave bracket at Samaria (*Samaria-Sebaste*, I, 35 and plate 85. 1–2).

23. E. von Mercklin, *Das antike Figuralkapitelle* (Berlin, 1962), 27–30 and Abb. 109–31; and in *R.M.*, LX-LXI (1953–4), 184–99. See also *Proceedings of the British Academy*, LI (1965), 192 and plate LV (bull brackets at Hatra). The motif of the bull protome used as a bracket had, of course, already entered the wider hellenistic repertory independently, though doubtless from the same source; e.g. Stoa of Antigonus and the Pythion at Delos (A. W. Lawrence, *Greek Architecture* (*The Pelican History of Art*) (Harmondsworth, 1957), figures 149, 152).

320. 24. One suggestion is that the hexagonal court-yard framed a sacred tree; it apparently represents a change of plan. The original intention may have been to build a rectangular outer court the full width of the inner courtyard (or else to extend the existing court to the propylaea).

25. The so-called 'arcuated lintel' or 'Syrian arch'; see above, pp. 282–3; below, p. 341 and Note 64.

26. R. Krautheimer, *Early Christian and Byzantine Architecture* (*Pelican History of Art*), 3rd ed. (Harmondsworth, 1980), 164–5. For coins of Abila in the Decapolis illustrating a similar façade, see H. Seyrig, *Syria*, XXXVI (1959), 60–2, plate XII, 1–4. See also below, pp. 337 and 339 ff., and Note 64.

27. For the probable articulation of the inner façade in relation to the arcuated lintel of the façade proper, cf. the Temple of Hadrian at Ephesus.

28. Cf., for example, the lantern of Borromini's church of S. Ivo della Sapienza in Rome. But there is no evidence that drawings of Baalbek were available in Italy in Borromini's time.

322. 29. The accounts of Kalat Fakra, Niha, and some of the other lesser sanctuaries given by Krencker and Zschietzschmann require some modification in the light of later work. For Machnaka, see H. Kalayan, *Bulletin du Musée de Beyrouth*, XVII (1964), 105–10. A larger, 13 feet (4 m.) square version of the columnar type of altar has now been excavated in front of the Temple of Nabô at Palmyra (A. Bounni, *Annales Archéologiques de Syrie*, XV (1965), 127–35). For the great tower at Kalat Fakra, see P. Collart, *Syria*, L (1973), 137–61. It is neither an altar nor a mausoleum, though the form is closely related to some of the tower tombs discussed by E. Will (*Syria*, XXVI (1949), 258–313). There is no evidence of a pyramidal roof. It was probably terraced and built as a treasury.

30. Niha, Temple A: Krencker-Zschietzschmann, 106–15. The somewhat similar adyton of the Temple of Ba'alshamin at Palmyra must in this context reflect the influence of Baalbek, not local Palmyrene usage.

31. E.g. Niha, Temple B (for which see Krencker-Zschietzschmann, 116–18), the spring-side shrine of Temnin el-Foka (*ibid.*, 138–40) and Zekweh, which is relatively late in date but of archaic design, *ibid.*, 198–202.

323. 32. *ibid.*, 40–6.

325. 33. J. Lauffray, *Bulletin du Musée de Beyrouth*, VII (1945), 13–80; Seyrig, *ibid.*, VIII (1949), 155–8.

34. G. Downey, *A History of Antioch*, 154–7.

35. D. Levi, *Antioch Mosaic Pavements* (Princeton, 1947). The promised study of the architectural remains is still awaited.

36. 'Bath C' [224B] (*Antioch*, I, 19–31) is said to be a rebuilding (*c.* 350–400) on the same foundations as an early-second-century building. The central octagonal

hall, inscribed within a square with apsidal recesses in the diagonal angles, has many Pompeian and Roman precedents. The plan suggests vaulting, but if so it must have been in very light materials.

37. *Antioch*, III, plan VIII (p. 259); cf. the far more elaborate house at Daphni (no. 1) in *Antioch*, III, plan VII = Levi, *op. cit.*, figure 26 (the 'House of Menander'). For an exceptionally symmetrical house plan, see *Antioch*, II, 183–6 = Levi, figure 63 (second half of the third century).

326. 38. At Laodiceia (Latakieh), remains of colonnaded streets and a four-way arch: C. M. de Vogüé, *La Syrie centrale*, plate 29; J. Sauvaget, *Bulletin d'études orientales*, IV (1934), 81–114. For recent work at Apamea, see Note 1; cf. Butler, *Architecture*, 52–7.

39. For the individual sites referred to in this area, see Butler, *North Syria*, and Tchalenko. Cf. also Krautheimer, *op. cit.* (Note 26), 146–7.

40. E.g. the hunting lodge of Caliph Walid I (705–15) at Qasr el-Amr: K. A. C. Creswell, *Early Muslim Architecture*, I (Oxford, 1932), 253–72. Cf. the military bath-buildings at Dura (*Sixth Season*, 84–105) and 'Bath E' at Antioch (Levi, *op. cit.*, figure 100; Constantinian).

328. 41. Seyrig, *Syria*, XXVII (1950), 34–7.

42. Watzinger and Wulzinger, Abb. 18.

329. 43. E.g. Commagene, the extraordinarily eclectic quality of whose art is admirably exemplified in the great dynastic sanctuary of Nemrud Dag. Italian-style opus reticulatum is reported from the city walls of the capital, Samosata. It was used also in the tower tomb of C. Iulius Samsigeramos, a member of the royal family of Emesa (A.D. 79–80).

44. For a convenient statement of the traditional view, see M. Lyttleton, *Baroque Architecture in Classical Antiquity* (London, 1974), 61–83.

45. A decisive answer to the chronological problem can only be given by systematic, large-scale excavation. In the meantime the terms of the problem have been greatly clarified by the limited excavations undertaken by P. J. Parr and G. R. H. Wright, summarized in *Syria*, XLV (1968), 1–40.

330. 46. The distinctively blocked-out 'Nabataean' capital, here illustrated on the mausoleum of ed-Deir [213] and on the tombs at Hegra, where it was the only form used [212], had a long life, going back at least to the beginning of the first century, if not earlier, and still in use in Trajanic Bostra (see below, p. 345). In its fully worked form it is a derivative Corinthian capital, with elaborately carved scrollwork filling the whole of the central field, a version of the 'heterodox' type of Corinthian capital, which is analysed by D. Schlumberger in *Syria*, XIV (1933), 233–317. Found in almost identical form and treatment on the Qasr el-

Bint and on the Khasne, the richest of all the temple tomb façades, a somewhat evolved version of it was still in use in the middle of the second century on the pilasters of the monumental arch.

47. The Hegra cemetery was first published by RR. PP. Jaussen and Savignac, *Mission archéologique en Arabie* (Paris, 1909), 307–404. The most recent analysis of the cemetery, with its many dated tombs (A. Negev, *Revue Biblique*, LXXXIII (1976), 203–36), claims to support the earlier chronology, believing the total absence of the more elaborate, typologically more developed forms to be a matter of social status, not date. But it is hard to believe that, if the prestigious temple tombs of Petra had already been in existence for half a century, or more, they would have left no visible trace on the architectural vocabulary of the tombs of men of whom some were quite senior military officials.

332. 48. For the arch, see G. R. H. Wright, *Palestine Exploration Quarterly* (1961), 124–35; it is demonstrably later structurally than the colonnaded street, which was certainly in existence by 114 (P. J. Parr, *ibid.* (1960), 130 ff.). The earliest surviving arch to incorporate free-standing columns (a feature of the arch at Petra) is the Arch of Hadrian (*c.* 130) at Antalya (Attaleia) in Pamphylia (K. Lanckoronski, *Städte Pamphyliens und Pisidiens* (Vienna, 1892), I, 154 ff.).

334. 49. For the temple, see Wright, *op. cit.*, 8–37; and for the most recent excavations, P. J. Parr and G. R. H. Wright, *Syria*, XLV (1968), 1–40. For the inscription of Aretas IV, J. Starcky and J. Strugnell, *Revue Biblique* (1966), 236–47.

50. See above, pp. 314 ff.

51. N. Glueck, *Deities and Dolphins* (New York, 1965), 73–160. For this well attested Nabataean form, see further pp. 339–41.

52. See below, pp. 349.

53. Krautheimer, *op. cit.*, 151 and note 21.

54. R. Amy, *Syria*, XXVII (1950), 82–136. Araq el-Emir, between Jericho and Amman, is now identified as a temple of the same general type, begun by Hyrcanus and left unfinished on his death in 175 B.C.: P. W. Lapp, *B.A.S.O.R.*, CLXXI (October 1963), 3–38; cf. Butler, *South Syria*, 1–22. Cf. also coins of Capitolias in the Decapolis, depicting a temple façade with angle-turrets above the pediment and what appears to be an altar on the roof, above the cella (Seyrig, *Syria*, XXXVI (1959), 66–70, plate XII. 6–14). For the temple at Dmeir, see Amy, *art. cit.*

335. 55. The general topography of Gerasa is admirably shown in *Atlas of Classical Archaeology*, ed. M. I. Finley (London, 1977), 223.

56. As defined on pp. 260–2.

336. 57. The wedge-shaped plan of this gate, with two diverging façades, anticipates the more sophisticated third-century arch across the main colonnaded street at Palmyra (see p. 359).

338. 58. Other Syrian analogies: Creswell, *op. cit.* (Note 40), figures 382 (Mausoleum of Qusayr an-Numajjis) and 386 (Samaria, pagan tomb).

59. No doubt from the Hauran, where there are similar vaults (cf. below, p. 343).

339. 60. For the fountain buildings of Asia Minor, see p. 299. Lepcis Magna, p. 390. Amman: Butler, *South Syria*, 54–9. Pella: Seyrig, *Syria*, XXXVI (1959), 42.

61. 'The Hauran' may for convenience be used to describe the whole area, south-east of Damascus, of which the Djebel Hauran is the centre. Unless otherwise noted the buildings referred to in this section are all published in Butler, *South Syria*.

341. 62. D: Schlumberger, *Proceedings of the British Academy*, XLVII (1961), 77–95. Preliminary reports annually in the *Journal Asiatique*, from 1959.

63. Below, p. 354 and Note 83.

64. For the 'Syrian arch' or 'arcuated lintel', see D. F. Brown, *A.J.A.*, XLVI (1942), 389–99; Crema, 142–3, 344–5. The motif first appears on Assyrian reliefs. The towered façade stems ultimately from Persepolis; E. F. Schmidt, *Persepolis* (1955), 125, figure 59. For its uses in Roman Syria, see above, pp. 320 and 337.

343. 65. R. Naumann, *Der Quellbezirk von Nîmes* (Berlin-Leipzig, 1937), 46–53; J. B. Ward-Perkins, *J.R.S.*, XXXVIII (1948), 64.

66. Perhaps even as early as A.D. 160–9 over the central bay of the military shrine (the 'Praetorium') at Mismiyeh (Roman Phaena) [221], seen and drawn by De Vogüé (*La Syrie centrale*, plate VII) and other early travellers before it was destroyed for its building stone; see also E. Weigand, *Festschrift H. Bulle* (Stuttgart, 1938), 71. The four corner bays were roofed with flat slabs, the four arms of the internal cross with barrel-vaults, also of slabs, buttressing the central bay.

344. 67. Butler, *Architecture*, 327–34.

346. 68. In the West, military camps very commonly occupied virgin sites, forming a nucleus independent of the civil settlements that grew up alongside or around them. In the East, where most of the important strategic sites had already been inhabited for centuries, it was common, though not invariable (cf. Melitene and Satala in Cappadocia, both Flavian foundations on new sites), to adopt a policy of integration, with the military installations often widely scattered throughout the town. Severan Dura and Diocletianic Palmyra offer well documented examples of what must in fact have been a common practice.

347. 69. The use of the triconchos for the domestic audience hall of the Residence at Bostra, and probably also at Dura (Note 79), anticipates what was to become a commonplace of the palace architecture of late antiquity, including Early Muslim Syria; cf. below, p. 463. For the palace at Apollonia, see R. G. Goodchild, *Antiquity*, XXXIV (1960), 246–58; and in J. Pedley (ed.), *Apollonia, the Port of Cyrene* (*Supplements to Libya Antiqua*, IV) (Department of Antiquities, Tripoli, 1976), 245–65.

70. Umm el-Jemal: G. U. S. Corbett, *P.B.S.R.*, XXV (1957), 39–66. Busan: Butler, *South Syria*, 336–40.

349. 71. Rostovtzeff, 17–18. No detailed publication has yet appeared.

72. *Dura, Ninth Season*, part 3.

73. Interim accounts of most of the temples at Dura are given in the Reports on the successive seasons; cf. Rostovtzeff, 41–6. The only substantial publication of the excavations at Hatra (begun in 1950), by F. Safer and M. A. Mustafa, is in Arabic (Baghdad, 1974), though an English version is said to be in preparation. For a good summary, with some sketch plans, see H. Lenzen in *Anz.* (1955), 334–75; cf. F. Safer in *Sumer*, VIII–IX (1952–3). The great temple complex is now securely dated to the second century, not the first (a vital inscription had been misread), and it is certainly a temple, not a palace. The plan of the second (later hellenistic) Citadel Palace at Dura is plausibly restored as embodying a façade consisting of three great open-fronted, barrel-vaulted halls (*iwan*). This is a characteristically Mesopotamian plan, closely analogous to that of the huge central temple at Hatra, which in its turn reveals a reciprocal Western influence in its bold use, unique in Mesopotamia, of dressed masonry. In many respects Dura and Hatra are complementary sites; see J. B. Ward-Perkins, *Proceedings of the British Academy*, LI (1965), 175–99.

74. E.g. in the temple of 'Qasr el-Bint' at Petra (pp. 332–4).

352. 75. The house-church at Dura: *Dura, Fifth Season*, 238–53; C. H. Kraeling, *The Christian Building* (*The Excavations at Dura-Europos. Final Report*, VIII. 2) (New Haven, 1967); Krautheimer, *op. cit.* (Note 26), 27–8. The synagogue: C. H. Kraeling, *The Synagogue* (*ibid.*, VIII. 1) (New Haven, 1956).

76. *Dura, Seventh and Eighth Seasons*, 62–134.

77. *Dura, Fifth Season*, 201–37 (the praetorium); *Sixth Season*, 49–63, 84–104 (bath-buildings). One of the latter in its original form dates back to the Parthian period and is one of the earliest tangible traces of Roman architectural influence on Dura.

78. *Dura, Ninth Season*, part 3, 1–25.

79. The larger room at the south end of the façade, adjoining the private suite, was probably a domestic audience hall of triapsidal (*triconchos*) plan; cf. Bostra, p. 347. Unfortunately all but the side wall and one lateral apse have disappeared over the cliff.

80. *Dura, Sixth Season*, 84 (Bath M 7) and 266 (House of the Scribes). For its use in Asia Minor, see p. 277.

81. Rostovtzeff, *passim*.

354. 82. Of which Palmyra was probably at the time a political protégé (Appian, *Civil War*, V. 9). See also above, pp. 308–9 and Note 2.

83. Seyrig, *Syria*, XXI (1940), 277–337, discussing a deposit found in the precinct of the Temple of Bel, which included the earliest known Palmyrene inscription (44 B.C.), and which almost certainly comes from the predecessor of the present temple. To this can now be added comparable material from the foundations of the Temple of Nabô and from deposits related to the earliest buildings of the sanctuary of Ba'alshamin; see below, Notes 91 and 92.

84. The date of the temple itself is given by an inscription (J. Cantineau, *Syria*, XIV (1933), 170–4), that of the porticoes by a comparison (D. Schlumberger, *ibid.*, 283–317) with the capitals of such dated monuments as the tower-tombs of Iamblichos (A.D. 83) and Elahbel (A.D. 103). Inscriptions on the porticoes giving dates as early as A.D. 14 (*ibid.*, 291, note 4) are recut, replacing earlier texts – a common Palmyrene practice.

356. 85. For the term *thalamos*, see Lucian's description (*The Syrian Goddess*, 31) of the temple at Hierapolis.

357. 86. See E. Will, *A.A.A.S.*, XXII (1971), 261–7; also M. Colledge (*The Art of Palmyra*, 237–8: 'On to this quiet scene exploded the gigantic temple of Bel'), emphasizing the impact of ideas and workmen brought in from Antioch and possibly some of the other coastal cities. Will demonstrates the influence at second hand of the second-century B.C. architect Hermogenes (who was much admired by Vitruvius), an influence that is reflected not only in the general proportions but also in such tell-tale details as the pair of Ionic half-columns set between the angle pilasters of the two ends of the cella, an obvious vestigial reflection of the free-standing Ionic columns of a conventional pronaos and opisthodomos. A Seleucid liking for the Corinthian order is evident in the Olympieion at Athens, which was commissioned by Antiochus IV Epiphanes (see above, p. 263).

87. See Note 84 above.

359. 88. Inscriptions of A.D. 76 and 81 may well be another instance of the disconcerting Palmyrene habit of re-cutting earlier texts.

89. Kraeling, *Gerasa*, 117–23; *Forschungen in Ephesos*, III (1923), 172–88. The processional way leading to the Temple of Bel, if built as planned, would have been nearly 130 feet (40 m.) wide.

360. 90. Interim account by Seyrig in *C.R.A.I.* (1940), 237–49. For the basilica as a possible kaisareion, see *P.B.S.R.*, XXVI (1958), 181–2.

91. A. Bounni and N. Saliby, *A.A.A.S.*, XV (1965), 124.

92. For the reconstruction of the adyton, see P. Collart, *A.A.A.S.*, XI (1969), 21–4.

93. They include an instance of the 'Rhodian' peristyle, in which one colonnade is taller than the rest.

361. 94. Tower-tombs: E. Will, *Syria*, XXVI (1949), 87–116. Hypogea: e.g. the tomb of Iarhai (A.D. 108), *Syria*, XVII (1936), 229–66. Pedimental tombs: e.g. Tomb 86, with a hexastyle, pedimental façade, *Palmyra*, I, 71–6; II, plates 38–44.

95. The view that the 'Chapel of the Standards' is an earlier temple converted to military use (e.g. *Enciclopedia dell'Arte Antica*, V, s.v. 'Palmira') is not generally accepted. For the successive wall circuits of Palmyra, see N. Gawlikowski, *Syria*, LI (1974), 231–42; and for Palmyra as a garrison town, R. Fellman, *Mélanges Collart* (Lausanne, 1976), 173–91. The bath-building beside the axial street dates from this occasion. Luxor: U. Monneret de Villard, *Archaeologia*, XCV (1953), 96. Lambaesis: F. Rakob and S. Storz, *R. M.*, LXXXI (1974), 253–80.

CHAPTER 13

363. 1. L. Borchardt, *J.D.A.I.*, XVII (1903), 73–90; cf. the small Hadrianic Temple of Serapis at Luxor, tetrastyle and peripteral on three sides, built throughout of brick (J. Leclant, *Orientalia*, XX (1951), 454, and XXX (1961), 183). For what is claimed to be the platform of a prestige temple of Roman type begun (but not finished) by Cornelius Gallus in 23–22 B.C. in the fortress of Qasr Ibrim, on the frontier towards Nubia, see *I.L.N.* (11 July 1964), 50–3. Kiosk of Trajan: L. Borchardt and H. Ricke, *Aegyptische Tempel mit Umgang* (1938), 13 f. Arch of Diocletian: U. Monneret de Villard, *La Nubia romana*, 5–10, figures 4–8. The extreme conservatism of much Roman architecture in Egypt is well exemplified in the Augustan (23–10 B.C.) temple from Dendur, above Aswan, now re-erected in New York: C. Aldred, *The Temple of Dendur* (Metropolitan Museum of Art, 1978); a full publication is in preparation.

366. 2. *I.L.N.* (19 November 1966), 32. A. Adriani, *Annuaire du Musée gréco-romain d'Alexandrie*, 1935–9 (1940), 136–48.

3. Cf. also the yet earlier Ptolemaion, erected soon after 304 B.C. by the Rhodians in honour of Ptolemy I

and described by Diodorus (XX. 100. 4) as a long rectangular temenos with two inward-facing porticoes. I owe this reference to the late Eric Sjöqvist.

4. For the originally late hellenistic date of this building, see S. Stucchi, *Architettura Cirenaica*, 125–7. His identification of the enclosed temple as dedicated to the deified Hadrian (*ibid.*, 244–5) rests on the slenderest of evidence.

368. 5. S. Stucchi, *Quaderni*, IV (1961), 55–81; *Architettura Cirenaica*, 237–9. For other temples of Roman Cyrene, see Stucchi, *passim*; also R. G. Goodchild, J. M. Reynolds, and R. C. Herington, *P.B.S.R.*, XXVI (1958), 30–62 (Temple of Zeus), and R. G. Goodchild, *Quaderni*, IV (1961), 83–7 (the Valley Street excavations).

6. A well documented example is the Severan rebuilding, in Proconnesian marble, of the courtyard building (a macellum?) which preceded the fourth-century Market Theatre; see J. B. Ward-Perkins and S. Gibson, article forthcoming in *Libya Antiqua*.

7. The date is controversial, and pending controlled stratigraphic excavation it is likely to remain so. Some recent writers (e.g. H. Lauter in *J.D.A.I.*, LXXXVI (1971), 158–78, and M. Lyttleton, *Baroque Architecture in Classical Antiquity*, 53–68) favour the hellenistic date proposed by the original excavator, Gennaro Pesce. The present writer (most recently in *A.J.A.*, LXXX (1976), 322–4, reviewing Lyttleton) believes firmly in the Early Imperial date proposed by A. von Gerkan (*Gnomon*, XXIII (1951), 341), R. Martin (*Revue des Études Grecques*, LXV (1952), 235–7), and others. For a full bibliography, S. Stucchi, *Architettura Cirenaica*, 217, note 1. Stucchi prefers the later chronology, but has succeeded in further confusing the issue (p. 216 and figure 5) by dreaming up an earlier structural phase consisting of three distinct houses. The Palazzo does incorporate earlier structures, but demonstrably not in the pattern proposed by Stucchi.

369. 8. In later Roman terminology the *triclinium*; see above, p. 187.

370. 9. See above, p. 341; below, p. 389.

10. Common at Ptolemais. To be distinguished formally from the Syrian 'arcuated lintel'; see above, Chapter 11, Note 17. The latter form is also found in the domestic architecture of Cyrenaica.

11. Goodchild and Kraeling in Kraeling, *Ptolemais*, 89–93.

376. 12. G. Caputo, *Dioniso*, XIII (1950), 164–78. For other African theatre-temples, see E. Frézouls, 'Teatri romani dell'Africa francese', *Dioniso*, XV (1952), 90–101; Hanson, *Roman Theater-Temples*, 59–67.

13. The *porticus post scaenam* of epigraphy; cf. Vitruvius, V. 9. 1. The colonnade around the head of

the auditorium (*porticus in summa cavea*) is a later addition.

379. 14. Provisional account in *Reports and Monographs of the Department of Antiquities in Tripolitania*, II (1949), 23.

380. 15. In this context presumably a legacy from pre-Imperial North African usage. This familiar hellenistic type is recorded from South Italy (Minturnae) and Sicily (Halaesa).

384. 16. Many of these vaults were built up on a framework of tubular tiles, a technique that was widely employed in Roman North Africa and Sicily, whence it spread to central and northern Italy in late antiquity; see p. 465.

17. Krencker and Krüger, *op. cit.* (Chapter 9, Note 20), 224–5, Abb. 317, after *Anz.* (1905).

393. 18. In some African cities, e.g. at Sabratha, such streetside porticoes can be shown in some cases to have carried projecting upper storeys; cf. Herculaneum [89].

19. Corresponding to the 'petit appareil' of Roman Gaul or the coursed rubblework of Asia Minor. In one of its most characteristic versions, incorporating piers of larger blocks laid alternately vertically and horizontally so as to bond with the smaller-stone infilling, this is conventionally known as 'opus africanum' or, in Italian, as 'opera a telaio' [cf. 269, the right-hand wall, in shadow; the rear wall is a modern restoration, omitting the horizontal members]. The technique appears to have originated from the use of mud brick or mud and rubble within a framework of dressed stone orthostates.

20. It seems to have had a portico and a small temple at the head of the cavea and a single portico behind the stage-building (*porticus post scaenam*), as at Thugga. For the upper portico, cf. Caesarea (Cherchel), Lepcis, and Thugga (Caputo, *Il Teatro di Sabratha*, 50–6); and for similarly placed temples, above, p. 376 and Note 12.

394. 21. There must have been some provision for the imperial cult, either in the basilica or in one of the rooms opening off the forum.

22. Gsell, *Mdaourouch*, 66 and 71–2, plate XVII; probably the 'basilica vetus' of *Inscriptions latines d'Algérie*, 2135. Professor F. Rakob informs me that the basilica at Simitthu (Hadrianic) was a plain hall with internal piers along the walls and an apse at either end.

23. Tipasa (unpublished; *not* Gsell, *Monuments*, figure 38) had longitudinal colonnades and an apse flanked by 'chapels'. Sigus: Gsell, *Monuments*, 129–32, figure 37. Thubursicu: Gsell, *Khamissa*, 67–74, plate 11.

24. See Merlin, *Le Forum de Thuburbo Maius*, 34, for a list of African curiae.

25. Carthage: *C.I.L.*, VIII, 1013. The known African Capitolia are very varied, some with tripartite cella (Cuicul, Thibilis, Thuburbo Maius), some single (Thugga), and at least one bipartite (Lambaesis). Sufetula [274] had three separate temples. A distinctive local form has lateral projections flanking the cella, as at Abthugni and Althiburos: Cagnat and Gauckler, 1–18; Gsell, *Monuments*, 133–54; Gsell, *Announa*, 70–3 (Thibilis); cf. Sabratha (above, p. 380).

26. For the arches and monumental gates of Algeria, see Gsell, *Monuments*, 155–85. In Africa such arches were used indiscriminately across streets or street-crossings, as gates into cities or into major sanctuaries (e.g. that of Mercurius Sobrius at Vazi Sarra, Cagnat and Gauckler, 68–9, plate XXI) or as independent monuments (Arch of Caracalla at Volubilis). All but the simplest must be visualized as having normally carried statuary.

395. 27. Hippo Regius: J. Lassus, *Libyca*, VII (1959), 311–16. With pavilion: Cuicul (below, p. 401) and possibly Thugga (Poinssot, *Ruines de Dougga*, 33–4), where it opened off a large courtyard. Without pavilion: Gigthis (Constans, 'Gigthis', plate XIII) and Thibilis (Gsell, *Announa*, 76–9, plate XIX, 2). At Thuburbo Maius (Merlin, 49–51) one whole side of this forum is occupied by a Temple of Mercury and a market complex comprising a plain open courtyard, a courtyard surrounded on three sides by shops, and a partly covered, peristyle market. See further the article forthcoming in *Libya Antiqua* (above, Note 6); also Romanelli, 146–52.

28. A. Ballu, *Les Ruines de Timgad: sept années de découvertes* (Paris, 1911), 13–16; Romanelli, plate 108.

396. 29. H. F. Pfeiffer, *M.A.A.R.*, IX (1931), 157–65; Romanelli, 202–3, plate 153.

398. 30. Lézine, *Monuments romaines*, 9–28, with sketch-plans. Lambaesis: Krencker and Krüger, *op. cit.* (Note 17), 214–15, Abb. 295. Lepcis: R. G. Goodchild, *Libya Antiqua*, II (1965), 15–27. Also Thysdrus (El-Djem): *Bulletin Archéologique* (1920), 465–71. The baths at Carthage are noteworthy for the skilful relegation of most of the service areas to vaulted corridors and chambers beneath the main platform, as in the Kaiserthermen at Trier (p. 448), as well as being an early example of the extensive use in Africa of fine imported stones, marble from Greece (Attica) and Asia Minor (Proconnesus), and red granite from Egypt.

399. 31. For many of these buildings, see Romanelli, 170–90 and plates 128–42.

401. 32. For further details of these buildings, see interim accounts in *Bulletin Archéologique* (1911–21), notably the Old Forum (1915, 117–23), the Market (1916, 218–34), the Temple of Venus Genetrix (1911,

106–9), and the Baths (1919, 87–94, and 1921, lxvii).

404. 33. A. Merlin, *Forum et maisons d'Althiburos* (*Notes et documents*, VI) (1913), 39–45; R. Étienne, *Le Quartier nord-est de Volubilis*, 77–80. Cf. the 'House of the Laberii' at Uthina in Tunisia: P. Gauckler, *Monuments et Mémoires Piot*, III (1896), 177–299. For a very compact, two-storeyed version of early date, see the 'House of the Figured Capitals' at Utica, A. Lézine, *Karthago*, VII (1956), 3–53. For a useful repertory of published house plans in North Africa, see R. Rebuffat, *Mélanges d'archéologie et d'histoire* (École Française de Rome), LXXXI (1969), 659–729; LXXXVI (1974), I, 445–99.

407. 34. Much of the evidence is epigraphic and is conveniently assembled in Warmington, 35–40.

408. 35. See A. Lézine, *Architecture punique: recueil de documents* (Tunis, 1956). The excavations at Carthage have amply confirmed the continuity of building and paving techniques from Punic into Roman times.

409. 36. See now the pair of tall, tower-like tombs, concave triangular in plan and crowned by a slender pyramidal shaft, found at Sabratha and ascribed by the excavator to the early second century B.C. The elaborately carved ornament, finished in coloured stucco, includes Phoenician volute capitals ('proto-Aeolic' capitals), an 'Egyptian' cornice, and Ionic capitals of South Italian or Sicilian derivation. A. Di Vita, *R.M.*, LXXXIII (1976), 273–85.

410. 37. A. Lézine, *Architecture romaine*, 99–118. Lixus, information from M. Taradell.

412. 38. Lambaesis: R. Cagnat, *Mem. Pont.*, I (1923), 81–8. Gsell, *Monuments*, 140–3. Zaghouan: F. Rakob, *R.M.*, LXXXI (1974), 41–89. The aqueduct was possibly begun by Hadrian; the Nymphaeum is dated on the basis of its ornament to c. 160–70. In North Africa, as in most other provinces, springs were very commonly regarded as sacred and accompanied by sanctuaries of greater or lesser elaboration.

CHAPTER 14

415. 1. Malalas, *Chr.* XII, 299.

421. 2. Much, if not all, of the exterior was stuccoed, including the mouldings.

426. 3. A. Fraser, *A.J.A.*, LXXVII (1973), 45–8. Professor F. W. Deichmann tells me that tile-stamps prove the building, traditionally the tomb of the Gordians, to have been erected c. 300.

428. 4. This account is based on an unpublished survey undertaken by the writer in collaboration with Alfred Fraser. For the extensive bibliography concerning this building and its identification, see Nash, II, 268.

5. It is tempting to restore a split pediment, framing the dome behind; but there is no evidence for this. The alternatives are a pair of small gables or else a pair of flat entablatures, perhaps embellished with statues over the columns.

430. 6. The reliefs from the Arcus Novus of Diocletian (303–4), now in the Boboli Gardens, Florence, must similarly have been looted from some monument of the first half of the third century. For the reliefs see H. Kähler, *Zwei Zockel eines Triumphbogens im Boboligarten zu Florenz* (*Winckelmannsfeste*, XCVI) (Berlin, 1936), a study which assumes them to be of Diocletianic date.

434. 7. As was clearly demonstrated by Cozzo.

435. 8. 'Non ... a cassetta, ma veramente massivi in mattoni' (G. Giovannoni in *Atti del II Congresso Nazionale di Studi Romani* (1931), 291, reporting *sondages* by himself).

438. 9. Professor Rakob has pointed out to me that, here too, Hadrian's Villa anticipates later practice. The winter triclinium known as the 'Latin Library' was directly accessible from the garden through just such a columnar exedra.

CHAPTER 15

441. 1. The current excavations at Sirmium (Sremska Mitrovica) have revealed the location of the hippodrome, the foundations of the Licinian Baths, and a rather indeterminate complex of rooms believed to be part of the palace. A richly appointed peristyle-house with a separate bath suite is clearly a private residence.

442. 2. See above, pp. 229–30 and illustration 139.

446. 3. For possibly similar buildings at Aquileia and at Veldidena in Austria, see below, p. 464 and Note 18. The blind arcading of the exterior is a motif that was picked up by the fourth-century architects of North Italy.

448. 4. Cf. the Antonine Baths at Carthage.

450. 5. For a systematic bibliography of the known remains of the palace buildings at Thessalonike, see A. Avramea in *Tabula Imperii Romani*, sheet K 34, *Naissus*, ed. J. Šašel (Ljubljana, 1976), 143–4, s.v. nos. 149–56.

454. 6. See above, p. 276 and Chapter 11, Note 4.

7. Professor H. Torp informs me that the mausoleum was apparently unfinished on the death of Galerius, and that the upper part of the dome was only completed when it was converted into a church.

8. Cf. the gallery of the palace at Antioch (p. 458). Such galleries derive ultimately from the porticoes of the porticus villas, through buildings such as the villa of Sette Bassi (p. 208).

457. 9. E.g. Sümeg and Fenékpuszta, near Lake Balaton in Hungary: A. Mócsy, *Pannonia and Upper Moesia* (London, 1974), 302, figures 49, 50.

458. 10. E.g. Gamzigrad, a strongly fortified rectangular settlement laid out about two intersecting colonnaded streets, about forty miles north of Naissus (Nish). Excavation is revealing this as a palatial residence, probably the centre of an imperial estate, and thus a rather special case. But the model was widely followed in other contexts. Gamzigrad was itself rebuilt by Justinian as a small fortified township.

11. Libanius, *Orations*, XI. 204–7 (written in 360). Once again there are close analogies with contemporary military architecture, notably the headquarters building of the camp established by Diocletian at Palmyra.

12. Durm, *Baukunst*, figure 857. Crema, figure 753. For the semi-engaged internal orders within the mausoleum, cf. the late Severan circular temple at Ostia (*M.A.A.R.*, VIII (1930), 161–9), and the 'Tempio di Portunno' mausoleum at Portus (Crema, 563–4, figure 745).

461. 13. The identification of the owner as Maximian, first proposed by H. P. L'Orange (*Symbolae Osloenses*, XIX (1952), 114–28), and accepted by the excavator, Gentili, is difficult to square with the evidence (largely unpublished) of the associated pottery and of the mosaics, as viewed in the context of the North African series. For a well balanced assessment, with extensive bibliography, see K. M. Dunbabin, *The Mosaics of Roman North Africa* (Oxford, 1978), 196–212 and Appendix V, 243–5.

463. 14. Notably in I. Lavin ('The House of the Lord'; see bibliography). There does not seem to be any comprehensive recent review of the architecture of these buildings to match the rapid advance in knowledge of the mosaics that were their most striking feature.

15. R. Naumann and H. Belting, *Die Euphemiakirche am Hippodrom zu Istanbul und ihre Fresken* (*Istanbuler Forschungen*, XXV) (Berlin, 1966). Cf. the accounts of the early-fifth-century palace of Lausus: I. Bekker, *Corpus Scriptorum Byzantinorum*, I (Bonn, 1838–9), 564, s.v. Kedrenos.

464. 16. *Order of Famous Cities*, VV. 35–45.

17. Krautheimer, 82–6, ill. 35.

18. S. Simpliciano: Krautheimer, ills. 39, 40. Aquileia: M. Mirabella Roberti, *Aquileia Nostra*, XXXVI (1965), 45–78. Veldidena: A. Wotschitzky, *J.Ö.A.I.*, XLIV (1959), Bb. 5–32. S. Irminio warehouses: see above, illustration 300.

465. 19. Krautheimer, 185, 186.

20. See R. Krautheimer's volume in *The Pelican History of Art* (*op. cit.*).

SELECT GLOSSARY

In the glossary which follows Greek terms are given in their Latin form, where such is attested, or else in the English form in common use. The extent of anglicization, especially as regards plurals, is a matter of taste. The classical plurals are here added in brackets to those words that are most likely to be met with in this form.

Fuller glossaries will be found in W. B. Dinsmoor, *The Architecture of Ancient Greece* (London and New York, 1950), and in D. S. Robertson, *A Handbook of Greek and Roman Architecture*, 2nd ed. (Cambridge, 1943). These should be consulted particularly for the terminology of Roman architectural ornament, a great deal of which is directly borrowed or adapted from Greek architectural usage. For the names of the various types of building construction used in Rome and Central Italy, see further G. Lugli, *La Tecnica edilizia romana con particolare riguardo a Roma e Lazio*, 2 vols (Rome, 1957), 48–50.

abacus. The upper member of a capital.
acropolis. Citadel (Latin, *arx*).
acroterium (-a). Ornamental finial(s) at the apex or outer angles of a pediment.
adyton. Sanctuary of a Syrian temple; also occasionally *thalamos* (p. 356).
aedicula (-ae). Diminutive of *aedes*, a temple; whence a small columnar or pilastered tabernacle used ornamentally.
agger. Rampart.
agora. The Greek-speaking equivalent of the forum.
ala (-ae). Wings extending to right and left at the far end of the traditional atrium, in front of the tablinum. Obsolescent by the first century A.D.
ambulatio. Terrace for exercise. Cf. illustrations 119, 121.
amphitheatre. Oval building with seating facing inwards on to a central arena for gladiatorial or similar spectacles.
anathyrosis. The smooth marginal dressing of the outer contact band of a masonry joint, the central portion being left roughened and sunk so as to avoid contact.
andron. Room in a Greek house reserved for men. The passage between two peristyles (Vitruvius, VI. vii. 5). In Roman Syria a public hall (see pp. 327–8).

anta (-ae). Pilasters forming the ends of the lateral walls of a temple cella. When the façade consists of columns set between two antae the columns are said to be *in antis*.
antefix. Decorative termination of the row of covering tiles (*imbrices*) laid over the joints between two rows of flat tiles (*tegulae*) of a roof.
apodyterium (-a). The changing room of a bath-building.
ara (-ae). Altar.
architrave. The horizontal element, of stone or timber, spanning the interval between two columns or piers.
araeostyle (Greek, *araiostylos*). With columns very widely spaced. Vitruvius (III. iii. 1–5) classifies colonnades in terms of the sizes of their intercolumniations relative to the base diameters of their columns, as follows: *araeostyle* (more than three diameters), *diastyle* (three diameters), *eustyle* (two and a quarter diameters), *systyle* (two diameters), and *pycnostyle* (one and a half diameters). Like so many Vitruvian classifications it is over-rigid, but the terms araeostyle and pycnostyle are convenient.
arcuated lintel. Conventional term for the arching-up of the members of a horizontal entablature over the central opening of a columnar façade, as in illustration 220 (Temple of Dushara). Originating in Syria, it is sometimes referred to as the 'Syrian arch'. Very common in the ceremonial architecture of later antiquity.
arx. Citadel (Greek, *acropolis*). In Rome the name of the northern part of the Capitoline Hill.
ashlar. Regular masonry of squared stones laid in horizontal courses with vertical joints.
atrium (-a). The central hall of a traditional Italic private house. By the first century A.D. the atrium, though still widely used in Italy and occasionally in the provinces, was obsolescent as a contemporary building type. In the Late Republican and Early Imperial atrium the central part of the roof sloped inwards towards a rectangular opening (*compluvium*) situated above a similarly shaped shallow fountain basin (*impluvium*). See illustration 115.
attic. Upper storey, or block of masonry with independent mouldings, situated above a cornice; e.g. illustrations 35, 101. It often served, notably on monumental arches, as a basis for statuary.

balneum, balineum (-a). Bath-building, public or private, of ordinary size, as distinct from the great public baths (*thermae*).

basilica. In strict architectural usage an elongated rectangular building with an internal ambulatory enclosing a taller central area, or else with a central nave and lateral aisles, in either case lit by a clerestory; often provided with one or more apses or tribunes. During the Empire the term came to be used of any hall that was basilican in plan, irrespective of its purpose; and also of any large covered hall, irrespective of its plan.

basis villae. The platform of a Roman villa.

baths (balnea, thermae). For the individual rooms of a Roman bath-building, *see* caldarium, frigidarium, laconicum, natatio, palaestra, tepidarium; *also* hypocaust, musaeum, piscina, praefurnium, suspensurae, testudo.

bessalis (-es). A small, multi-purpose brick, or flat tile, two-thirds of a Roman foot (*c.* 20 cm.) square. Commonly used in the processes of constructing a vault; also for the suspensurae of hypocausts.

bipedalis (-es). See tegula.

bucraneum (-a). Decorative motif in the form of an ox-skull (or bull's head), shown frontally. See illustration 13 (in metopes), 2 (on keystone).

bustum. Enclosure for the performance of cremation and the conservation of ash-urns.

caementa. The irregular chunks of stone or brick used as aggregate in Roman concrete (*opus caementicium*).

caldarium (-a). The hot room, or rooms, of a Roman bath.

capital. The upper member of a classical column or pilaster.

carceres. The starting gate of a hippodrome or circus.

cardo (-ines). In ancient usage the word (literally 'hinge', here visualized in terms of the earth's rotation) is attested only in the context of laying out a countryside on the basis of a grid of intersecting field tracks (*limites*) of which, strictly speaking, the *cardines* run from north to south, the *decumani* from east to west. Hence, by extension, often used as a convenient term for the units of the grid of a formally planned city; and by a further, but more questionable, extension for the two main streets of any town, whether they comply with the rules of surveying or not.

caryatid. Sculptured female figure used instead of a column to carry an entablature. See illustration 9. The corresponding male figure is a *telamon*.

castellum aquae. The distribution point from which the water delivered by an aqueduct was despatched to the various points of the town which it served.

castrum. Military camp, theoretically square or rect-

angular though commonly trapezoidal in plan. The layouts normally conform to one of two main types, one with two parallel transverse streets (*via principalis* and *via quintana*), the other characteristic of many permanent camps, particularly under the later Empire, with two main streets intersecting at right angles.

cavea. The auditorium of a theatre, so called because originally excavated from a hillside. The seating of an amphitheatre.

cella. The central chamber or sanctuary of a temple.

cenaculum. Dining-room; later an upper storey.

cenatio (-nes). General term for a dining-room.

chalcidicum. Monumental porch constituting the façade of some other building. In particular the porch in front of the short end of a basilica.

circus (Greek, *hippodrome*). Long narrow arena, curved at one end (exceptionally at both ends), for chariot racing.

clerestory. Upper row of windows lighting the nave of a basilica, above the inner colonnades.

coffers (lacunar, -aria). The recessed elements of a monumental ceiling or vault. Originally evolved in timberwork, coffering was later copied both in stone ceilings (e.g. in the peristasis of temples) and in concrete vaulting. See illustrations 56, 298.

colonia. Originally a military colony of Roman or Latin citizens. Later the term was used to denote a privileged form of municipal status.

columbarium (-a). Literally pigeon-cote, whence a sepulchral chamber with rows of small recesses like nesting-boxes to hold the ash-urns.

colymbēthra. Tank for aquatic spectacles. See p. 262.

comitium. Enclosed place of political assembly, notably that at the north-western corner of the Forum Romanum.

compluvium. See atrium.

Composite capital. Form of capital embodying elements both of Ionic and of Corinthian usage, as in illustration 293 (nearest pair).

concameratio (-nes). Vault, vaulting.

confornicatio (-nes). Vault, vaulting.

consoles. The brackets supporting the projecting part of a fully developed Corinthian cornice. See illustrations 16, 34. Also known as modillions.

corbel. Stone bracket supporting a projecting feature.

Corinthian order. The commonest and most versatile of the orders in Imperial Roman use. See illustrations 14, 52, 137, 204.

cornice. The upper member, above the frieze and architrave, of a classical entablature.

crypta. Subterranean gallery. Crypt.

cryptoportico. Underground vaulted corridor, often the substructure for a portico and lit obliquely through splayed apertures in the vault. The Latin

form, *cryptoporticus*, is attested only once and is better avoided. *Crypta* is a better Latin equivalent.

cubiculum. Bed chamber.

cunei. The wedge-shaped blocks of seating, divided by radiating passages, in a theatre or amphitheatre.

curia. The meeting-place of the Roman Senate, whence the assembly place of any municipal council. In Greek, *bouleuterion*.

dado. The lower part of a wall when treated decoratively as a continuous plinth or wainscot.

decastyle. Consisting of ten columns.

decumanus. *See* cardo.

dentils. Decorative motif of rectangular blocks in the bed-mould of a cornice, or occupying the place of a frieze; derivative from the ends of the joists carrying a flat roof. See illustrations 16, 34.

diaeta (-ae). Living-room.

diastyle. *See* araeostyle.

domus (-ūs). House. The well-to-do residence of a single family, as distinct from the taberna of the artisan and small tradesman and the apartment houses (*insulae*) of the middle-classes.

Doric order. The order of the Parthenon. In monumental architecture of the Imperial age it was little used outside a limited range of conventional contexts (e.g. the lowest of the three applied orders of the Colosseum), but derivative versions were widely used in domestic architecture, particularly in the western provinces.

drafting. The dressing back of one or more edges of a block of stone to facilitate the laying of a neat joint. Also used decoratively, to accentuate the pattern of the jointing of an ashlar wall.

echinus. The convex moulding which supports the abacus of a Doric capital. The moulding, carved with egg-and-dart, placed under the cushion of an Ionic capital.

engaged order. Decorative order projecting from, but forming an integral part of, the wall against which it stands. 'Semi-engaged' when only the entablature is engaged and the columns are free-standing.

entablature. The horizontal superstructure carried by a colonnade, or the equivalent superstructure over a wall.

epistyle. An alternative term for architrave (from the Latin *epistylium (-a)*, the Greek *epistylion*).

eustyle. See araeostyle.

exedra (-ae). Semicircular or rectangular recess.

extrados. The outer curved face of an arch or vault.

fastigium. Roof or gable (pediment).

fauces. The entrance to an atrium. The passageway between an atrium and a peristyle.

flat arch. Composite lintel or architrave, built up of voussoirs or of bricks laid radially as in an arch. See illustration 83.

fornix. By Imperial times this early term for a monumental arch had been generally replaced by *arcus*.

forum (-a). An open square or piazza for public affairs. Market-place. The Roman equivalent of the Greek *agora*.

frieze. The middle member of an entablature, between the cornice and the architrave. Often enriched with relief carving (e.g. illustration 1); whence any horizontal band so carved or otherwise ornamented.

frigidarium. The cold room of a Roman bath.

gymnasium (-a). By the first century A.D. the gymnasium, originally a Greek institution, was rapidly merging with the Roman bath-building, both as an institution and as an architectural form. In Greek *gymnasion* remained the normal term for a large public bath-building.

hellenistic. As a chronological term, used of the period between the death of Alexander the Great (323 B.C.) and the battle of Actium (31 B.C.). Culturally a term to be used with caution since in many provinces, particularly in the Greek-speaking world, there was a very substantial overlap into the early Empire.

hexastyle. Consisting of six columns.

hippodrome. *See* circus.

horreum (-a). Building for storage. Granary.

hortus. Garden. Park.

house. For the parts of a Roman house, *see* ala, andron, atrium, cenaculum, cenatio, cubiculum, diaeta, fauces, ianua, peristyle, tablinum, triclinium, vestibulum; *also* compluvium, hypocaust, impluvium.

hypocaust. Floor with an airspace beneath for the circulation of hot air.

ianua. The outer door of a house.

imbrex. Roof-tile, semicircular or triangular in section, covering the joint between the flanges of two rows of flat roof-tiles (*tegulae*).

impluvium. *See* atrium.

impost. Block interposed between the capital and the arches of a columnar arcade.

insula. Tenement or apartment house, as distinct from a private house (*domus*). Also, in conventional modern usage, a city block (see p. 192).

intrados. The inner curved face of an arch or vault.

Ionic order. The order of the Erechtheion. In rather limited use in the Roman west, but still common in many of the eastern provinces. See illustrations 32 (the middle order; cf. illustration 3) and 180.

isodomic masonry. Ashlar masonry cut to standard

sizes and laid in uniform courses (see Vitruvius II. viii. 5)

laconicum (-a). The hot dry room of a Roman bath.
limitatio. The laying-out of field-boundaries (*limites*).
lotus-and-acanthus capital. A hybrid form first recorded in the Tower of the Winds at Athens. Cf. illustration 259.

macellum. Market (strictly a meat market).
maenianum. Balcony.
'*marble style*'. Style associated with the widespread diffusion of marble as a building material in the second century A.D.
meander. Key pattern, as in illustration 223.
merlons. The crenellations of a fortress wall. Used as a decorative motif in Roman Syria. Cf. illustrations 207, 212.
meta. Turning-point for the chariots in a Roman circus.
metope. The panel, plain or sculptured, between the triglyphs of a Doric entablature.
modillions. See consoles.
module (Latin, *modulus*). The unit of length multiples (or fractions) of which are used to establish the dimensions of an architectural scheme that is based on relative proportions.
monopteros. A columnar building of circular plan that is roofed but contains no cella.
musaeum (-a). See nymphaeum. Also a room devoted to the study or display of the arts.

naiskos. Diminutive of *naos*. A small shrine.
naos. Shrine. In the Greek east the cella of a temple.
natatio. The swimming pool of a public bath.
nymphaeum (-a). Originally a cave with running water, dedicated to the Nymphs. Whence, any artificial fountain grotto (*musaeum, specus aestivus*). By extension, any monumental public fountain-building (e.g. illustration 219) or, particularly in later antiquity, a comparable fountain in domestic use (e.g. illustration 129).

octastyle. Consisting of eight columns.
odeum (Greek, *odeion*). Small .roofed theatre, for concerts and lectures.
oecus (-i) (Greek, *oikos*). The principal living-room of a Greek house. Introduced into Roman domestic architecture at the same time as the peristyle, the oecus was frequently used as a dining-room (*triclinium*). Vitruvius (VI. iii. 8–10; cf. vii. 3) uses the two terms almost indiscriminately, distinguishing four architectural types: Tetrastyle, Corinthian, Egyptian, and Cyzicene.

opus africanum. Conventional term for a type of masonry common in North Africa, in which a framework of massive dressed stone uprights and horizontals is used to contain panels of lighter masonry, such as mud brick or faced rubblework.
opus caementicium (*structura caementicia*). Roman concrete masonry of undressed stones (*caementa*) laid in a mortar of lime, sand, and, in Rome and Campania, pozzolana (q.v.). By extension, any comparable mortared rubblework in the provinces, even though made without pozzolana.
opus incertum. The facing of irregularly shaped small blocks used with opus caementicium from the second century B.C., and developed from the irregular rubble facing of the previous century, as at Cosa. In its later stages, as the irregularities assumed a more regular pattern, it is known (in modern usage) as *opus quasi reticulatum*.
opus latericium. Masonry of crude brick.
opus mixtum. Conventional name for opus caementicium faced with panels or bands of reticulate and brick.
opus quadratum. Ashlar masonry, of large squared stones laid in horizontal courses.
opus reticulatum. The successor to opus incertum (earliest known example the Theatre of Pompey, 55 B.C.), with a facing consisting of a network of small squared blocks laid in neat diagonal lines. From the Latin *reticulum*, a fine net. Cf. illustration 51.
opus sectile. Paving or wall decoration made of shaped tiles of coloured stone or marble.
opus signinum. Floor of concrete varied by irregular splinters of terracotta, stone, and marble. Used conventionally also of any Roman waterproof concrete made with crushed brick.
opus spicatum. Paving of small bricks laid on edge to form a herringbone pattern.
opus testaceum. Masonry of Roman concrete faced with fired brick.
opus vittatum. Conventional term for opus caementicium with a facing of courses of small squared blocks of stone (normally tufa) alternating with one or more courses of brick. Often used also of the provincial masonry here referred to as 'petit appareil', but better restricted to metropolitan usage and its immediate derivatives. The hybrid term 'opus listatum' (from the Italian 'opere listato') should be avoided.
orchaestra. Originally the circular 'dancing floor' of a Greek theatre; whence the corresponding semicircular space in front of the stage (*proscaenium*) of a Roman theatre.
orders. The three distictive groupings (Doric, Ionic, and Corinthian) of the elements (columns, capitals,

entablatures) of classical columnar architecture. An Italic variant of the Doric order, described by Vitruvius (IV. vii. 1–5) under the heading of *dispositiones tuscanicae*, has been treated by many post-classical writers as if it were a distinct fourth order, but it is far from clear that the Romans so regarded it, and it is wiser to use such terms as 'Roman Doric' or 'derivative Doric'. Mixed orders (cf. illustration 13) were already in widespread use in late hellenistic times.

orthostat (or *orthostate*). Upright slab of stone; particularly of those used in the Greek manner to form the lower part of a wall, as in illustrations 172 and 179.

palaestra. Porticoed enclosure for sport and exercise. The exercise yard of a Roman bath-building.

parascaenium (-a). The wings projecting forward from the two ends of the stage-building of a Roman theatre.

parodos. Lateral entrance to the orchestra of a theatre.

pedalis. See tegula.

pediment. The triangular gabled end of a ridged roof, comprising the tympanum and the raking cornice above it.

pendentive. Concave triangle of spherical section, constituting the transition from a square or polygonal building to a dome of circular plan (see illustration 218). Cf. squinch.

peripteral. Having a continuous outer ring of columns.

peristasis. The ring of columns round a peripteral building.

peristyle. An open courtyard, or garden, surrounded by porticoes. The central feature of a very widely distributed type of hellenistic and Roman house. Also used by Vitruvius as the equivalent of peristasis.

'petit appareil'. Conventional name for the characteristically Gallo-Roman type of opus caementicium, with a core of mortared rubble and a facing of courses of small squared blocks of stone. See p. 223. Widely used in many other provinces and often, from the second century A.D. onwards, laced with courses of brick.

piscina (-ae). Pool (literally 'fish-pool'). The plunge baths of a Roman bath-building.

pisé. Stiff clay used as a building material, laid within a shuttering of boards and regularly faced with stucco.

pitched brick. Brickwork laid edge to edge across the vertical curvature of an arch or vault, instead of radially as in normal western Roman usage. Apparently an eastern innovation. See pp. 276, 453, and illustration 176.

platea (Greek, *plateia*). Wide street or avenue, in contrast to *angiportus (-ūs*, Greek *stenōpos*), a lane or alleyway.

podium (-a). Platform, used most commonly of temples or columnar façades; normally with mouldings at top and bottom.

porticus in summa cavea. The portico commonly found running round the head of the seating of a Roman theatre. Cf. illustration 197.

porticus post scaenam. The portico or porticoed enclosure commonly found behind the stage-building of a Roman theatre.

pozzolana (Latin, *pulvis puteolanus*). The volcanic ash of Central Italy, so named from Puteoli (Pozzuoli), where its properties were first recognized; the material which gave Roman concrete its strength and hydraulic properties. See p. 98.

praecinctio. Horizontal passageway between the successive tiers of seats of a theatre or amphitheatre.

praefurnium. The stokehole of a bath-building.

principia. The headquarters building of a Roman camp.

pronaus (Greek, *pronaos*). Porch in front of the cella of a temple.

propylaeum (-a). Entrance gate-building(s) to the enclosure of a temple or other monumental building. Also *propylon*, strictly a simpler version of the same.

proscaenium. The stage of a Roman theatre, the space framed between the two projecting wings (*parascaenia*) of the stage-building (*scaena*) and its façade (*scaenae frons*).

prostyle. Having a projecting columnar façade.

pseudoperipteral. As peripteral, but with some of the columns engaged instead of free-standing.

pulpitum. The raised platform of the stage of a Roman theatre.

puteal. Stone well-head.

pycnostyle. See araeostyle.

quadrifrons (Greek, *tetrapylon*). Monumental arch with two intersecting passageways and four façades.

quadriga. Four-horsed chariot.

quadriporticus. Enclosed courtyard with porticoes on all four sides.

relieving arch. Arch incorporated within a masonry mass in order to distribute the load above a potential point of weakness. See illustrations 79, 86.

reticulate (work). See opus reticulatum.

revetment. Superficial facing (e.g. of terracotta or marble) applied to a wall built of some other material.

Rhodian peristyle. Peristyle of which one portico is taller than the other three.

ridge pole. Beam along the ridge of a roof.

rostra. The speakers' tribune of the comitium of the Forum Romanum, so called because it was ornamen-

ted with the prows (*rostra*) of the ships captured at Antium in 338 B.C. By extension, any speakers' platform.

rustication. The use of masonry in its crude, quarry-dressed state as a form of sophisticated decoration.

sarcophagus. Stone coffin.

scaena (Greek, *skene*). Stage-building of a Roman theatre. The façade of it (*scaenae frons*) formed the backdrop of the stage (*proscaenium*).

segmental arch. Arch of which the curvature is substantially less than a full semicircle. Cf. the central doorway in illustration 76.

semi-column. Half-column, of an engaged order or composite pier.

sesquipedalis. See tegula.

sigma. Semicircular portico (from the late Greek capital S (*sigma*), which was written 'C'). See p. 463.

sima. The crowning moulding (originally the gutter) of a cornice. See illustrations 16, 34.

sine postico. Vitruvian term for a temple peripteral on three sides only, with a plain back wall or a back wall with short projecting wings.

siparium. Curtain. The curtain of a theatre, which was raised from a slot in the front of the stage.

socle. The lower part of a wall. Originally a constructional feature, in Roman times it was commonly treated as a purely decorative dado.

soffit. The exposed undersurface of an architectural member, especially of an architrave or arch.

specus. Cave. The channel of an aqueduct.

spina. The long, narrow dividing wall down the centre of a circus.

squinch. Arched structure across the interior angle of a square chamber, to support the spring of a circular or octagonal vault or dome. Cf. pendentive.

stadium. A racecourse for foot-racing, from the Greek *stadton*, a unit of 600 Greek feet, the length of the course at Olympia. A stadium-shaped enclosure, as in a formal garden.

stele. Upright stone slab, as used for tombstones, for all kinds of sculptured reliefs, and for inscriptions.

stoa. The Greek equivalent of the Latin *porticus.* Praticularly of public buildings, often with multiple colonnades and sometimes two-storeyed.

stylobate. The course of masonry, at ground level, upon which the columns of a colonnade are seated.

suspensurae. The supports for the raised floor of a hypocaust.

systyle. See araeostyle.

taberna (*-ae*). Rectangular chamber opening directly off the street and used as shop, workshop, or habitation for the lower classes. See pp. 146–7.

tablinum (*tabulinum*). The central room at the far end of an atrium, originally the main bedroom; record room (whence the name).

tabularium. Archive building.

tegula (*-ae*). Flanged roof-tile, or flat tile as used in opus testaceum masonry. Standard sizes include the *bipedalis* (two Roman feet), the *sesquipedalis* (one and a half Roman feet), the *pedalis* (one Roman foot), and the *bessalis* (two thirds of a Roman foot).

telamon. See caryatid.

temenos (*-oi*). Sacred enclosure or precinct.

templum. Originally the place marked out by an augur for the purpose of taking auspices. Whence any consecrated place, sanctuary, asylum.

tepidarium (*-a*). The warm room of a Roman bath.

tetrakionion. Pavilion, or aedicula, carried on four columns. Monument consisting of four independent columns or groups of columns placed at a street intersection.

tetrapylon. See quadrifrons.

tetrastyle. Carried on four columns, e.g. of a façade, of an aedicula, or of an atrium with columns at the four corners of the impluvium.

theatre. For the parts of a Roman theatre, see pp. 259–60; also cf. cavea, cunei, orchaestra, porticus in summa cavea, porticus post scaenam, praecinctio, proscaenium, pulpitum, scaena, siparium, vomitorium.

thermae. Large public baths, as distinct from *balnea.*

tholos. Circular pavilion, often in the form of a monopteros.

torus. Rounded convex moulding; as (twice) in the typical Attic column base (e.g. illustration 47).

travertine. Silvery-grey calcareous building stone quarried near Tivoli and extensively used in Late Republican and Early Imperial Rome.

tribunal. Raised platform for formal official use.

triclinium (*-a*). Originally a dining-room, so-called from the conventional arrangement of three banqueting couches (*klinai*) around three sides of a square. In later Roman usage the principal reception room, or rooms, of a house. See pp. 188, 463.

triconchos. Room of trefoil or three-lobed plan.

triglyph. Projecting member separating the metopes of a Doric frieze and divided into three strips by two vertical grooves.

tufa. The principal local building stone of Latium and Campania, a concreted volcanic dust. The many qualities include capellaccio, peperino, and the stones of Monte Verde, Grotta Rossa, Grotta Oscura, and Gabi.

tympanum. The vertical wall-face of a pediment beneath the raking cornice.

ustrinum (*-a*). Place for burning corpses.

velum, *velarium*. The awning stretched above a forum, a theatre, or an amphitheatre to protect the public from the sun.

vestibulum. Vestibule; especially of the entrance from the street to the fauces of a house.

volutes. The spiral scrolls at the angles of an Ionic capital (as illustration 245) or a Corinthian capital (as illustrations 169, 184).

vomitorium (-*a*). Entrance to a theatre or amphitheatre.

voussoir. Wedge-shaped stone forming one of the units of an arch.

xystus. Covered colonnade in a gymnasium. Enclosed garden.

BIBLIOGRAPHY

A. GENERAL

I. GENERAL WORKS ON ROMAN ARCHITECTURE

ANDERSON, W. J. *Architecture of Greece and Rome*, II, *The Architecture of Ancient Rome*, by W. J. Anderson and R. P. Spiers, revised and rewritten by T. Ashby. London, 1927.
BIANCHI BANDINELLI, R. *Rome, the Centre of Power: Roman Art to A.D. 200*. London, 1970.
BIANCHI BANDINELLI, R. *Rome, the Late Empire*. London, 1971.
BOËTHIUS, A. *Roman and Greek Town Architecture* (*Acta Universitatis Gotoburgensis*, LIV). Gothenburg, 1948.
BROWN, F. E. *Roman Architecture*. New York, 1961.
CHOISY, A. *L'Art de bâtir chez les Romains*. Paris, 1873.
COZZO, G. *Ingegneria romana*. Rome, 1928. Second ed. 1970.
CREMA, L. *L'Architettura romana* (*Enciclopedia classica*, III, vol. 12, 1). Turin, 1959. Quoted as: Crema.
DURM, J. *Die Baukunst der Etrusker. Die Baukunst der Römer* (*Handbuch der Architektur*, II, vol. 2). Stuttgart, 1905. Quoted as: Durm, *Baukunst*.
Enciclopedia dell'arte antica classica e orientale. Rome, 1958–66.
GIOVANNONI, G. *La Tecnica della costruzione presso i Romani*. Rome, 1925.
Mostra augustea della Romanità. 4th ed. 2 vols. Rome, 1938.
PLOMMER, H. *Ancient and Classical Architecture* (*Simpson's History of Architectural Development*, 1). London, 1956.
PRICE, M. J., and TRELL, B. L. *Coins and their Cities: Architecture on the Ancient Coins of Greece, Rome and Palestine*. London, 1977.
RAKOB, F. 'Römische Architektur', in T. Kraus, *Das römische Weltreich* (*Propyläen Kunstgeschichte*, II), 153–201. Berlin, 1967.
RIVOIRA, G. T. *Roman Architecture*. Oxford, 1925 (translation of *Architettura romana*, Milan, 1921).
ROBERTSON, D. S. *A Handbook of Greek and Roman Architecture*. Cambridge, 1929. Second revised ed. Cambridge, 1943. Reprinted under title *Greek and Roman Architecture*, London, 1969.

STILLWELL, R. (ed.) *The Princeton Encyclopedia of Classical Sites*. Princeton, 1976.
VITRUVIUS. *De architectura*. Ed. by various authors (Collection Guillaume Budé, Paris, with French translation and detailed commentary). Already published, or in preparation: vols. II (A. Balland), III and IV (P. Gros), VII (P. Liore), VIII (L. Callebat, 1973), IX (J. Soubiran, 1969), X (L. Callebat).
VITRUVIUS. *De architectura*. Ed. F. Granger (Loeb edition). 2 vols. Harvard University Press, 1945 and 1970.
VITRUVIUS. Ed. by Krohn (Teubner, 1912).
WARD-PERKINS, J. B. 'From Republic to Empire: reflections on the early provincial architecture of the Roman West', *J.R.S.*, LX (1970), 1–19.
WARD-PERKINS, J. B. *Roman Architecture*. New York, 1977.
An unrevised translation of *Architettura Romana* (Milan, 1974).
WHEELER, R. E. M. *Roman Art and Architecture*. London, 1964.

2. GENERAL WORKS ON ROMAN TOWN PLANNING

CASTAGNOLI, F. *Orthogonal Planning in Antiquity*. Cambridge, Mass., 1972.
Revised translation of *Ippodamo di Mileto e l'urbanistica a pianta ortogonale* (Rome, 1956).
DILKE, O. A. W. *The Roman Land Surveyors*. Newton Abbot, 1971.
GERKAN, A. VON. *Griechische Städteanlagen*. Berlin–Leipzig, 1924.
LEHMANN, K. 'Städtebau Italiens und des römischen Reiches', *P.W.*, III–A, 2016–2124.
MANSUELLI, G. A. *Architettura e città*. Bologna, 1970.
SCHMIEDT, G. *Atlante aerofotografico delle sedi umane in Italia*. Florence, 1970.
WARD-PERKINS, J. B. *Cities of Ancient Greece and Italy: Planning in Classical Antiquity*. New York, 1974; London, 1975.
WARD-PERKINS, J. B. 'Early Roman Towns in Italy', *Town Planning Review*, XXVI (1955), 127–54.

3. GENERAL WORKS ON THE ARCHITECTURE
OF ROME AND ITALY

BLAKE, M. *Ancient Roman Construction in Italy from the Prehistoric Period to Augustus.* Washington, 1947. Quoted as: Blake (1947).

BLAKE, M. *Roman Construction in Italy from Tiberius through the Flavians.* Washington, 1959. Quoted as: Blake (1959).

BLAKE, M. E., and TAYLOR-BISHOP, D. *Roman Construction in Italy from Nerva through the Antonines.* Philadelphia, 1973. Quoted as: Blake and Taylor-Bishop.

BLANCKENHAGEN, P. VON. 'The Imperial Fora', *Journal of the Society of Architectural Historians*, XIII (1954), 21–6.

BLOCH, H. *I Bolli laterizi e la storia edilizia romana* (reprinted from *Bull. Comm.*, LXIV–LXVI, 1936–8). Rome, 1947; reprint, 1967.

BOËTHIUS, A. *The Golden House of Nero* (Jerome Lectures, ser. v). Ann Arbor, 1960.

CARETTONI, G., COLINI, A. M., COZZA, L., and GATTI, G. *La Pianta marmorea di Roma Antica.* 2 vols. Rome, 1960. Quoted as: Forma Urbis.

CASTAGNOLI, F. *Roma antica* (Istituto di Studi Romani, *Storia di Roma*, XXII. *Topografia e urbanistica di Roma* di F. Castagnoli, C. Cecchelli, G. Giovannoni, M. Zocca, 1). Bologna, 1958.

COARELLI, F. *Rome.* London, 1973.

COLINI, A. M. *Studi di topografia romana.* Rome, 1968.

DUDLEY, D. R. *Urbs Roma: A Source Book of Classical Texts on the City and its Monuments.* Aberdeen, 1966.

GERKAN, A. VON. *Von antiker Architektur und Topographie. Gesammelte Aufsätze.* Stuttgart, 1959.

LANCIANI, R. *Forma Urbis Romae.* Milan, 1893–1901. Reprinted in: *Le Piante di Roma*, a cura di A. P. Frutaz, II, LI. 1–9 (plates 102–9). *Le Piante di Roma*, I–III. A cura di A. P. Frutaz (Istituto di Studi Romani). Rome, 1962.

LUGLI, G. (ed.) *Fontes ad topographiam veteris urbis Romae pertinentes colligendos atque edendos curavit Josephus Lugli* (Università di Roma. Istituto di topografia antica). Rome, 1952– (in progress).

LUGLI, G. *La Tecnica edilizia romana con particolare riguardo a Roma e Lazio.* 2 vols. Rome, 1957.

LUGLI, G. *Monumenti minori del Foro Romano.* Rome, 1947.

LUGLI, G. *Studi minori di topografia antica.* Rome, 1965.

LUGLI, G. *I Monumenti antichi di Roma e suburbio.* 3 vols. Rome, 1930–8. Suppl., 1940.

LUGLI, G. *Roma Antica: il centro monumentale.* Rome, 1946.

MACDONALD, W. L. *The Architecture of the Roman Empire*, I: *an introductory study.* Yale University Press, 1965. Quoted as: MacDonald.

NASH, E. *Pictorial Dictionary of Ancient Rome.* 2nd ed. 2 vols. London, 1968. Quoted as: Nash.

NORDH, A. *Libellus de regionibus urbis Romae* (*Acta Rom. Suec.*, in 8°, III). Rome, 1949.

PLATNER, S. B., and ASHBY, T. *A Topographical Dictionary of Ancient Rome.* London, 1929. Quoted as: Platner–Ashby.

RICHMOND, I. A. *The City Wall of Imperial Rome.* Oxford, 1930. Reprinted Wilmington, North Carolina, 1971.

VALENTINI, R., and ZUCCHETTI, G. *Codice topografico della città di Roma.* 4 vols. Rome, 1940–53.

4. INDIVIDUAL TYPES OF BUILDING

ASHBY, T. *The Aqueducts of Ancient Rome*, ed. I. A. Richmond. Oxford, 1935. Reprinted Wilmington, North Carolina, 1971.

BECATTI, G. *La Colonna coclide istoriata.* Rome, 1960.

BROWN, D. F. *Temples as Coin Types* (*American Numismatic Notes and Monographs*, XC). New York, 1940.

CAGIANO DE AZAVEDO, M. 'I "Capitolia" dell' Impero Romano', *Mem. Pont.*, V (1941), 1–76.

CALLMER, C. 'Antike Bibliotheken', *Acta Rom. Suec.*, X (1944), 145–93.

ÉTIENNE, R. (ed.) *Les Cryptoportiques dans l'architecture romaine.* École française de Rome, 1973.

GAZZOLA, P. *Ponti romani.* Florence, 1963.

GÖTZE, B. 'Antike Bibliotheken', *J.D.A.I.*, LII (1937), 225–47.

GRIMAL, P. *Les Jardins romains.* 2nd ed. Paris, 1969.

HANSON J. A. *Roman Theater-temples.* Princeton, 1959.

HORNBOSTEL-HÜTTNER, G. *Studien zur römischer Nischenarchitektur.* Leiden, 1979.

KÄHLER, H. *Der römische Tempel.* Berlin, 1970.

KÄHLER, H. 'Triumphbogen (Ehrenbogen)', *P.W.*, VII a, 373–493.

KRENCKER, D., and KRÜGER, E. *Die Trierer Kaiserthermen.* Augsburg, 1929.

MANSUELLI, G. A. *El Arco honorifico ed el desarollo de la arquitectura romana* (*Archivio español de Arqueología*, XXVII). 1954.

MANSUELLI, G. A., and others. *Studi sull'arco onorario romano.* Rome, 1978.

NASH, E. 'Obelisk und Circus', *R.M.*, LXIV (1957), 232–59.

NEUERBERG, N. *L'Architettura delle fontane e dei ninfei nell'Italia antica* (*Mem. Nap.*, v). Naples, 1965.

RICKMAN, G. E. *Roman Granaries and Store Buildings.* Cambridge, 1971.

SWOBODA, K. M. *Römische und romanische Paläste.* Vienna, 1924.

VAN DEMAN, E. B. *The Building of the Roman Aqueducts.* Washington, 1934.

See also the following articles in the *Enciclopedia dell'Arte Antica*, most of which list all the examples in Italy and the provinces known to the writers, together with a substantial bibliography:

'Anfiteatro' G. Forni (I, 374–90)
'Arco onorario e trionfale' M. Pallottino (I, 588–98)
'Basilica' E. Coche de la Ferté (II, 2–15)
'Biblioteca' H. Kähler (II, 93–9)
'Circo e Ippodromo' G. Forni (II, 647–55)
'Magazzino (horreum)' R. A. Staccioli (IV, 767–72)
'Monumento funerario' R. A. Mansuelli (V, 170–202)
'Palestra' G. Carettoni (V, 882–7)

5. ARCHITECTURAL ORNAMENT AND DECORATION

GNOLI, R. *Marmora romana.* Rome, 1971.

HEILMEYER, W.-D. *Korinthische Normalkapitelle: Studien zur Geschichte der römischen Architekturdekoration (R.M.* Ergänzungshefte, XVI). Heidelberg, 1970.

LEON, C. *Die Bauornamentik des Trajansforums.* Vienna, 1971.

LYTTLETON, M. *Baroque Architecture in Classical Antiquity.* London, 1974.

MERCKLIN, E. VON. *Antike Figuralkapitelle.* Berlin, 1962.

MIELSCH, H. *Römische Stuckreliefs (R.M.* Ergänzungshefte, XXI). Heidelberg, 1975.

SEAR, F. B. *Roman Wall and Vault Mosaics (R.M.* Ergänzungshefte, XXIII). Heidelberg, 1977.

STRONG, D. E. 'Some Early Examples of the Composite Capital', *J.R.S.,* L (1960), 119–28.

STRONG, D. E. 'Some Observations on Early Roman Corinthian', *J.R.S.,* LIII (1963), 73–84.

TOEBELMANN, F. *Römische Gebälke.* Heidelberg, 1923.

B. BY CHAPTERS

NOTE. For only a few of the buildings in Rome referred to in Chapters 1–5 and 8 is there a single definitive monograph. In almost every case the bibliography is cumulative over many years and has been recently and well summarized in Blake (1947 and 1959), in Blake and Taylor-Bishop, and in Nash. See also Platner-Ashby (especially for the classical sources), Crema, and Lugli, *Centro.* The bibliographies of the individual chapters that refer to the city of Rome are limited to works that are of particular importance for the individual buildings or topics discussed in each.

CHAPTER 1

CALZA-BINI, A. 'Il Teatro di Marcello', *Bollettino del Centro di Studi per la Storia dell'Architettura,* VII (1953), 1–43.

CARETTONI, G. 'I problemi della zona Augustea del Palatino alla luce dei recenti scavi', *Rend. Pont.,* XXXIX (1966–7), 56–75.

COLINI, A. M. 'Il Tempio di Apollo', *Bull. Comm.,* LXVIII (1940), 1–40.

EHRENBERG, V., and JONES, A. H. M. *Documents illustrating the Reigns of Augustus and Tiberius.* 2nd ed. Oxford, 1955. Pp. 1–31: *Res Gestae Divi Augusti.*

FELLMANN, R. *Das Grab des Lucius Munatius Plancus bei Gaeta (Schriften des Institutes für Ur- und Frühgeschichte der Schweiz,* XI). Basel, 1957.

GASPARRI, C. *Aedes Concordiae Augustae.* Rome, Istituto di Studi Romani, 1979.

GIGLIOLI, G. Q. 'Cariatidi dell'Eretteo nelle porticus del Foro di Augusto', *R.M.,* LXII (1955), 155–9.

GROS, P. *Aurea Templa. Recherches sur l'architecture religieuse de Rome à l'époque d'Auguste.* École française de Rome, 1976.

LUGLI, G. 'Architettura italica', *Mem. Linc.,* II (1949), 189–218.

MORETTI, G. *L'Ara Pacis Augustae.* Rome, 1948.

RICCI, C. 'Il Foro d'Augusto e la Casa dei Cavalieri di Rodi', *Capitolium* (1930), 157–89.

SHIPLEY, F. W. 'The Building Activities of the Viri Triumphales from 44 B.C. to 14 A.D.', *M.A.A.R.,* IX (1931), 9–60.

SHIPLEY, F. W. *Agrippa's Building Activities in Rome.* St Louis, 1933.

STRONG, D. E., and WARD-PERKINS, J. B. 'The Temple of Castor in the Forum Romanum', *P.B.S.R.,* XXX (1962), 1–30.

TOYNBEE, J. M. C. 'The Ara Pacis Reconsidered', *Proceedings of the British Academy,* XXXIX (1953), 67–95.

WARD-PERKINS, J. B. 'An Early Augustan Capital in the Forum Romanum', *P.B.S.R.*, XXXV (1967), 23-8.

ZANKER, P. *Forum Augustum.* Tübingen, 1968.

CHAPTER 2
(See note at head of Section B)

BENDINELLI, G. 'Il Monumento sotterraneo di Porta Maggiore in Roma', *Mon. Ant.*, XXXI (1926), 601-848.

BOËTHIUS, A. *The Golden House of Nero.* Ann Arbor, 1960.

TAMM, B. *Neros Gymnasium in Rom.* Stockholm, 1970.

UCELLI, G. *Le Navi di Nemi.* 2nd ed. Rome, 1950.

WARD-PERKINS, J. B. 'Nero's Golden House', *Antiquity*, XXX (1956), 209-19.

CHAPTER 3
(See note at head of Section B)

BLANCKENHAGEN, P. H. VON. *Flavische Architektur und ihre Dekoration.* Berlin, 1940.

COZZO, G. *Il Colosseo.* Rome, 1927. Reprinted Rome, 1970.

COZZO, G. *The Colosseum, the Flavian Amphitheatre.* Rome, 1971.

FIORANI, G. 'Problemi architettonici del Foro di Cesare', *Quaderni dell'Istituto di Topografia Antica*, V (1968), 91-103.

LEHMANN-HARTLEBEN, K. *Die Trajansäule.* Berlin–Leipzig, 1926.

LEON, C. F. *Die Bauornamentik des Trajansforums und ihre Stellung in der früh- und mittelkaiserlichen Architekturdekorations Roms* (Österreichisches Kulturinstituts in Rom, Abt. I, 4). Vienna-Cologne-Graz, 1971.

LUGLI, G., and FILIBECK, G. *Il Porto di Roma Imperiale e l'Agro Portuense.* Rome, 1935.

TAMM, B. *Auditorium and Palatium.* Stockholm, 1963.

WARD-PERKINS, J. B. 'Columna Divi Antonini', *Mélanges Paul Collart*, 345-52. Lausanne, 1976. For the chronology of Trajan's Forum.

WATAGHIN CANTINO, G. *La Domus Augustana: personalità e problemi dell'architettura flavia.* Turin, 1966.

ZANKER, P. 'Der Trajansforum in Rom', *Anz.* (1970), 499-544.

CHAPTER 4
(See note at head of Section B)

BRUZZA, L. 'Iscrizioni dei marmi grezzi', *Annali dell'Istituto di Corrispondenza Archeologica*, XLII (1870), 106-204. Quarry-inscriptions on blocks of marble found in the Tiber-side marble yards.

CECCHELLI, C. 'Origini del mosaico parietale cristiano', *Architettura ed Arti Decorative*, II (1922), 3-27, 49-56.

COZZO, G. *Ingegneria romana.* Rome, 1928.

GIOVANNONI, G. 'Contributi allo studio della tecnica nelle costruzioni romane', *Atti del II Congresso Nazionale di Studi Romani* (1931), 281-4.

LICHT, K. DE F. *The Rotunda in Rome.* Copenhagen, 1968.

LUGLI, G. *La Tecnica edilizia romana.* 2 vols. Rome, 1957.

MACDONALD, W. L. *The Architecture of the Roman Empire*, I: *an introductory study.* Yale, 1965.

VIGHI, R. *The Pantheon.* Rome, 1955.

WARD-PERKINS, J. B. 'Tripolitania and the Marble Trade', *J.R.S.*, XLI (1951), 89-104.

CHAPTER 5
(See note at head of Section B)

APOLLONJ-GHETTI, B. M., and others. *Esplorazioni sotto la Confessione di San Pietro in Vaticano eseguite negli anni 1940-1949.* 2 vols. Vatican City, 1951.

BARATTOLO, A. 'Il Tempio di Venere e di Roma', *R.M.*, LXXX (1973), 243-69.

BENARIO, H. W. 'Rome of the Severi', *Latomus*, XVII (1958), 712-22.

CALZA, G. *La Necropoli del Porto di Roma nell'Isola Sacra.* Rome, 1940.

KAMMERER-GROTHAUS, H. 'Der Deus Rediculus in Triopion des Herodes Atticus: Untersuchungen am Bau in Ziegelarchitektur des 2. Jahrhunderts n. Chr. in Latium', *R.M.*, LXXXI (1974), 131-252.

STRONG, D. E. 'Late Hadrianic Architectural Ornament in Rome', *P.B.S.R.*, XXI (1953), 118-51.

TOYNBEE, J. M. C., and WARD-PERKINS, J. B. *The Shrine of St Peter and the Vatican Excavations.* London, 1956.

VOGEL, L. *The Column of Antoninus Pius.* Harvard, 1973.

CHAPTER 6

BECATTI, G. 'Case Ostiensi del Tardo Impero', *B. d'Arte*, XXXIII (1948), 102-28 and 197-224.

CALZA, R., and NASH, E. *Ostia.* Florence, 1959.

MEIGGS, R. *Roman Ostia*. Oxford, 1960. Second revised ed. Oxford, 1973.

PACKER, J. *The Insulae of Imperial Ostia* (*M.A.A.R.*, XXXI). Rome, 1971.

Scavi di Ostia, I. G. Calza and others, *Topografia Generale*. Rome, 1953.

CHAPTER 7

A great deal of the essential bibliography for the Roman architecture of provincial Italy is scattered in small local monographs, in the national periodicals (of which *Notizie degli Scavi* (*N.S.*), *Bollettino d'Arte* (*B. d'Arte*), and *Monumenti Antichi* (*Mon. Ant.*) are the three most important in this respect), or in local periodicals too numerous to name. In nearly all cases this bibliography will be found under the name of the appropriate town or site in the *Enciclopedia dell' Arte Antica*. Another valuable bibliographical source is the series *Italia Romana: Municipi e Colonie* published by the Istituto di Studi Romani, the published volumes of which cover the following cities:

Italy, North of Rome:

Ancona, Ariminum (Rimini), Auximum (Osimo in the Marche), Caesena (Cesena), with Forum Popili (Forlimpopoli) and Forum Livi (Forlí) in the Romagna, along the Via Aemilia, Faesulae (Fiesole), Florentia (Florence), Forum Iulii (Cividale nel Friuli), Mevania (Bevagna, prov. Perugia), Ocriculum (Otricoli, on the Via Flaminia north of Rome), Sestinum (Sestino, prov. Arezzo), Spoletium (Spoleto), and Tergeste (Trieste).

Latium and Southern Italy:

Aquinum (Aquino), Casinum (Cassino), Centumcellae (Civitavecchia, with Castrum Novum (Torre Chiaruccia) on the Via Aurelia), Iteramna Lirenas (near Cassino), Tibur (Tivoli), and Velitrae (Velletri).

1. Southern Italy

ANDREAE, B., and KYRIELEIS, H. (ed.) *Neue Forschungen in Pompeji*. Recklinghausen, 1975.

CARRINGTON, R. C. *Pompeii*, Oxford, 1936.

Cronache Pompeiane, I–. Naples, 1975–. In progress.

D'ARMS, J. H. D. *Romans on the Bay of Naples*. Harvard, 1970.

DE FRANCISCIS, A., and PANE, R. *Mausolei romani in Campania*. Naples, 1957.

DUBOIS, C. *Pouzzoles antique* (*Bibliothèque des écoles françaises d'Athènes et de Rome*, XCVIII). Paris, 1907.

ENGEMANN, J. *Architekturdarstellung des frühen Zweiten Stils: illusionistische römische Wandmalerei der ersten Phase und ihre Vorbilder in der realen Architektur*. Heidelberg, 1967.

ESCHEBACH, H. *Die Städtebauliche Entwicklung der antiken Pompeji* (*R.M.* Ergänzungshefte, XVII). Heidelberg, 1970.

MAIURI, A., in *Enciclopedia dell' Arte Antica*, S.V. Ercolano (III, 408) and Pompei (VI, 354–6). For comprehensive bibliographies on Herculaneum and Pompeii.

MAIURI, A. *I Campi Flegrei* (*Itinerari*, no. 32). 4th ed. 1938.

MAIURI, A. *Ercolano. I nuovi scavi* (*1927–1958*). Rome, 1958.

MAIURI, A. *La Villa dei Misteri*. Rome, 1931.

MAIURI, A. *L'Ultima Fase edilizia di Pompei*. Rome, 1942.

MAU, A. *Pompeji in Leben und Kunst*. Leipzig, 1908.

Pompei, 79. Raccolta di studi per il decimonono centenario dell'eruzione vesuviana, a cura di Fausto Zevi. Naples, 1980

RAKOB, F. ' "Litus Beatae Veneris Aureum": Untersuchungen am "Venustempel" in Baiae', *R.M.*, LXVIII (1961), 114–49.

SPINAZZOLA, V. *Pompei alla luce degli scavi di Via dell'Abbondanza* (*anni 1910–1923*). Rome, 1953.

VAN BUREN, A. W. *A Companion to Pompeian Studies*. American Academy in Rome, 1927.

2. Northern Italy

AURIGEMMA, S. *Velleia* (*Itinerari*, no. 73). Rome, 1940.

FORMIGÉ, J. *Le Trophée des Alpes* (*La Turbie*) (II^e Supplément à *Gallia*). Paris, 1949.

FRIGERIO, F. 'Antiche Porte di città italiche e romane', *Rivista archeologica dell'antica provincia e diocesi di Como*, fasc. 108–110 (1934–5).

KÄHLER, H. 'Die römischen Stadttore von Verona', *J.D.A.I.*, L (1935), 138–97.

MARCONI, P. *Verona Romana*. Bergamo, 1937.

RICHMOND, I. A. 'Augustan Gates at Torino and Spello', *P.B.S.R.*, XII (1932), 52–62.

Storia di Milano (Fondazione Treccani, Milan), I (1953), parts 5 and 9: A. Calderini, 'Milano Romano fino al tempo del cristianesimo' and 'Milano archeologico'.

Verona e il suo territorio (Istituto di Studi Storici Veronesi), I (1960): L. Beschi, 'Verona Romana, i monumenti'.

CHAPTER 8

For Herculaneum and Pompeii, see bibliography to Chapter 7.

BECATTI, G. 'Case Ostiensi del Tardo Impero', *B. d'Arte*, XXXIII (1948), 102–28 and 197–224.

CALZA, G. 'La Preminenza dell' "Insula" nella edilizia romana', *Mon. Ant.*, XXIII (1914), 541–608.

CALZA, G. 'Le Origini latine dell'abitazione moderna', *Architettura e arti decorative*, III (1923–4), 3–18 and 49–63.

GRIMAL, P. *Les Jardins romains* (*Bibliothèque des écoles françaises d'Athènes et de Rome*, CLV). Paris, 1943. Second revised ed. Paris, 1969.

KÄHLER, H. *Hadrian und seine Villa bei Tivoli*. Berlin, 1950.

MACKAY, A. G. *Houses, Villas and Palaces in the Roman World*. London, 1975.

MAIURI, A. *Capri: storia e monumenti* (*Itinerari*, no. 93). Rome, 1956.

ROSTOVTZEFF, M. 'Die hellenistische-römische Architekturlandschaft', *R.M.*, XXVI (1911), 1–185.

SWOBODA, K. M. *Römische und romanische Paläste*. Vienna, 1924.

CHAPTER 9

1. Spain and Portugal

ALARCÃO, J., and ÉTIENNE, R. *Fouilles de Conimbriga*, I: *L'Architecture*. Paris, 1977.

ALMAGRO, M. *Guia de Mérida*. Madrid, 1961.

BALIL, A. *Casa y urbanismo en la España antigua*, I–IV. Valladolid, 1972–4.

GARCIA Y BELLIDO, A. *Arte romano*[2]. Madrid, 1972.

GORGES, J. G. *Les Villas hispano-romaines*. Paris, 1979.

TARACENA, B. 'Arte romano', in *Ars Hispaniae*, II. Madrid, 1947.

WISEMAN, F. J. *Roman Spain: an introduction to the Roman antiquities of Spain and Portugal*. London, 1956.

2a. Gaul: General Works

Detailed references to the very large and scattered bibliography referring to the buildings of Roman Gaul will be found in the relevant volumes of Grenier, *Manuel*. For the more important post-war excavations and discoveries, see also the annual accounts in *Gallia*. The bibliography that follows is restricted to a few of the more useful general works and monographs on individual sites and monuments.

AGACHE, R., and BRUART, B. *Atlas d'archéologie de Picardie*. Amiens, 1975.

AGACHE, R. *La Somme préromaine et romaine*. Amiens, 1978.

BLANCHET, A. *Recherches sur les aqueducs et cloaques de la Gaule romaine*. Paris, 1908.

BROGAN, O. *Roman Gaul*. London, 1953.

Gallia, I (1946). In progress.

GRENIER, A. *Manuel d'archéologie gallo-romaine*. vol. III. *L'Architecture* (Paris, 1958). Fasc. 1: *L'Urbanisme*. Fasc. 2: *Ludi et Circenses*. vol. IV. *Les Monuments des eaux* (Paris, 1960). Fasc. 1: *Aqueducs, thermes*. Fasc. 2: *Villes d'eau et sanctuaires de l'eau*.

MACKENDRICK, P. *Roman France*. London and New York, 1972.

MAEYER, R. DE. *De Romeinsche Villa's in België*. Antwerp, 1937. With French summary.

PERCIVAL, J. *The Roman Villa*. University of California, 1972. The villa system; useful bibliography.

STAEHELIN, F. *Der Schweiz in römischer Zeit*. 3rd ed. Basel, 1948.

2b. Gaul: Individual Sites and Monuments

AMY, R., and others. *L'Arc d'Orange* (XVe Suppl. à *Gallia*). Paris, 1962.

AMY, R., and GROS, P. *La Maison Carrée* (XXXVIIIe Suppl. à *Gallia*). Paris, 1979.

AUDIN, A. *La Topographie de Lugdunum*. Lyon, 1958.

AUDIN, A. *Lyon, miroir de Rome dans les Gaules*. Lyon, 1979.

CONSTANS, L. A. *Arles antique* (*Bibliothèque des écoles françaises d'Athènes et de Rome*, CXIX). Paris, 1921.

FORMIGÉ, J. *Le Trophée des Alpes* (*La Turbie*) (IIe Suppl. à *Gallia*). Paris, 1949.

FOUET, G. *La Villa gallo-romaine de Montmaurin* (*Hte-Garonne*) (XXe Suppl. à *Gallia*). Paris, 1969.

LAUR-BELART, R. *Führer durch Augusta Raurica*. 2nd ed. Basel, 1948.

LUGLI, G. 'La Datazione degli anfiteatri di Arles e di Nîmes in Provenza', *Rivista dell'Istituto Nazionale d'Archeologia e Storia dell'Arte*, XIII–XIV (1964–5), 145–99.

NAUMANN, R. *Der Quellbezirk von Nîmes* (*Denkmäler antiker Architektur*, IV). Berlin, 1937.

PIGANIOL, A. *Les Documents cadastraux de la colonie romaine d'Orange* (XVe Suppl. à *Gallia*). Paris, 1962. Remains of marble plans recording the survey of the territories of the colonia and details of the assignment of the individual plots.

ROLLAND, H. *Fouilles de Glanum (Saint-Rémy-de-Provence)* and *Fouilles de Glanum, 1947–56* (I^re and XI^e Suppl. à *Gallia*). Paris, 1946 and 1958.

ROLLAND, H. *Le Mausoleé de Glanum* (XXI^e Suppl. à *Gallia*). Paris, 1969.

ROLLAND, H. *L'Arc de Glanum* (XXXI^e Suppl. à *Gallia*). Paris, 1977.

SAUTEL, J. *Vaison dans l'antiquité.* 3 vols. Avignon, 1941–2, and Lyon, 1942.

WUILLEUMIER, P. *Fouilles de Fourvière à Lyon* (IV^e Suppl. à *Gallia*). Paris, 1951.

For the date of the theatre, see, however, A. Audin in *Latomus* (1957), 225–31.

3. The Germanies

FREMERSDORF, F. *Der römische Gutshof Köln-Mungersdorf* (Römisch-Germanische Forschungen, VI). Frankfurt-am-Main, 1933.

For numerous other publications of villas and farmsteads in the Rhineland, see *Anz.* (e.g. F. Oelmann, 'Römische Villen im Rheinland' (1928), 228–50) and *Bonner Jahrbücher* (e.g. H. Mylius in CXXIII (1916) and CXXIX (1924), two articles with tentative restored views that have left their mark on much subsequent work); also articles in *Germania* and *Trierer Zeitschrift.*

Germania Romana: Römerstädte in Deutschland, vols. I and II (*Gymnasium*, Beihefte 1 and 5). Heidelberg, 1960 and 1965.

GOSE, E. *Der gallo-römische Tempelbezirk in Altbachtal.* Mainz, 1972.

KRENCKER, D., and KRÜGER, E. *Die Trierer Kaiserthermen.* Augsburg, 1929.

Neue Ausgrabungen in Deutschland. Berlin (Römisch-Germanische Kommission des Deutschen Archäologischen Instituts), 1958.

PETRIKOVITS, H. VON. *Das römische Rheinland.* Cologne, 1960.

ROEREN, R. 'Zur Archäologie und Geschichte Sudwestdeutschland im 3–5 Jahrhunderts', *Jahrbuch des Römisch-Germanische Zentralmuseums Mainz*, VII (1960), 214–94.

WIGHTMAN, E. M. *Roman Trier and the Treveri.* London, 1970.

For Trier, see also Bibliography to Chapter 15.

4. Britain

Good classified bibliographies to the extensive and widely scattered literature of Roman Britain will be found in the works of Richmond, Rivet, and Wacher, quoted below, and in W. Bonser, *A Romano-British Bibliography, 55 B.C.–A.D. 448*, Oxford, 1964. See also 'The Year's Work in Roman Britain' annually in

J.R.S. until 1969; now superseded by *Britannia*, I (1970), in progress.

For interim reports on the post-war excavations at Verulamium (St Albans) and Corinium (Cirencester), see *Antiquaries Journal* since 1956 and 1960, respectively.

The bibliography that follows is limited to a few general works and to sites mentioned in the text.

CUNLIFFE, B. W. *Roman Bath.* Society of Antiquaries of London, 1969.

CUNLIFFE, B. W. *Excavations at Fishbourne.* Society of Antiquaries of London, 1971.

FRERE, S. S. *Britannia.* London, 1967. Second revised ed., 1978.

KENYON, K. M. 'The Roman Theatre at Verulamium', *Archaeologia*, LXXXIV (1934), 213–60.

LEWIS, M. J. T. *Temples in Roman Britain.* Cambridge, 1966.

LIVERSIDGE. J. *Britain in the Roman Empire.* London, 1968.

RADFORD, C. A. R. 'The Roman Villa at Ditchley, Oxon.', *Oxoniensia*, I (1936), 24–69.

RICHMOND, I. A. *Roman Britain.* London, 1963.

RICHMOND, I. A. 'The Roman Villa at Chedworth', *Transactions of the Bristol and Gloucestershire Archaeological Society*, LXXVIII (1959), 5–23.

RIVET, A. L. F. (ed.) *Town and Country in Roman Britain.* London, 1958.

RODWELL, W., and ROWLEY, T. *Small Towns of Roman Britain* (British Archaeological Reports, XV). Oxford, 1975.

WACHER, J. S. (ed.). *The Civitas Capitals of Roman Britain.* Leicester, 1966.

WACHER, J. *The Towns of Roman Britain.* London, 1975.

WHEELER, R. E. M. and T. V. *The Prehistoric, Roman and Post-Roman site in Lydney Park, Gloucestershire.* Society of Antiquaries of London, 1932.

WHEELER, R. E. M. and T. V. *Verulamium: a Belgic and two Roman Cities.* Society of Antiquaries of London, 1936.

5a. South-eastern Europe: General Works

Much of the bibliography of Roman architecture in the Adriatic, Balkan, and Danubian provinces is scattered and difficult to locate, but for the provinces of Noricum, Pannonia, Upper Moesia, and Dalmatia (an area corresponding to the modern Austria south and east of the rivers Danube and Inn, Hungary south and west of the Danube, and most of Yugoslavia) there now exist well documented general accounts in the work by Alföldi, Mócsy, and Wilkes, cited below. For Austria and for earlier work within the Austro-

Hungarian Empire, see also *J.Ö.A.I.* For Bulgaria, the bibliography contained in the notes of Hoddinott (see below) is useful, though selective; *Izvestiya na Bulgarskiya Archeologischeskiya Institut (I.B.A.A.)* includes short summaries in other languages. The principal Romanian publication is *Dacia (Recherches et découvertes archéologiques en Roumanie)*, I (1924)–XII (1947), and new series since I (1957).

ALFÖLDI, G. *Noricum*. London, 1974.

HODDINOTT, R. F. *Bulgaria in Antiquity*. London, 1975.

IVANOV. T. 'Der Städtebau in Ober- und Untermoesien und Thrakien in der Römerzeit und der Spätantike', *Actes du Premier Congr. Int. des Études Balkaniques et Sud-est Européennes*, 491–502. Sofia, 1969.

MÓCSY, A. *Pannonia and Upper Moesia*. London, 1974.

THOMAS, B. *Römische Villen in Pannonien*. Budapest, 1964.

WILKES, J. J. *Dalmatia*. London, 1969.

5b. South-eastern Europe: Some Sites mentioned in the Text

ADAMKLISSI
Florescu, F. B. *Das Siegesdenkmal von Adamklissi*. Bonn, 1965.

AENONA
Cagiano de Azevedo, M. 'Aenona e il suo Capitolium', *Rend. Pont.*, XXII (1946–7), 193–226.

AQUINCUM
Szilagyi, J. *Aquincum*. Berlin, 1956.

ASSERIA
J.Ö.A.I., XI (1908), Beiblatt 32–44 (Arch) and 47–53 (Forum).

BUTHROTUM (BUTRINTO)
Ugolini, L. M. *Albania Antica*, III: *L'Acropoli di Butrinto*. Rome, 1942.

CARNUNTUM
Swoboda, E. *Carnuntum: seine Geschichte und seine Denkmäler*. 2nd ed. Vienna, 1953.

DOCLEA
Sticotti, P. *Die römische Stadt Doclea in Montenegro (Schriften der Balkankommission, Antiquarische Abteilung, VI)*. 1913.

HISTRIA
Condurachi, E. *Histria*. Bucharest, 1962.

SALONA
Ceci, E. *I Monumenti pagani di Salona*. Milan, 1962.

SERDICA
Serdika: arkheologicheski materiali i prouchvoniya (Serdica: Matériaux et recherches archéologiques), I.

Archaeological Institute of the Bulgarian Academy, Sofia, 1964.
In Bulgarian, but liberally illustrated and with French summaries.

VIRUNUM
J.Ö.A.I., XV (1912), Beiblatt 24–36.
For Sirmium and Spalato (Split), see Bibliography to Chapter 15.

CHAPTER 10

Ancient Corinth: a guide to the excavations. 6th ed. American School of Classical Studies at Athens, 1954.

Corinth: Results of the Excavations conducted by the American School of Classical Studies at Athens. I, I (1932)–6 (1964) and II (1952). Quoted as: *Corinth*.

GINOUVÈS, R. *Le Théâtron à gradins droits et l'Odeion d'Argos*. École française d'Athènes, 1972.

GIULIANO, A. *La Cultura artistica delle province della Grecia in età romana*. Rome, 1965.

Hesperia (Journal of the American School of Classical Studies at Athens), I– (1932–).

HILL, I. T. *The Ancient City of Athens: its topography and monuments*. London, 1953.

HÖRMANN, H. *Die inneren Propyläen von Eleusis (Denkmäler antiker Architektur, I)*. Berlin–Leipzig, 1932.

JUDEICH, W. *Topographie von Athen (Handbuch der Altertumswissenschaft, 2, 2)*. 2nd ed. Munich, 1931.

KOUROUNIOTES, K. *Eleusis: a guide to the excavations and museum*, transl. O. Broneer. Archaeological Society at Athens, 1936.

ROBINSON, H. S. *The Urban Development of Ancient Corinth*. American School of Classical Studies at Athens, 1965.

THOMPSON, H. A., and WYCHERLEY, R. E. *The Agora at Athens (The Athenian Agora, XIV)*. American School of Classical Studies at Athens, 1972.

THOMPSON, H. A. (ed.). *The Athenian Agora, Guide³*. American School of Classical Studies at Athens, 1976.

TRAVLOS, J. *A Pictorial Dictionary of Ancient Athens*. New York, 1971.

CHAPTER 11

(a) General Works

AKURGAL, E. *Ancient Civilizations and Ruins of Turkey*. Istanbul, 1970.

DE BERNARDI FERRERO, D. *Teatri classici in Asia Minore*, I–IV. Turin, 1966–74.

DELORME, J. *Gymnasion*. Paris, 1960.
Especially pp. 243–50.

MAGIE, D. *Roman Rule in Asia Minor.* 2 vols. Princeton, 1950.

Mansel'e Armağan (*Mélanges Mansel*). 3 vols. Ankara, 1974.

Monumenta Asiae Minoris Antiqua, I (1928)–VIII (1962). Manchester University Press.

Proceedings of the X International Congress of Classical Archaeology, Ankara-Izmir, 1973. Ankara, 1978.

Türk Arkeoliji Dergisi. Ankara. Commonly cited as *T.A.D.*

Annual reports of excavations and finds in Turkey, published in the languages of the contributors. Reports include Anemurium (by J. W. Russell) since 1971; Aphrodisias (by K. T. Erim) since 1960; Hierapolis (by P. Verzone) since 1971; Knidos (by I. C. Love) since 1973; Sardes (by G. A. Hanfmann) since 1960.

VERMEULE, C. C. *Roman Imperial Art in Greece and Asia Minor.* Harvard, 1968.

WARD-PERKINS, J. B. 'Notes on the Structure and Building Methods of Early Byzantine Architecture', in D. Talbot Rice (ed.), *The Great Palace of the Byzantine Emperors*, II (Edinburgh, 1958), 52–104. Building practices in Roman Asia Minor.

(b) Some Area Studies and Individual Sites

Altertümer von Pergamon, I (1912)–. Berlin. In progress.

ALZINGER, W. *Augusteische Architektur in Ephesos* (*Sonderschriften d. Öst. Arch.-Inst. in Wien*, XVI). Vienna, 1974.

BEAN, G. *Aegean Turkey.* London, 1966.

BEAN, G. *Turkey's Southern Shore.* London, 1968.

BEAN, G. *Turkey beyond the Maeander.* London, 1971.

DES GAGNIERS, J., and others. *Laodicée du Lykos: le Nymphée.* Quebec–Paris, 1969.

ERIM, K. T. 'Recent Discoveries at Aphrodisias', *Proc. X Int. Congr. of Classical Archaeology*, II, 1065–76.

Forschungen in Ephesos veröffentlicht vom Österreichischen Archäologischen Institut in Wien, I (1906)–. In progress.

GOUGH, M. 'Anazarbus', *Anatolian Studies*, II (1952), 85–150.

Jahreshefte des Österreichischen Archäologischen Institutes in Wien (J.Ö.A.I.), I (1898). In progress (containing year-by-year accounts of the Austrian excavations at Ephesus).

KEIL, J. *Führer durch Ephesos.* 5th ed. Vienna, 1964. With bibliography.

KLEINER, G. *Die Ruinen von Milet.* Berlin, 1968. Good classified bibliography.

KRENCKER, D., and SCHEDE, M. *Der Tempel in Ankara* (*Denkmäler antiker Architektur*, III). Berlin–Leipzig, 1936.

LANCKORONSKI, K. *Städte Pamphyliens und Pisidiens.* 2 vols. Vienna, 1892.

LAVIOSA, C. 'Les Fouilles de Iasos', *Proc. X Int. Congr. of Classical Archaeology*, II, 1093–9.

LOVE, I. C. 'A Brief Summary of Excavations at Knidos, 1967–1973', *Proc. X Int. Congr. of Classical Archaeology*, II, 1111–33.

Also brief interim reports in *A.J.A.* since LXXII (1968).

MACCANICO, R. 'Ginnasi romani ad Efeso', *Arch. Cl.*, XV (1963), 32–60.

MANSEL, A. M. 'Bericht über Ausgrabungen und Untersuchungen in Pamphylien', *Anz.* (1956), 34–120 and (1975), 49–96.

MANSEL, A. M. *Die Ruinen von Side.* Berlin, 1963.

Milet. Ergebnisse der Ausgrabungen und Untersuchungen seit dem Jahre 1899, ed. Th. Wiegand. Berlin–Leipzig. Especially the following:

I, 5 (1919) The Nymphaeum
I, 6 (1922) The North Market
I, 7 (1924) The South Market
I, 9 (1928) Baths and Gymnasia

MILTNER, F. *Ephesos: Stadt der Artemis und des Johannes.* Vienna, 1958.

NAUMANN, R. *Der Zeustempel zu Aizanoi* (*Denkmäler antiker Architektur*, XII). Berlin, 1979.

NAUMANN, R., and KANTAR, S. 'Die Agora von Smyrna', in *Kleinasien und Byzanz* (*Istanbuler Forschungen*, XVII), 69–114. Berlin, 1950.

ROSENBAUM, E., and others. *A Survey of Coastal Cities in Western Cilicia.* Ankara, 1967.

RUSSELL, J. 'Recent Excavations at Roman Anemurium', *Proc. X Int. Congr. of Classical Archaeology*, 911–23.

SCHNEIDER, A. M., and KARNAPP, W. *Die Stadtmauer von Iznik (Nicaea)* (*Istanbuler Forschungen*, IX). Berlin, 1938.

VETTERS, H., and others. 'Grabungen in Ephesos von 1960–69 bzw. 1970', *J.Ö.A.I.*, L (1972–5), Beiblatt, 224 ff.

CHAPTER 12

(a) General Works

Annales Archéologiques Arabes Syriennes (*Annales Archéologiques de Syrie*), I (1951). Direction Générale des Antiquités de Syrie. Quoted as: *A.A.A.S.* In progress.

BUTLER, H. C. *Publications of an American Archaeological Expedition to Syria in 1899–1900*, pt. 2:

Architecture and Other Arts. New York, 1903. Quoted as Butler, *Architecture.*

BUTLER, H. C. *Princeton University Archaeological Expeditions to Syria in 1904–5 and 1909:* Division II, part A (quoted as Butler, *South Syria*). Leiden, 1906–19. Division II, part B (quoted as Butler, *North Syria*). Leiden, 1907–20.

COLLEDGE, M. A. R. *Parthian Art.* London, 1977.

FRÉZOULS, E. 'Recherches sur les théâtres de l'Orient Syrien', *Syria*, XXXVI (1959), 202–27; XXXVIII (1961), 54–86.

HARDING, G. L. *The Antiquities of Jordan.* London, 1959.

KOHL, H., and WATZINGER, C. *Antiker Synagogen in Galiläea.* Leipzig, 1916.

KRENCKER, D. M., and ZSCHIETZSCHMANN, W. *Römische Tempel in Syrien* (*Denkmäler antike Architektur*, V). Berlin–Leipzig, 1938.

ROSTOVTZEFF, M. *Caravan Cities.* Oxford, 1932. *Syria*, I (1920). Institut français d'archéologie de Beyrouth. In progress.

(b) Some Area Studies and Individual Sites

Antioch-on-the Orontes, I, *The Excavations of 1932;* II, *The Excavations of 1933–36;* III, *The Excavations of 1937–39.* Princeton, 1934–41. Quoted as: *Antioch.*

AVI-YONAH, M., and others. *Masada, Survey and Excavations, 1955–6.* Jerusalem, 1957. The excavation of the 'Hanging Palace'.

Baalbek, ed. Th. Wiegand. 2 vols. Berlin–Leipzig, 1921–3.

BACHMANN, W., and others. *Petra* (*Wissenschaftliche Veröffentlichungen des deutsch-türkischen Denkmalschutz-Kommandos*, III). Berlin–Leipzig, 1921.

COLLART, P., and COUPEL, J. *L'Autel monumental de Baalbek.* Institut français d'archéologie de Beyrouth, 1951.

COLLART, P., and VICARI, J. *Le Sanctuaire de Baalshamin à Palmyre*, I and II. Institut Suisse de Rome, 1969.

COUPEL, J., and FRÉZOULS, E. *Le Théâtre de Philippopolis en Arabie.* Paris, 1956.

DOWNEY, G. *A History of Antioch in Syria.* Princeton, 1961.

FINSEN, H. *Théâtre romain à Bosra, Syrie* (*Analecta Romana Instituti Danici*, VI, Supplement). Copenhagen, 1972.

KRAELING, C. H. *Gerasa, City of the Decapolis.* New Haven, 1938.

Palmyra: Ergebnisse der Expeditionen von 1902 und 1917 (ed. Th. Wiegand). 2 vols. Berlin, 1932. Quoted as: *Palmyra.*

PARR, P. J., WRIGHT, G. R. H., STARCKY, J., and BENNETT, C. M. 'Découvertes récentes au Sanctuaire du Qasr à Petra', *Syria*, XLV (1968), 1–66.

PERKINS, A. *The Art of Dura.* Oxford, 1973.

RICHMOND, I. A. 'Palmyra under Roman Rule', *J.R.S.*, LIII (1963), 43–54.

ROSTOVTZEFF, M. *Dura-Europos and its Art.* Oxford, 1938.

Samaria-Sebaste, I. J. W. Crowfoot and others, *The Buildings.* London, 1942.

SAUVAGET, J. 'Le Plan antique de Damas', *Syria*, XXVI (1949), 314–58.

Scavi di Caesarea Maritima (ed. A. Frova), I. Milan, 1965.

SEYRIG, H. 'Palmyra and the East', *J.R.S.*, XL (1950), 1–7.

SEYRIG, H., AMY, R., and WILL, E. *Le Temple de Bel à Palmyre* (*Institut français d'Archéologie de Beyrouth*, LXXXIII). Paris, 1979.

TCHALENKO, G. *Villages antiques de la Syrie du nord: le massif du Bélus à l'époque romaine.* 3 vols. Paris, 1953.

The Excavations at Dura-Europos. Preliminary Reports. First Season (1927–28)–Ninth Season (1935–36). New Haven, 1929–52. Quoted as: *Dura.*

WATZINGER, C., and WULZINGER, K. *Damaskus: die antike Stadt.* Berlin, 1921.

WRIGHT, G. R. H. 'The Khazne at Petra: a review', *Annual of the Department of Antiquities of Jordan*, VI/VII (1962), 24–54.

YADIN, Y. 'The Excavation of Masada, 1963–64: preliminary report', *Israel Expedition Quarterly*, XV (1965), pts 1–2.

YADIN, Y. *Masada: Herod's Fortress and the Zealots' Last Stand.* London, 1966.

CHAPTER 13

1. Egypt

BOAK, A. E. R., and PETERSON, E. E. *Karanis. Excavations, 1924–28* (*University of Michigan Humanistic Series*, XXV). Ann Arbor, 1931.

BOAK, A. E. R. *Soknopaiou Nesos. Excavations at Dîme, 1931–32* (*ibid.*, XXIX). Ann Arbor, 1935.

KRAUS, T., and RÖDER, J. 'Mons Claudianus', *Mitteilungen des deutschen archäologischen Instituts, Abteilung Kairo*, XVIII (1962), 80–120.

MONNERET DE VILLARD, U. 'The Temple of the Imperial Cult at Luxor', *Archaeologia*, XCV (1953), 85–105.

MONNERET DE VILLARD, U. *La Nubia romana.* Rome, Istituto per l'Oriente, 1941.

SJÖQVIST, E. 'Kaisareion: a study in architectural iconography', *Acta Rom. Suec.*, XVIII (1956), 86–108.

WACE, A. J. B., and others. *Hermoupolis Magna, Ashmunein.* Alexandria, 1959.

2. *Cyrenaica*

(a) Publications covering both Cyrenaica and Tripolitania

Africa Italiana: Rivista di Storia e d'Arte a cura del Ministero delle Colonie. 8 vols. 1927–41.
Annual Report of the Society for Libyan Studies, I (1969–70). Since 1980 titled *Libyan Studies. Annual Report* etc. In progress.
GOODCHILD, R. G. *Libyan Studies: Select Studies of the late R. G. Goodchild.* Society for Libyan Studies, London, 1976.
Libya Antiqua, I (1964), and Supplements. Department of Antiquities, Libya. In progress.
Monografie di Archeologia Libica, I (1948). Rome. In progress.
Notiziario Archeologico del Ministero delle Colonie, I (1915)–IV (1927).
Quaderni di Archeologia della Libia, I (1950). In progress.
SICHTERMANN, H. 'Archaeologische Funde und Forschungen in Libyen, 1942–1961', *Anz.* (1962), 439–509.

(b) Publications related specifically to Cyrenaica

GOODCHILD, R. G. *Cyrene and Apollonia: an historical guide.* Department of Antiquities, Cyrenaica, 1959.
HUMPHREY, J. H. (ed.) *Apollonia, the Port of Cyrene: Excavations by the University of Michigan, 1965–1967 (Supplements to Libya Antiqua, IV).*
KRAELING, C. H. *Ptolemais, City of the Libyan Pentapolis.* University of Chicago, 1962.
MINGAZZINI, P. *L'Insula di Giasone Magno a Cirene (Monografie, VIII).* Rome, 1966.
PESCE, G. *Il 'Palazzo delle Colonne' in Tolemaide (Monografie, II).* Rome, 1950.
STUCCHI, S. *L'Agora di Cirene*, I (*Monografie*, VII). Rome, 1965.
STUCCHI, S. *Architettura Cirenaica (Monografie, IX).* Rome, 1975.
WARD-PERKINS, J. B., and BALLANCE, M. H. 'The Caesareum at Cyrene and the Basilica at Cremna', *P.B.S.R.*, XXVI (1958), 137–94.

3. *Tripolitania*
(See also 2(a), s.v. 'Cyrenaica', above; also Romanelli,

Topografia e archeologia dell'Africa Romana, s.v. 'Tunisia, Algeria, Morocco', below)

BARTOCCINI. R. *Le Terme di Lepcis.* Bergamo, 1929.
BIANCHI BANDINELLI, R. (ed.). *Leptis Magna.* Rome, 1963.
CAPUTO, G. *Il Teatro di Sabratha e l'architettura teatrale africana (Monografie, VI).* Rome, 1959.
DEGRASSI, N. 'Il Mercato romano di Leptis Magna', *Quaderni*, II (1951), 27–70.
DI VITA, A. *Tripolitania ellenistica e romana alla luce delle più recenti indagini archeologiche (Monografie, XII).* Rome, forthcoming.
HAYNES, D. E. L. *An Archaeological and Historical Guide to the pre-Islamic Antiquities of Tripolitania.* 2nd ed. Tripoli, 1955.
PESCE, G. *Il Tempio di Iside in Sabratha (Monografie, IV).* Rome, 1953.
ROMANELLI, P. *Leptis Magna.* Rome, 1925.
SQUARCIAPINO, M. F. *Leptis Magna.* Basel, 1966.
TOYNBEE, J. M. C., WARD-PERKINS, J. B., and FRASER, R. 'The Hunting Baths at Leptis Magna', *Archaeologia*, XCIII (1949), 165–95.
WARD-PERKINS, J. B. 'Severan Art and Architecture at Leptis Magna', *J.R.S.*, XXXVIII (1948), 59–80.
WARD-PERKINS, J. B. 'Tripolitania and the Marble Trade', *J.R.S.*, XLI (1951), 89–104.

4. *Tunisia, Algeria, Morocco*
Much of the essential bibliography of Roman Tunisia, Algeria, and Morocco is scattered in local periodicals that are not generally accessible. In addition to the works listed below and in the Notes, descriptions of many of the excavated sites and buildings here mentioned will be found in the annual reports published in the *Bulletin archéologique du Comité des travaux historiques et scientifiques*.

BALLU, A. *Les Ruines de Timgad (antique Thamugadi).* 3 vols. Paris, 1897, 1903, 1911.
BESCHAOUCH, A., HANOUNE, R., and THÉBERT, Y. *Les Ruines de Bulla Regia.* École française de Rome, 1977.
CAGNAT, R., and GAUCKLER, P. *Les Monuments historiques de la Tunisie: les temples païens.* Paris, 1898.
Cedac Bulletin, I (1978). Institut National d'Archéologie et d'Art, Carthage. In progress. Includes detailed bibliography of reports on the recent excavations at Carthage.
CONSTANS, L.-A. 'Gigthis: étude d'histoire et d'archéologie sur un emporium de la Petite Syrte', *Nouvelles Archives des Missions Scientifiques*, XIV (1916), 1–113.

COURTOIS, C. *Timgad: antique Thamugadi*. Algiers, 1951.

ÉTIENNE, R. *Le Quartier nord-est de Volubilis*. Paris, 1960.

FRÉZOULS, E. 'Teatri romani dell'Africa francese,' *Dioniso*, XV (1952), 90–103.

GSELL, S. *Monuments antiques de l'Algérie*, I. Paris, 1901.

GSELL, S., and JOLY, C. A. *Khamissa, Mdaourouch, Announa*, I, *Khamissa* (Thubursicu Numidarum); II, *Mdaourouch* (Madauros); III, *Announa* (Thibilis). Algiers–Paris, 1914–22.

Karthago, I (1950). Paris, Centre d'études archéologiques de la Méditerranée occidentale (formerly Mission archéologique française en Tunisie). In progress.

LESCHI, L. *Djémila: antique Cuicul*. Algiers, 1953.

LÉZINE, A. *Architecture romaine d'Afrique*. Tunis, n.d. [*c*. 1961].

Libyca: Bulletin du Service des Antiquités de l'Algérie, I (1953) – IX (1961).

MAREC, E. *Hippone la Royale: antique Hippo Regius*. Algiers, 1954.

MERLIN, A. *Le Forum de Thuburbo Maius*. Tunis–Paris, 1922.

PICARD, G.-C. *Civitas Mactaritana* (*Karthago*, VIII). 1957.

PICARD, G.-C. *La Civilisation de l'Afrique romaine*. Paris, 1959.

POINSSOT, C. *Les Ruines de Dougga*. Tunis, 1958.

RAKOB, F. 'Das Quellenheiligtum in Zaghouan und die römische Wasserleitung nach Karthago', *R.M.*, LXXXI (1974), 41–97.

REBUFFAT, R. 'Maisons à peristyle d'Afrique du Nord: répertoire de plans publiés', *Mélanges d'archéologie et d'histoire de l'École française de Rome*, LXXXI (1969), 659–724.

ROMANELLI, P. *Topografia e archeologia dell'Africa Romana* (*Enciclopedia classica*, III, vol. 10, 7). Turin, 1970.

THOUVENOT, R. *Volubilis*. Paris, 1949.

WARMINGTON, B. H. *The North African Provinces from Diocletian to the Vandal Conquest*. Cambridge, 1954.

CHAPTER 14
(See also note at beginning of Section B, above, and bibliographies to Chapters 1–5, particularly 4.)

BARTOLI, A. *Curia Senatus: lo scavo ed il restauro* (*I monumenti romani*, III). Florence, 1963.

DEICHMANN, F. W. 'Untersuchungen an spätrömischen Rundbauten in Rom', *Anz.* (1941), 733–48.

FRAZER, A. 'The Iconography of the Emperor

Maxentius' Buildings in Via Appia', *Art Bulletin*, XLVIII (1966), 385–92.

L'ORANGE, H. P., and GERKAN, A. VON. *Der spätantike Bildschmuck des Konstantinsbogens*. Berlin, 1939.

MINOPRIO, A. 'A Restoration of the Basilica of Constantine', *P.B.S.R.*, XII (1932), 1–25.

PISANI SARTORIO, G., and CALZA, R. *La Villa di Massenzio sulla Via Appia*. Rome, 1976.

RICHMOND, I. A. *The City Wall of Imperial Rome*. Oxford, 1930.

STETTLER, M. *Jahrbuch der Zentralmuseum, Mainz*, IV (1957), 123 ff.
For the Licinian Pavilion.

CHAPTER 15

KRAUTHEIMER, R. *Early Christian and Byzantine Architecture* (*Pelican History of Art*), chapter 3. 3rd ed. Harmondsworth, 1979.

Sirmium. Institute of Archaeology, Belgrade, I (1971)–.
Jugoslav-American and Jugoslav-French excavation reports, in progress.

WARD-PERKINS, J. B. In D. Talbot Rice (ed.), *The Great Palace of the Byzantine Emperors*, II, 52–104. Edinburgh, 1958.

1. North Italy

DUVAL, N. 'Que savons-nous du Palais de Théodoric à Ravenne?', *Mélanges d'archéologie et d'histoire de l'École française de Rome*, LXXII (1960), 337–71.

GHERARDINI, G. 'Gli Scavi del Palazzo di Teodorico a Ravenna', *Mon. Ant.*, XXIV (1917), 737–838.

GHISLANZONI, E. *La Villa romana in Desenzano*. Milan, 1962.

Storia di Milano (Fondazione Treccani, Milan), I (1953), parts 5 and 9: A. Calderini, 'Milano durante il Basso Impero' and 'Milano archeologico'.

2. Piazza Armerina

DUNBABIN, K. M. D. *The Mosaics of North Africa*, 196–212 and appendix V. Oxford, 1978.

GENTILI, G. V. *La Villa Imperiale di Piazza Armerina* (*Itinerari*, no. 87). Rome, 1954.

GENTILI, G. V. *La Villa Erculia di Piazza Armerina: i mosaici figurati*. Milan, 1959.

LAVIN, I. 'The House of the Lord: aspects of the role of palace *triclinia* in the architecture of late antiquity and in the early Middle Ages', *Art Bulletin*, XLIV (1962), 1–27.

LUGLI, G. 'Contributo alla storia edilizia della villa

romana di Piazza Armerina', *Rivista dell'Istituto Nazionale di Archeologia e Storia dell'Arte*, XI–XII (1963), 28–82.

NEUERBERG, N. 'Some Considerations on the Architecture of the Imperial Villa at Piazza Armerina', *Marsyas*, VIII (1959), 22–9.

3. Spalato (Split) and Salona

CLAIRMONT, C. W., and others. *Excavations at Salona, Yugoslavia (1969–1972)*. Park Ridge, N.J., 1975.

DUVAL, N. 'La Place de Split dans l'architecture du Bas-Empire', *Urbs* (Split, 1961–2), 67–95.

HEBRARD, E., and ZEILLER, J. *Spalato. Le Palais de Dioclétien*. Paris, 1911.

MARASOVIĆ, J. and T. *Diocletian (sic) Palace*. English ed. Zagreb, 1970.

MARASOVIĆ, J., and others. *Excavations in the Southeast Quarter of Diocletian's Palace, Split*. Town Planning Institute, Split. Vol. 1, 1972, and 2, 1976.

NIEMANN, G. *Der Palast Diokletians in Spalato*. Vienna, 1910.

SCHULZ, B. 'Die Porta Aurea in Spalato', *J.D.A.I.*, XXIV (1909), 46–52.

4. Thessalonike (Salonica)

DYGGVE, E. 'La Région palatiale de Thessalonique', *Acta Congressus Madvigiani* (Copenhagen, 1958), I, 353–65.

HÉBRARD, E. 'L'Arc de Galère et l'église Saint-Georges à Salonique', *B.C.H.*, XLIV (1920), 5–40.

MAKARONAS, C. I. 'To oktagōnon tēs Thessalonikēs', *Praktika* (1950), 303–21.

Tabula Imperii Romani, sheet K34 (*Naissus* etc.), ed. J. Šašel, Ljubljana, 1979, contains a map and excellent bibliography of classical Thessaloniki, by A. Avramea.

5. Trier

EIDEN, H., and MYLIUS, H. 'Untersuchungen an den spätrömischen Horrea von St Irminen in Trier', *Trierer Zeitschrift*, XVIII (1949), 73–106.

GOSE, E. *Die Porta Nigra in Trier*. 2 vols. Berlin, 1969.

KRENCKER, D., and KRÜGER, E. *Die Trierer Kaiserthermen*. Augsburg, 1929.

REUSCH, W. *Anz.* (1962), 875–903. Summarizing recent work on the Aula Palatina, with bibliography to 1962.

REUSCH, W. *Augusta Treverorum: ein Gang durch das römische Trier*. Trier, 1965.

REUSCH, W. *Die Kaiserthermen in Trier*. Trier, Landesmuseum, 1965. Guidebook.

WIGHTMAN, E. *Roman Trier and the Treveri*. London, 1970.

LIST OF ILLUSTRATIONS

*From this point onwards, all dates are A.D. unless otherwise noted.

The drawings and adaptations were made by Miss Sheila Gibson

INDEX

References to the notes are given to the page on which the note occurs, followed by the number of the chapter and the number of the note; thus, 484(12)²⁶ indicates page 484, chapter 12, note 26. Notes are indexed only when they contain information other than bibliographical, to which there is no obvious reference from the text. Classical authors are indexed only if they are referred to in the text; divinities only if they themselves are the object of substantial comment.

THE PELICAN HISTORY OF ART

COMPLETE LIST OF TITLES

*Published only in original large hardback format.
†Latest edition in integrated format (hardback and paperback).
‡Latest edition in integrated format (paperback only).
§Published only in integrated format (hardback and paperback).
‖Not yet published.

ART AND ARCHITECTURE IN BELGIUM: 1600–1800* *H. Gerson and E. H. ter Kuile, 1st ed., 1960*

FLEMISH BAROQUE ART AND ARCHITECTURE‖ *Hans Vlieghe*

DUTCH ART AND ARCHITECTURE: 1600–1800‡ *Jakob Rosenberg, Seymour Slive and E. H. ter Kuile, 3rd ed., 1977*

ART AND ARCHITECTURE IN FRANCE: 1500–1700‡ *Anthony Blunt, 4th ed., 1980, reprinted with revisions 1982*

ART AND ARCHITECTURE OF THE EIGHTEENTH CENTURY IN FRANCE* *Wend Graf Kalnein and Michael Levey, 1st ed., 1972*

ART AND ARCHITECTURE IN SPAIN AND PORTUGAL AND THEIR AMERICAN DOMINIONS: 1500–1800* *George Kubler and Martin Soria, 1st ed., 1959*

ARCHITECTURE IN BRITAIN: 1530–1830‡ *John Summerson, 7th ed., 1983*

SCULPTURE IN BRITAIN: 1530–1830† *Margaret Whinney, 2nd ed., revised by John Physick, 1988*

PAINTING IN BRITAIN: 1530–1790† *Ellis Waterhouse, 4th ed., 1978*

PAINTING IN BRITAIN: 1790–1890‖ *Michael Kitson*

ARCHITECTURE: NINETEENTH AND TWENTIETH CENTURIES‡ *Henry-Russell Hitchcock, 4th ed., 1977, reprinted with corrections 1987*

PAINTING AND SCULPTURE IN EUROPE: 1780–1880‡ *Fritz Novotny, 2nd ed., 1970, reprinted with revisions 1978*

PAINTING AND SCULPTURE IN EUROPE: 1880–1940‡ *George Heard Hamilton, 3rd ed., 1981, reprinted with revisions 1987*

AMERICAN ART* *John Wilmerding, 1st ed., 1976*

THE ART AND ARCHITECTURE OF ANCIENT AMERICA‡ *George Kubler, 3rd ed., 1984*

THE ART AND ARCHITECTURE OF RUSSIA‡ *George Heard Hamilton, 3rd ed., 1983*

THE ART AND ARCHITECTURE OF ANCIENT EGYPT† *W. Stevenson Smith, 3rd ed., revised by W. Kelly Simpson, 1981*

THE ART AND ARCHITECTURE OF INDIA: HINDU, BUDDHIST, JAIN‡ *Benjamin Rowland, 4th ed., 1977*

THE ART AND ARCHITECTURE OF THE INDIAN SUBCONTINENT§ *J. C. Harle, 1st ed., 1986*

THE ART AND ARCHITECTURE OF ISLAM: 650–1250§ *Richard Ettinghausen and Oleg Grabar, 1st ed., 1987*

THE ART AND ARCHITECTURE OF ISLAM: 1250–1800‖ *Sheila Blair and Jonathan Bloom*

THE ART AND ARCHITECTURE OF THE ANCIENT ORIENT‡ *Henri Frankfort, 4th revised impression, 1970*

THE ART AND ARCHITECTURE OF JAPAN‡ *Robert Treat Paine and Alexander Soper, 3rd ed., 1981*

THE ART AND ARCHITECTURE OF CHINA‡ *Laurence Sickman and Alexander Soper, 3rd ed., 1971*

CHINESE ART AND ARCHITECTURE‖ *William Watson, 2 vols.*

THE ARTS OF AFRICA‖ *B. J. Mack*

THE ARTS OF OCEANIA‖ *Stephen Hooper*

*Published only in original large hardback format.
†Latest edition in integrated format (hardback and paperback).
‡Latest edition in integrated format (paperback only).
§Published only in integrated format (hardback and paperback).
‖Not yet published.